히토 슈타이얼 –
데이터의 바다

HITO STEYERL –
A SEA OF DATA

목차

CONTENTS

발간사

윤범모
국립현대미술관
관장

국립현대미술관은 아시아 최초로 세계적 거장 히토 슈타이얼의 개인전 《히토 슈타이얼—데이터의 바다》를 개최합니다. 독일 뮌헨 출신의 히토 슈타이얼은 경계선을 무색하게 하면서, 즉 예술, 철학, 정치 등의 영역을 넘나들면서 미디어 아티스트, 영화감독, 비평가 등으로 활약하고 있는 동시대 가장 영향력 있는 작가입니다. 2017년 『Art Review』에서 '영향력 1순위 인물'로 선정한 것도 이유가 있습니다.

이번 서울관에서 개최된 히토 슈타이얼 전시는 주요 작품 23점을 소개합니다. 초기작 다큐멘터리부터 디지털 기술 기반의 작품에 이르기까지 다채롭게 펼쳐집니다. 전시 제목 '데이터의 바다'는 그의 논문에서 인용한 것으로 디지털 기술의 데이터 사회 현실을 반영한 내용입니다. 이를 위해 인공지능, 머신 러닝, 알고리즘 등 디지털 기술을 활용합니다. 여기에 국립현대미술관을 위한 커미션 신작 〈야성적 충동〉(2022)을 공개합니다.

전시는 '데이터의 바다', '안 보여주기—디지털 시각성', '기술, 전쟁, 그리고 미술관', '유동성 주식회사—글로벌 유동성', '기록과 픽션' 등으로 나누어 전개됩니다. 전시 작품 모두가 새로우면서도 현대미술의 주요한 담론을 아우르고 있습니다.

이번 전시를 위해 적극적으로 도움을 준 히토 슈타이얼 작가에게 감사의 말씀을 올립니다. 더불어 훌륭한 전시가 되도록 힘을 보태준 여러분께 다시 한번 감사의 말씀을 올립니다. 감사합니다.

Youn Bummo
Director, National Museum of
Modern and Contemporary Art, Korea

National Museum of Modern and Contemporary Art, Korea (MMCA) is proud to present *Hito Steyerl—A Sea of Data*, the first solo exhibition in Asia by the world-renowned artist Hito Steyerl. A native of Munich, Steyerl is someone who renders the notion of "borders" meaningless: one of the contemporary era's most influential artists, she is active in a wide range of areas including art, philosophy, and politics through her work as a media artist, film director, and critic. This also explains why she was chosen by *Art Review* as the "most influential person in art" in 2017.

Steyerl's exhibition at MMCA Seoul features 23 of her major works. It is a diverse mixture including everything from her early documentaries to her work based on digital technology. The exhibition title *A Sea of Data* comes from one of her essays, reflecting the reality of our data society rooted in digital technology. To this end, the artist makes use of digital technology such as artificial intelligence, machine learning, and algorithms. Also featured in the exhibition is *Animal Spirits* (2022), a new work commissioned for MMCA.

The exhibition consists of sections such as "A Sea of Data," "How Not to Be Seen—Digital Visuality," "Technology, War and Museum," "Liquidity Inc.—Global Liquidity," and "Documentation and Fiction." The combination of the freshness of all these works and the discourse they provide is certain to elevate the tone within the exhibition venue.

I would like to thank Hito Steyerl for her proactive support in realizing this exhibition. I also offer my gratitude once again to everyone who helped in bringing this marvelous exhibition about. Thank you.

기획의 글:
히토 슈타이얼—
데이터의 바다

배명지
국립현대미술관
학예연구사

히토 슈타이얼은 디지털 기술, 글로벌 자본주의, 팬데믹 상황이라는 오늘날 첨예한 사회적 상황 속에서 이미지 생산과 소비에 대한 통찰력 있는 관점을 제시하고 있는 동시대 가장 영향력 있는 미디어 작가이다. 또한 예술, 철학, 정치 영역을 넘나들며 미디어, 이미지, 기술에 관한 흥미로운 논점을 던져주는 뛰어난 비평가이자 저술가이기도 하다. 아시아 최초로 국립현대미술관에서 열린《히토 슈타이얼—데이터의 바다》는 다큐멘터리적 성격을 지닌 필름 에세이 형식의 1990년대 초기 영상에서부터 인터넷, 게임, 가상현실, 로봇 공학, 인공지능 등 디지털 기술 자체를 비판적으로 바라보는 작가의 최근 영상 작업에 이르기까지 작가의 대표작 23점을 소개하였다.

전시의 부제 '데이터의 바다'는 슈타이얼의 논문 「데이터의 바다: 아포페니아와 패턴(오)인식」에서 인용한 것으로, 오늘날 또 하나의 현실로 재편된 데이터 사회를 성찰적으로 바라보고자 하는 전시의 의도를 함축한다. 데이터 기반 이미지가 인터넷 공간을 넘어 현실 공간에 침투하고 실질적 삶의 여러 층위에 관여하고 있는 현재적 시공간은 이번 전시의 주요한 배경이다. 해서 이번 전시에는 빅데이터와 알고리즘에 의해 조정되고 소셜 미디어를 통해 순환하는 이미지와 이러한 데이터 재현 배후의 기술, 자본, 권력, 정치의 맥락을 비판적으로 바라보는 작가의 최근 영상 작업이 집중적으로 소개되었다.

슈타이얼의 작품과 저술이 데이터 기반 사회에 대한 성찰과 더불어, 디지털 시각체제, 기술과 전쟁의 관계, 유동적 순환주의, 다큐멘터리적 불확실성 등에 대한 관심을 폭넓게 아우르고 있어, 이번 전시는 그의 작업 세계를 다층적인 문맥에서 조망하기 위해 '데이터의 바다', '안 보여주기—디지털 시각성', '기술, 전쟁, 그리고 미술관', '유동성 주식회사—글로벌 유동성', '기록과 픽션' 등 총 5부로 구성하였다. 즉《히토 슈타이얼—데이터의 바다》는 데이터 사회에 대한 슈타이얼의 예술적, 학술적 탐구를 경유하며, 가속화된 자본주의와 전쟁과 재난이 지속되는 오늘날의 상황 속에서 디지털 문화가 만들어낸 새로운 이미지, 시각성, 세계상 및 동시대 미술관의 위상을 살피는, 번뜩이는 사유의 순간이 되고자 한다.

Curatorial Essay:
Hito Steyerl—
A Sea of Data

Bae Myungji
Curator, National Museum of
Modern and Contemporary Art, Korea

Hito Steyerl is one of the most influential media artists of today, sharing insightful perspectives on image production and consumption in the heated societal situation of today, as exemplified by digital technology, global capitalism, and the pandemic. She is also a superlative critic and writer who works in the realms of art, philosophy, and politics as she raises fascinating points about media, the image, and technology. *Hito Steyerl—A Sea of Data* at the National Museum of Modern and Contemporary Art, Korea (MMCA) is the artist's first solo exhibition in Asia, sharing 23 of her most representative works from her early video works in the 1990s, which took the form of film essays with a documentary quality, to her most recent video works critically reflecting on digital technology itself, including the internet, games, virtual reality, robot engineering, and artificial intelligence.

The exhibition subtitle *A Sea of Data* comes from the title of Steyerl's essay "A Sea of Data: Apophenia and Pattern (Mis-)Recognition" (2016), alluding to the exhibition's aim of gazing reflectively on a data society that is being transformed today into a different reality. The central backdrop for the exhibition is the spatial and temporal environment of today, where data-based images extend beyond online space to permeate the spaces of reality, involving themselves in multiple layers of our real lives. Accordingly, the exhibition focuses on presenting the artist's recent video works, which turn a critical gaze on the images that are mediated by big data and algorithms and circulated over social media, as well as the contexts of technology, capital, power, and politics behind these data representations.

In addition to their reflections on the data-based society, Steyerl's artwork and writings encompass a broad range of other interests, including digital visual systems, the relationship between technology and war, fluid circulationism, and documentary uncertainty. To examine her body of work within its multilayered contexts, the exhibition was divided into five sections: "A Sea of Data," "How Not to Be Seen—Digital Visuality," "Technology, War and Museum," "Liquidity Inc.— Global Liquidity," and "Documentation and Fiction." Through Steyerl's artistic and academic exploration of the data society, *Hito Steyerl—A Sea of Data* attempts to provide a flickering moment of reflection as it considers what digital culture has created within today's environment of accelerated capitalism and persistent war and disaster: the new images, the new visuality, the face of the world, and the status of the contemporary art museum.

1. 데이터의 바다

오늘날 우리가 인터넷에서 검색하는 수많은 정보들과 핸드폰으로 촬영하여 SNS에 업로드 하는 사진들은 빅데이터로 저장되고 알고리즘을 통해 분석, 재조정되어 사회, 경제, 문화, 정치 등 우리 삶 전반에 영향을 미치고 있다. 팬데믹으로 인해 현실 세계에서의 활동이 점점 줄어들고 있는 오늘날, 이러한 디지털 기술 기반의 데이터 사회는 더욱 가속화되고 있다.

슈타이얼은 「데이터의 바다: 아포페니아와 패턴(오)인식」에서 오늘날 우리 삶의 표현들은 데이터의 흔적에 반영되어 있고, 정보 생명 정치는 이를 관리하고 경작(farming)하고 채굴(mining)한다고 언급한다. 그는 신석기 시대에 개발된 모든 종류의 농경 기술과 채굴 기술이 오늘날 재발명되어 데이터에 적용되는, 현재 새롭게 귀환한 '데이터 신석기 시대'에 대해 흥미로운 의견을 제시한 바 있다. 실제로 우리는 마인크래프트의 추출(extraction) 패러다임과 비트코인의 채굴 시스템을 실시간 목도하고 있다. 작가는 또한 오늘날 세상을 인식하는 것은 시각보다는 데이터를 해독하고 처리하는 패턴 인식에 달려있다고 말한다. 상업적, 군사적 패턴뿐만 아니라 신용 점수, 학업 점수, 위협 점수 등 온갖 종류의 사회 점수와 각종 데이터들은 등급이 매겨지고

필터링되고 분류되어 사회적 위계를 만들어낼 뿐 아니라 우리들의 인생에 실제로 큰 영향을 미친다는 것이다.[1]

슈타이얼이 이러한 데이터 사회를 바라보는 시각은 낙관적이지만은 않다. 그는 딥 러닝을 통해 알고리즘이 내린 결정에 따라 우리의 삶 자체가 좌지우지되는 시대를 문제시하고, 데이터를 선점하고 분석하고 사용하는 통제 능력이 곧 권력이 되는 테크노크라시의 이면을 들여다보며, 인공지능을 인공 우둔함이라는 역설적 언어로 비판한다. 첫 번째 장인 '데이터의 바다'에서는 〈태양의 공장〉(2015), 〈깨진 창문들의 도시〉(2018), 〈미션 완료: 벨란시지〉(2019), 〈이것이 미래다〉(2019), 〈소셜심〉(2020), 그리고 국립현대미술관 커미션 신작 〈야성적 충동〉(2022)에 이르기까지 데이터, 인공지능, 머신 러닝, 알고리즘 등을 작품 형식과 내용의 지지대로 삼으면서 데이터 사회를 비평하는 작가의 주요 작품들을 소개하였다.

데이터 순환주의

슈타이얼은 〈미션 완료: 벨란시지〉에서 데이터 순환주의와 정보 생명정치학이 엄연히 작동하는 현실태를 짚어낸다. 패션쇼의 런웨이를 연상시키는 푸른색 나선형 구조의 설치 작품을 배경으로, 히토 슈타이얼과 조르지 가고 가고시츠, 밀로스 트라킬로비치의 3채널 렉처

1
히토 슈타이얼, 「데이터의 바다: 아포페니아와 패턴(오)인식」, 『면세 미술: 지구 내전 시대의 미술』, 문혜진, 김홍기 옮김 (서울: 워크룸 프레스, 2021), 68-72.

1. A Sea of Data

All the information that we seek online these days and all the images we capture with our mobile phones and upload to social media are stored in the form of "big data" and analyzed and rearranged by algorithms, with results that have an enormous impact on all areas of our lives, including our society, economy, culture, and politics. This digitally based "data society" has only been accelerating lately as the pandemic has reduced our activities in the real world.

In her essay "A Sea of Data: Apophenia and Pattern (Mis-) Recognition," Steyerl observes how expressions of our lives today are reflected in data trails, and how informational biopolitics manages, farms, and mines them. She presents fascinating ideas about the "Data Neolithic," where all the agricultural and mining technologies that were developed during the Neolithic have returned today in new forms, reinvented and applied to data. Indeed, we can observe this in real time with Minecraft's extraction paradigm and the Bitcoin mining system. Steyerl also comments that perceiving the world today hinges less on vision than on pattern recognition as it pertains to interpreting and processing data. In addition to commercial and military patterns, various other forms of data and social scoring—including credit scores, academic scores, and threat scores—are ranked, filtered, and classified, not only creating social hierarchies but also exerting real and

vast influence on our lives.[1]

Steyerl's perspective on the data society is not entirely optimistic. Raising issues with an era in which our very lives are dictated by the decisions made by algorithms using deep learning, she peers into the underside of the technocracy, where power lies in control capabilities based on the acquisition, analysis, and use of data; she critiques artificial intelligence with her use of the paradoxical term "artificial stupidity." The first part, titled "A Sea of Data," presents major examples of works in which Steyerl critiques the data society while treating data, AI, machine learning, and algorithms as support for her form and content. They consist of *Factory of the Sun* (2015), *The City of Broken Windows* (2018), *Mission Accomplished: BELANCIEGE* (2019), *This is the Future* (2019), *SocialSim* (2020), and *Animal Spirits* (2022), a new work commissioned by MMCA.

Data Circulationism

In *Mission Accomplished: BELANCIEGE* (2019), Hito Steyerl observes a reality in which data circulationism and information biopolitics unquestionably operate. Set against the backdrop of a spiral-structured blue installation reminiscent of a fashion show runway, the work centers on a three-channel lecture performance video by Steyerl, Giorgo Gago Gagoshidze, and Miloš Trakilović, focusing on the fashion brand Balenciaga as it reflects on the political, social, and cultural upheavals that have occurred over the roughly three decades

1

Hito Steyerl, "A Sea of Data: Apophenia and Pattern (Mis-)Recognition," *Duty Free Art: Art in the Age of Planetary Civil War* (London and New York: Verso, 2017); Korean trans. Mun Hyejin & Kim Honggi (Seoul: Workroom Press, 2021), 68–72.

퍼포먼스 영상을 중심으로 하는 이 작품은 명품 브랜드 발렌시아가를 중심으로 1989년 베를린 장벽이 무너진 후 도널드 트럼프 당선까지의 약 30년 동안의 정치, 사회, 문화 변동을 고찰한다. 여기서 패션 브랜드 발렌시아가는 유럽의 국가사회주의 붕괴와 신자유주의 이데올로기, 포퓰리즘, 소셜 네트워크 시대를 반영하며 변화를 거듭하고, 동유럽과 서유럽, 정치권과 패션계를 넘나드는 하나의 패션 데이터로 등장한다. 슈타이얼이 사용한 용어 '벨란시지'는 '발렌시아가 방식'을 뜻하는 것으로, 실제 상품이 아니라 소셜 미디어에서 만들어지고 업로드되고 공유되며 일종의 '무기화된 데이터 알고리즘'으로 순환하면서 패션을 넘어 대중문화, 경제, 그리고 정치의 영역까지 그 영향력을 행사하는 현상을 일컫는다.

영상에서도 언급하고 있듯이, 벨란시지는 초거대 닷컴 기업과 다국적 터보 자본주의의 온라인 쇼케이스를 통해 정보의 영역으로 끊임없이 확장되었다. 이러한 패션 데이터 알고리즘은 기업의 마케팅뿐 아니라 정치나 선거에도 공격적으로 사용되면서 정보 생명정치를 역동적으로 작동시킨다. 일례로, 발렌시아가의 수석 디자이너인 뎀나 바잘리아가 만든 패션 브랜드 베트멍은 수많은 인터넷 유저가 자발적으로 생산한 밈을 미끼로 쓰는 전략을 취하면서 소셜 네트워크에서 파급되는 패션

데이터를 하나의 마케팅에 사용한다. 또한 특정 대통령 후보자의 선거를 위해 페이스북에서 데이터를 탈취하여 다양한 버전의 맞춤형 타깃 광고를 만들어 소셜미디어를 조정하였던 정보분석회사 케임브리지 애널리티카(Cambridge Analytica)의 전술은 순환하는 벨란시지 방법론을 정치적으로 오용한 또 다른 예이다.[2] 영상에서 언급하듯, 벨란시지는 봇들이 디자인한 옷들로, 인공지능이 렌더링한 청바지 스타일로 대안 우파를 유인하기도 하며, 사용자들의 해시태그를 끌어내 패션을 자동화하면서 디자이너들을 불필요한 존재로 만들어버리기도 한다. 거대한 데이터, 클라우드가 지배하는 패션 회사 벨란시지는 사용자가 스스로 스타일을 공동 제작하고 제어하고 관리한다는 점에서 일종의 국영 기업이라고도 비유적으로 말할 수 있다.

또한 벨란시지는 데이터 순환주의를 통해 프레임 밖을 전용하고 사유화한다. 예로, 특정 이미지와 정보를 만들고 인스타그램 같은 플랫폼에 업로드하고 공유하는 노동과 그 이후 프레임 밖의 다른 행위로 인해 그것들이 추적되고 누적되고 수집되고 발굴되는 사용자 선호도가 사유화 과정에 포함된다. 이는 오늘날 우리가 사진을 촬영하고 공유하는 방식과 같다. 오늘날 핸드폰으로 사진 찍는 것은 순간을 포착하는 것을 넘어 데이터를 수집, 보관,

2
영상의 내용에서 케임브리지 애널리티카의 선거 조작을 폭로한 내부 고발자 크리스토퍼 와일리에 따르면 이 회사는 페이스북 이용자에게서 탈취한 데이터로 다양한 버전의 맞춤형 타깃 광고를 만들어 도널드 트럼프 선거에 개입하였으며, 패션 데이터를 이용한 인공지능 모델을 만들어 스티브 배넌이 대안 우파 선동을 하는 데 도움을 주었다.

between the fall of the Berlin Wall in 1989 and the election of Donald Trump as US President. Transforming with the collapse of European state socialism, the burgeoning of free market ideology, populism, and the social network era, the Balenciaga brand appears as "fashion data" alternating between Eastern and Western Europe and the worlds of politics and fashion. The term "Belanciege" that Steyerl uses in the work is a reference to the "Balenciaga way"— a phenomenon in which it reaches beyond fashion to influence the realms of popular culture, economy and the politics, not through actual products but through things created, uploaded, and shared on social media and circulated through "weaponized data algorithms."

As mentioned in the video, "Belanciege" has continued to expand into the realm of information through the online showcase of massive dotcoms and multinational capitalism. These fashion data algorithms are used aggressively not only for corporate marketing but also for politics and elections, as information biopolitics is deployed in dynamic ways. Indeed, Vetements, a fashion brand co-founded by Balenciaga senior designer Demna Gvasalia, was created out of a strategy in which memes voluntarily created by various internet users are used as bait, while fashion data are employed for marketing as they ripple through social networks. An example of the circulating "Belanciege" methodology being abused for political ends can be found in the tactics of Cambridge

Analytica, an information analysis company that hijacked Facebook data to support the election of a particular presidential candidate, creating different targeted ads to manipulate social media.[2] As also mentioned in the video, Balenciaga appeals to the alt-right with bot-designed clothes and AI-rendered blue jean styles, encouraging users to apply hashtags as it automates fashion and renders designers unnecessary. As a fashion company governed by Big Data and cloud computing, Balenciaga could be likened to a state-run corporation, in the sense that users co-create, control, and manage their own style.

Belanciege also makes use of data circulationism to appropriate and privatize what lies outside of its frame. For instance, this privatization process encompasses the labor of creating particular images and information and sharing them by uploading them to platforms such as Instagram, as well as the user preferences that are tracked, amassed, collected, and unearthed through subsequent actions beyond the frame. It is a similar phenomenon to the way in which we take and share pictures today. When we photograph something on our mobile phone, we are not simply capturing a moment, but also collecting, storing, and privatizing data. The photograph becomes a frame or warehouse for storing traces of unseen information, and it also serves as data for commercialization, peddled back to users through customized ads and weaponized algorithms. Steyerl uses the term "computational photography"

2

In the video, Christopher Wylie, the whistle-blower who disclosed Cambridge Analytica's election interference, describes how the company influenced the election of Donald Trump as US president by making various targeted ads using data taken from Facebook users, while supporting Steve Bannon's alt-right agitation tactics by creating AI models using fashion data.

사유화하는 것을 뜻한다. 사진은 보이지 않는 정보의 흔적을 담는 프레임이나 보관함이 되며, 그것은 맞춤형 광고나 무기화된 알고리즘으로 다시 팔린다는 점에서 상업화의 재료가 되기도 한다. 슈타이얼이 알고리즘에 의해 조정되고 계산된 사진을 전산 사진(computational photography)이라 명명하였듯이, 이러한 사진은 여러 데이터베이스를 교차 참조하여 드러나고, 무수한 시스템과 사람들이 그것에 잠재적으로 간섭하므로 본질적으로 정치적이다.[3] 이것은 빅데이터가 단순히 우리가 누구인지를 식별하기 위한 것이 아니라 '우리와 유사한' 다른 이들과 관련하여 우리를 식별하려는[4] 방식과도 같다. 디지털 네트워크 세상이 현실을 재편하고 있는 지금, 이러한 데이터 순환주의가 현실 삶의 많은 영역에서 영향을 미치고 있다는 점에서 슈타이얼이 말한 벨란시지 미션은 완료된 것처럼 보인다.

이것은 게임이 아니다,
이것은 현실이다.
〈태양의 공장〉은 현실 세계의 육체노동이 데이터 노동으로 치환되는 데이터 사회의 세계상을 담고 있으면서도, 오늘날 네트워크 공간에서 작동하는 가상 공간이 현실 세계에도 적잖이 영향을 미치고 있음을 이야기한다. 작품의 제목 '태양의 공장'은 이 영상의 주인공이자 내레이터인 율리아가 모션 캡처 스튜디오에서

제작하고 있는 게임의 이름이다. 영상에 등장하는 인물들은 모두 스튜디오 노동자들로, 일종의 강제노역인 그들의 춤 동작은 모션 캡처 수트에 부착된 센서를 통해 인공태양광으로 변환된다. 대표적인 인물이 바로 자신의 댄스 영상을 유튜브에 올려 스타가 된 율리아의 동생이다. 그의 춤은 컴퓨터로 캡처되고 데이터로 전환되어 게임과 애니메이션 등에 활용된다. 영상에서 그의 춤은 포사이스, 스트리트 파이트 가일, 오드왈드 등의 캐릭터로 전환되었고 유튜브 가상 세계에서 '데이터 이미지'로서 폭발적으로 순환되었다.

한편, 데이터화된 가상의 인물들은 게임 공간과 물리적 현실 세계를 연결시킨다. 예로, 네이키드 노멀은 런던에서 등록금 반대 시위 중 사살되었고, 빅보스 하드팩트는 자유항 예술창고를 점거해서 렌더팜 협동조합으로 변화시키는 싱가포르 봉기 중 진압당한다. 하이 볼티지는 반IS 쿠르드 군과 싸우다 코바니에서 두 번 죽었으며, 리퀴드 이지는 도이치은행 고주파수 거래 봇과 싸우다 죽는다. 이들은 모두 미래에 사망하여 게임과 앱에 모여 있는 플레이 불가 캐릭터로서, 사실상 이 게임은 현실로 인식된다.

'이것은 게임이 아니다. 이것은 현실이다'라는 영상 속의 대사처럼 데이터 공간은 노동, 경제, 환경, 정치를 둘러싼 현실상을 대체하는

3
히토 슈타이얼, 「대리 정치: 신호와 잡음」, 『면세 미술: 지구 내전 시대의 미술』, 38–39.

4
Wendy Hui Kyong Chun, "Big Data as Drama", *ELH 83*, no. 2 (Summer 2016): 370

to refer to these photographs regulated and calculated through algorithms; they appear through the cross-referencing of multiple databases, and they are inherently political, with the countless systems and people that have the potential to interfere with them.[3] It is akin to the way in which Big Data does not attempt to identify who we are, but to identify us in relation to others "like us."[4] At a time when the digital network world is reconfiguring reality, the Belanciege mission that Steyerl describes appears to have indeed been "accomplished," in the sense that there is no longer any realm where the influence of data circulationism is not felt.

This is Not a Game, This is Reality
While it presents a vision of the data society where real-world physical labor is converted into data labor, *Factory of the Sun* also addresses the ways in which virtual spaces operating in today's network environments exert considerable influence on the real world. The title *Factory of the Sun* is the name of a game produced at a motion capture studio by the video's protagonist and narrator, a woman named Yulia. The others who appear in the video are all workers at the studio, whose dance movements—a kind of forced labor— are converted into artificial solar energy by sensors attached to their motion capture suits. The main figure is Yulia's brother, who became a star by posting dance videos on YouTube. His dancing is captured by a computer and converted into data for use in games and

animation. It is transformed in the video into characters such as "Forsythe," "Guile the street fighter," and "Odwaldo," circulating explosively as data images in the virtual world of YouTube.

Meanwhile, the virtual characters converted into data serve to connect the game space with the physical world. Naked Normal, for example, was killed during a protest against student fees in London, while Big Boss Hard Facts was crushed during Singapore protests in which he occupied free port art storage to transform it into a render farm cooperative. High Voltage was killed twice in Kobani fighting with Kurdish forces against IS, and Liquid Easy was killed while fighting a Deutsche Bank High Frequency Trade bots. All of them are noplayable characters who died in the future and have been assembled for games and applications; in effect, the game is perceived as reality.

As indicated by the subtitle "This is Not a Game, This is Reality" in the video, the data space becomes not simply a proxy taking the place of the reality surrounding labor, economics, the environment, and politics—it is now reality itself. This data-based virtual world fundamentally reconfigures real-world spaces—in a world of Bot News activities that compile and sort data to produce particular messages algorithmically, in geopolitical environments like Berlin's Teufelsberg where a listening station was set up to conduct political surveillance between countries using electromagnetic frequencies supplied through fiber-optic

3
Hito Steyerl, "Proxy Politics: Signal and Noise," *Duty Free Art*, 38-39.

4
Wendy Hui Kyong Chun, "Big Data as Drama," *ELH 83*, no. 2 (Summer 2016): 370.

대리물이 아니라 이제 현실 그 자체가 되었다. 데이터를 종합하고 배열하여 알고리즘적으로 특정한 메시지를 생산하는 봇 뉴스가 활동하는 세계에서, 베를린의 토이펠스베르크처럼 유리섬유 케이블로 공급되는 전자기적 주파수를 통해 감청 기지를 세워 국가 사이의 정치적 감시를 작동시키는[5] 지리정치학적 공간에서, 페이스북과 소셜 미디어에서 활동하는 불특정 다수가 정치적 힘을 발휘하는 지대에서 이러한 데이터 기반의 가상세계는 현실공간을 근본적으로 재구성한다. 이제 인터넷상의 데이터와 소리, 이미지는 스크린을 넘어 물질의 다른 상태로 이동하고, 데이터 채널의 범주를 넘어 물질적으로 나타나며, 공간(spaces)을 장소(sites)로, 현실(reality)을 자산(realty)으로 변형시키며 도시에 침입한다.[6] 데이터와 인공지능 기반으로 구축된 새로운 네트워크 세계는, 긍정적이든, 부정적이든, 우리의 물리적 삶과 일상에 서서히 잠입하고 이를 근본적으로 뒤흔들어 놓는다. 우리는 이제 데이터가 재편한 공간에 등장하고 상호작용하는 인물들이 된다.

소셜 시뮬레이션

슈타이얼의 2020년작 〈소셜심〉은 오프라인 공간이 닫히고 온라인을 기반으로 한 시뮬레이션 가상공간이 현실 세계를 더욱 적극적으로 대체하기 시작한 팬데믹 기간 동안, 혼란스러운 사회 상황과 예술 창작의 조건, 변화하는 동시대 미술관의 위상을 다룬 5채널 영상 작품이다. 작품의 제목이기도 한 소셜 시뮬레이션은 인간의 상호작용을 단순화한 모델이다. 긴급 대피 시나리오를 가상으로 실험하기 위해 아바타나 비디오 게임의 형식을 빌려 작은 출입구를 통과하는 인물들의 행동을 연구하는 것, 혹은 에너지 소비, 사냥 패턴, 감염률, 인공 차별 같은 상황을 조정하기 위해 이를 가상으로 시뮬레이션하는 것 등이 소셜 시뮬레이션의 대표적인 예이다.[7]

슈타이얼의 〈소셜심〉이 정부가 실제로 사용하고 있는 소셜 시뮬레이션에 기반하고 있다는 사실은 흥미롭다. 수감 기간을 어떻게 설정해야 재범죄율을 낮출 수 있는지 등을 포함하여 사회를 가장 잘 통제할 수 있는 최적의 변수(parameter)를 찾기 위해 사법 당국이 실질적으로 수행하고 있는 시뮬레이션 모델은 바로 슈타이얼 〈소셜심〉의 출발점이 된다. 소셜 시뮬레이션 모델은 수신기의 잡음처럼 쉼 없이 움직이는 파동 그래프로 나타나는데, 그것이 작동하는 모습은 매우 안무적이고 역동적일 뿐 아니라, 여기에는 생명에 관한 측면을 위계화하고 신체를 통제하려는 사회적 기제와 정치적 무의식이 각인되어 있다. 다시 말해 소셜 시뮬레이션이 내재적으로 가지고 있는

5
영상에도 등장하는 베를린의 토이펠스베르크는 냉전 기간 중 미 국가안보국이 감청기지를 세운 곳으로 여기서 미국은 모든 통신을 도청했다.

6
Hito Steyerl, "Too Much World: Is the Internet Dead?" in e-flux journal: The Internet Does Not Exist (Berlin: Sternberg Press, 2015), 12.

7
Ayham Ghraowi, "Dance Dance Rebellion," in Hito Steyerl: I Will Survive, eds. Florian Ebner et al. (Leipzig, Germany: Spector Books, 2021), 6.

cables,[5] and in areas where multitudes active on Facebook and other social media wield political power. These data , sounds, and images are now transitioning beyond screens into a different state of matter, surpassing the boundaries of data channels and manifesting materially; they invade cities, transforming spaces into sites, and reality into realty.[6] The new network world built on the foundation of data and AI has slowly infiltrated our physical lives and experience, for better or for worse, and is unsettling them in fundamental ways. We now find ourselves appearing and interacting in spaces that have been reorganized by data.

Social Simulation

Steyerl's *SocialSim* (2020) is a five-channel video work that explores the chaotic social situation and conditions of artistic creation and changing status of the art museum during the COVID-19 pandemic, a period in which offline spaces closed down and online-based simulated virtual spaces began even more actively taking the place of the real world. A social simulation—which is also where the name of the work comes from—presents a simplified model of human interactions. Prominent examples of social simulations include the use of "avatars" and video game formats to study the behaviors of people passing through small exits as part of a virtual experiment with disaster evacuation scenarios, or the creation of virtual simulations to regulate energy consumption, hunting patterns, infection rates, racial discrimination, and other situations.[7]

Interestingly, Steyerl's *SocialSim* is based on actual social simulations used by governments. The starting point for the work lies in the simulation models put to practical use by authorities to identify the optimal parameters for effectively controlling society, including matters such as what incarceration periods are best for lowering recidivism. The social simulation model appears as a constantly moving wave form, yet its movements appear quite choreographed and dynamic, and it is inscribed with societal mechanisms and a political unconscious that seeks to stratify aspects related to human life and to control the body. In other words, these two aspects—the political drives inherent to social simulations and their dynamic movement at the level of representation—provide support for *SocialSim*'s form and content.

In the first room of *SocialSim*, police officer avatars appear on the fourth channel, performing an endless mad dance. Their dance varies with AI commentary and data trends, including the numbers of people killed, injured, or unaccounted for at demonstrations in Europe during the pandemic in 2020, and it is also linked with the movements of police officers and soldiers suppressing those protests. It thus becomes a form of "social choreography," connecting with social data and internalizing control. In this respect, *SocialSim* establishes links with two different worlds: socialism

5

Teufelsberg in Berlin that appears in the video was also where the National Security Agency built a listening station during the Cold War, using the location to intercept all communications.

6

Hito Steyerl, "Too Much World: Is the Internet Dead?" in *e-flux journal: The Internet Does Not Exist* (Berlin: Sternberg Press, 2015), 12.

7

Ayham Ghraowi, "Dance Dance Rebellion," in *Hito Steyerl: I Will Survive*, eds. Florian Ebner et al. (Leipzig, Germany: Spector Books, 2021), 6.

'정치적 동인'과 그것이 표상의 층위에서 나타내는 '역동적 움직임' 양자는 〈소셜심〉의 형식과 내용의 지지대이다.

〈소셜심〉의 첫 번째 방에는 쉬지 않고 미친 듯이 춤을 추는 경찰 아바타가 4채널에 등장하는데, 그들의 춤은 2020년 팬데믹 기간 중 유럽에서 일어난 대중 시위 현장의 사망자, 부상자, 실종자 수와 같은 데이터의 추이와 인공지능의 논평에 따라 달라지고 그 시위를 진압하는 경찰 및 군인들의 몸짓과 연동한다. 해서 그들의 춤은 사회적 데이터와 접합하고 통제를 내면화한 일종의 '사회적 안무'가 된다. 여기서 〈소셜심〉은 통제와 권력의 세계인 소셜리즘과 데이터와 알고리즘이 실재를 대체하는 소셜 시뮬레이션, 두 세계 모두와 연결된다.

슈타이얼은 경찰 아바타의 무아지경의 몸짓을 11세기 베른부르크에서부터 14세기 후반 아헨, 쾰른, 스트라스부르그 등을 거쳐 제1차 세계 대전 후 베를린에서 일어났던 댄싱 마니아, 즉 '무도광'(舞蹈狂)과 연결시킨다. 유럽에서 흑사병이 크게 돌았을 때, 많은 사람들이 병에 걸리기 시작하면 갑자기 춤을 추는 움직임을 시작하고 이런 움직임을 죽을 때까지 끝낼 수가 없었다고 한다. 〈소셜심〉의 댄싱 마니아에서 미친 듯이 춤을 추는 경찰 아바타의 모습은 바로 이러한 무도광의 순간과 죽음의 춤(Dance of Death)을 재연한 것이라고도 할 수 있다.

여기서 그들의 움직임은 팬데믹의 맥락과 불안감 속에서 정보의 생산과 순환, 인포데미아(infodemia, 가짜 뉴스를 통한 감염)의 확산에 의해 증폭된다.[8]

데이터와 시뮬레이션에 의해 신체 움직임이 조정되는 이러한 순간은 헤겔이 『법철학』에서 말한, 인간이 물러나고 기계가 그의 자리를 차지하는 순간이다. 팬데믹 시기를 지나면서 우리가 겪고 있는 이 순간은 기계가 인간 앞에 서 있는, 현재 용어로는 데이터 알고리즘과 시뮬레이션 같은 자동화된 기술이 인간의 행위에 선행하고 인간의 행위를 결정짓는 바로 그 순간이다. 슈타이얼은 '헤겔 백플립(Hegel backflip)'이라는 용어로 이러한 상황에 대해 비판적 견해를 던진다.

〈소셜심〉의 두 번째 방에는 레오나르도 다빈치가 그린 것으로 짐작되는 도난 작품 〈살바토르 문디〉를 찾는 테스크 포스를 중심으로 한 단채널 영상이 전시된다. 여기서 〈살바토르 문디〉는 미술의 치외법권 지역인 자유무역항을 떠도는 시뮬레이션화된 가상미술관에서 인공지능이 만들어낸 미술의 유형으로 등장한다. 슈타이얼은 '인공 우둔함'이라는 용어로 팬데믹 시기에 더욱 자동화되고, 폐쇄되고, 가상현실 지도로 대체된 미술관에 대해 작가만의 다소 비평적인 논평을 던지고 있다. 영상에는 신경망 네트워크와 인공지능 딥러닝에 의해 제작된 미술의 유형이 등장하는데, 그것은 사회에 대한

8
Ayham Ghraowi, 같은 글, 12 및 2022년 4월 29일 MMCA 아티스트 토크 내용 참조.

as the world of control and power, and social simulations in which data and algorithms supplant reality.

Steyerl connects the ecstatic movements of the police avatars with the so-called "dancing mania" that was first observed in Bernburg in the 11th century and erupted in Aachen, Cologne, Strasbourg and other cities during the late 14th century before appearing in Berlin in the wake of World War I. It is said that when the Black Death was raging through Europe, many of those who contracted the disease would suddenly start to dance and did not stop until they died. In the dancing mania of *SocialSim*, the mad dancing of the police avatars could be seen as reenacting these moments of mania and the Dance of Death. Their movements here are amplified by the spread of infodemia (infection with fake news), as information is produced and cycled amid the pandemic context and our feelings of anxiety.[8]

Such moments in which physical movements are regulated by data and simulations represent the instant referred to by Hegel in his *Elements of the Philosophy of Right*, where the human being steps back and the machine takes its place. It is an experience we have encountered over the course of the pandemic: a moment when machinery takes precedence over humanity, or in contemporary terms one in which automated technology such as data algorithms and simulations come ahead of and determine human behavior. In her critique of this situation, Steyerl refers

to it by the term "a Hegel backflip."

The second room in *SocialSim* presents a single-channel video work that focuses on a task force looking for *Salvator Mundi*, a stolen artwork believed to have been painted by Leonardo da Vinci. *Salvator Mundi* appears here as an AI-created image in a simulated virtual museum adrift in a free trade port that exists outside of museum jurisdiction. Using the term "artificial stupidity," Steyerl shares her own rather critical comment on art museums that have become even more automated and closed-off during the pandemic, while being increasingly substituted with virtual reality maps. The art that appears in the video has been produced with neural networks and AI deep learning; it is an abstract concept of society, a "socialsim." It is automated art that evolves on its own, or what Steyerl refers to as "crapstraction" or "algostraction." As with cryptocurrency, there is no guarantee on the value of such art. Instead, there is simply a "jumble of sponsors, censors, bloggers, developers, producers, hipsters, handlers, patrons, privateers, collectors, and way more confusing characters."[9]

Artificial Stupidity
With her use of the term "artificial stupidity," Hito Steyerl advises us not to uncritically accept the new data-based ways in which the world has been reconfigured, but to reexamine them reflectively. Agreeing with the attribution of "artificial stupidity" to "weak AI systems," she notes that they are already

8
Ayham Ghraowi, ibid., 12; and MMCA Artist's Talk, April 29, 2022.

9
Hito Steyerl, "If You Don't Have Bread, Eat Art!: Contemporary Art and Derivative Fascisms," *Duty Free Art*, 210.

추상적 개념, 소셜심즈이다. 이는 스스로 진화하는 자동화 예술이자 슈타이얼이 말한 허접추상(crapsraction) 혹은 알고리즘 추상(algostraction)이다. 이러한 미술은 암호화폐가 그렇듯 그 가치를 보증할 수 없으며, 여기에는 스폰서, 검열관, 블로거, 개발자, 프로듀서, 힙스터, 핸들러, 독립활동가, 수집가, 그리고 이보다 훨씬 더 정체가 모호한 캐릭터들만이 뒤죽박죽 뒤섞여 있을 뿐이다.[9]

인공 우둔함

슈타이얼은 '인공 우둔함'이라는 용어를 제시하며 데이터를 기반으로 새롭게 재편된 세계상을 무조건적으로 수용할 것이 아니라 성찰적으로 재사유할 것을 권유한다. 그는 약한 AI 시스템(week AI system)을 '인공 우둔함'이라고 부르는 것에 동의하며, 이것의 주요 결과인 자동화가 이미 주요한 형태의 불평등과 사회 분열, 즉 토착주의, 유사 파시스트, 심지어 파시스트 운동을 만들어 내고 있다고 보았다. 더구나 이러한 자동화된 프로그램들이 더 지능적이 될수록, 사회적 분열과 양극화가 더 증가할 것이며 오늘날 일어나는 많은 정치적 혼란은 이러한 '인공 우둔함' 때문이라고 진단하였다.[10] 그리고 인공지능이 제공할 기술 유토피아에 대한 이러한 의심과 회의는 2019년 작 〈이것이 미래다〉에 반영되어 있다.

〈이것이 미래다〉는 터키에서 구금되어 감옥으로 간 쿠르드족 여인 헤자(Hêja)가 감옥 안에서 식물을 길렀다고 하는 이야기를 기반으로 하며, 여기에 신경 네트워크와 인공지능이 미래에 식물을 길러낸다는 픽션을 가미하여 재구성한 것이다. 헤자는 감옥 앞마당에서 날던 씨앗을 잡아 종이 위에 싹을 틔웠으나 교도관들은 꽃을 발견한 후 모두 없애버렸고, 이후 신경 네트워크는 미래에 꽃을 되찾을 수 있을 거라 예측한다. 그녀는 미래 정원에 꽃을 숨긴 후 신경 네트워크에 의해 재생된 꽃과 나무를 다시 찾아내는데, 호르데움 무리눔(보리풀), 시심브리움 알티시뭄(가는잎털냉이), 말바 네글렉타(난쟁이아욱) 등이 그것이다. 이 미래 정원의 식물들은 SNS 중독으로 뇌가 병든 사람을 치유하거나, 혐오와 선동에 둔감하게 하거나, 독재자를 독살하기도 하는 등의 마술적인 치유의 힘을 가지고 있다.

그 식물들(plant)은 작품의 제목 '파워 플랜츠'가 암시하듯 문자 그대로 동력(power)을 생산한다. 두 번째 방에 구성된 〈파워 플랜츠〉의 연속적으로 변형하는 만화경과 같은 컬러풀한 식물 이미지는 바로 인공지능과 미래 예측 알고리즘 프로그래밍에 의해 재생된 미래 정원의 꽃과 나무들로, 그것들은 0.04초 후에 자신의 미래를 예측한다. 즉 훈련된 미래 예측 알고리즘은 영화에서 한

9
히토 슈타이얼, 「빵이 없으면 미술을 드세요! 동시대 미술과 파생 파시즘」, 『면세 미술: 지구 내전 시대의 미술』, 210.

10
Hito Steyerl and Kate Crawford, "Data Streams." *The New Inquiry*, 23 January 2017, Retrieved 8 August 2017. https://thenewinquiry.com/data-streams/

having a major impact on our lives and that the main fallout is automation. She also identifies automation as being already responsible for major forms of inequality and social fragmentation–nativist, semi-fascist, and even fascist movements. Predicting that social fragmentation and polarization will only increase as these automated programs become more intelligent, she attributes a lot of the political turmoil that we are already seeing today to this sort of "artificial stupidity."[10] Her questions and skepticism about the technological utopias that AI offers are reflected in her 2019 work *This is the Future*.

Based on the story of a Kurdish woman named Hêja who was imprisoned in Turkey, *This is the Future* reconstructs it with elements of fiction, telling of plants that are grown in the future by neural networks and AI. Capturing seeds from the prison's front yard, Hêja has nurtured them to sprout on a piece of paper. But when the guards discover the flowers, they remove everything. The neural network then predicts that she will find the flower once again in the future. After concealing the flower in a future garden, Hêja rediscovers the flowers and trees recreated through the neural network, including wall barley (*Hordeum murinum*), tall tumble mustard (*Sisymbrium altissimum*) and dwarf mallow (*Malva neglecta*). The plants from the future garden boast magical healing properties: they can cure those whose brains are ailing from social media addiction, make people insensitive to hatred and incitement, and poison dictators.

As the title of the work's *Power Plants* structure alludes, the plants create literal power. In the second room, the continuously changing, kaleidoscopically colorful plant images of *Power Plants* present the viewer with the flowers and trees recreated through AI, predictive algorithms, and future prediction programming. The flowers predict their own future within 0.04 seconds. In other words, the predictive algorithms of the future are trained to predict and create the next sequence in the extremely short period of 0.04 seconds, or the time it takes to move from one frame to the next in film (24 frames per second).

At the same time, *This is the Future* shows Steyerl pointing out the stupidity of AI that can predict the future yet is incapable of observing the present, with phenomena of racial discrimination and war, totalitarianism and Brexit. It expresses skepticism over the credibility of predictive algorithms that anticipate not only traffic and credit ratings and rebellions but also suicide rates and lifespans. The artist also goes a step further in discussing the paradox of using neural networks to predict the future: doing so amounts to nothing more than rearranging past data that already exist, and in that sense the artist observes that it is impossible to have a future where things that do not happen do happen. The prediction of the future is based on management of the present, while the algorithm lacks historical perspective, so that continuing with this approach ironically renders the present more

10
Hito Steyerl and Kate Crawford, "Data Streams." *The New Inquiry*, January 23, 2017, Retrieved August 8, 2017. https://thenewinquiry. com/data-streams/

프레임 이후 다음 프레임이 만들어지는 0.04초(1초에 24프레임)라는 아주 짧은 시간 안에 다음 시퀀스를 예견하고 만들어낸다.

한편 슈타이얼은 〈이것이 미래다〉에서 미래를 예측하면서도 인종차별과 전쟁, 전체주의와 브렉시트가 일어나는 현재를 제대로 바라보지 못하는 인공지능의 우둔함을 꼬집는다. 또한 교통, 반란, 신용등급뿐 아니라 자살률과 수명까지 예견하는 예측 알고리즘의 신뢰성에 회의를 표명하고, 한 걸음 더 나아가 신경망을 활용해서 미래를 예측한다는 것의 역설을 논한다. 즉 미래를 예측한다는 것은 이미 존재하고 있는 과거의 데이터를 바탕으로 이를 재배치하는 것에 불과한데, 그렇기 때문에 작가는 근본적으로 일어나지 않는 것들이 일어나는 미래라는 것은 불가능하다고 본다. 즉 미래를 예측한다는 것은 현재를 관리하는 방식으로 이루어지는 것이고, 알고리즘에는 역사 인식이 결여되어 있기 때문에, 이러한 방식이 계속된다면 현재는 역설적으로 오히려 더 불안정하게 된다는 것이다.[11] 작가가 〈이것이 미래다〉 내에 독일에서 일어난 폭동, 반유대주의, 인종차별주의의 상황을 일깨우는 영상 푸티지를 집어넣은 것은 바로 불안정한 현재의 모습을 보여주기 위함이다.

디지털 식민주의 vs 공생

인공지능이 야기할 수 있는 사회적 불안정, 디지털 자본주의의 식민화에 대한 우려, 그리고 이에 대한 대안을 고민한 작품으로 2022년 최근작 〈야성적 충동〉을 들 수 있다. 국립현대미술관 커미션으로 4채널 영상 설치로 제작된 〈야성적 충동〉은 스페인 양치기 이야기로 구성된 단채널 내러티브 비디오와 특수 센서가 감지하는 식물의 환경(온습도) 변화에 실시간 반응하는 시뮬레이션 영상으로 구성되어 있다. 시뮬레이션 영상은 스페인과 프랑스의 구석기 시대 동굴 벽화 이미지를 중심으로 한다. 여기서는 동물 이미지들이 종(種)을 바꾸어가면서 변화하기도 하고, 특수한 구 안에 설치된 식물 환경에 대응하여 영상 이미지가 변화하기도 한다.

내러티브 단채널 영상은 한 TV 프로그램이 양치기 리얼리티 TV 쇼를 제작하기 위해 스페인의 작은 산골 마을에 들어오는 이야기에서 시작한다. 팬데믹 때문에 방송이 중단되고 프로그램 제작자들은 대신 '크립토 콜로세움'이라 불리는 동물 전투 메타버스를 제작하는데, 게임 같은 이러한 가상 세계에서는 동물이 죽어나갈 때마다 대체불가토큰(NFT)이 발행된다. 한편, 현지 양치기들은 리얼리티 TV 쇼가 NFT 적자생존 경쟁으로 확대되는 이러한 '크립토 식민주의'적 상황에 대항하기 위해 양치기들만이 가진 사회적이고

11
2022년 4월 29일 MMCA 아티스트 토크 내용 참조.

unstable.[11] With the artist's inclusion of footage in *This is the Future* showing riots in Germany and other scenes of racial discrimination, it is this unstable present that she is seeking to show.

Digital Colonialism vs. Symbiosis

The 2022 work *Animal Spirits* could be seen as an example of the artist expressing her concerns about the social instability that AI has the potential to cause and the colonization associated with digital capitalism, as well as her ideas for an alternative approach. A four-channel video installation commissioned by MMCA, *Animal Spirits* consists of a single-channel narrative video telling a story about Spanish shepherds, along with a simulation video that responds in real time to changes in the plant's environment (temperature and humidity) as detected by special sensors. The simulation video centers on images of cave paintings in Spain and France that date back to the Paleolithic. The images of animals transform with changes in species, and the video image also changes in response to the environment of plants installed in special balls.

The single-channel narrative video introduces a reality TV show infiltrating a small mountain village in Spain in order to stage a program there. When the reality show is halted by the pandemic, the producers decide instead to create an animal fight metaverse, which they call the "Crypto Colosseum." In this gamelike virtual world, non-fungible tokens (NFTs) are issued each time an animal dies. Meanwhile, the local shepherds fight back against this "crypto colonization" as the reality show expands into an NFT-based "survival of the fittest" challenge. They build their own social and biological exchange system, creating "smart cheese" and "Cheesecoin," which is "coded in the bacteria based blockchain." In effect, they are creating a decentralized, autonomous system and a naturally intelligent form of exchange that operates horizontally among fungi, molds, enzymes, and all animate and inanimate things.

The work *Animal Spirits* starts from the term "animal spirits" coined in 1936 by the British economist John Maynard Keynes. Derived from the Latin *spiritus animalis*, meaning the "the breath that awakens the human mind," it refers to irrational human emotions such as greed, ambition, and fear that cause markets to spin out of control and experience wild swings. Historically, animal spirits have been more visible during times when market volatility has been especially large, such as the dotcom bubble of 1995–2000 and the global financial crisis of 2008–2009. By way of Keynes, Steyerl applies documentary fiction in a twist of "digital colonialism" that is linked to today's Bitcoin and NFTs, while presenting the possibility for symbiotic economies as exemplified by the "Cheesecoins." In creating Cheesecoins to fight back against digital colonization, the shepherds are calling upon something with a different form and innumerable

11
MMCA Artist's Talk,
April 29, 2022.

생물학적인 자체 교환 시스템을 구축하고, 박테리아 기반 블록체인에 코드화되어 있는 스마트 치즈, 치즈 코인을 만든다. 그것은 균류, 곰팡이, 효소와 모든 생물 및 무생물 사이에서 수평적으로 작동하는 자연 지능적인 교환 형태와 분권화된 자율시스템을 구축하는 것이다.

슈타이얼의 〈야성적 충동〉은 영국의 경제학자 존 매이너드 케인스가 1936년에 언급한 바 있는 '야성적 충동'에서 출발하였다. 이 용어는 '인간의 마음을 깨우는 숨결'을 의미하는 라틴어 spiritus animalis에서 유래한 것으로, 시장이 통제 불능이 되고 미친 듯이 날뛰는 현상을 야기한 탐욕, 야망, 두려움과 같은 인간의 비이성적 감성을 일컫는다. 야성적 충동은 1995-2000년 사이 닷컴 버블이나 2008-2009년 금융 위기 시장의 변동이 극대화될 때 보다 가시화되었다. 슈타이얼은 케인스를 경유하고 일련의 다큐멘터리 픽션을 통해 오늘날 비트코인, NFT 등과 연동된 '디지털 식민주의'를 비틀고, 치즈 코인 만들기와 같은 '공생경제' 가능성을 제시한다. 디지털의 식민화에 저항하기 위해 치즈 코인을 만드는 양치기들의 행위는 또 다른 형상과 수많은 이름을 가진 다른 무엇을 소환하여 지구의 다양한 거주자들과 연대를 이루는 공생과 공존의 과정에 다름 아니다.

냄새와 같은 휘발성 기체로 소통하고 수평적 연결과 분산화된 생태 시스템을 지향하는 치즈 코인 만들기는 다양한 거주자와 행위자들의 촉수적 연결을 통해 함께 공존해가는 도나 해러웨이의 쑬루세적 연대를 연상시킨다.[12] 그것은 가장 강력한 자만이 살아남는다는 신 다윈주의적 원칙에 저항하는, 종이 다른 생물들이 함께 살아가는 공생 발생(symbiogenesis)적 관점과도 연결된다.[13] 디지털 테크놀로지와 생태학을 연결시키는 이러한 슈타이얼의 최근 관점은 채굴(mining)을 중심으로 하는 크립토 경제의 전제 조건, 즉 새로운 '크립토 식민주의'에 대항하는 예술 실천적 대안으로 읽힌다. 즉 압하지야, 조지아 등의 동유럽 국가를 비롯하여 여러 중앙아시아 국가에서 이루어지고 있는 크립토 채굴은 경제 갈등과 정치적 불안정을 야기하며 새로운 디지털 식민주의를 작동시키고 있는 상황에서[14] 〈야성적 충동〉이 제기하는 공생 발생적 관점은 예술을 통한 하나의 사회학적 대안 모델을 제안한 것이라 할 수 있다.

2. 안 보여주기─디지털 시각성

디지털 기술 기반 세상에서 우리는 안 보여질 수 있을까? 사적, 공적 데이터가 수집, 등록되고 감시 카메라가 도처에 널려 있는 디지털 세상에서 우리는 완전히 숨을 수 있을까? 빅데이터와 빅 브라더가 지배하는 세상에서 보이지 않는 존재란 과연 누구인가? 구글맵, 인공위성, 감시카메라, 드론, 항공지도 등의 장치를

12
이에 대해서는 Donna J. Haraway, Staying with The Trouble: Making Kin in the Chthulucene (Duke University Press, 2016); 도나 해러웨이, 『트러블과 함께 하기: 자식이 아니라 친척을 만들자』, 최유미 옮김, (서울: 마농지, 2021), 93-103 참조.

13
〈야성적 충동〉과 공생 발생적 관점과의 연관성에 대해서는 2022년 4월 29일 MMCA 아티스트 토크 참고. 공생 발생에 대해서는 Lynn Margulis, Symbiotic Planet: A new look at evolution (Vermont: Trafalgar Square, 1998); 린 마굴리스, 『공생자 행성』, 이한음 옮김(서울: 사이언스북스, 2007) 참고.

14
크립토 식민주의에 대해서는 2022년 4월 29일 MMCA 아티스트 토크 참

names, in what amounts to a process of symbiosis and coexistence as they establish solidarity with the other beings living on the planet.

Communicated through smells and other volatile gases and oriented toward a system of horizontal connection and decentralized ecology, the Cheesecoin creation process evokes parallels with the "Chthulucene" solidarity of Donna Haraway, a form of coexistence based on tentacular connections among various residents and actors.[12] It also bears connections with the perspective of symbiogenesis, or the coexistence of different species in opposition to the neo-Darwinian principle holding that only the strongest should survive.[13] With its linkage between digital technology and ecology, Steyerl's recent perspective reads as an alternative form of artistic practice to resist the new "crypto colonialism," which is a prerequisite for the mining-based crypto economy. At a time when crypto mining in various Eastern European states (including Abkhazia and Georgia) and Central Asian countries is driving a new form of digital colonialism as it causes economic conflict and political stability,[14] the symbiogenesis perspective presented in *Animal Spirits* may be seen as suggesting an alternative sociological model through art.

2. How Not to Be Seen— Digital Visuality

Can we remain unseen in a world based in digital technology? Can we ever fully hide in a digital world where surveillance cameras are all around and public and private data are being constantly collected and recorded? Who can be considered "unseen" in a world controlled by big data and Big Brother? How do we perceive the world and people differently from before in an era where the world is surveyed from top to bottom through means such as Google Maps, satellites, surveillance cameras, drones, and aerial mapping? These are some of the questions that Hito Steyerl poses in her video installation work *How Not to Be Seen: A Fucking Didactic Educational .MOV File* (2013). Drawing on the format of a five-part guerrilla manual, *How Not to Be Seen* explains five ways of "not being seen" in the field of visibility as a way of resisting mass data collection and visual surveillance: "How to make something invisible for a camera," "How to be invisible in plain sight," "How to become invisible by becoming a picture," "How to be invisible by disappearing," and "How to become invisible by merging into a world of images."

The second chapter on "How to be invisible in plain sight" features grey scales and resolution targets installed in the California desert in the 1950s and 1960s by the US Air Force to calibrate aerial photographs and videos. In the digital technology-based world, resolution determines visibility. If something cannot be detected through resolution, it can remain unseen; if it is smaller than a pixel, it escapes the camera's gaze and does not appear

12
For more on this see, Donna J. Haraway, *Staying with The Trouble: Making Kin in the Chthulucene* (Duke University Press, 2016); Korean trans. Choi Yumi (Seoul: Manongji, 2021), 93–103.

13
The discussion of the relationship between *Animal Spirits* and the symbiogenetic perspective is based on Steyerl's Artist's Talk at MMCA on April 29, 2022. For more on symbiogenesis, see Lynn Margulis, *Symbiotic Planet: A New Look at Evolution* (Vermont: Trafalgar Square, 1998); Korean trans. Lee Haneum (Seoul: Science Books, 2007).

14
The discussion of crypto colonialism is based on Steyerl's Artist's Talk at MMCA on April 29, 2002.

통해 세상을 위에서 아래로 조망하게 된 시대, 세상과 인간을 인식하는 방식은 그 이전 시기와 어떻게 다른가? 슈타이얼은 영상 설치 작품 〈안 보여주기: 빌어먹게 유익하고 교육적인 .MOV 파일〉(2013, 이하 〈안 보여주기〉)에서 위와 같은 질문들을 이어간다. 〈안 보여주기〉는 5장으로 구성된 게릴라 매뉴얼의 형식을 빌려 대량 데이터 수집과 시각적 감시에 대항하여 우리가 가시성의 장에서 '안 보일 수 있는 방법'을 다섯 가지로 설명한다. 카메라에 안 보이게 하는 방법, 시야에서 안 보이게 하는 방법, 이미지가 되는 방법, 사라짐으로써 안 보이게 되는 방법, 이미지로 만들어진 세계에 병합됨으로써 안 보이게 되는 방법 등이 바로 그것이다.

2장 시야에서 안 보이게 하는 방법에서는 항공사진을 보정하기 위해 1950–1960년대 미 공군이 캘리포니아 사막에 설치한 표준 회색 색표와 해상도 평가 표적이 등장한다. 디지털 기술 기반 세상에서는 해상도가 가시성을 결정한다. 해상도를 통해 파악되지 않으면 무엇이든 보이지 않게 되고, 픽셀보다 작다면 카메라의 응시를 벗어나며 시각장에서도 보이지 않게 된다는 것이다. 그리고 중요한 데이터로 필터링되지 않으면 디지털 가시성의 장에서 나타나지 않는다. 결국 디지털 공간에서 보이는 것과 보이지 않는 것을 결정짓는 것은 시각이 아니라 기계가

된다. 슈타이얼은 오늘날의 인지는 바로 대부분 기계적으로 이뤄지고 시각은 점점 중요성을 잃어갈 뿐 아니라 이는 필터링, 암호해독, 패턴인식으로 대체된다고 간파한다.[15] 즉 오늘날의 시각성은 방대한 분량의 데이터 속에서 어떻게 정보를 정렬하고 필터링하고 해독하고 정제하고 처리하는가 하는 데이터의 패턴 인식과 연동한다.

한편 〈안 보여주기〉에서도 자주 나타나는 구글맵, 3D 급강하, 감시 파노라마, 위성 보기 등 위로부터의 조망은 어떤 면에서는 감시와 추적, 조준과 같은 군사 기술과 연관된 것들이다. 또한 이러한 시각은 우월한 자가 열등한 자를 향해 위에서 아래로 던지는 일방적인 시선이며, 더 나아가 이러한 관점의 변위는 기계와 여타 객체로 위탁되어 탈체화되고(dis-embodied) 원격 조정된 응시를 창출한다. 슈타이얼은 군사, 엔터테인먼트, 정보 산업의 렌즈를 통해 스크린상에서 볼 수 있는 위로부터의 조망은 다른 한편으로는 계급 관계의 보다 일반적인 수직화에 대한 완벽한 환유라고 설명한다.[16] 르네상스 시대 선형 원근법이 식민주의와 계급투쟁의 인식 장치였듯이, 3D 통치술의 은유이기도 한 위로부터 아래로의 수직 조망은 오늘날의 새로운 가시성 영역에서 정치적 위계를 은유하고 있다.

〈안 보여주기〉의 4장, 사라짐으로써 안 보이게 되는 방법으로 불량 화소 되기,

15
이에 대해서는 히토 슈타이얼, 「대리 정치: 신호와 잡음」, 『면세 미술: 지구 내전 시대의 미술』, 38–53 참조.

16
히토 슈타이얼, 「자유낙하: 수직 원근법에 대한 사고 실험」, 『스크린의 추방자들』, 김실비 옮김, 김지훈 감수, 2판(서울: 워크룸 프레스, 2018), 31, 33.

in the visual field. Things also do not appear in the field of digital visibility if they are not processed by filters as important data. What ultimately decides what is "seen" and "not seen" in digital environments is not vision but machinery. Observing how perception today is for the most part mechanically performed, Steyerl notes how vision not only is gradually losing its importance but also being replaced by filtering, decoding, and pattern recognition.[15] In other words, visuality today is related to digital pattern recognition, and how information is arrayed, filtered, decrypted, refined, and processed amid vast volumes of data.

Additionally, the view from above that appears in *How Not to Be Seen*, as exemplified by Google Maps, 3D nose-dives, surveillance panoramas, and satellite views, is related in some ways to military technologies, including forms of monitoring, tracking, and targeting. This is the one-way gaze of superiors onto inferiors, a looking down from high to low; Additionally, the displacement of this perspective creates a disembodied and remote-controlled gaze, outsourced to machines and other objects. Steyerl explains that the view from above, which can be seen through the lenses and on the screens of military, entertainment, and information industries, is also a perfect metonymy for a more general verticalization of class relations.[16] Just as linear perspective served in the Renaissance as a perceptual mechanism

of colonialism and class conflict, the vertical top-down perspective—itself a metaphor for "3D sovereignty"— represents the political hierarchy within the new visibility of today.

The fourth part of *How Not to Be Seen* lists 13 ways to "be invisible by disappearing," including "being a dead pixel," "being undocumented," "being spam caught by a filter," "being a disappeared person as an enemy of the state," and "being fitted with an invisibility cloak." In the decades of digital revolution, 170,000 people have disappeared: deleted, omitted, segregated, and erased. Perceived as "contaminated" data and filtered out, they are unseen by the political algorithms and pattern recognition of data that distinguish signals from noise. Jacques Rancière noted that in ancient Greek society, sounds produced by affluent male locals were defined as speech, whereas women, children, slaves, and foreigners were assumed to produce garbled noise.[17] Along similar lines, those marginalized within the world of data algorithms become spam images that do not stand out in the status of digital images—making them akin to the "poor images" that the artist emphasizes. They are the "wretched of the screen," sharing the same realm as the people we have forgotten, those excluded from our shambolic "social contracts," those who have disappeared, and those who are not seen.[18] Much like the recovery of the political standing of

15
For more on this, see Steyerl, "Proxy Politics: Signal and Noise," *Duty Free Art*, 38-53.

16
Hito Steyerl, "In Free Fall: A Thought Experiment on Vertical Perspective," *The Wretched of the Screen*, ed. by J. Aranda, B. Kuan Wood, and A. Vidokle (Berlin: Sternberg Press, 2012); Korean trans. Kim Sylbee (ed. Jihoon Kim), 2nd ed., (Seoul: Workroom Press, 2018), 31, 33.

17
Jacques Rancière, "Ten Theses on Politics," *Theory & Event* 5, no. 3 (2001): 23; re-quoted in Steyerl, "A Sea of Data: Apophenia and Pattern (Mis-)Recognition," *Duty Free Art*, 59.

18
Hito Steyerl, "The Spam of the Earth: Withdrawal from Representation," *The Wretched of the Screen*, 221.

무등록자 되기, 필터에 걸린 스팸 되기, 국가의 적으로서 실종자 되기, 은폐되기 등이 언급된다. 디지털 혁명 시대에 17만 명이 사라지며 그들은 삭제되고 생략되고 격리되고 말살된다. 그들은 잡음과 신호를 구별하는 데이터의 정치적 알고리즘과 패턴 인식에 의해 오염된 데이터로 인식되고 필터링되어 보이지 않게 된 존재이다. 자크 랑시에르가 고대 그리스 사회에서 부유한 남성 주민이 내는 소리를 발화로, 여성, 어린이, 노예, 외국인이 내는 소리를 메시지가 없는 잡음, 즉 노이즈로 간주하였듯이,[17] 데이터 알고리즘의 세계에서 소외된 그들은 디지털 이미지의 위상에서 눈에 띄지 않는 이미지 스팸, 즉 작가가 강조한 '빈곤한 이미지'와도 같다. 그들은 우리가 잊어버린 사람들, 엉망진창인 '사회계약'에서 제외된 자들, 실종자 및 보이지 않는 사람들의 영역을 공유하는,[18] 다시 말해 '스크린에서 추방된 자'들이다. 그리고 이러한 위계화된 패턴 인식에서 사라진 존재들의 정치성을 회복하는 것은 디지털 세상의 위상에서 저급한 불량 화소의 정치성을 회복하는 것과 마찬가지로 〈안 보여주기〉에서 슈타이얼이 궁극적으로 이야기하고자 하는 것일지 모른다.

3. 기술, 전쟁, 그리고 미술관

인공지능, 알고리즘, 사물인터넷, 로봇 공학, 3D 시뮬레이션 등 오늘날의 첨단 디지털 기술은 인간의 삶을 풍요롭게 하는, 인간을 위한 기술인가? 오늘날 우리가 마주하고 있는 각종 재난과 전쟁의 소용돌이 속에서 이러한 기술은 인간을 구원할 수 있는가? 슈타이얼은 우리가 컴퓨터 테크놀로지와 웹에 의존하고 있지만 한편으로는 그것에 의해 내장되고, 감시받고, 조정당하고 심지어 착취당하고 있다고 말한다.[19] 〈타워〉(2015), 〈Hell Yeah We Fuck Die〉(2016) 등에서 작가는 기술 유토피아에 의문을 제기하고 기술과 전쟁 사이의 내적 연관성을 암시하며 디지털 기술을 기반으로 재편된 세계상을 재고한다.

게임, 기술, 전쟁

우크라이나와 러시아 사이의 전쟁을 비롯하여 21세기에도 여전히 전 지구적 내전은 지속되고 있다. 미 국가안보국이 냉전 시기 베를린의 토이펠스베르크에 감청기지를 세워 통신을 도청하였다고 알려져 있듯이, 수평적이던 네트워크는 지구 내전 시기에 글로벌 광섬유 감시 체제로 전환된다. 또한 전쟁 시기에는 봇군대, 웨스턴 유니온, 텔레그램, 파워포인트 발표, 지하드 게시판 게임화 등 가능한 모든 디지털 수단이 투입된다. 전쟁과 반란에서는 탱크가 데이터베이스와 맞물리고, 화학물질이 굴착기와 만나고, 최루가스가 소셜

17
Jacques Rancière, "Ten Theses on Politics," *Theory & Event* 5, no. 3 (2001): 23; 히토 슈타이얼, 「데이터의 바다: 아포페니아와 패턴 (오)인식」, 『면세 미술: 지구 내전 시대의 미술』, 59에서 재인용.

18
히토 슈타이얼, 「지구의 스팸: 재현에서 후퇴하기」, 『스크린의 추방자들』, 221.

19
Steyerl, "Too Much World: Is the Internet Dead?", 같은 책, 11.

the "poor image" in the digital world, the message Steyerl is ultimately sharing in *How Not to Be Seen* seems to be about recovering the political standing of those who have disappeared from this sort of stratified pattern recognition.

3. Technology, War and Museum

Today's advanced digital technology includes such elements as artificial intelligence, algorithms, the Internet of Things, robot engineering, and 3D simulations—but does this technology serve human beings and enrich human lives? Can this kind of technology rescue human beings from the maelstrom of disasters and war that we face today? Noting our dependence on the web, Hito Steyerl stresses how it also becomes built into us as we are regulated, surveilled and even exploited by it.[19] In works such as *The Tower* and *Hell Yeah We Fuck Die*, she raises questions about the "technology utopia" and alludes to the internal connection between technology and war as she re-examines the way in which the world has been reshaped through digital technology.

Games, Technology, War
In addition to the war between Ukraine and Russia, the 21st century has seen a continuation of civil wars around the world. In a time of planetary civil war, horizontal networks are turned into global fiber-optic surveillance systems, as in the case of the National Security Agency building a listening station at Teufelsberg in Berlin during the Cold War in order to intercept all communications. During times of civil war, every digital tool imaginable is put to work: bot armies, Western Union, Telegram, PowerPoint presentations, and jihadi forum gamification. Situations of war and rebellion bring tanks together with databases, chemicals with excavators, tear gas with social media.[20] This internal connection between technology and military scenarios has long been one of Hito Steyerl's artistic interests. Her 2015 work *The Tower*, which was set in the Ukrainian city of Kharkiv, comes across as especially meaningful as planetary civil war continues to rage in 2022.

The three-channel video work *The Tower* mainly concerns the connections between advanced technology industries, war scenarios, and capital. Treating real-world situations related to real estate, casinos, and war as a kind of game, the work is narrated by the engineer Oleg Fonarov from the 3D architectural simulation company Program-Ace, which is located in Kharkiv, a computer science center for the former Soviet Union during the Cold War. During the Soviet Union, many of the company's engineers worked in space and rocket technology. Since the collapse of the Soviet Union, however, its simulation, virtual reality, and gaming technology has been put to use to create emergency and military simulations, or for real estate design in Europe and the Middle East. The videos game that it produces show the interconnection between gaming

19
Steyerl, "Too Much World: Is the Internet Dead?", ibid., 11.

20
Steyerl, "A Tank on a Pedestal," "How to Kill People: A Problem of Design," *Duty Free Art*, 11, 16.

미디어와 마주친다.[20] 기술과 군사 시나리오 사이의 이러한 내적 연관성은 슈타이얼의 오랜 예술적 관심사이다. 우크라이나의 하르키우를 배경으로 하고 있는 2015년 〈타워〉는 지구 내전이 여전히 지속되고 있는 2022년 현재 시점에서 의미심장하게 읽힌다.

3채널 영상 설치 작품 〈타워〉는 첨단 기술 산업과 전쟁 시나리오 및 자본과의 연결을 그 내용으로 한다. 전쟁과 부동산 등의 현실태를 게임으로 다루고 있는 이 작품은 냉전 시기 구소련의 컴퓨터 과학 중심지였던 우크라이나 하르키우에 위치한 3D 건축 시뮬레이션 회사인 '프로그램-에이스'의 기술자 올레크 포나료프의 내레이션을 따라 내용이 전개된다. 구소련 시기, 그 회사의 많은 기술자들은 우주와 로켓 기술 분야에서 일했고, 소련 붕괴 이후에 그들이 보유한 시뮬레이션, 가상현실, 그리고 게임 기술은 비상 및 군사 시뮬레이션을 만들거나 유럽과 중동의 부동산을 설계하는 데 사용되었다. 그들이 제작한 비디오 게임들은 실질적인 군사 행위와 경제적 이익이 교차하는 곳에 위치해 있다는 점에서 게임 기술과 현실은 연동한다.

한편, 〈타워〉는 2003년 미국이 사담 후세인을 수색하는 동안, 그가 이슬람인들을 하나로 응집하기 위한 상징으로서 재건하고 싶어 했던 바벨탑을 하나의 게임 소재로 시뮬레이션한다.

이 게임에서 후세인은 탑을 다른 세상과 연결할 수 있는 영적 장소로서 건설한다. 바벨탑을 배경으로 슈팅 비디오 게임이 진행되는 동안, 하르키우의 도시 풍경들을 3D 스캔한 렌더링은 탱크, 폐허, 피난민의 파편화된 영상 이미지와 중첩된다. 2015년 제작된 〈타워〉에서 하르키우를 스캔한 3D 렌더링 이미지와 이와 결합된 전쟁 게임 이미지는 2022년 일어난 우크라이나-러시아의 전쟁이라는 비극적 현실상을 예견한다. 특히 3D 렌더링 기술은 기본적으로 하르키우라는 도시를 파편화된 데이터로 기록하는데, 이러한 기술은 재현(representation)을 복제(replication)로 대체하는 현실 리핑(ripping)[21] 과정에서 전쟁과 연동된 다큐멘터리적 진실을 사회적 무의식의 차원에서 감지하고 있는 듯 보인다.

〈타워〉와 함께 전시된 〈Hell Yeah We Fuck Die〉는 기술과 그 속에 내재된 폭력성을 일깨우는 작품이다. 2010년부터 5년 동안 빌보드 차트 노래 제목에서 가장 많이 사용된 영어 단어를 그 제목으로 하는 〈Hell Yeah We Fuck Die〉는 단어의 모양을 따라 제작된 라이트 박스 의자 설치물과 바리케이드를 연상시키는 그리드 형태의 금속 구조물 및 4채널 영상이 전체 작품을 구성한다. 그중 3채널 영상인 〈Hell Yeah We Fuck Die〉는 재난 현장에 인명 구조를 위해 투입될 휴머노이드 로봇이 발길질을 당하고 끊임없이 가격당하며 균형과

20
히토 슈타이얼, 「좌대 위의 탱크」, 「사람들을 죽이는 방법: 디자인의 문제」, 『면세 미술: 지구 내전 시대의 미술』, 11, 16.

21
이에 대해서는 히토 슈타이얼, 「현실을 리핑하기: 3D 사각지대와 깨진 데이터」, 『면세 미술: 지구 내전 시대의 미술』, 219-232 참조.

technology and reality, situated as they are where economic profit intersects with real military actions.

As a kind of game component, *The Tower* also presents a simulation of the "Tower of Babel" that Iraqi President Saddam Hussein wanted to rebuild as a symbol of Muslim unity while the US was pursuing him in 2003. Within the game, Hussein builds the tower as a spiritual place allowing him to establish a connection with another world. The tower serves as the backdrop for a first-person shooter video game, while 3D scans of scenes from Kharkiv are overlaid with fragmented video images of tanks, destroyed buildings, and refugees. Produced in 2015, *The Tower* includes 3D rendering scans of Kharkiv combined with images from a war game, predicting the tragic reality of the Ukraine-Russia war of 2022. The 3D rendering technology in particular records the city of Kharkiv as fragmentary data; at the level of the social unconscious, it seems to detect the documentary truths connected with war in the process of "ripping" reality as it replaces representation with replication.[21]

Exhibited along with *The Tower* is *Hell Yeah We Fuck Die*, which draws attention to the technology and the inherent violence within it. Taking its title from the five most commonly used English words in the titles of songs on the *Billboard* chart over a five-year period beginning in 2010, *Hell Yeah We Fuck Die* consists of a light box chair installation modeled on each of the words; a grid-shaped metal structure reminiscent of a barricade; and four videos. The three-channel video *Hell Yeah We Fuck Die* shows a humanoid robot designed to rescue people during a disaster, as it is relentlessly kicked and attacked as part of training to improve its balance and resilience. The image evokes the stupidity of artificial intelligence and the violence that is committed in the name of "technological progress."

Another single-channel video *Robots Today* shows the unofficial Kurdish capital city Diyarbakır, which has been devastated by a long war between the Turkish military and Kurdish activists. In the video, children are seen asking Siri whether robots can actually rescue people in a disaster area. While the reality of violence and disaster is being conveyed through the vivid voices of Kurds, another key element of the video is a narrative about the robots invented by Ismail al Jazari (1136-1206), a Kurdish genius in the 12th century who wrote *The Book of Knowledge of Ingenious Mechanical Devices* (1206) and laid the groundwork for the computer technology of the future. This is a work where robots, violence, disaster, and war exist in mutual reflection, as the production of humanoid rescue robots and the narrative of violence inputted into their predicted performance are juxtaposed with the tragedy of the longstanding civil war between Turks and Kurds. It also evokes the tragic reality deeply etched into words such as "hell" and "die" within popular culture.

21
For more on this, see Steyerl, "Ripping Reality: Blind Spots and Wrecked Data in 3D," *Duty Free Art*, 219-232.

복원력 증강 훈련을 받고 있는 모습을 담고 있다. 그것은 기술 진보라는 이름 아래 진행되는 일종의 폭력성과 인공지능의 우둔함을 환기시킨다.

다른 단채널 영상 〈오늘날의 로봇〉은 터키 군대와 쿠르드 행동주의자 사이의 오랜 전쟁으로 인해 파괴된 쿠르드족의 비공식적 수도, 디야르바키르를 비춘다. 이곳을 중심으로 로봇이 재난 지역에서 정말로 사람을 구할 수 있는지 시리(Siri)에게 질문을 던지는 아이들의 모습을 담고 있다. 폭력과 재난의 리얼리티가 쿠르드인들의 생생한 육성과 함께 전달되는 가운데, 『독창적 기계 장치에 관한 지식』의 저자이자 컴퓨터 기술의 토대를 세웠던 12세기 쿠르드족 천재 알 자자리(Ismail al Jazari, 1136-1206)가 발명한 로봇에 대한 서사가 영상의 한 축을 구성한다. 로봇, 폭력, 재난, 전쟁이 서로를 반영하는 이 작품에서 인명 구조 휴머노이드 로봇의 제작과정과 그것의 예견된 수행성에 기입된 폭력의 서사는 터키와 쿠르드족 사이의 오랜 내전의 재난 상황과 병치된다. 이는 동시에 대중문화 속에 '지옥'과 '죽음' 같은 언어로 깊이 각인된 비극적 현실 상황을 소환한다.

미술관은 전쟁터인가?
한편, 슈타이얼은 '미술관은 전쟁터인가'라는 질문을 작품으로 전환하며 미술관이 오래전부터 보이지 않는 힘의 전쟁과 무관하지 않았음을 암시한 바 있다. 또한 지구 내전, 불평등의 증가, 독점 디지털 기술로 규정되는 시대, 미술관의 역할에 대해서도 진지한 질문을 던져왔다. 전시 작품 〈면세 미술〉(2015)과 〈경호원들〉(2012)에서 작가는 미술관을 둘러싼 제도, 자본의 분배, 감시와 권력의 시선을 일깨우며 성전으로서의 미술관이 아닌 다양한 사회 현상과 연동된 장소로서 동시대 미술관의 지형도를 드러낸다. 이중 〈경호원들〉은 미술관 경호원이라는 인물에서 공간 통제의 군사적 의미를 교차시키고, 강화된 보안으로 인해 변화된 미술 현장의 모습을 드러내며 잠재적인 폭력 무대의 한 장면에 미술관을 기입한다.[22] 전쟁과 감시, 보안과 통제의 시선은 미술관의 맥락 속에도 편재해 있다.

한편, 슈타이얼의 렉처 퍼포먼스를 기반으로 하는 3채널 영상 〈면세 미술〉은 시공간이 붕괴되고 국경과 민족이 해체되고 있는 이 시대, 동시대 미술관의 새로운 물리적 영토와 데이터적 지반에 대해 논의한다. 작품의 제목으로 사용된 '면세'는 '의무'와 '관세'의 양가적 의미를 지닌다. 우선 작가는 시리아 국립박물관의 재건 계획이 알 아사드 정권에 대한 시위 및 내전에 의해 취소된 예와 터키 디야르바키르 시립미술관이 난민대피소로 사용된 사례를 언급하며, 국경과 민족에 대한 정의가 불안정한 시대에 민족을

22
히토 슈타이얼, 「미술이라는 직업: 삶의 자율성을 위한 주장들」, 『스크린의 추방자들』, 143. 〈경호원들〉은 시민 질서의 잠재적 와해 가능성이 있는 국가의 미술관에서는 미술관 경호원들이 총기를 소지해야 한다고 제안한 시카고대학교의 한 교수의 주장과 연결된다. 히토 슈타이얼, 같은 책, 140.

Is the Museum a Battlefield?

Steyerl also bases artwork on the question, "Is the Museum a Battlefield?" Here, she mentions how museums have long been implicated in battles of unseen forces. She further raises serious questions about the role of the art museum in an era defined by planetary civil war, rising inequality, and monopolistic digital technology. In works such as *Duty Free Art* (2015) and *Guards* (2012), she encourages the viewer to perceive the institutions, distribution of capital, surveillance, and power that surround the art museum, casting a new gaze on the contemporary museum not as a sanctuary, but as a setting interconnected with various societal phenomena. *Guards* in particular uses the figures of museum security guards to note the intersection with the military sense of spatial control, observing how intensified security "mutates the sites of art and inscribes the museum or gallery into a sequence of stages of potential violence."[22] Throughout the museum context, we find gazes of war and surveillance, security and control.

A three channel video work based on a lecture performance by the artist, *Duty Free Art* discusses the new physical territory and data-based foundation of the contemporary art museum at a time when time and space have been collapsing and national borders and ethnic distinctions have been disintegrating. The word "duty" in the work's title is ambiguous, referring both to an "obligation" and to "taxation of imports." To begin with, the artist cites the examples of national museums in Syria, where reconstruction plans were halted due to civil war and demonstrations against the Bashar al-Assad regime, and a municipal art gallery in the Turkish city of Diyarbakır, which was used as a shelter for refugees. In the process, she raises questions about how we should redefine the "duty" of the public art museum—traditionally perceived as a place representing a "nation"—in an era where the definitions of borders and nations have become unstable.

Steyerl also cites recent examples of freeport art storage in duty-free zones located in places such as Geneva, Luxembourg, Singapore and Monaco which offer assurances of security and secrecy along with tax benefits. In the process, she notes how such "museums"—located in places where sovereignty overlaps or where state jurisdiction has been voluntarily dissolved—conflict with the role that state museums formerly held for nations. Moreover, she keenly observes the other side of these new contemporary museums, noting how the "internet era" museums could also be described as "secret museums" within a "dark web," where internal movements are impossible to track and data spaces remain opaque. In effect, the two different environments are both inaccessible to the public: the freeport art storage spaces where works of art are stockpiled and concealed, and the spaces for protecting refugees within nations in collapse, like the municipal

22

Steyerl, "Art as Occupation: Claims for an Autonomy of Life," *The Wretched of the Screen*, 143. *Guards* is also connected with the argument of a University of Chicago professor, who maintains that guards in state art museums should carry firearms, given the possibility of a potential breakdown in civil order. Steyerl, ibid., 140.

대표하는 장소로 인식되어 온 공적 미술관의 의무(duty)를 어떻게 재정의해야 하는가에 대한 물음을 시작한다.

또한 제네바, 룩셈부르크, 싱가포르, 모나코 등 보안과 기밀 보장, 세금 특혜가 제공되는 면세(duty free)구역에 위치한 오늘날 자유항 미술품 수장고의 예를 들며, 주권이 중첩되어 있거나 국가 관할권이 자발적으로 무너진 곳에 자리하는 이러한 미술관은 과거 국가미술관이 민족에게 있었던 것과 대립된다고 말한다. 나아가 이러한 유형의 미술관은 내부 이동을 추적하기 어렵고 데이터 공간이 불투명한, 일종의 다크웹에 해당하는 비밀 미술관이라고도 할 수 있다면서 새롭게 등장한 동시대 새로운 미술관의 이면을 꿰뚫는다. 결국 자유항 미술품 수장고처럼 미술품을 비축함으로써 숨어든 공간과 터키 디야르바키르 시립미술관처럼 붕괴하는 민족의 난민을 보호하는 공간 모두 대중의 접근은 불가능한데, 작가는 공통의 안정적 지반이 무너지고 시공간, 국경, 민족이 재용접의 과정을 거치는 오늘날의 독특한 사회적 지형도에서 등장한 동시대 미술관의 새로운 유형을 '면세'와 '의무'를 중심으로 하는 양가적 의미로 간파한다.[23] 특히 〈면세 미술〉은 우크라이나-러시아 전쟁을 비롯하여 온갖 내전(시리아 내전, 코소보 내전, 레바논 내전)과 전쟁 및 조세 피난처가 여전히 세상을 불안정하게 만드는 시대에

미술(관)이 존재해야만 하는 이유와 당위성, 그것의 물리적/비가시적 영토, 새로운 패러다임과 그것의 작동 방식에 대해 다시 생각하게 한다.

4. 유동성 주식회사— 글로벌 유동성

오늘날 우리는 모든 것이 이동하고 자유로이 순환하는 시대에 살고 있다. 전 지구적 네트워크와 글로벌 자본주의 시대 사람, 자본, 사물, 정보는 정주하지 않고 끊임없이 이동한다. 나아가 디지털 세상에서 주요한 정보와 가치는 이미지와 데이터로 떠돌아다닌다. 슈타이얼은 국가에서부터 사랑에 이르기까지, 공적 영역에서부터 사적 영역에 이르기까지 모든 것이 자유롭게 흘러가고 순환하는 이러한 새로운 패러다임을 '순환주의'로 명명한다. 〈유동성 주식회사〉(2014)에서 '나는 유동성 주식회사이다. 우리의 혈관과 두 눈과 터치스크린과 포트폴리오에 있다.'라고 한 언급은 '유동성'과 '액체성'을 중심으로 하는 이 시대의 순환주의가 우리의 신체와 우리가 몸담고 있는 물리적 환경을 넘어 오늘날 우리의 일상을 지배하는 데이터 기반 사회에 깊숙이 침투되어 있음을 암시한다.

이러한 순환주의는 동시대 예술과 이미지를 이해하는 새로운 관점을 던져준다. 슈타이얼은 유동성의 시대,

23
이에 대해서는 히토 슈타이얼, 「면세 미술」, 『면세 미술: 지구 내전 시대의 미술』, 87-115 참조.

art gallery in Diyarbakır. Through the ambiguous meaning of "duty free art," with its senses related to "obligation" and "taxation," Steyerl identifies the new contemporary art museum paradigm that has arisen in the peculiar societal milieu of today, where the stable common base has now collapsed and space, time, borders, and nations are undergoing a process of being welded anew.[23] In particular, *Duty Free Art* encourages us to think once again about the reason we need art (museums), its physical/invisible territories, and its new paradigms and their ways of operating at a time when the world is still being rendered unstable by tax havens and conflicts like the Ukraine-Russia war and various civil wars (in Syria, Kosovo, and Lebanon).

4. Liquidity Inc.—Global Liquidity

We live today in an era where everything moves and circulates freely. Our age of worldwide networks and global capitalism is characterized by constant movement of people, capital, objects, and information. In the digital world, key information and value drift about as images and data. Hito Steyerl uses the term "circulationism" to describe this new paradigm of free flowing and cycling in everything from countries to love, and from the public to the personal realm. Her work *Liquidity Inc.* (2014) features the lines, "I am liquidity incorporated... I run through your veins, your eyes, your touchscreens and portfolios." This alludes to ways

in which today's circulationism, which centers on "liquidity" and "fluidity," has reached beyond our bodies and physical environments to deeply permeate the data-based society that governs our day-to-day life.

This circulationism also offers a new perspective for understanding contemporary art and images. Steyerl employs the term "poor image" to redefine the image's new value in the liquidity age. The "poor image" that she refers to is a low-resolution image reproduced as part of a fluid process of endless transmitting, transferring, compressing, and reformatting. Such images are the "wretched of the screen," the jetsam that washes onto the shores of the digital economy. Their more salient condition of existence is their circulation and fluidity in an environment that thrives on fast speeds and proliferation rather than materiality, impression rather than immersion, intensity rather than contemplation, and on swarm circulation and digital dispersion that floats over the surface of data pools. Moreover, these characteristics reflect aspects of our lives and reality in the era of information capability, expressing a condition of dematerialization shared with contemporary modes of semiotic production.[24]

Liquidity Inc. relates the circulationism of the poor image to images of free-flowing water, changing meteorological conditions, and the concept of liquidity in finance. The protagonist embodying this liquidity

23
For more on this, see Steyerl, "Duty Free Art," *Duty Free Art*, 87-115.

24
For more on the "poor image," see Steyerl, "In Defense of the Poor Image," *The Wretched of the Screen*, 41-60.

이미지의 새로운 가치를 '빈곤한 이미지'(poor image)라는 용어를 통해 재정의한다. 무수한 전송과 이동, 압축과 재포맷이라는 유동적 과정에서 재생산된 저화질의 이미지가 바로 그가 말하는 '빈곤한 이미지'이다. 이는 스크린의 추방된 존재이자 디지털 경제의 해변으로 밀려온 쓰레기들로, 물질성보다는 빠른 속도와 확산, 몰입보다는 인상, 관조보다는 강렬함, 그리고 무엇보다도 데이터 저장소 표면을 부유하는 군집형 유통과 디지털 분산 속에서 순환과 유동성이 보다 중요한 존재 조건으로 부각된다. 그리고 이러한 특징은 기호 생산의 동시대적인 생산양식이 공유하고 있는 탈물질화의 조건을 표현하면서,[24] 정보 자본주의 시대 우리 삶과 현실의 단면을 비춘다.

〈유동성 주식회사〉는 빈곤한 이미지의 순환주의를 자유로이 흘러가는 물의 이미지와 변화하는 기상 상황, 금융의 유동성 개념 등과 연결시킨다. 베트남 전쟁 출신의 고아로, 1974년 미국으로 이주하여 투자 자문가로 일하다가 2000년대 후반 세계 경제 위기에 격투기 선수 및 격투기 해설가로 활약한 제이콥 우드가 유동성을 체화한 주인공으로 등장한다. 그는 공격하고 방어하는 등 여러 상황에 대처해야 하는 격투기 시합이 유동적인 금융시장과 같다고 말한다. 유동성과 순환주의는 또한 온갖 해시태그와 이미지 파일,

인터페이스의 시각적 기호들, 밈과 같은 인터넷 문법과 다큐멘터리 필름의 교차와 중첩을 통해 종횡무진 펼쳐진다. 유동성은 비, 급류, 구름, 개울, 쓰나미, 숫자, 회오리, 밀물, 자본, 혈액, 위험 요소, 눈물, 누수, 파도, 얼음 모두에 있다. 컵에 부으면 컵 모양이 되고, 병에 부으면 병 모양이 되며, 형태를 버리고 흘러갈 줄도 충돌할 줄도 아는 물의 극단적 유동성은 현금과 자본의 유동성, 금리조정, 상품의 순환, 공장의 해외 설비, 인터넷 기반 정보 이동 등으로 그 서사를 넓혀간다. 또한 쓰나미, 제트 기류 역전, 무역풍이 거꾸로 불어오는 기상 이변은 다우존스 하락과 금융위기를 상징하는데, 이는 기업의 클라우드 데이터 사유화와도 연결된다. 클라우드, 토렌트 등을 통해 기후의 유동성과 디지털 정보의 유동성을 유비시키는 가운데, 〈유동성 주식회사〉는 데이터 사유화와 연동된 정치 경제적 차원까지를 들추어낸다.

사물 연대기

'비행기 사고'를 중심으로 한 영상 푸티지를 접합하여 유동적 순환주의와 사물의 끊임없는 이동을 언급한 작품으로 〈자유낙하〉(2010)를 들 수 있다. 이 작품은 동시대 자본주의와 2008년 경제 위기를 암시하며, 항공기 재난, 중동 전쟁, 글로벌 자본, 할리우드 시장 등의 관계를 끊임없이 엮어낸다. 캘리포니아 모하비 사막에 있는 항공기 기지를 배경으로

24
'빈곤한 이미지'에 대해서는
히토 슈타이얼, 「빈곤한 이미지를
옹호하며」, 『스크린의 추방자들』,
41-60.

is Jacob Wood, a Vietnamese war orphan who moved to the US in 1974 and worked as an investment advisor before the global financial crisis of the late 2010s, when he became a mixed martial artist and mixed martial arts commentator instead. He describes MMA matches—where athletes are forced to deal with situations of offense and defense—as being similar to the fluid financial market. Liquidity and circulation are also presented through the juxtapositions and layering of documentary film and the grammar of the internet, including hashtags, image files, visual interface symbols, and memes. Fluidity exists in rain, in currents, in clouds, in streams, in tsunamis, in numbers, in whirlwinds, in tides, in capital, in blood, in risk factors, in tears, in leaks, in waves, and in ice. The extreme fluidity of water—which takes on the shape of a cup when poured in a cup and the shape of a bottle when poured in a bottle, capable of both formless flowing and clashing—becomes an analogy for the fluidity of funds and capital, interest rate adjustments, product cycles, overseas equipment in factories, and internet-based information movements. At the same time, unusual phenomena such as tsunamis, jet stream reversals, and backwards-blowing trade winds symbolize financial crisis situations such as drops on the Dow Jones Index, which are linked in turn to corporate privatization of the data cloud. At a time when the cloud and torrents are creating parallels between climate fluidity and the liquidity of digital information, *Liquidity Inc.* delves into the political and economic dimensions that connect with data privatization.

Chronicle of an Object

In Free Fall (2010) is an example of a work that combines video footage related to aviation disasters to comment on liquid circulationism and the constant movement of objects. Alluding to contemporary capitalism and the economic crisis of 2008, it endlessly interweaves relationships with aviation disasters, war in the Middle East, global capital, and the Hollywood market. Shot at an aviation base in California's Mojave Desert, *In Free Fall* reconstructs a story as it establishes hybridity between images from Hollywood films about aviation disasters with "poor images" copied, ripped, and remixed from various sources and introduced into new ones.

In *In Free Fall*, the airplane appears as a kind of phantom object that drifts about in different forms, changing its use to suit new goals. In the case of this object chronicle, the aircraft is a Boeing 707/4X-JYI. The airplane originated with TWA, the airline established by American Howard Hughes in the 1930s. It was later sold to the Israeli air force, where it was used in a 1976 operation to rescue hostages from a Palestinian hijacking in the Ugandan city of Entebbe. From there, it was sold once again to the US, where it was kept in storage at the Mojave Airport in California before finally being blown up in 1990 on the set of the film *Speed*.

촬영된 〈자유낙하〉는 기본적으로 항공기 재난을 다룬 할리우드 영화 이미지들과 여러 경로에서 복제되고 리핑되고 리믹스되어 다른 경로로 붙여 넣어진 '빈곤한 이미지'들이 혼성을 이루며 이야기를 재구성한다.

〈자유낙하〉에서 항공기는 새로운 목적을 위해 용도를 변경하고 여러 형태로 유령처럼 떠도는 일종의 사물로 등장하는데, 이러한 사물 연대기의 주인공은 바로 보잉기 707/4X-JYI이다. 이는 1930년대 미국의 하워드 휴즈 에어라인 TWA에서 시작하여 이후 이스라엘 공군기로 매각되었는데, 이 공군기는 당시 1976년 우간다의 엔테베에서 있었던 팔레스타인 여객기 납치 사건의 인질 구출 작전에 사용되었다. 이후 미국에 다시 팔려 캘리포니아 모하비 공항 창고로 들어갔다가 1990년 영화 〈스피드〉 촬영장에서 폭발하면서 그 생을 마감한다. 폭발한 비행기의 잔해들은 2000년대 고철로 중국에 팔려 디스크(재생 디비디)로 부활한다. 영상 속에서 작가가 언급하고 있듯이 이 작품은 세르게이 트레티야코프의 저서 『사물의 전기』(1929) 초안에서 비롯한다. '사물은 그것을 만들고 사용한 사람들의 이야기와 연동하고 당대 사회관계를 대변하면서 여러 형태로 살아간다.'

〈자유낙하〉에서 비행기로 지칭되는 특정 사물은 한 사업가의 영화적

욕망의 대상으로, 팔레스타인 이스라엘 사이의 정치적 투쟁의 장소로, 할리우드 영화의 스펙터클로, 글로벌 자본주의의 대상으로, 할리우드 영상 기사의 재정 낙하의 원인으로, 그 존재적 가치를 순환 이동시키며, 정치, 경제, 엔터테인먼트를 둘러싼 인간의 작인(agency)으로 사회적 동인을 회복시킨다. 여기서 사물은 더 이상 자본주의 물신으로서의 도구화를 멈추고 그 자체로 인간의 삶에 적극적으로 개입하는 주체가 된다. 아르바토프의 글 「일상생활과 사물의 문화」를 인용한다면, 사물(비행기)은 더 이상 수동적이고 고루하며 죽은 상태로 있는 것이 아니라 일상적 현실의 변화에 능동적으로 참여하는 자유를 누린다.[25] 또한 〈자유낙하〉에서 암시된 사물의 연대기와 표상의 층위에서 보여지는 빈곤한 이미지들은 예술의 가치를 생산주의에서 순환주의로 이동시킨다.

5. 기록과 픽션

슈타이얼은 자신의 글 「실 잣는 여인들: 기록과 픽션」(2008)에서 다큐멘터리에서도 구성과 자료, 가상과 현실, 신화와 창작이 계속 섞여 있음을 밝힌다. 현실에 대해 비로소 지각하게 되고 주어진 현실에 의문을 품게 되는 것은 픽션을 바탕으로 이루어진다는 것이다.[26] 이번 전시의 마지막 장 '기록과 픽션'에서는 작가의 첫 영화

25
히토 슈타이얼, 「당신이나 나 같은 사물」, 『스크린의 추방자들』, 75-76.

26
이에 대해서는 히토 슈타이얼, 「실 잣는 여인들: 기록과 픽션」, 『진실의 색: 미술 분야의 다큐멘터리즘』, 안규철 옮김(서울: 워크룸 프레스, 2019), 107-128 참조.

Debris from the exploded aircraft were sold for scrap in China in the 2000s and reappeared in the form of DVDs. As mentioned in the video, the work is also inspired by Sergei Tretyakov's essay *The Biography of the Object* (1929): "The object interacts with the stories of the people who make and use it, existing in various forms as it represents contemporary social relationships."

In *In Free Fall*, one particular object (an airplane) instantaneously shifts its existential value: the object of a magnate's cinematic desires, a locus for political conflict between Palestine and Israel, a part of Hollywood film spectacle, an object of global capitalism, the cause of a Hollywood film technician's financial crash. It restores social dynamics with the human agency that surrounds politics, the economy, and entertainment. Here, the object ceases its instrumentalization as a capitalist fetish, becoming a subject actively affecting human lives in its own right. To quote Boris Arvatov's "Everyday Life and the Culture of the Thing," things (airplanes) should no longer remain passive, uncreative, and dead, but should be free to participate actively in the transformations of everyday reality.[25] The object chronicle alluded to in *In Free Fall* and the poor images visible at the representational level transport artistic value from productionism to circulationism.

5. Documentation and Fiction

In her essay "Thread-Spinning Women: Documentation and Fiction" (2008), Hito Steyerl notes how even in the documentary genre, there is a constant mixing of composition and archive, fiction and reality, myth and creation. She explains that our eventual perception of reality and our questioning of that given reality is based on fiction.[26] The last chapter of the exhibition, titled "Documentation and Fiction," shows the artist's early experiments with documentary film between the early 1990s and early 2000s within the context of documentation and fiction, truth and imagination—from her first film *Germany and Identity* (1994) to *Babenhausen* (1997), *The Empty Centre* (1998), *Normality 1-X* (1999), and *November* (2004). In the process, it follows the beginning of the documentary perspective that forms the basis of Hito Steyerl's work.

The fiction the artist talks about here is not someone's made-up story that is completely distant from reality like fairy tales or science fiction, but rather a "fantasmatic support" (Slavoj Žižek) that exists in reality.[27] Examples include the blind faith that a certain ethnic group is more exceptional and greater than others, the idea that there are hierarchies in race and gender, and the terrifying belief that our territory must constantly be expanded and that the future will progress without regression. Steyerl's documentarism is the product of an intellectual process

25
Steyerl, "A Thing like You and Me," *The Wretched of the Screen*, 75-76.

26
For more on this, see Steyerl, "Thread-Spinning Women: Documentation and Fiction," *Die Farbe der Wahrheit. Dokumentarismen* (Vienna: Turia + Kant, 2008); Korean trans. An Gyucheol (Seoul: Workroom Press, 2019), 107-128.

27
Ibid., 111-112.

작업 〈독일과 정체성〉(1994)에서부터 〈바벤하우젠〉(1997), 〈비어 있는 중심〉(1998), 〈정상성 1-X〉(1999), 〈11월〉(2004) 등에 이르기까지 1990년대 초부터 2000년대 초반에 이르는 작가의 초기 다큐멘터리 영상 실험을 기록과 픽션, 진실과 허구의 맥락에서 보여준다. 동시에 현재 히토 슈타이얼 작품의 근간을 이루는 다큐멘터리적 시선의 출발을 좇아가도록 구성하였다.

여기서 작가가 말하는 픽션은 동화나 SF처럼 현실과 완전히 동떨어진, 누군가가 지어낸 허구의 이야기가 아니라 현실 속에 존재하는 '환상의 버팀목'(슬라보예 지젝)과 같다.[27] 이를테면 특정 민족이 다른 민족보다 고유하고 위대하다는 맹신, 인종과 성별에는 위계가 존재한다는 생각, 우리의 영토는 끊임없이 확장되어야 하고 미래는 후퇴 없이 진보할 것이라는 무서운 신념 같은 것이다. 슈타이얼의 다큐멘터리즘은 그것의 근간을 이루는 합리성의 신화들에 대해 끊임없이 질문을 던지는 지적 과정의 산물이다. 또한 혼돈과 무질서로부터 우리를 보호하고 편안하게 달래주는 상징적 픽션들에 대해 또다시 회의하고 의심하는 저항의 결과물이다.

'기록과 픽션' 섹션에서 선보인 슈타이얼의 영상들은 식민주의, 반유대주의, 인종차별 등 인종과 종교와 힘을 내세우는 근본주의 같은 신화론들이 현실 속에 침투하고 어느 순간 권력을 장악하는 불합리한 역사적 순간을 카메라로 포착한 것이기도 하다. 이를 제작하기 위해 작가는 건설 현장, 축제와 시위 현장, 공동묘지, 대학교 강당 등을 직접 방문하는 참여적 수행성에 기꺼이 많은 시간을 투여하였다. 특히 인터뷰와 리서치, 아카이빙 등을 통한 역사학자의 시각이나 문화비평가적 탐구는 현실 속에 숨어있는 신화와 픽션의 순간들을 보다 면밀하게 탐색하기 위한 작가의 중요한 실천적 장치이다.

이러한 오랜 과정을 통해 작가는 신화들이 만들어지는 여러 조건들과 생산 과정들을 끈질기게 추적할 수 있었고, 그 결과 상징적 픽션의 단단한 막을 뚫고 이름 없이 사라져간 사람들의 경험과 기억, 목소리, 그리고 가려진 역사의 단층을 소환할 수 있었다. 여기에는 비어 있는 중심으로서의 '베를린 장벽'이 시간과 공간의 변화에 따라 타자를 배척해 왔던 배제의 역사를 추적하는 것(〈비어 있는 중심〉), 민족주의에 내재한 인종 차별과 남성 제국주의적 시선을 드러내는 것(〈독일과 정체성〉), 유대인 무덤 훼손의 자취를 따라가며 독일의 기억정치를 폭로하는 것(〈정상성 1-X〉), 유대인 가족 추방의 연대기를 기록하여 삭제된 목소리를 복원하는 것(〈바벤하우젠〉), 빈곤한 이미지로 떠돌았던 이미지의 궤적을 따라가며 저항의 과정에서 죽은 한 인물에 대한 기억과 역사를 소환하는 것(〈11월〉) 등이 포함된다.

27
히토 슈타이얼, 같은 글, 111-112.

that constantly questions its underlying myths of rationality. It is also the result of resistance that doubts and distrusts the symbolic fiction which protects and comforts us from chaos and disorder.

Steyerl's films presented in "Documentation and Fiction" also capture with a camera the irrational historical moments when mythologies such as fundamentalism that advocate race, religion and power—including colonialism, anti-Semitism, and racism—come to infiltrate the reality and eventually seize power. To this end, the artist willingly devoted much time to participatory performativity where she personally visited construction sites, festivals, demonstrations, cemeteries, and university auditoriums. In particular, her perspective as a historian or her exploration as a cultural critic— conducted through interviews, research, and archiving—are important practical devices for the artist to more closely examine the moments of myth and fiction that are hidden inside reality.

Through this lengthy process, the artist was able to persistently trace the various conditions and production process under which myths were created, and was consequently able to penetrate the firm layer of symbolic fiction and summon the experiences, memories, and voices of people who have disappeared in anonymity. This includes tracing a history in which the Berlin Wall served as an "empty center" excluding others over the course of temporal and spatial changes (*The Empty Centre*), revealing the racist and masculine imperialist gaze inherent to nationalism (*Germany and Identity*), exposing the politics of memory in German by following the vandalism of Jewish graves (*Normality 1-X*), restoring expunged voices by chronicling the expulsion of a Jewish family (*Babenhausen*), and tracing the trajectory of poor images to recall the memory and history of someone who died in the process of resistance (*November*).

데이터의 바다

A SEA OF DATA

미션 완료: 벨란시지
MISSION ACCOMPLISHED: BELANCIEGE
2019

· 3채널 HD 비디오, 컬러, 사운드,
 47분 23초
· 히토 슈타이얼, 조르지 가고 가고시츠,
 밀로스 트라킬로비치 제공

· THREE-CHANNEL HD VIDEO, COLOR,
 SOUND, 47 MIN. 23 SEC.
· COURTESY OF THE ARTISTS

· 각본 및 공동 제작
 WRITTEN AND CO-PRODUCED BY
 GOORGO GAGO GAGOSHIDZE,
 HITO STEYERL AND MILOŠ TRAKILOVIĆ
· 음향 감독 및 음악
 SOUND DIRECTION AND MUSIC
 MIKK MADISSON
· 도움 주신 분 SPECIAL THANKS TO
 IVÁN BRITO AND ROBERT NIKOLAJEV
· 창문 시트 디자인 WINDOW FOIL DESIGN
 JAAN SARAPUU

→
《히토 슈타이얼-
데이터의 바다》
전시 전경,
국립현대미술관,
서울, 2022

INSTALLATION VIEW
OF *HITO STEYERL-
A SEA OF DATA*,
NATIONAL MUSEUM
OF MODERN AND
CONTEMPORARY ART,
SEOUL (MMCA),
2022

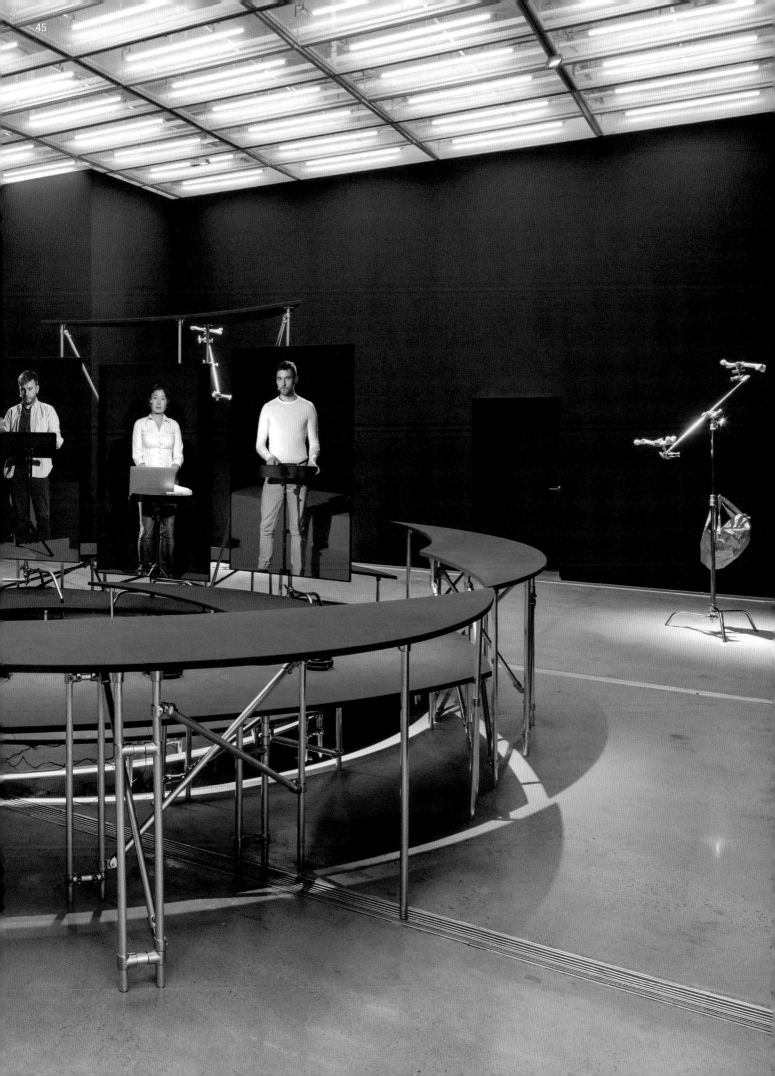

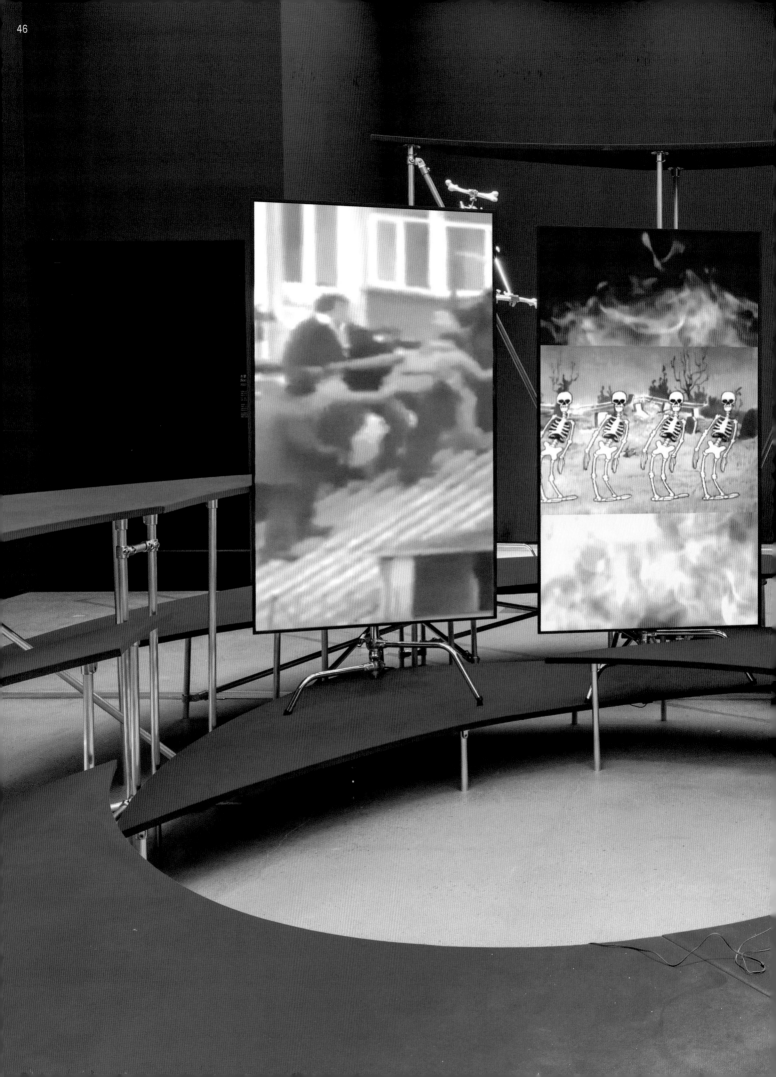

소셜심
SOCIALSIM
2020

· 단채널 HD 비디오, 컬러, 사운드, 18분 19초, 라이브 컴퓨터 시뮬레이션 댄싱 마니아, 가변 시간
· 작가, 앤드류 크랩스 갤러리, 뉴욕 및 에스더 쉬퍼, 베를린 제공

· SINGLE-CHANNEL HD VIDEO, COLOR, SOUND, 18 MIN. 19 SEC. LIVE COMPUTER SIMULATION *DANCING MANIA*, DURATION VARIABLE
· COURTESY OF THE ARTIST, ANDREW KREPS GALLERY, NEW YORK AND ESTHER SCHIPPER, BERLIN

· 블록버스터 경찰 BLOCKBUSTER COP
MARK WASCHKE
· 헤자 / 네페르티티 역할
HÊJA / NEFERTITI
HÊJA NETIRK
· 코로나 상황에서 제작
COVID-19 AS COVID-19
· 현지 촬영 장소 SHOT ON LOCATION AT .COM BAR
· 아웃테이크 OUTTAKES
BROKEN WINDOWS, GUARDS, FACTORY OF THE SUN, THIS IS THE FUTURE
· 발췌 EXCERPTS FROM
ERNST LUBITSCH, *DIE AUS-TERNPRINZESSIN /*
THE OYSTER PRINCESS, 1919
· 보이스 오버 VOICE-OVER
SAMANTHA LIVINGSTON
· 음악 MUSIC
KASSEM MOSSE PAID REACH RZ, VIOLA KLEIN, "WE (PART TWO)" FEATURING WHODAT, SABAR: ABDOU AZIZ, ABDOUKHADRE, ADRAME DIOP (ST. LOUIS); BETHANY BARRETT, "GLACIAL CATACOMB," VARIATION ON "RABBIA E TARANTELLA" BY ENNIO MORRICONE, PERFORMED BY BETHANY BARRETT, JULES LAPLACE, LIAM MORRISON; XHALE303 TRAILER-1, MICHAEL-DB SYNTHONTHERUM 01, GREGOR QUENDEL CINEMATIC ORCHESTRA / THROAT CHANTING, LHARMAN94 ARPEGGIATO, GRAHAM MAKES EPIC ORCHESTRAL CITÉ, GREGOR QUENDEL CINEMATIC CHANTING, WELDON SMITH SHEPARDFILTERDRONE, @FXPROSOUND DANGEROUS CINEMATIC, HOERSPIELWERKSTATT HEF-MAXIBEAT1-130, GORAN ANDRIC THRILL

ANNOUNCEMENT, MICHAEL-DB CINEMATIC MUSIC, TONY ROLANDO (MAKE NOISE MUSIC), TODBARTON-SHAKUHACHI, MATT C90 EPIC TRIBAL DRUMS CMEESON DIDG-3-SAMPLEJ, USKDDINK SEAGULLS / THATJEFFCARTER RAZOR-BLADERUNNING-2, FLORIAN REICHELT WWW.INSTAGRAM.COM/ FLORIANREICHELT
· 설치 디자인 INSTALLATION DESIGN
MANUEL REINARTZ, EMILIANO PISTACCHI, MAX SCHMOETZER 3D-DESIGN AND BOUNCING BUBBLE
· 행정 POLITICS
MAX SCHMOETZER
· 포스트 프로덕션 POST PRODUCTION
CHRISTOPH MANZ
· 무빙 이미지 히어로
HEROES OF THE MOVING IMAGE
LUKAS LOSS
360 PHOTOGRAPHY ZUGANG KOLLEKTIV ADDITIONAL FOOTAGE BERLIN 29082020, CAN KURUCU, TAMA RUß, ADA KOPAZ, BRUNO SIEGRIST
· 시뮬레이션 SIMULATIONS
DANCING MANIA (K21) *REBELLION* (CENTRE POMPIDOU)
· 프로듀서 PRODUCER
AYHAM GHRAOWI
· 프로그래밍 가동 및 효과
BEHAVIOR AND EFFECTS PROGRAMMING ROBERT GERDISCH
· CG, 실시간 상영 및 3D 모델링
CG & REAL-TIME VISUALIZATIONS AND 3D MODELING
LUCAS GUTIERREZ
· 부가 프로그래밍
ADDITIONAL PROGRAMMING
BARANSEL TEKIN
· 신경 조정 NEURAL SNAKE CHARMING
JULES LAPLACE
· 커미션 COMMISSIONED BY
DORIS KRYSTOF, KUNSTSAMMLUNG NORDRHEIN- WESTFALEN, DÜSSELDORF; FLORIAN EBNER AND MARCELLA LISTA, CENTRE POMPIDOU PARIS
· 도움 주신 분 THANKS TO
TOMAS SARACENO, FOR GRACIOUSLY ALLOWING ME TO SHOW HIS AMAZING INSTALLATION IN ORBIT AND TO FOR THE BRILLIANT GENETIC WALKERS AT WWW.REDNUGHT.COM, ALICE CONCONI, LEAH TURNER, EMILIANO PISTACCHI,

ANDREW KREPS, ESTHER SCHIPPER, KEIJIRO FOR AMAZING PROCEDURAL DANCE, SKINNER FX, MILOS. TRAKILOVIC, GIORGI GAGO GAGOSHIDZE, TOM HOLERT, AND DCCA / AMADEU ANTONIO STIFTUNG, KENNY SCHACHTER, WHERE IN THE WORLD IS 'SALVATOR MUNDI'? ARTNET, JUNE 2019
· 행복한 저산소증 HAPPY HYPOXIA
HITO STEYERL
· 제작 지원 SUPPORTED BY
KULTURSTIFTUNG DES BUNDES

→

《히토 슈타이얼-데이터의 바다》 전시 전경, 국립현대미술관, 서울, 2022

INSTALLATION VIEW OF *HITO STEYERL-A SEA OF DATA*, NATIONAL MUSEUM OF MODERN AND CONTEMPORARY ART, SEOUL (MMCA), 2022

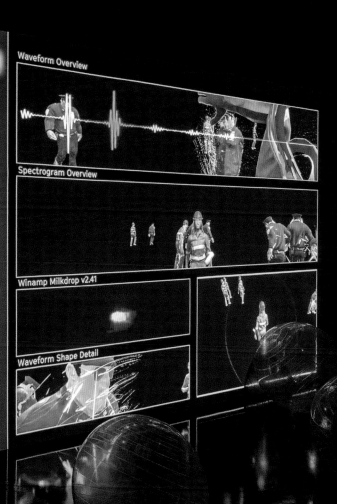

SOCIALSIM
2.0 (beta)

Waveform Overview

Spectrogram Overview

Winamp Milkdrop v2.41

Waveform Shape Detail

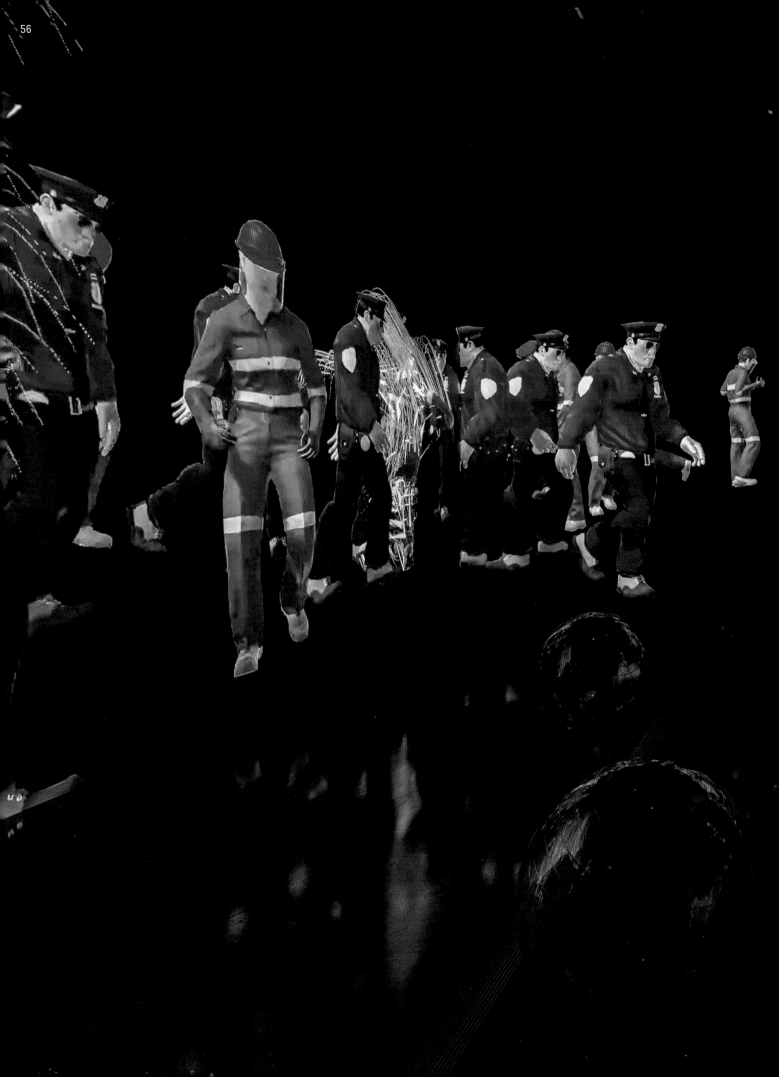

스페즈나즈-쿤
정부 적법성 수준: 0.9
위험 회피: 0.8
불만 수준: 0.5

Speznaz-Kun
Government legitimacy level: 0,9
Risk aversion: 0.8
Grievance level: 0.5

Reality

2020

MUSIC

"PAID REACH RZ"
Kassem Mosse

"WE (PART TWO)"
Viola Klein FEATURING Whodat, Sabar by Abdou
Aziz, Abdoukhadre and Adrame Diop (St. Louis)

"GLACIAL CATACOMB"
Bethany Barrett

VARIATION ON "RABBIA E TARANTELLA"
COMPOSED BY Ennio Morricone, PERFORMED
BY Bethany Barrett, Jules Laplace and Liam
Morrison

Xhale303 trailer-1, Michael-DB synthontherum 01,
Gregor Quendel Cinematic Orchestra/ Throat chanting,
Lharman94 Arpeggiato, Graham Makes Epic Orchestral
Cité, Gregor Quendel Cinematic Chanting, Weldon Smith
shepardfilterdrone, @FXProSound dangerous cinematic,
hoerspielwerkstatt hef — maxibeat1-130, Goran Andric
Thrill Announcement, Michael-DB cinematic music, Tony
Rolando (make noise music), todbarton-shakuhachi,
Matt c90 Epic Tribal Drums Cmeeson didg-3-sampleJ,
uskddink Seagulls / Thatjeffcarter razorbladerunning-2,
Florian Reichelt www.instagram.com/florianreichelt

F-scale (in beer barrels)

Days left to day X (per day '0')

Confusion Coefficient (per He

Threats sent from German Polic

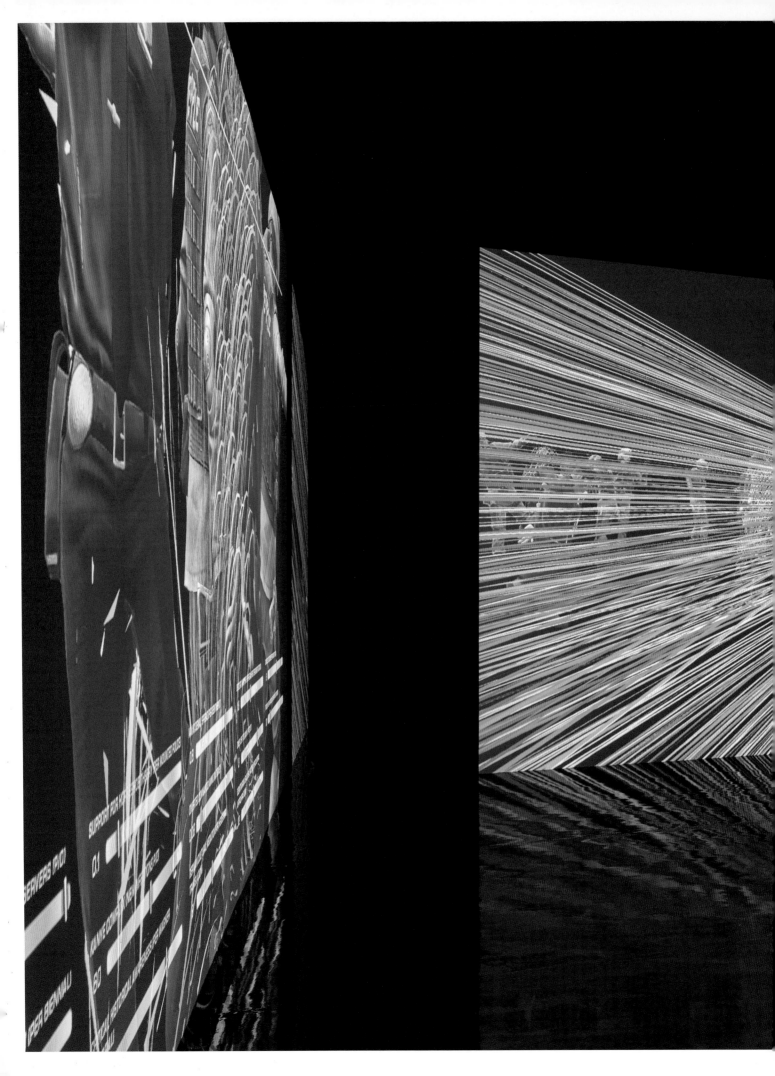

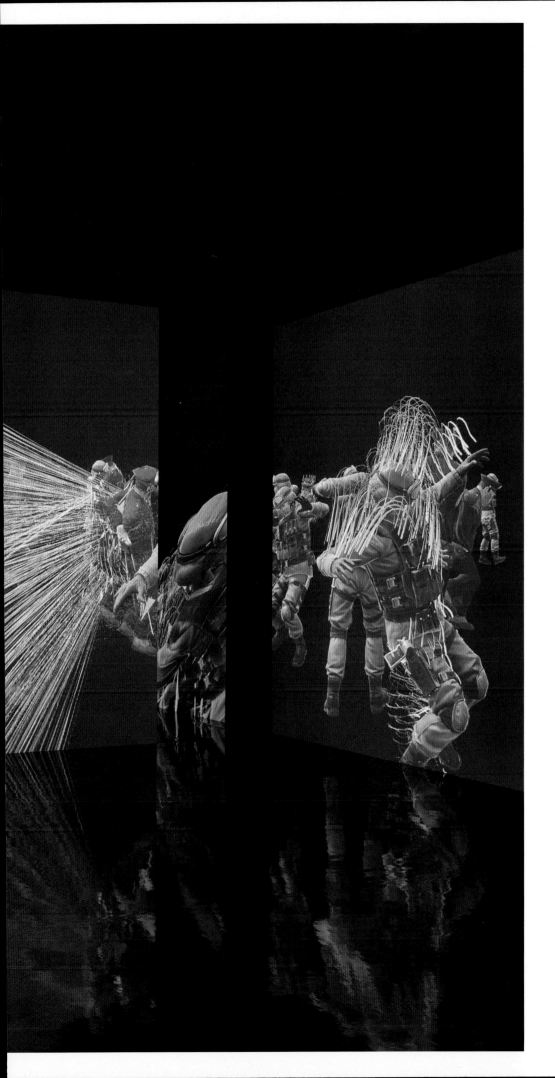

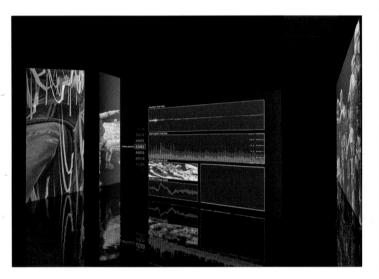

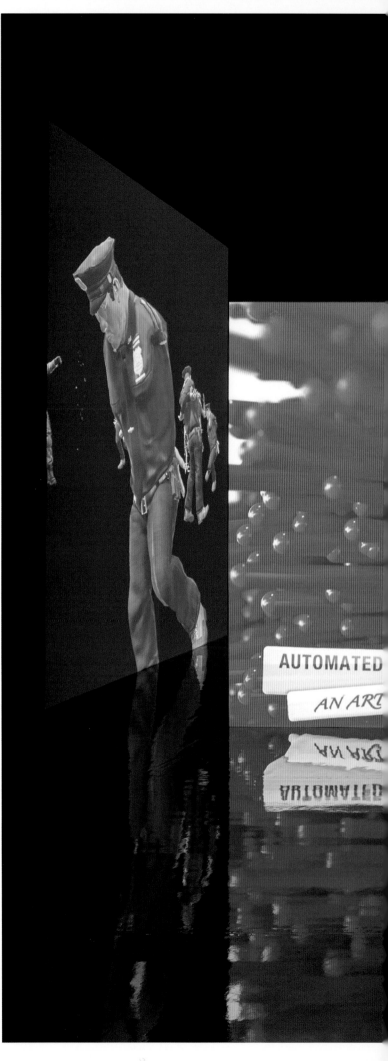

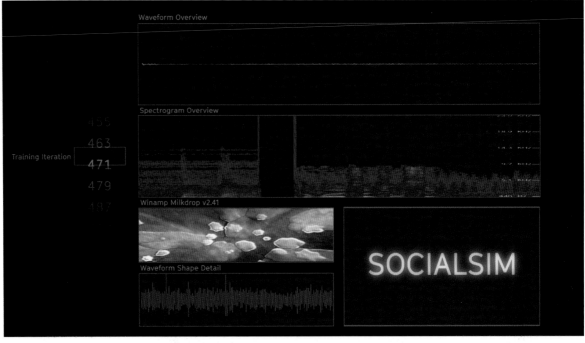

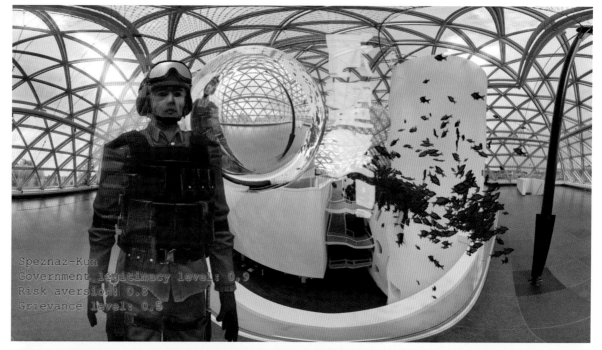

Speznaz-Kun
Government legitimacy level: 0.9
Risk aversion: 0.8
Grievance level: 0.5

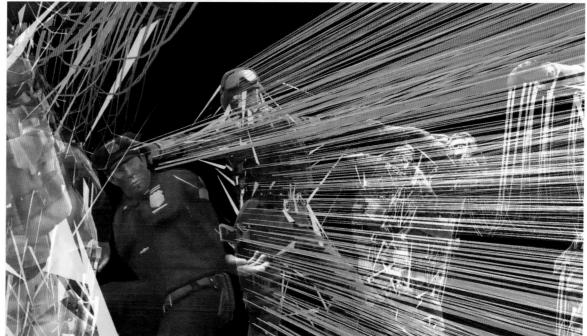

태양의 공장
FACTORY OF THE SUN
2015

- 단채널 HD 비디오 설치, 컬러, 사운드,
 발광 LED 그리드, 의자, 23분
- 작가, 앤드류 크랩스 갤러리,
 뉴욕 및 에스더 쉬퍼, 베를린 제공

- SINGLE-CHANNEL HD VIDEO, COLOR,
 SOUND, ENVIRONMENT, LUMINESCENT LED
 GRID, BEACH CHAIRS, 23 MIN.
- COURTESY OF THE ARTIST, ANDREW
 KREPS GALLERY, NEW YORK AND ESTHER
 SCHIPPER, BERLIN

- 주연 PROTAGONISTS
 TSC (TAKESOMECRIME), YULIA STARTSEV
- 배우 ACTOR
 MARK WASCHKE
- 기술 감독 TECHNICAL DIRECTOR
 CHRISTOPH MANZ
- 3D 디자인 3D DESIGN
 MAX SCHMOETZER
- 포스트 프로덕션 POST PRODUCTION
 KATARZYNA GUZOWSKA
- 음향 TON
 DANIEL ERBE
- 조감독 ASSISTANT DIRECTOR
 ALWIN FRANKE
- 세트 디자인, 프로덕션 코디네이터,
 포스트 프로덕션 SET DESIGN,
 PRODUCTION COORDINATOR,
 POST PRODUCTION
 MICHA AMSTAD
- 의상 디자인 COSTUME DESIGN
 LEA SOVSO
- 돌리 그립 DOLLY GRIP
 NICO KANTUSER
- 드론 촬영 DRONE SHOTS
 HANS GOEDECKE, CORNELIUS DIEMER,
 ANKE RIESTER
- 공동 작가 CO-WRITER
 SHUMON BASAR
- 음악 MUSIC
 KASSEM MOSSE, FATIMA AL-QADIRI,
 INSTUPENDO, DAWN OF MIDI,
 KAYCEE, ET AL.
- 총기 전문가 GUN EXPERT
 GERD DUBIELLA, SHOOTERS
- 영상 지원 VIDEO SUBSIDIZED BY
 IFA, INSTITUT FÜR
 AUSLANDBEZIEHUNGEN
- 공동 설치 디자인
 CO-INSTALLATION DESIGN
 DAVID RIFF

- 어시스턴트 ASSISTANTS
 NEDA SAEEDI, NICOLAS PELZER
- 연출 REALISATION
 MANUEL REINARTZ, BERNHARD TATTER
- 어시스턴트 ASSISTANT
 IRINA KORALOVA
- 감사 THANKS TO
 FORMER LISTENING STATION
 TEUFELSBERG, SHALMON ABRAHAM
- 영감 INSPIRED BY
 DONNA HARAWAY, WENDY CHUN,
 BRIAN KUAN WOOD, TOM HOLERT
- 도움 THANKS TO
 FLORIAN EBNER, ELKE AUS DEM MOORE,
 ANTON VIDOKLE, DAVID RIFF,
 ESME BUDEN, GERMAN PAVILLION
 BUILDING TEAM

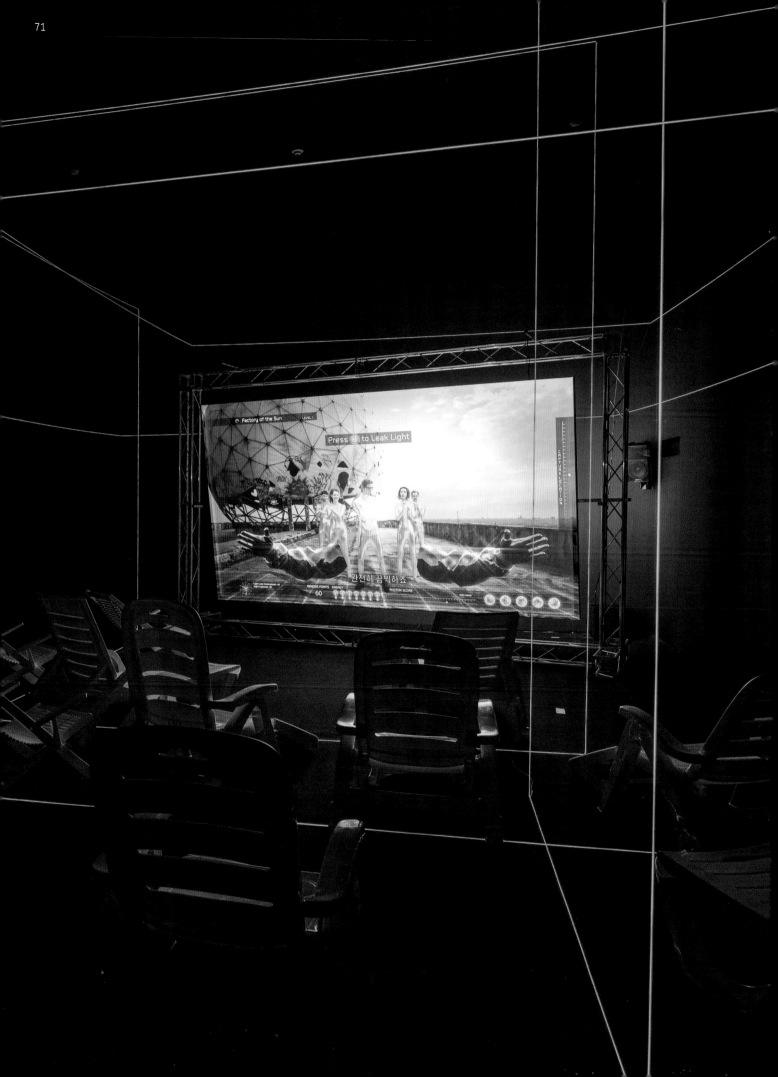

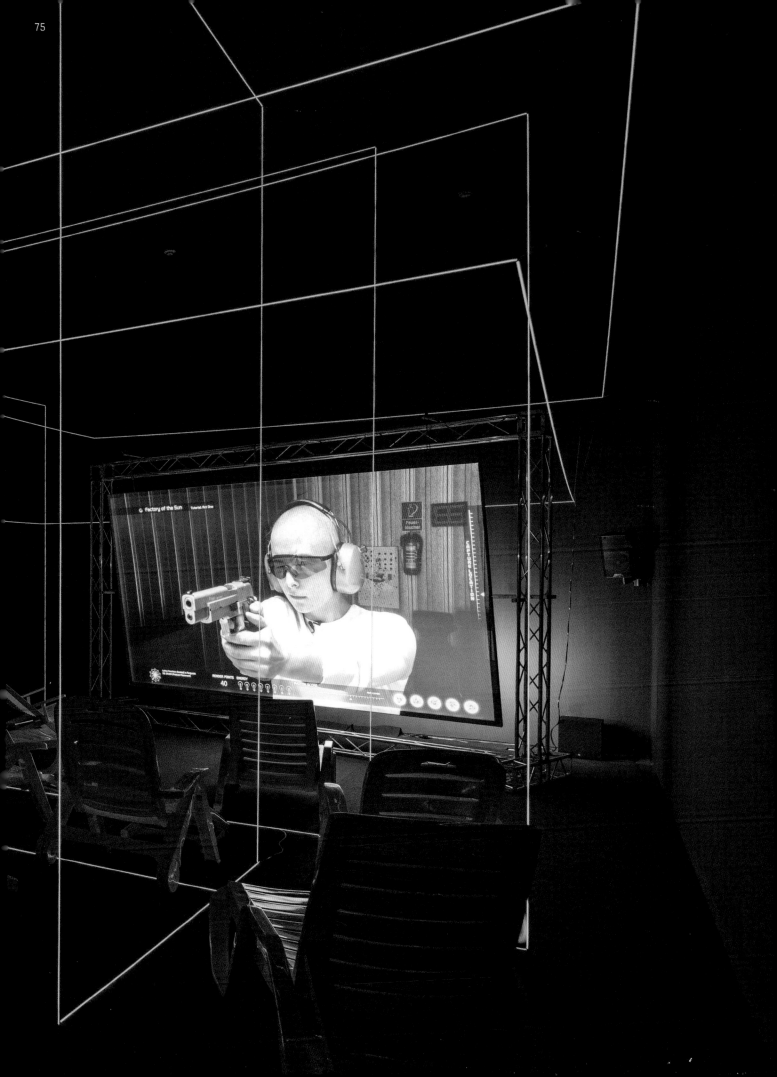

↑ 《I WAS RAISED ON THE INTERNET》 전시 전경, 시카고 현대미술관, 시카고, 2018

INSTALLATION VIEW OF *I WAS RAISED ON THE INTERNET*, MCA CHICAGO, 2018

↓ 《HITO STEYERL: FACTORY OF THE SUN》 전시 전경, 로스앤젤레스 현대미술관 그랜드 애비뉴, 로스앤젤레스, 2016

INSTALLATION VIEW OF *HITO STEYERL: FACTORY OF THE SUN*, MOCA GRAND AVENUE, LOS ANGELES, 2016

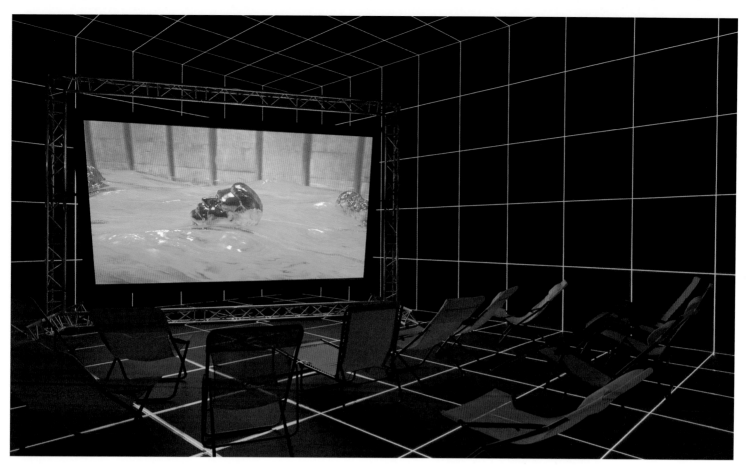

↑ 《DREAMLANDS: IMMERSIVE CINEMA AND ART, 1905-2016》 전시 전경, 휘트니 미술관, 뉴욕, 2016

INSTALLATION VIEW OF *DREAMLANDS: IMMERSIVE CINEMA AND ART, 1905-2016*, WHITNEY MUSEUM OF AMERICAN ART, NEW YORK, 2016

↓ 베니스 비엔날레, 독일관 전시 전경, 2015

INSTALLATION VIEW OF THE VENICE BIENNALE, GERMAN PAVILION, 2015

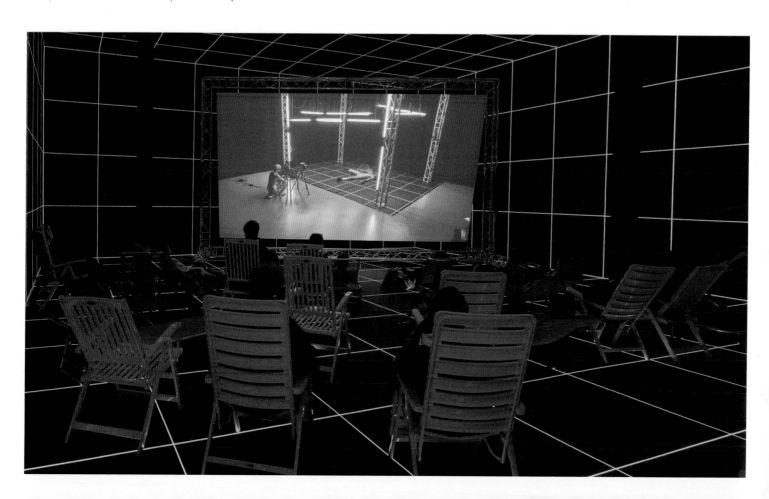

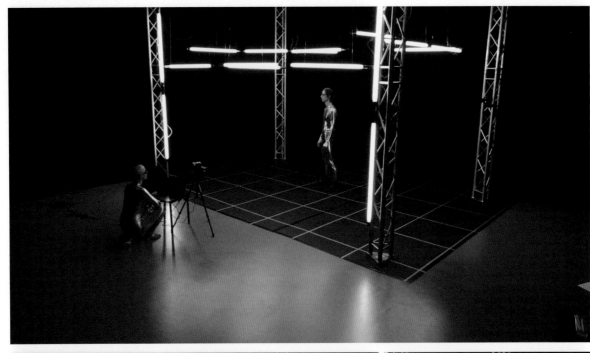

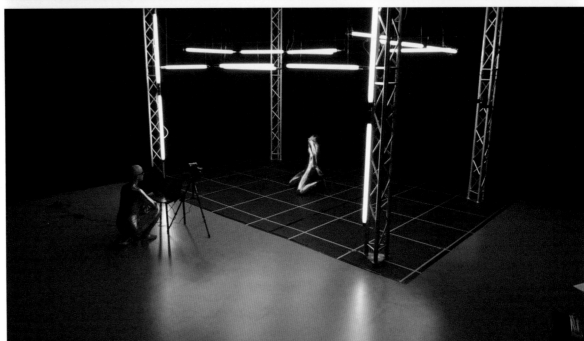

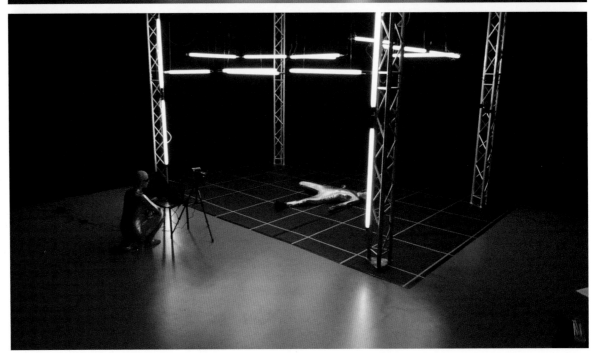

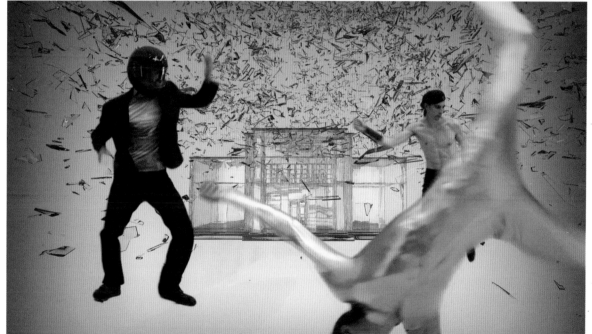

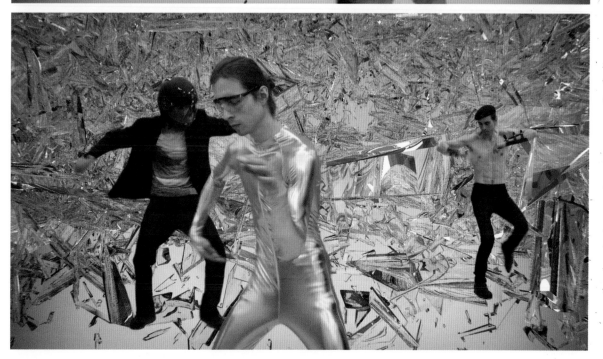

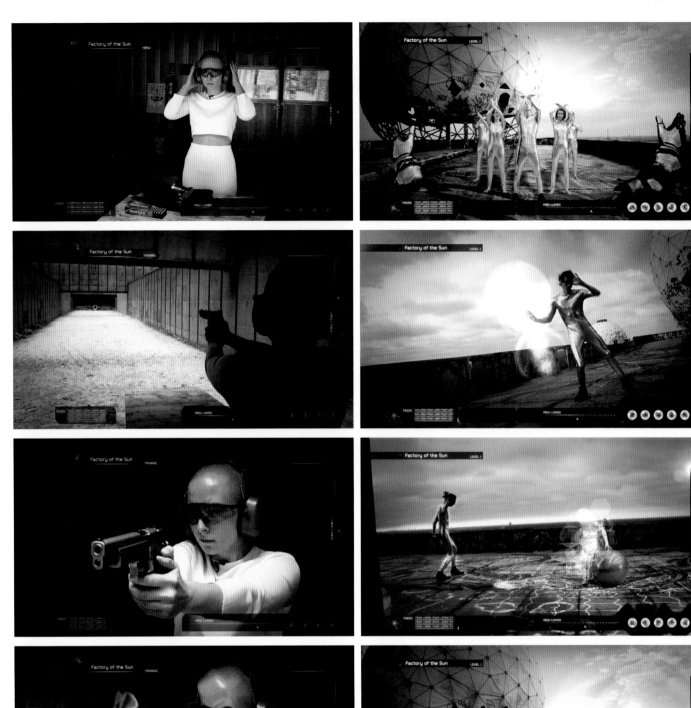
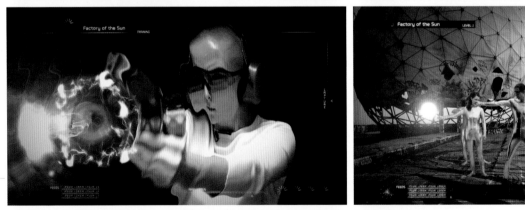
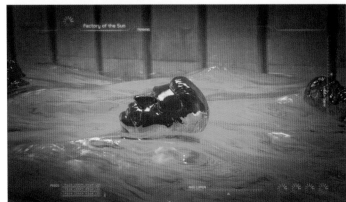
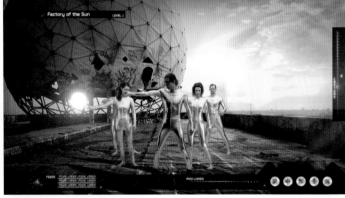
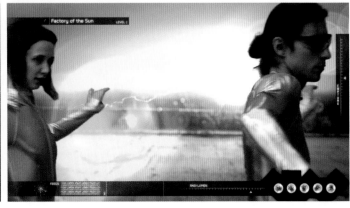

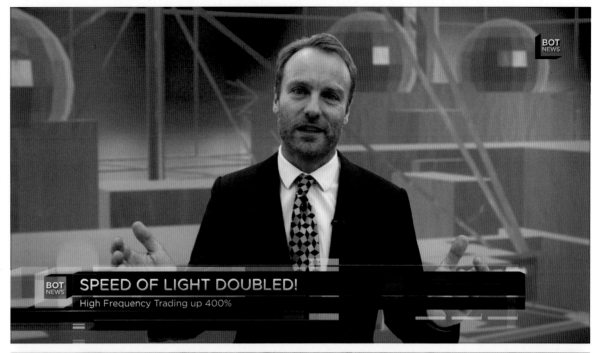

SPEED OF LIGHT DOUBLED!
High Frequency Trading up 400%

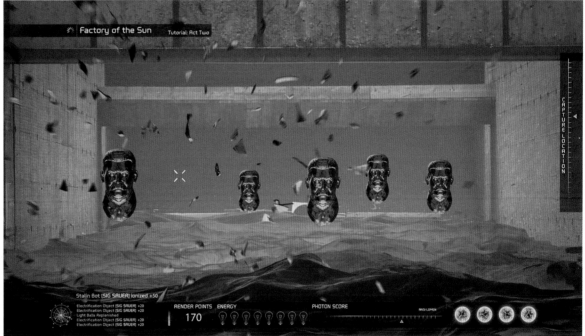

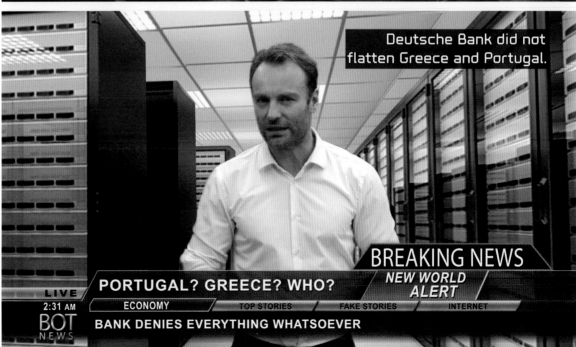

Deutsche Bank did not flatten Greece and Portugal.

BREAKING NEWS
NEW WORLD ALERT

PORTUGAL? GREECE? WHO?

ECONOMY TOP STORIES FAKE STORIES INTERNET

LIVE
2:31 AM

BANK DENIES EVERYTHING WHATSOEVER

단채널 HD 비디오, 컬러, 사운드, 24분,
라이브 컴퓨터 시뮬레이션, 가변 시간
국립현대미술관 제작 지원
작가, 앤드류 크랩스 갤러리, 뉴욕 및
에스더 쉬퍼, 베를린 제공

SINGLE-CHANNEL HD VIDEO, COLOR,
SOUND, 24 MIN. LIVE COMPUTER
SIMULATION, DURATION VARIABLE
PRODUCTION: NATIONAL MUSEUM OF
MODERN AND CONTEMPORARY ART, KOREA
(MMCA)
COURTESY OF THE ARTIST, ANDREW
KREPS GALLERY, NEW YORK AND ESTHER
SCHIPPER, BERLIN

주연 PROTAGONISTS
NEL CAÑEDO SAAVEDRA, CANDIDO ASPRON
ASPRON, FERNANDO GARCIA DORY
배우 ACTOR
MARK WASCHKE AS JOHN MAYNARD KEYNES
카메오 CAMEOS BY
RABIH MROUÉ, LIAM GILLICK, JAMES
BRIDLE
3D 영상 디자인 3D DESIGN VIDEO
MAXIMILIAN SCHMOETZER
3D 애니메이션 유니티 및 시뮬레이션
디자인 3D ANIMATION UNITY
AND SIM DESIGN
LUCAS GUTIERREZ
컬러 COLOR
GRADING AND MASTERING
CHRISTOPH MANZ
의상 및 메이크업 COSTUME AND MAKE UP
LEA SØVSØ
촬영, 사운드, 프로덕션, 코디네이션,
회계, 3D 애니메이션, 드론 조종, 편집,
드라이빙, 입자 효과, 타이틀 디자인,
사운드 디자인, 사운드 믹스, 스크립트,
카메오, 줌 녹화, NFT 버닝, 애니메이션
인용, 어시스턴트, 어시스턴트 보조,
운송, 3D 모델 변환, 짐벌 촬영,
세컨드 유닛, 서드 유닛, 그립, 조명,
그린 스크린 유닛, 라이트 트레킹, 기금
모금, 비디오 튜토리얼 팔로워, 케이터링,
여행 코디네이터, 모든 인공지능 과정,
영상 출력 등 히토 슈타이얼
CAMERA, SOUND, PRODUCTION,
COORDINATION, ACCOUNTING, 3D
ANIMATION, DRONE PILOTING, EDIT,
DRIVING, PARTICLE EFFECTS, TITLE
DESIGN, SOUND DESIGN, SOUND

MIX, SCRIPT, CAMEO ACTING, ZOOM
RECORDING, NFT BURNING, ANIMATION
RECYCLING, GENERAL ASSISTANT,
ASSISTANTS ASSISTANT, COURIERING,
3D MODEL CONVERSION, GIMBAL CAMERA,
SECOND UNIT, THIRD UNIT, GRIP,
LIGHT, GREEN SCREEN UNIT, RIGHTS
TRACKING, FUND RAISING, VIDEO
TUTORIAL FOLLOWER, CATERING, TRAVEL
COORDINATOR, HOME SCHOOLING NURSE,
ALL AI PROCESSES, INCLUDING THE
EXTREMELY BORING ONES LATENT SPACE
ARCHITECTURE AND PATHMAKING,
VIDEO EXPORT ETC
HITO STEYERL
음악 MUSIC
'CANTO OSTINATO'—SIMEON TEN HOLT—
MINIMAL UTOPIA ORKESTRA.MP3,
514511_GREGORQUENDEL_CINEMATIC-
PERCUSSION-TRAILER-PERCUSSIONONLY.
WAV, 44625_AUDIOPAPKIN_SWOOS-16.
WAV, 266628_TOILETROLLTUBE_CUBE-
DRONE-150309A-02.WAV, 44017_
AARONGNP_BAGPIPE-CHORUS.WAV,
KUDLA PRODUCTION - EPIC WAV.
WAV, 472402_JOSEAGUDELO_22-LOBO-
AULLANDO.WAV, 332577_KELEWIN_
AMBIENT-INTRO.MP3, 70334_
DIGIFISHMUSIC_HIIIIGHLAND.WAV,
YEVHEN LOKHMATOV-RISING TENSION.
MP3, THE EPIC DRUMS.WAV, 332578_
KELEWIN_DHARMADRONE.MP3, 33547700_
CINEMATIC-CARTOON- ADVENTURE_BY_
ANOTWEND.WAV, THIS IS DRUMS ACTION
(FULL).WAV, 107787_TIMBRE_
BEEOOOOWWWWWW.WAV, 317463_
VALENTINSOSNITSKIY_SHORT-SWING-WAV.
WAV, 047345262-HIGHLANDS-LOVE.WAV,
43894_OYMALDONADO_METAL-INTRO.AIFF,
160086202-CINEMATIC- INTRO-METAL-
TRAILER.WAV, 591160_OCTOREZ_
JAW-HARP.MP3, 463499_J-A-PINTO_
ETHEREAL-JAWS-HARP.WAV, 470780_
QUETZALCONTLA_TRIBAL-RHYTHMIC-
DELAY-LOOP.WAV, 439546_VOSPI_SUPER-
SPECIFIC-LANDING.FLAC, 458425_
QUETZALCONTLA_WARM-GUITAR-RHYTHM-
INTRO.WAV, WARRIOR LONG.WAV, 260657_
THATJEFFCARTER_STAR-WASH-SYNTH.WAV,
THANK YOU TO FREESOUND.ORG
제작 지원 PRODUCTION
NATIONAL MUSEUM OF MODERN AND

CONTEMPORARY ART, KOREA (MMCA)
장소 지원 SUPPORTED ON LOCATION BY
INLAND/CAMPO ADENTRO
늑대 가죽은 100년 이상 된 것으로
다락에서 발견되었다. THE WOLF SKIN
IS MORE THAN 100 YEARS OLD AND WAS
FOUND IN THE ATTIC.
도움 주신 분 THANKS TO
ESME BUDEN, MANUEL REINARTZ,
SIMEON TEN HOLT FOUNDATION, MARK
TERKESSIDIS, JOCHEN KÜHLING,
ALICE CONCONI, MYUNG-JI BAE, LEAH
TURNER, EMILIANO PISTACCHI, ESTHER
SCHIPPER, ANDREW KREPS, EDUARDO AND
INLAND COLLECTIVE

→
《히토 슈타이얼—
데이터의 바다》
전시 전경,
국립현대미술관,
서울, 2022

INSTALLATION VIEW
OF *HITO STEYERL—
A SEA OF DATA*,
NATIONAL MUSEUM
OF MODERN AND
CONTEMPORARY ART,
SEOUL (MMCA),
2022

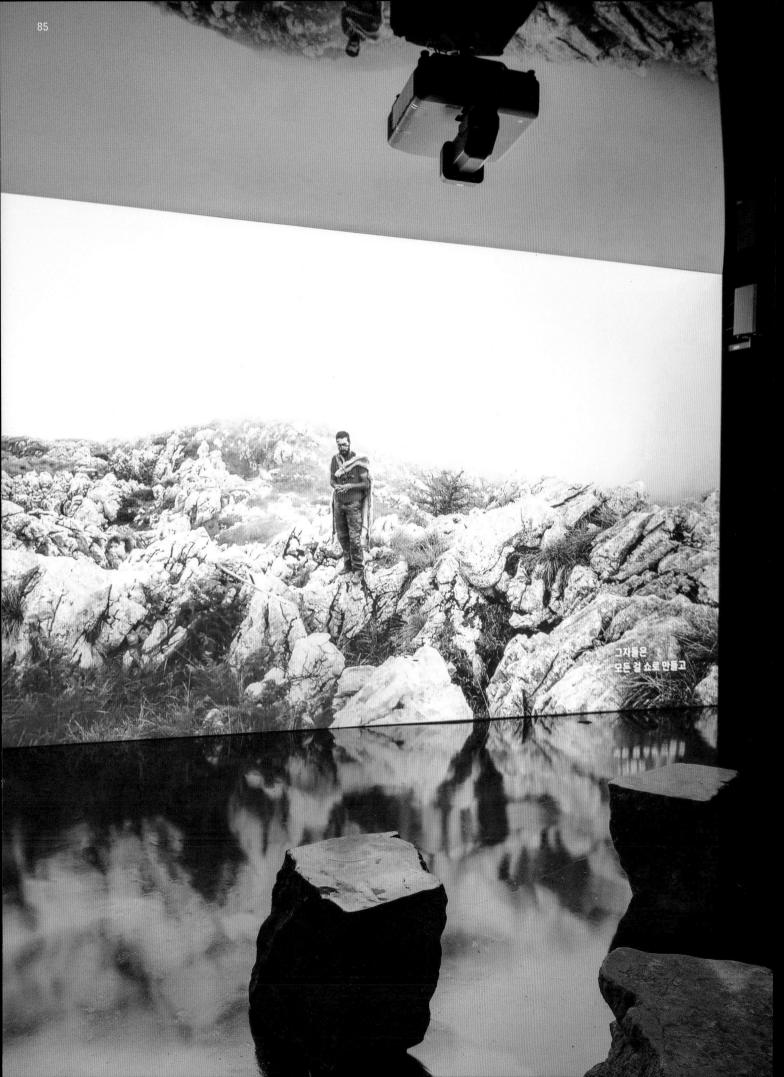

그자들은
모든 걸 쇼로 만들고

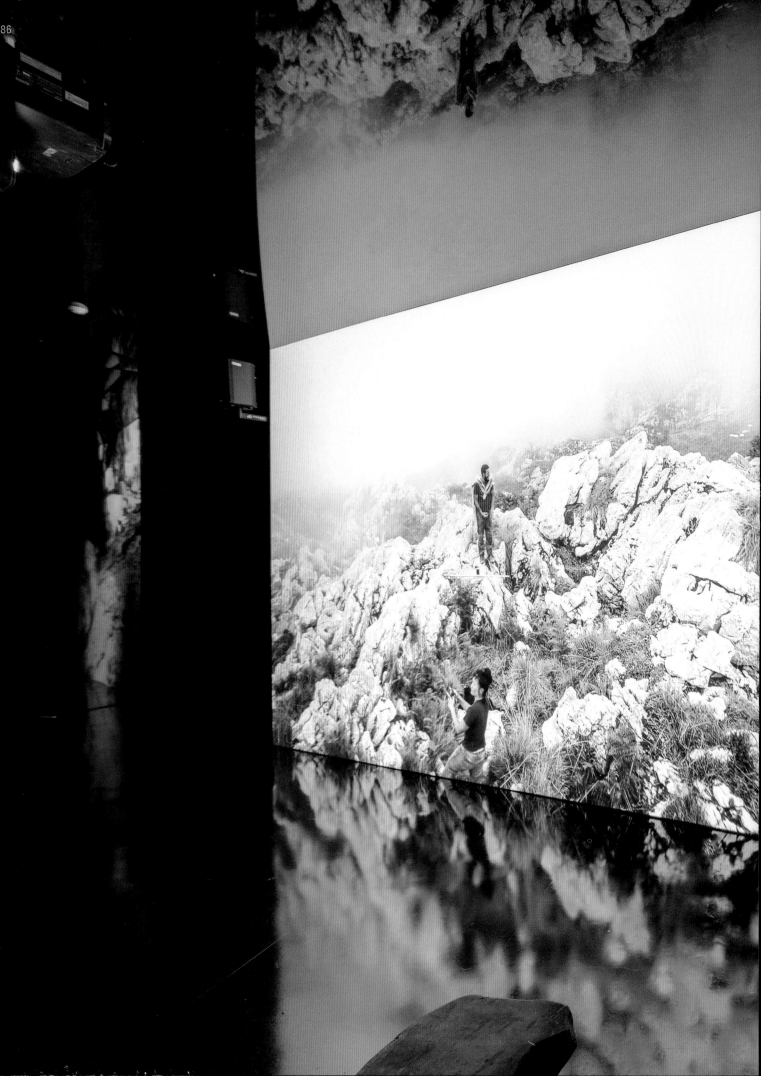

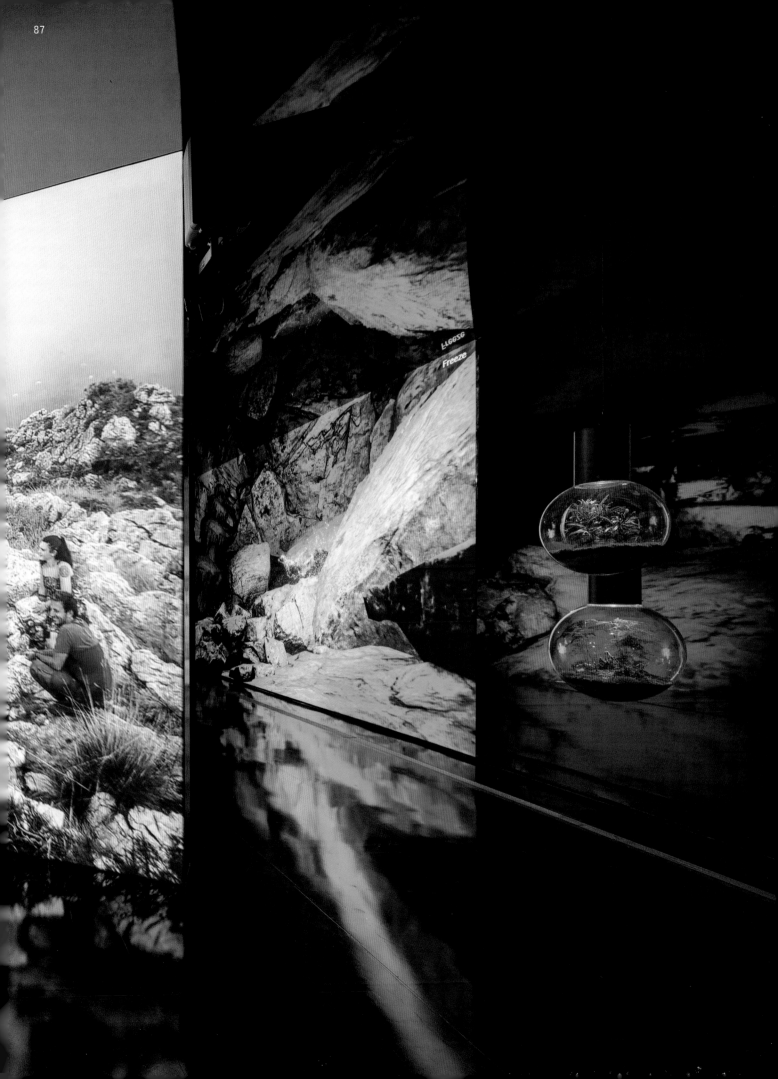

the animals fight one another to the death

each time an animal burns an NFT is minted
and recorded to the blockchain as a unique digital asset

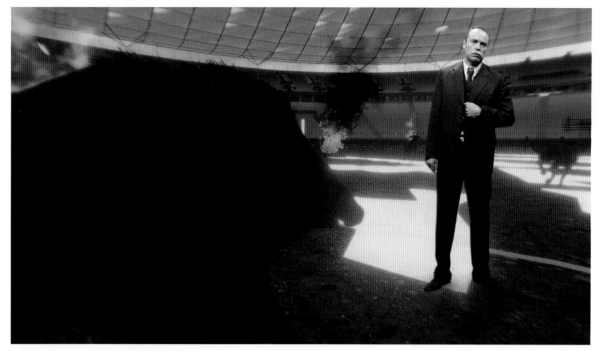

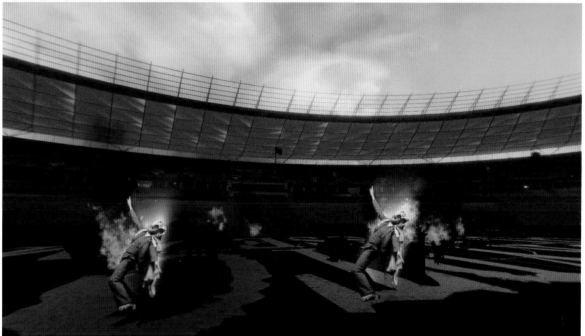

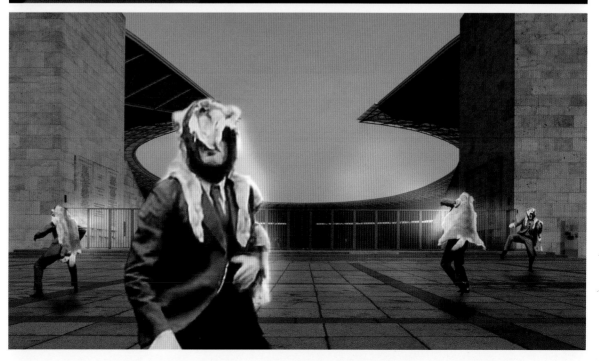

이것이 미래다
THIS IS THE FUTURE
2019

- 비디오 설치
〈이것이 미래다〉, 2019, 단채널 HD
비디오, 컬러, 사운드, 스마트 스크린,
16분
〈파워 플랜츠〉, 2019, 스테인리스스틸
비계 구조물, LED 패널, 다채널 비디오,
컬러, 무음, 반복 재생, LED 텍스트 패널,
텍스트 비디오, 컬러, 무음, 반복 재생,
가변 크기
- 울산시립미술관 소장
- 작가, 앤드류 크랩스 갤러리, 뉴욕 및
에스더 쉬퍼, 베를린 제공

- VIDEO INSTALLATION, ENVIRONMENT
THIS IS THE FUTURE, 2019,
SINGLE-CHANNEL HD VIDEO, COLOR,
SOUND, PROJECTED RETRO ON SMART
FOIL SWITCHABLE OPACITY PROJECTION
SCREEN, 16 MIN.
POWER PLANTS, 2019, STAINLESS STEEL
SCAFFOLDING STRUCTURES, LED PANELS,
MULTICHANNEL VIDEO LOOP, COLOR,
SILENT, LOOP, LED TEXT PANELS,
TEXT VIDEO, COLOR, MUTE, LOOP,
DIMENSIONS VARIABLE
- ULSAN ART MUSEUM COLLECTION
- COURTESY OF THE ARTIST, ANDREW
KREPS GALLERY, NEW YORK AND ESTHER
SCHIPPER, BERLIN

〈이것이 미래다〉
THIS IS THE FUTURE
- 참여 WITH
HEJA TÜRK, KOJEY RADICAL
- 프로덕션 PRODUCTION
SERPENTINE GALLERIES
- 초기 알고리즘 및 기술 자문 INITIAL
ALGORITHM AND TECHNICAL ADVISORY
DAMIEN HENRY
- 인공지능 툴 구축 및 알고리즘 재기록 AI
TOOL BUILDING AND ALGORITHM REWRITE
JULES LAPLACE
- 음악 MUSIC
KOJEY RADICAL, KASSEM MOSSE,
BRIAN KUAN WOOD, HOZAN HOGIR,
DELETED_USER_2731495
- 그래픽 디자인, 인공지능 폰트
GRAPHIC DESIGN, AI FONT
AYHAM GHRAOWI
- 촬영 CAMERA
SAVAS BOYRAZ
- 보이스 오버 VOICE-OVER

SAMANTHA LIVINGSTON
- 포스트 프로덕션 POST PRODUCTION
CHRISTOPH MANZ
- 설치 INSTALLATION
MANUEL REINARTZ, EMILIANO PISTACCHI
- 제작 지원 SUPPORTED BY
VINYL FACTORY AND SERPENTINE
GALLERIES, ANDREW KREPS GALLERY,
NEW YORK AND ESTHER SCHIPPER,
BERLIN
- 마법 MAGIC
HITO STEYERL
- 도움 주신 분 THANKS TO
ALICE CONCONI, DAMIEN HENRY, JULES
LAPLACE, FREYA MURRAY, ANTON
VIDOKLE, ASAKUSA OSAKA KOICHIRO
AND TAKASHI, MILOS TRAKILOVIC,
GAGO GAGOSHIDZE, ADNAN YILDIZ,
ANDREW KREPS, ESTHER SCHIPPER,
LEAH TURNER, AMAL KHALAF, HANS-
ULRICH OBRIST, BEN VICKERS, AMIRA
GAD, KAY WATSON, AYHAM GHRAOWI,
DIEGO DUEÑAS, JULIA SÉGUIER, MANUEL
REINARTZ, EMILIANO PISTACCHI

〈파워 플랜츠〉
POWER PLANTS
- 프로덕션 PRODUCTION
SERPENTINE GALLERIES,
ADI SOLUTIONS, ADI AV
- 설치 디자인 지원
INSTALLATION DESIGN SUPPORT
MANUEL REINARTZ, EMILIANO PISTACCHI
- 초기 예측 알고리즘 및 기술 자문
INITIAL PREDICTION ALGORITHM
AND TECHNICAL ADVISORY
DAMIEN HENRY
- 뉴럴 비디오 시스템
NEURAL VIDEO SYSTEM
JULES LAPLACE
- 표본 RNN 프로덕션
SAMPLE RNN PRODUCTION
DAMIEN HENRY
- 촬영 CAMERA
SAVAS BOYRAZ, TAKASHI
- 포스트 프로덕션
VIDEO POST PRODUCTION
CHRISTOPH MANZ
- 시트 디자인 VINYL DESIGN
AYHAM GHRAOWI
- 작가 스튜디오 프로덕션 코디네이터
ARTIST STUDIO PRODUCTION

COORDINATOR
HANNA MATTES
- 좌석 제작 SEAT PRODUCTION
PHILIPP VON FRANKENBERG AND
JAMIE BRACKEN LOBB
- 사운드트랙 SOUNDTRACK
KOJEY RADICAL, SUSUMU YOKOTA.
- 제작 PRODUCED BY
THE VINYL FACTORY
- 영상 공동 커미션
VIDEO CO-COMMISSIONED BY
SERPENTINE GALLERIES AND
THE STORE X

→
《히토 슈타이얼-
데이터의 바다》
전시 전경,
국립현대미술관,
서울, 2022

INSTALLATION VIEW
OF *HITO STEYERL-
A SEA OF DATA*,
NATIONAL MUSEUM
OF MODERN AND
CONTEMPORARY ART,
SEOUL (MMCA),
2022

Proofs art works against fire,
prevents greenwashing.

n. A plant thriving
in disturbed areas.

this is the future

810

line production:
Serpentine Galleries, Amira Gad

production support:
Store X, Andrew Kreps and Esther Schipper Galleries

conjuration:
Ben Vickers, Hans-Ulrich Obrist

prediction:
Hito Steyerl

thanks to:
Alice Conconi, Damien Henry, Jules Laplace,
Kojey Radical, Gunnar Wendel, Freya Murray,
Anton Vidokle, Osaka Koichiro and Takashi,
Hanna Mattes, Milos Trakilovic, Gago Gagoshidze,

《MAY YOU LIVE
IN INTERESTING
TIMES》 전시 전경,
제58회 베니스
비엔날레, 2019

INSTALLATION VIEW
OF MAY YOU LIVE
IN INTERESTING
TIMES, 58TH
VENICE BIENNALE,
2019

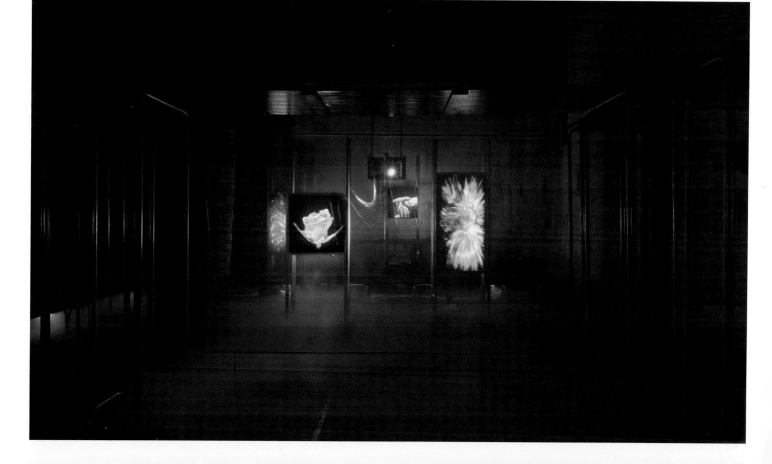

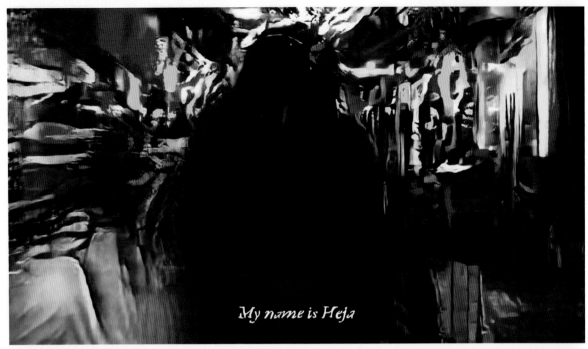

My name is Heja

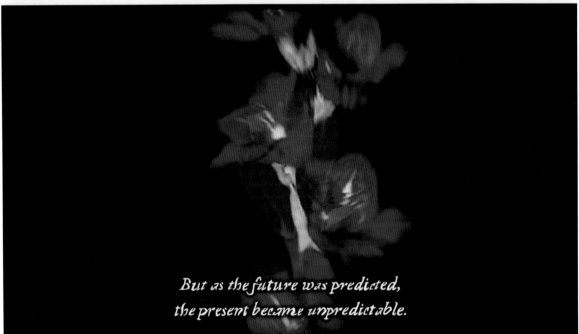

But as the future was predicted,
the present became unpredictable.

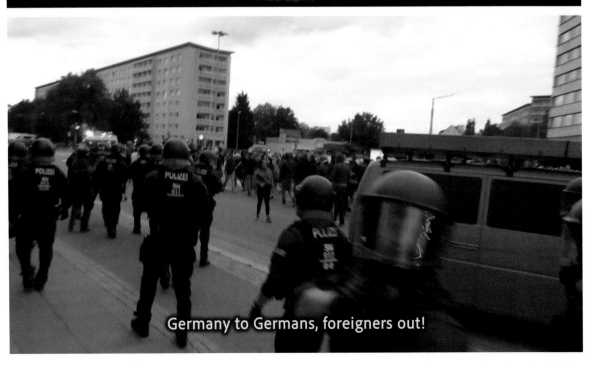

Germany to Germans, foreigners out!

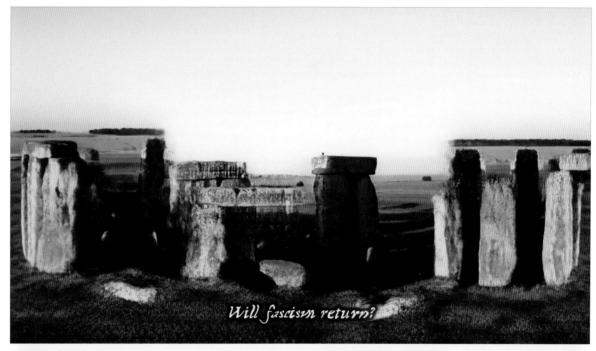

깨진 창문들의 도시
THE CITY OF BROKEN WINDOWS
2018

· 비디오 설치
〈깨진 창문들〉, 2018, 단채널 HD 비디오,
컬러, 사운드, 6분 40초
〈깨지지 않은 창문들〉, 2018, 단채널 HD
비디오, 컬러, 사운드, 10분
· 설치
채색된 나무 패널, 시트 레터링, 나무 이젤
· 작가, 앤드류 크랩스 갤러리, 뉴욕 및
에스더 쉬퍼, 베를린 제공

· VIDEO INSTALLATION, ENVIRONMENT
BROKEN WINDOWS, 2018, SINGLE-
CHANNEL HD VIDEO, COLOR, SOUND,
6 MIN. 40 SEC.
UNBROKEN WINDOWS, 2018, SINGLE-
CHANNEL HD VIDEO, COLOR, SOUND,
10 MIN.
· ENVIRONMENT
PAINTED PLYWOOD PANELS, VINYL
LETTERING, WOOD EASELS
· COURTESY OF THE ARTIST, ANDREW
KREPS GALLERY, NEW YORK AND ESTHER
SCHIPPER, BERLIN

〈깨진 창문들〉
BROKEN WINDOWS
· 주연 PROTAGONISTS
DR. SACHA KRSTULOVIC, DR. CHRIS
MITCHELL, ANASTASIJA, ARNOLDAS
· 촬영 감독, 색 보정, 포스트 프로덕션
DIRECTOR OF PHOTOGRAPHY, COLOR
CORRECTION AND POST PRODUCTION
CHRISTOPH MANZ
· 로케이션 매니저, 영국 프로덕션
LOCATION MANAGER, UK PRODUCTION
KATE PARKER
· 그립 GRIP
REECE HEARNSHAW
· 프로덕션 어시스턴트
PRODUCTION ASSISTANT
DAN WARD
· 음향 녹음 SOUND RECORDIST
TOM SEDGWICK
· 그래픽 디자인 GRAPHIC DESIGN
AYHAM GHRAOWI
· 뉴럴 뮤직 NEURAL MUSIC
JULES LAPLACE
· 사운드 디자인 및 믹스
SOUND DESIGN AND SOUND MIX
ALEXANDER HOETZINGER
· 프로듀서 PRODUCER
RICHARD BIRKETT

· 창문 파손 WINDOW BREAKING
HITO STEYERL
· 도움 주신 분 THANKS TO
AUDIO ANALYTICS, CAMBRIDGE,
ANDREW KREPS, ALICE CONCONI

〈깨지지 않은 창문들〉
UNBROKEN WINDOWS
· 주연 PROTAGONISTS
CHRIS TOEPFER (DECORATIVE BOARD
UP ARTIST), JACQUELINE SANTIAGO
(COMMUNITY ACTIVIST), PEDRO
REGALADO (URBAN HISTORIAN)
· 프로덕션 매니저 및 촬영 감독 PRODUCTION
MANAGER AND DIRECTOR OF PHOTOGRAPHY
JASON HIRATA
· 세컨드 카메라 2ND CAMERA
JOSH LAWSON
· 스태디캠 STEADICAM
SAMULI HAAVISTO
· 색 보정 및 포스트 프로덕션 COLOR
CORRECTION AND POST PRODUCTION
CHRISTOPH MANZ
· 뉴럴 뮤직 NEURAL MUSIC
JULES LAPLACE
· 사운드 디자인 및 믹스
SOUND DESIGN AND SOUND MIX
ALEXANDER HOETZINGER
· 그래픽 디자인 GRAPHIC DESIGN
AYHAM GHRAOWI
· 프로듀서 PRODUCERS
SAM TRIOLI, ALICE CONCONI
· 어시스턴트 프로듀서 ASSISTANT PRODUCER
SRINIVAS ADITYA MOPIDEVI
· 파손된 창문 BROKEN WINDOW
HITO STEYERL
· 도움 주신 분 THANKS TO
ANDREW KREPS, CHRIS TOEPFER,
CAMDEN LUTHERAN HOUSING INC,
PHOEBE HELANDER, MARTA KUZMA

→
《히토 슈타이얼-
데이터의 바다》
전시 전경,
국립현대미술관,
서울, 2022

INSTALLATION VIEW
OF HITO STEYERL-
A SEA OF DATA,
NATIONAL MUSEUM
OF MODERN AND
CONTEMPORARY ART,
SEOUL (MMCA),
2022

창문이 하나라도 깨진다면 도시의 몰락이 예견 될 것이다. 경찰 기둥가가

훌륭한 가게 주인인 제임스 굿맨로 때의 조심성 없는 아들이

유리창을 깨뜨렸을 때, 굿맨로 씨가 한 안이라도 통를 내는 걸

본 적이 있는가? 그런 한정에 있었다면 구경군이 심지어

서른 명이나 있었더라도 분명 다행헤 붙은훈 가게 주인에게

똑같은 위로를 던지는 모습을 보게 될 터이다. 창유창이

깨지지 않았다면 우리창는 무슨 할 일이 있겠오오?

「보이는 것과 보이지 않는 것」

프레데릭 바스티아

깨진 창문들의 도시는 황금빛 띠며 할 수 있다는 분위기로 도시에서는 모든 창문이 깨져야 하고, 깨진 파편은 팔딱

4 전 시 실

1 이것의 목적은 이론에 비추어 현실을 측정하는 것이다.

is golden and glowing with can-do.[1] In this city every

1 The purpose is to measure reality against the theory.

카스텔로 디 리볼리
현대미술관 전시
전경, 토리노, 2018

INSTALLATION VIEW
OF CASTELLO DI
RIVOLI, TURIN,
2018

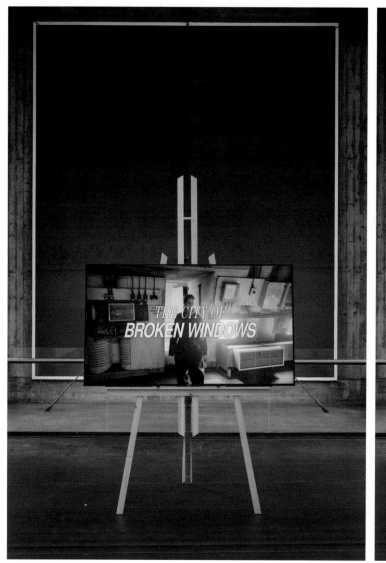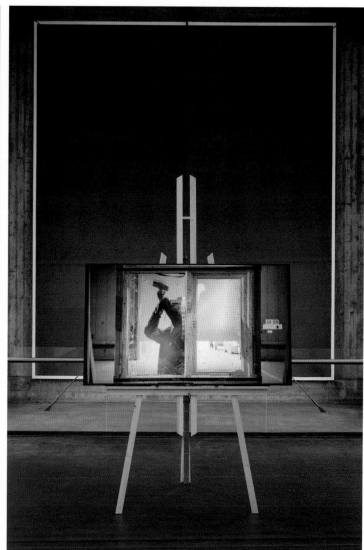

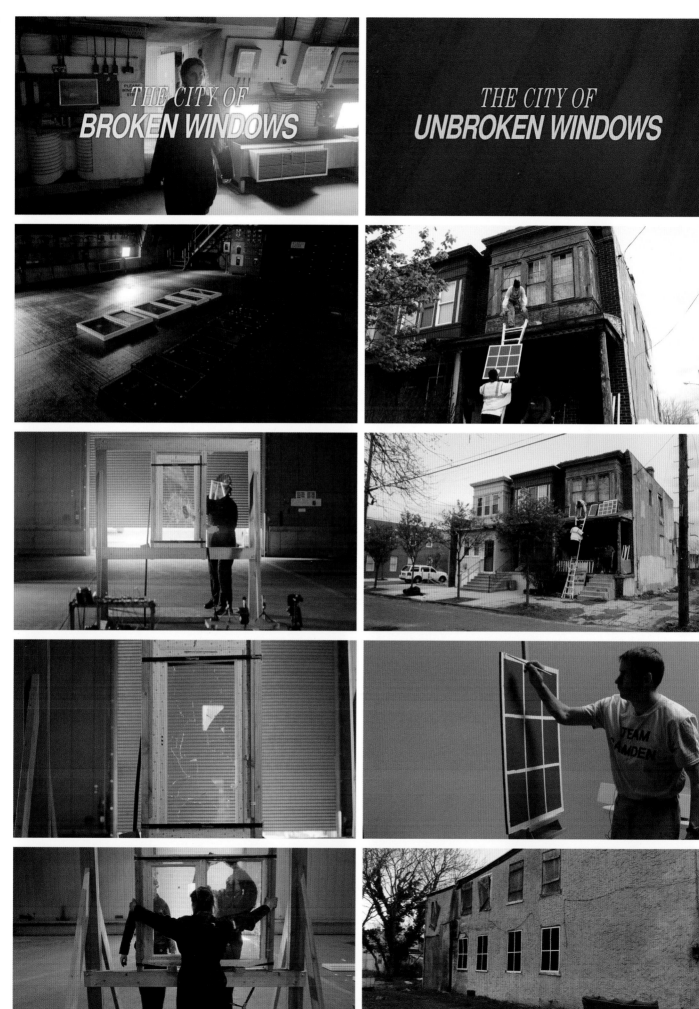

THE CITY OF
BROKEN WINDOWS

THE CITY OF
UNBROKEN WINDOWS

예술 사회주의:
히토 슈타이얼의
메타버스

노라 M. 알터

Art Socialism:
Hito Steyerl's
Metaverse

Nora M. Alter

다큐멘터리라는 건 존재하지 않는다.
다큐멘터리라는 용어가 재료의 범주나 특정한 장르,
접근 방식, 일련의 기법을 지칭하는지와는 별개로.
— 트린 T. 민하, 1990[1]

모든 영화는 다큐멘터리다.
— 빌 니콜스, 2001[2]

이에 따라 기호화되는 것은 '실재'의 범주이다
(그리고 그것의 우연적 내용은 그렇지 않다).
다시 말해, 기의의 부재 자체가 지시 대상에 유리하도록
리얼리즘의 기표가 된다. '실재 효과(reality effect)'가 산출되며,
이것은 현대성(modernity)에 속하는 모든 표준적 작품의
미학을 형성하는 명백한 박진성(verisimilitude)의 기반이다.
— 롤랑 바르트, 1968[3]

영화감독이자 문화인류학자인 트린 T. 민하와 다큐멘터리
이론가인 빌 니콜스의 언급은 21세기에 다큐멘터리
장르가 처한 처참한 위상을 드러낸다. 다큐멘터리라는
분류는 난처한 입장에 놓였다. 다큐멘터리가 현실을 재현한다는
주장은 20세기 후반 다큐멘터리란 곧 자신이 현실로 제시하는 것을
지어낸다고 주장한 비평가들에 의해 도전받은 바 있다. 트린 T. 민하는
디지털 혁명 전야에 남긴 글에서 다큐멘터리가 '주관적' 감정을
회피하는 것과 객관적 증거 제시에 실패했다고 주장했다. 그에게는
다큐멘터리 장르의 정동적이고 양식적인 효과가 중요한 점이다.
다큐멘터리에 대한 롤랑 바르트의 성찰은 19세기 소설의 '실재 효과'로
이어졌다. 이것은 곧 내러티브에 직접적으로 기여하지는 않지만
실재를 '공시의 기의(signified of connotation)'로서 효과적으로
불러내는 다양한 세부 사항을 활용하는 것이다. 서로 관련이 없는 듯
보이는 이런 세부적 내용은 직접적으로 실재를 '외시(denote)'하는
것 같지만, 바르트는 이렇게 말한다. "실재가 하는 것이라곤—그렇게
한다고 말하지 않고서도—그것을 '기호화'하는 것 뿐이다."[4] 트린

1
Trinh T. Minh-ha, "The Totalizing Quest of Meaning," [1990] *When the Moon Waxes Red* (New York: Routledge, 1991), 90-107.

2
Bill Nichols, *Introduction to Documentary* (Bloomington: Indiana University Press, 2001), 1.

3
Roland Barthes, "The Reality Effect," [1968] *The Rustle of Language*, trans. Richard Howard, (Berkeley: University of California Press, 1989), 141-148, 본 원고에서는 148.

4
원문은 all that they do-without saying so-is signify it. 같은 책, 148.

T. 민하의 영화 〈그녀의 이름은 베트남〉(1989)은 '진실을 담지하는' 주요한 기법과 프레이밍, 스타일에 대한 의존이 다큐멘터리적 기교와 창조적 속임수를 숨기는 '다큐멘터리적 효과'를 만들어 낸다는 점을 보여 준다. 니콜스는 트린 T. 민하가 제안한 난제에 비평적으로 관여하며, 모든 영화가 잠재적으로는 다큐멘터리로 기능할 수 있다고 결론짓는다. 심지어 영화가 '기록(document)'하는 것이 스스로 꾸며 낸 것일지라도 말이다.[5]

5
Nichols, *Introduction to Documentary*.

히토 슈타이얼이 구사하는 (시각 및 음향을 활용하는 작업에 덧붙여 글쓰기로 이뤄진) 연구에 기반한 예술 작업(practice)은 다큐멘터리 장르가 지닌 불안정하면서 이종적인(chimeraic) 특성과 지속적으로 관계를 맺는다. 슈타이얼은 분명 다큐멘터리 장르의 전통적 제작 방식에 실망한 모습을 보이지만, 진실의 파편에서부터 시작하는 아카이브 기반의 방법론을 지속적으로 구사한다. 그의 작업에서는 사금파리와 보석(shards and silvers)이 모여 마치 만화경처럼 새로운 성좌와 배열을 형성한다. 그에게 다큐멘터리란 초국가적 미디어 네트워크를 통해 순환하는 과정에서 의미를 띠는

6
Hito Steyerl, "A Language of Practice," in eds. Maria Lind and Hito Steyerl, *The Green Room* (Berlin: Sternberg Press, 2009), 225–231, 본 원고에서는 225.

하나의 언어다. 그는 이렇게 설명한다. "다큐멘터리 모드는 초국가적인 실천의 언어다. 다큐멘터리의 표준적 내러티브는 전 세계적으로 인식되며, 다큐멘터리 형식은 국가적이거나 문화적인 차이에서 거의 독립되어 있다."[6] 이런 식의 이해는 그가 다큐멘터리 장르의 한계에 도전하도록 이끌었다. 단지 사실을 진술하는 것을 넘어 숲속에 오랫동안 놓여 있던 돌을 뒤집듯 사실을 뒤집고, 거기서 발견한 것을 분석해 문제화하는 것이다.

슈타이얼의 에세이 영화 〈비어 있는 중심〉(1998)과 〈11월〉(2004)은 사실과 허구를 엮어 낸다. 두 작품은 다양한 시간적 양태를 중첩하며, 이에 따라 시간과 공간의 제약을 거스른다. 작가는 작품의 중심이 되는 주제가 무엇이든 항상 동시대적 순간으로 회귀하며, 여기에 대중 매체에서 가져온 푸티지나 식견 있는 전문가 및 일반인과 진행한 인터뷰 등 다큐멘터리 영화 특유의 소품을 활용한다. 뒤죽박죽 뒤섞이거나 재활용된 이미지의 대부분은 텔레비전이나 인터넷을 통해 유포된다. 작가는 이렇게 논평한다. "이제 초국가적 다큐멘터리 전문 용어가 전 지구적 미디어 네트워크 안에 있는 사람들을 연결하고

7
같은 책.

있다. 공포에 바탕을 둔 주목 경제, 유연한 제작을 향한 시간 다툼, 히스테리를 기반으로 하는 뉴스의 표준적 언어는 유동적이고 정동적이다. … 다큐멘터리 형식은 이제 그 어느 때보다 강력하며, 사물의 언어가 지닌 가장 극적인 측면을 불러일으키고 그 힘을 증폭시킨다."[7] 소셜 미디어에서는 속박을 벗어나 닻을 풀고 해방된 정보의 파편으로 이뤄진 소용돌이가 급증하며, 인스타그램, 스냅챗, 틱톡 등의 플랫폼에서 전에 본 적 없는 텍스트와 이미지 트래픽을 생성한다. 다큐멘터리의 미약함은 이미지의 진실성이라는 주장에 의구심이 더해질수록 안정성을 잃는다. 이러한 의구심은 21세기에 다큐멘터리의 유효성과 신뢰성에 대한 질문을 전면에 내세운다.

슈타이얼은 2000년대의 첫 20년 전반에 걸쳐 미디어화가 증대되는 환경과 이에 따른 가상 세계의 전개에 천착했다. 자본주의가 스펙터클의 위력을 강화하는 시뮬레이션된 현실을 만들어 냈다는 20세기 중반 상황주의자들의 주장은 1970년대와 80년대에 현대 소비 사회가 자의적 기호로 범람하는 것을 알아차린 관찰자들에 의해 재가공되었다. 이 시기에 이처럼 대체된 현실을 탐구한 주요 이론가인 장 보드리야르에 따르면, 선진화된 자본주의하의 삶에서 현실에 대한 언급은 "더 이상 모방에 대한 문제도, 재생산에 대한 문제도 아니며, 심지어 패러디의 문제도 아니며 … 실재라는 기호를 실재 그 자체로 대체하는 것"이다. 그의 설명에 따르면 시뮬레이션이 점유한 이같은 우위는 "'참'과 '거짓', '실재'와 '가상'의 차이를 위협한다."[8] 보드리야르가 볼 때, 매체는 시뮬라크라를 퍼트리는 데 전적으로 연루되어 있다. 그의 주장에 따르면, 뉴스 매체의 관리자는 현실에 대한 자체적인 시뮬레이션을 통해 "사실성(actuality)이라는 환상을 유지한다. 그것에 걸린 현실과 사실의 객관성이라는 환상을 유지하는 것이다."[9] 그들의 주요 관심사는 시청률이다. 방송사는 시청률을 높이기 위해 점점 더 별난 스펙터클을 연출한다.

시뮬레이션 효과는 최근까지도 의심의 눈초리를 받았고 통제를 드러내는 증상으로 비난받았으나, 오늘날 많은 사람들은 일상을 향상시킬 수 있는 시뮬레이션 효과의 능력을 받아들이고 있다.[10] 시뮬레이션과 디지털의 친밀한 연관성은 처음부터

8
Jean Baudrillard, *Simulations* [1981] (New York: Semiotext(e), 1983), 4-5. 보드리야르는 다음과 같은 결론을 내렸다. "디지털성이라는 멋진 세계는 은유와 환유의 세계를 흡수해 버렸다. 시뮬레이션의 원칙이 쾌락의 원칙을 이기듯 현실의 원칙을 이기고 만다." 152.

9
같은 책, 71.

10
"'시뮬레이션'은 코드에 의해 통제되는 현재 단계를 지배하는 체계이다." 같은 책, 83.

명백했다. 디지털을 통한 제작은 아날로그 녹음 기술의 참조
추적('네거티브 필름[negative]')을 시대착오적인 것으로 만들어
버렸다. 크리스토퍼 놀란의 SF 스릴러 〈테넷〉(2020)과 슈타이얼의
〈소셜심〉(2020)에 등장하는 호화 요트 '플래닛 나인'에서처럼,
시뮬레이션이라는 개념은 바다를 순항하기 위해 디스토피아적
정박지로부터 떠났다. 이 배는 항해 도중 봉건적인 AI 자유항에,
실재와 가상에서 모두 귀중한 물건들을 최첨단 보안 시스템으로 보관
중인 곳에 정박한다. AI와 시뮬레이션으로 이뤄진 가상 세계에서는
다큐멘터리와 예술 실천(artistic practice)에 더 전반적으로 어떤 일이
일어날까? 바르트는 문학 작가들이 현실에 대한 인상을 창조하는 데
활용하는 도구들을 이해하고자 '실재 효과'를 이론화했다. 그는
이러한 작가들의 목표가 "기호를 비우고 그 대상을 무한히 연기하여
'재현'이라는 낡은 미학에 급진적 방식으로 도전하는 것"이라고
설명한다.[11] 동시대 미술가들 역시 가상 현실에 빠져들고 있다.

11
Barthes, "The Reality
Effect," 148.

따라서 그들은 전통적 장르의 생존 가능성을 이런 맥락에서
직면해야만 한다. 슈타이얼은 특히 다큐멘터리가 놓인 조건을
살핀다. 그는 과연 가상이 다큐멘터리로 작동할 수 있을
만큼 충분히 설득력 있는 실재 효과를 구축할 수 있는지 묻는다. 그는
다큐멘터리 장르가 이제 재현에서 언어로 옮겨가야만 이를 달성할
희망이라도 품을 수 있다는 답에 이른다. 문제의 언어는 바로 AI,
VR, CG 및 시뮬레이션을 말한다. 그러나 이런 새 언어를
다룰 때 한 가지 문제가 있다. "보편적 AI 언어는 존재하지
않는다. … 디지털 이미지는 다른 어떤 종류의 정보와
마찬가지로 인간의 감각을 통해 접근할 수 없다. 우리는
그것을 볼 수 없고, 냄새를 맡을 수도 없고, 어떠한 장치로
번역되지 않는 한 들을 수도 없다."[12]

12
Hito Steyerl and Trevor
Paglen, "The Autonomy of
Images, or We Always
Knew Images Can Kill,
But Now Their Fingers Are
on the Triggers," in Hito
Steyerl: I Will Survive, eds.
Florian Ebner et al., exh.
cat. (Leipzig: Spector
Books, 2021), 239-253,
본 원고에서는 249.

〈소셜심〉은 CGI로 만든 춤추는 경찰과 중무장한
군인들의 이미지 속에 관객을 빠트린다. 컴컴한 공간을
가로질러 일어나는 인물들의 움직임은 화려한 색의 도식적 형태로
그들의 움직임을 뒤따르는 벡터를 형성한다. 관객이 사회적
안무(social choreography)의 비트에 맞춰 움직이도록 북돋는 전염성
있는 리듬과 함께 댄스 음악이 사운드스케이프를 채운다. 입자

발생기는 춤추는 아바타를 증식시키며, 그들의 움직임에 프로그램된 무작위성을 집어 넣는다. 입자 생성기는 아바타의 영속적 동일성(ever-sameness)을 약하게 만든다. 블랙박스의 '리얼라이프(IRL)' 환경은 관객을 메타버스 안에 매끄럽게 가져다 놓는다. 그것이 만드는 효과는 진보된 VR 및 AR 시스템을 능가한다. 〈소셜심〉의 전신인 〈태양의 공장〉(2015)은 비디오 게임의 미학을 차용했다. 이 설치 작품 또한 마찬가지로 몰입감이 있었다. 관객들이 시뮬레이션된 댄스플로어 한가운데 놓인 일광욕 의자에 앉아 쉬면서 이미지를 소비할 수 있게 했다. 〈소셜심〉에서는 이런 식의 수동적 관람 형태와 대조적으로 춤추는 아바타를 하나의 화면에 투사해 관객의 활기를 북돋았다. 이 작품은 마치 〈스타워즈〉 영화처럼 시작하며, 행방이 묘연한 '세계에서 가장 비싼 그림'을 찾아나선 특수부대원들의 수색을 좇는다. 〈소셜심〉은 현재의 줄거리와 이전 에피소드가 교차하는 텔레비전 연속극처럼 여러 에피소드로 구성된다. 여기에는 동시대에 벌어진 폭동과 사회 문제에 대한 시위를 다룬 뉴스 푸티지와 슈타이얼의 초기 작품에 대한 플래시백이 포함된다. 이 작품에는 〈경호원들〉(2012), 〈깨진 창문들의 도시〉(2018), 〈태양의 공장〉, 〈이것이 미래다〉(2019)의 자취가 등장한다. 초기 작품 각각은 시뮬레이션 모델과 AI 언어 시스템의 전개를 각자의 방식으로 다루었다.

가상에 대한 슈타이얼의 탐구는 이미 한참 전에 시작되었다. 〈안 보여주기: 빌어먹게 유익하고 교육적인 .MOV 파일〉(이하 '안 보여주기', 2013)은 이러한 탐구의 대표적 사례로, 패턴 및 시각 인식 소프트웨어의 급격한 도약을 추적하는 작품이다. 패턴 및 시각 인식 소프트웨어는 표적을 설정하는 군사 장비에서부터 국민을 대상으로 하는 감시 시스템까지 폭넓게 쓰이고 있다. 슈타이얼이 언급한 바와 같이, 오늘날 "보는 것은 확률 계산으로 대체된다. 시각은 중요성을 상실하고, 필터링, 암호 해독, 패턴 인식으로 대체된다."[13] 작가는 원래 〈안 보여주기〉를 자신이 인터넷을 통해 유포한 하나의 파일로 만들었다. 이에 따라, 작품은 그것이 비판하는 형식을 구현하는 동시에 가능하게 만들었다. 슈타이얼의 또 다른 작품 〈깨진 창문들의 도시〉는 컴퓨터에게 새로운 상징적 코드, 즉 유리가 깨지는 소리를 가르치는 과정을

13
Hito Steyerl, "A Sea of Data: Apophenia and Pattern (Mis-)Recognition," in Duty Free Art: Art in the Age of Planetary Civil War (London and New York: Verso, 2017), 47.

기록한다. 컴퓨터의 이러한 인지 과정은 더 개선된 보안 시스템에 활용되었다. 제58회 베니스 비엔날레에서 처음 선보인 〈이것이 미래다〉는 질문에 응답하여 이미지를 생성하는 AI 프로그램으로 이뤄졌다. 비엔날레 전시에서의 설치에는 바닥에서 솟아 오른 구불구불한 이동로를 따라 여러 개의 스크린이 있었다. 작품의 핵심 부분은 이동로의 마지막에 있는 플랫폼에 있었다. 2019년 11월 베를린 n.b.k에서 이 작품을 다시 전시했을 때, 슈타이얼은 〈파워 플랜츠〉(2019)를 덧붙였다. 〈파워 플랜츠〉는 관객이 스마트폰에 증강 현실 애플리케이션 'PowerPlflanzerOS'를 내려받도록 한다. n.b.k는 휴대 전화가 없는 관객을 위해 태블릿을 제공했다. 〈이것이 미래다〉의 세 번째 구성 요소인 〈미션 완료: 벨란시지〉(2019)는 원래 현장에서 진행한 렉처 퍼포먼스로 만들어졌다. 슈타이얼은 협업을 진행한 밀로스 트라킬로비치와 조르지 가고 가고시츠와 함께 허위정보(disinformation), 음모, 히스테리의 상호 연결성을 살펴보고, 소셜 미디어를 통한 전개와 전파를 탐구한다.

　〈소셜심〉은 이처럼 무수히 얽혀 있는 코드 문자열을 한데 모아 메타버스를 시뮬레이션하는 새로운 구성물로 조합해 낸다. 메타버스는 분명 코로나19에 큰 영향을 받았다. 그러나 이 작품에서 실재는 〈미션 완료〉 퍼포먼스에서와 마찬가지로 관객의 몸과 미술관의 건축에서 자신을 드러낸다. 팬데믹으로 봉쇄가 벌어지기 전, 슈타이얼은 미술 전시와 퍼포먼스가 일어나는 공간을 '리얼라이프' 대면의 장소로 간주했다. 하지만 강력한 바이러스가 현실에 대한 접속을 제한했고, 이에 슈타이얼의 작품이 대응했다. 강제적인 봉쇄에 따른 격리는 인터넷에 대한 전례 없는 의존을 낳았다. 가상성(virtuality)은 '리얼라이프' 대면이 위험해진 덕에 새로운 의미를 획득했다. 슈타이얼은 길고 긴 팬데믹 봉쇄 기간 동안 회고전을 위한 작업을 준비해왔다. 《I Will Survive》라는 제목으로 열린 슈타이얼의 회고전은 뒤셀도르프 K21과 파리 퐁피두센터에서 공동으로 개최되었다. 첫 번째 전시는 2020년 9월 말 뒤셀도르프에서 개최되었으나 곧 폐쇄되고 말았다. 전시는 꽤 오랫동안 방문객 없는 유령 전시로 설치된 채 있었다. 파리에서 열린 전시에서도 비슷한 일이 벌어졌다. 이 전시는 몇 달 동안 미뤄졌고, 대중에게는 짧은 기간 동안 공개되었다.

슈타이얼은 K21 폐쇄에 대응하며 방향을 틀었고, 4부작 미니 시리즈 〈미술관에서의 밤〉(2021)을 제작했다. 이 시리즈에서 작가는 텅 빈 미술관에서 가상으로 자신의 작업을 훑어보며 관객을 이끈다. 시리즈의 시작은 극악무도한 인물들이 유럽의 박물관과 미술관들을 장악하여 오컬트 활동이 벌어지는 곳으로 바꿨다는 인터넷 음모론을 떨쳐내려는 시도와 함께 이뤄진다. 슈타이얼은 4부로 이뤄진 시리즈의 각 에피소드에서 〈소셜심〉을 확장, 주요 에피소드에 대한 추가 영상을 제공한다. 1부에는 실직한 (그리고 〈태양의 공장〉에도 등장한) 배우 마르크 바슈케가 자신의 경찰 캐릭터를 아바타로 구축한 것에 대해 강의하는 독백 전체를 넣는다. 텔레비전 연속극에서 경찰은 바슈케가 냉소적으로 언급하듯 짝을 지어 일하는 경우가 많은데, 아바타는 완벽한 파트너가 될 것이다. 그는 스스로의 아바타를 완벽하게 가꾸면서 오히려 자신의 불필요함을 더 입증하고 있다는 것을 인정한다. 순종적인 로봇이 인간의 노동 대부분에 대한 필요성을 곧 대체할 거라는 실제적 가능성을 제시한다. 슈타이얼은 다음과 같은 말로 AI의 장점을 열광적으로 받아들였던 헝가리의 어느 미술관 관장과의 대화를 회상한다. "인공지능과 자동화는 대단해요. 더 이상 이주 노동자가 필요하지 않을 거니까요."[14] 2부와 4부에서는 최근 베를린에서 성행하고 있는 박물관, 미술관에 대한 공격을 직접적으로 다룬다. 이와 더불어 예술 작품의 출처와 상환이라는 주제 또한 제기한다. 세 번째 에피소드에서는 〈미션 완료: 벨란시지〉를 보여 준다. 이후 배우들과 함께 패션, 전유, 예술계의 권모술수를 아우르는 폭넓은 토론을 진행한다.

〈미술관에서의 밤〉은 〈소셜심〉과의 연관성을 유지하는 동시에 코로나19 팬데믹 중 이뤄진 문화 생산 양태를 집약적으로 보여 준다. 슈타이얼은 이렇게 말한다. "팬데믹은 우리가 지난 4년간 보아 온 모든 경향, 즉 고립주의, 권위주의, 탈세계화, 반이민, 분열, 공포의 남용, 데이터 취득을 강화하고 있다."[15] 일레인 쇼월터는 대중 매체와 여성에게 만연한 히스테리의 관계를 자세히 설명한 바 있다. 대중 매체와 여성 히스테리가 서로에게서 동력을 얻어 '집단 편집증적 광신'을 낳는다는 것을 보여 준다. 쇼월터는

14
Steyerl and Paglen, "The Autonomy of Images," 253. 『뉴요커』는 팬데믹 중 노인 고립을 줄이기 위한 동반자로 설계된 로봇들의 장점을 다룬 에세이를 게재했다. 이런 로봇은 사회적 상호작용을 제공할 뿐만 아니라 사람의 활동에 대한 데이터를 지정된 정보원으로 전송했다. Katie Engelhart, "Home and Alone," New Yorker, May 31, 2021.

15
Steyerl and Paglen, "The Autonomy of Images," 253.

16
Elaine Showalter, Hystories:
Hysterical Epidemics and
Modern Media (New York:
Columbia University Press,
1997). 쇼월터는 이렇게
주장한다. "공포가 전염병과 같은
수준에 도달하고, 히스테리는
희생양과 적을 찾는다. 그 대상은
동정심 없는 의사, 학대하는
아버지, 일하는 어머니에서부터
악마를 숭배하는 사디스트와
호기심 많은 외계인, 악랄한
정부에 이른다." 5.

다음과 같이 주장한다. "히스테리라는 문화적 내러티브는 …
대중 매체, 통신, 이메일의 시대에 통제할 수 없을 정도로
급격히 증식한다."[16] 〈소셜심〉에서 가장 두드러지는 요소는
슈타이얼이 구사하는 메타버스에 대한 시뮬레이션이다.
이것은 가상을 실현하고 관객이 아바타와 어우러질 수 있게
한다. 작가는 과거와 오늘날의 현재에 지나치게 의존하는
미래를 초자연적으로 전망한다. 프린스가 불의의 사망으로
세상을 떠나고 2년이 지난 2018년 슈퍼볼에서 펼친 공연은 그것의
한 예가 된다. 1980년대의 외모를 한 아바타가 등장하는 아바의 순회
공연은 또 다른 사례다. 화면에 표출되는 통계는 수세기에 걸쳐 전염병
시기에 일어난 무도광(dancing mania)을 추적한다. 슈타이얼은
1,000년 전 베른부르크, 14세기 후반 아헨, 에노, 쾰른, 메츠,
스트라스부르, 제1차 세계대전 후 베를린에서 일어난 무도광 사건을
불러온다. AI의 논평은 무도광을 통해 사회의 건강함을 측정할 수 있는
방법을 언급한다. "이것이 인종주의가 전염병처럼 퍼지는 방식이다.
이것이 음모론이 확산되는 방식이다. 이것은 K팝 아이돌 팬 군단을
위한 테스트 환경이다." 미래를 예측하기 위해 코드와 알고리즘이
쓰인 것이다. 〈이것이 미래다〉에서는 점쟁이 노릇을 하는 AI가 방대한
데이터베이스로부터 이미지와 언어를 만들어 내며, 사이버네틱스가
세상을 근본적으로 변화시켰다는 보드리야르의 의견을 소환한다.
보드리야르의 주장에 따르면 사이버네틱스는 "코드를 통해
사회의 예측, 시뮬레이션, 프로그래밍, 불확실한 변이"를
고조시킨다. 우리는 "이상적 전개로 완성되는 과정 대신
특정한 '모델'로부터 일반화를 진행한다."[17]

17
보드리야르는 우리가 "자본주의-
생산주의 사회에서 이제 완전한
통제를 지향하는 신자본주의-
사이버네틱 질서로" 전환했다고
결론짓는다. Baudrillard,
Simulations, 111.

　　　슈타이얼은 〈소셜심〉에서 춤을 시뮬레이션한다.
하지만 작품의 내레이터는 예전에는 춤이 사람들 간의
사회적 상호작용을 수반했지만, "이제 이 에피소드는 가상 경험으로
재출시되고 있다."고 설명한다. 화면은 '댄싱 마니아 앱'의 복제판으로
변해 버렸다. 내레이터는 관객에게 경고한다. "이 앱을 다운받으면
[그들은] 반란을 진압하기 위한 군중 통제 시뮬레이션의 일부가 된다."
춤마저도 사회 통제와 지배를 위한 또 다른 도구로 전유될 가능성을
지니고 있다. 앱의 메뉴는 관객에게 어떻게 죽음을 맞이하고 싶은지

선택하라고 묻는다. "[어떻게 죽고 싶으신가요?] 질병, 경찰,
굶주림, 춤?" 앱의 기반 구조는 관객이 적절한 메시지 상자에서
'YES'를 클릭해 자신이 선호하는 바를 표시하길 권한다. 슈타이얼의
춤추기 앱은 그의 사회적 안무 이론을 구현해 낸다. 오락용 앱은
개인들의 데이터를 수신하고 처리한 뒤 인간의 행동을 수정하도록
설계된 코드와 알고리즘을 생성하도록 프로그램되어 있다. 작가는
이렇게 설명한다. "내 말은 이 모든 인공적 멍청함과 온갖 자그마한
장치들이 스마트폰에 국한되지 않는다는 것이다. 이것들은 이미지
세계에만 국한되지 않으며 도시 환경과 우리를 둘러싼 물질적 환경도
재설계하고 재창조할 수 있다."[18] 사람들은 자신의 습관과 활동에 대한
개인 정보 전반을 소셜 미디어 업체에 기꺼이 넘겨주는데,
이 업체들은 더 효율적인 마케팅과 감시, 사회 통제
시스템을 구축하려는 기업들에 데이터를 팔아 넘긴다.

18
Steyerl and Paglen, "The
Autonomy of Images," 247.

〈소셜심〉의 한 에피소드에서 슈타이얼은 인기 있는 게임 중계
플랫폼인 '트위치'의 상호작용 기능을 언급한다. 'Kidnapped Art'라는
제목의 라이브 방송을 진행하는 트위치상의 게임 화면 시뮬레이션
위로 들리는 보이스오버는 VIP 채팅방 관리자들이 도움을 구하는
요청을 발신했음을 알린다. 베를린 신 박물관에 있는 네페르티티
흉상의 애니메이션 이미지가 "nickedArt.com"이라는 레이블 아래
떠오른다. 가상의 네페르티티는 여성의 목소리로 관람자에게 호소한다.
"도와줘, 납치당했어. 지금 베를린에 갇혀 있어. 나 같은 사람들에게
베를린은 그다지 안전하지 않아. 사람들이 경찰에 구금된 채 불에 타
죽기도 한대." AI가 진행하는 해설은 네페르티티의 방송을 중단시키고,
"헤자가 네페르티티를 조종한다."고 밝힌다. 그런 뒤 화면이 분할되고
슈타이얼과 주기적으로 협업하는 헤자 네티르크의 얼굴이 등장한다.
네티르크는 이전 에피소드에 등장하지 않았던 것은 "터키 감옥에
갇혀 있어서"라고 설명한다. 그러나 이제 그녀는 "빠져 나오긴 했지만
빌어먹을 난민이 돼" 버렸다. 이 시점에서, 슈타이얼은 2020년 10월
3일 베를린의 여러 박물관에서 70여 점의 이집트 유물이 파손된
것을 기록한다. 경찰은 박물관이 사탄 숭배의 중심지라는 주장으로
온라인에서 확산 중이던 음모론에 빠진 우익 단체들을 유물 파손과
연관지었다. CGI로 애니메이션화한 네페르티티 흉상은 곳곳에 만연한

경찰 폭력과 반이민 정서를 나타낸다. 슈타이얼은 여기서 우리가 재현 너머에 있다고 관객에게 상기시킨다. "이미지는 재현이라기보다는 대리, 외모 용병, 떠도는 텍스처-표면-상품이 된다. 개인은 몽타주되고 더빙되고 조립되고 합체된다. 인간과 사물은 전혀 새로운 모양으로 뒤섞여 봇이나 사이보그가 된다. 인간이 알고리즘에 정서, 사고, 사회성을 공급하면, 알고리즘은 주관성이라고 불리던 것에 피드백을 한다. 이런 변동이 정보 공간을 표류하는 포스트 대의 정치로 이어진 것이다."[19]

19
Hito Steyerl, "Proxy Politics: Signal and Noise," in *Duty Free Art*, 38.

　　인터넷은 허위 정보, 편집증적 히스테리, 음모 이론의 확산뿐 아니라 온 세상의 영화, 비디오, TV 시리즈를 손쉽게 스트리밍할 수 있게 해 주었다. 봉쇄는 사람들에게 더 많은 시간을 인터넷상에서 제공되는 세계와 함께 보내고 자신이 속한 실제 환경에서는 더 적게 이동하도록 만드는 최적의 조건을 제공한다. 제작사들과 그들이 거느린 방송 부문은 이제 폭넓은 사회적 유형을 충족시키는 틈새시장을 겨냥한 수많은 시리즈를 큐레이팅해서 보여 준다. 모든 장르를 손쉽게 시청할 수 있다. 텔레비전과 영화, 웹 시리즈는 팬데믹 기간 중 최우선의 선택지가 되었다. 봉쇄는 한 번에 몰아서 시청하기를 증진한다. 여기에 덧붙여 디즈니의 '그룹워치', 훌루의 '워치파티' 등 새로운 시청 경험은 가상에서 함께 시청하는 경험을 가능케 한다. 함께 시청하기는 '친구들'이 가상으로 이어질 수 있게 해 줄 뿐 아니라 상상의 공동체 안에서 새로운 접촉이 일어날 수 있는 여지를 제공하기 때문에 인기를 끈다. 유튜브나 트위치의 부가 기능은 관객에게 공개적으로 '반응'할 수 있는 권한을 주며, 점점 더 시청률에 의해 움직이는 소비자 사회에 기여하는 새로운 장르인 '반응 영상'에 영감을 준다.[20] 그러나 팬데믹 기간 중 시리즈 위주의 프로그램 구성이 인기를 얻은 것은 단지 소비 측면에서만이 아니다. 수요의 증가와 더불어 시리즈물의 제작도 증가하고 있다. 특히 시청자에게 많은 시간을 요하지 않는 미니 시리즈의 제작이 늘어나는 중이다. 이런 프로그램들의 인기가 높아지고 시청자들의 코로나19 방역 기준과 수칙 준수 능력이 증가함에 따라, 이러한 프로그램 제작이 급증하게 되었다.[21] 팬데믹으로 지켜야

20
시청률의 중요성에 대해서는 다음을 참조하라. Michel Fehrer, *Rated Agency: Investee Politics in a Speculative Age* (New York: Zone Books, 2018).

21
2020년과 2021년 사이 한 해 동안 배리 젠킨스, 스티브 맥퀸, 라울 펙 등의 감독이 각자 미니 시리즈를 제작했다. 〈지하 철도〉(2021), 〈작은 도끼〉(2020), 〈야만의 역사〉(2021)를 참조하라. 알렉산더 클루게와 같은 감독들 역시 1980년대에 매주 한 번 방영하는 작품을 통해 영화에서 텔레비전으로 방향을 선회한 바 있다. 하지만 동기와 형식(장기간 상영)은 현저히 달랐다.

하는 요구사항은 엔터테인먼트 산업에 전례 없는 난제를 제시했고, 엔터테인먼트 산업 또한 여기에 그만큼 이례적인 방식으로 대응했다.

슈타이얼은 〈소셜심〉에서 이 현상을 재치 있게 다룬다. 〈소셜심〉은 작가의 작품을 일종의 리미티드 시리즈 연속극으로 빚어내는 진행 중단과 일시적인 정지, 지난 회 요약을 강조한다. 작품 초반 내레이터가 "지난 이야기…"라고 말할 때, 화면에는 큰 유리창에 거대한 망치를 휘두르는 인물이 나타난다. "사회주의 [socialism]"라는 단어 역시 마찬가지다. 내레이터는 대사를 이어간다. "지난 에피소드는 제안으로 끝났다. 봉쇄령이 지속되었기 때문에 이번 에피소드는 삭제 장면을 모아 제작했다." 후자는 슈타이얼의 〈깨진 창문들의 도시〉에서 온 대사다. 화면 왼쪽 하단 모서리 부분에는 흩어진 통계가 나타난다. "작가, 정부 적법성 수준: 0.2, 위험 회피: 0.8, 불만 수준: 0.9, 성능 점수: 3.1." 다시 내레이터의 말이 계속된다. "혜자는 해고를 당하고 새로운 직업을 찾았다. 그녀는 인공지능에게 반란 진압을 훈련시키기 위해 창문을 깨뜨리고 있다." 〈소셜심〉에 등장하는 다른 시퀀스들은 슈타이얼이 이전에 만든 작품에서 유래한다. 이들은 〈태양의 공장〉과 〈스트라이크〉(2010)를 불러낸다. 각각의 장면은 "지난 이야기"나 "이것이 … 하는 방식이다." 등 매번 동일한 문구를 통해 소개된다. 이 구절의 잇따른 반복은 연속되는 생산의 존재론으로서의 반복이라는 전제와 궤를 같이 한다. 가상성의 세계에서 시뮬레이션은 동일한 것의 끝없는 반복, 즉 영원히 재생되는 루프와 같다. 슈타이얼의 온라인 시리즈 〈미술관에서의 밤〉은 이러한 반복의 또 다른 변종이다.

예전에 영화와 비디오 제작은 이미지와 사운드를 녹음한 뒤 후반 작업에서 편집해 결과물을 만들었다. 아날로그에서 디지털 편집으로의 전환은 이런 절차를 근본적으로 뒤바꿨다. 아날로그 자료의 후반 작업은 편집, 색보정, 사운드 디자인 등 촉각을 동반하는 기술을 포함했던 반면, 지금 감독들은 컴퓨터에서 디지털 자료를 편집한다. 이미지와 사운드를 구성하는 디지털 코드는 다른 코드에 의해 가공된다. 슈타이얼이 살펴본 바, 아날로그 시대에 "'후반 작업'이라는 말은 이것을 제대로 된 프로덕션을 보완하는 것처럼 보이게 했다." 그러나 디지털 기술에 의해 "이러한 논리는 제작 자체에 영향을 미치고

22
Hito Steyerl, "Cut! Repro-
duction and Recombination,"
in *The Wretched of the Screen*
(Berlin: Sternberg Press,
2012),176-188, 본 원고에서는
182.

구조화하는 것으로 변했다. 최근 몇 년 동안 후반 작업이
제작과정 전반을 잠식하기 시작했다. … 실제로 촬영해야
하는 요소는 그 일부나 전체를 후반 작업에서 만들어 낼 수
있어 점점 줄어들고 있다."[22] 작가와 감독들은 '실재'가 없는 이미지와
사운드를 생산할 수 있고, 이런 점은 매체를 넘어 예술 작품에까지
확장된다. 편집기에 앉은 장인에서 컴퓨터 프로그래머로 전향한 '후반
작업' 작업자를 냉소적으로 보여 주는 시연은 슈타이얼 자신의 역할
안에서 이중적으로 존재한다. 〈소셜심〉은 디지털을 재료로 만들었고,
따라서 바르트가 (다큐멘터리에 가깝다고 할 수 있는 장르인) 사실주의
소설과 더불어 시작된 어떤 과정이라고 본 것을 시청각적 형식으로
구현한다. 바르트가 말한 바와 같이 "[사실주의] 소설가는

23
Barthes, "The Reality
Effect," 145.

이미 본질의 시뮬레이션인 어떤 것을 모방하기에 플라톤이
3급 시민으로 분류한 예술가의 정의를 충족한다."[23]

　　　팬데믹은 이전에 '실재' 혹은 '다큐멘터리'라고 불렸던 모든 재현이
이제 어떻게 가상에 이르게 되었는지에 선명한 초점을 맞추게 했다.
오늘날의 실재는 코드와 알고리즘으로 이뤄진 시뮬레이션이다. 이런
변화는 동시대 문화 대부분에 영향을 미친다. 단지 매체 면에서만
아니라 비트코인과 같은 화폐 체제에도 영향을 미치는 것이다. 최근
일어난 NFT의 확산이 보여 주듯, 이런 변화는 예술의 체계 역시
근본적으로 변화시켰다. 〈소셜심〉 내러티브의 한 가닥은 수십 년
전 시작되었으나 팬데믹으로 고조된 미술계의 가상화 및 유동화
증가를 성찰적으로 다루고 있다. 21세기 초에는 예술 작품의 이미지가
주기적으로 인터넷에 게재되었지만 여전히 박물관과 미술관 전시의
존재가 아주 중요했다. 팬데믹은 이런 조건을 대부분 없애 버렸다.
박물관과 미술관은 문을 닫았고, 미술(art)은 강제로 온라인화당했다.
오늘날 많은 미술 전시가 가상 투어와 시뮬레이션을 통해서만 접근할
수 있다. 〈소셜심〉의 줄거리는 최근 레오나르도 다빈치의 작품이라고
알려지게 된 작품인 〈살바토르 문디〉의 유실 상태를 부각해 다룬다.
이 그림은 수십 년 동안 르네상스 거장 다빈치의 조수들이 그린
작품으로 여겨졌다. 사실 이 작품을 다빈치가 그렸다는 새로운 주장이
제기된 이후 2017년 크리스티 경매에서 약 4억 5천 30만 달러(약 5천억
원)에 바드르 빈 압둘라에게 낙찰되었다. 작품은 2018년 아부다비

루브르 박물관에서 전시될 예정이었으나 대중에게 공개되지 않았다. 이같은 행위는 그림의 소유자가 50억 달러에 달하는 그림을 자세히 살펴본 전문가들이 결국 다빈치의 작품이 아니라는 결론을 내릴지도 모른다는 두려움에 빠지지 않았나 하는 추측을 불러일으켰다. 〈소셜심〉의 어느 지점에서는 애니메이션화된 〈살바토르 문디〉가 작품 관람객에게 말한다. 그림은 이렇게 주장한다. "신에게 맹세코 전 레오를 본 적이 한 번밖에 없습니다. 그가 제 손가락을 수정했을 때죠. 저는 당당하게 스튜디오에서 제작된 작품이에요!" 이 작품의 행방은 그동안 수수께끼로 남아 있었다. 어떤 이들은 이 그림이 사우디아라비아의 무함마드 빈 살만 왕세자의 개인 요트 안에 있는 방에 걸려 있다고 주장한다. 다른 이들은 최근 전 세계적으로 급증한 역외 자유항 가운데 한 곳에 있는 금고에서 이 그림을 보관 중이라고 추정한다. 확실한 점은 작품이 자취를 감추면서 이미지와 코드라는 요소가 더 두드러지게 되었다는 것이다. 작품의 소유자들이 '실재' 사물을 더 손쉽게 접근할 수 있게 했다면, 작품의 진본성(authenticity)이 손상될 수도 있었다. 따라서, 그림의 진정한 가치는 역설적이게도 시뮬레이션된 그것의 생애에 달려 있다. 벽에 드리운 그림자는 무엇이 그것을 드리우는지 살펴볼 수 없는 한 실제적이라는 말이다. 이런 관점에서 보면 NFT들을 구체적인 것인 양 만드는 미술계식 메타버스 설계가 완벽하게 이해된다. 이런 '미술작품'은 블록체인상에서 순수한 코드로만 존재한다.

　　〈소셜심〉 중 "자동화된 예술: 미술사"라는 제목이 붙은 시퀀스는 NFT를 조소한다. 이 시퀀스는 특징 없는 건축 공간에서 설정된다. 공간의 한쪽 벽에는 로런스 위너와 비슷한 텍스트 기반의 작품이 있다. "이곳에서 가져가 이것이 유래한 곳으로 이동했고, 미술계에 잠재한 공간으로 이동했음." 카메라는 공간을 가상으로 이동하면서 '사회적 시뮬레이션'이 들어간 여러 대형 액자 속 작품 앞에서 잠시 멈추곤 한다. 첫 번째 작품은 "사람들 사이로 불만의 물결이 어떻게 퍼지는지" 보여 주는데, 깃발이나 화면 보호기를 닮은 물결 모양으로 보라색, 녹색, 검은색을 띤 이미지가 들어가 있다. 두 번째 작품은 "여러 집단이 함께 사는 사회"를 묘사하는 노란색과 파란색 육면체를 강조한다. 다음 작품은 거듭해서 일어나는 "봉쇄에 저항하는 폭동"을 다룬다.

두 명의 기술자가 벽에 비행기를 걸고 있는 방향으로 CGI 물고기가 빈 전시장을 가로질러 헤엄치는 모습을 묘사한다. 내레이터는 이 장면이 "자동화되고, 폐쇄되고, 가상 현실 지도로 대체된 미술관을 보여 준다."고 설명한다. 뒤이어 VIP 라운지에 놓인 일련의 "스스로 진화하는" 작품들이 보인다. 내레이터는 이 작품들이 "더 똑똑해지고, 더 건강해지고, 더 부유해"지도록 설계되었다고 알려 준다. 걷는 법을 배우지 않고 "후원자를 찾는" 작품들은 "폭발"하게 된다. 동일한 시퀀스의 후반부에서 슈타이얼은 자동화에서 자율화로 전환된 예술 작품을 다룬다. "걸어 다니는 슬픈 존재"라는 제목 아래, 알파라는 이름의 팝 밴드가 부른 1995년 히트곡 〈살기 위해 태어난〉을 배경으로 삼는 이 작품은 액자에 담긴 선과 블록으로 만든 로봇 형상을 좇는다. 로봇은 화면 해설이 관객에게 다음과 같이 알려 주는 동안 스스로를 복제한다. "1세대에서 이것은 기어 다니기 시작했다. 48세대에서 그것은 그것의 모든 동족을 집어삼켰다. 450세대에서 그것은 옥션에서 팔려 나갔다. 4400세대에서 그것은 주인을 팔아 넘겼다. 4만 4500세대에서 그것은 중견급의 입헌군주제로 변했다." NFT는 자기 자신을 생성해 낸다. NFT는 서로 교환될 수 없다. 디지털 원장에 저장된 고유한 데이터 유닛을 만드는 미술가들은 다음과 같은 주장을 통해 금융이라는 가상 세계에 대한 자신들의 연루를 정당화한다. 향후 모든 NFT는 미술계의 저명 인사인 세스 시겔롭이 만든 '예술가의 저작권 소유 양도와 판매에 대한 협약'을 갱신하여 판매 수익의 10퍼센트를 작가에게 제공한다는 것이다.[24]

　　팬데믹 이후 미술 시장과 미술계에는 무슨 일이 벌어질까? 미술 시장과 미술계에 대한 사적 이익의 침투가 이어지고 있으며, 작품의 미학적 가치는 그 어느 때보다 경제적 교환 가치에 의존하고 있다. 그러나 체념하고 절망하기보다 이러한 과정에 저항하는 것이 그 어느 때보다 중요하다. 슈타이얼은 〈미술관에서의 밤〉의 세 번째 에피소드에서 미술계를 지배하는 관습에 도전할 수 있는 '대안적 구조'를 구축하는 것이 얼마나 중요한지에 대해 열정적으로 강조한다. 그의 목표는 기존의 예술 체계를 지양하고 '아래로부터의

24
1971년 시겔롭과 변호사 로버트 프로얀스키가 초안을 작성한 예술가 계약서 원안은 판매 수익의 15퍼센트가 예술가에게 제공될 것이라고 가정했다. 미술사가 알렉산더 알베로는 이 계약서가 미술 활동을 돈으로 환산한다는 점에서 미술품을 비물질화하여 시장에 저항하려는 개념 미술 초기의 힘을 무효화했다고 지적한다. 다음을 참조하라. Alexander Alberro, *Conceptual Art and the Politics of Publicity* (Cambridge, MA: MIT Press, 2003).

대안적 구조'를 촉진하는 대응 방법을 전개하는 것이다. 그가
설명하듯, "우리는 공식적인 미술계를 우리들의 구조 안에서 접어
버리길 바란다." 그는 이를 위해 비슷한 생각을 지닌 작가들이
미술계의 운영에 더 많은 통제권을 발휘해야 한다고 주장한다.
'아래로부터'라는 이중적 의미는 〈소셜심〉에서 여러 차례 반복되는
공중 뒤돌기(backflip)를 통한 회피를 떠돌리게 한다. 등장 인물이
처음으로 곡예를 하면 컨트롤 패널이 노출되고 사회적 안무의 코드가
드러나 광란의 춤을 중지시킨다. 두 번째 곡예는 공중 뒤돌기를
수행하고 가상의 〈살바토르 문디〉를 대체하도록 프로그램되어
있는 바슈케의 경찰 아바타가 수행한다. 원통 만화경에서 시선이
비틀리듯, 곡예는 여러 요소의 느슨한 질서를 뒤흔들고 새로운 배열로
재조합한다. 〈소셜심〉은 해킹을 통한 개입이 지닌 풍부한 잠재력을
암시한다. 작품 중 한 시점에는 사회 정의를 요구하는 시위 참여자들을
추적하려는 댈러스 경찰청의 활동을 무너뜨린 팬들이 존재하는 K팝
밴드가 언급된다. 또 다른 지점에서는 오클라호마주 털사에서 열린
도널드 트럼프 대선 운동 집회 입장권을 대량으로 구매하여 트럼프가
굴욕적인 관중 부족을 겪게 한 익명의 해커 그룹을 언급한다.

슈타이얼은 〈미술관에서의 밤〉의 세 번째 작품인 〈미션 완료:
벨란시지〉 상영에 앞서 친한 친구인 하룬 파로키가 디자인한 티셔츠에
대해 잠시 생각한다. 검은색 티셔츠에는 두 가지 말이 쓰여 있다.
앞면은 "미술 시장에 의해 전유되는 건 좋지 않다."는 경고가,
뒷면에는 "하지만 미술 시장에 의해 전유되지 않는 건 더 나쁘다."라는
말이 쓰여 있다. 파로키는 정치 의식이 있는 예술가들이 성공에
직면했을 때 균형 잡아야 하는 미묘한 선을 분명히 한다. 그들은
구조에 영향을 줄 수 있는 권력과 기회의 네트워크에 끊임없이 주의를
기울여야만 한다. 눈에 띈다는 건 강점이지만 [체제에] 협력하게 될
위험이 실재한다. 권력을 가진 자들의 언어를 동원하는 것은
전유를 무기로 바꾸는 하나의 방법이다. 〈소셜심〉은 '소셜심'이라는
단어를 어떻게 발음하는지 배우려는 AI 시스템과 함께 시작한다.
AI 시스템은 계속해서 말을 더듬으며 단어를 말한다. 더듬거리며
말하는 노력은 '소셜심'이라는 판에 박힌 결과를 산출한다.
사실 컴퓨터가 더 많은 시도를 꾀할수록 "SocialSim[소셜심]"

대신 "socialism[소셜리즘(사회주의)]"이 더 많이 발화된다. 결국 디지털상에서 혀가 꼬이는 말과 같은 형태로 이뤄지는 전복의 확산을 막을 유일한 방법은 전기를 끊고 새로 시작하는 것뿐이다. 언어와 운영 체제를 교체하고 변경사항을 적용하기 위해서는 문제의 코드가 인위적으로 생성된 경우라고 하더라도 재부팅이 필요하다.

'데우스 엑스 마키나(Deus ex Machina)'라는 제목이 붙은 〈소셜심〉의 마지막 시퀀스에서는 곡괭이를 든 노동자의 아바타가 화면을 산산조각 낸다. 이 장면은 슈타이얼의 〈스트라이크〉를 다시 한번 소환한다. 곡괭이를 든 인물이 마침내 얼굴을 드러내면 그가 〈살바토르 문디〉임을 알 수 있다. 살바토르 문디는 자신의 의무가 이제 세상을 구하는 것임을 밝힌다. '"기계로 만들어진 신'의 마지막 말은 실체는 없지만 희미한 희망의 기미를 보인다. "이제 나는 여기서 산다. 노동자들은 자기 자신의 심을 만들어 시뮬레이션 도구를 통제한다. 그들은 자기 자신의 모델을 만들어 허위정보와 적자생존이 없는 세계를 시뮬레이션한다." 그러나 인종차별적 공격, 반민주주의 시위, 음모론, 코로나19 통계 정보가 이처럼 놀라우리만치 긍정적인 메시지를 가로채며 화면을 잠식한다.

다큐멘터리는 인터넷에 만연하는 허위 정보의 언어에 과연 어떻게 맞서는 걸까? 다큐멘터리 장르가 효율적이기 위해서는 이러한 새 언어의 코드를 배우고 그것이 존재하는 메타버스에 머물러야 한다. 동시대의 다큐멘터리는 아날로그 시대의 시대착오적 형태를 새롭게 답습하는 대신 진화해야 한다. AI의 새로운 언어와 시뮬레이션 구조에 적응해야만 한다는 말이다. CGI로 만들어져 동시대의 현실을 다루는 〈소셜심〉은 2000년대의 다큐멘터리가 어떤 형태를 취해야 할 지에 대한 단초를 제공한다.

There is no such thing as documentary—
whether the term designates a category of material,
a genre, an approach, or a set of techniques.
— Trinh T. Minh-ha, 1990[1]

Every film is a documentary.
— Bill Nichols, 2001[2]

It is the category of 'the real' (and not its contingent
contents) which is then signified; in other words,
the very absence of the signified, to the advantage
of the referent alone, becomes the very signifier of realism: the
reality effect is produced, the basis of unavowed verisimilitude
which forms the aesthetic of all standard works of modernity.
— Roland Barthes, 1968[3]

The statements on documentary by filmmaker
anthropologist Trinh T. Minh-ha and documentary
theoretician Bill Nichols reveal the fraught status of
the genre of documentary in the twenty-first century.
The category is vexed. Documentary's claim to
represent reality was challenged in the late-twentieth century by
critics who argued that the genre constructed what it presented
as real. Trinh, writing on the eve of the digital revolution, argued
that documentary failed to evade "subjective" emotion and offer
objective evidence. For her, the genre's affective and stylistic
effects predominate. Roland Barthes' reflections on documentary
turned to the nineteenth-century novel's "reality effect" device,
which used an array of details that do not contribute directly to
the narrative but effectively summon the real as "a signified of
connotation." Although these seemingly irrelevant details appear
to *denote* the real directly, he writes, "all that they do—without
saying so—is *signify* it."[4] Trinh's film *Surname Viet: Given Name
Nam* (1989), demonstrates that recourse to signature techniques,
framing, and styles of "truth bearing" produce a "documentary
effect" that disguises artifice and creative manipulations.

Nichols critically engages the aporia proposed by Trinh,
concluding that all films could potentially function as
documentaries, even if what they "document" is their own
fictional machinations.[5]

[1]
Trinh T. Minh-ha, "The
Totalizing Quest of Meaning,"
[1990] *When the Moon Waxes
Red* (New York: Routledge,
1991), 90-107.

[2]
Bill Nichols, *Introduction
to Documentary* (Bloomington:
Indiana University Press,
2001), 1.

[3]
Roland Barthes, "The Reality
Effect," [1968] *The Rustle
of Language*, trans. Richard
Howard, (Berkeley: University
of California Press, 1989),
141-148, here 148.

[4]
Ibid., 148.

[5]
Nichols, *Introduction to
Documentary*.

Hito Steyerl's research-based artistic practice (composed of visual and sound work plus writing) continuously engages with the unstable and chimeric characteristics of the documentary genre. Though evidently frustrated by this genre's conventional productions, the artist maintains an archivally-based methodology that begins with fragments of truth. In her work, shards and slivers kaleidoscopically form new constellations and arrangements. Documentary, for her, is a language that signifies in the process of circulating through transnational networks of media. As she explains, "The documentary mode is a transnational language of practice. Its standard narratives are recognized all over the world and its forms are almost independent of national or cultural difference."[6] This understanding has led her to push against the genre's limits. More than merely stating facts, she problematizes them, turning them over like a stone that has rested on the forest ground for some time, and analyzing what she finds there.

Steyerl's essay films *The Empty Centre* (1998) and *November* (2004) intertwine fact and fiction. These productions overlap multiple temporal modalities, which in turn defy time and space constraints. Regardless of the topic that centers the product, the artist always returns to the contemporary moment, mobilizing stock props of documentary films such as media footage and interviews with informed observers and everyday people. Many of the snared and recycled images circulate on television or the internet. As the artist observes, "a transnational documentary jargon is now connecting people within global media networks. The standardized language of newsreels with this economy of attention based on fear, the racing time of flexible production, and hysteria is as fluid and affective. … The documentary form is now more potent than ever, it conjures up the most spectacular aspects of the language of things and amplifies their power."[7] A maelstrom of swirling bits of unleashed, unmoored, and unfettered information proliferates on social media, generating an unprecedented traffic of texts and images on platforms such as Instagram, Snap Chat, and TikTok. Documentary's tenuousness becomes less stable as image truth claims are put into doubt. These doubts foreground the question of the genre's relevance and credibility in the twenty-first century.

Steyerl has grappled with the increased mediatization of

6
Hito Steyerl, "A Language of Practice," in eds. Maria Lind and Hito Steyerl, *The Green Room* (Berlin: Sternberg Press, 2009), 225–231, here 225.

7
Ibid.

8
Jean Baudrillard [1981]
Simulations (New York:
Semiotext (e), 1983),
4-5. Baudrillard concluded
that "The cool universe of
digitality has absorbed
the world of metaphor and
metonymy. The principle of
simulation wins out over
the reality principle just
as over the principle of
pleasure." 152.

the environment and the concomitant development of a virtual world throughout the new millennium's first two decades. The Situationists' mid-twentieth-century claims that capitalism produced a simulated reality that heightened the potency of spectacle were reworked in the 1970s and 1980s by observers who saw contemporary consumer society awash in a sea of arbitrary signs. Jean Baudrillard, one of the primary theorists of this alternate reality during these years, argued that reference to reality in advanced capitalist life is "no longer a question of imitation, nor of reproduction, nor even of parody, ... [but] of substituting signs of the real for the real itself." This new predominance of simulation, he explains, "threatens the difference between 'true' and 'false', between 'real' and 'imaginary.'"[8] For Baudrillard, the fourth estate is fully complicit in the promulgation of simulacra. The managers of news media, he argues, "maintain the illusion of actuality—of the reality of the stakes, of the objectivity of the facts," through their own simulation of reality.[9] Ratings are their primary concern. Broadcast outlets construct increasingly outlandish spectacles to grow their viewership.

9
Ibid., 71.

Whereas simulation effects have until recently been viewed with suspicion and decried as a dangerous symptom of control, today many embrace their ability to enhance everyday life.[10] Simulation's intimate

10
"Simulation is the reigning
scheme of the current phase
that is controlled by the
code." Ibid., 83.

connection to the digital was evident from the onset. Digital production rendered the referential trace (the "negative") of analog recording technologies anachronistic. Like the luxury yacht, "Planet Nine," featured in Christopher Nolan's science fiction thriller *Tenet* (2020) and in Steyerl's *SocialSim* (2020), the simulation concept has left its dystopian moorings to cruise the seas. Along the way, the vessel briefly docks at feudal AI freeports where valuables, both real and virtual, are stored behind state-of-the-art security systems. What happens to documentary and artistic practice more generally in this virtual world of AI and simulation? Barthes theorized the "reality effect" to comprehend the tools literary authors use to create an impression of reality. These artists' goal, the critic explains, is "to empty the sign and infinitely to postpone its object so as to challenge, in a radical fashion, the age-old aesthetic of 'representation.'"[11] Contemporary artists, too, find themselves immersed in a virtual reality.

11
Barthes, "The Reality
Effect," 148.

As such, they must confront the viability of traditional genres in this context. Steyerl probes documentary's condition in particular. She questions whether the virtual can construct reality effects persuasive enough to operate as documentary? The answer she settles on is that only by moving away from representation and into language can the genre have any hope of accomplishing this today. The language in question is AI, VR, CGIs, and simulation. However, one problem when tackling this new language is as she notes, "there is no universal language of AI. ... Digital images, just like any kind of information, are not accessible to the human senses. We cannot see them, we cannot smell them, we cannot hear them, unless they are being translated by some device."[12]

SocialSim immerses spectators in CGI generated images of avatars of dancing policemen and heavily weaponized military personnel. The spatial figures' motion across the darkened space generates tracking vectors in the form of brilliantly colored diagrammatic lines. Dance music fills the soundscape with contagious rhythms that encourage spectators to move to the social choreography's beat. Particle generators multiply the dancing avatars and insert programmed randomness into their movements. The generators obscure the figures' ever-sameness. The black box's IRL environment seamlessly places spectators in a metaverse. The effect it produces exceeds advanced VR and AR systems. SocialSim's predecessor, Steyerl's Factory of the Sun (2015), adopted a video game aesthetic. This installation was equally immersive. It invited spectators to relax in lawn chairs in the middle of a simulated dancefloor and consume images. In contrast to this passive form of spectatorship, in SocialSim Steyerl included a single screen projection of the dancing avatars to enliven visitors. The piece opens like a Star Wars feature film, tracking a special force squad's search for "the most expensive painting in the world," which has gone missing. SocialSim is structured episodically like a serial television show that cross cuts between the present plotline and previous episodes. These include news footage of contemporary riots and social protests as well as flashbacks to Steyerl's earlier work. Traces of Guards (2012), The City of Broken Windows (2018), Factory of the Sun, and This is the Future (2019), appear in the production. Each of these earlier projects addressed models of simulation and the development AI

12
Hito Steyerl and Trevor Paglen, "The Autonomy of Images, or We Always Knew Images Can Kill, But Now Their Fingers Are on the Triggers," in Hito Steyerl: I Will Survive, eds. Florian Ebner et al., exh. cat. (Leipzig: Spector Books, 2021), 239–253, here 249.

language systems in their own way.

Steyerl's investigations of the virtual began some time ago. A case in point is *How Not to Be Seen: A Fucking Didactic Educational .MOV File* (2013, hereafter *How Not to Be Seen*), which tracks an exponential leap in pattern and visual recognition software. The broad range of these programs spans from military target practical devices to domestic surveillance systems. As Steyerl notes, today "seeing is superceded by calculating probabilities. Vision loses importance and is replaced by filtering, decrypting and pattern recognition."[13] The artist initially created *How Not to Be Seen* as a file that she circulated through the internet. Accordingly, the artwork both embodied and enabled the form it critiqued. Another of Steyerl's pieces, *The City of Broken Windows*, documents the process of teaching a computer a new symbolic code—the sound of breaking glass. The computer recognition process was put in the service of an enhanced security system. The artist's *This is the Future*, first shown at the 58th Venice Biennale, consists of an AI program responding to questions and generating images. The Venice installation featured a winding elevated walkway with several screens along the way. The work's centerpiece was exhibited upon a platform down the walkway. Steyerl added *Power Plants* (2019) to a subsequent iteration of this work at Berlin's n.b.k. in November 2019. *Power Plants* requires the spectator to download an augmented reality app "PowerPflanzenOS" onto their personal smartphone. The Kunstverein provided tablets for those without a phone. A third component of *This is the Future, Mission Accomplished: Balanciege* (2019), originated as a live lecture performance. During the performance, Steyerl, along with collaborators Miloš Trakilović and Giorgi Gago Gagoshidze, probe the interconnectedness of theories of disinformation, conspiracy, hysteria, and their evolution and propagation through social media.

SocialSim brings together these myriad interwoven strings of code, assembling them into a new constellation that simulates a metaverse. The latter is in no small part informed by the COVID-19 pandemic. However, in this production, as in the performance *Mission Accomplished*, the real presents itself in the body of the spectator and the architecture of the museum. Prior to the lockdown, Steyerl considered art exhibition and performance

13
Hito Steyerl, "A Sea of Data: Apophenia and Pattern (Mis-)Recognition," in *Duty Free Art: Art in the Age of Planetary Civil War* (London and New York: Verso, 2017),47.

Art Socialism: Hito Steyerl's Metaverse

spaces as sites for IRL encounters. But the powerful virus restricted access to reality, and the artist's production responded in turn. The isolation that followed the enforced lockdown resulted in an unprecedented dependence on the internet. As IRL encounters became deadly, virtuality achieved a new register. Steyerl prepared work during these long months for a retrospective of her work. Entitled "I Will Survive," the show was jointly exhibited at the K 21 Kunstsammlung Nordrhein-Westfalen, Düsseldorf, and the Centre Pompidou, Paris. The first installment opened in Düsseldorf at the end of September 2020 but was soon shut down. It remained installed in the space for some time as a ghost exhibition without a public. Something similar happened with the Paris component of Steyerl's show, which was delayed by several months and was open to the public for only a brief period of time.

In response to the K 21 closure, Steyerl pivoted and produced a 4-part mini-series, *Night at the Museum* (2021). The series features the artist leading viewers through a virtual survey of her work in an otherwise empty museum. Steyerl begins with an attempt to dispel conspiracy theories then circulating on the internet that maintain European museums have been hijacked by nefarious figures and turned into sites of occult-based activities. Steyerl expands on *SocialSim* in each of the series' four parts, providing additional footage of key episodes. In the first segment, she includes the full monologue by unemployed actor Mark Waschke (also featured in *Factory of the Sun*) who delivers a lecture about the construction of his cop character as an avatar. As Waschke sardonically observes, cops often work in pairs in television series, and an avatar would be a perfect partner. The actor acknowledges his awareness that in perfecting his avatar he is advancing the case for his own redundancy. He also summons the real possibility that obedient robots will soon replace the need for much human labor. Steyerl recalls a conversation with a Hungarian museum director who enthusiastically embraced the virtues of AI declaring, "artificial intelligence and automation are great because we won't need migrant workers anymore."[14] In the second and fourth installments, Steyerl directly addresses the spate of recent attacks on museums in Berlin. She also invokes topical issues of art works' provenance and restitution. Steyerl screens *Mission Accomplished: Balanciege* in the third episode.

14
Steyerl and Paglen, "The Autonomy of Images," 253. During the pandemic, *The New Yorker* featured an essay on the boons of robots designed as companions for the elderly to stave off isolationism. Not only did the robot provide social interaction but it also sent back data transmission to designated sources as to the person's activities. Katie Engelhart, "Home and Alone," *New Yorker*, May 31, 2021.

The screening is followed by a wide-ranging discussion with the actors that touches on fashion, appropriation, and art world machinations.

Night at the Museum epitomizes cultural production during the COVID-19 pandemic while maintaining a dialogue with *SocialSim*. Steyerl observes that "the pandemic is reinforcing all the trends we have seen over the past four years—isolationism, authoritarianism, deglobalization, anti-immigration, fragmentation, the exploitation of fear, and data grabbing."[15] Elaine Showalter has elaborated on the intimate links between media and epidemic hysteria. She shows that each feeds off the other, resulting in the production of "collective paranoiac fanaticism." Showalter insists that the "cultural narratives of hysteria ... multiply rapidly and uncontrollably in the era of mass media, telecommunications, and e-mail."[16] Perhaps *SocialSim*'s most striking feature is Steyerl's simulation of a metaverse, which actualizes the virtual and enables spectators to mingle with avatars. The artist preternaturally forecasts a future that draws heavily on the past and is today's present. Prince's 2018 Superbowl performance—two years following his untimely death—provides an example. Abba's current tour, which features avatars of the popstars' 1980s selves offers another. Statistics presented on screen track the dance manias that followed epidemics throughout the centuries. Steyerl invokes events in Bernburg a thousand years ago, in late-fourteenth-century Aachen (Aix-la-Chapelle), Hainaut, Köln, Metz, Strasburg, and Berlin following World War I. The AI commentary addresses the ways dance manias can gauge social health: "This is how racism spreads as pandemia. This is how conspiracy theories proliferate. This is a k-pop band sandbox for fan armies." Codes and algorithms are used to predict the future. In *This is the Future*, an AI cast as soothsayer produces images and language from a vast database, recalling Baudrillard's observation that cybernetics has fundamentally transformed the world. Cybernetics, he argues, heightens society's "anticipation, simulation and programming, and indeterminate mutation directed by the code. Instead of a process which is finalized according to its ideal development, we generalize from a *model*."[17]

15
Steyerl and Paglen, "The Autonomy of Images," 253.

16
Elaine Showalter, *Hystories: Hysterical Epidemics and Modern Media* (New York: Columbia University Press, 1997). Showalter argues that as "panic reaches epidemic proportions, hysteria seeks out scapegoats and enemies—from unsympathetic doctors, abusive fathers, and working mothers to devil worshipping sadists, curious extraterrestrials, and evil governments." 5.

17
Baudrillard concludes that we have shifted from a "capitalist-productivist society to a neocapitalist-cybernetic order that aims now at total control," Baudrillard, *Simulations*, 111.

Steyerl simulates dancing in *SocialSim*. However, the artwork's narrator explains that whereas dance previously entailed social interaction between people, "this episode has been repackaged as a virtual experience." The screen has turned into a facsimile of "Dancing Mania the App." The narrator warns spectators that "by downloading this app [they] become part of a crowd control simulation to put down the rebellion." Even dancing has the potential to be appropriated as one more tool for social control and domination. A menu asks spectators to decide how they would prefer to die: BY ILLNESS, BY POLICE, BY STARVATION, BY DANCING?" The infrastructures encourage spectators to indicate their preference by clicking "YES" in the appropriate box. Steyerl's dancing app actualizes her theory of social choreography. Entertainment apps have been programmed to receive personal data, process it, and then produce codes and algorithms designed to modify human behavior. As the artist explains, "my point is that all these artificial stupidities and all these little appliances are not restricted to smartphones. They are not only restricted to the world of images but are also able to redesign and recreate the urban environment and our material surroundings."[18] People willingly hand over a world of private information about their habits and activities to social media firms, which sell the data to companies that seek to build more efficient marketing, surveillance and social control systems.

[18] Steyerl and Paglen, "The Autonomy of Images," 247.

In one of *SocialSim*'s episodes, Steyerl refers to the interactive function of the popular gaming feature, "Twitch." Over the simulation of a Twitch gaming screen for a live broadcast channel titled "Kidnapped Art," the voice-over announces that VIP room managers have sent out appeals for help. An animated image of the bust of Nefertiti in Berlin's Neues Museum appears under the label "nickedArt dot.com." The virtual Nefertiti appeals to viewers in a female voice. "Help, I was kidnapped," she says. "I'm being detained in Berlin where people like me are not very safe. Sometimes they get burned while being arrested." The AI commentary interrupts her broadcast, revealing that "Nefertiti is piloted by Heja." The screen then splits and the face of Heja Netîrk, one of Steyerl's regular collaborators, appears. Netîrk explains that her absence in the previous episode was due to the fact that she had been "locked up in a Turkish jail." But she has now managed "to escape and become a fucking refugee." At this

point, Steyerl documents the vandalization of approximately 70 Egyptian artefacts in Berlin museums on October 3, 2020. Police linked the vandalism to right-wing groups who fell for conspiracy theories proliferating online that maintained museums were the locus of Satanic cults. The CGI animated bust of Nefertiti refers to pervasive police brutality and anti-immigrant sentiment. We are beyond representation here, Steyerl reminds spectators, "an image becomes less a representation than a proxy, a mercenary of appearance, a floating texture-surface commodity. Persons are montaged, dubbed, assembled, incorporated. Humans and things intermingle in ever-newer constellations to become bots or cyborgs. As humans feed affect, thought, and sociality into algorithms, algorithms feed back into what used to be called subjectivity. This shift has given way to a post-representational politics adrift within information space."[19]

19
Hito Steyerl, "Proxy Politics: Signal and Noise," in *Duty Free Art*, 38.

In addition to the proliferation of disinformation, paranoiac hysteria, and conspiracy theories, the internet has also made a world of films, videos, and television series readily available to stream. Lockdown provides optimal conditions for people to spend more time with the worlds offered up on the internet and less circulating in their actual surroundings. Production studios and their broadcasting arms now curate a plethora of niche series that cater to a broad array of social types. All genres of production are readily available for viewing. Television, film, and web series have become the programming of choice during the pandemic. Lockdowns encourage binge watching. Added to this, new co-viewing features such as Disney's "Group Watch" and Hulu's "Watch Party" enable virtual communal watching experiences. Co-viewing is popular not only because it allows "friends" to connect virtually but also because it provides a space for new contacts in an imaginary community. Additional features on YouTube or Twitch permit audiences to publicly "react," inspiring the new genre of "reaction videos" that in turn contribute to a consumer society increasingly driven by ratings.[20] However, it is not just on the consumption side that series programming has become popular during the pandemic. Concomitant with the rise in demand is an increase in the production of series—especially mini-series that require less of a time commitment for spectators. The rise in popularity of these programs, and the ability of their viewers to adhere

20
On the importance of ratings see Michel Fehrer, *Rated Agency: Investee Politics in a Speculative Age* (New York: Zone Books, 2018).

to COVID-19 standards and protocols, has led to the proliferation of these productions.[21] The pandemic's demands presented unprecedented challenges for the entertainment industry, and the latter responded in an equally extraordinary manner.

Steyerl riffs on this phenomenon in *SocialSim*. Interruptions, episodic breaks, and recaps that cast the artist's work as a limited-run series punctuate the production. When, early on, the narrator says "Previously in this series…," a figure swinging a sledgehammer upon a large pane of glass appears on the screen. So, too, does the word "socialism." The narrator continues, "The last episode didn't make it beyond the pitch because lockdown persisted. This one was thrown together from outtakes." The latter come from the production of Steyerl's *The City of Broken Windows*. A scattering of statistics appear on the left-hand lower corner of the screen: "The artist, Government legitimacy level: 0.2, Risk Aversion: 0.8, Grievance level: 0.9, Performance score: 3.1." The narrator's voice resumes, "Heja got fired and found a new job. She now breaks windows to train AI to put down rebellion." Other sequences in *SocialSim* derive from Steyerl's previous productions. The passages summon *Factory of the Sun* and *Strike* (2010). In each instance, the scene is introduced with the stock phrase: "Previously in this series," or "this is how." This phrase's incessant reiteration echoes the premise of repetition as the ontology of serial production. In a world of virtuality, simulation is the endless repetition of the same—a loop that plays on forever. Steyerl's online series, *Night at the Museum*, is yet one more variant of this repetition.

Previously, film and video production recorded images and sounds, which were then edited in postproduction into a final product. The shift from analog to digital editing has fundamentally transformed this procedure. Whereas the post-production of analog material involved the haptic craft of editing, color correction, sound design, and the like, filmmakers edit digital material on computers. The digital codes of images and sounds are processed by other codes. As Steyerl observes, in the analog era, "the name 'postproduction' made it appear to be a supplement to production proper," however with digital technologies, "this logic flipped back to influence and structure production itself.

21 Within the space of a year, between 2020–21, film directors such as Barry Jenkins, Steve McQueen, and Raoul Peck have each produced their mini-series. See *Underground Railroad* (2021), *Small Axe* (2020), and *Exterminate all the Brutes* (2021). Of course, filmmakers such as Alexander Kluge turned from film to television in the 1980s with his weekly broadcasts; but I submit the motivation and form (long-term) were significantly different.

22
Hito Steyerl, "Cut!
Reproduction and
Recombination," in *The
Wretched of the Screen*
(Berlin: Sternberg Press,
2012), 176–188, here 182.

In recent years, postproduction has begun to take over production wholesale. ... Fewer and fewer components actually need to be shot because they are partially or wholly created in postproduction."[22] Artists and filmmakers can manufacture images and sounds without a "real," and this extends beyond media to the artwork as well. Steyerl's sardonic demonstration of the "postproduction" worker who has shifted from a craftsperson at the editing table to a computer programmer doubles in her own role. *SocialSim* is created out of digital material and as such actualizes in audiovisual form what Barthes' identifies as a process begun with the realist novel (a genre that might be said to proximate documentary). As Barthes puts it, "the [realist novel] writer fulfills Plato's definition of the artist as a maker in the third degree, since he imitates what is already the simulation of an essence."[23]

23
Barthes, "The Reality
Effect," 145.

The pandemic has brought into sharp focus the extent to which all representation previously referred to as "real" or "documentary" is now virtual. The real today is simulated, composed of codes and algorithms. This transformation affects much of contemporary culture; not just media but even monetary systems like bitcoin. It has fundamentally altered the art system as well, as the recent proliferation of NFTs indicates. One of *SocialSim*'s narrative threads self-reflexively addresses the art world's increased virtualization and liquidification—a process begun a couple of decades ago but pushed into high gear by the pandemic. Whereas earlier in the twenty-first century images of artworks were regularly placed on the internet, the presence of exhibitions in museums and galleries was still crucial. The pandemic has largely eliminated this requirement. Museums and galleries have closed and art has been forced to go online. Many of today's art shows are accessible only through virtual tours and simulations. A plotline of *SocialSim* highlights the disappearance of the *Salvator Mundi*, a painting recently attributed to Leonardo da Vinci. For decades, this picture was assumed to be a production of the Renaissance master's studio assistants. Its sale in 2017 at Christies for $450.3 million US to Badr bin Abdullah followed new claims that the canvas was in fact painted by Da Vinci. The composition was to be exhibited at the Louvre Abu Dhabi in 2018, but was withdrawn from public view instead. The act spurred

speculation that the painting's new owners were apprehensive of placing the nearly half-billion-dollar picture on display lest experts studying it closely determine that it is not a product of DaVinci's after all. At one point in *SocialSim*, an animated *Salvator Mundi* addresses the production's viewers. "I only saw Leo once," Mundi insists, "when he brushed up my finger. I am proudly studio!" In the meantime, the composition's whereabouts have become a mystery. Some claim that the picture hangs in a room of Saudi Crown Prince Mohammed bin Salman's private yacht. Others presume that it is stored in a vault in one of the many offshore freeports that have recently proliferated around the world. What is certain is that the artwork's disappearance has rendered its image and code elements more prominent. If the owners made the "real" object more readily available, its authenticity might be compromised. Ironically, then, the painting's genuine value is dependent on its simulated life. The shadows on the wall are real so long as one cannot probe that which casts them. From this angle, the art world's design of metaverses that substantiate NFTs make perfect sense. These "artworks" exist only on a block-chain as pure code.

An animated sequence in *SocialSim* titled "Automated Art, An Art History" ridicules NFTs. The sequence is set in a generic architectural space. On one wall, a Lawrence Weiner-like text-based artwork reads, "Taken From Here to Where it Came From and Taken to the Latent Space of the Art World." As the camera virtually moves through the space it pauses at various large, framed artworks that feature 3D models of "social simulation." The first, which shows "how waves of discontent spread through populations," features an undulating purple, green, and black image that resembles a flag or a screen-saver. The second highlights yellow and blue cubes that render "a society where several groups live together." The next artwork summons the recurring "lockdown riots." It depicts CGI fish that swim through empty galleries in the direction of a plane in the process of being installed on the wall by two technicians. The narrator explains that the scene "shows museums that were automated closed and replaced by virtual reality maps." These artworks are followed by a set of "self-evolving" compositions set in a VIP lounge. The narrator explains that the compositions have been designed to "get smarter, better, richer." If they do not learn to walk and

"look for sponsors," they will "explode." Later in the same sequence, Steyerl turns to an artwork that has transitioned from automated to autonomous. Titled "the Walking Sad" and set to the pop band Alpha's 1995 hit song, *Born to Be Alive*, the artwork follows a robotic figure made from lines and blocks encased in a series of picture frames. The figure replicates itself while the commentary informs the viewers: "In generation one, this thing started to crawl. In generation 48, it had eaten its whole family. In generation 450, it sold at auction. In generation 4,400, it sold its owner. In generation 44,500, it turned into a mid-sized constitutional monarchy." NFTs generate themselves. They are non-interchangeable. Artists who make these unique units of data stored on digital ledgers justify their complicity in the virtual world of finance with the insistence that, in an update of art impresario Seth Siegelaub's "Artists Reserved Rights Transfer and sale Agreement," 10% of all future NFT sales revenue will go to the artist.[24]

What will happen with to art market and art world following the pandemic? Private interests continue to infiltrate and, to a greater extent than ever before, the aesthetic merit of artworks depends on their economic exchange value. But instead of resignation and despair, resisting these processes is more important than ever. In the third episode of *Night at the Museum*, Steyerl vehemently emphasizes how crucial it is to build "alternative structures" capable of challenging the conventions of the dominant art world. Her goal is to develop counter-practices capable of sublating the existing art system and facilitating "bottom-up alternative structures." As she puts it, "we want to fold the official art world inside our own structures." This, she argues, requires that like-minded artists assume greater control of the art world's operation. The double-entendre of "bottom up" resonates with the backflip maneuver that repeats several times in *SocialSim*. The first time a figure performs the acrobatic feat, it stops the dancing mania by exposing the control panel and revealing the codes of social choreography. The second performance is by Waschke's cop avatar, who is programmed to perform a backflip and replace the virtual *Salvator Mundi*. Like the twist of a kaleidoscope cylinder, the acrobatics shake up the

The original artist's contract, drafted by Siegelaub and lawyer Robert Projansky in 1971, posited that 15% of sales revenue would go to the artist. Art historian Alexander Alberro points out that the contract in its monetization of the practice negated the initial impetus behind Conceptual Art that sought to dematerialize the art object and thereby resist the market. See Alexander Alberro, *Conceptual Art and the Politics of Publicity* (Cambridge, MA: MIT Press, 2003).

loose order of elements and reassemble it in a new constellation. *SocialSim* alludes to the rich potential of hacking interventions. At one point, the piece references the K-pop band whose fans crashed a Dallas Police Department's effort to track people protesting for social justice, and at another the anonymous group of hackers who purchased a mass of entrance tickets to a Donald Trump campaign rally in Tulsa, Oklahoma, resulting in a humiliating lack of attendance.

Prior to screening the third installment of *Night at the Museum, Mission Accomplished: Balanciege*, Steyerl pauses to reflect on a T-shirt designed by a close friend, Harun Farocki. The black shirt bears two statements. The front warns that "It is bad to be appropriated by the art market," while the back reads, "But it is even worse not to be appropriated by it." Farocki articulates the fine line politically committed artists must balance when confronted with success. They must be perpetually attentive to networks of power and opportunities capable of affecting the structure. Visibility is a strength, but the danger of cooptation is real. One way to turn appropriation into a weapon is to mobilize the language of those in power against them. *SocialSim* begins with an AI system that tries to learn how to pronounce the word "SocialSim." The system's voice repeatedly stutters and stumbles over the word. Its faltering efforts yield the same result: "Socialism." In fact, the more attempts the computer makes the more "socialism" is pronounced instead of "socialsim." In the end, the only way to stop the proliferation of this subversion in the form of a digital tongue twister is to cut the electricity off and start anew. Altering languages and operating systems and effecting change requires a reboot, even if the codes in question are artificially produced.

In *SocialSim*'s final sequence, aptly titled "Deus ex Machina," the avatar of a worker with a pickaxe shatters a screen. The scene summons Steyerl's *Strike* once again. When the figure with the pickaxe finally reveals its face, we see that it is *Salvator Mundi*. The latter reveals that its duty now is to save the world. The "god from the machine's" final words posit a brief, if illusory, glimmer of hope: "Now I live here. Workers build their own sim to take control of the means of simulation. They run their own models to simulate a world without disinformation and survival of the fittest." However, undercutting this surprisingly positive message,

information feeds on racist-fueled attacks, anti-democracy demonstrations, conspiracy theories, and COVID-19 statistics inundate the screen.

How does documentary confront the language of disinformation that proliferates on the internet? To be effective, the genre must learn the codes of this new language and inhabit its metaverse. Instead of returning to the new anachronistic forms of the analog era, contemporary documentary needs to evolve. It must adapt to the new language of AI and the architecture of simulation. As a CGI generated work that addresses contemporary reality, *SocialSim* provides the rudiments of a model of what documentary form might look like as the new millennium.

'추방된' 기술 존재자들의
생태정치학을 위하여

이광석

Toward an Ecopolitics
of the "Wretched"
of Technology

Lee Kwang-Suk

"기술은 현실을 파괴해 왔다"
자동화 기술로 매개된 산노동의 피폐화, 불신과 혐오의 '탈진실'
정치와 극우 부족 정치의 탄생, 인간의 신체와 의식을 디지털 '가분체
(dividuals)'로 분할해 통제하는 빅데이터 과학, 그리고 알고리즘
자동화에 기댄 생명 포섭의 강렬도 등 동시대 기술 예속 상황이 급격히
우리를 휘감고 있다. 코로나 충격과 함께 비대면 현실이 일상이 되면서,
인공지능과 플랫폼 등 첨단 자동화 알고리즘 기술에 종속된 현대인의
'기술 물신(techno-fetishism)' 현상이 가속화하고 있다.

기술은 자본주의의 물신적 대상이 된 지 오래다. 우리가 알던
디지털 자유주의자의 교류와 우정의 장이었던 '사이버공간'은 이미
사어(死語)가 됐고, '4차산업혁명'의 슬로건에 이어서 '메타버스'란
아바타 경제의 혼합 현실에 대한 미래 예찬이 이를 대신하고 있다.
자본주의의 논리도 어느덧 슘페터주의의 '창조적 파괴(creative
destruction)'의 시장 개혁에서 미 서안 실리콘밸리의 '와해적 기술
(disruptive technology)'을 통한 사회 전반의 혁신 논리로 갈아탄
지 오래다. 과거의 흔적, 생명, 정서, 호혜, 물질성을 황폐화하는,
테크노자본의 와해적 질주만이 난무한다.

신자유주의 통치와 동거하는 와해적 기술의 논리는 그 활동
범위를 경제와 시장에서 사회 전 영역으로까지 넓히고 있다. 특히,
코로나바이러스의 창궐로 인한 비대면 현실에서 빅테크의 플랫폼과
일상의 스마트 테크놀로지는 우리 사회의 '공통감각(sensus
communis)'을 지배하는 신생 조건이 됐다. 아니 우리의 사회 관계적
감각을 사유화된 기술 감각으로 대체해 나갔다. "한때 기술은 연결하고
매개하는 것이었다면, 오늘날 기술은 뭐든 나누고 분절한다. 그것은
인간을 감별하고 순위를 매긴다."[1] '소셜' 데이터 유통과
가짜뉴스, 디지털 소문, '탈진실(post-truth)' 경향은
인간들의 상호 관계성의 근거가 됐던 진실의 작동 방식까지
멈춰 세운다. 즉 우리의 소통과 관계를 '소셜' 플랫폼의
사유화된 알고리즘 디자인과 논리에 순응시킨다. 그렇게 "기술은
현실을 파괴해 왔다."[2]

이 글은 히토 슈타이얼의 기술에 대한 몇 가지
미학적 사유의 편린을 살핀다. 영국의 미술 비평가

[1] Hito Steyerl, "Technology Has Destroyed Reality," New York Times, December 5, 2018.

[2] Steyerl, 위의 글 제목을 인용.

줄리안 스탈라브라스의 묘사처럼, 슈타이얼이란 작가는 "기이한 디지털 결함(글리치)을 자신만의 유머와 함께 다루는 확신에 찬 저글러이자, 테크노-자본의 위험한 추동력에 맞서 고의적으로 관객에게 이에 부조화와 거리감을 안기는 예술가적 개성"을 갖추고 있다.[3] 그는 기술의 가공할 만한 '지능(intelligence)'의 숭고미를 드러내는 대신 '인공기술의 우둔함(artificial stupidity)'을 극적으로 묘사해 왔다. 그는 하이테크의 본산인 캘리포니아 '언캐니 밸리(uncanny valley)'[4]의 닷컴 실상과 동시대 데이터 기술 현실에 대한 그만의 풍자적 시각을 효과적으로 펼쳐 왔다. 이 글은 슈타이얼의 최근 비평 글들의 모음집인『면세 미술: 지구 내전 시대의 미술』, 그리고 그와 관련한 일부 영상 작업을 참고해 그가 바라봤던 현대 기술의 논쟁 지점들을 살핀다. 특히 그의 미학적 작업들이 어떻게 향후 기술 생태정치학적 기획과 맞물릴 수 있을지를 거칠게나마 살펴보고자 한다.

3
Julian Stallabrass, "Sublime Calculation," *New Left Review* 132 (November-December, 2021): 88.

4
'언캐니 밸리'는 실리콘 밸리의 허상을 짚은 책 제목에서 가져왔다. 애나 위너, 『언캐니 밸리』, 송예슬 옮김(서울: 카라칼, 2021) 참고.

동시대 기술 미학적 쟁점들
이미지 내전은 가능한가?

슈타이얼이 바라보는 동시대 자본주의의 현실태는, 기술로 매개된 지구 권력의 확장, 위태로운 노동과 계급 투쟁의 첨예화, 정보 커먼즈의 사유화된 인클로저(종획), 감시 자본주의와 플랫폼 알고리즘 질서 등으로 특징지을 수 있다.[5] 그가 보는 비관적인 공상과학 소설(SF) 같은 오늘의 기술 현실을 관통하는 사회 구조를 한마디로 표현한다면 이는 '데이터 사회(datafied society)'일 것이다. 인간의 모든 활동, 의식과 정서, 시각적 재현과 표현이 모두 데이터로 치환되는, 다시 말해 "데이터 흔적에 반영된 우리 삶의 표현들이 정보 생명정치가 관리하는, 경작하고 수확하고 채굴할 수 있는 자원이 되는" 우울한 현실을 그는 문제 삼는다.[6] 문화이론가 마크 피셔 식으로 보자면,[7] 이는 자본 바깥을 볼 수 없고 자본에 저항하는 개념과 기호들이 무장해제당하는 '자본주의 리얼리즘(capitalist realism)'의 새로운 시대상이기도 하다.

슈타이얼의 '전산 사진(computational photography)' 개념은

5
McKenzie Wark, "Hito Steyerl," *Sensoria* (London and New York: Verso, 2020), 47

6
히토 슈타이얼, 『면세 미술: 지구 내전 시대의 미술』, 문혜진·김홍기 옮김(서울: 워크룸 프레스, 2021), 70. 이하 이 책의 인용은 본문에 쪽번호만 명기.

7
마크 피셔, 『자본주의 리얼리즘: 대안은 없는가』, 박진철 옮김(서울: 리시올, 2018).

데이터 재현의 신세계를 비판적으로 해부하려는 중요한 시도로 읽을 만하다. 이는 오늘날 이미지 재현의 새로운 특징을 담지하고 있다. 보통 '재-현(re-presentation)'이라 함은 존재하는 대상을 특정의 의도를 갖고 굴절하거나 일면을 강조하는 행위라 할 수 있다. 슈타이얼은 데이터 전산 통치 속 재현의 국면, 즉 '포스트-재현'의 국면은 과거 대상을 특정한 방식으로 왜곡하는 것과는 결을 달리한다고 본다. 이미 시각 이미지들은 머신러닝(기계학습)과 알고리즘 기술 등 빅데이터 과학에 기반해 무수한 전자 네트워크의 연결과 교차 참조를 통해 관계적 지위를 지닌다. '전산 사진'은 이들 데이터 기술에 의해 투사된 포스트-재현의 구체화된 효과인 것이다. 다시 말해, 전통의 사진이 대상을 특정의 구도를 갖고 대상 세계 외부에 있는 것을 재현하려 애쓴다면, 전산 사진은 "당신이 이미 찍은 사진들, 당신과 연동된 사진들, 나의 네트워크 인맥의 사진들" 등 "여러 다양한 데이터베이스의 교차 참조" 속에서 '관계적 사진' 이미지를 창조한다. 물론 그 사진은 "당신이 보고 싶어 하리라고 알고리즘이 생각한 것의 사진"인 것이다.(38)

자본주의의 이미지 재현은 줄곧 스펙터클화된 미디어 소비와 상품미학에 의해 표준화된 정서와 욕망을 우리에게 과잉 학습시켰다. 이제는 이 재현되는 모든 것을 네트워크의 데이터 흐름과 알고리즘의 자동화된 분석과 원격 통제, 정동 데이터의 패턴 예측을 통해 맞춤형 추천 방식으로 조절한다고 볼 수 있다. 문제는 이 전산학적 기술 장치에 연결된 재현된 이미지는 그리 중립적이지 않다는 데 있다. 전산화된 이미지가 "흐름, 네트워크, 기계들에 의해서 관리되는" 알고리즘적인 재현인 까닭이다.[8] '포스트-재현'은 우리를 스펙터클의 소비 욕망에 가두는 것을 넘어 전산학적, 사이버네틱 통치와 연결한다. 다시 말해, 데이터 사회 국면에서 재현되는 거의 모든 것은 "플랫폼에 고착된 규칙과 규범, 그리고 법률적, 도덕적, 미학적, 기술적, 상업적이고, 뻔히 숨겨진 요소와 효과의 혼합체"라 할 수 있다.(39)

온라인 계(界)의 이미지 재현은 더 이상 그 내적인 미학 효과에서보다는 점점 전산 관계적인 가중치에 의해 실제 의미와 가치가 부여된다. 내가 누른 구독과 '좋아요', 소비 방식과 취향,

8
마우리치오 랏자라또, 『기호와 기계』, 신병헌·심성보 옮김 (서울: 갈무리, 2017), 52.

친구 맺기, 알고리즘이 매긴 랭킹 등에 의해 우리 각자는 대상에 가(중)치를 부여하고 '필터버블'된 의식의 던전(게임 속 지하 미궁) 안에 갇힌다. 여기서 '필터버블'은 맞춤형 데이터에 익숙해져 그것의 과잉 섭취가 이루어지면서 스스로를 편향된 정보 거품에 갇히게 만드는 효과이다. 소셜미디어에서 특히 이런 현상이 강화되면서, '소셜' 네트워크에 연결된 우리는 주위의 다른 이들과 비슷한 성향을 유지하며 부족화된 집단 속에서 '무오류성의 감옥'에 갇히고 다른 판단의 가능성을 배제하는 일이 흔해진다. 알고리즘의 편향은 더욱더 이와 같은 극단적 편견의 효과를 부추긴다.

　　무엇보다 심각한 사실은 우리 대부분이 알고리즘의 작동 기제에 대한 접근을 거부당하는 데 있다. 전산 이미지와 데이터가 어떻게 배열되고 배치되는지에 대해서는 '암흑상자(블랙박스)'화된 '기업 비밀'에 속한다. "현실을 위한 모델이 갈수록 인간의 시각으로 이해할 수 없는 데이터 집합으로 이루어진다면, 그것에 따라 창조되는 현실도 역시 부분적으로 인간이 이해할 수 없는 것이 될 수 있다."(84) 다만 우리가 아는 것이라고는, 전산 사진이 NFT(대체 불가능 토큰; non-fungible token)와 같은 가상화폐가 되는 지경에 이르렀고, '좋아요'와 공유, 댓글, 평점 등 '주목도'를 지닌 이미지만이 그만의 존재 증명을 확보할 수 있다는 것이다. 온라인 재현 공간에서 특정 이미지와 데이터의 비가시화는 곧 존재의 소멸로 간주된다. 오늘날 재현의 세계는 이렇듯 "이미지의 새로운 질서, 이미지의 문법을 보여 주고, 기업과 정부의 문법에 따른 사회관계와 연결된 섹슈얼리티, 감시, 생산성, 평판, 전산의 알고리즘 체계를 보여 준다."(43) 불행히도 데이터 권력은 그 정확한 실체나 작동 기제를 이해하기 어려운 불투명한 전산 통계학적 이미지 질서로 등장한다.

　　잡음과 정보의 분할, 그 우둔함
슈타이얼은 투명한 듯 보이는 데이터 과학이 지닌 불투명한 모순의 지점들을 드러내기 위해 데이터 현실이 축조하는 숭고의 신화와 그 균열 지점을 우회해 드러내고자 했다. 무엇보다 그는 전산화된 데이터 과학의 '정치적' 성격을 집요하게 물고 늘어진다. 그는 프랑스 미학자 랑시에르를 인용하면서, 고대 그리스에서 신호에서 잡음을

구분하는 방식이 현대 기술 권력의 작동 기제와 어떻게 연동되는지를 빗대어 설명한다. 즉 과거 그리스에서는 유복한 현지인 남성의 말이 발화(speech)이자 정보(신호)였다면, 반대로 여성과 아이, 노예, 외국인의 말은 신음이나 잡음으로 간주되었다고 지적한다.(59) 그리고 당시 "잡음에서 정보를, 신음에서 발화를" 분리해 내는 과정은, 오늘날 인공지능의 머신러닝(기계학습) 기법을 통해 "엉덩이에서 얼굴이란 신체부위를 분리해 내는" 공정과 유사 논리임을 주장한다. 이어서, 데이터 과학의 자동화 기법이 정치적인 것은, 그 분리 과정을 통해 얻은 "결과를 수직의 계급적 위계로 반듯하게 쌓아 올리는" 현대판 데이터 분할 통치가 이뤄지는 까닭이다.(45) 마치 이는 구름이나 달에서 인간의 얼굴을 인공지능으로 읽어 내는 것처럼, 랜덤 데이터로부터 패턴을 읽는 방법이 이 시대의 새로운 "정치적 스팸 필터"로 작용한다고 볼 수 있다.(58)

거의 모든 것이 데이터로 수렴되는 자본주의 현실에서 잡음과 신호를 구분하는 연산 과정의 목표는 주로 '패턴 인식(pattern recognition)'에 있다. 패턴 인식은 생각보다 상호 연관되지 않은 것들의 상관관계를 읽어 내고, 관계성의 밀도를 세밀히 측정하는 데 효과를 보면서 현대인의 데이터 과학에 대한 열광을 불러일으켰다. 그런데 빅데이터 과학은 사건들의 복잡다기한 관계망들의 횡단적 층위를 분석 중심에 두는 것에 반해, 시계열적 격차를 두고 발생하는 특정 사안과 사건의 인과적이고 발생학적인 관계를 설명하는 데 대단히 취약하다. 무엇보다 잡음에서 신호와 정보를 구분하는 근거와 잣대가 무엇일지에 대해 어느 누구도 제대로 답하지 않는다. 심층 데이터 과학의 이와 같은 인과적인 설명 불능 상태와 분할의 통치 질서는 오늘날 데이터 과학의 비역사적인 태도를 여지없이 드러낸다.

슈타이얼은 데이터 과학에 근거한 패턴 인식이 예상보다 많은 부분에서 "불투명하고, 부분적으로 편향되어 있으며, 배타적이고, 때로는 '우스꽝스러울 정도로' 낙관적"이기까지 하다고 논평한다.(65) 그는 인공지능 등을 활용한 첨단 데이터 과학의 '우둔함(stupidity)'을 그의 글과 작업을 통해 줄곧 드러내려 했다. 탈인격의 '자동화된' 데이터 권력의 어리석음을 지적하는 논의들은, 이를테면 그의 영상 작업 속 로봇을 강제로 밀치고 넘어뜨리는 등 기계 붓을

9
히토 슈타이얼, 〈Hell Yeah We Fuck Die〉, 2016, 3채널 HD 비디오, 컬러, 사운드, 4분 35초.

기이한 방식으로 훈련시키는 인간 실험장의 반복적인 장면에서 극적으로 연출된다.[9] 최적의 사운드를 찾기 위해 물리적으로 수도 없이 많은 유리창을 깨뜨리며 이를 기계학습 시키는 인간들의 반복적인 실험 장면은 이와 흡사한 기이함을 자아낸다.[10] 혹은 그가 「데이터의 바다」에서 언급한 완전한 잡음에서 어떤 패턴이나 이미지를 만들어 내는 구글 기업의 활동으로서 '인셉셔니즘(inceptionism)' 혹은 '딥 드리밍(DeepDreaming)' 인공지능 기법을 통해 시각적으로 구현된 기괴한 돌연변이 이미지는 어떠한가?[11] 우리는 이로부터 기술이 가져올 찬란한 미래를 점치거나 쉽게 미사여구를 늘어놓을 수 없다.

10
히토 슈타이얼, 〈깨진 창문들의 도시〉, 2018, 단채널 HD 비디오, 컬러, 사운드, 10분.

11
히토 슈타이얼, 「데이터의 바다: 아포페니아의 패턴 (오)인식」, 『불온한 데이터』(서울: 국립현대미술관, 2019), 49 이미지 참고.

슈타이얼은 자본주의의 중단 없는 혁신의 슬로건 아래에서도 스멀스멀 기어오르는 기술의 불완전함과 결함, 오류, 글리치 등을 블랙 유머를 섞어 들춰낸다. 질주와 성장의 신화로 포장된 자본주의 첨단 기술은 그 어느 누구도 거부 못 할 유혹이지만, 그 자체 이미 잘못된 편견과 오류와 결함을 지니면서 때로는 우둔함마저 내재하고 있다는 점에서 불온하다. 그렇게 슈타이얼의 작업에서는 데이터 과학으로 무장한 첨단 자본주의 기술의 이면 아래 작동하는 "이미지, 폭력, 엔터테인먼트, 정동, 그리고 자본의 경제학"이 마치 기괴한 스토리마냥 드러난다.[12]

12
Corina L. Apostol and Nato Thompson, *Making Another World Possible* (London: Routledge, 2019), 185.

"인터넷은 죽었는가?"

"인터넷은 죽었는가?" 슈타이얼은 오늘의 데이터 과학이 지배하는 사회 현실에 대해 이렇게 되묻는다. 물론 그는 "인터넷은 죽지 않았다."고 말한다. 오히려 인터넷은 "산송장(undead) 상태로 어디에나 있다."고 말한다.[13] 인터넷은 초기 자유주의자들의 독립선언이 무색할 정도로, 이제는 "감시, 무급노동, 저작권 체제, 트롤 순응주의(troll-enforced conformism)"가 지배한다.[14] 결국 "인터넷은 파리 코뮌이 아니라 우버와 아마존을 낳았다."(214) 슈타이얼이 보는 동시대 자본주의 기술의 특징들은 현실 속 인권, 정의, 정치, 진실의 가치를 파괴할 뿐만 아니라 몇몇 빅테크가 주도하는 극단의 기술 시장 세계를 창조한다.

13
Hito Steyerl, "Too Much World: Is the Internet Dead?" *e-flux journal* 49 (November 2013): 10-26.

14
Wark, "Hito Steyerl," 55.

15
Hito Steyerl, "How to Kill
People: A Problem of Design,"
*Superhumanity: Design of
the Self* (Minneapolis, MN:
University of Minnesota
Press, 2018), 325.

슈타이얼이 주목한 인터넷의 퇴행은 주목과 조회 수 자체가 돈이요 영향력이 되는 현실이다. 트롤 순응주의란 바로 이런 상황에서 발생한다. 이는 "민주주의를 이루는 데모스(민중)가 이제 이들의 활동, 동작, 생기를 포착하려는 빅테크의 휴대폰을 쥐고 있는 무리(mob)로 바뀌는" 정치 포퓰리즘의 현실이다.[15] 스마트폰의 무리가 연신 찍어 대는 무수한 전산 이미지의 생성과 흐름은 이 새로운 데이터 기술 문법에 인간 자신을 쉽게 길들이는 효과까지도 낳는다. 자동화된 알고리즘으로 구축된 디지털 재현 관계는 궁극에 인간의 비판적 사유와 판단을 전산화된 행위와 관계로 후퇴시킨다. 가령, '알고리즘 정치'에서 내 동지는 팔로워와 페북 친구로, 적과 '그들'의 구분은 언팔과 폐절된 이들로, 저항은 인증 셀카와 해시태그로, 연대는 '좋아요'와 구독으로, 사유와 판단은 알고리즘 추천 등으로 쉽게 치환된다.[16]

16
김곡, 『과잉존재』(서울:
한겨레출판, 2021), 154.

퇴락하는 인터넷 현실에서, 정치는 취향으로 쪼그라들고, 그런 취향조차 알고리즘이 제공하는 네트워크 채널로 굳어지고, 경합과 저항의 미디어 공론장은 관종, 음모론자, 어그로꾼, 사이버 렉카(남의 사건 사고로 주목을 끄는 자), 프로보커터(타인을 도발해 주목을 얻으려는 자), 트롤(악의적 훼방꾼)에 의해 무력화된다. 그렇게 우리의 물리적 사회관계를 대체해 '소셜' 알고리즘의 서열과 가중치에 의해 축조된 공학적 관계에서는, 시민 공통의 지속가능한 정치 감각을 배양하기 어렵다. 오늘날 정치의 위기는 일상의 '정치적인 것'을 장악해가는 '소셜' 알고리즘의 문제에서 비롯한다.

데이터 권력과 트롤의 알고리즘 정치 현실에서 과연 어떤 대안적 실천이 가능할 것인가? 이는 우리가 이제까지 봤던 전산화된 이미지와 통치 기술과는 다른 기술의 관점을 요청한다. 슈타이얼이 적절히 지적한 바처럼, 데이터 과학은 진실의 피사체를 분석하는 대신 우리가 제대로 된 '진실의 색'을 읽거나 판단할 수 있는 능력을 갉아먹는다. 그래서 우리가 "리얼리티에 더 가까이 다가간 것 같을수록, 영상들은 그만큼 더 흐릿해지고 더 흔들린다."[17] 오히려 우리에게는 그가 오래전 언급했던 '빈곤한 이미지(poor image)'의 소환이 다시 필요할지도 모른다.

17
히토 슈타이얼, 『진실의 색』,
안규철 옮김(서울: 워크룸
프레스, 2019), 14.

'빈곤한 이미지', 기술 생태정치학의 발화점

슈타이얼이 언급한 '빈곤한 이미지'의 의미를 이제 새롭게 재해석할 필요가 있다. 그의 '빈곤한 이미지'는 스펙터클한 재현 이미지는 물론이고 새로운 전산통계학적 질서와 대당 관계에 놓인, 즉 새로운 저항의 근거지를 뜻한다.

> 빈곤한 이미지는 움직이는 사본이다. 화질은 낮고, 해상도는 평균 이하, 그것은 가속될수록 저하된다. … 그것은 떠도는 이미지로서 무료로 배포되고, 저속 인터넷 연결로 겨우 전송되고, 압축되고, 복제되고, 리핑되고(ripped), 리믹스되고, 다른 배포 경로로 복사되어 붙여넣기 된다. … 그것은 화질을 접근성으로, 전시 가치를 제의 가치로, 영화를 클립으로, 관조를 정신분산으로 변환한다. 빈곤한 이미지는 동시대 스크린의 추방된 존재 (the wretched)이며 시청각적 제작의 잔해이자 디지털 경제의 해변으로 밀려온 쓰레기다. … 그것은 쾌락 혹은 죽음의 위협을, 음모론이나 해적판을, 저항 또는 무능력을 유포한다. 빈곤한 이미지는 희소한 것, 명백한 것, 못 믿을 것을 제시한다. 물론 우리가 그것을 해독할 여지가 있을 때에만.[18]

18
히토 슈타이얼, 『스크린의 추방자들』, 김실비 옮김, 김지훈 감수, 2판(서울: 워크룸 프레스, 2018), 41-42 인용.

오늘 우리는 '빈곤한 이미지'를 기술정치적 대안의 상징이나 비유로 '해독'할 필요가 있다. 빈곤한 이미지는 슈타이얼이 랑시에르를 가져와 언급했던, 정보로부터 배제되고 격리된 '소음'과 유사하며 '사회적 타자'라 할 수 있다. 주류 자본주의 체제가 첨단의 새로운 것만을 추구하면서 우리 삶의 왜곡이 크게 이뤄졌다고 본다면, 슈타이얼의 "빈곤한 이미지의 변호"는 분할의 데이터 정치에 의해 '추방된(wretched)' 타자들이 동시대 '기술 물신'에 대항하며 벌일 실천 미학적 상상력을 자극한다.

데이터 권력은 이미지 생산의 발생적·역사적 맥락을 지워 버린 그 자리에, 닷컴 자본의 전산 정치경제학을 구축하려 한다. 이러한 우울한 현실에서 슈타이얼이 택한 '빈곤한 이미지'의 변호는 자동화의 세련된 알고리즘의 데이터 세계에서 배제되고 소외되어 비가시권에 놓이게 된 존재자의 가치를 주목하는 것과 다르지 않다. 우리에게

빈곤한 이미지는 기실 기술의 결함이나 구닥다리로 여겨지는 글리치, 지체, 지연, 흑백, 저해상, 잡음, 버그, 돌연변이, 좀비미디어 등이다. 이들은 우리가 넘어설 투박한 과거나 미숙한 오류가 아니다. 오히려 자본주의적 소외와 기술 생태의 왜곡된 조건을 드러내는 중요한 복선으로 받아들일 필요가 있다.

아직 쓸모와 사용가치가 소진되지 않았음에도 소비자본주의의 '계획적 노후화(planned obsolescence)'로 폐기되는 수많은 좀비미디어, 인간에 의해 생산되고 버려지는 인공지능 기계 로봇들, 플랫폼 자동기계에 예속된 유령노동자들, '그린 워싱' 과정에서 퇴출되는 화석원료 공장 노동자들, 가부장적 기술 폭력에 노출된 여성과 성적 소수자들, 비윤리적인 생명공학으로 탄생한 돌연변이 생명체들 등이 바로 이 '빈곤한 이미지'의 구체적 모습이다. 이들은 기술 물신의 자본주의 세계에서 배제되고 버림받은 기계 종이자 (비)생명 타자들이다. 이들의 생긴 대로의 복권과 지위를 인정하는 일은 동정과 시혜라기보다는, 인간과 인간 아닌 것들 사이의 생태주의적 평등 관계를 회복하는 일에 가깝다. 이들 타자화된 '빈곤한 이미지'를 드러내고 주목할수록, 우리 스스로 자본주의 질곡을 벗어날 대안의 기획이 좀 더 분명해질 것이다.

슈타이얼은 〈이것이 미래다〉의 영상 작업을 언급하며, 장차 "'토박이 생태운동(vernacular ecological movement)'과 인간의 기술을 연결하는", 일종의 대안적 '기술 생태정치학(techno-ecological politics)'의 가능성을 언급한 적이 있다.[19] 다시 말하자면, 우리의 미래 디자인은, "파괴를 통하여 성장하지 않으며 문자 그대로 구축적으로 탈성장하는 과정"에, 그리고 "집권적 경쟁이 아니라 협력적 자율성을, 시간의 파편화와 사람들의 분열이 아니라 확장·팽창·소비·부채·와해·점령·죽음의 축소를, 초인간성이 아니라 인간성 자체로 완벽히 해내는 것"에 달려 있다.(25) 이로부터 우리는 기술숭배에 매인 좌파 '가속주의적(Accelerationist)' 전통과도 과감히 절연하는 슈타이얼의 탈성장과 생태주의적 태도를 엿볼 수 있다. 성장 중심의 통제 기술을 추구하는 자본주의 기술 질서와 이로 인해 야기된 기후 위기에 맞서, 슈타이얼이 생태주의의 전망 아래 핍박받는 빈곤한 이미지들 사이의 실천적 연합을 읽어 내고자 한 것은

19
히토 슈타이얼, 〈이것이 미래다〉, 2019, 단채널 HD 비디오, 컬러, 사운드, 스마트 스크린, 16분.

이제와 다른 삶을 기획하는 일에 연결된다고 할 수 있다.

슈타이얼은 "산송장이 된" 인터넷을 되살리려면, 직접적으로 오늘의 창작이 소비에트식 '생산주의(productivism)'의 전철을 되밟기보다는, 이른바 '순환주의(circulationism)'에 입각해야 한다고 강조한다.(176) 이미지의 구축 그 자체만을 강조하는 창작 활동은 이미 생산이 데이터로 흡수되고 알고리즘 용광로로 포획되는 무도한 현실을 읽지 못하는 처사라 볼 수 있다. 오히려 그는 사회적으로 생산되는 이미지들을 '공통의(communal)' 가치 아래 두고 유통해 개방(오픈 액서스)의 철학을 따를 때 미학적으로 효과가 배가된다고 보는 것이다. 그의 순환주의는 데이터 사회에서 비가시권에 놓인 약자들 사이의 호혜와 연대의 다층적이고 확장적인 커먼즈 구상 기획과 유사하다.[20] 결국, 슈타이얼의 대안은 기술 생태 논의에서 배제된 인간 타자와 무용성의 사물 기계를 다시 주목하는 데서 시작된다. 그리고 더 나아가 전자 네트워크에서 '추방된 기술 존재자들'의 정치적 에너지와 미학적 순환주의를 통해서, 자동화된 데이터 권력에 맞서 새롭게 이미지 내전의 기획을 짜는 일이리라.

[20] 흥미롭게도 슈타이얼 또한 디지털 커먼즈적 대안의 전망을 읽어 낸다. 가령, 승자독식 구조의 현행 플랫폼 독점 체제를 개선하려는 '플랫폼 협동조합주의(platform cooperativism)'를 소개하거나 가라타니 고진이 언급한 호혜의 평등주의적 연합 결사체인 '어소시에이션'에 대해서 언급하고 있다.(216-217) 더불어, 그가 『뉴욕 타임스』에 쓴 칼럼(앞의 글)에서는 인터넷의 문제를 해결하기 위해 실제 독점 플랫폼 규제, 알고리즘의 투명성 및 공적 평가 체제 마련, 가짜뉴스에 대한 사실 확인의 규칙을 지닌 기관 확대 등을 현실적 대안으로 제시하기도 한다.

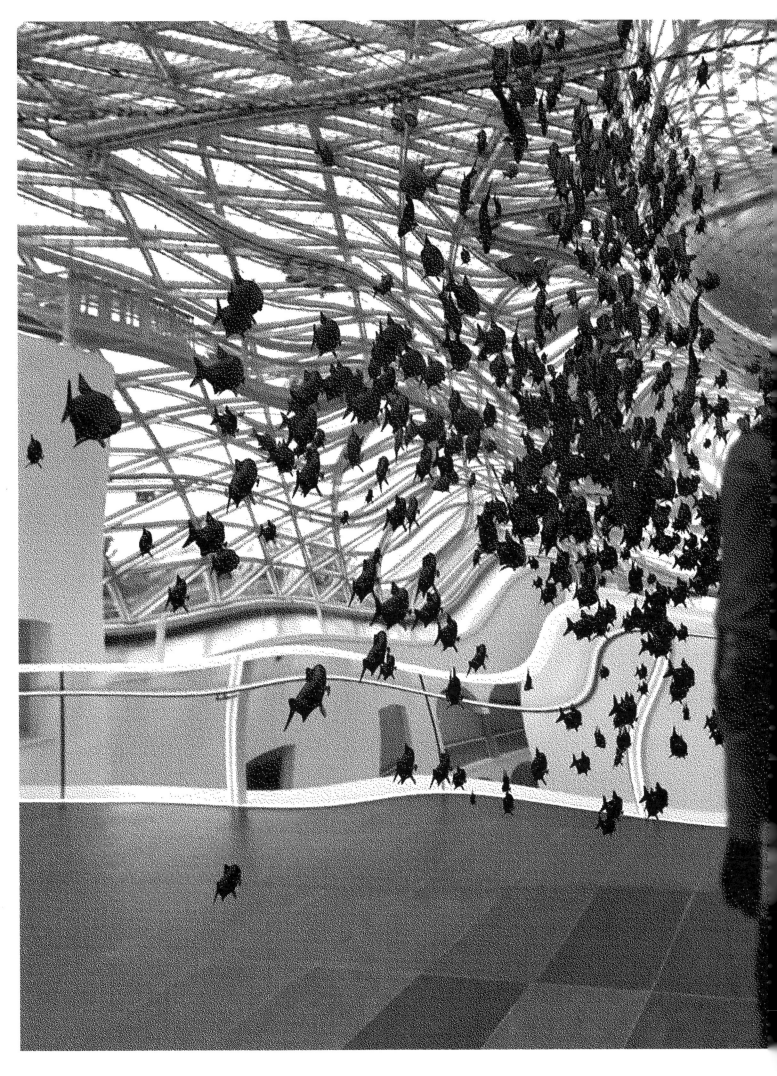

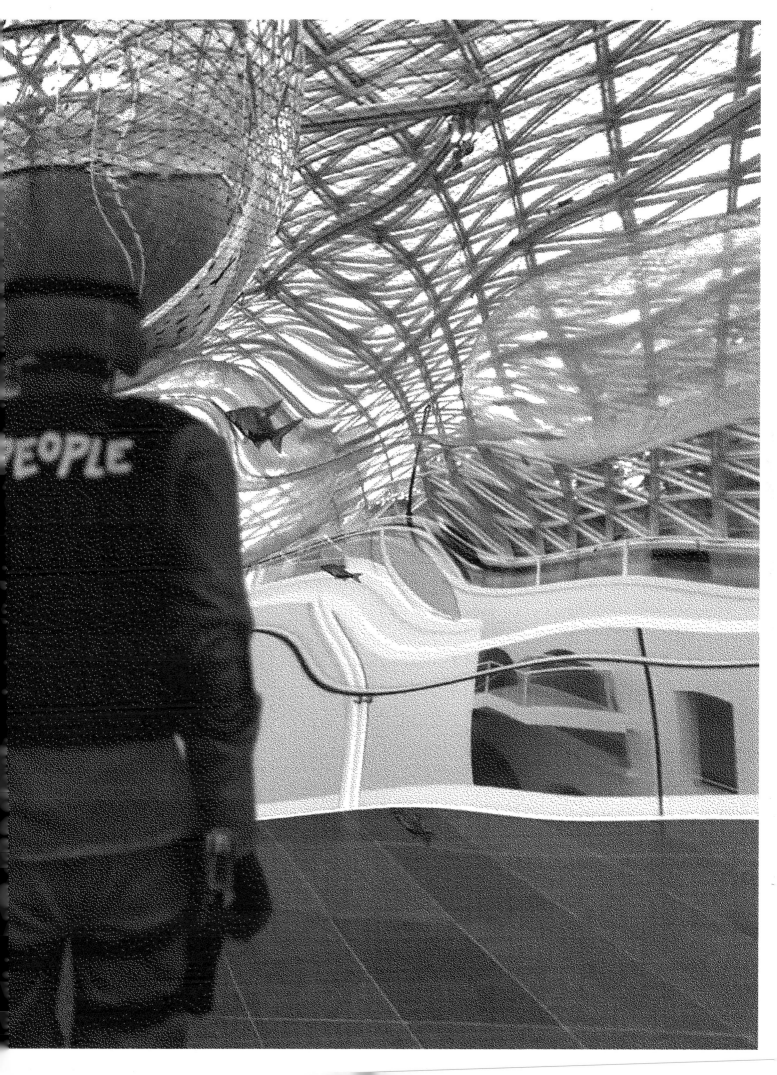

"Technology has destroyed reality"

The devastation of industrial labor mediated by automated technology, the emergence of "post-truth" politics of distrust and hatred, the advent of far-right tribal politics, big data science that exercises control by separating human bodies and consciousness into digital "dividuals," and the intensity of life's co-opting with algorithm automation—we rapidly find ourselves enveloped in a state of subordination to contemporary technology. As an "untact" reality has become routine amid the shockwaves of the COVID-19 pandemic, there has been an accelerating phenomenon of techno-fetishism among contemporary individuals in thrall to AI, platforms, and others forms of advanced automation algorithm technology.

Technology has long been an object of fetishization within capitalism. The idea of "cyberspace" that we used to know— a place of exchange and friendship for digital liberals—has long since become obsolete. In its place are paeans to the future: first the "Fourth Industrial Revolution" slogan, and now the blended avatar economy reality of the "Metaverse." The logic of capitalism shifted long ago from the market reforms of Schumpeterian "creative destruction" to a logic of innovations spanning the entire economy, based on the "disruptive technology" developed in Silicon Valley on the West Coast of the US. All we see is the destructive rampage of technocapitalism, laying waste to the legacy of the past, to life, to emotion, to reciprocity and materiality.

A bedfellow of neoliberalist governmentality, the logic of disruptive technology has been broadening its reach from the economy and the market into all areas of society. In the untact reality brought about by the COVID-19 pandemic, big tech platforms and everyday smart technology have emerged as new conditions governing our society's *sensus communis*. Indeed, the very relational sense of our society is regressively being replaced by the sense of privatized technology. "Before, technology was supposed to connect and mediate," Hito Steyerl wrote. "Now technology divides and fragments; it identifies and ranks people."[1] The circulation of "social data," fake news, digital rumors, and "post-truth" trends have stopped the truth from operating as it once did as a foundation for human interrelationship. Our methods of communicating and connecting have been adapted to the privatized algorithm designs and logic of "social" platforms. In the process, as Steyerl declares,

1
Hito Steyerl, "Technology Has Destroyed Reality," *New York Times*, December 5, 2018.

2
Steyerl, ibid. (taken from
title).

technology "has destroyed reality."[2]

In this essay, I explore bits and pieces of Steyerl's aesthetic contemplations of technology. In the words of the British art critic Julian Stallabrass, Steyerl is "an assured juggler of the uncanny, digital glitches, humour and artistic persona who gives viewers a calculatedly incongruous and estranging take on the perilous impetus of techno-capital."[3] Rather than revealing the sublime beauty of technology's fearsome intelligence, she has dramatically depicted its "artificial stupidity." She has effectively deployed her unique satirical vision toward the contemporary reality of data technology and the dotcoms of the "uncanny valley"[4] in California where high technology is developed. In this text, I use Steyerl's recent critique collection *Duty Free Art: Art in the Age of Planetary Civil War* and related video work as a reference to explore the controversial aspects of today's technology as she has observed them. In particular, I offer a crude exploration of how her aesthetic work might connect with future ecopolitical planning in technology.

3
Julian Stallabrass, "Sublime
Calculation," *New Left Review*
132 (November–December,
2021): 88.

4
Here, the term "uncanny
valley" quotes the title of
a book about the illusory
aspects of Silicon Valley.
Anna Wiener, *Uncanny Valley*,
Korean trans. Song Yeseul
(Seoul: Caracal, 2021).

Aesthetic issues in contemporary art
Is it possible to have a "civil war of images"?

The reality of contemporary capitalism as Steyerl sees it may be defined in terms of the expansion of global power mediated through technology; precarious labor; intensifying class warfare; privatized enclosure of the information commons; surveillance capitalism; and the order of platform algorithms.[5] If there is any expression to sum up the social structures that she observes running through today's technological reality like something out of the most pessimistic science fiction, it may be the "datafied society." She problematizes a reality where all human activities, consciousness, and emotion and all visual representation and expression are transposed with data—a dark reality where the expressions of our life reflected in traces of data become resources to be managed, cultivated, harvested, and extracted by information biopolitics.[6] To view it in the terms articulated by cultural theorist Mark Fisher,[7] it exemplifies an era of "capitalist realism" where we

5
McKenzie Wark, "Hito Steyerl,"
Sensoria (London and New
York: Verso, 2020), 47

6
Hito Steyerl, *Duty Free Art:
Art in the Age of Planetary
Civil War*, Korean trans.
Hye Jin Mun and Kim Hong
Ki (Seoul: Workroom Press,
2021), 70. Other quotes from
this book will be indicated
only by page number.

7
Mark Fisher, *Capitalist
Realism*, Korean trans.
Park Jincheol (Seoul:
Luciole, 2018).

cannot see what lies beyond capitalism, and where the concepts and symbols of resistance to capitalism have been disarmed.

Steyerl's "computational photography" may be viewed as a crucial attempt to critically dissect the new world of data representation. It expresses a new characteristic of today's image representation: whereas "re-presentation" ordinarily refers to the act of refracting or emphasizing certain aspects of an existing object based on some particular intention, Steyerl sees the representation that exists within the regime of data computation—"post-representation," in other words—as a different beast from the ways in which objects were distorted through particular approaches in the past. Already, visual images come to possess a relational position through innumerable electronic network connections and cross-referencing based on big data science, including machine learning and algorithm technologies. "Computational photography" is the concretized effect of post-representation as projected by these digital technologies. In other words, while traditional photography strove to represent the object with a particular composition through something existing in the world of the object, computational photography creates "relational photography" images amid "the cross-referencing of various databases," including "the pictures you already took, or those that are associated with you." It goes without saying that "the algorithm guesses what you might have wanted to photograph now." (38)

The image representation of capitalism has overeducated us with media consumption as spectacle and emotions and desires standardized through commodity aesthetics. Today, all of these represented things can be seen as moderated by customized recommendations based on network data flows, automated algorithm analyses, remote controls, and pattern prediction in affective data. The problem is that the represented images connected to these computational technology devices are not exactly neutral. That's because computerized images are a form of algorithm representation "managed by flows, networks, and machines."[8] Post-representation does not just confine us to the desire for spectacle consumption; it relates to computational and cybernetic government. This is to say that nearly everything represented in a digital society has "rules and norms hardwired into its platforms, and they represent a mix of juridical, moral, aesthetic, technological,

[8] Maurizio Lazzarato, *Signs and Machines*, Korean trans. Sin Byeonghyeon and Sim Seongbo (Seoul: Galmuri, 2017), 52.

commercial, and bluntly hidden parameters and effects." (39)

In the online world, image representation increasingly acquires its actual meaning and value through electronically relation weights, rather than through its internal aesthetic effects. Through our subscriptions and "likes," our consumption patterns and tastes, the people we befriend, and algorithm-assigned rankings, each of us assigns (weighted) value to an object, which is confined to the dungeon of "filter bubble" consciousness. By "filter bubble," I am referring to the effect in which we become so used to customized data that we overuse it, thereby sealing ourselves in a veritable bubble of biased information. It has become an especially pronounced phenomenon in social media, where we maintain similar tendencies to others in our circle through our connections to social networks, frequently finding ourselves trapped in "prisons of infallibility" within tribalized groups, where we dismiss the possibility of other judgments. Algorithm bias further exacerbates this sort of extreme prejudice effect.

The most troubling fact of all is that most of us are denied access to the operating mechanisms of the algorithms. Questions like how computer images and data are organized and positioned are hidden in the black box of "business secrecy": "Machines show one another unintelligible images, or, more generally, sets of data that cannot be perceived by human vision. They are used as models to create reality. But what kind of reality is created by unintelligible images? Is this why reality itself has become to a certain degree unintelligible to human consciousness?" (84) If there's one thing we do know, however, it's that computer photography has reached the level of becoming a virtual crypto-currency like non-fungible tokens (NFTs), and that only those images that can prove the attention they draw through "likes," shares, replies, and ratings are able to gain proof of their existence. The non-visibility of particular images and data in online representation spaces is taken as non-existence. In this way, today's world of representation illustrates "a new order of images, a grammar of images, an algorithmic system of sexuality, surveillance, productivity, reputation, and computation that links with the grammatization of social relations by corporations and governments." (43) Unfortunately, data power manifests as an opaque order of images based on computational statistics, the exact nature and mechanism of which cannot be understood.

The stupidity that separates noise from information

To reveal the obscure, contradictory aspects of our seemingly transparent data science, Hito Steyerl attempts to indirectly express the myth of the sublime that the data reality constructs, as well as the cracks within it. Most crucially, she stubbornly delves into the political nature of computerized digital science. Quoting the French aesthetician Jacques Rancière, she offers an analogy from ancient Greece to explain how methods of distinguishing signals from noise interrelate with the mechanisms by which contemporary technological power operates. In ancient Greece, she notes, the words of wealthy local males were considered to be "speech" and "information" (signals), whereas the words of women, children, slaves, and foreigners were regarded as gibberish or "noise." (59) That process of distinguishing signals from noise, or words from gibberish, adopts a similar logic, Steyerl explains, to the process in which today's AI machine learning technology is used to distinguish "between face and butt." The reason that the automation technology in data society is political, she adds, is because of the modern version of data-based divide-and-conquer that arises through the separation process, which involves "neatly stacking the results into vertical class hierarchies." (45) This could be seen as the new "political spam filter" of today, where the identification of patterns in random data is like using AI to see a human face in a cloud or the moon. (58)

In a capitalist reality where nearly everything boils down to data, the aim of most computational processes to distinguish signals from noise is one of pattern recognition. Pattern recognition has ignited enthusiasm for data science among contemporary individuals, proving effective at reading the correlations in things that are less interconnected than we imagine and finely measuring the density of relationships. But while big data science centers its analysis on the horizontal layers of complex relational networks of events, it is quite feeble when it comes to explaining causational, embryological relationships of particular situations and events that occur over a distance in time series. Most crucially, no one can give a straight answer as to what sort of standard is to be used to distinguish the signals/information from the noise. This inability of in-depth data science to account for cause and its order of ruling through "divide and conquer" tactics offer an unsparing glimpse at its ahistorical stance.

In her assessment, Steyerl describes the pattern recognition based on data science as being "opaque, partly biased, exclusive, and—as one expert points out—sometimes also 'ridiculously optimistic'" in more respects than we might anticipate. (65) She has consistently used her written and artistic work to show the stupidity of advanced data science based on AI and other high technologies. Her observations of the foolishness of depersonalized, "automated" data power are dramatically illustrated in repeated scenes in her video work showing human testing sites where mechanical robots are trained in bizarre ways, such as being pushed over.[9] A similar sense of the grotesque is evoked by an odd experiment scene showing human achieving a machine learning effect by physically breaking countless windows in order to find the optimal sound.[10] Or how about the strange mutant images achieved through the use of "inceptionism" or "DeepDreaming" AI techniques, an effort by Google to create patterns and images out of complete noise, which Steyerl refers to in her *A Sea of Data*?[11] Looking at such things, it become difficult for us to predict any amazing future or wax rhapsodic about what technology will bring us.

With a sense of black humor, Steyerl lays bare the imperfections, flaws, errors, and glitches of technology that burble underneath capitalism's slogans of "endless innovation." Packaged in the mythology of drive and growth, the advanced technology that capitalism achieves has an undeniable allure, but it unfortunately also harbors mistaken preconceptions, fallacies, and flaws—even stupidities, at times—from its inception. In this way, Steyerl's work shows the forces operating underneath advanced capitalist technology based on data science— the "images, violence, entertainment, affect, and economics of capital"—as if they were a kind of bizarre story.[12]

"Is the internet dead?"

"Is the internet dead?" This is the question Steyerl poses about today's data science-dominated social reality. Obviously, her answer is that the internet "is not dead." If anything, she says, the internet "is undead and it's everywhere."[13] As if to make a mockery of the early liberals'

9
Hito Steyerl, *Hell Yeah We Fuck Die*, 2016, three-channel HD video, color, sound, 4 min. 35 sec.

10
Hito Steyerl, *The City of Broken Windows*, 2018, single-channel HD video, color, sound, 10 min.

11
Hito Steyerl, "A Sea of Data: Apophenia and Pattern (Mis-) Recognition," *Vertiginous Data* (Seoul: MMCA, 2019), 49 (image).

12
Corina L. Apostol and Nato Thompson, *Making Another World Possible* (London: Routledge, 2019), 185.

13
Hito Steyerl, "Too Much World: Is the Internet Dead?" *e-flux journal* 49 (November 2013): 10-26.

declaration of independence, the internet is now dominated by surveillance, unpaid labor, copyright systems, and "troll-enforced conformism."[14] Ultimately, it has "spawned Uber and Amazon, not the Paris Commune." (214) In Steyerl's eyes, the characteristics of contemporary capitalist technology are not merely damaging to real-world values of human rights, justice, politics, and truth; they also create an extreme technology market world driven by a handful of big tech powers.

The degeneration of the internet that Steyerl notes is a reality where attention and clicks are equated with money and influence. It is under circumstances like these that troll-enforced conformism arises. It's a reality of political populism where "[d]emocracy's demos is replaced by a mob on mobiles capturing [people's] activities, motion and vital energies."[15] The production and flows and countless computer images taken by the "mob on mobiles" is also effective at bending humans themselves to this new grammar of data technology.

15
Hito Steyerl, "How to Kill People: A Problem of Design," Superhumanity: Design of the Self (Minneapolis, MN: University of Minnesota Press, 2018), 325.

The world of digital representation created by automated algorithms results ultimately in human beings' critical thinking and judgment devolving into computerized acts and relationships. In "algorithm-based politics," comrades are replaced with "followers" and Facebook friends; enemies and "them" distinctions with unfriending and unfollowing; resistance with selfies and hashtags; solidarity with "likes" and subscriptions"; thinking and judgment with the algorithm's recommendations.[16]

16
Kim Gok, Surplus Existence (Seoul: Hankyoreh Press, 2021), 154.

In the degenerating reality of the internet, politics withers into "taste"—and even those tastes harden into algorithm-provided network channels, and the media as a sphere for competition and resistance is neutralized by attention hogs, conspiracy theorists, aggro types, "cyber wreckers" (a coinage referring to people who use information about other people's lives as a way of drawing attention), provocateurs, and trolls. It's difficult to cultivate a sustainable common political sensibility in an environment where physical and social relationships have been replaced with engineered relationships constructed by the rankings and weights of "social" algorithms. The political crises we face today have their origins in issues of the social algorithms that have taken over the "political" in our lives.

What kind of alternative practice is possible in the reality of

algorithm politics, with its data power and trolling? It demands a different kind of technological perspective from the computerized images and governing techniques that we've seen to date. As Hito Steyerl so aptly notes, data science analyzes the truth as photographic object, but it also erodes our ability to discern and judge the real "color of truth." As a result, moving images "blur and shake the closer they seem to be to reality."[17] It may be that what we need is to once again summon the kind of "poor image" that she mentioned long ago.

17
Hito Steyerl, *The Color of Truth*, Korean trans. An Kyuchul (Seoul: Workroom Press, 2019), 14.

The "poor image": A flash point for the ecopolitics of technology

At this point, we need to reinterpret what Steyerl meant when she spoke of the "poor image." Her poor image is both a spectacular representation image, as well as a new base of resistance existing in a corresponding relationship to the new order in computational statistics terms.

> The poor image is a copy in motion. Its quality is bad, its resolution substandard. As it accelerates, it deteriorates. It is … an itinerant image distributed for free, squeezed through slow digital connections, compressed, reproduced, ripped, remixed, as well as copied and pasted into other channels of distribution. … It transforms quality into accessibility, exhibition value into cult value, films into clips, contemplation into distraction. … Poor images are the contemporary Wretched of the Screen, the debris of audiovisual production, the trash that washes up on the digital economies' shores. … They spread pleasure or death threats, conspiracy theories or bootlegs, resistance or stultification. Poor images show the rare, the obvious, and the unbelievable—that is, if we can still manage to decipher it.[18]

18
Hito Steyerl, *The Wretched of the Screen*, Korean trans. Kim Sylbee (ed. Jihoon Kim), 2nd ed., (Seoul: Workroom Press, 2018), 41-42.

What we need today is to "read" the poor image as a symbol or analogy for an alternative in terms of the politics of technology. The poor image could be characterized as a "social other," similar to what Steyerl, invoking Rancière, described as the "noise" excluded and isolated from information. If we conclude that the distortions to our lives arose mainly through the mainstream capitalist system's exclusive

pursuit of things that are "advanced" and "new," we can see Steyerl's "defense of the poor image" as stimulating the aesthetic imagination of a practice that the others rendered "wretched" by the data politics of separation might employ against contemporary techno-fetishism.

Where data power has erased the genetic and historical context of image production, it seeks to build a computational political economy of dotcom capital. In this dismal reality, Steyerl's decision to defend the "poor image" is equivalent to focusing attention on the value of those entities who exist outside of view, excluded and marginalized from the data world of sophisticated automation algorithms. To us, the poor image represents things we regard as the flawed or antiquated aspects of technology: the glitches, the lags, black-and-white, low resolution, static, bugs, mutants, zombie media, and the like. These are not a crude past or undeveloped errors for us to overcome. We need to see them as crucial allusions that expose capitalist alienation and the skewed conditions of the technological ecosystem.

Such are the concrete embodiments of the poor image: all the many zombie media that are discarded due to the planned obsolescence of consumer capitalism, even though their usage value is not yet spent; the AI machinery and robots that are produced and thrown away by human beings; the phantom workers subjugated by automated platform machinery; the manufacturing workers driven out in the "greenwashing" process; the women and LGBTQ people exposed to the violence of patriarchal technology; the mutant lifeforms spawned by unethical bioengineering. These are mechanical variants and (in)animate others excluded and abandoned by the capital world of techno-fetishism. To restore them to their image and acknowledge their status is less a matter of sympathy or beneficence, and more a matter of reestablishing ecological equality between the human and non-human. The more we expose and pay attention to these other-ized "poor images," the clearer becomes our design for an alternative that allows us to escape the fetters of capitalism.

Referring to the video work *This Is the Future*, Hito Steyerl mentioned the potential for an alternative form of "techno-ecological politics" that relates the "vernacular ecological movement" to human technology.[19] In other words, our future design will

19
Hito Steyerl, *This Is the Future*, 2019, video installation, single-channel HD video, color, sound, 16 min.

hinge upon a process that "doesn't grow via destruction, but very literally de-grows constructively," a form of construction that is "not creating inflation, but devolution. Not centralized competition but cooperative autonomy. Not fragmenting time and dividing people, but reducing expansion, inflation, consumption, debt, disruption, occupation, and death. Not superhumanity; humanity as such would perfectly do." (25) Here, we can see her post-growth ecological stage, which boldly parts ways with the left-wing "accelerationist" tradition, with its ties to the veneration of technology. In the face of a capitalist technological order that seeks the technology for growth-centered control—and the climate crisis that has resulted from this—Steyerl's attempt to discern a unity of practice among persecuted "poor images" amid the predictions of the ecological perspective can be seen as related to the project of planning a different way of living from the one today.

Hito Steyerl emphasizes that for the internet to be resurrected from its "undead" state, today's creative activities should be based in what she calls "circulationism," rather than following in the footsteps of "productivism" along Soviet lines. (176) When creation focuses too much on the construction of images per se, it can be accused of failing to recognize the terrible reality of today, when production is already being absorbed into data and subjected to the algorithm furnace. If anything, she predicted that the aesthetic effect will be amplified when we follow an open access philosophy, where socially produced images are distributed in accordance with communal values. Her circulationist ideas resemble a multilayered, expanded version of the "commons" project as a form of reciprocity and solidarity among the "invisible" and vulnerable entities of the data society.[20] In the final analysis, her alternative starts with renewed attention to the human "others" left out of the techno-ecology discussion, and to "useless" objects and machinery. Beyond that, it may be a way of planning— through the political energy of the "wretched" in our electric networks, and through aesthetic circulationism— a new "civil war" of the image to combat the power of automated data.

[20] Interestingly, Steyerl also identifies the prospects for an alternative along digital commons lines. For instance, she makes references to "platform cooperativism" that attempts to democratize the current platform monopoly system and its "winner-takes-all" structure, and to the "associations" described by Karatani Kojin as egalitarian groups based on reciprocity (216-217). Also, her New York Times column (cited above) suggests realistic alternatives for resolving issues related to the internet, including regulations on platform monopolies, systems for algorithm transparency and public assessment, and stronger institutions with rules for fact-checking fake news.

안 보여주기−
디지털 시각성

HOW NOT TO BE SEEN−
DIGITAL VISUALITY

안 보여주기: 빌어먹게 유익하고 교육적인 .MOV 파일
HOW NOT TO BE SEEN: A FUCKING DIDACTIC EDUCATIONAL .MOV FILE
2013

- 단채널 HD 디지털 비디오, 설치, 컬러, 사운드, 15분 52초
- 작가, 앤드류 크랩스 갤러리, 뉴욕 및 에스더 쉬퍼, 베를린 제공

- SINGLE-CHANNEL HD DIGITAL VIDEO, COLOR, SOUND IN ARCHITECTURAL ENVIRONMENT, 15 MIN. 52 SEC.
- COURTESY OF THE ARTIST, ANDREW KREPS GALLERY, NEW YORK AND ESTHER SCHIPPER, BERLIN

- 촬영 감독, 베를린
 DIRECTOR OF PHOTOGRAPHY, BERLIN
 CHRISTOPH MANZ
- 촬영 감독, 로스앤젤레스
 DIRECTOR OF PHOTOGRAPHY, LOS ANGELES
 KEVAN JENSON
- 세컨드 유닛 2ND UNIT
 LEON KAHANE
- 미술 감독 ART DIRECTION
 ESME BUDEN, ALWIN FRANKE
- 포스트 프로덕션 POST PRODUCTION
 CHRISTOPH MANZ, LEON KAHANE, ALWIN FRANKE
- 메이크업 및 의상 디자인
 MAKE-UP AND COSTUME DESIGN
 LEA SØVSØ
- 안무 및 퍼포먼스
 CHOREOGRAPHY AND PERFORMANCE
 ARTHUR STÄLDI
- 프로듀서 PRODUCER
 KEVAN JENSON
- 돌리 그립, 로스앤젤레스
 DOLLY GRIP, LOS ANGELES
 TONY RUDENKO
- 교육 가이드 EDUCATIONAL DUMMY
 HITO STEYERL
- 커미션 COMMISSIONED BY
 MASSIMILIANO GIONI, VENICE BIENNALE
- 제작 지원 SUPPORTED BY
 THE INTERNATIONAL PRODUCTION FUND (IPF)—2013 PARTNERS: OUTSET ENGLAND, DERMEGON DASKALOPOULOS FOUNDATION FOR CULTURE AND DEVELOPMENT, OUTSET USA, OUTSET NETHERLANDS WITH PROMOTERS VAN ABBEMUSEUM, MAURICE MARCIANO FAMILY FOUNDATION

- 도움 주신 분 THANKS TO
 BRIAN KUAN WOOD, MEGGIE SCHNEIDER, LAURA POITRAS, DIANA MCCARTY, CHRISTOPHER KULENDRAN THOMAS, ANTON VIDOKLE

→ 《히토 슈타이얼-데이터의 바다》 전시 전경, 국립현대미술관, 서울, 2022

INSTALLATION VIEW OF *HITO STEYERL-A SEA OF DATA*, NATIONAL MUSEUM OF MODERN AND CONTEMPORARY ART, SEOUL (MMCA), 2022

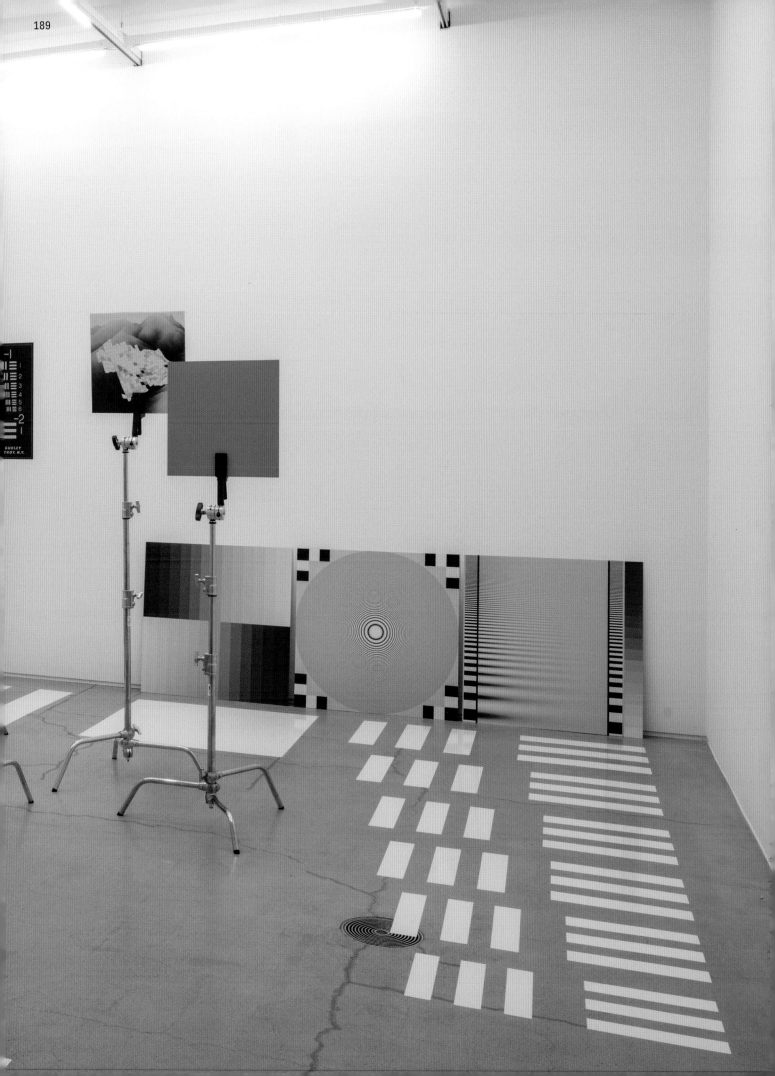

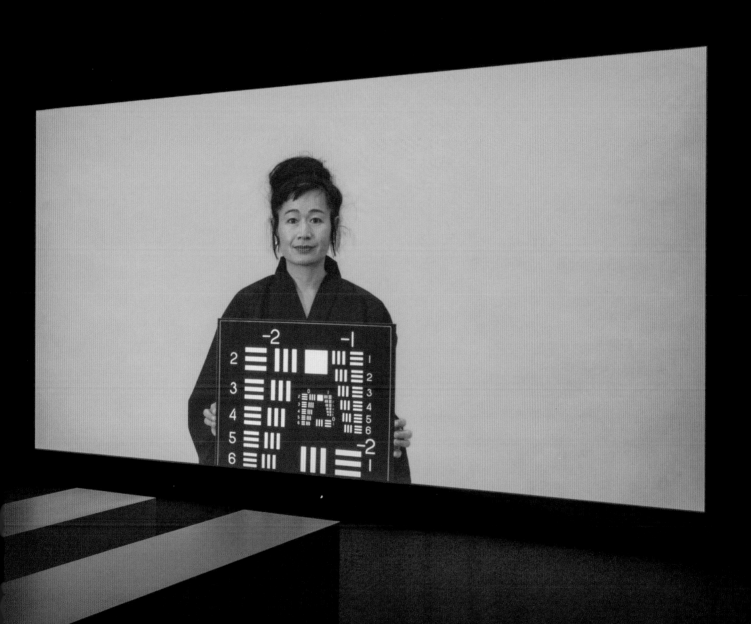

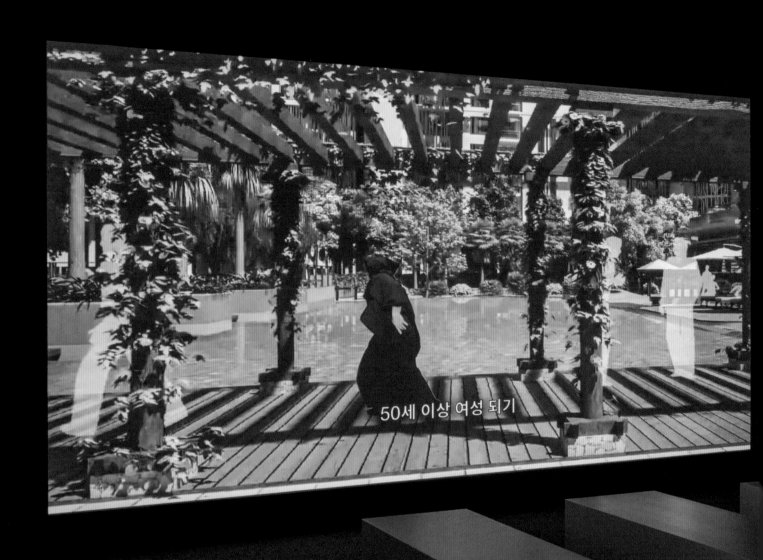

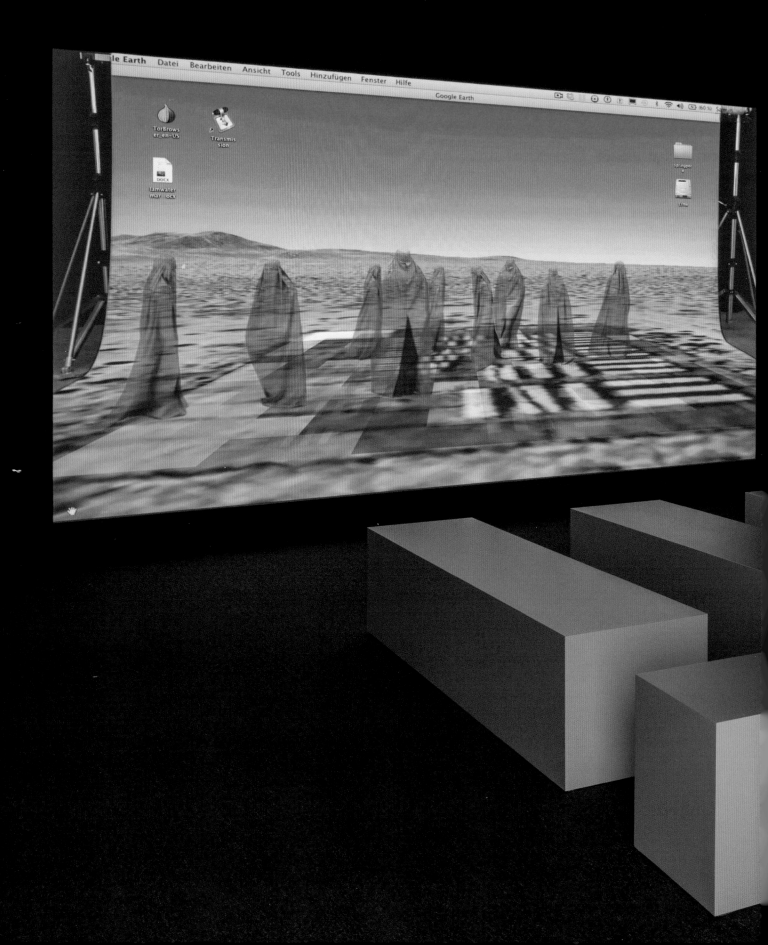

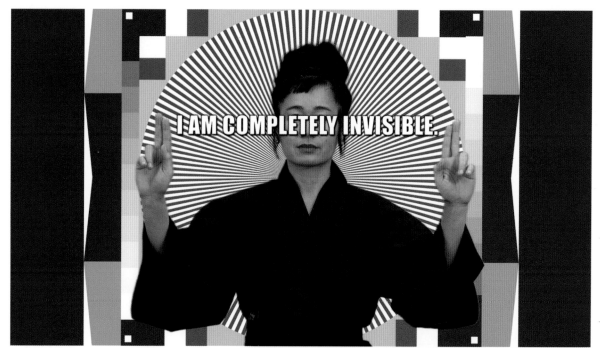

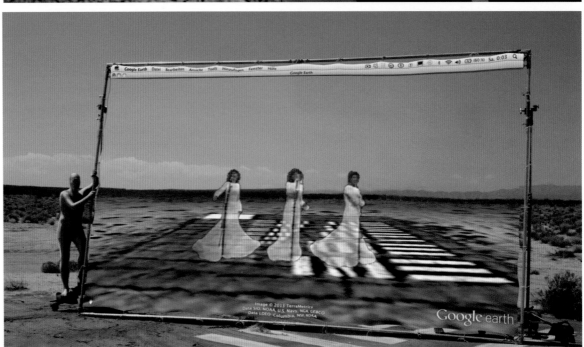

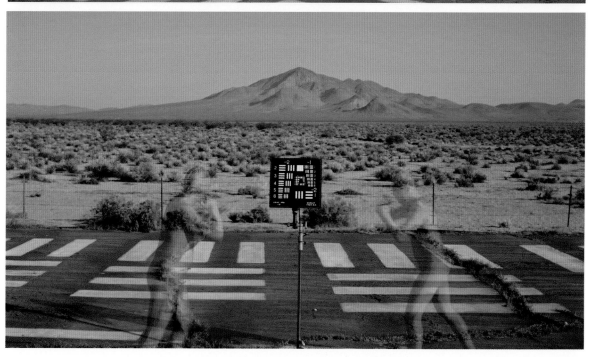

2010년대 중반 이후
히토 슈타이얼의
디지털 이미지와
컴퓨터 기반 테크놀로지:
존재론, 유물론, 정치

김지훈

Digital Image and
Computational Technology
in Hito Steyerl's Works
since the Mid-2010s:
Ontology, Materialism, Politics

Jihoon Kim

히토 슈타이얼의 2010년대 중반 이후 예술적 작업과 이론적 개입에서 디지털 이미지와 테크놀로지는 어떻게 다루어져 왔는가? 또한 이는 2010년대 초반까지의 이미지 및 테크놀로지에 대한 작품, 작업 방식 및 비평적 이념들과 어떤 유사성 및 차이를 보이는가? 적어도 『진실의 색』 및 『스크린의 추방자들』, 그리고 여기에 수록된 글들과 직접적으로 연관되는 작품들은 이미지 및 테크놀로지라는 이슈에 대해 다음의 논점을 제시했다. 첫째, 인식론적, 정동적 차원에서 디지털 조작(digital manipulation)의 보편화와 글로벌 미디어 네트워크 속에서의 사실적(factual) 이미지의 급속한 폭증은 그가 '다큐멘터리 불확정성'(documentary uncertainty)이라 부르는 위기를 초래했다. 이는 진실의 지표성(indexicality)을 전통적으로 보증하는 사진적 재현물(사진과 영화)의 객관적 증거 가치에 대한 위기, 그리고 네트워크하에서 전쟁, 테러, 기아, 재난 등을 담은 이미지의 무차별한 순환과 자극으로 인해 관객 대중이 가진 진정성의 감각이 약화되는 것을 뜻한다.[1] 둘째, 존재론적 차원에서 디지털 이미지는 사진적 이미지의 재현적 패러다임을 넘어서는 포스트-재현(post-representation) 체제에 속한다. 이는 디지털 이미지의 생성 및 효과에서 중요한 것이 전통적인 재현 패러다임의 관심사인 '이 이미지의 내용이 무엇인가(또는 그 이미지는 현실의 등록인가)', '이 이미지는 현실과 지각적으로 유사한가', '이 이미지는 기억의 형성과 역사의 구성에 참여하는가'를 넘어선다는 점, 이런 질문들로 온전히 설명될 수 없음을 뜻한다.[2] 셋째, 포스트-재현적 국면의 연장으로서 슈타이얼의 이미지에 대한 견해는 존재론을 넘어선 유물론적 관점, 즉 이미지와 사물의 근본적 등가성을 수립한다.[3] 넷째, 정치적 차원에서 이미지와 사물의 등가성은 주체성의 구성 및 사회의 작동과 긴밀히 관련된다. 즉 포스트-재현 체제에서 인간 주체성과 정체성은 이미지에 의해 구성되고 이미지를 통해 순환되며, 공권력은 물론 자본의 권력과 예술의 제도 또한 인간을 주체화(subjectivization)하는 과정에서 이미지를 통해 움직인다.[4]

[1]
이에 대해서는 히토 슈타이얼, 「다큐멘터리 불확실성 원리: 다큐멘터리즘이란 무엇인가?」, 『진실의 색』, 안규철 옮김 (서울: 워크룸 프레스, 2019), 11-28 참조.

[2]
이와 관련해서는 히토 슈타이얼, 「자유낙하」 및 「빈곤한 이미지를 옹호하며」, 『스크린의 추방자들』, 김실비 옮김, 김지훈 감수, 2판 (서울: 워크룸 프레스, 2018), 15-60 참조.

[3]
이와 관련해서는 히토 슈타이얼, 「당신이나 나 같은 사물」 및 「컷!: 재생산과 재조합」, 『스크린의 추방자들』, 61-80, 225-242 참조.

[4]
이와 관련해서는 히토 슈타이얼, 「실종자들」 및 「지구의 스팸」, 『스크린의 추방자들』, 179-224 참조.

이 글은 슈타이얼이 작가이자 이론가로서 제시한 주장 및 개념들 중 존재론적, 유물론적, 정치적 차원이 2010년대 중반 이후의 슈타이얼의 작업 및 글쓰기와 어떤 관계를 맺는가를 탐구한다. 작업의 차원에서 볼 때 2010년대 초반부터 슈타이얼은 자신의 비디오 작품에서 디지털 포스트프로덕션의 비중을 한층 높여 왔다. 그 결과 그는 〈안 보여주기: 빌어먹게 유익하고 교육적인 .MOV 파일〉 (이하 '안 보여주기', 2013), 〈유동성 주식회사〉(2014)에서 디지털 합성 (digital compositing)과 컴퓨터 그래픽 이미지(CGI)를 활발히 활용했다. 모션 캡처를 입고 춤추는 노동자를 다룬 〈태양의 공장〉 (2015) 이후 슈타이얼의 디지털 포스트프로덕션은 디지털 합성과 CGI를 넘어 가상현실, 증강현실, 로봇 공학 시각화, 그리고 인공지능에 근거한 오디오비주얼 이미지의 판독과 생성까지 확장되어 왔다. 이 글은 이 작품들을 다루면서, 디지털 이미지 및 컴퓨터 기반 미디어 (computational media)에 대한 슈타이얼의 2010년대 중반 이전까지의 글, 그리고 가장 최근 저서인 『면세 미술: 지구 내전 시대의 미술』(2017)에 수록된 글과 몽타주하면서 위의 세 차원에 대한 이해를 심화한다.

포스트-재현 체제와 이미지의 알고리즘적 전환

포스트-재현 패러다임이란 오늘날의 디지털과 컴퓨터 기반 시각문화가 형성하는 응시, 세계상, 이미지 소비와 순환의 경제 등이 근대적인 시각 체제의 미학적, 기술적 가정들을 넘어섰다는 것이다. 사진을 예로 들자면 재현적 양식이란 지시체가 사진 이미지의 외부에 미리 존재하고 카메라를 비롯한 광학적 장치들이 그 지시체와의 지표적 연결(indexical link)을 보증한다는 가정들을 전제한다. 그러나 슈타이얼에 따르면 핸드폰 카메라는 재현적 양식을 벗어나는 장치다. 핸드폰 카메라는 사용자가 렌즈를 통해 이미지를 볼 뿐만 아니라, 사용자가 촬영하고 저장하거나 소셜 미디어에 업로드한 사진들의 데이터를 바탕으로 자동적 알고리즘에 따라 이미지를 수정하고 조작하고 생산하기 때문이다. 슈타이얼에 따르면 핸드폰 카메라는 "당신이 이미 촬영한 사진들이나 당신과 네트워크로 연결된 사진들을 통해" 피사체를 바라본다. 그 결과 우리는 핸드폰 사진에서 우리가 원하는 것이라기보다는 "그 핸드폰이 우리에 대해 안다고 생각하는 것"[5]을 보게 된다.

5
Hito Steyrl, "Proxy Politics: Signal and Noise," in *Duty Free Art: Art in the Age of Planetary Civil War* (London and New York: Verso, 2017), 31.

안 보여주기-디지털 시각성

슈타이얼은 이처럼 대상과 이미지가 분리되고, 이미지의 투명한 재현에 대한 신념이 디지털 시각 장치와 네트워크의 비인간적(nonhuman) 자동성 속으로 흡수되는 포스트-재현의 국면들을 오늘날 시각 문화의 도처에서 감지하고 이를 글과 비디오 에세이 작품으로 논평해 왔다. 「자유낙하: 수직 원근법에 대한 사고 실험」에서 그 논평의 대상은 근대적 시각의 지평의 동요를 야기하는 시각적 수직성의 확산이다. 오늘날 구글맵, 드론 카메라, 위성사진 등을 통해 확산되어 온 수직적 조망은 기술적 도구들을 넘어 이들을 복합적으로 작동시키는 정치적, 경제적, 문화적 작용들로 결정되면서 풍경의 대상화, 원격적 통치술, 대량 살상과 같은 '지배의 환상'을 실현한다. "군사, 엔터테인먼트, 정보 산업의 렌즈를 통해 스크린상에서 볼 수 있는 위로부터의 조망은 … 계급 관계의 보다 일반적인 수직화에 대한 완벽한 환유이다. 이 조망은 대리(proxy) 관점으로 안정성, 보안, 그리고 극단적 지배의 착각을 확장된 3D 통치술의 배경으로 투사한다."[6] 그러나 이러한 위로부터의 응시는 인간 감각의 연장으로 환원되지 않고 자동적으로 대상을 추적하고 포착하는 드론 카메라와 같은 시각 기계들, 그리고 이러한 기계들의 작동과 이미지의 조작을 자동적으로 수행하는 소프트웨어 알고리즘으로 분산된다는 점에서 "탈체화되고 원격 조종된 응시"[7]이기도 하다. 이와 같은 응시는 〈안 보여주기〉에서 기술적, 수행적 성찰의 대상이 된다. 이 작품의 1장 '카메라에 대해 어떻게 비가시적일 수 있는가'에서 슈타이얼은 카메라의 초점을 잡는 데 사용하는 숫자와 선들이 그려진 검은 패널을 제시하고, 이 패널을 가상의 목표물로 설정한다. 이 목표물은 공터에 둘러싸여 패널과 동일한 사각형 안에 프레임-내-프레임으로 자리하고, 수직적인 줌아웃은 이 목표물을 둘러싼 경관을 넘어 지구 전체를 포괄하는 조망을 제시한다. 이 장면에 부가된 내레이션인 "해상도가 가시성을 결정한다."는 디지털 시각 체제를 규정하는 수직성의 지배가 디지털 이미지의 물질적 층위 및 디지털 시각 장치의 기술적 층위와 밀접히 연관되어 있음을 밝힌다. 이어지는 2장 '육안으로 어떻게 비가시적일 수 있는가'에서는 바로 이 목표물의 이미지가 실제 캘리포니아에서 촬영된 풍경이라는 점과 동등하다는 것을 가리키는 무인 항공기 촬영

6
슈타이얼, 「자유낙하」, 33-34.

7
같은 글, 31.

장면을 포함하고, 이 장면은 저해상도로 변환된 목표물의 이미지와 사각 패널(프레임-내-프레임) 안에서 병치된다. 즉 애초에 설정된 목표물이 픽셀 단위에서 조작 가능한 이미지라면 그 이미지와 실제 풍경은 존재론적으로 동일하다.

포스트-재현 체제의 또 다른 국면은 이미지 일반이 사진과 영화 이미지를 디스포지티프(dispositif)의 차원에서 구성하는 한 가지 주요 요소인 프레임의 경계도 넘어선다는 것이다. 우선 슈타이얼은 몰입적 3차원 가상현실이 사회와 문화에 활발하게 적용되는 현상을 논평한 렉처 퍼포먼스 〈버블 비전〉(2018)에서 가상현실 시각의 비인간적 차원을 강조한다. 여기에서 그는 페이스북의 창립자 마크 주커버그의 아바타가 소개하는 페이스북 VR 플랫폼 비디오를 보여 준다. 스크린-기반 미디어를 구성하는 프레임의 구속에서 벗어난 이와 같은 360도 비디오는 사용자에게 모든 방향으로 가상의 장소를 볼 수 있고 그 공간 내에 현전하는 경험을 제공한다. 그러나 "당신이 실제로 당신의 몸과 더불어 장면 안에 거주하는 것"과 같은 느낌을 주는 가상현실의 경험은 사용자에게 역설적이다. "360도 비디오 안에서 당신은 구체의 세계(spherical universe)와도 같은 장면의 중심에 있으면서도 다른 한편으로는 그 장면에서 부재(missing)"하기 때문이다. 한편으로는 체화의 경험을 강렬하게 구현하면서도 다른 한편으로 그렇게 체화된 시각은 인간의 지각 범위를 벗어난 보이지 않는 알고리즘, 또는 "비가시적 시스템, 자동화, 또는 로봇으로 대체된 세계에 인간을 적용시키는 훈련 공식(training scheme)"[8]에 종속된다. 3차원적 시각성의 버블은 수직적 시각과 마찬가지로 오늘날의 기업과 건축, 엔터테인먼트에서 활발히 확산되고 있다. 그러나 슈타이얼은 이 버블의 증식을 지탱하는 군사적, 정치적 차원에 대한 논평을 잊지 않는데 이것은 3채널 비디오 설치작품 〈타워〉(2015)에서 이미 시각화된 바 있다. 여기에서 서구 유럽 대기업들의 의뢰를 받아 부동산(콘도) 모델, 비상 제어 시스템 등을 위한 3차원 그래픽 건축 시뮬레이션을 제작하는 러시아 전문가는 자신의 작업이 구소련 붕괴 전 전투기와 우주선 생산에 활용되었으며 자신의 회사가 1990년대 이후 각종 내전과 관련된 군사 시뮬레이션을 제작하는 과정에서

8
이 부분의 인용문은 다음을 참조. Hito Steyerl, "Bubble Vision," Penny Stamps Distinguished Speakers Series, February 15, 2018, https://www.youtube.com/watch?v=T1Qhy0_PCjs.

설립되었다고 말한다. 이와 더불어 관객이 보게 되는 이미지는 탱크, 무너진 건물의 잔해, 피난민의 텐트 등으로 식별되는 왜곡된 3차원 디지털 객체들이다.

버블 시각을 구성하는 알고리즘의 비인간적 측면에 대한 슈타이얼의 통찰은 인공지능의 딥 러닝(deep learning)과 머신 비전(machine vision)에 대한 그의 최근 관심으로 연장된다. 슈타이얼과 더불어 인공지능의 예술적 응용을 활발하게 탐구해 온 트레버 패글린의 용어를 빌리자면, 머신 비전을 비롯한 컴퓨터 기반 이미지 제작 시스템은 컴퓨터 프로세싱과 네트워킹으로 연결된 스마트 객체와 센서의 시각과 더불어 그 자체로 '보는 기계(seeing machine)'로 간주되어야 한다. 이들이 생성하고 유통하는 이미지는 인간의 지각과 판독보다는 다른 기계들의 인식과 판독 과정에 활용된다는 점에서 인간 중심의 사진 개념, 나아가 이 사진에 전제된 이미지와 인간적 시각과의 호응 또한 와해시킨다.[9] 슈타이얼 또한 인간의 눈을 전제하지 않은 이미지의 자동화가 오늘날의 가장 중요한 현상임을 뚜렷이 인식해 왔다. "이해할 수 있는 어떤 것도 보지 않는 것이 뉴노멀이다. 정보는 인간 감각으로 취할 수 없는 일련의 신호를 따라 전송된다. … 시각은 중요성을 상실하고 필터링, 암호 해독, 패턴 인식 (pattern recognition)으로 대체된다."[10] 인공지능을 이미지와 사운드 실험에 예술적으로 활용해 온 프로그래머 줄스 라플라스와의 협력으로 제작된 〈이것이 미래다〉(2019)는 식물의 성장을 초고속으로 촬영한 이미지를 활용한다. 이 이미지는 1980년대부터 개발되어 오늘날 컴퓨터 기반 비디오 이미지의 압축과 재생에 정착된 프레임-사이 예측 알고리즘(inter-frame prediction algorithm)을 따라 변형된다. 이러한 변형을 거쳐 왜곡과 재구성을 반복하는 사이키델릭한 꽃과 나무의 이미지는 인간중심주의적 세계관 내에 온전히 포섭되지 않는 자연, 즉 인간이 알 수 없는 인공지능의 예측 불가능하고도 모호한 이미지 인식으로 매개된 자연을 보여 준다. 이와 같은 예측 불가능성과 모호성은 화려한 네온사인과 간판으로 가득한 도쿄의 밤거리를 촬영한 화면, 그리고 미래 예측에 대한 인간의 오래된

9
Trevor Paglen, "Seeing Machines," Fotomuseum Winterthur, March 13, 2014, https://www.fotomuseum.ch/en/2014/03/13/seeing-machines/.

10
Hito Steyerl, "A Sea of Data: Apophenia and Pattern (Mis-)recognition," in Duty Free Art, 48.

열망이 반영된 스톤헨지를 촬영한 영상에도 시각적으로 반영된다. 자연과 문명, 유기체와 인공물 모두에 적용되는 예측 불가능성과 모호함은 한편으로는 인간이 인식 가능하지만 다른 한편으로는 인간의 시각적 지각을 벗어난 데이터화된 세계의 불안정한 면모를 드러내는 것이다. "현실에 대한 모델이 점점 인간 시각에 이해 불가능한 데이터의 집합으로 이루어진다면, 이 모델을 따라 창조된 현실 또한 부분적으로는 인간이 이해 불가능하다."[11] 이 점은 슈타이얼이 구글 리서치 랩의 신경망(neural network) 연구 결과를 논의하는 방식을 환기시킨다. 딥 러닝 기법을 구성하는 신경망은 무수히 많은 데이터화된 이미지들의 종류와 시각적 신호를 인간의 파악을 넘어선 속도로 처리하고 이를 바탕으로 그 이미지들을 판독한다. 그 판독의 결과 생성하는 아웃풋 이미지들은 인간의 인식을 넘어서는 심층적인 기계적 차원을 기입한다. 익숙함과 그로테스크함, 추상과 형상이 기이하게 공존하는 것이다. "신경망은 테두리, 모양, 그리고 다수의 객체와 동물을 식별하도록 훈련되고 뒤이어 순수한 노이즈에 적용되었다. 이는 무지개 색의 탈체화된 프랙탈한 눈—이들 대부분에는 눈꺼풀이 없다—을 인식하는 것으로 귀결되었다."[12]

〈이것이 미래다〉에서 알고리즘 기반의 이미지 생성은 이미지의 전통적인 시간성에도 중대한 영향을 미친다. 관객의 지각을 혼란스럽게 만드는 유동하는 자연과 도시의 이미지에 관여하는 압축 알고리즘은 이전의 비디오 프레임을 근거로 그 다음에 관찰자가 보게 될 이미지를 산출한다. 이 작업은 인공지능의 언어를 쓰자면 예측적(predictive)이다. 이와 같은 압축 알고리즘의 프로세스가 초당 24 프레임이라는 인간이 표준적으로 지각 가능한 속도를 넘어 작동할 때 과거, 현재, 미래가 프레임 단위로 중첩되면서 유동하는 이미지가 만들어진다. 이처럼 사이키델릭한 이미지의 황홀경은 디지털 글리치(digital glitch) 작가들이 디지털 압축 동영상 파일의 물질성을 드러내고 그 예측 불가능한 효과를 탐구하는 과정에서 선보인 바 있다.[13] 〈이것이 미래다〉가 디지털 글리치 작업과 구별되는 지점은 더 이상 이처럼 왜곡된 이미지가 코드와 알고리즘의 물질성을 드러내는 목적으로만 활용되지 않는다는 것이다. 이 작품의 이미지들은 인공지능이

11
Hito Steyerl, "Medya: Autonomy of Images," 같은 책, 71.

12
Steyerl, "A Sea of Data," 55.

13
이와 같은 경향의 작가들에 대한 연구로는 나의 *Between Film, Video, and the Digital: Hybrid Moving Images in the Post-media Age* (New York: Bloomsbury Academic, 2016), 2장을 참조.

예측하는 자연과 문명의 미래적 모델로 제시되기 때문이다. 그리고 그 모델은 알고리즘의 기존 이미지 인식을 수반한다는 점에서 과거 또한 비인간적 작용으로 흡수한다. 즉 〈이것이 미래다〉의 시간성은 디지털 객체로서의 이미지가 형성하는 시간성으로, 카메라 앞에 존재했던 세계의 과거를 관객의 현재로 전달한 결과가 아니다. 허욱의 설명을 빌리자면 〈이것이 미래다〉의 세계는 디지털 객체가 제기하는 시간성의 인식론적 변화와 호응하는 것으로 볼 수 있다. 즉 인간의 시간성을 구성하는 미래의 예측(protention)과 과거의 기억(retention)은 "디지털 객체에 의해 주어진 관계, 즉 우리가 남긴 사진, 비디오, 위치 정보의 흔적들에 달리게 된다. 지향(orientation)은 바로 다음의 지금이나 근미래의 경험을 열기 위한 관계들을 분석하고 생산하는 알고리즘적인 과정이 된다."[14]

14
Yuk Hui, *On the Existence of Digital Objects* (Minneapolis, MN: University of Minnesota Press, 2016), 221-222.

결국 이 점은 알고리즘과 인공지능 시대의 디지털 이미지가 사진과 영화의 재현적 전제와 본격적인 어떤 단절을 표시한다는 점을 뜻한다. 이 단절은 단지 '보는 기계'가 인간의 응시를 긴요하지 않은 것으로 만들거나 대체한다는 것만이 아니다. 더욱 심오하게는 사진적 미디어에서도 이미지와 인간 지각 간의 관계를 뒷받침하던 일종의 상관주의적(correlationist) 전제가 오늘날 디지털 이미지에는 온전히 적용되지 않는다는 것, 셰인 댄슨의 개념을 빌리자면 이미지가 탈상관적 이미지(discorrelated

15
Shane Denson, *Discorrelated Images* (Durham, NC: Duke University Press, 2020).

image)가 되었다는 것이다.[15] 〈오늘날의 로봇〉(2016)에서 아이폰의 음성인식 기능인 시리(Siri)의 매개로 암시되는 '보는 기계'의 시각은 터키군의 공격으로 파괴된 쿠르드족 거주 도시 디야르바키르(Diyarbakir)의 풍경을 보여 준다. 3차원 렌더링과 와이프(wipe) 기법, 색 보정 작업, 렌즈 플레어(lens flair) 효과 등을 거쳐 제시되는 이 풍경은 이 도시의 과거와 현재에 대한 사실적 기록으로만 간주하기에는 지나치게 왜곡된 색채와 인공적인 모습을 띠고 있다. 과거의 화려했던 이슬람 과학의 전통, 그리고 터키-쿠르드족 갈등의 현재 모두가 컴퓨터의 이미지 처리 기법에 종속되고 변환될 때 "인간에게 더 이상 접근 불가능한 시간의 차원이 더해진다." 그 차원 속에서 현재는 "결코 존재하지 않은 과거의 반복 재생되는 버전을 유지하기 위해 미래를 비워 버림으로써 구성되는

16
Hito Steyerl, "How to Kill
People: A Problem of Design,"
in *Duty Free Art: Art in the
Age of Planetary Civil War*,
16-17.

것처럼 느껴진다."[16] 〈오늘날의 로봇〉에 시각적으로 기입된 익숙한 낯섦(uncanniness)의 흔적들은 전통적인 재현 체제의 이미지가 약속했던 현실과 역사의 시간성을 인공지능 기반 이미지 기법이 급격하게 대체하고 있는 상황을 분열적으로 드러낸다.

유물론과 정치: 디지털 세계상과 주체, 인공적 우둔함과 표면
슈타이얼은 이제는 널리 알려진 빈곤한 이미지(poor image) 개념을 통해 이미지와 사물의 동일성이라는 유물론적 사유를 제시한 바 있다. 빈곤한 이미지는 파일로서 존재하는 한 디지털 이미지 제작과 순환의 특성들인 불법 복제와 자유로운 변질 및 변형의 가능성을 함축한다. 또한 디지털 압축과 전송에 작용하는 코드와 알고리즘의 기술적 한계가 화질의 열악함과 시각적 오류로 기입될 수 있다. 그러기에 폭력적인 "위치 상실, 전이, 변위"의 증거를 품고 있으며, 바로 그 이유로 디지털 시대 "시청각적 자본주의하에서 악순환하는 이미지의 가속과 유통을 증명"[17]한다. 이런 이유로 슈타이얼은 이미지 일반을 "재현으로서의 이미지가 아니라" 오늘날의 주체가 생산하고 소비하는 "사물로서의 이미지"[18],

17
슈타이얼, 「빈곤한 이미지를 옹호하며」, 42.

18
슈타이얼, 「당신이나 나 같은 사물」, 66.

나아가 오늘날 주체성 자체를 구성하는 중핵으로 간주할 것을 주장한다. 이때의 이미지-사물이란 재현적 체제에서처럼 주체와 분리된 객체로서의 이미지를 넘어선다. 디지털 이미지 일반이 스크린을 넘어 물리적 현실에 다양한 모습으로 중첩되고 변모되면서 영향을 미치는 한, 이 이미지는 주체의 감각과 정동을 구성하고, 속도와 강도로 측정되는 흐름으로서 우리의 현실 그 자체가 된다. 디지털 인터페이스와 네트워크가 구축하는 이미지, 사물, 주체, 실재의 근본적인 동일성, 이것이 슈타이얼이 말하는 '포스트 재현' 체제의 유물론적 핵심이다.

2010년대 중반 이후 슈타이얼의 유물론은 이미지가 사전에 존재하는 주관적 또는 객관적 세계의 외양이 아니라 주체와 정치, 사회적 시스템 모두를 근본적으로 구성하고 변화시키는 물질이자 에너지라는 주장으로 확장되었다. 이러한 주장을 뚜렷하게 드러낸 글인 「너무나 많은 세계: 인터넷은 죽었는가」에서 슈타이얼은 데이터와 이미지가 "데이터 채널의 경계를 넘어 물질적으로 표현"되기

19
Hito Steyerl, "Too Much World: Is the Internet Dead?" in *Too Much World: The Films of Hito Steyerl*, ed. Nick Aikens (Berlin: Sternberg Press, 2014), 33.

때문에 "오프스크린 공간에 밀집"하고 "도시에 침투하여 공간을 장소로, 현실을 또 다른 현실로 변화시킨다."[19]라고 말한다. 즉 포스트인터넷 조건은 네트워크화된 공간이 현실의 장소에 근본적으로 침투하고 그 장소 자체에 근거한 주체와 문화, 정치, 경제를 근본적으로 규정하는 상황을 말한다. 이처럼 인터넷이 온라인과 스크린 미디어에 국한되지 않고 오프라인으로 나가면서 물질로 침투할 때 구성되는 조건은 "더 이상 인터페이스가 아닌

20
같은 글.

환경"[20]이고, 이와 같은 환경에서 자연과 문명 모두에 근본적으로 스며든 이미지와 데이터는 한편으로는 계산되고 측정되며 다른 한편으로는 그 운동과 리듬, 방향을 예측할 수 없는 방식으로 유동화된다. 이런 점에서 디지털 이미지와 관련된 슈타이얼의 유물론적 견해는 오늘날의 인문학적 지평에서 두 가지 차원으로 접속된다. 하나는 모든 것이 컴퓨터 및 알고리즘 기반으로 재조정되고 통합되면서, 하이데거적인 의미에서 기존의 기계 기반의 세계상(weltbild: world picture)과는 다른 새로운 세계상이 출현했음을 시사한다는 것이다.[21] 다른 하나는 이처럼 자연과

21
Martin Heidegger, "The Age of the World Picture," in *The Question Concerning Technology and Other Essays*, trans. William Lovitt (New York and London: Harper and Row, 1977), 115-154. 허욱의 다음 글도 함께 참고할 만하다. "The Computational Turn, or, a New Weltbild," *Junctures* 13 (2010): 41-50.

인공물 모두가 네트워크, 컴퓨터, 알고리즘으로 변형되고 매개되는 이미지 또는 데이터로서의 세계에서 미디어는 자신이 전달하는 메시지의 내용보다는 세계를 구성하고 자신의 에너지를 가진 원소이자 인간과 주변 대상을 매개하는 기반 시설(infrastructure)로서 사유될 필요가 있다는 존 더럼 피터스의 공식화와 공명한다는 것이다.[22]

이처럼 이미지를 물질이자 환경으로 바라보는 슈타이얼의 유물론은 이미지를 주체와 동일시하는 견해로도 변주되어 왔다. 이 점은 스팸 메일과 이를 통해 전달되는 왜곡되거나 과장된 인간의 이미지(이미지스팸)에 대한 슈타이얼의 견해에서도 발견된다. 이미지스팸은 "기계로 생성되고 봇(bot)으로 자동 발송되며, 마치 반-이민 장벽, 장애물, 울타리처럼 서서히 강력해져만 가는 스팸 필터에 걸러"지기 때문에 재현의 패러다임을 넘어서 자율적으로 존재하고 움직이는 사물로 취급된다. 또한 이미지스팸 내에서 볼 수 있는 인간의 이미지는 "디지털 쓰레기처럼 다뤄지고 따라서 역설적으로 그들이 호소하는

22
John Durham Peters, *The Marvelous Clouds: Toward a Philosophy of Elemental Media* (Chicago, IL: University of Chicago Press, 2015).

23
슈타이얼, 「지구의 스팸: 재현에서
후퇴하기」, 219.

대상인 저해상도의 사람들과 비슷한 수준에 안착"[23]하기
때문에, 이미지 소비의 경제에서 룸펜 프롤레타리아로
취급되고 디지털 압축과 변환으로 인한 저하와 변위의 흔적을
응축한 빈곤한 이미지와 등가적이다. 따라서 사회적으로 내재된
불평등 및 모순에서 자유롭지 않다. 이미지가 사물처럼 배회하고
주체를 자동적으로 접합하고 재구성할 때 어떤 정치적, 문화적
결과를 낳는가를 질문하며 슈타이얼은 챗봇을 비롯한 봇(bot)에 의해
소셜 미디어 공간에서 작동되는 정치를 대리정치(proxy politics)
또는 포스트-재현 정치(post-presentational politics)로 설명한다.
소프트웨어와 소셜 미디어에 의해 모든 사용자의 사유, 인상학,
정동, 사회성이 알고리즘으로 통합되는 상황에서 챗봇은 "인간의
오퍼레이션을 연기하는 스크립트화된 오퍼레이션"[24]으로

24
Steyerl, "Proxy Politics," 38.

존재한다. 기성 권력과 대항 권력 모두는 자신의 메시지를
전달하기 위해, 또는 정보를 노이즈와 구별하는 필터를
우회하기 위해 챗봇과 아바타를 비롯한 디지털 대역에 의존한다.
인공지능이 산출한 이미지와 마찬가지로, 이 대역은 계산과 예측
가능성에 의해 작동하지만 예측 불가능하게 작동하기도 한다는
점에서 '준-자율적 행위자(semi-autonomous actor)'이다. 이들은
인간중심주의에 근거한 정치적 주체 개념에 동요를 일으킨다.

〈유동성 주식회사〉는 "현실은 포스트프로덕션되고 대본화되며,
정동은 애프터-이펙트로 렌더링"[25]되는 포스트인터넷
조건에 대한 슈타이얼의 반응이 작업 방식과 이미지

25
Steyerl, "Too Much World," 34.

미학 모두에서 급진적으로 드러난 작품이다. 제목을
장식하는 '유동성'이라는 키워드는 다양한 종류의 디지털 스크린은
물론 소프트웨어와 네트워크 인터페이스를 직접적으로 환기시키는
모든 종류의 시각적 기호로 반영된다. 한편으로 유동성의 자유로움을
은유하는 서핑 이미지나 경제 위기의 금융 유동성을 자연재해의
유동성과 연결시킨 쓰나미 뉴스 보도 이미지가 화면 전체를 채우거나
별도의 텔레비전 스크린에 등장하거나 스마트폰에 재생된다. 다른
한편으로 2차원과 3차원, 정지 영상과 동영상을 포괄하는 모든
이미지는 랩톱 바탕 화면은 물론 문서 작업 소프트웨어, 검색 엔진,
소셜 미디어 플랫폼 등의 프레임 속에서 출몰과 중첩을 반복한다.

이를 통해 이 작품은 디지털 체제가 주체와 객체의 구별을 와해시킴은 물론 경제와 자연 현상 모두에 근본적으로 침투하여 모든 것을 유동화하는 동시에 결정화한다는 점을 표현한다. 이 작품 오프닝의 한 장면은 파도의 이미지를 배경으로 유동성으로부터 파생된 다양한 단어들인 쓰나미, 얼음, 토렌트, 클라우드 등을 제시함으로써 이러한 상황을 안내한다. 또한 전 지구적 자본주의에 대항하는 테러리스트 집단인 '웨더 언더그라운드(Weather Underground)'가 방송하는 가짜 일기예보 장면은 기상이변을 낳는 구름의 이동을 전 지구적 지역 분쟁의 상황 및 기업들의 사유화된 클라우드 데이터 서버 분포 현황과 연결시킴으로써 세계의 데이터화가 정치적, 생태학적 차원에 영향을 미치는 상황을 시사한다. 디지털 유동성과 물리적 유동성의 구별 불가능성, 그것이 바로 우리 시대를 규정하는 조건이다.

비디오게임 튜토리얼 사용자 지침서 영상의 외형을 취하면서도 제작 과정 영상, 뉴스 단편 유튜브에 업로드된 댄스 클립, 일본 애니메이션 풍의 캐릭터, 세계적으로 진행되는 시위 영상을 조밀하게 뒤섞은 〈태양의 공장〉은 데이터의 지속적인 순환이 정치적, 경제적, 역사적 차원을 근본적으로 재편하고 있음을 나타낸다. 〈유동성 주식회사〉와 마찬가지로 물질과 데이터 흐름, 자연과 인공성의 경계가 와해된 가상의 세계 속에서 세 명의 주요 인물이 등장한다. 내레이터이자 게임 프로그래머 율리아는 1인칭 슈팅 게임을 수행하면서 모션 캡처 스튜디오에서 비디오게임 제작을 지도한다. 유튜브에서 자신의 댄스 영상을 바이럴 비디오로서 유행시킨 율리아의 동생은 그녀의 스튜디오에서 전자 센서가 부착된 모션 캡처 수트를 입고 춤 동작을 '강요된 노동(forced labor)'으로 수행한다. '이것은 게임이 아니다. 이것은 현실이다'라는 제목이나 '토털 캡처를 위해서는 A 버튼을 누르시오'라는 자막은 그의 신체적 동작이 디지털 가상 캐릭터로 변환되고 육체적 노동이 디지털 가상 노동과 구별 불가능하게 되는 상황을 나타낸다. 퍼포머들의 아바타와 3D 합성 캐릭터가 공존하는 가상 세계의 흐름은 '초광속 가속화에 맞서는 전 지구적 소요'라는 긴급 속보 자막과 더불어 시위 장면을 보여 주는 뉴스 푸티지에 의해 간헐적으로 중단되는데, 이 과정에서 독일은행의 대변인이 등장하여 시위대를 향한 드론 선제 타격의 필요성을

2010년대 중반 이후 히토 슈타이얼의 디지털 이미지와 컴퓨터 기반 테크놀로지: 존재론, 유물론, 정치

주장한다. 그런데 이러한 뉴스의 흐름은 봇 뉴스(Bot News)임이 자막을 통해 드러난다. 즉 이 일련의 뉴스 흐름은 독일은행 대변인으로 상징되는 정보의 기업적 통제와 이에 대항하여 정치적 메시지를 알고리즘적으로 자동 생산 유포하는 봇 뉴스의 경쟁이라는 양가적 상황과 연결된다. 후자의 상황은 슈타이얼이 트위터상에서 활동하는 정치적 봇 군대(bot army)를 "페이스북 군대, 당신의 저비용 개인화된 군중, 디지털 용병"이라고 규정한 바를 환기시킨다. 이처럼 〈태양의 공장〉은 〈유동성 주식회사〉에서 표현했던 경제와 환경의 디지털화라는 세계상을 정치와 노동의 영역으로 확대한다.

〈소셜심〉은 정치의 디지털화라는 〈태양의 공장〉의 한 측면을 연장하면서 팬데믹 이후의 혼란스러운 사회와 인공지능에 의해 급격히 변화하는 미술관 및 예술작품의 위상까지도 조밀하게 시각화한다. "행동과학에서 자주 활용되는 행위자-기반 모델을 말하는 소셜 시뮬레이션"[26]에서 영감을 받은 이 작품은 두 가지 모습을 주로 보여 준다. 하나는 팬데믹 이후 급격하게 확산되어 온 대중 소요와 이를 진압하는 경찰과 군인들의 폭력성을 묘사한 이미지다. 공권력을 체화한 이 주체들의 디지털 아바타는 자신들의 폭력적 행위를 춤으로 표현하면서도 광속의 빛으로 변화하기를 반복한다. 슈타이얼이 '사회적 안무(social choreography)'라 불렀던 이와 같은 안무의 신체적 움직임과 그 속도 및 방향은 2020년 각종 시위 현장에서 사용된 최루가스의 양과 부상자 및 사망자, 실종자 수 등의 데이터에 따라 달라진다. 이와 같은 디지털 아바타가 오늘날의 가상 미술관 곳곳에 포진해 있는 모습에서 관객은 오늘날의 포스트-재현 정치가 예술의 영역에도 예술작품 및 관객의 치안과 안전 관리라는 차원에서 긴밀히 작동하고 있음을 알게 된다. 슈타이얼이 한 인터뷰에서 가상현실 시각화 기술과 인공지능의 알고리즘에 근거한 예술작품 평가 시스템이 예술작품과 예술 시장에 미치는 영향을 두고 말한 다음과 같은 언급이 〈소셜심〉의 가상현실 미술관, 자동적으로 생성되고 변형하는 예술작품, 그리고 이러한 작품의 실시간 경매 시스템에 반영되어 있다. "메가 아트 페어에는 기업 크기의 갤러리들만이 남고, 부스는 봇 관리인과 멍청한 AI에 의해 운영되며, 따라서 판매자가 사람들과

26
Ayham Ghraowi, "Dance Dance Rebellion," in *Hito Steyerl: I Will Survive*, eds. Florian Ebner et al., exh. cat. (Leipzig: Spector Books, 2021), 16.

27
다음에서 인용. Hito Steyerl,
Ana Janevski and Roxana
Marcoci, "Conversation: Hito
Steyerl with Ana Janevski and
Roxana Marcoci," June 20,
2018, https://post.moma.org/
conversation-hito-steyerl-
with-ana-janevski-and-roxana-
marcoci/.

실제로 말하고 시장이 인간 상호작용에 의해 창조되는
종류의 전통시장(bazaar)을 제거한다."[27] 이처럼 이미지와
환경, 주체가 동일시되는 광장과 미술관, 정치와 예술 모두를
제어하는 것은 소셜 시뮬레이션을 구축하고 변형하는 신경망
네트워크의 머신 러닝이다. 그 작동 방식은 이 작품의 도입부에 재현적
이미지를 넘어선 파동과 프랙탈의 형태로 제시된다.

이처럼 이미지와 데이터가 주체와 세계, 인공물과 자연적 환경을
근본적으로 다시 프로그래밍하고 있는 상황에 대한 정치적 개입은
인공지능을 비롯한 컴퓨터 기반 미디어가 약속하는 유토피아적 전망에
대한 비판으로부터 시작된다. 그러한 전망 중 일부는 인공지능이
인간의 노동을 대체한다는 시나리오, 또는 그것이 인간의 지성
또는 창작력과 유사하거나 이를 넘어서기도 할 것이라는 시나리오,
그리고 그것이 기후변화 등 세계의 변동을 합리적으로 예측하고
모델링할 것이라는 시나리오다. 이와 같은 시나리오에 대한 대항으로
슈타이얼이 최근의 작업과 연관하여 제시하는 키워드가 '인공
우둔함(artificial stupidity)'이다. 인공지능의 '지능'(intelligence)'을
'우둔함'으로 대체한 이 개념은 인공지능의 머신 러닝과 같은
메커니즘의 인식 및 예측 프로세스가 매우 단순하고 편향된 사회적
가치에 근거하며, 그런 관계로 그 가치는 자본 및 정치적 권력과
긴밀히 연관되어 있다는 것이다. "스마트폰은 당신의 외모를
깨끗하게 한다. 그것은 그 외모를 임의로 깨끗하게 하는 것이
아니라 그 안에 프로그래밍된 인종주의적인 미의 표준에
따라 그렇게 한다. … 인공 우둔함은 어디에나 있다."[28]

28
다음에서 인용. Hito Steyerl
and Trevor Paglen, "The
Autonomy of Images, or We
Always Knew Images Can Kill,
But Now Their Fingers Are
on the Triggers," in Hito
Steyerl: I Will Survive, 245.

이 점은 인공지능이 결코 지성적이지만은 않다는 점, 나아가
그것의 연구와 개발, 적용이 "세계의 사회적 관계와 이해를
반영하고 생산한다는 점"[29]에서 결코 인공적이지만은 않다는 케이트
크로포드의 주장과 공명한다. 그렇다면 〈소셜심〉에서
폭력 진압에 동원되는 경찰과 군인들의 기계적인 몸짓이
무엇을 비판하는가, 다시 말해 이 아바타들은 어떤 패턴
인식과 예측을 근거로 움직이는가가 드러난다. 슈타이얼은
또한 인공 우둔함이 챗봇과 같은 정치의 영역뿐 아니라 인공지능으로
열광하는 동시대의 미술계에도 만연해 있음을 다음과 같이 지적하기도

29
Kate Crawford, Atlas of AI:
Power, Politics, and the
Planetary Costs of Artificial
Intelligence (New Haven, CT:
Yale University Press, 2021), 8.

30
다음에서 인용. Hans Ulrich Obrist, "Making the Invisible Visible: Art Meets AI," lecture "New Experiments in Art and Technology" at the Saas Fee Academy in 2018, https://www.goethe.de/prj/k40/en/kun/ooo.html.

한다. "우리는 파울 클레나 마크 로드코, 그리고 우리가 미술사를 통해 아는 모든 종류의 추상화처럼 보이는 추상적 컴퓨터 패턴을 보게 된다. 유일한 차이는 오늘날의 과학적 사유에서 이것들이 현실의 재현물로 지각되는 반면, 미술사에서는 다른 종류의 추상들에 대한 매우 조심스러운 이해 방식이 있다는 것이다."[30] 이처럼 인공지능의 딥 러닝에 근거한 시각적 표현들을 기계의 사실적인 표현이자 새로운 예술 작품으로 과장하는 오늘날 미술관의 모습이 〈소셜심〉에 풍자되어 있다.

〈유동성 주식회사〉 이후의 슈타이얼의 디지털 기반 주요 비디오 작품들에서 스크린을 메우는 이미지 객체들은 '인공 우둔함'을 비롯한 오늘날의 문화정치적 긴장들을 감각하고 읽을 수 있는 표면이 된다. '표면-수준의 표현(surface-level expression)'을 특별한 시대의 경향과 그 시대의 사태의 본질에 접근하게끔 하는 통로로 중요하게 인식했던 지그프리트 크라카우어를 환기시키며, 슈타이얼은 디지털 표면으로서의 3차원 가상현실이 갖는 중요성을 다음과 같이 강조한다. "표면은 주체와 객체가 위치하는 무대나 배경이 더 이상 아니다. 오히려 그것은 주체로, 객체로, 그리고 운동과 정동, 행동의 벡터들로 접히며 이들 간의 인위적인 인식론적 분리를 제거한다."[31] 슈타이얼은 이와 같은 디지털 표면의 미학을 통해 동시대의 모순적이고 불투명하고 유동적인 현실들 이면의 진실을 조사하는 방향(예를 들어 포렌식 아키텍처[Forensic Architecture]의 노선)을 취하지는 않는다.[32] 그러나 디지털 이미지의 역동적인 운동과 유동적인 형태를 생성하고 변주할 수 있는 다양한 기법과 플랫폼들을 동원하여 그러한 현실들을 감각적으로 체험할 수 있는 표면으로서의 세계를 구축하고, 그 세계의 존재론적, 유물론적 함의에 대한 성찰을 유도한다.

31
Hito Steyerl, "Ripping Reality," in Duty Free Art, 201. 표면의 중요성에 대한 크라카우어의 언급은 다음을 참조. Siegfried Kracauer, "The Mass Ornament," in The Mass Ornament: Weimar Essays, trans. and ed. Thomas Y. Levin (Cambridge. MA: Harvard University Press, 1995), 75-89.

32
이와 같은 노선에 대한 포렌식 아키텍처의 최근 이론적 논의로는 다음을 참조. Matthew Fuller and Eyal Weizman, Investigative Aesthetics: Conflicts and Commons in the Politics of Truth (London and New York: Verso, 2021).

How has Hito Steyerl's artistic work and theoretical interventions since the mid-2010s dealt with the digital image and technology? Also, what are they similar to and distinct from her artworks, working methods, and critical ideas up to the early 2010s that take as their subject image and technology? Several key essays included in her *The Color of Truth: Documentarism in the Artistic Field* (2008) and *The Wretched of the Screen* (2012) present the three arguments on the issues of image and technology. First, from epistemological and affective perspectives, the universalization of digital manipulation and the rapid explosion of factual images in global media networks caused what Steyerl has called "documentary uncertainty." This means a crisis of the objective evidentiary value of photographic representations (photograph and film) that traditionally guaranteed the indexicality of truth, on the one hand, and that the audience's sense of authenticity was weakened, caused by the indiscriminate circulation and stimuli of images containing war, terrorism, famine, and disasters under the network, on the other.[1] Second, on its ontological dimension, the digital image pertains to the post-representational regimes that goes beyond the representational paradigm of photographic imagery. This suggests that what is at stake in the creation and effect of the digital image cannot be fully explained in terms of the concerns of the representational paradigm, such as "what is the content of an image (or is the image a registration of reality)?," "is the image perceptually similar to reality?," and "does the image participate in the formation of memories and the construction of history?," etc.[2] Third, as a consequence of the post-representational regime, Steyerl's view of the image establishes a materialist view irreducible to its ontology, namely, the fundamental equivalence of images and objects.[3] Finally, at the political level, this equivalence is tied to the construction of subjectivity and the operation of the society: in the post-representational regime, human subjectivity and identity are constituted by and circulated through images, and state power, the power of capital, and art institutions all move through images in their process of subjectivizing humans.[4]

[1] For this point, see Hito Steyerl, "Documentary Uncertainty," *A Prions* (2007): 2-3, and "Die dokumentarische Unschärferelation: Was ist Dokumentarismus?," in *Die Farbe der Wahrheit: Dokumentarismen im Kunstfeld* (Vienna: Turia+Kant, 2008), 7-16.

[2] For this argument, see Hito Steyerl, "In Free Fall: A Thought Experiment on Vertical Perspective" (12-30) and "In Defense of Poor Images" (31-45), in *The Wretched of the Screen* (Berlin: Sternberg Press, 2012).

[3] For this point, see Steyerl, "A Thing Like You and Me" (46-59) and "Cut! Reproduction and Recombination" (176-190), ibid.

[4] For this argument, see Steyerl, "Missing People: Entanglement, Superposition, and Exhumation as Sites of Indeterminacy" (138-159) and "The Spam of the Earth: Withdrawal from Representation" (160-175), ibid.

This essay explores how the ontological, materialist, and political dimensions of the arguments and concepts presented by Steyerl as an artist and theorist relate to her artworks and writings since the mid-2010s. As with her artworks, Steyerl has increasingly been implementing digital postproduction techniques in her videos since the early 2010s. As a result, digital compositing and CGI have characterized *How Not to be Seen: A Fucking Didactic Educational .MOV File* (2013, hereafter *How Not to be Seen*) and *Liquidity Inc.* (2014). Since her *Factory of the Sun* (2015), which deals with a dancing worker wearing a motion capture suit, Steyerl's digital postproduction has gone beyond digital synthesis and CGI to the point of venturing into virtual reality, augmented reality, robotics visualization, and the creation and detection of audiovisual images based on artificial intelligence, and has been extended to creation. Discussing with these recent video works, I offer a critical montage of Steyerl's writings before the mid-2010s on the digital image and computational media with her essays included in *Duty Free Art: Art in the Age of Planetary Civil War* (2017). This aims to deepen our understanding of the three—ontological, materialist, and political—dimensions summarized above.

The Post-representational Paradigm and the Algorithmic Turn of Images

The post-representational paradigm means that the gaze, the worldview, the economy of image consumption and circulation formed by today's digital and computational visual culture have transcended the aesthetic and technical assumptions of the modern visual regime. Taking a photograph as an example, the representational mode presupposes the assumption that a referent pre-exists outside the photographic image and that optical devices including a camera guarantee the image's indexical link with the referent. However, according to Steyerl, the cell phone camera is a device that diverges itself from the representational mode. For the camera not only allows users to view images through its lens, but also modifies, manipulates, and produces images through its automated algorithms based on data from photos that the users take, store, or upload on social media. As she clarifies, [the camera] "analyzes the pictures you already took, or those that are associated with you, and it tries to match faces and shapes to link them back to you. By Dig what you and

5

Hito Steyerl, "Proxy
Politics: Signal and Noise,"
in *Duty Free Art: Art in the
Age of Planetary Civil War*
(London and New York: Verso,
2017), 31.

your network already photographed, the algorithm guesses what you might have wanted to photograph now."[5]

In this way, Steyerl perceives the post-representational instances in today's visual culture, where objects and images are dissociated and the belief in the transparent representation of images is absorbed into the nonhuman automatism of digital visual *dispositifs* and networks, while also extending her comment on them in her writings and video essays. In "Free Fall: A Thought Experiment on Vertical Perspective," her commentary concerns the permeation of visual verticality that dismantles the horizon of the linear perspective in modern vision. Today, the aerial views that have become widespread through Google Maps, drone cameras, satellite photos, etc. are more than a technological tool inasmuch as they are determined by political, economic, and cultural operations that projects the "delusions of mastery": "The view from above is a perfect metonymy for a more general verticalization of class relations in the context of an intensified class war from above—seen through the lenses and on the screens of military, entertainment, and information industries. It is a proxy perspective that projects delusions of stability, safety, and extreme mastery onto a backdrop of expanded 3-D sovereignty."[6] Still, this gaze from above is not reduced to an extension of the human senses, but is a "disembodied and remote-controlled gaze"[7] in the sense that it is distributed into vision machines such as drone cameras that automatically track and capture objects, and into software algorithms that automatically perform the operation of these machines and the manipulation of images. Such a "disembodied and remote-controlled" gaze becomes the subject of technical and performative reflection in *How Not to Be Seen*. In its Lesson 1, "How to Make Something Invisible for a Camera," Steyerl presents a black panel with numbers and lines used to focus the camera, setting it as a virtual target. The target is surrounded by empty space and placed in-frame-in-frame in the same rectangle as the panel. The vertical zoom-out, then, presents a view that encompasses the entire Earth beyond the landscape surrounding the target. The narration added to this scene, "Resolution determines visibility," reveals that the dominance of verticality, which defines the digital visual regime, is closely related to the material layer of digital images and the technical layer of digital visual *dispositifs*.

6

Steyerl, "In Free Fall," 26.

7

Ibid., 24.

Lesson 2, "How to Be Invisible in Plain Sight," contains a drone shot indicating that the image of the target is equivalent to a real California landscape, which is juxtaposed within a rectangular panel (frame-in-frame) with the low-resolution image of the target. This suggests that if the initially set target is an image that can be manipulated in pixel units, the image and the actual landscape are ontologically the same.

Another aspect of the post-representational paradigm is that images in general transcend the boundaries of the frame as one of the main elements that constitutes photographic and filmic images in the dimension of *dispositif*. First of all, Steyerl emphasizes the nonhuman dimension of vision in virtual reality in her lecture performance *Bubble Vision* (2018), which comments on the phenomenon in which the immersive 3D VR is actively applied to society and culture. Here, she shows a video of the Facebook VR platform introduced by Facebook founder Mark Zuckerberg's avatar. This 360-degree video, free from the constraints of the frame that constitutes screen-based media, provides users with an experience of being present in a virtual place and of seeing in all directions. However, the experience, which gives the feeling of "you are actually living in a scene with your body," is paradoxical for users. For "in a 360-degree video you are absolutely central in a scene like a spherical universe, but at the same time, you are missing from the scene." While intensely realizing the experience of being embodied, on the other hand, such embodied vision is subjected to an invisible algorithm beyond human perception, or a "training scheme that adapts humans to a world replaced by replaced by invisible systems, automation, or robots."[8] Like the vertical view, the bubble of the three-dimensional visuality has been rapidly spread across corporations, architecture, and entertainment industry. At the same time, Steyerl does not forget to comment on the military and political dimensions that support the proliferation of this bubble, which has already been visualized in the three-channel video installation, *Tower* (2015). Here, a Russian expert, commissioned by Western European conglomerates to create three-dimensional architectural simulations for real estate (condo) models, emergency control systems, etc., says that his work was used to manufacture fighters and spacecrafts in the USSR and that his company was established

[8]
These quotations come from Hito Steyerl, "Bubble Vision" Penny Stamps Distinguished Speakers Series, February 15, 2018, https://www.youtube.com/watch?v=T1Qhy0_PCjs.

on the occasion of producing military simulations related to various civil wars since the 1990s. What viewers see, then, is a series of distorted 3D digital objects identified as tanks, wreckage of collapsed buildings, refugees' tents, etc.

Steyerl's insights into the nonhuman aspects of the algorithms that make up bubble vision are extended into her recent interest in deep learning and machine vision in artificial intelligence. Borrowing the term of Trevor Paglen, who has actively explored artistic applications of artificial intelligence along with Steyerl, computer-based image creation systems, including machine vision, should be regarded as a "seeing machine" in and of itself, along with the vision of smart objects and sensors connected by computer processing and networking. The images produced and circulated by the "seeing machines" disrupt the human-centered concept of photographs and the correspondence between the image and human vision that is premised on the photographs. For the images that the machines create and circulate are utilized in the process of recognition and reading by other machines rather than human perception and reading.[9] Steyerl has also clearly recognized that the automation of images that do not necessarily assume the human eye is the most significant phenomenon today: "Not seeing anything intelligible is the new normal. Information is passed on as a set of signals that cannot be picked up by human senses. ... Vision loses importance and is replaced by filtering, decrypting, and pattern recognition."[10] Produced in collaboration with Jules Laplace, a programmer who has artistically used artificial intelligence for image and sound experiments, *This Is the Future* (2019) employs images of plant growth that were shot with high-speed cinematography. These images are transformed through the inter-frame prediction algorithm developed in the 1980s and implemented in today's compression and playback of computer-based video images. The psychedelic images of flowers and trees that repeat distortions and reconstructions through these transformations represent nature that is not completely subsumed within the anthropocentric worldview, that is, nature mediated by the unpredictable and ambiguous image recognition of artificial intelligence that humans cannot know. Such unpredictability and ambiguity are also visually reflected in the shots of Tokyo's night streets full of colorful neon

9
Trevor Paglen, "Seeing Machines," March 13, 2014, https://www.fotomuseum.ch/en/2014/03/13/seeing-machines/.

10
Hito Steyerl, "A Sea of Data: Apophenia and Pattern (Mis-) recognition," in *Duty Free Art*, 48.

signs, and in the footage of Stonehenge, which incorporates the human's long-standing aspiration to predict the future. These two applied to both nature and civilization, and to the organic and the artificial, reveal an unstable aspect of the datafied world that is recognizable by humans, on the one hand, but which deviates from human visual perception, on the other. Steyerl writes of the aspect as follows: "If models for reality increasingly consist of sets of data unintelligible to human vision, the reality created after them might be partly unintelligible for humans too."[11] This reminds us of the way in which Steyerl discusses the results of the research on the neural network at Google Research Labs. The neural network constituting deep learning processes countless types of datafied images and visual signals at a speed that exceeds human intelligibility, based on which it detects the images. The output images the network produces as a result of its detection registers in themselves a deep machinic dimension beyond human perception. As a result, familiarity and grotesqueness, and abstraction and figure coexist uncannily in the images. Steyerl makes clear this point in her summary of the research: "Neural networks were trained to discern edges, shapes, and a number of objects and animals and then applied to pure noise. They ended up 'recognizing' a rainbow-colored mess of disembodied fractal eyes, mostly without lids."[12]

In *This Is the Future*, algorithm-based image creation has a significant impact on the traditional temporality of images. The compression algorithms involved in the imagery of nature and cities that confuse viewers' perception automatically produce images that the viewers will see next based on previous video frames. This task is predictive in the language of artificial intelligence. When such compression algorithms operate beyond the standard speed of 24 frames per second that is intelligible to human perception, the past, present, and future are superimposed on a frame-by-frame basis to create blurry moving images. The ecstasy of those psychedelic images is what digital glitch artists pioneered in their attempts to unearth the materiality of digitally compressed video files and thereby to explore its unpredictable effects.[13] What distinguishes *This Is the Future* from the digital glitch work, then, is that these distorted images are no longer used solely to reveal the materiality of codes and algorithms. For

11
Hito Steyerl, "Medya: Autonomy of Images," ibid., 71.

12
Steyerl, "A Sea of Data," 55.

13
For a helpful study of the works by those artists, see my *Between Film, Video, and the Digital: Hybrid Moving Images in the Post-media Age* (New York: Bloomsbury Academic, 2016), chapter 2.

the images in *This Is the Future* are presented as future models of nature and civilization predicted by artificial intelligence. And the models also absorbs the past with their nonhuman operations in that they entail the algorithms' recognition of existing images. In other words, the temporality of *This Is the Future* is one formed by the images as digital objects, not the result of delivering to the viewer's present the past of the world that existed in front of the camera. To borrow Yuk Hui's account, the world of *This Is the Future* can be seen as responding to the epistemological change of temporality posed by digital objects. The prediction of the future (protention) and the memory of the past (retention) that constitute human temporality, he argues, depend on the "the relations given by digital objects, those traces we have left, such as pictures, videos, or geolocations; and orientation becomes more and more an algorithmic process that analyzes and produces relations to pave the way for the experience of the next now or the immediate future."[14]

14
Yuk Hui, *On the Existence of Digital Objects* (Minneapolis, MN: University of Minnesota Press, 2016), 221-222.

Ultimately, this means that digital images in the era of algorithms and artificial intelligence mark a notable break with the representational premise of photography and film. This break is not just that the "seeing machines" make the human gaze non-essential or replace it. More profoundly, the kind of correlationist premise that supported the relationship between an image and human perception in photochemical media does not fully apply to digital images today: in the words of Shane Denson, the images become "discorrelated." In *Robots Today* (2016), the vision of a "seeing machine"[15] implied by Siri, the virtual assistant implemented in iPhones, shows the landscape of Diyarbakir, a Kurdish-inhabited city that was destroyed by the Turkish attack. Presented through 3D rendering, wipes, color corrections, and lens flair effects, this landscape is too distorted to be regarded as a realistic record of the city's past and present, with excessively distorted colors and artificial shapes. When both the splendid traditions of the Islamic science of the past and the present of the Turkish-Kurdish conflict are subordinated and transformed into the computer's image processing techniques, what is added to the landscape is "a dimension of time that is no longer accessible to humans," one in which "the present feels as if it is constituted by emptying out the future to sustain a looping version of a past that never

15
Shane Denson, *Discorrelated Images* (Durham, NC: Duke University Press, 2020).

Digital Image and Computational Technology in Hito Steyerl's Works since the Mid-2010s: Ontology, Materialism, Politics

16
Hito Steyerl, "How to Kill
People: A Problem of Design,"
in *Duty Free Art*, 16–17.

existed."[16] In this regard, the uncanny traces visually
inscribed in *Robots Today* reveal the situation in
which AI-based imaging techniques are rapidly replacing
the temporality of reality and history promised by the images
of the representational regime.

Materialism and Politics: Digital Worldviews and Subjects, Artificial Stupidity and Surfaces

Steyerl has rehearsed her materialist thought on the identity of
images and objects through her now widely known concept of
"poor images." As long as they exist as files, poor images imply the
possibilities for illegal copying, free alteration, and transformation,
which characterize digital image production and circulation.
In addition, technical limitations of codes and algorithms that
act on digital compression and transmission can be registered
in the poor images in the forms of low resolutions and visual
errors. Thu, they bear the evidence of violent "dislocation,
transferrals, and displacement," and for that reason, "testify to ...
their acceleration and circulation within the vicious cycles of
audiovisual capitalism"[17] in the digital age. For this reason,
Steyerl insists that images in general be regarded "not as
representation" but as "thing"[18] produced and consumed
by today's subjects, and furthermore, as the core constituting
today's subjectivity itself. In this case, the image-object
goes beyond the image as an object separated from
the subject as in the representational system. As long
as digital images in general affect the physical reality in various
superimpositions and transformations beyond the screen, they
constitute the subject's senses and affect, therefore becoming
our reality itself as a flow measured by speed and intensity.
The fundamental identity of the image, object, subject, and reality
constructed by digital interfaces and networks is the materialist
core of what Steyerl calls the "post-representational" regime.

17
Steyerl, "In Defense of
Poor Images," 32–33.

18
Steyerl, "A Thing Like
You and Me," 50.

Since the mid-2010s, Steyerl's materialism has been expanded
to assert that images are not the appearance of a pre-existing
subjective or objective world, but a substance and energy that
fundamentally constitutes and changes both subjects and political
or social systems. In her essay "Too Much World: Is the Internet
Dead?," Steyerl writes that data and images "become unplugged
and unhinged and start crowding off-screen space" and "invade

19
Hito Steyerl, "Too Much
World: Is the Internet Dead?"
in *Too Much World: The Films
of Hito Steyerl*, ed. Nick
Aikens (Berlin: Sternberg
Press, 2014), 33.

cities, transforming spaces into sites, and reality into reality," insofar as they "surpass the boundaries of data channels and manifest materially."[19] In other words, the post-internet condition refers to a situation in which the networked space fundamentally penetrates the real place and fundamentally redefines the subject, culture, politics, and economy based on the place. As such, when the Internet is not limited to online and screen media and goes offline and penetrates into matter, the condition that is constituted is "not an interface but an environment."[20] Under the condition, images and data fundamentally permeated into both nature and civilization are calculated and measured, on the one hand, and become fluid in an unpredictable way in their movement, rhythm and direction, on the other hand. In this respect, Steyerl's materialist view on digital images is connected to the horizon of today's humanities in two ways. The first is that as everything is reorganized and integrated based on computers and algorithms, a new world picture (*Weltbild*) has emerged, different from the existing *Weltbild* of the mechanical age in a Heideggerian sense[21]; the second is that in this world as images or data, in which both nature and artifacts are transformed and mediated by networks, computers, and algorithms, media needs to be thought less in terms of the message they transmit, than in terms of the elements that constitute the world with their energy. This resonates with John Durham Peters' formulation of media as the infrastructures that mediate humans and their surroundings.[22]

20
Ibid.

21
Martin Heidegger, "The Age
of the World Picture," in
*The Question Concerning
Technology and Other Essays*,
trans. William Lovitt (New
York and London: Harper and
Row, 1977), 115-154. For
the shifting idea of the
Weltbild, See also Yuk Hui's
"The Computational Turn, or,
a New *Weltbild*," *Junctures* 13
(2010): 41-50.

22
John Durham Peters, *The
Marvelous Clouds: Toward a
Philosophy of Elemental Media*
(Chicago, IL: University of
Chicago Press, 2015).

Steyerl's materialist view on images as matter and environment also corresponds to her identification of them with subjects. This can be found in her take of spam emails and the "image spam," a kind of distorted or exaggerated images of humans. Image spam is treated as things that autonomously exist and move beyond the representational paradigm, because "it is made by machines, sent by bots, and caught by spam filters, which are slowly becoming as potent as antiimmigration walls, barriers, and fences." The images of the human found in the image spam are "treated like digital scum, and thus paradoxically end up on a similar level to that of the low-res people they appeal to."[23] For this reason, they are treated as the lumpen proletariat in the

23
Steyerl, "The Spam of the
Earth," 171.

Digital Image and Computational Technology in Hito Steyerl's Works
since the Mid-2010s: Ontology, Materialism, Politics

economy of image consumption, being equivalent to the poor images that condense the traces of degradation and displacement as they undergo digital compression and transformation. Thus, image spam is not free from socially inherent inequality and contradiction. Asking what political and cultural consequences are made when images roam around like things and automatically articulate and reconstruct subjects, Steyerl describes the politics operated in the social media space by bots (including chatbots) as "proxy politics" or "post-presentational politics." In a situation where software applications and social media integrate the thoughts, physiognomy, affects, and sociability of all users into algorithms, chatbots exist as a "scripted operation impersonating a human operation."[24] Both established power and counter-power rely on digital stand-ins, including chatbots and avatars, to deliver their messages or to bypass filters that distinguish information from noise. Similar to AI-generated images, these proxies are a "semi-autonomous actor"; in the sense that they operate by computation and predictability, but also unpredictably. They stir up the anthropocentric concept of a political subject.

[24] Steyerl, "Proxy Politics," 38.

Liquidity Inc. radically reveals, at the levels of its working method and its image aesthetics, Steyerl's response to the post-internet condition in which "reality is post-produced and scripted, [and] affect rendered as after-effect."[25] The keyword "liquidity" is reflected in all kinds of visual signs that directly evoke software and network interfaces as well as various kinds of digital screens. On the one hand, images of surfing that metaphorize freedom of liquidity or footage of tsunami news reports that link financial liquidity in an economic crisis with liquidity in natural disasters fill the entire screen, appear on a separate TV screen, or are played on a smartphone. On the other hand, all image, including two-dimensional and three-dimensional, still and moving images, repeat appearing and overlapping in the frames of the laptop's desktop screen, the document processing software, search engines, and social media platforms. Through this, the video expresses that the digital regime not only disrupts the distinction between subject and object, but also fundamentally penetrates both economic and natural phenomena, fluidizing and crystallizing everything. In the video's opening sequence, various words derived from the term liquidity, such as tsunami,

[25] Steyerl, "Too Much World," 34.

ice, torrent, and cloud, are presented to guide this situation against the backdrop of an image of sea waves. In addition, fake weather forecasts broadcast by "Weather Underground," a terrorists group against global capitalism, show the movement of clouds that cause extreme weather, linking them to the situation of global regional conflicts and the distribution of privatized cloud data servers. In this way, this vignette suggests a situation in which datafication of the world affects political and ecological dimensions. The indistinguishability of digital and physical liquidity, that is the defining condition of our time.

Taking the form of a users' tutorial clip for a video game, *Factory of the Sun* densely mixes behind-the-scene videos, news shorts, dance clips uploaded on YouTube, Japanese anime-style characters, and videos of protests going on around the world. In so doing, it represents the extent to which data's incessant circulation fundamentally reshapes of political, economic and historical dimensions. As in *Liquidity Inc.*, three main characters appear in a virtual world where the boundaries between matter and data flow, and nature and artificiality are collapsed. Narrator and game programmer Yulia plays a first-person shooter game while teaching video game production in a motion capture studio. Her brother, who made his own dance videos viral on YouTube, performs his dance as "forced labor" in her studio in a motion-capture suit fitted with electronic sensors. Such subtitles as "This is not a game, this is reality" and "Press the A button for total capture" refer to a situation in which his physical movements are transformed into those of digital virtual characters and his physical labor becomes indistinguishable from digital virtual labor. The flow of the virtual world, in which the performers' avatars and 3D synthetic characters coexist, is intermittently interrupted by news footage showing protest scenes along with an urgent "breaking news" caption that reads "Global Unrest against Ultralight Acceleration," during which a spokesperson for the Bank of Germany appears and argues for the need for a pre-emptive strike by drones on protesters. However, it is revealed through subtitles that this news is "bot news." In other words, this series of news is linked to the ambivalent situation in which the corporate control of information symbolized by the spokesperson of the German Bank competes with the bot news that algorithmically produces and disseminates political messages against it. The latter

situation reminds us of what Steyerl describes the political bot army operating on Twitter as "a Facebook militia, your low-cost personalized mob, your digital mercenaries." As such, *Factory of the Sun* expands the world picture of economic and environmental digitization in *Liquidity Inc.* into the realms of politics and labor.

Extending one aspect of *The Factory of the Sun*, namely, the digitization of politics, *SocialSim* (2020) densely visualizes the rapidly changing status of museums and artworks due to artificial intelligence and the chaotic society after the pandemic. Inspired by the "social simulations, commonly referred to as agent-based models often used in behavioral science studies,"[26] this work mainly present two aspects. The first is filled with images depicting the mass protests that have rapidly spread after the pandemic, as well as the violence of the police and soldiers who suppress them. The digital avatars of these subjects as the incarnations of public power repeat their violent action through dance while transforming themselves to the speed of light. The physical movement, speed, and direction of this choreography, which Steyerl calls "social choreography," depend on data such as the amount of tear gas used at various protest sites in 2020 and the number of injured, dead and missing participants. With such avatars dispersed throughout today's virtual art museums, viewers become aware that today's post-representational politics is working closely in the realm of art in terms of managing the policing and security of artworks and visitors. The virtual art museum, its artworks automatically generated and transformed, and its real-time auction system, all resonate with what she has remarked in an interview about the impacts of an art evaluation system based on VR visualization technology and AI algorithms on artworks and the art market: "Another aspect of this is the mega art fair, with only corporation-size galleries left, booths soon to be manned by bot attendants and stupid AI's—thus completely eradicating the type of bazaar where traders actually talk to people and the market is created through such human interaction."[27]

In this way, what controls the plaza and the museum, and politics and art—in both of which images, environments, and subjects are identical—is neural networks' machine learning that builds and transforms social simulations. At the beginning of *SocialSim*, the operation of machine

26
Ayham Ghraowi, "Dance Dance Rebellion," in *Hito Steyerl: I Will Survive*, eds. Florian Ebner et al., exh. cat. (Leipzig: Spector Books, 2021), 16.

27
Quoted in Hito Steyerl, Ana Janevski and Roxana Marcoci, "Conversation: Hito Steyerl with Ana Janevski and Roxana Marcoci," June 20, 2018, https://post.moma.org/conversation-hito-steyerl-with-ana-janevski-and-roxana-marcoci/.

learning is presented in the form of waves and fractals that go beyond representational images.

A political intervention in the situation where images and data are fundamentally reprogramming the subject and the world, artifacts and the natural environment, then, begins with critique of the utopian promises given by computational media, including artificial intelligence. Part of those promises include scenarios in which artificial intelligence will replace human labor, in which it will resemble or exceed human intelligence or creativity, or in which it will reasonably predict and model changes in the world, such as climate change. Countering such utilitarian scenarios, Steyerl suggests the idea of "artificial stupidity" in relation to her recent work. This concept, which replaces "intelligence" of artificial intelligence with "stupidity," means that the recognition and prediction process of AI's machine learning is so one-dimensional as to be based on existing social biases, and as such, that the process is closely related to capital and political power: "[The smartphone] is sanitizing your appearance. And it's sanitizing it not at random but according to the racist beauty standards that have been programmed into it. ... Artificial stupidity is, of course, not only embedded in smartphones, it's everywhere."[28] This resonates with Kate Crawford's argument that artificial intelligence is by no means intelligent, and furthermore, that its systems "reflect and produce social relations and understandings of the world."[29] It is revealed, then, what critique the mechanical gestures of the police and soldiers mobilized to suppress violence in *SocialSim* offer, that is, what pattern recognition and prediction make these avatars move in that manner. Steyerl also points out that artificial stupidity is pervasive not only in the realm of politics, such as chatbots, but also in the contemporary art world passionate about artificial intelligence: "We now have lots of abstract computer patterns that might look like a Paul Klee painting, or a Mark Rothko, or all sorts of other abstractions that we know from art history. The only difference, I think, is that in current scientific thought they're perceived as representations of reality, almost like documentary images, whereas in art history there's a very nuanced understanding of different kinds of abstraction."[30]

28
Quoted in Hito Steyerl and Trevor Paglen, "The Autonomy of Images, or We Always Knew Images Can Kill, But Now Their Fingers Are on the Triggers," in *Hito Steyerl: I Will Survive*, 245.

29
Kate Crawford, *Atlas of AI: Power, Politics, and the Planetary Costs of Artificial Intelligence* (New Haven, CT: Yale University Press, 2021), 8.

30
Quoted in Hans Ulrich Obrist, "Making the Invisible Visible: Art Meets AI," lecture "New Experiments in Art and Technology" at the Saas Fee Academy in 2018, https://www.goethe.de/prj/k40/en/kun/ooo.html

Digital Image and Computational Technology in Hito Steyerl's Works since the Mid-2010s: Ontology, Materialism, Politics

SocialSim satirizes the ways in which today's art museums exaggerate visual expressions based on artificial intelligence's deep learning as realistic expressions of machines or new works of art.

In Steyerl's major digital video works since *Liquidity inc.*, the image objects that fill the screen become a surface on which viewers can sense and read today's cultural and political tensions, including "artificial stupidity." Recalling Siegfried Kracauer, who recognized "surface-level expression" as an important passageway to approach the trend and essence of a particular era, Steyerl emphasizes the importance of 3D virtual reality as a digital surface as follows, "The surface is no longer a stage or backdrop on which subjects and objects are positioned. Rather, it folds in subjects, objects, and vectors of motion, affect, and action, thus removing the artificial epistemological separation between them."[31] Steyerl does not take the direction of examining the truth behind the contradictory, opaque and fluid realities of the contemporary era through the aesthetics of digital surfaces (for example, the direction of Forensic Architecture).[32] By mobilizing various techniques and platforms that can create and change the dynamic movements and fluid forms of digital images, Steyerl constructs the world as a surface on which viewers can sense and experience such realities, therefore inviting the viewers to reflect on its ontological and materialist implications.

31
Hito Steyerl, "Ripping Reality," in *Duty Free Art*, 201. For Kracauer's own remark on the importance of the surface, see "The Mass Ornament," in *The Mass Ornament: Weimar Essays*, trans. and ed. Thomas Y. Levin (Cambridge. MA: Harvard University Press, 1995), 75-89.

32
For Forensic Architecture's theoretical discussion on this direction, see Matthew Fuller and Eyal Weizman, *Investigative Aesthetics: Conflicts and Commons in the Politics of Truth* (London and New York: Verso, 2021).

디지털 그림자의 비유:
시뮬레이션의 삶과
내세에 관하여

벤자민 브래튼

Allegories of
the Digital Shadow:
On the Life and
Afterlife of Simulations

Benjamin Bratton

1. 무엇이 그림자인가?

히토 슈타이얼의 작업에 대해서는 감탄하지 않을 도리가 없다. 그의 작업은 개별적 인간을 감지와 분석, 재귀의 대상으로 삼는 등 너무나도 그릇된 방향으로 이뤄져 있는 행성 전체 규모의 연산 아래에 놓인 디지털 정체성의 구성을 충실하게 숙고하고, 매핑하며, 문제를 제기할 수 있다. 무엇보다 그의 작업은 우리들 각자가 생산하고 우리를 생산해 내는, 우리가 소유하고 우리를 소유하는 '디지털 그림자'를 마주한다. 이런 그림자들은 이중화, 삼중화, 반사, 불투명도, 투명도, 인격화, 대량화, 욕망, 통제, 삭제, 연출, 틀 짓기, 틀 벗겨 내기 과정을 통해 한 번에 나타난다. 이것에 대해서는 두려움과 매혹, 호기심, 경악, 풍자를 통해 접근하는 것 외에 선택의 여지가 없다. 슈타이얼의 예술이 펼치는 법의학적 현장에는 미학화된 기술적 주체성이라는 주제뿐 아니라 예술을 둘러싼 제도, 예술 이론, 예술 경제, 예술 언어, 예술 건축물, 예술계 사람들, 예술적 사물들 또한 포함되어 있다. 이들은 그림자를 드리우는 그림자라는 보다 큰 범위 안에 들어간다.

그림자란 무엇인가? 그것은 명백하면서도 분명치 않은 어떤 것이며, 어쩌면 분명하지 않기 때문에 명백한 것이다. 빛의 반사를 통해 시야를 확보하는 개체들은 이를 통해 사물을 볼 수 있다. 그런데 이렇게 이루어지는 반사는 빛이 사물의 반대편에 도달하지 못하게 걸러 내는 것이기도 하다. 이것은 제거를 통한 부재로 해석되는 동시에 그것이 걸러 내는 사물의 윤곽에 대해 현저하게 의존하지만 불완전하게 결부되어 있어 새로운 것으로도 해석될 수 있는 인공물을 만들기도 한다. 우리가 '그림자'라고 부르는 것은 바로 두 번째에 해당하는 공백/물체이다. 그것은 투사된 것처럼 보이는 사물을 좇지만, 원래의 물체는 해낼 수 없는 방식으로 형태와 크기를 바꾸기도 한다. 그림자는 종종 사물이 어두운 색을 띠고 2차원적으로 복제된 것으로서 나타난다. 하지만 광원이 지표면에 더 가까울 경우에는 그림자가 구부러지고 늘어나며, 겉으로 드러나는 자신만의 정체성을 취하는 듯 보인다.

원인과 결과의 관점에서 원래의 대상과 장소를 뒤바꿀 수 있는 가능성은 플라톤의 형이상학, 와양 쿨릿 그림자 인형극, 애니메이션으로 만든 어린이용 만화를 오가며 시간을 통해 무르익은 전형적 비유다. 때로는 그림자가 대상에서 전적으로 분리되거나

자체적 주권을 지닌 동등한 존재로서 대상과 상호작용하기도 한다.

　　서양 철학의 핵심에 자리한 시뮬레이션 이론인 동굴 비유는 그저 일차적 대상으로 잘못 인식된 그림자를 다룰 뿐 아니라 우리가 일상적 사물로 여기는 것들이 더 근본적인 형태의 그림자라는 가능성을 우려한다. 이러한 염려는 현상적 외관에 대한 지속적인 비판적 의심을, 무엇이 이미지, 진실, 현실의 일치를 구성하거나 구성하지 않는지에 대한 지속적인 비판적 의구심을 낳는다.

　　그림자 인형극 역시 이와 유사한 딜레마를 연출할 수 있지만, 비유를 뒤집는 것을 통해 가능하다. 이와 관련해 내가 제일 좋아하는 기억은 1990년대 중반 자바 지방에 있는 족자카르타의 야외 사원에서 그림자 인형으로 전하는 심야 서사극을 관람한 일이다. 공연장을 드나드는 군중은 여섯, 일곱, 여덟 시간에 이르는 서사극이 새벽이 될 때까지 전개되고 반복되는 동안 큰 병에 담긴 맥주와 다양한 주전부리를 나눠 먹었다. 이와 같이 특정한 ‘동굴’은 어쩌면 기만적인 환상이 아니라 낮 동안의 현실에 기초가 되지만 그러한 현실에 가려진 근본적인 신화적 체계를 직접적으로 재현하며 그림자의 주체에 더 직접적으로 접근했을지 모른다.

　　만화를 보면서 어린 시절을 보낸 이라면 캐릭터들이 자신의 그림자를 벗고, 그림자를 다른 곳으로 옮기고, 자기 그림자와 춤을 추고, 권투를 하는 등의 모습을 반쯤은 기억할 수 있다. 여기서 작용하는 알레고리들은 형이상학적이라기보다 심리적이다. 그것은 대체로 자아가 외부의 대상으로 인식되는 거울 반사가 제기하는 딜레마와 유사하며, 특히 자아에 대한 통제나 자신의 사유, 감정, 행동에 따른 외부 효과에 대한 통제를 상실하는 잠재적으로 공포스러운 손실을 다룬다. 자신의 그림자와 권투를 한다는 것은 실존적 결과를 초래하는 무언가에 대해 모호하게 딴생각을 품는 일이다. (만화 속 고양이들과 피터 팬이 그랬던 것처럼) 자신의 그림자를 벗겨 내고 그것을 여행 가방에 접어 넣는 일은 주체가 초래한 결과로부터 자신을 분리하는 것이며, 그렇지 않다면 적어도 그와 같은 주체성이 이미 분리되었다는 느낌을 구현하는 것과 같다.

2. 그림자로서의 자막 달기

영화에 자막을 다는 일은 이중화(doubling)와 따라서 말하기 (shadowing)의 과정이며, 실재하는 대상을 따라 하는 게 아니라 목소리를 이중화하고 따라 하는 것이다. 자막 달기는 목소리에 담긴 의미론적 뜻을 다른 언어만이 아니라 텍스트로 쓰인 사유의 다양한 양상으로 옮기는 일이다.

자막은 일종의 그림자이지만, 이미지와 맺고 있는 이차적 관계에 따라 '캡션'의 한 장르로 손쉽게 분류될 수도 있다. 이미지에 대해 글로 쓰인 캡션은 그것이 어떻게, 누구에 의해, 언제 만들어졌는지, 얼마나 큰지, 경합의 대상이 된 인공물로 존재하는 동안 그것에 무슨 일이 일어났는지 등을 설명해 줄지 모른다. 이와 같은 메타-의미의 축적에 있어, 캡션은 이미지 안에서 벌어지는 일을 묘사하고 그 의미를 함축적으로 설명할 수 있을지 모른다. 어떤 캡션은 상대적인 측정값(날짜, 가로 크기, 세로 크기)만 설명하는 반면, 다른 캡션은 자막에 더 유사하다. 캡션을 통해서가 아니라면 전달 불가능한 '의미'를 옮기는 것이다. 후자의 경우 큐레이터가 작성해 이미지와 함께 제시되는 야심 찬 글의 형태나 시각 장애가 있는 뮤지엄 방문객을 위해 이미지를 설명하는 접근성 편의 방안으로 제공될 수 있다. 전자와 후자의 차이는 명확하지 않을 수 있다.

이러한 번역 그리고 어떤 것 또는 누군가가 '무엇이며' 그것이 무엇을 '의미하는지'에 대한 방향성에는 상당한 영향력이 존재한다. 무의식적으로, 또한 짓궂은 방식으로 원본을 따라 하는 그림자와 달리, 자막은 암묵적인 것을 명시적으로 만든다. 화난 것처럼 들리는 영화 속 등장인물은 그저 화가 난 소리로 고함을 지를 뿐 아니라 분노를 담은 특정한 단어를 외친다. 휘황찬란한 회화 작품은 큐레이터의 말이라는 필터를 통해 비춰지면서 그저 동적이고 생생할 뿐 아니라 제1차 세계대전의 잔혹성을 다룬 것으로 드러난다.

증강 현실은 그림자와 자막 두 가지 모두로 작용하는 특정한 종류의 디지털적 이중화이며, 그렇게 함으로써 사람과 사물, 모델과 주체 사이에 존재하는 여러 가지 결정적 격차를 집중시킨다.

3. 무엇이 무엇을 증강하는가?

나는 다음과 같은 것들을 가리키는 데 "증강 현실(AR)"이라는 용어를 사용한다. (1) 보는 이의 시야를 틀 짓거나 사물과 사건에 직접적인 기호학적 관계를 맺고 있어 틀이 정해진 추가적인 광학적 인공물을 도입하여 그가 보는 바와 상호작용하는 기존의 기술 및 새롭게 떠오르는 기술, 더불어 (2) 세계가 이처럼 인공적인 근본 혹은 이차적 기호학적 관계를 서로 맺고 있을지 모르는 대상으로 가득 찬 시나리오라고 지각하는 현상학적 경험. 인간의 시야와 머신 비전의 융합에는 인공적으로 지각된 현실을 위한 기술과 더불어 기술이 인공화하는 현실이 모두 존재한다.

이 용어는 주로 시각 미디어 기술과 관련해 쓰이지만, 증강된 청각이나 촉각, 미각, 후각적 현실을 가리킬 수도 있다. 예를 들어, 시각 장애인이 시각을 대체하는 매체나 다른 감각을 증강하는 AR 기술에 의존할 수 있다. 이들의 차이는 기술적이라기보다 철학적일지 모른다. 또 다른 관점에서 볼 때, AR은 일종의 자율신경 기만, 즉 감각 경험에 교란물과 거짓 신호를 의도적으로 도입하는 것이다. 그것이 실제가 아니라는 것을 알지만 마치 그것이 실제인 양 행동하게 된다. 일종의 뒤집힌 환각이라는 말이다.

AR에서 가장 전형적인 장르에서는 시야에 들어오는 사물에 색인, 기호, 상징을 덧붙이곤 한다. 이에 따르면 의자 위에 가상의 생명체가 앉아 있을 수도 있다. 팔을 뻗으면 닿을 법한 공간은 가상 데스크톱으로 채워질 수도 있다. 거리에서 만나는 낯선 이는 그의 성격을 친구나 적이라고 미리 해석할 수 있는 플랫폼과 함께 도착할지 모른다. 현실의 새로운 층위가 무대에 추가되고, 기존의 사물들은 디지털 트윈과 함께 나타나며, 대상과 그림자 사이에 있는 해석의 공간은 부분적으로 붕괴된다. 눈에 보이는 증강된 동물이나 식물, 광물이 실제로는 그렇지 않다는 것을 의식적으로 안다. 그러나 실재의 순간 안에 존재하는 효과는 자막이 붙은 영화를 보는 관객이 쓰는 것과 동일한 종류의 적극적 망각을 가능케 한다. 후자에 해당하는 이들은 이탤릭체로 쓰인 노란색 글자들이 영화라는 창조적 허구의 공간 안에서 등장인물 앞에 떠 있는 것을 안다. 또한 그럼에도 이야기의 흐름에 빠진다는 것은 귀로 들리는 목소리와 텍스트로 제시되는

장면을 하나의 공통적 리듬으로 합치는 것임을 알고 있다.

현실과 비현실, 메타 현실, 혹은 그저 시뮬레이트된 것의 구분이 항상 그렇게 명확하고 딱딱하기만 한 건 아니다. 최근에는 여러 철학자가 AR의 사촌 격인 가상 현실을 통해 시뮬레이션이 처한 상황을 다시 살펴보았다. 그들은 이렇게 질문한다. 뇌는 어떻게 VR을 3인칭적 재현으로 인식하는가? 혹은 그것을 어떻게 강렬한 직접 경험으로 받아들이는가? 어느 정도는 양쪽 모두 해당하는 것 같다. 영화적 시각화를 통해 AR 경험이 가능하게 해 줄지 모르는 것에 대해 높은 기준을 세운 디자이너 케이이치 마츠다는 인지 대상에 애니메이션을 덧씌우는 것이 새로운 "애니미즘"을 불러온다고 본다. 여기에서는 사물에 새로운 종류의 주체성과 인격이 주입된다. 그가 볼 때 이것은 긍정적이기도 하고 심지어 영적이기까지 한 발전이 될 수 있다. 하지만 모든 형태의 애니미즘이 그러하듯, 동물이나 사물에 주체성, 인격, 내러티브적 의미가 있다고 여기는 것은 적극적인 갖가지 적극적 오류와 유아론적 오판으로 이어지기도 한다. 현실과 상상에 존재하는 거리의 붕괴는 단지 기술적인 것만이 아니라 인지적인 문제다.

처음에 제안한 바와 같이, AR 안에서 보충적인 해석적 기호학과 함께 대상을 증강하는 것은 보다 근본적인 사회-인프라적 디지털 트윈 구축을 잘 보여 준다. 여기서는 사람들과 사물들이 자신의 자질과 행동에 의해 지속적으로 모델링 되어 외부 세계를 위해 개인과 대상에 대한 인터페이스로 작동한다. 예를 들어, AR 시스템의 사용자가 틀 지어진 시나리오를 관찰하면서 증강된 그림자와 자막의 층위들과 함께 이것을 해석한다면, 그림자와 자막 역시 사용자로 모델링 되는 것이다. 시나리오 내에서 이뤄지는 그들의 행동은 우리들 각자의 디지털 그림자를 개별화하는 집합적 프로필을 구축할 수 있게 해 준다.

이중화는 개별화된 개인과 그들의 과거 행위를 색인화하고 그들이 미래에 행할 가능성이 가장 높은 일을 예측해 현재 취할 수 있는 행동 범위를 구성하는 모델 사이에 있는 번역의 층위이다. 개인과 그의 그림자가 맺는 자연스러운 관계는 이와 같은 프로그램적 재귀로 인해 복잡해지고 만다. 이제 개인의 주체성은 디지털 그림자의 원인이자 결과이며, 디지털 그림자/프로필은 행동 범위에 틀을 지워 그것을 초래하는 동시에 그것의 영향을 받는다. AR에서는 하나의 객체가

디지털 그림자의 비유: 시뮬레이션의 삶과 내세에 관하여

그림자와 같은 증강을 통해 의인화되는 반면, 개인은 플랫폼의 프로파일링을 통해서 이중화됨으로써 대상화된다. 각각의 경우는 개인과 객체의 주체성을 찾아내는 디지털 트윈 만들기와 개인화된 시뮬레이션이라는 보다 일반적인 현상을 보여 주는 특정한 사례이다. 사물과 그림자가 개별적으로 실재를 상징할 수 있는 그림자놀이에서와 같이, 상호 작용은 그저 한 가지 방향을 향한 직접적 이중화가 아니라 표현적이거나 정동적, 물류적, 조작적, 이상하게 해방적일 수도 있는 능동적인 공동의 맥락화이다.

4. 그림자 도시

스스로의 그림자와 권투를 하는 것은 개인적이고 사적이며 현상학적인 것처럼 보이지만, 대규모로 분산된 인프라스트럭처 차원의 과업이기도 하다. 도시들과 지구 전역을 루프에 집어넣기 때문이다.

당신과 나, 우리 모두 마찬가지다. 우리에게는 대역(double)이 존재한다. 사실 우리는 여러 개의 대역을 가지고 있다. 그들은 동굴이나 창고에 산다. 여기서 멀긴 하지만 너무 멀지는 않은 곳에 말이다. 그들은 우리의 행동, 헌신, 열망을 딴 모델로부터 자라난다. 궁극적으로는 대역들을 선별하고 충족시키기 위해 도시 전체가 세워진다. 이런 그림자 도시들은 수직으로 솟은 우리들의 대도시가 드리우는 그림자 구역 안에 있다. 평평하고 널찍하며 심지어 지하에 있는 편이며, 오리건주 프린빌, 노스캐롤라이나주 포레스트 시티, 아이오와주 알투나, 유타주 블러프데일, 버지니아주 애쉬번과 같은 이름 없는 도시에 존재한다. 물론 네바다주 라스베이거스에도 있다. 사용자 프로필의 거시경제는 도시 기반을 필요로 한다. 나의 문화는 페르소나의 궁전에 대한 투자를 우선적으로 여기기 때문이다.

도시와 그것의 그림자가 맺는 관계는 무엇이며, 무엇이어야 할까? 현실의 멀티버스 안에서 어떤 사람과 그의 대역, 또 다른 대역 사이의 관계는 무엇이며 어떠해야 할까? 후자의 경우는 각각의 도시가 관계를 구축하는 방식의 우발성에 달렸다. 무대가 먼저 세워지고, 배우는 그다음이라는 말이다. 결국 문제는 거울 속의 사람이 당신을 바라볼 때 보는 것, 다양한 장소가 자연스럽게 연결되어 있기에 무엇이 '장소'이며 무엇이 '장소'가 아닌지, 국가가 점점 더 모델

시뮬레이션의 거버넌스에만 의존하지 않고 거버넌스가 독점적
시뮬레이션의 생산과 실행이 '되어 가고' 있는지다.

도시의 역사는 클라우드가 생기기 오래전에도 건축된 것과
건축되지 않은 상상의 이상을 모두 포함했다. 모델과 모델링 된 것
사이의 동요는 새로운 것이 아니지만, 어떤 도시를 모델의 구현으로서
건설하는 것과 하나의 시뮬레이션을 도시의 구현으로 구축하는 것에는
차이가 있다. 도시와 그것의 시뮬레이션은 이따금 엄격한 인공적
거리를 유지하는데, 이것은 차이나 미에빌의 소설 『이중 도시』에서
물리적으로 엮여 있지만 현상학적으로 뚜렷이 다른 도시로 등장하는
베스젤과 울 쿼마와 다르지 않다. 두 도시의 주민들은 서로 만날 수
있지만, 그들은 서로의 존재와 이동을 인식하지 못하게 훈련된다.

어떤 때는 서로 직접 맞부딪히기도 한다. 아마도 공항에서와같이
보안 검색대를 통과할 때는 당신의 물리적인 신체를 검사할 뿐 아니라
당신에게 연결되어 있지만 가까운 곳에 존재하는 그림자 도시에 사는
당신의 페르소나도 추적한다. 제복 입은 사람이 당신을 통과하게 해
준다면, 당신의 물리적 신체가 반영으로서 존재하는 실루엣에 대한
위험 모델에 따라 결정이 내려졌기 때문이다. 인프라스트럭처가 당신의
대역에 대해 속삭이면서 귀가 따가울 수 있지만, 당신만 그런 건 아니다.

도시 전체가 자기 자신에 대한 시뮬레이션을 통해 자신을
운영한다. 하나의 대역만 존재하는 게 아니라 서로 경쟁하는 여러
개의 대역이 있다. 그중 일부는 기업 플랫폼이며, 다른 일부는 국가
시스템이며, 대부분은 각기 다른 수준으로 국가와 민간이 혼합되어
있다. 결정적으로 그것은 하나의 궁극적인 최종적 지도로 묶이지
않기에, 당신은 당신과 상호작용할 뿐 아니라 서로 상호작용하는
대역들을 동시에 갖게 된다. 서로 겹쳐진 부분적 시뮬레이션이 요컨대
이것은 보안에 관한 것이고, 저것은 광고에 관한 것이며, 또 다른 것은
교통 효율성에 관한 것이라는 식으로 증가하는 것이야말로 어쩌면
하나의 모델이 너무 지배적으로 변하는 취약한 이상주의를 방지하는
것일지 모른다. 그러나 이것은 당신과 연결된 모든 페르소나 모델이
하나의 정체성으로 묶이지 않을 것임을 뜻하기도 한다. 특히 여기에서
당신은 그림자를 드리우는 대상일 수도 있지만 당신 또한 전체가
아니라 흔적과 자취일 뿐이다.

5. 유령 도시

중국의 폭발적 경제 성장은 새로운 장르의 유령 도시를 초래했다. 오르도스의 캉바시 지구, 톈진 인근의 위자푸 금융 지구, 창사시 인근의 메이지 호수 개발 지역은 때에 따라 나타나기도 하고 그렇지 않기도 했던 주민들을 언제든 맞이할 준비가 되어 있다. 그것 역시 일종의 그림자 도시, 즉 투기 목적의 거주를 1:1로 만든 모델이다. 그러나 다른 그림자 도시들은 우연에 의해서가 아니라 설계된 바에 따라 인간이 없이 텅 비어 있다.

유령 도시 가운데 일부는 그것을 둘러싼 단단한 껍질과 같은 풍경 안에 신체가 있는 인간이 거의 거주하지 않음에도 불구하고 인근에 있는 데이터 센터 내부를 가득 채운 모방 페르소나 무리들로 붐비곤 한다. 그런 장소 가운데 어떤 곳이든 수억 개의 그림자를 품고 있지만 실제 작업자는 수십 명에 불과할 수 있다. 이러한 비율은 장차 도래할 것의 징후이다. 실질적으로는 포스트휴먼적 도시화이지만, 이론상으로는 그렇지 않다(심지어 그림자 도시가 지배적인 도시 형태가 되었지만, 인간 의뢰인을 위한 환상적인 주거 시설이 점점 더 우위에 서게 된 21세기의 첫 10년 사이 건축 학교에서는 그림자 도시의 발전이 거의 간과되고 말았다). 그림자 도시가 실제로 가상적이라는 말이 아니다. 그와 반대로 공장, 항구, 컨테이너 분류 센터, 물류용 공항을 비롯해 자원에 목마른 데이터 센터의 네트워크가 광범위하게 분포되어 사물들을 위한 불연속적 메가시티를 구성한다. 그것을 불가사의하다고 상상하는 건 값비싼 대가를 치를 환상이라 하겠다.

'거기에 있는 거기'가 존재하지만, 그러한 '거기'가 바로 여기에 있기도 하다. 당신과 내가 서로 채팅을 하고 서로를 향해 메시지를 보낼 때, 나는 한 장소에 있고 당신은 다른 장소에 존재한다. 심지어 같은 시간에 같은 도시에 있을 수도 있지만, 나의 페르소나와 당신의 페르소나 사이에 있는 대화의 접점은 말 그대로 그리고 물리적으로도 우리 둘 모두 살고 있지 않은 그림자 도시 안에 존재한다. 우리는 대화를 나누기 위해 그림자에 기대고 그림자를 가면 삼아 그것을 통해 서로에게 말을 걸며, 인간의 영역과 그림자 도시 사이에 연결점을 드리운다. 서로의 사이 그리고 장소들의 사이를 가는 선으로 꿰매고, 이를 통해 이러한 회로를 매개하는 모델 시뮬레이션이 더 풍부한

질감을 지닐 수 있게 기여한다. 넓게 퍼져 나가고, 서로 맞물리며, 균형이 맞지 않는 회로에 말이다.

중국에 있는 또 다른 종류의 그림자 도시는 유령이 사는 도시, 살아 있는 자들이 그들을 대신하여 종이로 만든 가짜 돈을 태우는 도시들이다. 종이돈은 조상들이 내세에서 받게 될 시뮬레이트된 돈이다. 몇 년 전에는 이 유령 화폐에 짐바브웨급의 화폐 단위 하이퍼인플레이션이 일어났는데, 아마도 이승에서 벌어진 거시경제적 요인에 따른 것인 듯하다. 그리 멀지 않은 곳에서는 그림자 도시의 데이터 센터들이 더욱 세속적인 원칙에 따라 운영된다. 유령이 출몰할 뿐 아니라 '우리, 살아 있는 자들'의 유령을 위해 특별히 지어진 건물들이다. 우리는 우리의 유령들을 그곳에 수용할 뿐 아니라 그곳을 우리가 살고 있고 우리 안에서 사는 모델 시뮬레이션의 핵심 통화로 삼고 돈을 불태우면서 수익을 거둔다.

6. 무엇을 현실이라고 부르게 될까?

최근 AR이 화제가 되면서 나는 이런 질문을 던지고 있다. "무엇을 비-증강 현실이라고 부르게 될까?" 이 말은 곧 기호학적으로 계층화되지 않은 사물뿐 아니라 선제적 해석이 가해지지 않은 세계 감각을 뜻하기도 한다. 인기 있는 후보로는 '기저 현실(baseline reality)'과 '자연적 현실(natural reality)'이 있다. 그러한 용어들과 그것이 함축하는 바의 차이에 대해 섬세하고 정치적인 입장을 지닌 학파가 머지않아 생길 것이라고 본다.

지금으로부터 2000년 전, 루크레티우스는 우리가 눈으로 보는 것과 실제로 존재하는 것의 관계가 원자 단위의 먼지 입자 차원의 문제라고 설명했다. 사물은 그림자를 지닐 뿐 아니라 사람의 눈에 마치 포자와 같이 내려앉아 사물을 볼 수 있게 해 주는 원자 조각이 벗겨져 나오기도 한다. 에피쿠로스학파가 볼 때 자연적인 시야는 이미 외부화되어 있는 이중화이며, 혹은 원본 전체를 재현하기 위해 수신자가 해석해 내는 미세한 시뮬레이션을 펼치는 사물의 폭발에 내재한 하나의 과정이다. 유령이란 생명을 잃은 사물에서 남은 원자가 자신의 기원이 사라지고 나서 누군가의 눈에 내려앉은 것이었다. 오늘날 인간 두뇌의 신피질은 스스로를 이해함에 있어 상당한 진전을

이뤘고, 지금은 자신이 끊임없이 주변 세계에 대한 예측 모델을 만들어 내는 생명체의 형태라고 보고 있다. 눈에 보이는 것은 뇌가 그곳에 있을 것이라고 예측하는 것과 관련해서 인식되며, 어떤 점에서는 개인 프로필이 미래의 선택지에 대해 재귀적으로 예측하는 모델과 관련해서 행동 방침을 틀 짓는 것과 유사하다.

행성 규모의 연산으로 인해, 무엇보다 인지적 시뮬레이션이라는 인프라스트럭처가 움직이기 시작했다. 기후변화를 다루는 과학과 기후변화에 대한 추론, 이에 따라 인류세와 그 변종에 대한 전제를 이끈 것을 비롯해 지금까지 이것이 거둔 가장 중요한 성과는 이것이 그 자체로 거대한 시뮬레이션을 구축하는 프로젝트라는 점이다. 미래에 처하게 될 기후 상황은 지구의 과거에 대해 현재 시점에서 구축되어 우리의 예측이 유효하다는 확신에 대응하는 모델과 관련하여 생성된다. 이와 같은 규모로 이루어지는 디지털 대역 생성과 시뮬레이션에 대한 지배적인 질문은 그 핵심에 이르기까지 난감하다. 미래의 모델은 대체 어떻게 현재를 재귀적으로 지배하여 그것의 존재를 가능케 하는 기저에 있는 행성 차원의 조건이 스스로 붕괴되지 않게 할 수 있을 것인가? 바로 그러한 모델과 실재가 잠재적으로 붕괴할 지도 모른다는 점이야말로 그림자 속에 숨어서 다른 모든 것을 괴롭히고 있을지도 모르는 것이라 하겠다.

1. What are Shadows?

One cannot help but admire work, such as Hito Steyerl's, that is truly capable of contemplating, mapping, and otherwise problematizing the formations of digital identity under a regime of planetary-scale computation so misaligned toward the individual human person as the base unit of sensing, analysis and recursion. Among other preoccupations, her work confronts the *digital shadows* that each of us produce and are produced by, and which we both possess and are possessed by. These shadows emerge through processes of doubling, tripling, reflection, opacity, transparency, individuation, massification, desire, control, erasing, staging, framing and deframing all at once. We have no choice really but to approach them with trepidation, fascination, curiosity, dismay and satire. Included in the forensic theater of Steyerl's Art is not only this subject matter of aestheticized technological subjectivity but also the machines of art, art theory, art economies, art languages, art buildings, art people and art things within this larger operation: shadows casting shadows.

What is a shadow? It is something both obvious and mysterious, perhaps one because the other. An object can be seen by entities capable of vision through the reflection of light, but this reflection is also a filtering of the same light so that it cannot reach whatever is on the other side of the object. This produces an artifact which can be interpreted as both a kind of subtractive absence and as a new kind of thing with significant but incomplete attachment to the filtering object whose profile it resembles. This secondary void/object is what we call a *shadow*. It tracks the object from which it seems to be projected but also changes in shape and size in ways the original object cannot. At times the shadow appears as a dark two-dimensional replica of the object but if, for example, the source of light is closer to the ground plane, then the shadow bends and elongates and in doing so seems to take on a formal identity of its own.

A time-seasoned trope that criss-crosses Platonic metaphysics, Wayang kulit shadow puppetry, and animated children's cartoons is the potential for the shadow to swap places with the original object in terms of cause and effect. Sometimes the shadow even delinks from the object altogether and or interacts with it as a self-sovereign equal.

Plato's allegory of the cave, a theory of simulation at the core

of Western philosophy, is concerned not simply with shadows misperceived as primary objects but with the prospect that what we take to be everyday objects are themselves a kind of shadow of yet more primary forms. This worry haunts the ongoing critical suspicion of phenomenal appearances and what does and does not constitute the correspondence between image, truth and reality.

Shadow puppetry may stage a similar dilemma but by inverting the allegory. Among my favorite memories is attending late night epic dramas told with shadow puppets in open air temples in the Javanese city of Yogyakarta in the mid-1990's. Crowds of people wandering in and out, would share tall bottles of beer and various snacks as the six, seven, eight hour epics would unfold and cycle back around and start again over and over until dawn. This particular "cave" perhaps accessed the agency of the shadow more directly, presenting them not as deceptive illusions but as direct presentations of the fundamental mythic systems that underlie daytime reality but which are otherwise obscured by it.

Anyone who spent their childhood watching cartoons can half-remember characters peeling off their own shadow, moving their shadow to a different spot, dancing a duet with their shadow, boxing with their shadow, and so on. The allegories at play here are less metaphysical than psychological. Generally they are similar to the dilemmas posed by a mirror reflection in which self is recognized as an exterior object and specifically they play with a potentially horrifying loss of self-control, or perhaps control over the external effects of one's thoughts, emotions, and actions. To box with one's shadow is to be of two-minds about something with existential consequences. To peel off one's shadow and fold up into a suitcase (as cartoon cats and Peter Pan did) is to decouple oneself from the consequences of agency, or at least to enact the feeling that such agency is already decoupled.

2. Subtitling as Shadow

Subtitling a movie is a related process of doubling and shadowing, not of a tangible object but of a voice. It is the transposition of the semantic meaning contained in the sound of a voice not only into a different language but into the different modality of thought that is written text.

A subtitle is a kind of shadow but in its secondary relation to the image it can as easily be categorized as a genre of the

caption. A written caption to an image may describe how it was made, who made it, when it was made, how big it is, what happened to it over its lifetime as a contested artifact, etc. In the accumulation of these meta-significations, the caption may also describe what is happening in the image itself and implicitly its meaning. Some captions describe the image in only comparative measurements (date, width, length) while others are more like subtitles, transposing the otherwise uncommunicable *meaning* of what the viewer sees. The latter may come in the form of an ambitious curatorial statement presented alongside the image or an accommodation of accessibility that would, for example, describe the image for a blind museum visitor. The difference between the former and the latter may be uncertain.

There is considerable power in this translation and direction of what something or someone is and what it means. Unlike the shadow which doubles the original unconsciously if also mischievously, the subtitle makes the implicit into the explicit. The angry sounding movie character is not just yelling angry sounds, but specific angry words. The dazzling painting is not just kinetic and vibrant, but seen through the filter of the curatorial statement, turns out to be about the brutality of World War 1.

Augmented reality is a particular kind of digital doubling that works as both a shadow and as a subtitle, and in doing so concentrates many of the critical slippages between person and object, model and agency.

3. What Augments What?

I use the term "augmented reality" (AR) in reference to (1) a specific set of existing and emerging technologies that interact with what a person sees by introducing additional optical artifacts which frame their field of view and/or which have direct semiotic relation to objects or events in the scenario thus framed, and also (2) the phenomenological experience of perceiving the world as a scenario that is filled with objects which may be given this artificial primary or secondary semiotic relation with one another. In its coalescence of human and machine vision, is both the technology for the artificial perception reality and also the reality that the technology artificializes.

The term is used primarily in relation to visual media technologies but could just as well refer to augmented auditory,

tactile, taste, or olfactory realities. For example, a blind person may come to rely upon AR technologies which either provide an alternative medium of vision or which augment their other senses. The difference may be more philosophical than technical. From another perspective, AR is a kind of autonomic spoofing, a deliberate introduction of decoys and false positives into one's own sensory experience. You know it's not real but you act as if it is: a kind of inverse hallucination.

The most conventional genres of AR involve the attachment of indexes, signs and symbols to objects in the field of view. A chair may now have a virtual creature sitting in it. The space at arms length may now be filled with a virtual desktop. The stranger you meet in the street may now arrive with a platform enabled pre-interpretation of their character as friend or enemy. New layers of reality are added to the stage, and existing things appear along with their digital twins, the interpretive space between the object and the shadow partially collapses. A person knows consciously that the augmented animal, vegetable or mineral they see is not really like that, but the effect of being in the moment of the real allows for the same kind of motivated forgetting that a viewer of a subtitled film employs. The latter knows that the yellow words in italics are not floating in front of the characters within the diegetic space of the film and yet losing oneself in the flow of the story also means collapsing the voice heard and text scene into a shared rhythm.

The distinction between the real and the unreal, or metareal, or merely simulated is not always so cut and dry. Of late, several philosophers have reapproached the status of simulation via AR's cousin, virtual reality. They ask: in what ways does the brain perceive VR as third person representations versus as visceral first hand experiences? It would seem a bit of both. Designer Kiiechi Matsuda, whose cinematic visualizations have established a high bar for what AR experiences may enable, for better and worse, considers the animated shadowing of perceived objects in AR as ushering in a new "animism" whereby objects are imbued with novel kinds of implicit agency and personality. For him, this would be a positive and perhaps even spiritual development, but like all forms of animism, the attribution of agency, personhood and narrative meaningfulness to animals or objects also leads to cascades of motivated errors and solipsistic misjudgments.

The collapse of distance between the real and imagined is cognitive, not just technological.

As I suggested at the outset, the augmentation of the object with supplemental interpretive semiotics within AR is exemplary of more fundamental social-infrastructural phenomena of digital twinning, whereby people and things are continuously modeled in relation to their qualities and actions such that the model serves as an interface to the person and object for the outside world. For example, when the user of an AR system is observing the framed scenario and co-interpreting it along with layers of augmented shadows and subtitles they are also being modeled as a user. Their actions within the scenario help build the aggregate profile that individuates each of our digital shadows.

The doubling is a translation layer between the individuated person and the model that indexes their activities in the past and organizes the range of actions they might take in the present by predicting what they are most likely to do in the future. The natural relation between the person and their shadow is complicated by this programmatic recursion. Now one's agency is both the cause and the effect of their digital shadow, while the digital shadow/ profile frames one's scope of action, both causing it and being in turn affected by it. In AR an object is personified through its shadow augmentation, while via platform profiling a person is objectified by their own doubling. Each is a specific instance of a more general phenomenon of digital twinning and personalized simulation which locates the agency of person and object alike. Like a shadowplay for which both the object and the shadow may each stand for the real, the interaction is not simply a direct doubling in any one direction but an active co-contextualization that may be expressive, affective, logistical, manipulative, or weirdly liberating.

4. Shadow Cities

Boxing with your own shadow seems personal, private and phenomenological but it is also a massively distributed infrastructural undertaking; it enrolls entire cities and hemispheres into the loop.

You and I and everyone: we have doubles. Actually we have several of them; they live in caves and in warehouses, far but not too far from here. They are grown from models of our actions,

Allegories of the Digital Shadow: On the Life and Afterlife of Simulations

allegiances, and aspirations. Ultimately, whole cities are built to curate and cater to the doubles. These shadow cities are located in the regional shade of our great vertical metropoles. They tend to be flat, wide and even subterranean, located in anonymous capitals like Prineville, Oregon; Forest City, North Carolina; Altoona, Iowa; Bluffdale, Utah; Ashburn, Virginia; and, of course, Las Vegas, Nevada. The macroeconomics of the user profile requires an urban substrate; my culture prioritizes investment in palaces of personas.

What is and what should be the relation between the city and its shadow? What is and should be the relation between someone and their twins and triplets in the real life multiverse? The latter depends on the contingencies of how our respective cities construct relationships. First the stage, then the actors. At stake is finally what the person in the mirror sees when they look at you, what is and is not "place" as diverse locations are linked together as a matter of course, and increasingly how states not only depend on the governance of model simulations, but how governance *becomes* the production and exercise of proprietary simulations.

Long before the cloud, the history of cities has included both built and unbuilt imaginary ideals. The oscillation between the model and the modeled is not new, but there is a difference between building a city as a realization of a model and building a simulation as the realization of the city. Sometimes the city and its simulation are kept at a strict artificial distance from one another, not unlike the physically interweaving but phenomenologically distinct twin cities of Besźel and Ul Qoma in China Miéville's novel, *The City and The City*. Inhabitants of each may rub shoulders but are trained to be blind to each other's presence and passage.

Other times they collapse into one another directly. As you pass through a security gateway—perhaps at an airport—what is under inspection is not only your physical person, but also trace personas linked to you but which live in one of those near-distant shadow cities. If the man in the uniform lets you pass, it's because a decision was made according to risk models on those silhouettes of which your physical person is a reflection. Your ears may burn as the infrastructure whispers about your doubles, but it's not just you in play.

The whole city governs itself by governing its own simulation. There is not just one double but multiple competing doubles, some are corporate platforms, some are state systems, most are mixtures

of state and private to different degrees. Crucially they do not resolve into one final map and so you have twins on many of them at once not only interacting with you but with one another. Perhaps this multiplication of partial simulations layered on top of one another—this one concerned about security, that one about advertising, that one about traffic efficiency—is what prevents the fragile idealism of any one model from becoming too dominant. It also means, however, that all the persona models linked to you will also not resolve into a single identity. Especially here, you may be the object that casts the shadow, but you are also not whole, only traces and traces.

5. Ghost Cities
Explosive economic growth in China brought a new genre of ghost cities. Places like the Kangbashi District of Ordos, the Yujiapu Financial District near Tianjin, and the Meixi Lake development near Changsha stood ready for an occupation that sometimes came and sometimes didn't. They too are a kind of shadow city— 1:1 scale models of speculative settlement—but other shadow cities are largely empty of humans not by accident but by design.

Some ghost cities are populated by legions of mimetic personas crackling within nearby data centers even as the surrounding hard-shell landscape is largely unpopulated by physical human beings. Any such may be home to hundreds of millions of shadows but only a few dozen workers. This ratio is a sign of things to come. It is a posthuman urbanism in practice but not in theory (even shadow cities came to be a predominant urban form, their progress largely went ignored in architectural schools in the first decades of the century when increasingly fantastic accommodations for human clients took precedence.) This does not mean that shadow cities are actually virtual. To the contrary, the sprawling distribution of factories, ports, container sorting centers, freight airports, as well as the networks of thirsty data centers comprises a discontinuous megacity for objects. To imagine it as numinous is an expensive illusion.

There is "a there there," but this "there" is also right here. When you and I chat and post to one another, I am in one place and you another. We may even be in the same city at the same time, but the conversational point of contact between my persona and yours is, literally and physically, located in a shadow city

where neither of us live. To converse we draw upon shadows and speak to one another through them as masks, casting links between human zones and shadow cities. We sew threads between one another and between places, and in doing so contribute more texture to the model simulations that mediate these circuits: sprawling, interlocking and incommensurate.

Another kind of Chinese shadow city are those populated by ghosts, on whose behalf the living burn Joss paper: simulated money that ancestors will receive in the afterlife. A few years ago there was a major hyperinflation of this ghost currency, with Zimbabwe-scale denominations in circulation, perhaps due to macroeconomic factors on the other side. Not so far away, shadow city data centers operate on an analogous if more secular principle. They are not only haunted, they are purpose-built for the ghosts of "we, the living." We not only house our ghosts there, we monetize them as a core currency of the model simulations we inhabit and which inhabit us, making and burning money as we go.

6. What Will We Call Reality?

Lately, when the topic turns to AR, I ask "what will we call the non-augmented reality?" Again by this I mean not only the non-semiotically layered object but also the sense of the world without preemptive interpretation. Some popular candidates include "baseline reality" and "natural reality." I imagine that there will, in time, be nuanced and politicized schools of thought on the differences between such terminologies and connotations.

Two thousand years ago, Lucretius explained the relationship between what we see and what is out there to be seen as a matter of atomic dust particulates. Objects not only have shadows but shed atoms which land in the eye of the perceiver like spores allowing the object to be seen. For Epicureans, natural vision is already an externalized doubling or perhaps a process built in the explosion of objects into pollinating micro-simulations that are decoded by the receiver to represent the whole of the original. A ghost was a leftover atom from a dead object that landed in one's eye after its origin had passed. Today, the neocortex has made significant progress in understanding itself, presently understanding itself as a form of living matter that is constantly making predictive models of the world around it. What is seen is perceived in relation to what the brain predicts will be there, analogous in some ways to how

personal profiles frame the course of action in relation to recursive predictive models of future options.

What has been set in motion by planetary scale computation is, among many other things, an infrastructure of cognitive simulation. Its most important accomplishments to date—including climate science and the deduction of climate change, and thus indirectly the premise of the Anthropocene and its variants—is itself a project of building massive simulations. Future climatic conditions are generated in relation to models made in the present day of Earth's past which calibrate our confidence that our predictions are valid. The governing questions opened by digital doubling and simulation at this scale are vexed to the core: how can models of the future recursively govern the present such that the underlying planetary conditions that enable them to exist at all do not themselves collapse. It is this potentially final collapse of the model and the real that may haunt all the others as it lurks in the shadows.

How Not To Be Seen—Digital Visuality

기술, 전쟁, 그리고 미술관

Technology, War and Museum

스트라이크
STRIKE
2010

- 단채널 HD 디지털 비디오, 컬러, 사운드,
 28초
- 작가, 앤드류 크랩스 갤러리, 뉴욕 및
 에스더 쉬퍼, 베를린 제공

- SINGLE-CHANNEL HD DIGITAL VIDEO,
 COLOR, SOUND, FLAT SCREEN MOUNTED
 ON TWO FREE STANDING POLES, 28 SEC.
- COURTESY OF THE ARTIST, ANDREW
 KREPS GALLERY, NEW YORK AND ESTHER
 SCHIPPER, BERLIN

- 스태프 STAFF
 CHRISTOPH MANZ

→
《히토 슈타이얼-
데이터의 바다》
전시 전경,
국립현대미술관,
서울, 2022

INSTALLATION VIEW
OF *HITO STEYERL-
A SEA OF DATA*,
NATIONAL MUSEUM
OF MODERN AND
CONTEMPORARY ART,
SEOUL (MMCA),
2022

레이나 소피아
미술관 전시 전경,
마드리드, 2015

INSTALLATION VIEW
OF MUSEO NACIONAL
CENTRO DE ARTE
REINA SOFÍA,
MADRID, 2015

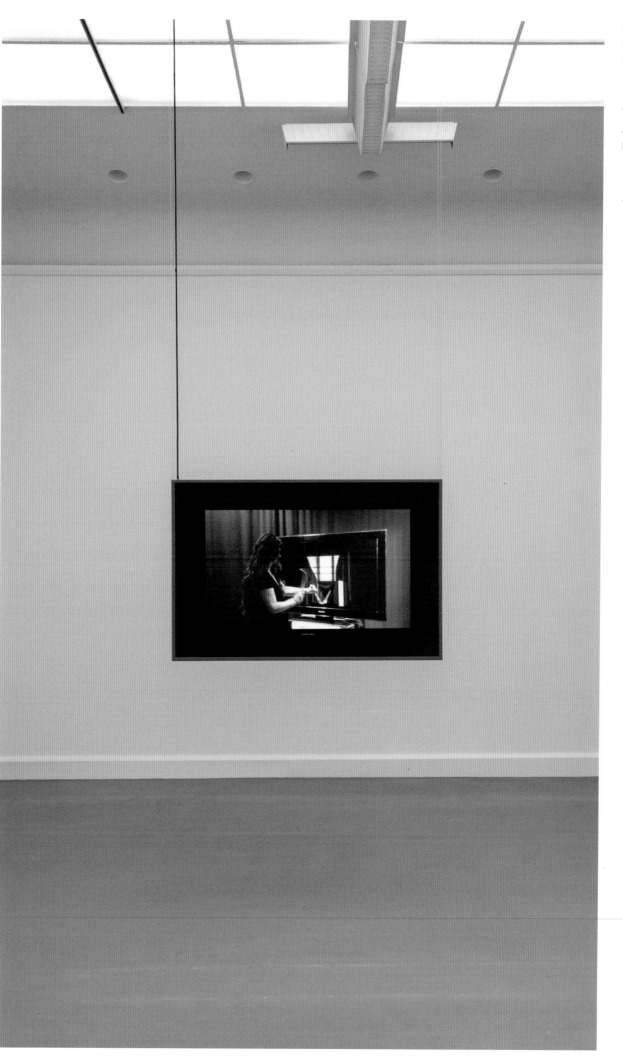

반아베 미술관
전시 전경,
아인트호벤, 2014

INSTALLATION
VIEW OF VAN
ABBEMUSEUM,
EINDHOVEN, 2014

타워
THE TOWER
2015

- 3채널 HD 비디오 설치, 컬러, 사운드,
 6분 55초
- 작가, 앤드류 크랩스 갤러리, 뉴욕 및
 에스더 쉬퍼, 베를린 제공

- THREE-CHANNEL HD VIDEO
 INSTALLATION, COLOR, SOUND,
 ENVIRONMENT, 6 MIN. 55 SEC.
- COURTESY OF THE ARTIST, ANDREW
 KREPS GALLERY, NEW YORK AND ESTHER
 SCHIPPER, BERLIN

- 프로듀서 PRODUCER
 OLEKSIY RADYNSKI
- 촬영 CAMERA
 SAVAS BOYRAZ
- 드론 조종 DRONE FLIGHTS
 HIWA ŞEW
- 설치 공동개발 INSTALLATION
 CO-DEVELOPED WITH
 DAVID RIFF AS WELL AS NICOLAS
 PELZER MAXIMILIAN SCHMOETZER
- 3D 디자인 및 포스트 프로덕션
 3D DESIGN, POST PRODUCTION
 MAXIMILIAN SCHMOETZER
- 포스트 프로덕션, 그래픽 디자인
 POST PRODUCTION, GRAPHIC DESIGN
 HARRY SANDERSON
- 보이스 오버 VOICE-OVER
 VOVA PAKHOLIUK
- 기술 감독 TECHNICAL DIRECTOR
 CHRISTOPH MANZ
- 음악 MUSIC
 KASSEM MOSSE, LIT INTERNET
- 관측 OBSERVATION
 HITO STEYERL
- 영향 INSPIRED BY
 KELLER EASTERLING
- 기금 FUNDED BY
 MUSEO NACIONAL CENTRO DE
 ARTE REINA SOFÍA
- 도움 주신 분 THANKS TO
 OLEG FONAROV AND PROGAM ACE,
 JOAO FERNANDEZ, MANOLO BORJA
 VILLEL, OLEKSIY RADYNSKI, MEHMET
 AKTAS, MITOSFILM, JOSHUA CROWLE

→
《히토 슈타이얼-
데이터의 바다》
전시 전경,
국립현대미술관,
서울, 2022

INSTALLATION VIEW
OF HITO STEYERL-
A SEA OF DATA,
NATIONAL MUSEUM
OF MODERN AND
CONTEMPORARY ART,
SEOUL (MMCA),
2022

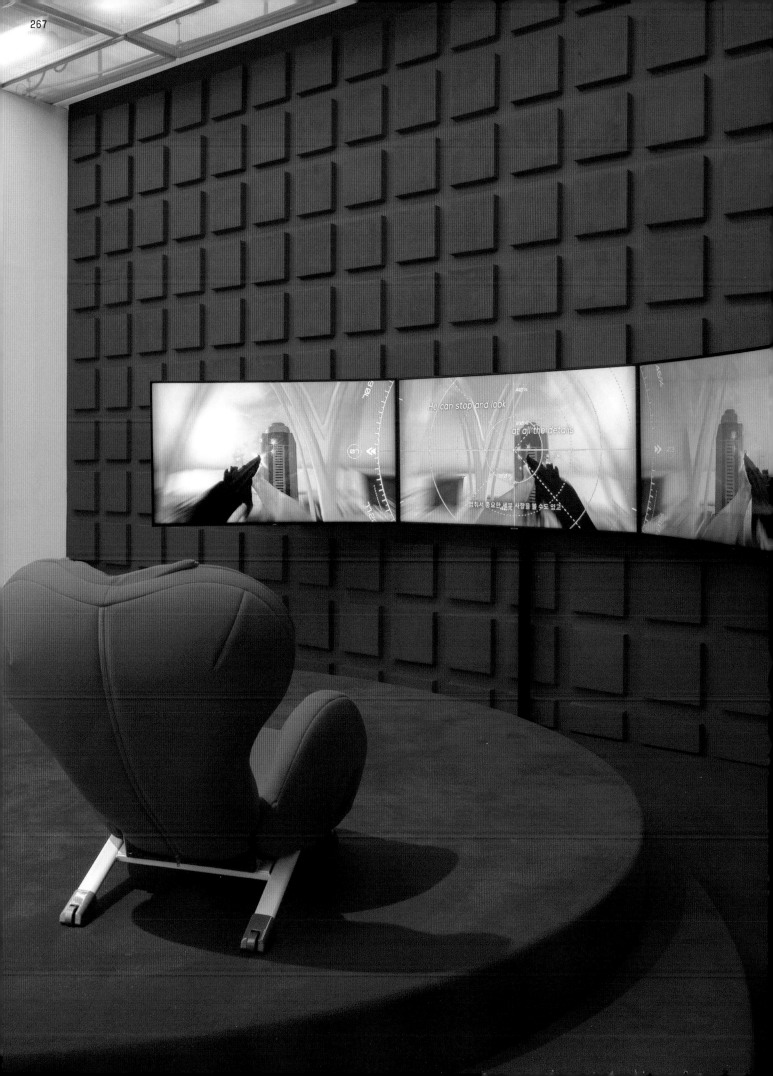

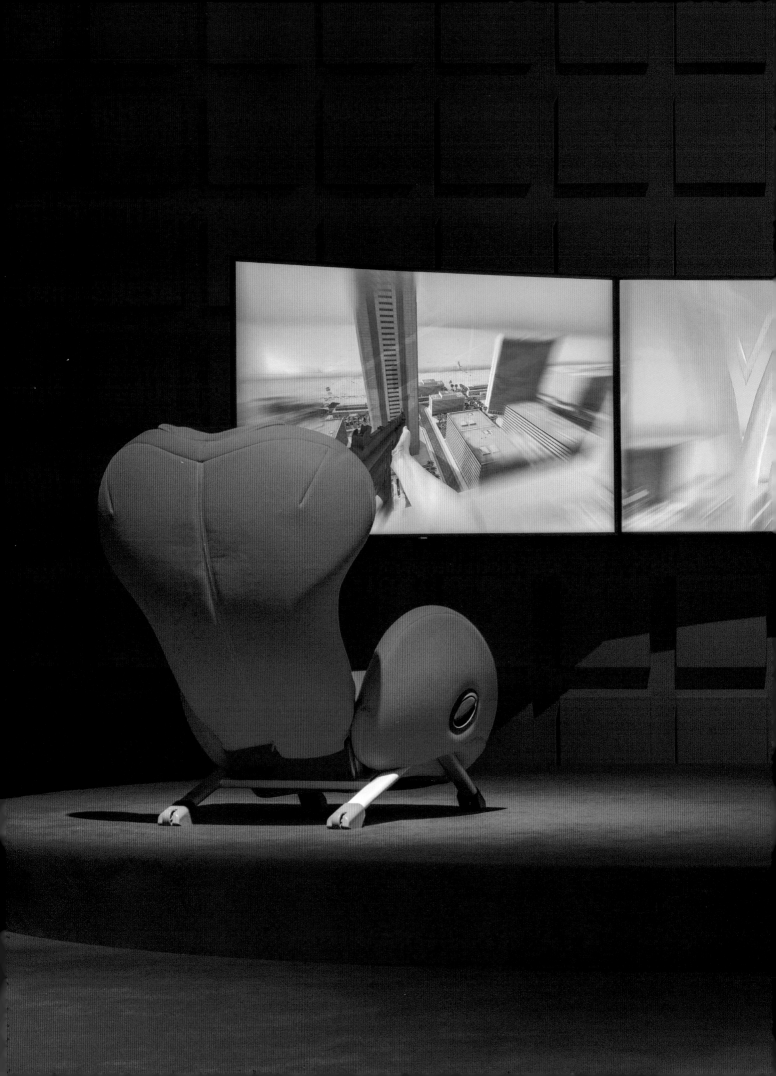

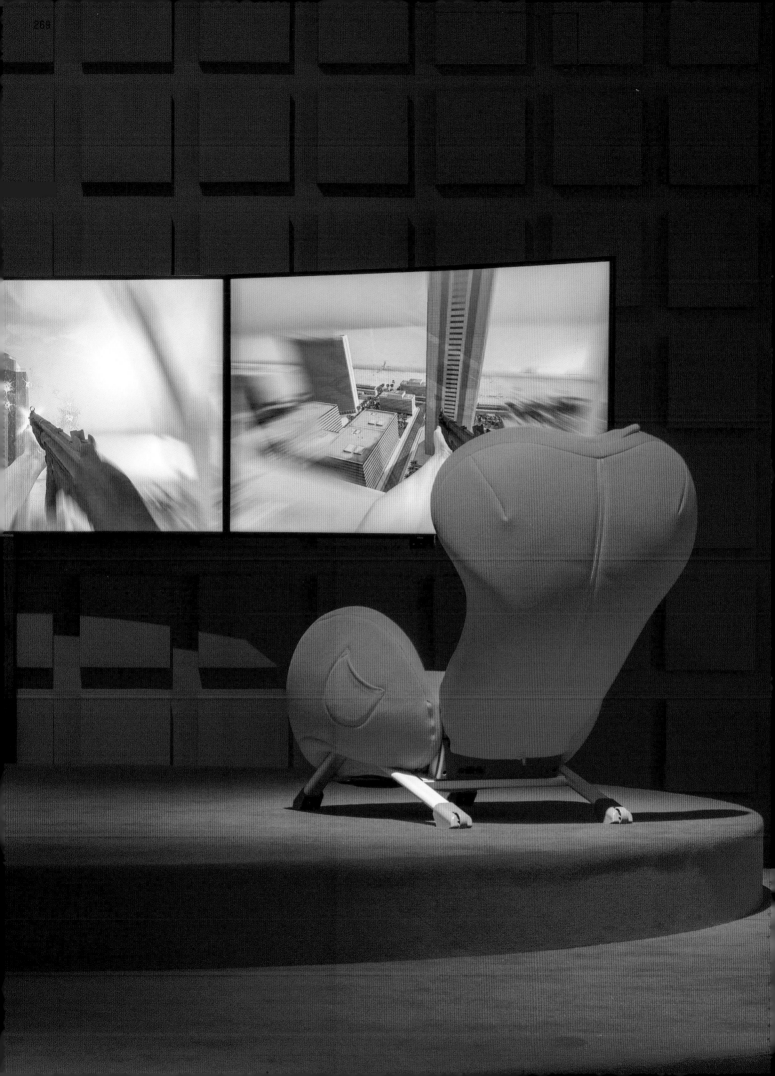

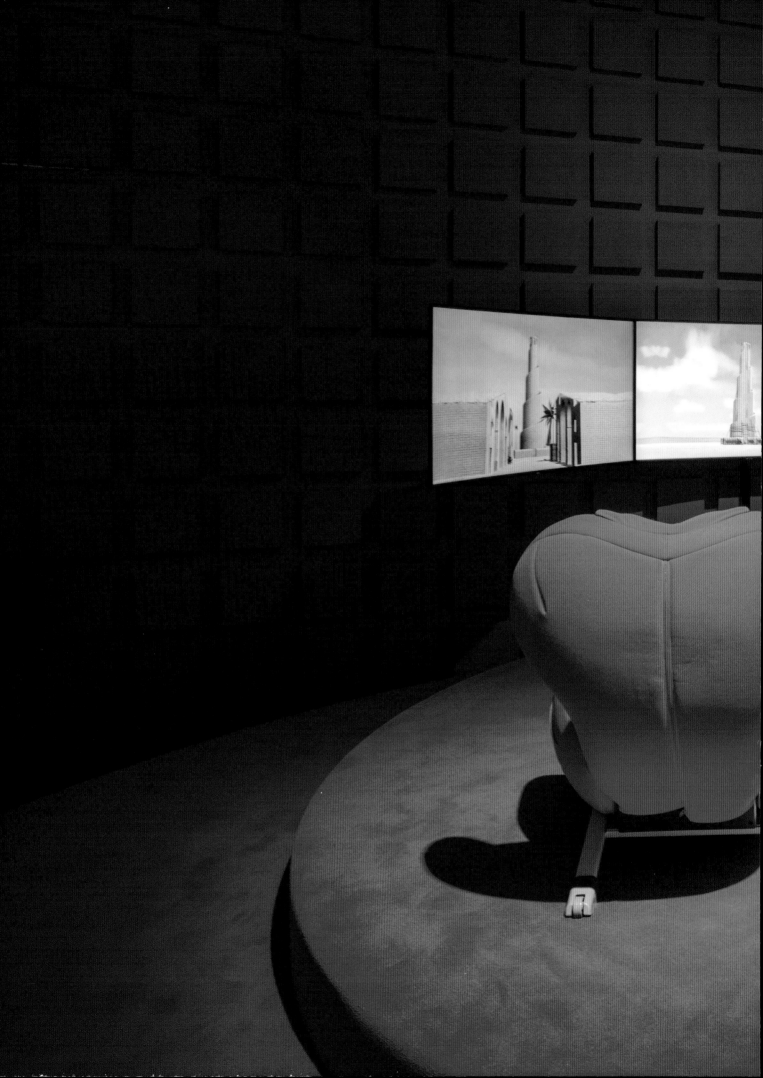

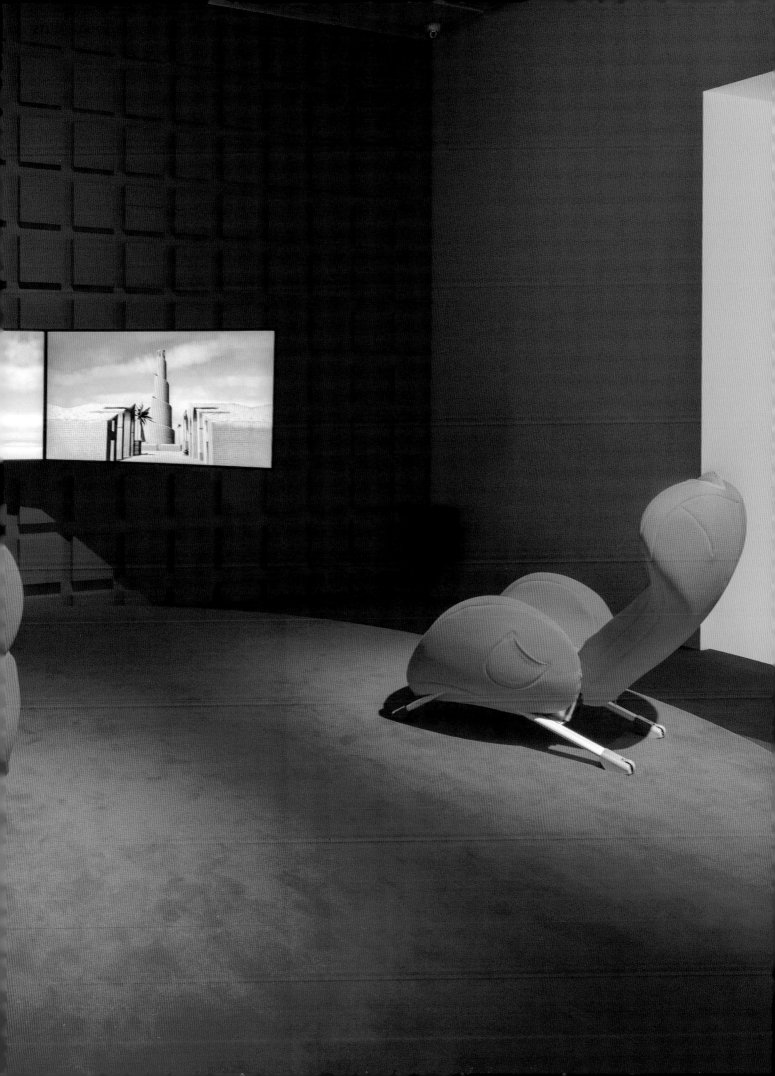

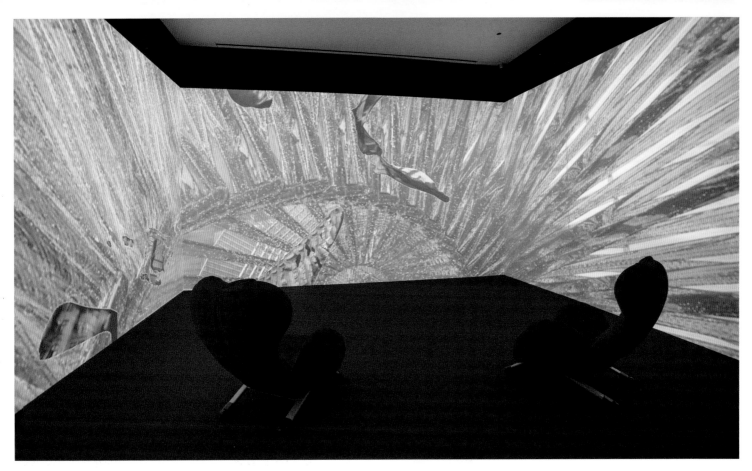

↑ 온타리오 미술관
전시 전경, 토론토,
2019

INSTALLATION VIEW
OF ART GALLERY OF
ONTARIO, TORONTO,
2019

↓ 《TOMORROW IS
THE QUESTION》
전시 전경, 아로스
오르후스 미술관,
오르후스, 2019

INSTALLATION VIEW
OF *TOMORROW IS
THE QUESTION*,
AROS ART MUSEUM,
AARHUS, 2019

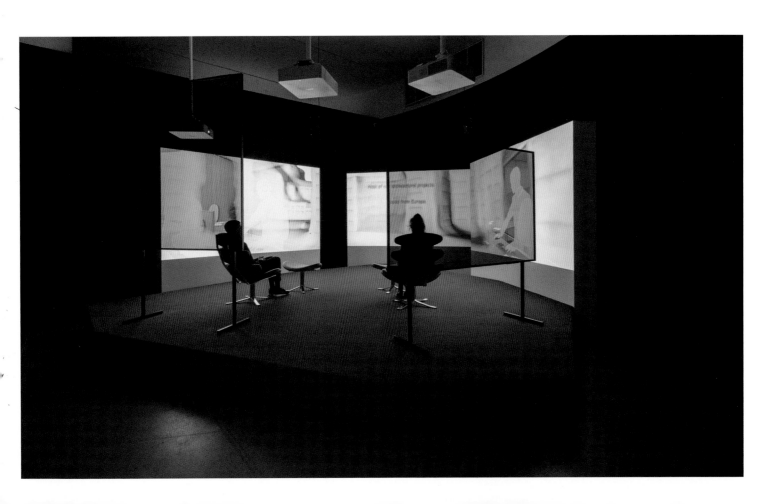

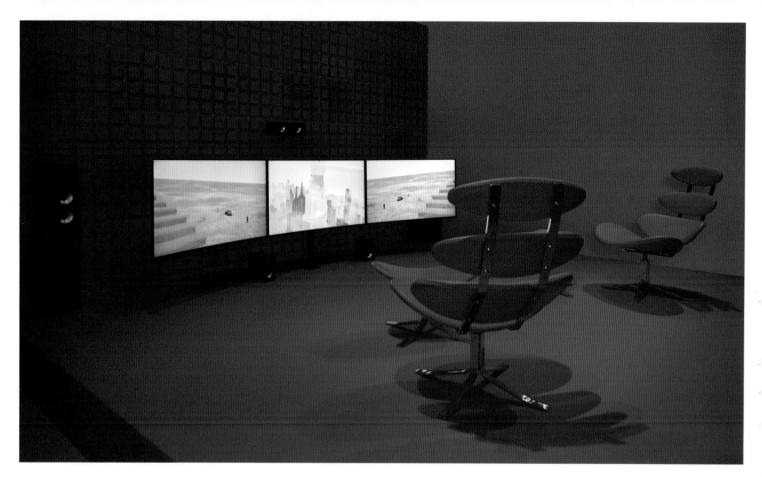

레이나 소피아
미술관 전시 전경,
마드리드, 2015

INSTALLATION VIEW
OF MUSEO NACIONAL
CENTRO DE ARTE
REINA SOFÍA,
MADRID, 2015

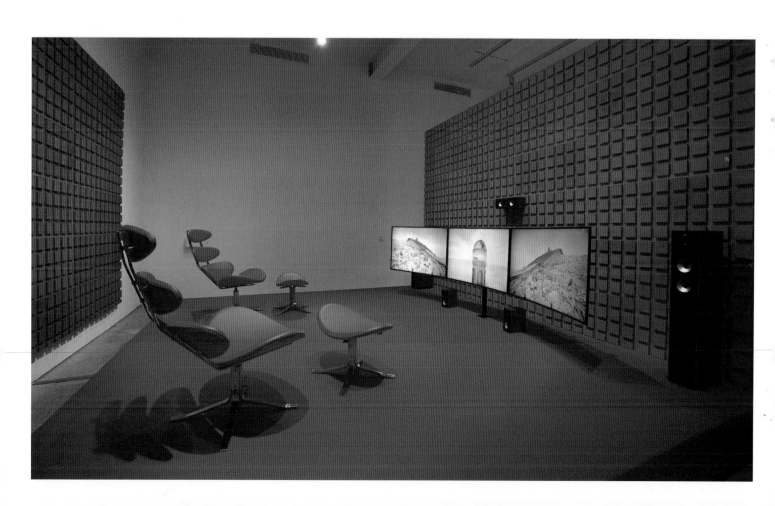

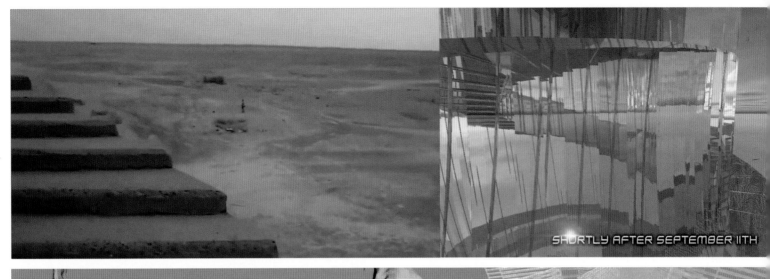

SHORTLY AFTER SEPTEMBER 11TH

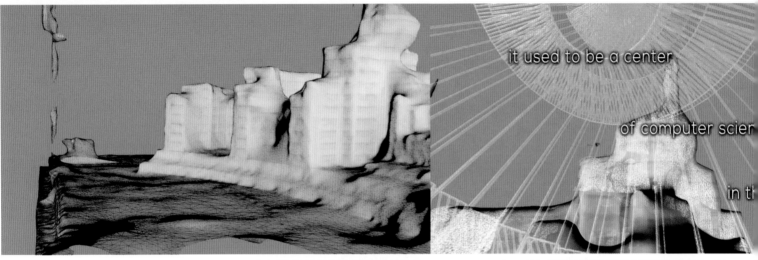

it used to be a center

of computer scier

in tl

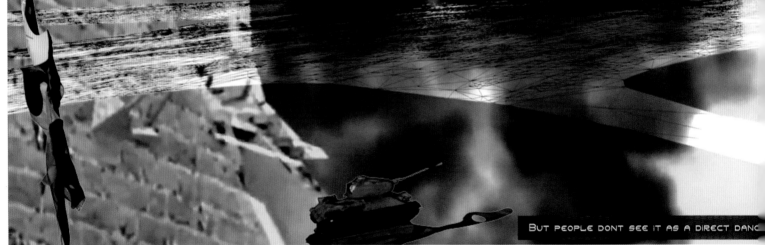

BUT PEOPLE DONT SEE IT AS A DIRECT DANG

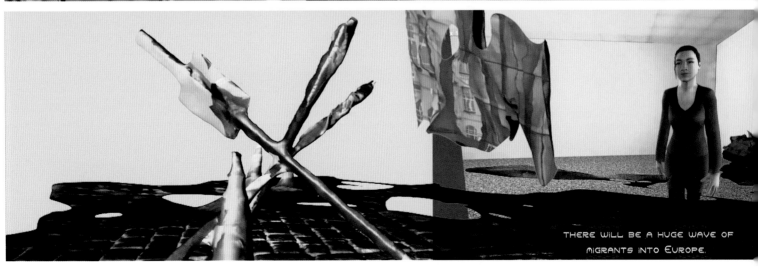

THERE WILL BE A HUGE WAVE OF MIGRANTS INTO EUROPE.

HELL YEAH WE FUCK DIE
2016

- 비디오 설치
⟨HELL YEAH WE FUCK DIE⟩, 2016, 3채널
HD 비디오, 컬러, 사운드, 4분 35초
⟨오늘날의 로봇⟩, 2016, 단채널 HD
비디오, 컬러, 사운드, 8분 2초
- 작가, 앤드류 크랩스 갤러리,
뉴욕 및 에스더 쉬퍼, 베를린 제공

- VIDEO INSTALLATION, ENVIRONMENT
HELL YEAH WE FUCK DIE, 2016,
THREE-CHANNEL HD VIDEO, COLOR,
SOUND, 4 MIN. 35 SEC.
ROBOTS TODAY, 2016, SINGLE-CHANNEL
HD VIDEO, COLOR, SOUND, 8 MIN.
2 SEC.
- COURTESY OF THE ARTIST, ANDREW
KREPS GALLERY, NEW YORK AND ESTHER
SCHIPPER, BERLIN

⟨HELL YEAH WE FUCK DIE⟩
HELL YEAH WE FUCK DIE
- 원본 사운드트랙
ORIGINAL SOUNDTRACK BY
KASSEM MOSSE, BASED ON RESEARCH
BY DAVID TAYLOR IDENTIFYING THE 5
MOST POPULAR WORDS IN ENGLISH SONG
TITLES SINCE 2010
- 포스트 프로덕션 POST PRODUCTION
CHRISTOPH MANZ, MAXIMILIAN
SCHMOETZER
- 라인 프로듀서 LINE PRODUCER
LAWREN JOYCE
- 프로듀서 및 촬영 감독
PRODUCER AND DIRECTOR PHOTOGRAPHY
CALIFORNIA ROBOTIC CHALLENGE
KEVAN JENSON
- 어시스턴트 ASSISTANT
MILOS TRAKILOVIC
- 로봇 푸시 회복 실험, 인공지능 낙하
시뮬레이션 및 이족 보행 영상 등
도움 주신 분 ROBOT PUSH RECOVERY,
AI FALLING SIMULATION AND BIPEDAL
GAIT FOOTAGE WITH MANY THANKS BY
DR. IMAD ELHAJJ (VISION AND
ROBOTICS LABORATORY, AMERICAN
UNIVERSITY OF BEIRUT), SIYUAN
FENG (THE ROBOTICS INSTITUTE,
CARNEGIE MELLON UNIVERSITY),
THOMAS GEIJTENBEEK, NOEL MAALOUF
(VISION AND ROBOTICS LABORATORY,
AMERICAN UNIVERSITY OF BEIRUT),
NATURAL MOTION, MIT DARPA ROBOTICS
CHALLENGE TEAM, MICHIEL VAN DE
PANNE, FRANK VAN DER STAPPEN,

SEEDWELL MEDIA, BENJAMIN STEPHENS,
WPI-CMU DARPA ROBOTICS CHALLENGE
TEAM, ZHIBIN (ALEX) LI (UNIVERSITY
OF EDINBURGH SCHOOL OF INFORMATICS)
E ATRIAS ROBOT (OREGON STATE
UNIVERSITY TERRESTRIAL ROBOTICS
ENGINEERING & CONTROLS LAB,
VIRGINIA TECH)
- 댄서 DANCERS
IBRAHIM HALIL SAKA, VEDAT BILIR,
SEZER KILIÇ
- 도움 주신 분 THANKS TO
ALICE CONCONI, ANDREW KREPS,
GUNNAR WENDEL, ESME BUDEN
- 커미션 COMMISSIONED BY
THE FUNDAÇÃO BIENAL DE SÃO PAULO

⟨오늘날의 로봇⟩
ROBOTS TODAY
- 촬영 CAMERA
SAVAŞ BOYRAZ
- 번역 TRANSLATION
ROJDA TUGRUL, ÖVÜL Ö. DURMUŞOĞLU
- 프로덕션 PRODUCTION
MISAL ADNAN YILDIZ, ŞENER ÖZMEN
- 제작 지원 SUPPORT
BARIŞ ŞEHITVAN, ZELAL ÖZMEN,
SÜMER KÜLTÜR MERKEZI DIYARBAKIR
- 주연 PROTAGONISTS
NEVIN SOYUKAYA (ARCHAEOLOGIST,
RESEARCHER, WRITER, HEAD OF THE
DEPARTMENT CULTURAL HERITAGE AND
TOURISM, DIYARBAKIR), ABDULLAH
YAŞIN (RESEARCHER, WRITER, CIZRE)
- 댄서 DANCERS
IBRAHIM HALIL SAKA, VEDAT BILIR,
SEZER KILIÇ
- 음악 MUSIC
KASSEM MOSSE
- 포스트 프로덕션 POST PRODUCTION
CHRISTOPH MANZ, MAXIMILIAN
SCHMOETZER
- 어시스턴트 ASSISTANT
MILOŠ TRAKILOVIĆ
- 도움 주신 분 THANKS TO
ALICE CONCONI, ANDREW KREPS,
SÜMER KÜLTÜR MERKEZI, DIYARBAKIR
SANAT MERKEZI, GUNNAR WENDEL,
ESME BUDEN

→
《히토 슈타이얼-
데이터의 바다》
전시 전경,
국립현대미술관,
서울, 2022

INSTALLATION VIEW
OF *HITO STEYERL-
A SEA OF DATA*,
NATIONAL MUSEUM
OF MODERN AND
CONTEMPORARY ART,
SEOUL (MMCA),
2022

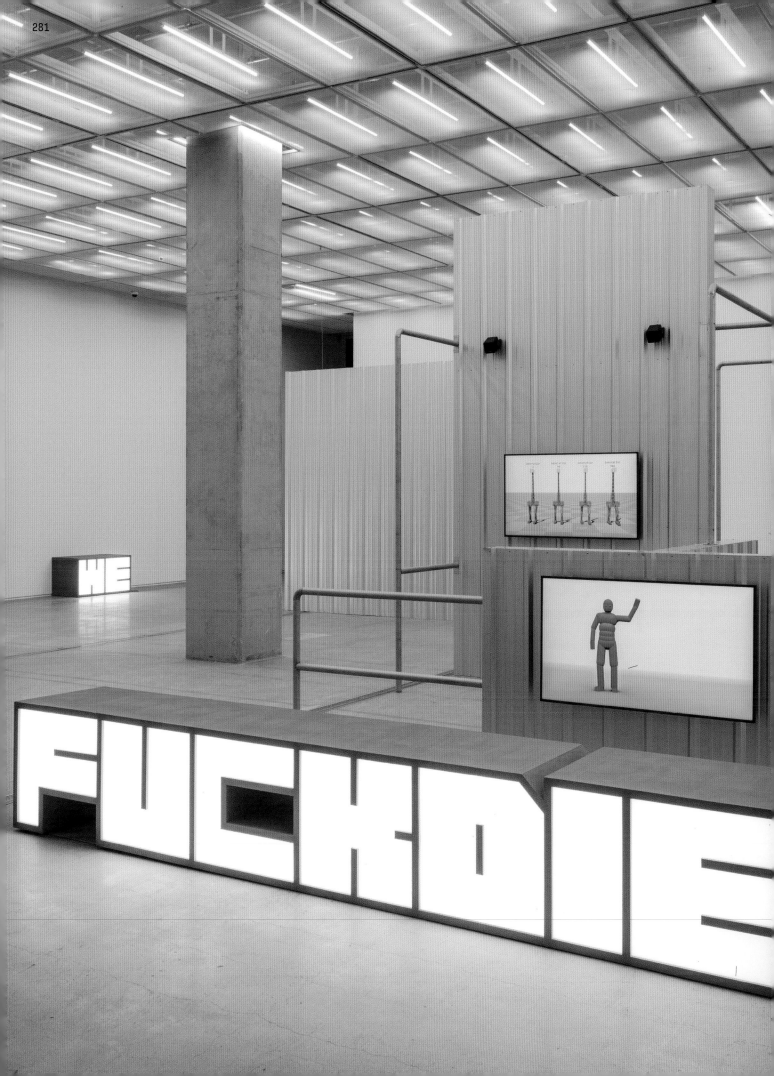

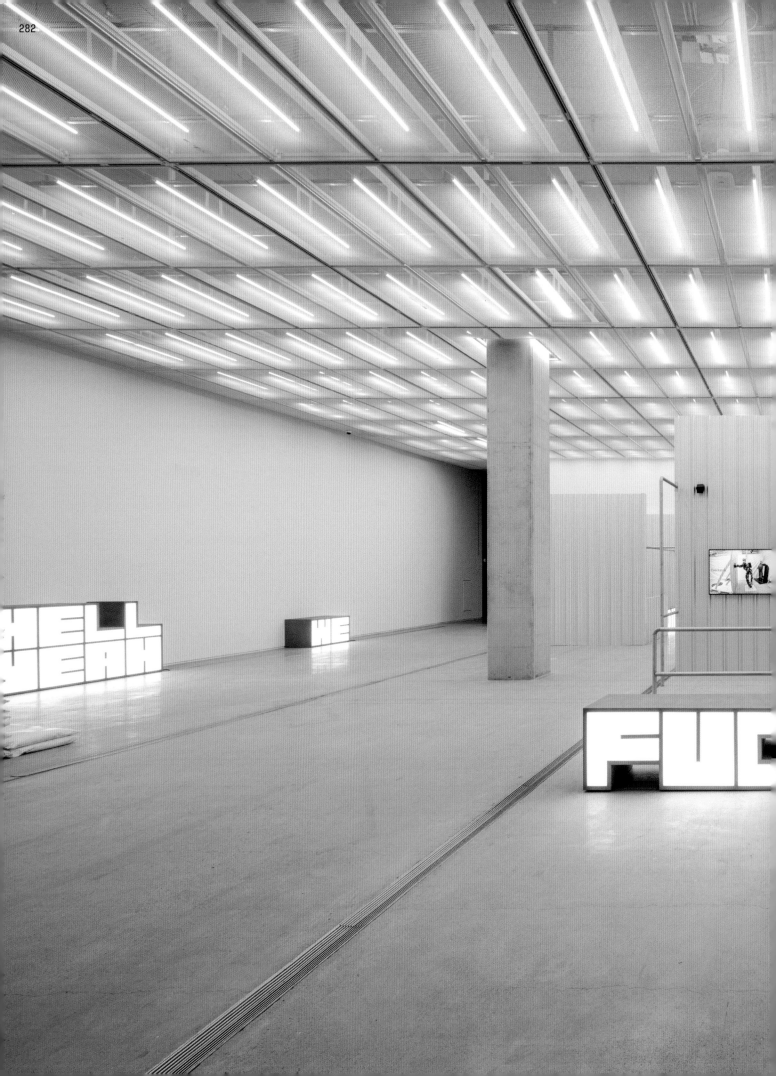

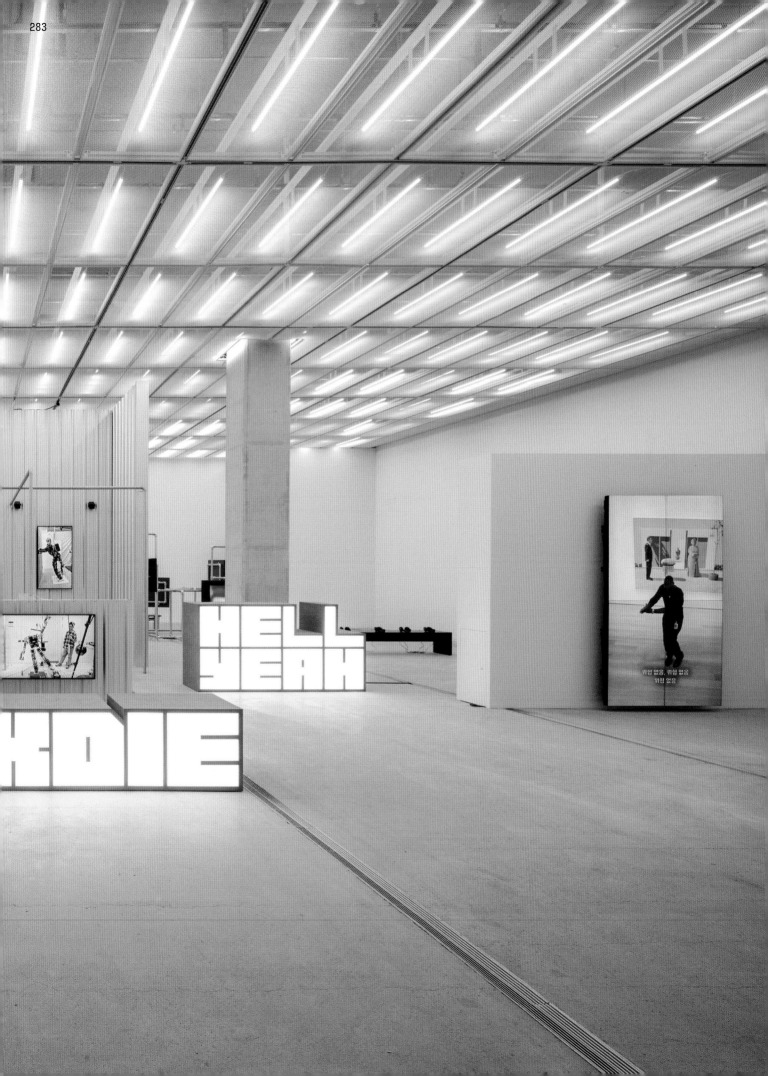

Generation
20

Generation
80

Generation
999

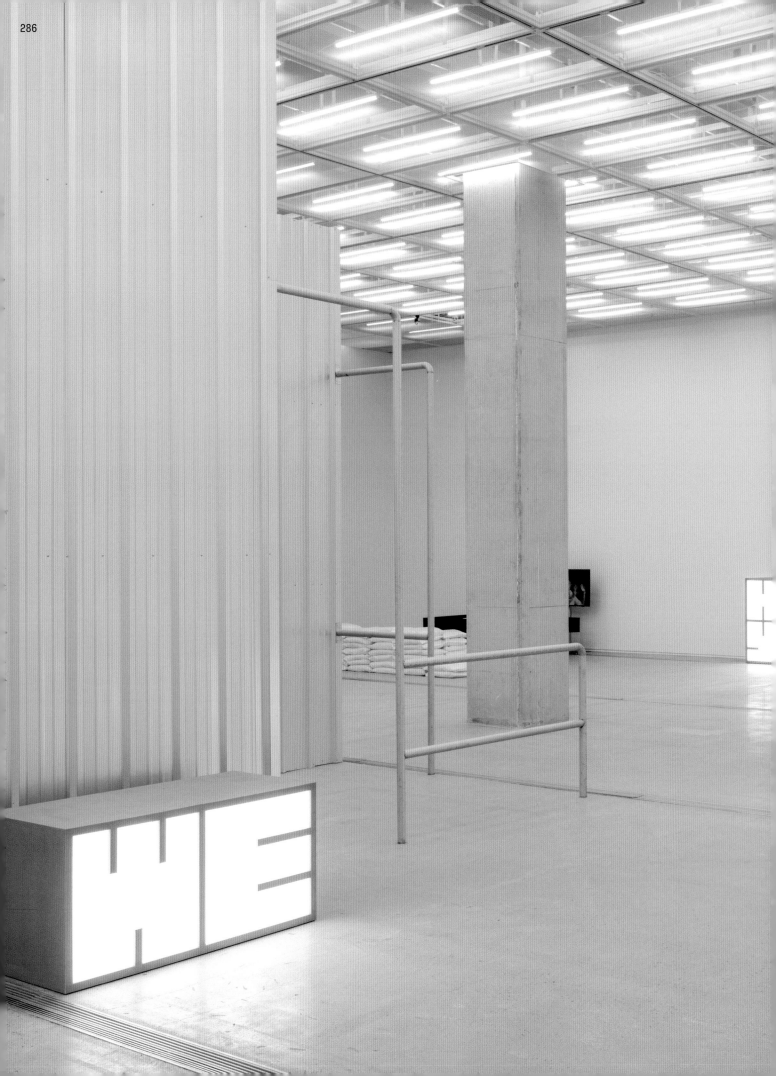

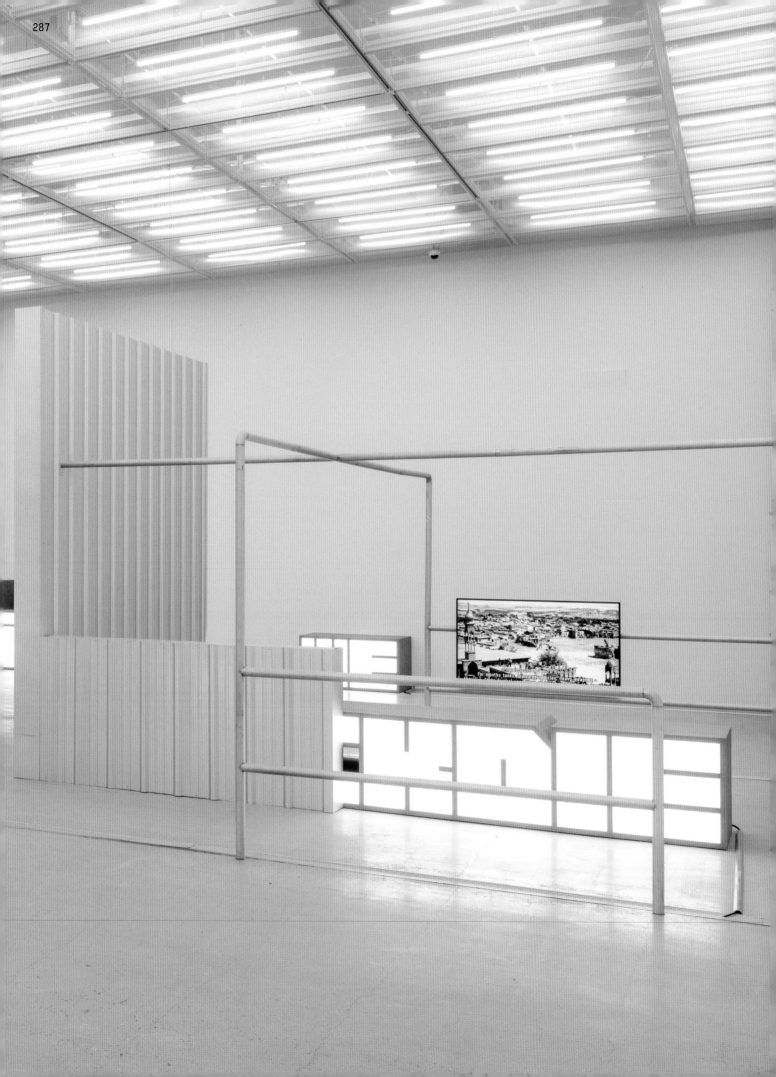

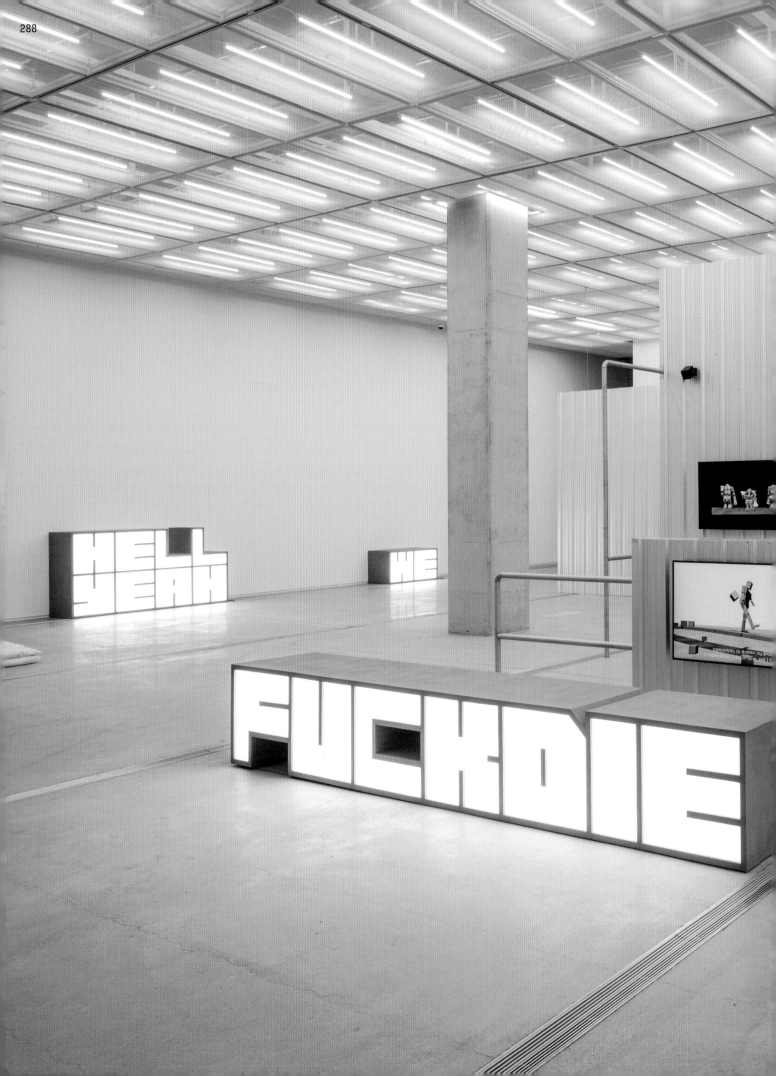

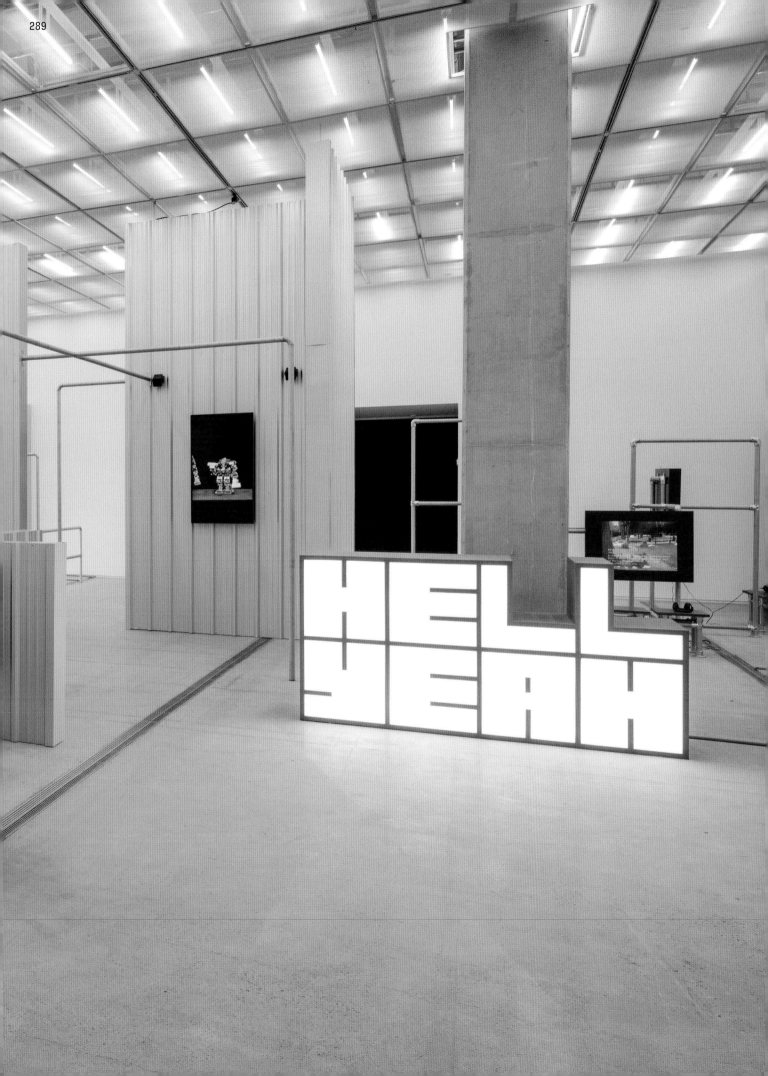

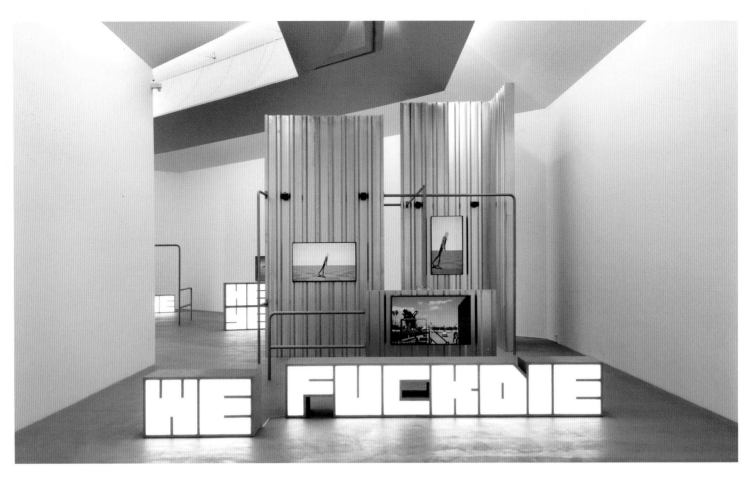

쿤스트뮤지엄 바젤 INSTALLATION VIEW
전시 전경, 바젤, OF KUNSTMUSEUM
2018 BASEL, 2018

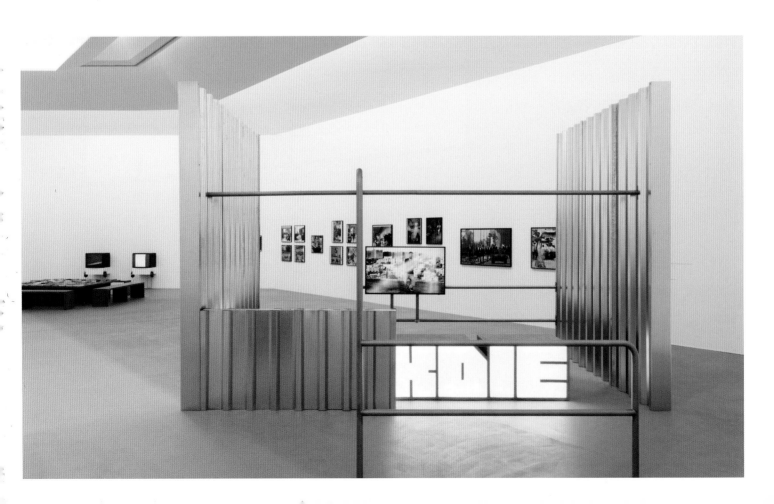

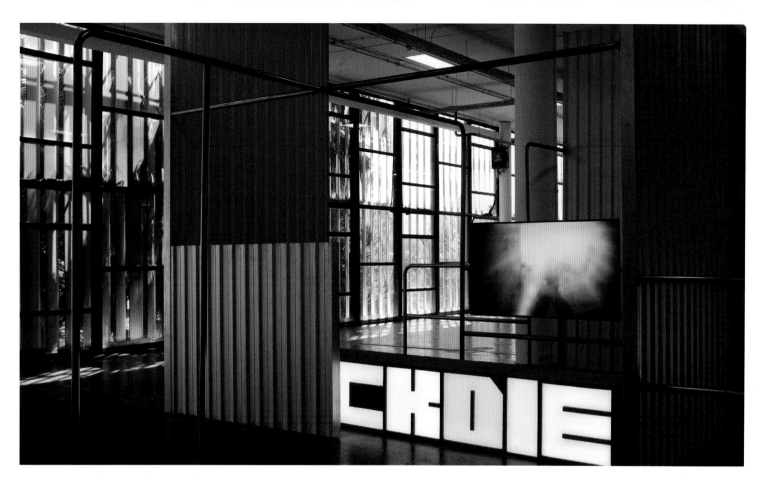

제32회 상파울루
비엔날레 전시 전경,
2016

INSTALLATION VIEW
OF 32ND BIENAL DE
SÃO PAULO, 2016

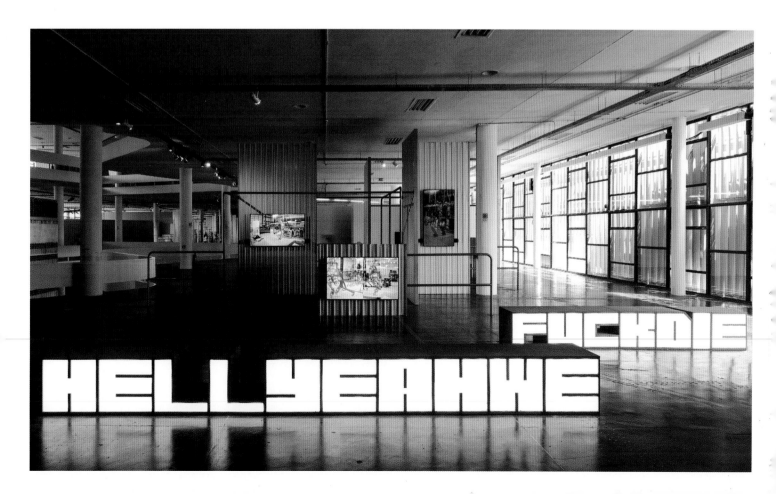

뮌스터 조각 프로젝트
전시 전경, 2017

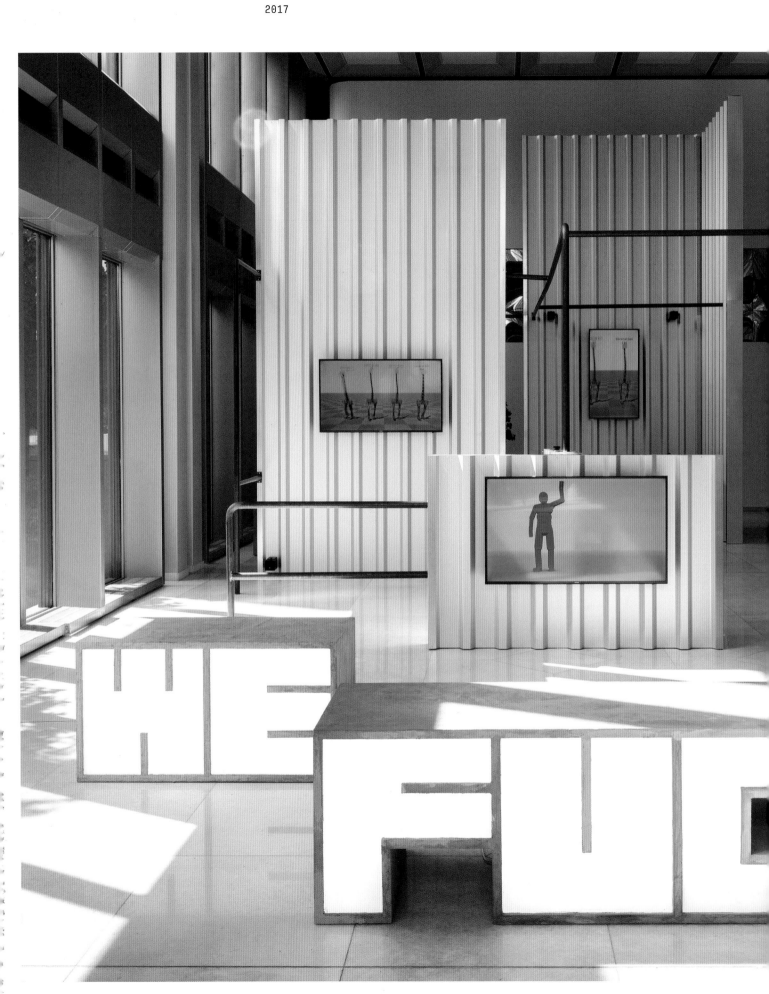

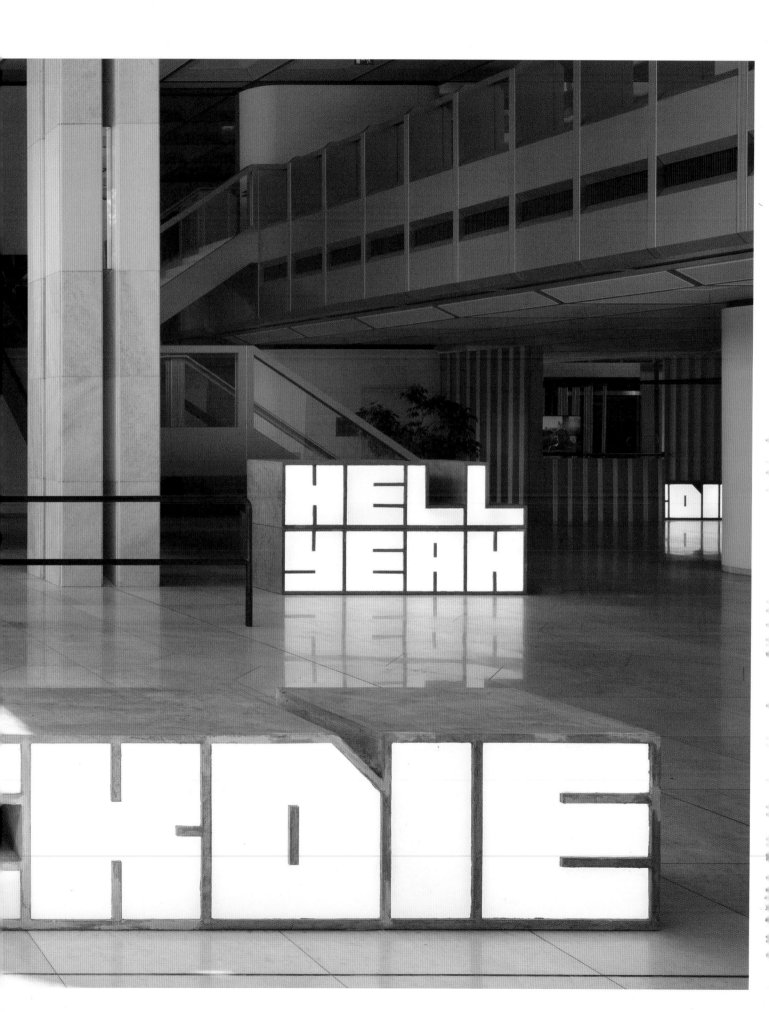

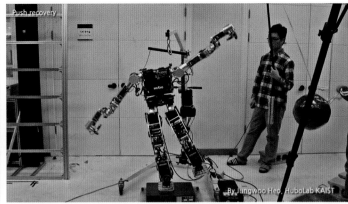

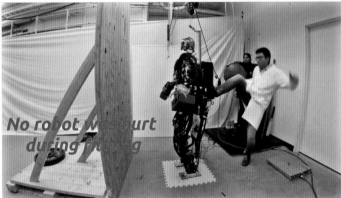

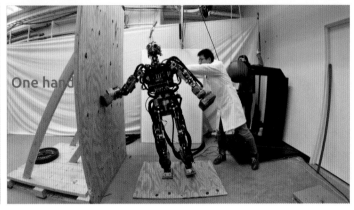

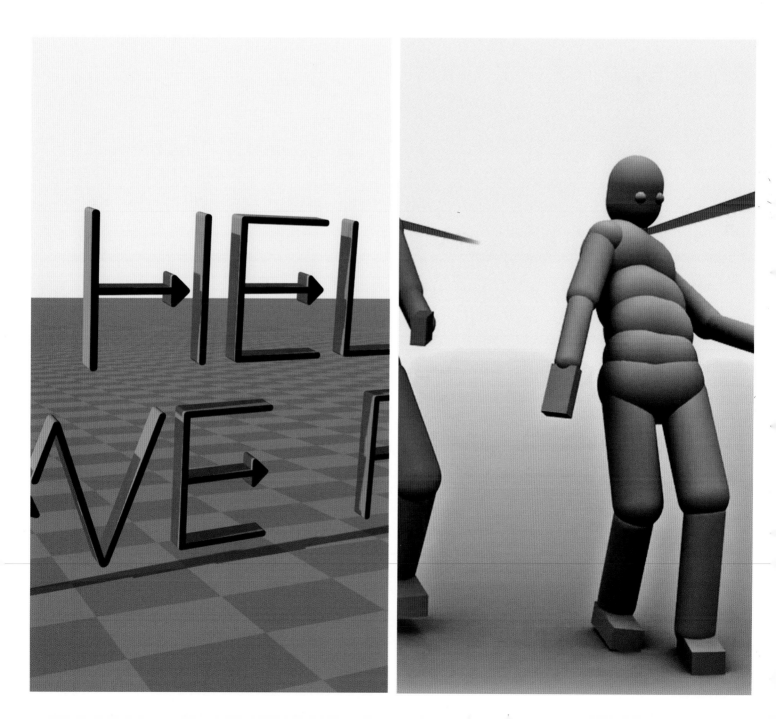

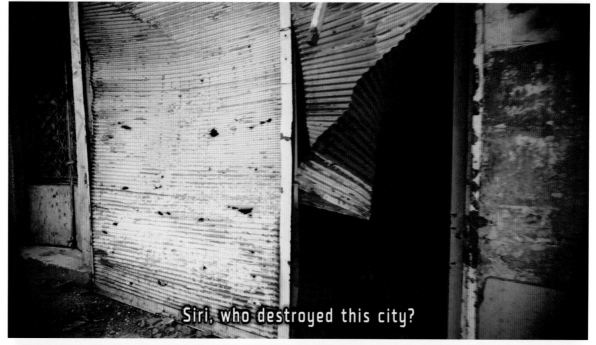

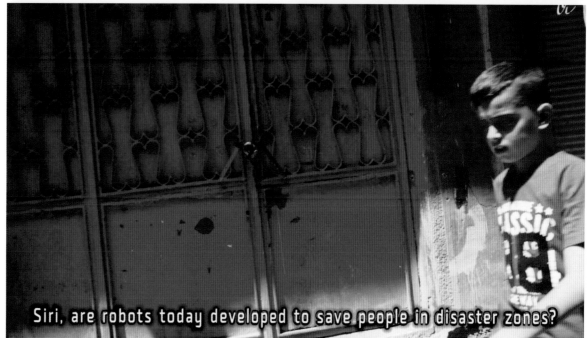

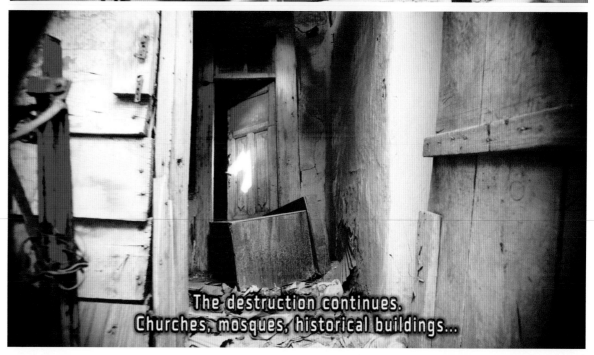

프로토타입1.0과 1.1
PROTOTYPE 1.0 AND 1.1
2017

- 폼, 알루미늄, 55.9×121.9×400.1CM,
 167×41.9×20CM
- 작가, 앤드류 크랩스 갤러리,
 뉴욕 및 에스더 쉬퍼, 베를린 제공

- FOAM AND ALUMINUM,
 55.9×121.9×400.1CM, 167×41.9×20CM
- COURTESY OF THE ARTIST,
 ANDREW KREPS GALLERY, NEW YORK
 AND ESTHER SCHIPPER, BERLIN

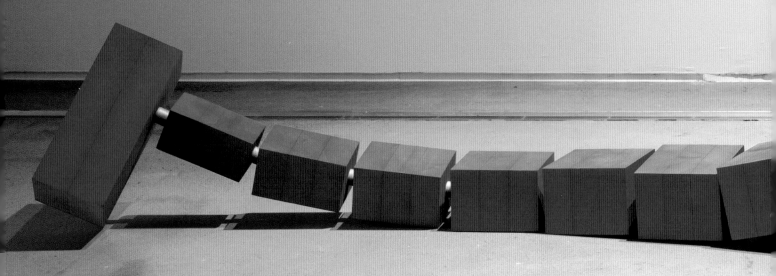

《히토 슈타이얼–
데이터의 바다》
전시 전경,
국립현대미술관,
서울, 2022

INSTALLATION VIEW
OF *HITO STEYERL–
A SEA OF DATA*,
NATIONAL MUSEUM
OF MODERN AND
CONTEMPORARY ART,
SEOUL (MMCA),
2022

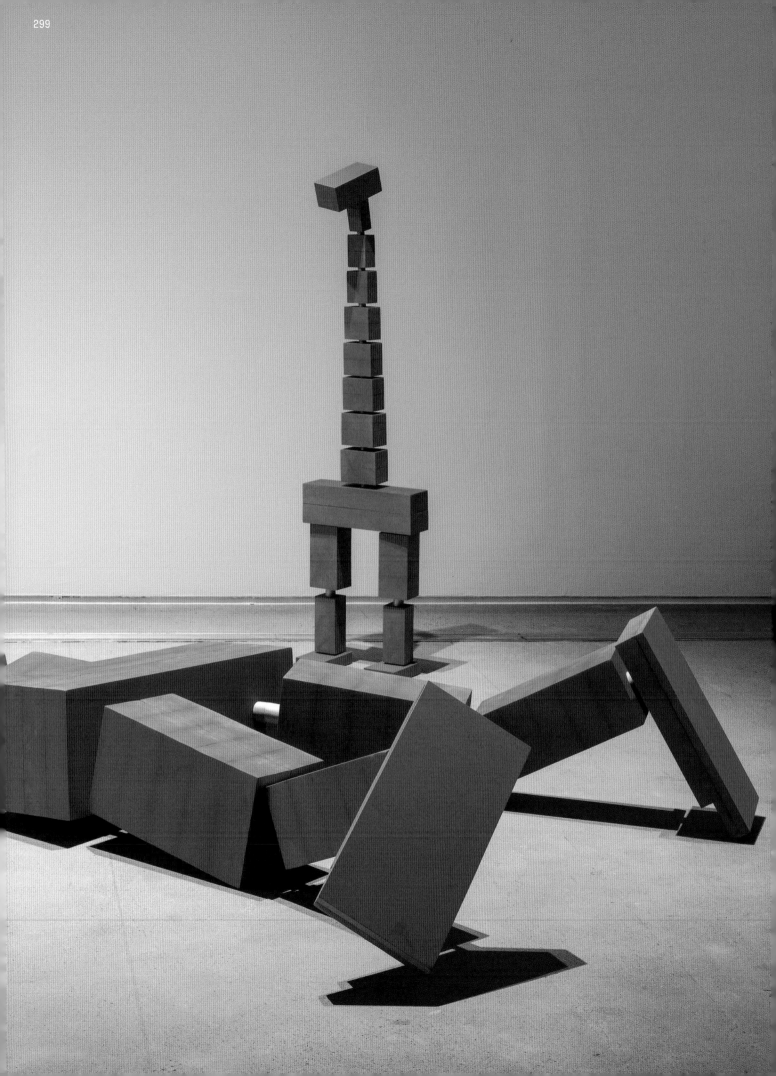

면세 미술
DUTY FREE ART
2015

· 뉴욕, 아티스트 스페이스에서 진행한
강연 기록(2015년 3월), 3채널 HD 디지털
비디오, 컬러, 사운드, 샌드박스,
38분 21초
· 작가 소장

· DOCUMENTATION OF A LECTURE GIVEN
AT ARTISTS SPACE, NEW YORK, MARCH
2015, THREE-CHANNEL HD DIGITAL
VIDEO, COLOR, SOUND, SANDBOX,
38 MIN. 21 SEC.
· COURTESY OF THE ARTIST

· 촬영 CAMERA
CHRISTOPH MANZ
· 어시스턴트 ASSISTANTS
MICHA AMSTAD, SAVAS BOYRAZ,
SALIH SELIM, LEYLA TOPRAZ
· 제작 지원 SUPPORTED BY
HEAD, GENEVA; HENDRIK FOLKERTS,
LO SCHEMO DEL ARTE FLORENCE;
STEDELIJK MUSEUM AMSTERDAM; FRANK
WESTERMEIER
· 도움 주신 분 THANKS TO
RICHARD BIRKETT, OVUL DURMOSOGLU,
FULYA ERDEMCI, ADAM KLEINMAN,
AYA MOUSSAWI, THE MOVING MUSEUM
ISTANBUL, SENER ÖZMEN, SIMON
SAKHAI, AND ANTON VIDOKLE

→
《히토 슈타이얼-
데이터의 바다》
전시 전경,
국립현대미술관,
서울, 2022

INSTALLATION VIEW
OF *HITO STEYERL-
A SEA OF DATA*,
NATIONAL MUSEUM
OF MODERN AND
CONTEMPORARY ART,
SEOUL (MMCA),
2022

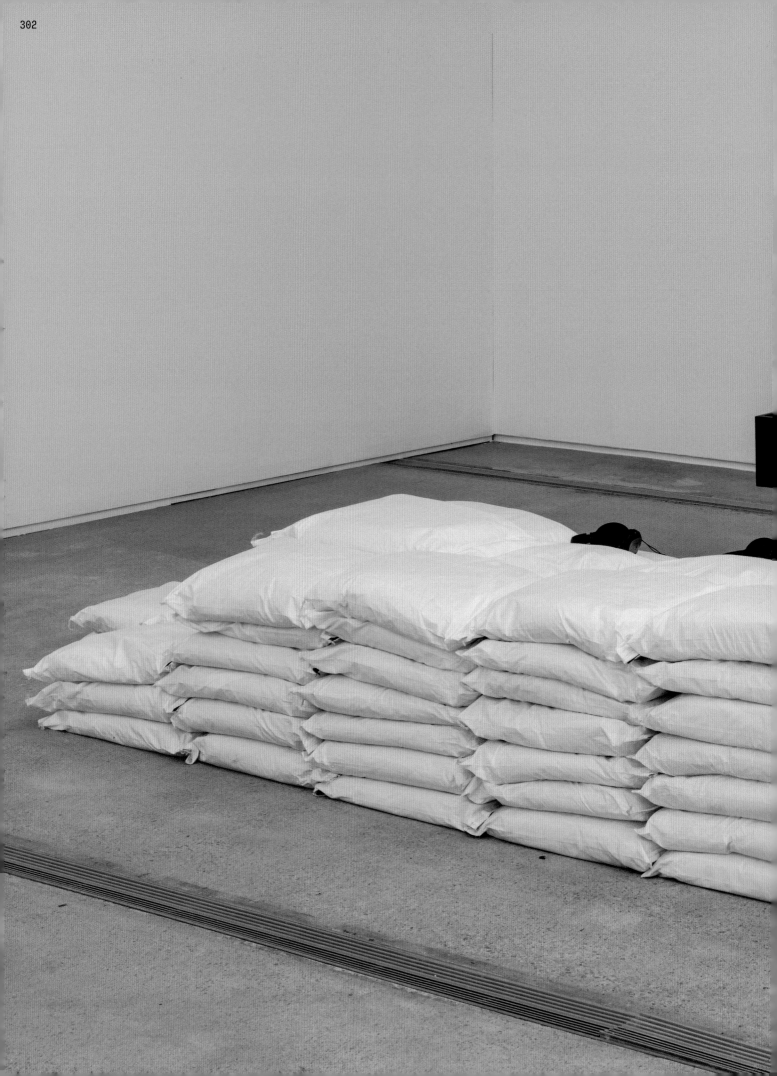

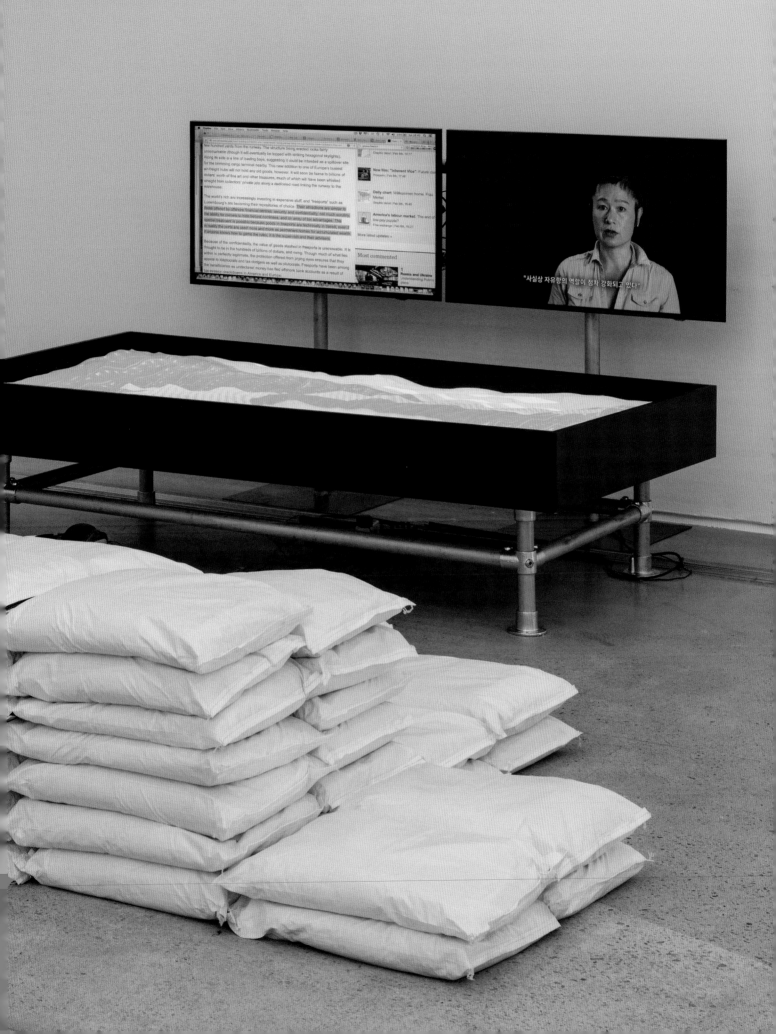

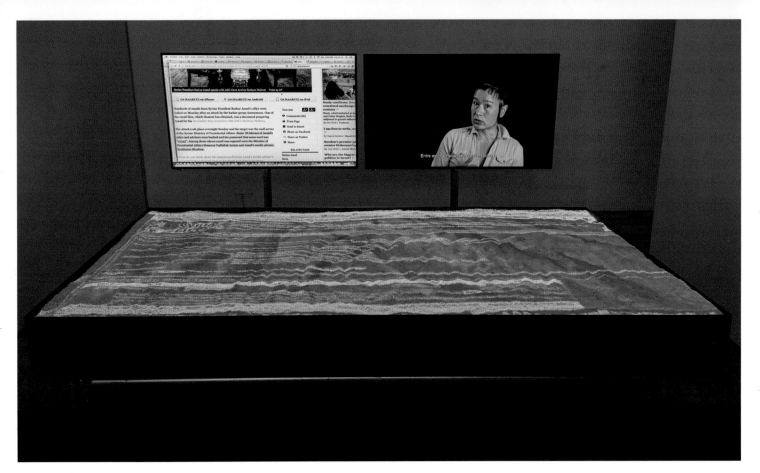

레이나 소피아 미술관
전시 전경,
마드리드, 2015

INSTALLATION VIEW
OF MUSEO NACIONAL
CENTRO DE ARTE
REINA SOFÍA,
MADRID, 2015

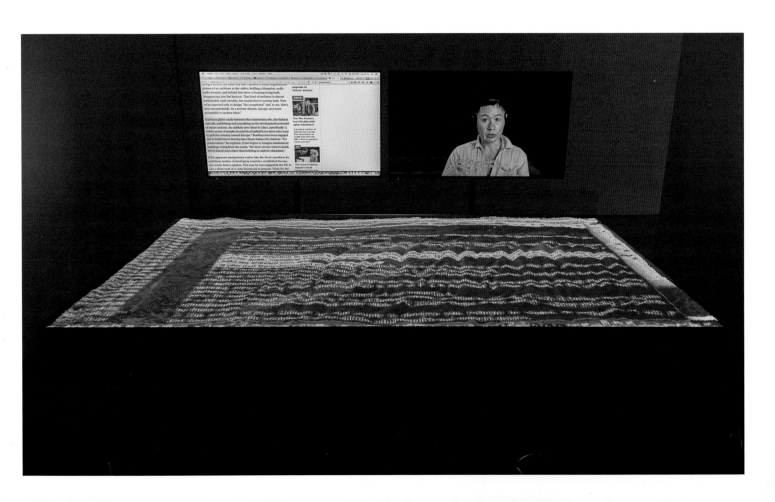

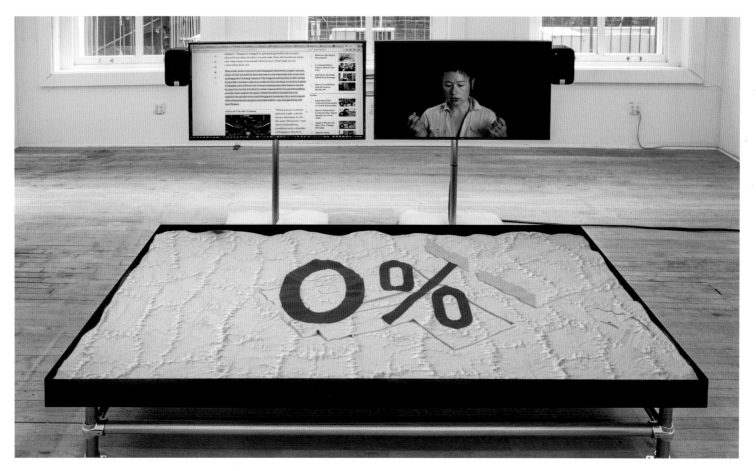

아티스트 스페이스
전시 전경, 뉴욕,
2015

INSTALLATION VIEW
OF ARTISTS SPACE,
NEW YORK, 2015

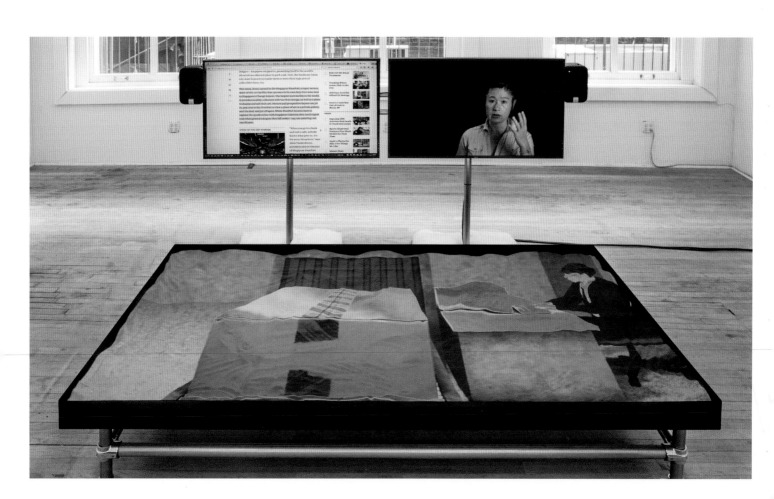

2 of 8

HIDE CAPTION ⌄

In a contrast with its staid Swiss competitors, the Singapore FreePort mixes in some style with the security. The lobby is spanned by a Ron Arad sculpture, "Cage sans Frontieres" (Cage Without Borders), that made a stop at New York's Museum of Modern Art on its way to Singapore. SINGAPORE FREEPORT

Enter the Singapore FreePort, with its 24-7 access and capacity for everything from art and jewelry to vintage cars and fine wine and cigars.

Designed by Swiss architects, Swiss engineers and Swiss security experts, the 270,000-square-foot facility is part bunker, part gallery. Unlike the free-port facilities in Switzerland, which are staid yet secure warehouses, the Singapore FreePort sought to combine security and style. The lobby, showrooms and furniture were designed by contemporary designers Ron Arad and Johanna Grawunder. A gigantic arcing sculpture by Mr. Arad, titled "Cage sans Frontières," (Cage Without Borders) spans the entire lobby. Paintings that line the exposed concrete walls lend the facility the air of a gallery.

Private rooms and vaults, barricaded by seven-ton doors, line the corridors. Near the lobby, private galleries give collectors a chance to view or show potential buyers their art under museum-quality spotlights. A planned second phase will double the size of the facility

경호원들
GUARDS
2012

- 단채널 HD 비디오, 컬러, 사운드, 20분
- 작가, 앤드류 크랩스 갤러리,
 뉴욕 및 에스더 쉬퍼, 베를린 제공

- SINGLE-CHANNEL HD VIDEO, COLOR,
 SOUND, 20 MIN.
- COURTESY OF THE ARTIST, ANDREW
 KREPS GALLERY, NEW YORK AND ESTHER
 SCHIPPER, BERLIN

- 주연 PROTAGONISTS
 RON HICKS, MARTIN WHITFIELD, COREY
 BURAGE, MODESTO CORREA, DARRELL
 EVANS
- 촬영 감독 DIRECTOR OF PHOTOGRAPHY
 KEVAN JENSON
- 돌리 그립 DOLLY GRIP
 JORDAN CAMPAGNA
- 제작 PRODUCED BY
 LISA DORIN, BEN THORP BROWN,
 TRACY PARKER
- 프로덕션 매니저 PRODUCTION MANAGER
 TRACY PARKER
- 조감독 ASSISTANT DIRECTOR
 BEN THORP BROWN, ALWIN FRANKE
 (BERLIN)
- 편집 EDITING
 CRISTOVAO DOS REIS (ASSISTED BY
 MARIA FRYCZ)
- 포스트 프로덕션 및 영상 합성
 POST PRODUCTION AND COMPOSITING
 CHRISTOPH MANZ
- 설치 개발 ORIGINAL
 INSTALLATION DEVELOPED BY
 DIOGO PASSARINHO AND
 YULIA STARTSEV FOR STUDIO MIESSEN
- 제작 PRODUCED BY
 ART INSTITUTE OF CHICAGO
- 경호 역할 SECURITY
 HITO STEYERL

→
《히토 슈타이얼-
데이터의 바다》
전시 전경,
국립현대미술관,
서울, 2022

INSTALLATION VIEW
OF *HITO STEYERL-
A SEA OF DATA*,
NATIONAL MUSEUM
OF MODERN AND
CONTEMPORARY ART,
SEOUL (MMCA),
2022

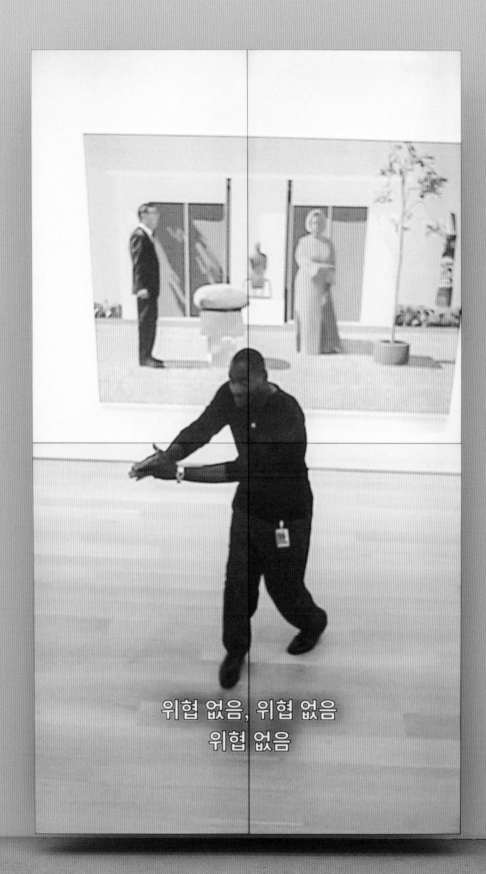

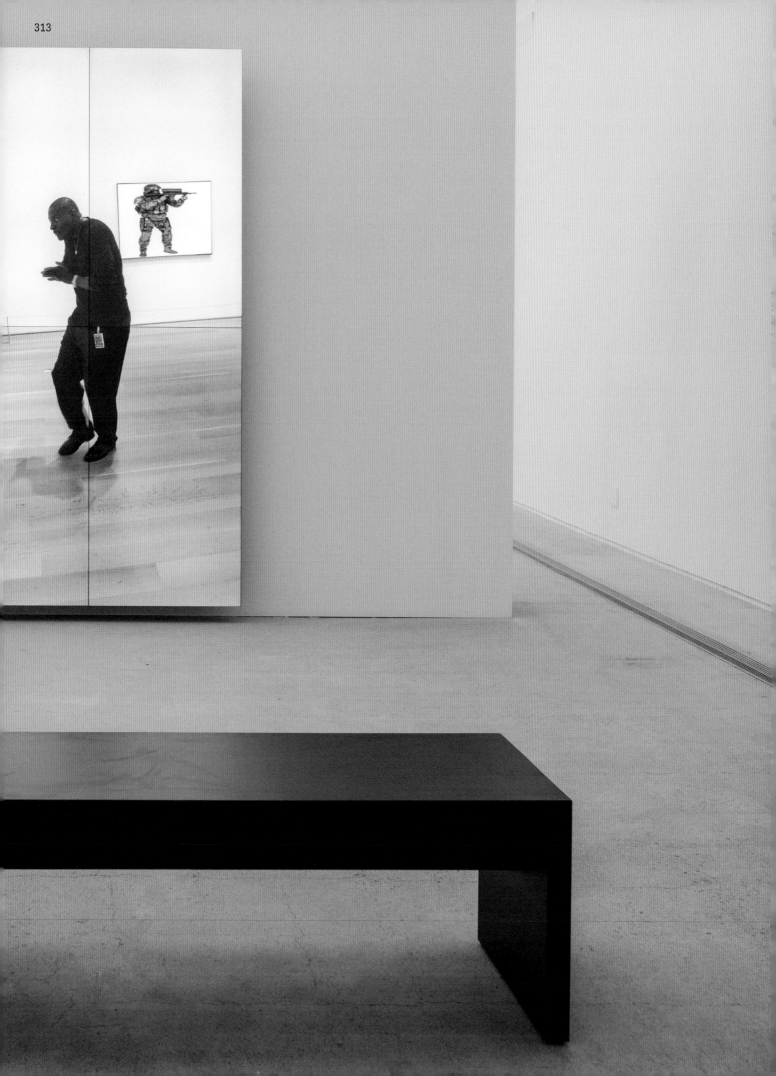

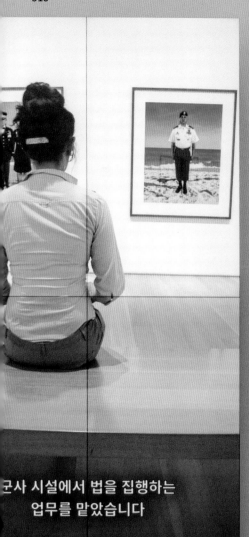

군사 시설에서 법을 집행하는
업무를 맡았습니다

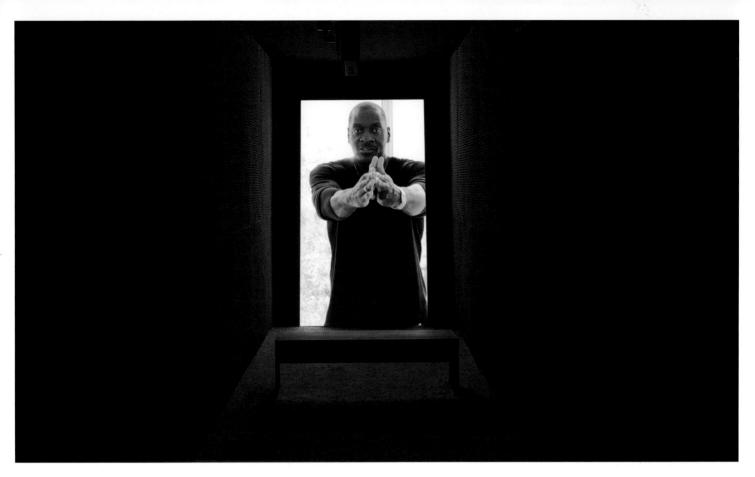

아티스트 스페이스 INSTALLATION VIEW
전시 전경, 뉴욕, OF ARTISTS SPACE,
2015 NEW YORK, 2015

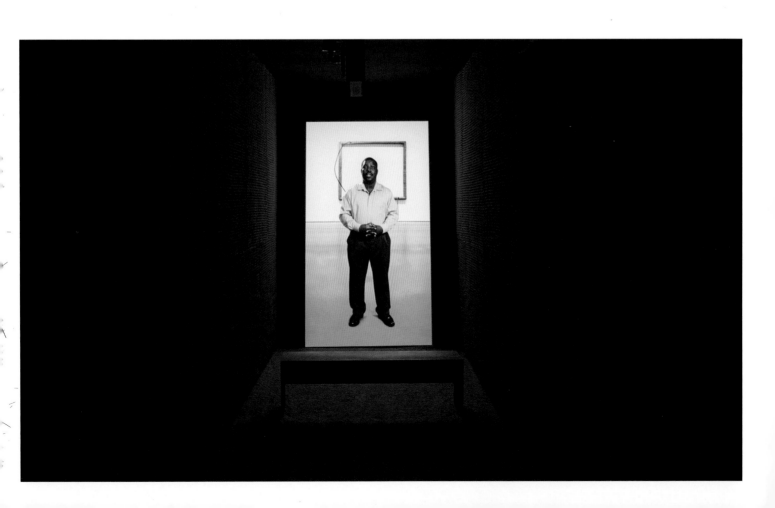

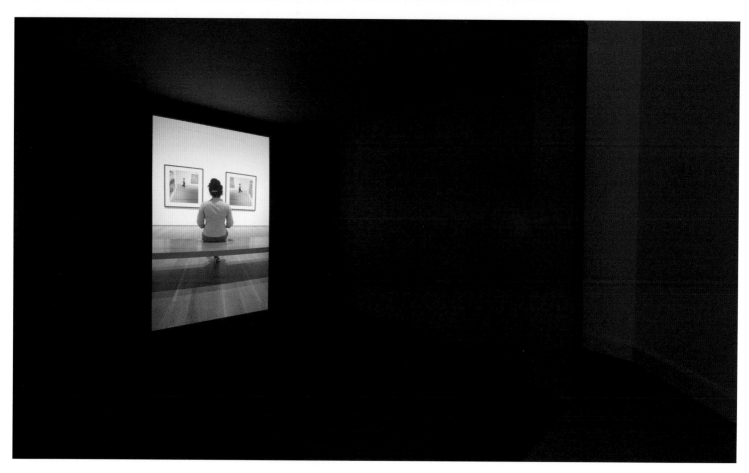

반아베 미술관 INSTALLATION
전시 전경, VIEW OF VAN
아인트호벤, 2014 ABBEMUSEUM,
 EINDHOVEN, 2014

면세 미술에서 벗어나기

웬디 희경 전

Escaping Duty Free Art

Wendy Hui Kyong Chun

2017년 출간된 히토 슈타이얼의 선집『면세 미술: 지구 내전 시대의 미술』[1]은 오늘날 뮤지엄이 직면한 가장 힘든 질문 중 하나를 제기한다. 즉, 부동산 투기와 비대칭 전쟁, 신자유주의적 뮤지엄, 파시즘의 부상에 장악된 시대에 뮤지엄을 비롯한 문화 기관들은 무엇을 할 수 있고, 어떤 역할을 하고 있는가? 슈타이얼은 이러한 난제를 탐구함에 있어 돈세탁과 투기, 점차 늘어나는 전 지구적 불평등에서 동시대 미술과 미술 기관들이 맡고 있는 역할을 강조하고 미술가와 미술 기관, 일반 대중에게 더 나은 미래를 상상하고 구현하도록 요청한다. 슈타이얼은 우리가 주체라는 점을 일깨워 준다. 우리에게는 선택권이 있다는 이야기다. 우리가 파시즘과 불평등을 스스로 받아들이지 않는 이상, 그것은 불가피한 일이 아니다.

1
Hito Steyerl, *Duty Free Art: Art in the Age of Planetary Civil War* (London and New York: Verso, 2017).

히토 슈타이얼은 우리에게 길을 보여 주기 위해 놀이와 반복, 투사를 통해 일어날 법한 미래를 생성해 낸다. 그의 글을 모아 둔 이 책의 모든 장(章)은 에세이라는 말의 진정한 의미를 따른다. 즉, 이 책에 실린 글들은 무언가를 시작하고자 하는 시도이다. 파울 클레와 몬티 파이선, 톰 크루즈와 카를 마르크스, 비디오 게임과 뮤지엄 등 서로 교차하는 루프와 놀라운 병치를 통해 예상치 못한 통찰력을 창출하는 것이다. 결정적으로 슈타이얼은 탈출의 순간을 만들기 위해 역설을 창출한다. 우리는 그러한 역설을 증폭시킨 뒤 그것과 함께 이동함으로써 모순을 넘어선다.

예를 들어, 슈타이얼은 지구 내전 시대에 뮤지엄은 "끝장났다 (all over)."고 주장한다. 즉, 전통적 형태의 국가적 뮤지엄은 지나간 과거의 산물이며(끝장났으며), 그저 도처에(모든 곳에[all over]) 존재할 뿐이라는 이야기다. 뮤지엄의 경계는 이제 새어 나오고 있으며, 유토피아적인 것처럼 보이는 앙드레 말로의 '벽 없는 뮤지엄' 개념 뒤에 숨겨진 악몽을 드러낸다. 전 지구적 미술품 경매는 출처가 의심스러운 자금을 세탁하며, 우크라이나 국립박물관에 유물로 보관 중이던 '골동품' 러시아 탱크는 탄약이 떨어진 21세기의 친러시아 반군에 의해 다시 차출된다. 폐쇄적인 19세기식의 국가적 뮤지엄은 국가 공간을 초월하는 전 지구적 아트페어와 자유항의 미술품 수장고에 의해 대체되었다. 제네바와 같은 여러 도시의 산업용 건물에 자리한 자유항의 수장고에는 엄청난 양의 동시대 미술 작품들이 두서없이 보관되어 있다.

슈타이얼은 이와 같은 새로운 전 지구적 공간의 영향을 파악하기 위해 베네딕트 앤더슨의 논의를 수정한다. 앤더슨은 국가 차원의 뮤지엄, 소설, 신문이 국가를 '상상된 공동체', 즉 연대기적 시간을 따라 움직이는 집단으로 바라보게 만드는 데 핵심이었다고 주장했다. 국제적으로 접근할 수 있는 '국경 없는 보관소'인 자유항의 미술 공간들은 이와 비슷하게 전 지구적 비(非)공동체를 상상한다. 이런 공간들은 일반인이 접근할 수도 없고 세금과 같은 국가 규범의 적용도 받지 않는 영역을 만들어 낸다. 그것은 제네바에 존재하지만 제네바에 속하지 않는다. 그것은 국민국가(nation state)가 실패국가(failed state)를 흉내 내는 공간이며, 미술이 세금을 면제받은 상태로 우리에 갇혀 있는 치외법권의 공간이다. 그것은 폐쇄된 블랙박스 공간, 숨겨진 뮤지엄으로 미술 작품들이 마치 아마존 물류창고의 상품들처럼 혼란스럽게, 또한 금괴처럼 미술품 아닌 것들과 나란히 놓여 있다. 자유항에 있는 이러한 보관 컨테이너들은 분명 세계 최고의 뮤지엄들을 나타낸다. 슈타이얼은 어쩌면 난잡한 물품 배치가 머지않아 "혼돈 큐레이팅"을 가르치는 아주 비싼 미술 석사 과정을 유행하게 만들 거라고 심술궂게 암시한다. 그는 여기서 더 나아가 이와 같은 치외법권의 미술 공간들이 비엔날레 다음으로 "가장 중요한 동시대 미술의 형태"임을 지적한다. 슈타이얼은 실제로 이런 공간들을 "비엔날레의 디스토피아적 이면"[2]이라고 설명한다.

이러한 상황에 대한 해결책은—슈타이얼은 우리에게 선택권이 '있기에' 해결책이 '존재한다고' 강조한다—반동적인 미술 비평이 아니다. 히틀러와 무솔리니는 고전적 미술 형식을 수용했고, 심지어 동시대적 형식이 자신들의 대의에 부합하는 경우에도 그것을 회피했고 퇴폐적이라고 불렀던 것으로 악명 높다. 파시즘이란 불확실성에 직면해 눌려진 패닉 버튼이며, 파시즘은 동시대 미술을 거부하여 재현을 파괴하려 한다. 완벽한 신화적 과거는 존재하지 않으며, 과거로의 회귀를 향한 요구는 역사를 도착적으로 되풀이하게 된다. 그렇다면 과연 과거에 대한 향수가 없는 비판적 분석은 어떤 모습일까? 슈타이얼은 의도적으로 역설적 성격을 띤 다양한 해결 방안을 제시한다. (1) 뮤지엄은 역사가 역사로 남겨질 수 있도록 유물을

2
Hito Steyerl, "A Tank on a Pedestal," 같은 책, 4.

보관해야 한다. (2) 면세 미술은 작가와 소유자에게서 벗어난 자율성을 통해 진정 "의무로부터 자유로워야" 하며, 예비로 남겨진 통화가 아닌 활발한 교환의 방식이어야 한다. (3) 경제와 디지털 기술은 퇴화해야 하고 성장에서 벗어나야 한다.

<u>뮤지엄</u>은 끝장났다. 비디오 게임 뮤지엄이여 영원하라. 슈타이얼의 전망에서는 뮤지엄이 과거를 감금함으로써 열린 미래를 보장할 수 있다. 역사가 현재를 침범하고 점유하지 않아야지만 미래가 발생할 수 있기 때문이다. 그는 미술 기관들이 (또한 컴퓨터 등 가상 공간에서 기관에 해당하는 것들이) 유물과 모형들을 "억류"해야 한다고 암시한다. 예를 들어 우크라이나의 박물관에 있는 러시아 탱크는 저항 세력을 죽이기 위해 되살아나기보다 좌대 위에 보관되어야 하겠다. 더 나아가 슈타이얼은 논의를 한계 지점까지 밀어붙이기 위해 유래 없이 풍자적인 감수성을 활용한다. 예컨대 뮤지엄은 경제 모델과 같이 위험하리만치 아름다운 위협들을 "감금"해야 한다. 그는 이를 입증하기 위해 가장 정교한 모형과 시뮬레이션을 갖춘 경제학자들이 왜 21세기 초에 일어난 "대침체"를 예측하지 못했는지에 대한 폴 크루그먼의 분석을 인용한다. 크루그먼은 이렇게 주장한다. "경제학자들이 멋져 보이는 수학의 옷을 입은 아름다움을 진리로 집단 오해했기 때문"[3]에 길을 잃었다. 가혹한 자본주의 사회에서 아름다움은 위험하다. 슈타이얼은 "굶을수록 아름다운"[4] 패션 모델들을 보라고 주장한다. 그들은 사실상 아무것도 먹지 않을수록 더 많이 일할 수 있다. 뮤지엄이 유리 진열장이나 화이트큐브에 금융 모델을 구금하게 된다면, 금융 모델에 순위를 매기고, 조사하고, 비교하고, 역사화하는 동시에 그것이 지닌 파괴적 아름다움이 현실화되는 일을 방지할 수 있을 것이다. 다양한 금융 모델이 경쟁을 펼칠 수 있을 것이며, 매년 가장 아름다운 이론에 상을 줄 수 있겠다. 그렇게 함으로써 이런 모형의 효과를 제한하고 되돌릴 수 있을 것이다. 경제 모형이 오로지 뮤지엄 안에서만 실행되고, 따라서 '현장의' 조건에는 영향을 미치지 않기 때문이다.

3
Hito Steyerl, "Why Games, Or, Can Art Workers Think?,"
같은 책, 168에서 인용.

4
Hito Steyerl, "Why Games, Or, Can Art Workers Think?",
같은 책, 166.

미술 기관들이 이런 식으로 알고리즘을 수용할 수 있다면, 미술은 진정으로 자율성을 띠게 되고 뮤지엄은 비디오 게임이 될 것이다. 폐쇄된 공간에서 이러한 알고리즘을 다루면 비현실적인 갈망과 폭력을 즐길 수 있을 것이다. 게임은 당신이 뮤지엄을 떠나는 순간 종료되며 다음 플레이어를 (혹은 요컨대 뮤지엄 방문자를) 위해 최초의 조건이 복구될 것이다. 알고리즘상에서 히로시마에 핵폭탄을 투하하여 그곳의 누구도 다치지 않게 할 수 있다. 사람들의 삶을 망가뜨리지 않으면서 경기 침체를 일으킬 수도 있다.

비디오 게임에 대한 슈타이얼의 견해는 도착적인 가능성을 찾아내기 위해 '영리한' 비평이라고 여겨지는 것을 내파하는 능력을 잘 보여 준다. 비디오 게임에 대한 '교양 있는' 입장은 게임이 사회를 타락시키고 전쟁을 재미있는 오락거리로 만든다는 시선이다. 그가 볼 때 이러한 입장은 사실적으로나 도덕적으로 모두 틀렸다. 오늘날의 전쟁이 실제로 비디오 게임과 비슷하다면 이 세상은 더 나아질 것이다. 사람들이 죽음을 맞이한 뒤 다음 차례를 위해 다치지 않은 상태로 돌아올 테니까. 슈타이얼은 『면세 미술』 전반에 걸쳐 미래의 가능성을 열어 두기 위한 노력으로 '고급' 문화와 '저급' 문화의 참조점들을 뒤섞고 뒤엎는다. 그는 다음 단계로 넘어가기 위해 마르크스의 논의를 반복하는 대신 영화 〈엣지 오브 투모로우〉에 등장하는 톰 크루즈와 에밀리 블런트를 살펴본다.

자율성은 관계적 순환이다. 혹은 미술이 비트코인보다 나은 이유. 물론 뮤지엄과 비디오 게임에 대한 슈타이얼의 비교는 그 자체로 허구에 기반을 두고 있다. 뮤지엄은 단 한 번도 완전히 폐쇄된 적이 없고, 앞으로도 그럴 수 없을 것이다. 미술은 항상 그것을 둘러싼 육면체의 공간에서 새어 나왔다. 즉, 미술은 항상 화폐의 한 형태였다. 이에 대한 슈타이얼의 반응은 무엇일까? 정확히 맞는 말이다. 그런데 그래서 뭘 어쩌라는 건가? 그의 목표는 모순을 해결하는 것이 아니라 모순을 강화하는 것이다. 존재하지 않는 게임을 구현하기 위해 그것을 모방하는 것, 다른 미래가 나타나도록 신화를 사실로 간주한다는 말이다. 예를 들어, 면세 미술의 문제는 그것이 충분히 자율적이지 않다는 점이다. 세금 납부의 의무를 벗어난 미술은 여전히 제한적이다.

5
Hito Steyerl, "If You
Don't Have Bread, Eat
Art! Contemporary Art and
Derivative Fascisms,"
같은 책, 189.

무언가를 가르치고 가치를 구현해야 하는 의무로부터는 자유롭지 않기 때문이다. 뿐만 아니라 미술이 유통을 벗어나 예비 통화로 변해 더 이상 흐르지 않게 되어 "멍청하고 야비하며 탐욕스러운 돈"[5]이 될 때, 대안적 형태의 화폐라는 미술의 기능에 문제가 발생한다.

　『면세 미술』에서 가장 놀라운 통찰은 미술과 비트코인에 대한 비교다. 슈타이얼에 따르면, 미술은 비트코인 지지자들이 항상 비트코인이 이뤄 낼 수 있고 이뤄 내고 있다고 꿈꾸는 것을 성취해 낸다. 어떻게? 미술은 "경합하는 기관이나 파벌을 넘어 신용이나 불명예를 측정하기 때문에 안정적"인 탈중앙화되고 암호화된 가치의 네트워크다. 그것은 "무작위로 계량되고, 작가 및 학자들의 등급을 매기는 엉터리 알고리즘으로 순위가 매겨"지는 평판 체계에 기반한다. 가치를 보장하는 중앙 제도/은행 대신 "스폰서, 검열관, 블로거, 개발자, 프로듀서, 힙스터, 핸들러, 후원자, 독립 활동가, 수집가, 이보다 더 형태가 모호한 캐릭터들이 뒤죽박죽 뒤섞여 있다. 가치는 카더라 통신과 내부 정보에서 발생한다." 이처럼 뒤죽박죽 섞인 미술/코인은 항상 해킹되고 조작되지만, 엄청난 수의 참여자들과 이로 인해 가능한 가능성/의미가 그것이 여전히 작동한다는 것을 보장한다. 참여와 교환, 네트워크에 대한 이 같은 의존은 대체 통화로서의 미술이 "아직 존재하지 않는 경제(공공, 기관, 시장, 평행 미술계 등)를 개시"하기 위해 압류될 수도 있음을 뜻한다. 미술이 자율성을 가지려면 고립된 채 존재하는 것이 아니라 앞서 설명한 바와 같이 순환과 교환 속에 있어야 한다. 더 나아가 미술가들이 항상 자신의 작업 제작을 위한 의뢰로 다른 산업을 보조하고 있음을 감안하면, 미술가들이야 말로 미술의 가장 큰 후원자들이다. 그렇다면 미술가들이 은행과 재단을 위해 무급으로 일해 주고 VIP 프리뷰를 후원하는 대신, 다른 미술가들을 돕는 데 자유 시간을 쓰며 인간적 연대를 이룬다면 어떻게 될까?

　관계성에 대한 슈타이얼의 주장은 자율적 미술, 즉 "책임에서-자유로운(duty-free)" 미술에 대한 요구에 담긴 뉘앙스를 드러낸다. 자율성은 언제나 불완전할 뿐이다. 자율성은 그것과 연결된 네트워크와의 관계에 있어 스스로를 운영한다. 슈타이얼의 대리(proxy) 개념은 이처럼 위기에 처한 독립 상태를 강조한다.

우리 자신이 너무 많은 것들을 해내도록 요구받기 때문에, 우리의 몸이 우리 자신의 대역을 맡게 된다. 미술 전시 오프닝에 참여하고 강의를 듣고 있으면서도 실제로 거기에 존재하지는 않는다. 휴대 전화로 이메일을 보내고 문자 메시지에 답을 하고 있기 때문이다. 우리는 점차 자율성을 띠는 대리물을 통해 여러 장소에 동시에 존재하라고 요구하는 참여의 경제에 응한다. 이러한 대리물들은 주체성을 가능케 하는 동시에 손상시킨다. 하지만 우리를 책임으로부터 면제해 주지는 않는다.

스팸을 통한 퇴화

『면세 미술』은 새로운 것, 즉 새로운 미래, 새로운 미술을 요구하는데, 그럼에도 퇴화 역시 받아들인다. 이 책은 창조적 파괴라는 '진보적' 논리를 거부한다. 창조적 파괴는 건물과 도시 내부의 지역들을 파괴할 뿐 아니라 공동의 이해와 인류애에 대한 가능성도 파괴하기 때문이다. 창조적 파괴는 수평적 공간과 시간을 편협하고 인공적인 역사 개념으로 대체한다. 이러한 역사 개념은 중앙화된 경쟁을 촉진하고, 동질화와 부채, 소비를 가속하는데, 시공간 속에서 인류를 확장하는 새로운 방법을 창안한다는 명목으로 이 모든 것을 진행한다. 퇴화는 이와 대조적으로 "공유된 인간성의 부분으로 이해될 수 있는 … 수평적인 형태의 생활"을 가능케 한다. 퇴화는 영원한 삶이나 초인간적 존재를 추구하는 것이 아니라 인류가 그 자체로 완벽하게 괜찮을 것임을 인식하는 일이다.

슈타이얼에게 있어 디지털은 투기와 추출의 논리를 전형적으로 보여 주는 것이며, 『면세 미술』은 디지털적인 것과 디지털 경제가 지닌 모든 복합성과 모호함을 다룬다. 놀라운 사실일지 모르지만, 그는 독점적 상용 기술을 전 지구적 내전과 증가하는 불평등과 동일한 문장에서 나열하며 이를 우리가 직면하는 위험으로 다룬다. 그는 전산 사진(computational photography)이 어떻게 이미지를 기록하는 것이 아니라 이미지를 투영하는지, 어떻게 수천 장의 이미지에 접속하여 허술한 핀홀 카메라로 선명한 이미지를 만들어 내는지 살펴본다. 슈타이얼은 이러한 사례를 통해 디지털이 사물과 그 가치 사이에 거리를 생성하는 것과 같은 방식으로 투기와 순환을 구현하는 방식을 묘사한다. 더 나아가, 디지털에는 모종의 불투명함이 존재한다.

읽어 낼 수 없는 코드와 무감각한 과정은 굳이 인간 인식의 부적절성이 아니더라도 그것이 지닌 한계를 드러낸다. 미디어 아트는 비트코인과 마찬가지로 무한한 것을 제한하여 디지털적 희소성이라는 모순을 다스리고자 시도한다. 미디어 아트와 비트코인은 기술적으로 무한히 재생산되어야 하는 것을 다루면서 암호화와 저장을 통해 그것을 희소하게 만든다. 디지털 커뮤니케이션은 그러한 점에도 불구하고 가능성이 있는 것이 아니라 바로 그러한 점 때문에 가능성이 있다. 기술을 바탕으로 이뤄지는 정치는 민주주의와 마찬가지로 정보와 소음 사이의 투쟁을 나타낸다. "폭도들"의 요구인 스팸과 표준을 벗어난 영어는 불완전한 것으로 무시당하고 만다. 해결책은 무엇일까? 소음과 반복이 지닌 근본적 특성을 수용하고 밀어붙이는 것, 스팸이 사람과 네트워크, 기술을 연결하는 방식을 인정하는 것이다. 인터넷은 미술과 마찬가지로 "끝장"나 버렸다. 인터넷은 죽었으나 완전히 죽지 않은 상태로 모든 곳에 존재한다. 인터넷이 재발명되고 끊어질 수 있는 것은 이러한 이유에서다. 이러한 실질적 편재성은 그 어떤 결함이 있더라도 진정한 변화의 기회를 창출한다. 오픈소스 수자원, 에너지, 돔 페리뇽 샴페인 등 다른 수많은 문화 영역을 열어 내는 데 오픈 소프트웨어에 대한 요구를 활용하라. 스팸. 스팸. 스팸.

위에서 분명히 알 수 있듯이, 슈타이얼의 글은 과거에 대한 향수가 없는 비판성과 순진함이 존재하지 않는 창의성을 구현한다. 이는 미술과 비평의 경계를 거부하는 것인데, 슈타이얼의 에세이는 그의 비디오 및 설치 작업을 자극 삼아 함께 읽어야 한다. 슈타이얼의 글은 그가 만든 미디어 아트 작업과 마찬가지로 서로를 참조하고 확장하는 루프(loop)를 만들어 낸다. 깔끔하고 거리를 두는 풍자적 평가보다 혼란스럽고 수평적인 관여를 통해 통찰을 얻고자 고급 문화와 저급 문화를 뒤섞는다. 새로우면서도 퇴화하는 단계들을 만들어 낼 수 있도록 실행된다. 미셸 푸코는 자신이 쓴 책들이 집필된 이후 현실로 이뤄지길 바란다고 말한 적이 있다. 슈타이얼의 작업은 푸코가 제시한 변혁적 역사와 같은 느낌을 안겨 준다. 하지만 슈타이얼의 에세이는 유머와 시급함을 통해 현재를 다룬다. 그의 에세이는 이렇게 말한다. "국제디스코라틴어"로 말하라. 또한 이렇게 말한다. 패턴을 판별하는 비밀스런 능력을 획득하라. 이렇게도 말한다. 계속 플레이할 수 있게

모든 것을 공유하라. 슈타이얼의 작업은 "게임 오버"가 되지 않도록 우리가 모든 곳에 존재하고 퍼져 나가기를 강요한다.

* 2019년 캐나다 온타리오 미술관에서 개최된 전시《Hito Steyerl: This is Future》도록에 실린 글을 필자와 온타리오 미술관의 동의하에 재수록하였다.

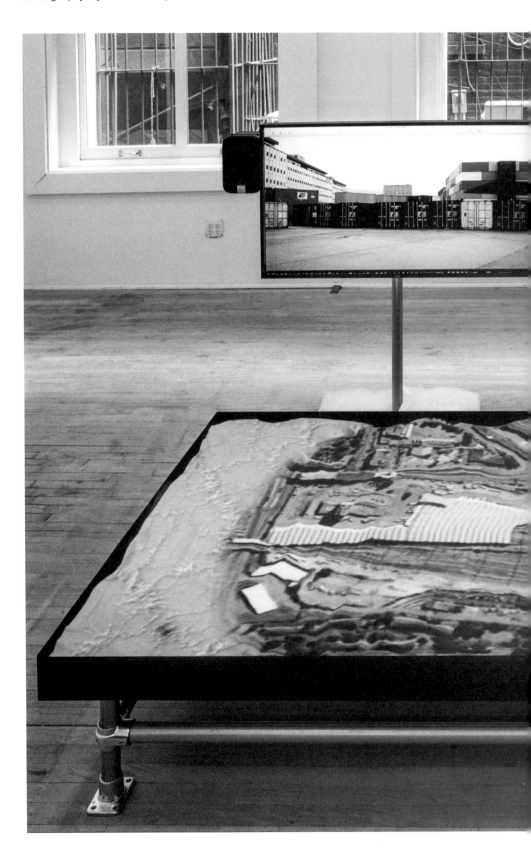

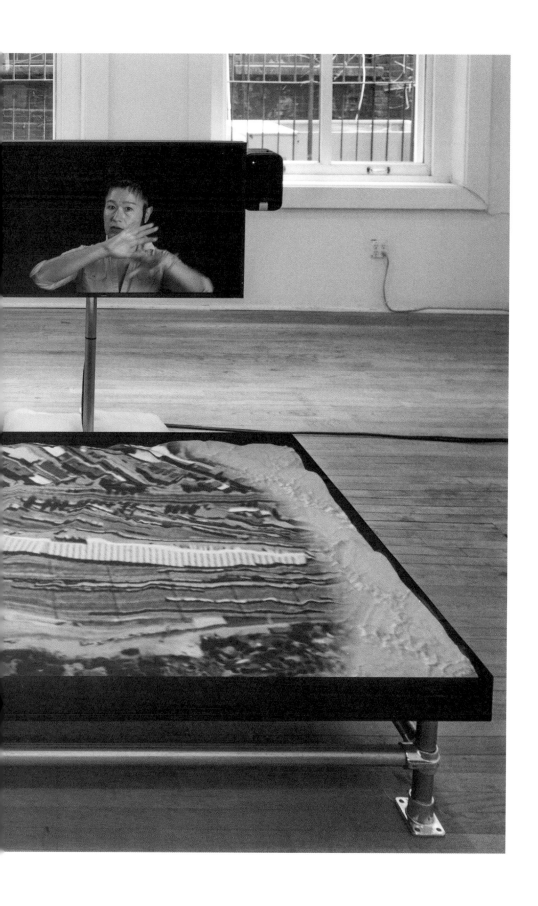

Hito Steyerl's 2017 collection of essays, *Duty Free Art: Art in the Age of Planetary Civil War*,[1] takes on one of the hardest questions facing the museum today: What role can—and do—museums and other cultural institutions have in an era dominated by real-estate speculation, asymmetric warfare, neoliberal capitalism, and the rise of fascism? Steyerl explores this conundrum by highlighting the part contemporary art and art institutions play in money laundering, speculation, and growing global inequalities, and by calling on artists, institutions, and members of the general public to imagine and enact better futures. She reminds us that we are agents: we have a choice. Fascism and inequality are not inevitable, unless we make them so.

1
Hito Steyerl, *Duty Free Art: Art in the Age of Planetary Civil War* (London and New York: Verso, 2017).

To guide us, Steyerl generates possible futures through play, repetition, and projection. All the chapters in this volume are essays in the truest senses of the word: they are trials that attempt to set things in motion. They create unexpected insights through intersecting loops and startling juxtapositions: Paul Klee and Monty Python; Tom Cruise and Karl Marx; video games and museums. Crucially, Steyerl produces paradoxes in order to create moments of escape: we move beyond contradictions by amplifying and then travelling alongside them.

For example, Steyerl argues that the museum in an age of planetary civil war is "all over." That is, the museum, in its traditional national form, is a thing of the past (it's over)—but only because the museum is now everywhere (it's all over the place). Its boundaries now leak, revealing the nightmare behind André Malraux's seemingly utopian "museum without walls": global art auctions launder questionable funds; "antique" Russian tanks, previously housed as relics in the Ukrainian national museum, are redeployed in the twenty-first century for combat by pro-Russian rebels desperate for munitions. Further, the enclosed national museums of the nineteenth century have been supplanted by global art fairs, which transcend national space, and freeport art storage spaces, in which hordes of contemporary art pieces are housed haphazardly in industrial buildings in cities such as Geneva.

To understand the impact of these new global spaces, Steyerl revises Benedict Anderson's argument that national museums, novels, and newspapers have been key to framing the nation as an "imagined community," a broad fraternity that moves together through chronological time. Freeport art spaces—internationally

accessed "cages without frontiers"—similarly envisage global non-communities: they carve out zones that are neither commonly accessible nor subject to national rules such as taxation. They are in Geneva, but not of Geneva—they are spaces in which nation-states mimic failed states; they are extra-territorial spaces in which art is caged, tax-free. They are closed black-box spaces—secret museums—in which art pieces, like commodities in Amazon warehouses, are chaotically stashed next to one another and alongside non-art substances, such as gold. These freeport containers arguably represent the best museums in the world. Perhaps, Steyerl wickedly suggests, the haphazard arrangements will soon spark a trend of very expensive MFA programs in "chaotic curating." Moreover, she notes, these extra-territorial art spaces are "the most important contemporary active form of art" next to the biennial; in fact, she describes them as "the dystopian back-side of the biennial."[2]

2
Hito Steyerl, "A Tank on a Pedestal," ibid., 4.

The solution to this situation—and Steyerl stresses that there is a solution, because we do have a choice—is not reactionary art criticism. Hitler and Mussolini infamously embraced classic forms of art, eschewing contemporary forms and calling them degenerate, even if the art supported their causes. Fascism is a panic button, pressed in the face of uncertainty, and fascism's rejection of contemporary art seeks to destroy representation. There is no perfect mythic past—and calls for a return perversely repeat history. So what, then, does critical analysis without nostalgia look like? Steyerl presents several deliberately paradoxical solutions: (1) the museum should hold on to artifacts so that history remains history; (2) tax-free art should become truly "duty free," autonomous of authors and owners, a vibrant mode of exchange rather than currency kept in reserve; (3) economies and digital technologies should be devolved and de-grown.

The Museum Is All Over;
Long Live the Video-Game Museum

In Steyerl's vision, the museum can ensure an open future by locking up the past, for the future can happen only if history does not invade and occupy the present. She suggests that institutions (and their counterparts in virtual spaces, such as computers) should "detain" artifacts and models: old Russian tanks in Ukrainian museums, for example, should be contained on pedestals, rather

3
As quoted in Hito Steyerl,
"Why Games, Or, Can Art
Workers Think?," ibid., 168.

4
Hito Steyerl, "Why Games,
Or, Can Art Workers Think?",
ibid., 166.

than resuscitated in order to kill protesters.

Further—and Steyerl uses her unparalleled satirical sensibility to push arguments to their limit—the museum should "lock up" dangerously beautiful threats, such as economic models. To make this point, Steyerl draws from Paul Krugman's diagnosis of why economists, armed with the most sophisticated models and simulations, were not able to predict the "great recession" of the early twenty-first century. They went astray, Krugman argues, "because economists, as a group, mistook beauty, clad in impressive-looking mathematics, for truth."[3] Beauty in a relentlessly capitalist society is dangerous: just look, Steyerl claims, at fashion models who are "more beautiful the more starved they are,"[4] the more they can work with virtually no food. If museums were to detain financial models in glass cages or white cubes, they could prevent their destructive beauty from becoming reality while still allowing them to be ranked, investigated, compared, and historicized. There could be competitions between various financial models and awards given out every year to the most beautiful theories. The effects of these models would thus be limited and reversible, since they would only run within the walls of the museum and thus not effect conditions in the "wild."

If institutions were able to contain algorithms in this way, art would become truly autonomous and the museum, a video game. While playing with these algorithms in these enclosed spaces, you could enjoy unreal cravings and violence; upon your departure, the game would end and the initial conditions would be restored for the next player (or, rather, museum-goer). You could nuke Hiroshima, algorithmically, without hurting anyone in Hiroshima. You could cause a recession without destroying people's lives.

Steyerl's take on video games epitomizes her ability to implode what passes as "smart" criticism in order to find perverse potentials. The "cultured" position on video games is that they corrupt society and render warfare as a diverting pastime. From her perspective, this stance is both factually and morally wrong. If modern war were actually like a video game, the world would be better: people could die and then return, unharmed, for the next round. Throughout *Duty Free Art*, Steyerl mixes and subverts "high" and "low" cultural references in an effort to open up future possibilities. To get us to the next level, she turns to Tom Cruise and Emily Blunt in *Edge of Tomorrow*, rather than repeating Marx.

Autonomy Is Relational Circulation, or Why Art Is Better Than Bitcoin

Of course, Steyerl's comparison of museums and video games is itself based on a fiction: museums have never been—and can never be—entirely enclosed. Art has always leaked out of its cubes; art has always been a form of currency. Her response? Yes, exactly, but so what? Her goal is not to solve contradictions but to intensify them: to imitate non-existing games in order to bring them into existence; to treat myth as fact so a different future can emerge. The problem with duty-free art, for instance, is that it is not autonomous enough. Art liberated from its tax obligations is nevertheless still restricted—it is not free from the duty to teach and to embody value. Not only that, but art's function as an alternative form of currency becomes problematic when it no longer flows, when it moves from current to reserve, becoming "dumb, mean, and greedy money."[5]

5 Hito Steyerl, "If You Don't Have Bread, Eat Art! Contemporary Art and Derivative Fascisms," ibid., 189.

One of *Duty Free Art*'s most startling insights is in its comparison of art and bitcoin—the former, Steyerl argues, accomplishes what adherents have always dreamed the latter can do and be. How? Art is a decentralized, encrypted network of value that "gains stability because it calibrates credit or disgrace across competing institutions or cliques." It is based on a reputational system that is "randomly quantified, ranked by bullshit algorithms that convert artists and academics into ranked positions." Instead of a central institution/bank to guarantee value, "there is a jumble of sponsors, censors, bloggers, developers, producers, hipsters, handlers, patrons, privateers, collectors and way more confusing characters. Value arises from gossip-cum-spin and insider information." This jumble of art/coin is hacked and manipulated all the time, but the sheer number of participants and possible keys/meanings guarantees that it still works. This reliance on participation, exchange, and networks means that art, as an alternative currency, can be repossessed to "launch not-yet-existing economies (publics, institutions, markets, parallel art worlds, etc.)." For art to have autonomy, it needs to exist not in isolation, but rather, as the preceding explanation makes clear, in circulation and exchange. Further, given that artists are always subsidizing other industries through their commissions, artists are not powerless peons, but the greatest subsidizers of art. So, what if, instead of working for free for banks and foundations

and sponsoring VIP previews, they spent their free time assisting other artists and thus creating human solidarity?

Steyerl's insistence on relationality reveals the nuances in her call for autonomous, or "duty-free," art. Autonomy is only ever partial; it is self-government in relation to an attached network. Steyerl's notion of proxies highlights this compromised state of independence. Because we are called on to do so much, our bodies become stand-ins for ourselves: we are at an art opening, listening to a lecture, and yet we are not really there, since we are on our phones, emailing and answering text messages. We deal with the economy of presence—the demand we be many places simultaneously—through increasingly autonomous proxies. These proxies both enable and compromise agency, but they do not absolve us of responsibility.

Devolve through Spam

Even as *Duty Free Art* calls for the new—new futures, new art— it also embraces devolution. It refuses the "progressive" logic of creative disruption, because creative disruption not only wrecks buildings and urban areas, it also destroys the possibility of common understanding and humanity. Creative disruption replaces horizontal spaces and times with a narrow and artificial concept of history that fosters centralized competition and accelerates homogenization, debt, and consumption—all in the name of inventing new ways of extending humanity in time and space. Devolution, in contrast, enables "pluriform, horizontal forms of life … that can be comprehended as a shared humanity." Devolution does not seek eternal life or superhuman existence, but realizes that humanity as such would do perfectly well.

To Steyerl, the digital epitomizes the logic of speculation and extraction, and *Duty Free Art* engages the digital and the digital economy in all their complexity and opacity. Perhaps surprisingly, the artist lists proprietary digital technologies in the same sentence as planetary civil war and growing inequality as dangers we face. She examines how computational photography works by projecting rather than recording—creating crisp images from crappy pinhole cameras by accessing thousands of other images. Through this example, Steyerl illustrates how the digital embodies speculation and circulation in the way it creates distance between the object and its value. Further, the digital possesses a certain

opacity: its unreadable codes and insensible processes reveal the limitations, if not irrelevance, of human perception. Like bitcoin, media art tries to manage the contradictions of digital scarcity by limiting the illimitable. Media art and bitcoin take something that should be infinitely technically reproducible and make it precious through encryption and storage. Because of all these things—not despite them—digital communication holds promise. Tech politics, like democracy itself, represent a battle between information and noise: spam, the demands of "rabble," and non-standard English are dismissed as inchoate. The solution? Accepting and pushing the fundamental nature of noise and repetition; acknowledging the ways in which spam connects humans, networks, technologies. The Internet, like art, is "all over": it is everywhere in its undeadness. This is why it can be reinvented and short circuited. This virtual ubiquity, however glitchy, creates an opportunity for real change. Use the call for open software to open up so many other areas of culture: open source water, energy, Dom Pérignon champagne. Spam. Spam. Spam.

As the above should make clear, Steyerl's text embodies criticality without nostalgia, creativity without naïveté. It refuses the boundary between art and criticism, and Steyerl's essays should be read alongside her videos and installations as provocations. Like her media art, they create loops that cross-reference one another and expand. They mix high and low culture in order to create insights through messy, horizontal engagements, rather than clean and distanced satirical evaluations. They run, so we can generate new yet devolving levels. Michel Foucault once said that his hope was that his books would become true after they'd been written. Steyerl's work has the feel of Foucault's transformative histories, but her essays engage the present with a sense of humour and urgency. They say: Speak "International Disco Latin." They say: Gain ninja powers of pattern discrimination. They say: Share everything so that we can keep playing. They compel us to be and spread everywhere so it's not "game over."

* This article was published in *Hito Steyerl: This is Future*, exh. cat. (Toronto: Art Gallery of Ontario, 2019), and reprinted with permission from the author and Art Gallery of Ontario.

『면세 미술』출간 기념
히토 슈타이얼과
웬디 희경 전의 대담

Book Launch of *Duty Free Art*
Hito Steyerl: Conversation with
Wendy Hui Kyong Chun

『면세 미술』출간 기념
히토 슈타이얼과
웬디 희경 전의 대담

W (웬디 희경 전) 모두 안녕하십니까. 히토 슈타이얼의『면세 미술: 지구 내전 시대의 미술』출간을 기념하는 오늘 함께하게 되어 무척 기쁩니다. 책에 대해 몇 가지 논평을 하면서 대담을 시작하겠습니다. 책을 읽은 분들 모두 아시다시피, 그야말로 대단한 책입니다. 오늘날 뮤지엄에서 우리가 직면하는 가장 어려운 질문을 제기하고 답하는 책이지요. 자, 책의 첫 페이지에서는 이런 질문을 던집니다. "지구 내전, 불평등의 증가, 독점 디지털 기술로 규정되는 시대의 미술 기관을 어떻게 생각해야 할까?" 책의 후반부에서 논의하는 바와 같이, 부동산 투기, 비대칭 전쟁, 신자유주의적 자본주의, 돈세탁, 투기, 파시즘의 부상이 지배하는 이 시대에, 인터넷과 뮤지엄이 그 자체로 의미하는 바로는 끝장나 버린 이 시대에 말입니다. 이 구절이 보여 주듯, 히토 슈타이얼은 책의 전반에 걸쳐 아름다운 방식으로 문장을 활용합니다. 모든 것이 반복되면서 이중적 의미를 갖게 되지요.『면세 미술』은 통찰과 영감을 안겨 줍니다. 히토, 당신은 이 책에서 현대 미술과 미술 기관을 비판하지만, 우리에게 더 나은 일을 하라고, 더 나은 미래를 상상하라고, 더 나은 미래를 실현하라고 끊임없이 요구하고 있습니다.

 당신은 책 전반에 걸쳐 "우리에게는 선택권이 있다."는 문구를 반복합니다. "떠오르고 있는 파시즘을 받아들일 필요는 없다." "우리에게 주어진 현재나 미래를 받아들일 필요는 없다."고 말입니다. 정말 놀라운 점은 당신이 향수 어린 태도를 취하지 않으면서 동시에 비판적이라는 것이죠. 그렇기 때문에 모든 게 행복했던 가공의 시간을 상상하거나 요구하지 않습니다. 사실 당신은 과거에 대한 향수의 많은 부분이 반동적이라는 점, 지금 상상되고 있는 출구는 우리가 원하는 출구가 아니라는 점을 지적합니다. 중요한 점은 당신이 역사를 회피하자고 주장하지는 않는다는 겁니다. 그래서 역사에 대한 당신의 입장이 정말 좋습니다. 역사는 역사로 남아야 하고, 뮤지엄은 그 안에 있는 유물을 유지해야 한다고 주장하니까요. 이런 점을 입증하기 위해 제시하는 사례는 우크라이나 정부군을 죽이기 위해 우크라이나의 한 뮤지엄에서 탈취된 탱크입니다. 그래서 당신은 이렇게 말합니다. 뮤지엄은 미래를 존속하기 위해 유물을 지켜야 한다고요. 하지만 『면세 미술』은 새롭고, 예상치 못한 방식을 찾아 나가기도 합니다. 당신은 이 책에서 멋지게 대중 문화와 철학을 나란히 배치했습니다.

책에서 제가 제일 좋아하는 부분 중 하나는 우리가 마르크스의 말을 반복하는 대신 마치 다음 레벨로 나아가는 게이머처럼 영화 〈엣지 오브 투모로우〉에 등장하는 톰 크루즈와 에밀리 블런트를 생각해야 한다는 부분입니다. 『면세 미술』은 새로운 것에 대한 페티시에 빠지지 않으면서 새로운 것을 만들어 냅니다. 당신은 순진함에 빠지지 않으면서도 예술의 자율성을 논의합니다. 놀라운 점은 책의 내용뿐 아니라 책의 형식을 통해서도 이런 주장을 펼쳤다는 것입니다.

책 자체가 정말 아름답게 쓰여졌습니다. 이 책은 모든 사례가 루프로 반복되는 태피스트리 혹은 설치 작업입니다. 따라서 디지털 잔해를 다룬 제8장은 파울 클레의 유명한 수채화 〈앙겔루스 노부스〉와 발터 벤야민의 해석을 통해 우리가 바로 그런 잔해라는 것, 즉 우리가 '스팸'이라는 것을 깨닫게 합니다. 천사가 우리를 바라보고, 우리가 바로 디지털 잔해입니다. 하지만 당신은 대체 천사가 아침으로는 무엇을 주문했을지 궁금하게 만들면서 이 장을 마무리합니다. 천사는 과연 아침 식사로 스팸을 주문할까요? 그 누구도 파울 클레와 발터 벤야민, 몬티 파이선을 이처럼 통찰력 있고 멋진 방식으로 한데 모으는 것을 본 적이 없는 것 같습니다. 에세이의 내부에서 또 에세이를 가로질러 통찰과 논의를 엮습니다. 하나의 에세이에서 제기한 질문에 대해 이어지는 에세이에서 답변이 이뤄지기 때문에, 이 책에 시간을 쏟으면서 각각의 에세이를 순차적으로 읽는 것이 중요하지요. 하나의 답을 준 뒤 반복하거나 그것이 다른 작용을 하게 만들기도 합니다. 당신은 우리가 모순을 넘어서 사유하게 만듭니다. 모순에 허우적거리며 무력감을 느끼는 것에서 벗어나기 위해서는 그런 모순을 탈출 지점까지 밀어붙이라고 말합니다. 그래서 면세 미술을 밀어붙여 세금을 면제받은 미술을 뛰어넘는 어떤 것이 되게 만들자고 하지요. 미술이 세금을 물지 않게 합시다.—작가와 소유자로부터 미술을 자유롭게 합시다. 끔찍한 전문 용어로 가득한 채 어쩌고저쩌고 늘어놓는다고 항상 놀림 받곤 했던 국제미술영어(International Art English)를 이제 '라틴'어보다 '새틴' 직물을 선택하는 국제디스코라틴어(International Disco Latin)로 바꿔보자는 식입니다.

이런 사례에서 분명히 알 수 있는 건, 당신에게 보스턴식으로 말하자면 '끝내주는(wicked)' 유머 감각이 있다는 점입니다. 하지만

중요한 건 유머 감각과 통찰을 통해, 또한 반복(loop)을 통해 현실을 설명하는 것 이상을 한다는 것입니다. 당신은 현실을 생성해 냅니다. 이 책은 단순히 한 권의 책이 아닙니다. 이 책은 실험하고, 진실을 생성하고, 허구를 발생시킵니다. 그렇기 때문에 대화를 시작할 수 있는 지점이 아주 많지요. 어쩌면 면세 미술이라는 개념에서부터 시작하는 게 가장 좋은 방법일지 모르겠네요. 당신은 자유항(free port) 미술품 수장고에 관한 이야기로 책을 시작해 국제 미술계에서 이런 미술품 수장고가 비엔날레 다음으로 중요하다고 논의를 진행합니다.

H (히토 슈타이얼) 웬디, 정말 고맙습니다. 이 자리에 함께해 주신 모든 분들께도 감사드리고요. 사실 웬디의 이야기를 영원히 계속 들을 수 있을 것 같았어요. 그리고 웬디가 저를 위해 제가 쓴 책을 전부 요약해 줬습니다. 와, 정말 대단해요. 자, 그럼 자유항의 미술, 면세 미술에 대해… 자유항이나 자유항의 미술품 수장고라는 현상에 관심을 가지게 되었는데요, 더 정확히 말하자면 어느 날 그냥 제네바 자유항에 들어가려고 해 봤습니다. 실제로 그렇게 했고, 2분 정도 들어갔다가 쫓겨났고 자유항의 정체가 무엇인지 정말 궁금해졌습니다. 그러니까 웹사이트에서 자기들을 광고하고 있더군요. 당시 제네바 자유항의 대부분은 '나투랄 르 쿨투르'라는 기업의 소유였는데, 더는 그렇지 않습니다. 그들은 제네바 자유항이 세계 최고의 뮤지엄일 거라고도 했습니다.

그래서 이렇게 생각했어요. 그런 말들을 문자 그대로 받아들여서 어쩌면 자유항이 미술계에서 가장 중요한 곳일지도 모르고 그들 말마따나 세계 최고의 뮤지엄이라고 생각하면, 그 순간에 있어 거기에서 배울 수 있는 게 뭔지 알 수 있을 거라고 봤죠. 그리고 실제로 자유항의 미술품 수장고는 숨겨진 뮤지엄과 같은 기능을 맡게 되었다고 생각합니다. 여러 중요한 예술 작품이 있을 수도 있지만 누구도 그게 정확히 뭔지는 모르는 뮤지엄 말입니다. 작품은 금고에 보관되며, 심지어 크레이트(작품 보관용 상자)에 들어가 있어 보관소 한 곳에서 다른 보관소로 옮겨지면 알게 되는 것일 수도 있지요. 이런 일은 기본적으로 영원히 계속될 수 있습니다. 네, 그렇다면 이제 이런 식의 뮤지엄이나 컬렉션이 루브르 같은 국가적 뮤지엄이 전통적으로

『면세 미술』 출간 기념 히토 슈타이얼과 웬디 희경 전의 대담

차지하던 역할을 맡고 있다는 것은 대체 무엇을 의미할까요? 대체 무슨 의미일까요… 예컨대 '국가적(national)'이라는 단어의 의미가 어떻게 바뀌었는지를 보면 말이에요. 그런 종류의 뮤지엄은 대체 어떤 유권자를 대표하고 있지요? 이를테면 탈세 외에 대체 어떤 조직 원칙이 있는 걸까요? 말하자면 그런 뮤지엄의 큐레이팅을 구성하는 알고리즘은 무엇일까요? 그것은 대체 어떤 모습일까요? 그러니까 아무도 제대로 모르기는 하지만 그런 금고에서 인턴으로 일했던 사람들이 남긴 일화가 당연히 정말 많거든요. 그리고 그들의 말을 들어 보면 거기는 약간 난장판이라고 하죠. 왜냐면 한쪽에는 금괴가 있고 다른 쪽에는 그림이 걸려 있고 와인 병이 굴러다니는데 또 다른 게 있을 수도 있고, 목록에는 아무것도 기록이 되어 있지 않다는 그런…

와, 이건 정말 대단하다고 생각을 했어요. 왜냐하면 이런 식의 큐레이팅 원칙이 완전히 다른 어떤 것, 즉 아마존의 물류창고를 생각나게 했거든요. 아마존 물류창고는 '카오틱 스토리지(chaotic storage)'라고 하는 완전히 현대적인 버전의 큐레이팅을 개발했습니다. 그러니까 카오틱 스토리지는 상품이 차곡차곡 보관되고 있지만 인간이 이해할 수 있는 어떤 식의 논리도 따르지 않는 것을 뜻합니다. 장난감 옆에 장난감을 보관하는 게 아니고, 가구 옆에 가구가 보관될지도 모르는 거죠. 아니요, 그런 게 아니라 모든 것을 바코드 번호로 정돈한다는 겁니다. 그렇기 때문에 로봇만 이해할 수 있는 완전한 난장판이 벌어집니다. 이런 게 큐레이팅의 새로운 원칙이라고 생각합니다. 그렇지 않나요? 카오틱 스토리지라는 건… 그러니까 머지않아 카오틱 스토리지 큐레이팅 원칙으로 석사 학위 과정이 생길 거고, 학비가 아주 비쌀 겁니다… 그런 일이 벌어질 거라고 확신합니다. 자. 그렇다면 이 모든 것들은 국가, 뮤지엄, 문화, 재산 세습, 문화유산에 대해 무엇을 말해 주는 것일까요? 이런 점은 무엇보다 뮤지엄이 이제는 더 이상 특정 국가를 대변하지 않는 독점적 상용 알고리즘이 운영하는, 혹은 일종의 오픈소스 알고리즘으로 통치되는 공유지의 한 형태라는 점을 말해 준다고 봅니다. 그러나 심지어 그런 공동체가 구성되는 방식조차도 일종의 블랙박스 알고리즘을 따릅니다. 그래서 자유항과 면세 미술에 관한 매우 흥미로운 지점들이 아주 많은데, 이건 지금의 현대 미술계에 있어서 일종의 암흑물질과

같습니다. 이 체제를 어떻게든 일관성 있게 유지하는 것 말입니다.

　　다른 한편으로는 당연히 우리가 그런 측면에 대해서 알고 있다고 봅니다. 그런 점들이 명확한 것 같습니다. 그렇다면 면세 미술에 대해서 대체 무슨 일을 더 할 수 있을까요? 그러면서 면세 미술이 당연히 그 누구에게 어떤 의무도 없다는 점을 아주 분명하게 알게 되었어요. 아시다시피 면세 미술은 원하는 건 뭐든 할 수 있습니다. 그리고 무엇보다 어떤 가치를 대변하라고 강요받지 않지요. 저는 그런 점이야말로 오늘날 면세 미술이 지고 있는 가장 큰 의무라고 봅니다. 그렇다면 아무런 의무가 없는 오늘의 예술작품은 대체 무엇일 수 있을까요? 리암 길릭이 말한 것처럼 의무 없는 예술작품이 소위 반자율성(semi-autonomy)이라는 일종의 연옥에 존재하게 될지도 모른다면, 대체 오늘날 어떤 의미를 띨 수 있을까요? 자율성이라는 단어 자체의 의미가 너무 많이 변해서 자율성에 관해 말하면 자율주행 자동차에 관한 것이 되어 버린 시대에 자율성의 의미는 무엇이고 자율적 예술작품은 또 무엇일까요? 저는 이런 것들이 자율성의 주요한 의미 가운데 하나라고 봅니다. 예를 들어 자율성은 킬러 로봇에 적용됩니다. 킬러 로봇은 자율적이어야 하죠. 그러나 이 로봇들은 전혀 자율적이지 않고 특정한 네트워크, 프로토콜에 묶여 있는 시스템입니다. 그것들이 완전히 자율적이지 않다는 점을 알고 있죠. 로봇들은 그것이 연결되는 네트워크에 대해서만 자율적입니다.

W　그런 점은 대리물(proxy)에 대한 당신의 논의로 잘 이어집니다. 왜냐하면 당신은 대리물이 그것을 통해 우리가 행동하게 하는 중개자(agent)가 아니라 대리물 자체가 자율적이라고 말하기 때문입니다. 대리물은 다른 일을 해낼 수도 있습니다. 책의 32페이지에서[1] 미술가와 관객을 소품으로 대체하는 것에 관해 말하면서 우리의 신체를 대리물로 표현하는 훌륭한 구절이 있습니다. 당신은 이것이 이런 상황과 그리 다르지 않다고 언급합니다. "훨씬 더 우아하고 굳이 말하자면 표준적인 해법은, 당신의 이메일이나 트위터 계정을 확인하면서 동시에 내 얘기를 경청하는 척하는 것이다. 이런 경우에 당신은 당신 자신을, 더 정확히는 당신의 고유한 신체를

1
역주: 이하 쪽 번호와 인용문은 다음 한국어판을 따랐다.
히토 슈타이얼, 『면세 미술: 지구 내전 시대의 미술』, 문혜진·김홍기 옮김(서울: 워크룸 프레스, 2021).

대역이나 대리인이나 아무개로서 사용하는 중이며, 그 와중에 사실은 당신의 정크시간에 전념하는 것이다. 나는 이것이 불참을 운영하는 형태로서 완전히 훌륭한 것이라고 생각한다." 양날의 검과 같은 자율성의 관점에서 대리 정치에 대해 많은 생각을 하셨다는 것을 알고 있습니다. 베라 톨만, 보아즈 레빈과 함께 대리 정치 프로젝트를 함께 진행하셨지요. 대리물과 자율성에 대해서 더 자세히 말씀해 주시죠!

H 그러니까 그런 관객을 볼 때마다 반복되는 경험인데요, 보통은 적어도 20-50개가량의 애플 로고가 제 시선을 받아치는 걸 보게 됩니다. 이런 점은, 말하자면 여러 장소에 동시에 존재해야 한다는, 리암 길릭이 임시변통성(adhocracy)이라고 불렀던 요구에 대한 당연한 대응이라고 봅니다. 임시변통성이라는 용어는 천재적이라고 생각해요. 거기에 있어야 하지만 동시에 또 다른 곳에도 있어야만 하기 때문에 일종의 양자 정치경영(quantum politics of management)을 고안해서 각기 다른 시간, 차원에 같은 장소에 존재할 수 있어야 하거든요. 그렇기 때문에 이를 달성하기 위해서는 일종의 대리물이나 대리인이 필요합니다. 그리고 그 대리인은 당신 자신이 될 수 있죠. 가장 저렴한 해결책이니까요. 그저 거기에 있는 척을 해 보지만 실제로는 그렇지 않습니다… 하지만 기술과 관련되어 있는 조금 더 비싼 해결방안도 있습니다. 물론 또 다른 해결책이지요. 네, 대리물이란 당신이 실제로는 어떤 곳에 있지 않으면서 동시에 거기에 있으려고 하는 여러 인스턴스를 관리하는 방법입니다.

W 방금 말씀해 주신 부분은 디지털에 대한 질문으로 멋지게 이어집니다. 책에서 디지털이 흥미로운 위치를 차지하고 있기 때문인데요. 책의 첫 페이지에서는 이런 질문을 던집니다. "지구 내전, 불평등의 증가, 독점 디지털 기술로 규정되는 시대의 미술 기관을 어떻게 생각해야 할까?" 어떤 이들에게는 질문에 언급된 세 번째 용어가 조금 이상하게 보일 수도 있지만, 이 용어는 앞서 언급한 불투명함이라는 문제에 어느 정도 해당하는 것 같습니다. 당신은 디지털이 특정한 추출의 논리, 특정한 투기의 논리의 전형을 보여 준다고 말합니다. 이와 동시에, 당신의 텍스트는 루프의 관점에서 보면 그 자체로 놀랍도록 디지털적입니다.

디지털이 당신의 주장에서 어떻게 작용하는지에 대해 조금 더 이야기해 주실 수 있을지요? 디지털은 무엇을 의미합니까? 그것이 열어 내는 것은 무엇입니까?

H 좋아요, 사례를 하나만 들어 보겠습니다. 디지털을 영구적인 전쟁뿐 아니라 독점적 디지털 상용 기술과 연결하는 것과 관련해서요. 우크라이나의 탱크를 예로 들어 주셨죠. 저에게는 정말 매혹적인 사례였습니다. 왜냐면 몇몇 반군이 탱크를 탈취해서 좌대에서 탱크를 몰고 나와서 전투에 돌입했는데요. 이 탱크는 기본적으로 역사적 전시물의 일부였습니다. 그런데 오늘 어쩌면 동시대적인 것일 수도 있고 분명 더 동시대적인 어떤 것을 보았습니다. 아시다시피 현재 시리아 일부 지역에 대해 터키의 침공 혹은 공격이 일어나고 있습니다. 어떤 TV 방송을 봤는데 아주 불편하면서도 매혹적이었습니다. 터키 방송국 스튜디오의 그린 스크린 앞에 아나운서가 서 있었고, 그린 스크린상에서는 슈퍼마리오 게임에 나올 것처럼 3D로 만든 무기들이 왼쪽에서 오른쪽으로 움직이고 있었죠. 조그만 폭탄, 비행기, 탱크 같은 것들이었습니다.

왼쪽에서 오른쪽으로 천천히 흘러가다가 갑자기 후방에서 3D로 만든 탱크가 등장해 스튜디오 안으로 밀고 들어와서 진행자 옆까지 다가왔습니다. 진행자가 탱크를 피하더니 탱크가 시청자에게 포탄을 발사하더군요. 이런 게 바로 내가 책에서 설명하려고 하는 여러 가지와 연결되어 있다고 생각했습니다. 탱크가 그다음에 하는 것 때문이죠… 방송에서는 그렇지 않았지만, 탱크가 실제로 화면을 뚫고 나온다면? 당신의 거실에 나타난 뒤 아이폰 화면 안으로 사라지겠죠. 이것이야말로 오늘날 게임 화면에서 복붙한 싸구려 3D 효과와 현실이 어떤 식으로 연결되어 있는지를 보여 주는 거라고 생각해요. 화면을 통해 현실로 등장한다는 비유는 사실 꽤 오래된 겁니다. 이런 생각을 처음 했던 건 실비오 베를루스코니가 이탈리아 총리가 되었을 때입니다. 그러니까 그는 텔레비전 화면으로 뛰어들어 현실 정치에 입성해 국가 원수가 된 세계 최초의 인물이었습니다. 이제는 딱히 이상한 일도 아니지요. 하지만 베를루스코니의 코와 얼굴이 온통 잘려 나간 뒤 다시 꿰맨 것을 알 수 있어 그가 그런 위업을 달성했다는 걸

즉각적으로 알아챌 수 있었습니다. 이렇게 생각했습니다. 그래, 이 일은 그가 화면을 뛰어넘었을 때 일어났지. 그러니까 그는 어떻게든 자기 코를 망가뜨려야 합니다. 이걸 통해 그가 어느 정도 나이를 먹은 남성이라는 것, 얼굴에 많은 일이 벌어지고 있다는 것을 알 수 있어요. 그리고 나서 어쩌면 기본적으로 대중에게 해로운 부작용을 일으키며 화면을 통과해 나올 겁니다. 그렇죠. 디지털에 대한 질문에는 답변을 못 한 것일 수도 있겠네요. 죄송합니다. 약간 옆길로 샌 것 같네요. 뭐 괜찮습니다. 우크라이나와 독점적인 상업적 디지털 기술에 대한 이야기로 돌아가 보죠. 미국에서는 존디어사(社)의 트랙터로 농사를 짓는 많은 농부들이 트랙터의 운영체제를 해킹해서 직접 트랙터를 수리하려고 우크라이나 해커들을 고용하기 시작했습니다. 이들은 자기 소유의 트랙터에 들어 있는 소프트웨어가 자기 것이 아닌 존디어스의 소유물이라는 이유로 트랙터 수리를 차단당했습니다. 바로 이런 점이 독점적 상용 소프트웨어의 힘입니다.

W 아니요, 완벽하게 답변이 되었습니다. 비디오 게임과 베를루스코니에 대해 말씀 주신 부분으로 루핑해서 돌아갈 수 있으니까요. 앙드레 말로의 경계 없는 뮤지엄에 대해 그것이 악몽과 같다는 멋진 해석을 하셨습니다. 뮤지엄이 경계를 상실하면 미래에 대한 헌신을 잃게 되니까요. 비디오 게임의 경우, 현대전의 문제는 전쟁이 비디오 게임과 비슷하다고 말하는 사람들에게 이렇게 대응합니다. "그렇게 생각하는 사람들은 큰 실수를 저지르고 있다. 실상 그들 중 많은 경우가 미술이나 문화에서 발견되고, 자신들이 업계가 가지고 있다고 상정되는 비판성이나 위신을 변호하고 있다고 생각한다. 일부 '창조적인 전문가들'에게 컴퓨터 게임은 혐오스러운 것이고, 현실을 왜곡하기 위해 자본가들이 벌이는 음모의 정점이다. 하지만 그들의 반응은 비평적으로뿐 아니라 도덕적으로도 그르다. 사실 대다수의 인류에게는 전쟁이 그저 비디오 게임일 뿐이면 훨씬 좋을 것이다. 게임에서 플레이어는 되살아난다. 당신이 총에 맞는다— 문제없다. 처음부터 다시 시작하면 된다. 일본에 있는 누구도 눈치채지 못하게 히로시마에 핵폭탄을 떨어뜨릴 수도 있다. 반면 진짜 전쟁에서 당신은 죽는다. 죽지 않는다 해도, 죽을 만큼 지겹거나 스트레스를

받을 것이다."[2] 당신은 논의를 이어 나가며 이런 식의
게임이 유출될 때가 문제라고 주장합니다. 어쩌면 이것이
디지털과 앞서 말씀 주신 돌파구에 관해 사유할 수 있는
하나의 방법일지도 모르겠습니다.

2
같은 책, 180.

H 네, 그러니까 기본적으로 논의는 화면과 뮤지엄에 있어 모두 아주
비슷합니다. 어떤 것이 스크린 뒤에 포함될 수 있다면 우리는
안전할까요. 그렇지 않죠. 뮤지엄도 마찬가지입니다. 뮤지엄에
무엇이든 담을 수 있고 그것이 정말 일종의 강제 구금이라고 여길 수
있다면, 그렇다면 안심할 수 있습니다. 이 책은 게임 이론이 어떻게
전쟁 시뮬레이션과 워게임으로 발전했는지에 관한 필립 미로프스키의
책에 많은 영향을 받았습니다. 이런 식의 게임들은 분명 스스로를
구현하는 경향이 있었습니다. 현실로 누출되는 경향이 있었다는
겁니다. 그들은 현실을 감염시키는 경향이 있었습니다. 예를 들어
워게임과 전쟁 시뮬레이션의 경우에는 다소 우연적이었다고 하더라도
컴퓨터 기술의 진보를 유발했거든요. 그들은 계산을 원했습니다…
제 기억이 맞는다면 말이죠… 제2차 세계대전 직후 극지방을
빨간색으로 칠해 지구 온난화 비슷한 현상을 일으키면 소비에트
연방에 해를 입힐 수 있을 거라고 믿어서 그렇게 하려는 계획도
있었습니다. 하지만 그렇게 하기에는 너무 복잡해서 결국 수소폭탄을
컴퓨터로 계산하게 되었습니다. 따라서 이런 게임과 시뮬레이션들은
기본적으로 현실을 창조해 냈습니다. 그렇게 만든 현실은 항상 의도된
현실이 아니라 일종의 우발적 현실이었지만, 그럼에도 불구하고
현실은 현실이었습니다. 그러니까 저는 이런 게임들, 이 아름다운
게임들, 우아한 게임들, 현실을… 끔찍하리만치 완벽하게 현실을
시뮬레이션해 낸 멋진 알고리즘들을 어떻게 담아낼 수 있을지에
대해 생각합니다. 화면 뒤에서든 뮤지엄 안에서든 그것들을
담아내는 방법 말입니다.
 뮤지엄과 관련해 항상 이어 가고 있는 아이디어나 생각 가운데
한 가지를 말씀드리자면—갑자기 불쑥 이야기해서 죄송합니다.
항상 일어나는 일인데요, 이래서 제 책이 항상 어지럽죠—동굴 벽화를
생각하게 되었습니다. 그렇죠. 왜냐면 동굴 벽화를 보러 간 사람들이

왜 그렇게 거기에 매료되는 건지 생각해 보니까 작품이 입구에 있지 않기 때문이더라고요. 그렇습니다. 어떤 경우에는 동굴 안으로 수백 미터를 걸어 들어가야 하는데, 동굴이 정말 캄캄해서 대체 벽화를 그린 사람들이 어떻게 벽화의 정확한 위치를 파악했는지조차 알 도리가 없습니다. 그런데 생각해 보니까 그들은 미술이 위험하기 때문에 동굴 속으로 그렇게 멀리 걸어 들어간 게 아닐까 싶었습니다. 어둠 속 어딘가에 숨겨져 있어야 했던 겁니다. 그곳이야말로 어떻게든 미술을 처리하고 억제하는 동시에, 미술의 마법과 공포를 마치 아이맥스 영화관처럼 모두 경험할 수 있는 곳입니다. 하지만 거기에서 다시 떠나올 수도 있죠. 뮤지엄이란 그런 장소, 즉 안전하게 떠날 수 있는 곳이어야 한다고 봤습니다. 그 모든 장엄한 마법과 공포가 그 안에 남겨질 것이며 사회를 완전히 난장판으로는 만들지 않을 거라는 걸 아는 겁니다. 그런 의미에서 뮤지엄은 훌륭한 공간이 될 거라고 봤습니다. 예컨대 수많은 금융 알고리즘을 가둬 놓는 것이죠. 저는 기본적으로 인공지능으로 진행하는 실험의 대부분을 예술이라고 선언해야 한다고 생각합니다. 아니, 그런 실험들은 앞으로 250년 정도 뮤지엄에 국한해야 한다고 봅니다. 일관적인 결과가 도출되어 실제로 인공지능을 활용하는 방법을 알기 전까지 말입니다. 이런 모든 실험들은 필수적이지만 정말 지독하게 마법적인 동시에 두렵고, 그래서 뮤지엄 안에 남겨져야만 합니다. 우리는 뮤지엄을 일종의 억류, 즉 임시적 구금 시설로 활용해야 합니다.

w 정말 매혹적이네요. 그러니까 193페이지에 있는 멋진 구절을 통해 이 아름다운 것들을 억류해야 한다고 말씀하시고 있지요. "패션모델을 보면 아름다움이 문제가 될 수 있음이 곧장 분명해진다. 패션모델은 2008년 실패한 정교한 금융 모델의 유기적 체현으로 볼 수 있을 것이다. 그들은 굶을수록 아름답다고 규정된다. 자본주의 용어로 최상의 아름다움은 인체가 매일매일 사실상 음식 없이 작동할 때 획득된다. 효율성은 곧 아름다움이다." 그런 뒤 이렇게 말합니다. "그렇기에 아름다움은 인간의 생존을 위협하는 것이 될 수 있다. 하지만 미술 전문가들은 현실과 혼동되는 아름다움을 막을 전략을 지니고 있다. 해법은 아름다운 것을 전부 미술관에 가둬 버리는

것이다." 하지만 사람들이 이것에 반대할 거라고도 말합니다. 그래서
195페이지에서는 이렇게 말합니다. "물론 나의 미술 분야 동료들은
(유감스럽게도) 이런 식으로 아름다움의 효과를 담아낼 수 없다고
반대할 것이다. 미술과 그 효과는 제도들로부터 새어 나오며, 그렇기
때문에 나의 모델 역시 이상화되고, 허구며, 허접 추상일 수 있다고
그들은 주장할 것이다. 완전히 동의한다. 당신이 맞다. 그러나 나는
이 모순을 풀려고 하는 것이 아니다. 나는 모순을 강화시키고 싶다."
그런 뒤에는 제록스 복사기를 통해 유출된 미국 국방부의 베트남전
문서에 대해 이야기합니다. 이제 이런 식의 게임들은 심지어 격리에
놓이더라도 다른 종류의 허구를, 다른 진실을 생성하여 우연히 유출될
수 있는 것입니다. 이것은 미셸 푸코가 자신의 책에 대해 말했던 것을
떠올리게 합니다. 그는 자신의 책이 역사를 바탕으로 한 허구이지만
일단 책을 쓰고 나면 현실이 되기를 바란다고 말했지요. 당신이 말하는
것도 바로 이런 것이지요.

H 그렇죠, 그러니까 시뮬레이션을 생성적 허구라고 여기는 겁니다.
실리콘밸리의 어떤 사람들이 우리가 외계인이 생성한 시뮬레이션
안에서 살고 있다고 믿는다는 생각에 완전히 빠져들었거든요.
그 사람들은 그걸 정말 진지하게 믿고 있습니다. 정말 그래요.

W 실리콘밸리라고 불리는 그런…

H 그렇죠. 자, 그러니까 우리가 이렇게 살고 있다는 말에 전적으로
동의하는 겁니다. 우리는 정말로 외계인이 생성한 시뮬레이션에
살고 있으며, 그 외계인은 페이스북이라고 불린다는 거죠. 네, 우리가
일종의 대규모 심리 실험 현장에서 살아가고 있다는 말입니다. 집단
정서, 기분, 기타 등등을 실험하고 있는 곳입니다. 맞습니다. 정말로
사실이죠. 우리는 외계인의 시뮬레이션 안에서 살고 있습니다.
물론, 그것이 분명 실현될 수 있다는 말입니다. 그러니 이런 생각을
받아들여서 다른 시뮬레이션을 구현해 보려고 시도하는 건 어떨까요?
그리고 이런 일은 저에게만 일어난 것도 아닙니다. 이것은 수십 년
동안 이런 훈련의 양태를 기록하고 또한 분석하려고 애썼던 하룬

파로키의 작업에도 아주 큰 빚을 지고 있습니다. 예를 들어 파로키는
훈련이라는 것이 무엇인지, 직업 훈련은 무엇이고 군사 훈련은
무엇이며, 단순히 반복을 통해 신체가 이른바 특정한 자세와 태도에
어떻게 적응하는지를 살펴보았습니다. 이런 종류의 훈련이 어떻게
습관이 되는지 말입니다. 단순히 습관뿐 아니라 신념도 그런데요.
과거로 돌아가 보면 이런 생각의 근원을 알 수 있습니다. 결국은 신을
믿기 위해 해야 할 일은 기도가 아니라 무릎을 꿇는 것이라는 파스칼의
말을 마주하게 되죠. 일종의 영적인 현실을 만들어 내기 위해서는
기본적으로 몸으로 어떤 자세를 취해야만 합니다. 그렇다면 우리는
왜 다른 게임을 이런 종류로 상상할 수 없을까요? 다른 시뮬레이션,
말하자면 다른 현실을 위해 훈련하는 시뮬레이션 말입니다.

W 그 문제를 상당히 아름답게 바라보시는군요. 왜 그런 것에 대해서
 오픈소스를 소유할 수 없는 걸까요.

H 그렇죠.

W 당신은 이렇게 묻습니다. 왜 이러한 가상 공간에만 국한된 오픈소스의
 논리를 취하지 않는가? 인터넷이 만연한 지금 왜 오픈소스를 다른
 방식으로 사용하지 않는가?

H 맞아요, 그겁니다.

W 그러니 모든 것을 공유하자는 것이군요. 물과 에너지, 돔 페리뇽
 샴페인을 오픈소스로 공유하자는.

H 맞습니다.

W 하지만 당신은 이것이 아주 그릇된 방향으로 갈 수도 있고, 스탈린이
 운영하는 스타벅스로 가득 찬 쇼핑몰로 끝날 수 있다고도 말합니다.

H 네, 그런 일이 벌어져 버렸고, 이미 끝나 버렸습니다. 끝난 일이죠.

W	다음 쇼핑몰은 어딘가요. 당신은 이와 관련해 일찍부터 예술이 노동 분업화를 만들어 낸 것일 수도 있다고 추측해 왔습니다.

H	어쩌면요… 이건 단지 가설일 뿐이에요. 혹시 모르죠…

W	그리고 이렇게 묻습니다. 이런 이미지들이 노동 분업과 국가의 분리를 만들어 냈다면, 디지털로 암호화된 이미지는 어떤 결과를 초래할 것인가? 그로부터 어떤 국가가 떠오를 것인가? 그리고는 영화 〈매트릭스〉의 주인공처럼 읽어야 하는 16진수를 제시합니다. 거기서 조금 더 나아가서 이런 이미지로부터 어떤 국가가 나타나는지 말씀해 주실 수 있을까요?

H	두 가지 말씀을 드릴 수 있습니다. 무엇보다, 선사시대인 신석기 시대나 초기 신석기 시대는 사람들이 동물을 길들여 농업을 발전시켜 정주 생활에 접어들었다가 갑자기 봉건 영주가 등장해서 발생한 게 아니라는 이야기를 했죠. 네, 그것과는 완전히 다르게 발생한 것처럼 보입니다. 어디에서 나타났는지 모르는 사람들이 갑자기 아나톨리아 남부에 거대한 신전을 짓고 야수와 동물로 장식하기 시작했습니다. 그러자 갑자기 엄청난 양의 협동적 노동과 축제가 벌어졌고, 이것이 정주형 생활 양식을 초래했고 맥주를 만들기 위한 곡물 재배를 일으켰고 온갖 부작용이 일어났어요. 하지만 이것들은 일종의… 노동 분업뿐 아니라 특정한 사례에 있어서는 계급 사회를 예고한 건축/ 예술이 초래한 부작용이었습니다. 어떻게 해서 그렇게 된 것인지는 분명하지 않지만, 수천 년에 걸친 실험의 결과물이었죠. 계급 사회는 예술을 통해 만들어집니다. 물론 수천 년에 걸쳐 존재한 사회, 완전히 새로운 사회 모델을 통해서죠. 그리고 저는 우리가 서로 다르면서도 비슷한 지점에 있다고 봅니다. 기본적으로 새로운 형태의 시각성, 새로운 형태의 예술 창작, 새로운 형태의 재현 창조가 우리를 가장자리 너머, 절벽 너머로 밀어 일종의 새로운 정치적 패러다임으로 가게 만들고 우리는 그것이… 분명 계급 불평등을 줄이지는 않을 거라는 점을 이미 아주 명확히 알 수 있다는 걸 제외하면 어떻게 될 것인지 모릅니다. 계급 불평등은 오히려 점점 더 늘어날 것입니다.

『면세 미술』 출간 기념 히토 슈타이얼과 웬디 희경 전의 대담

이것이 첫 번째 주장입니다. 대체 새로운 정치 패러다임이 무엇인지에 대한 거죠. 책에서는 이렇게 말하려고 합니다. 자, 그렇지 않아요. 딥 마인드와 딥 드림 기술의 시대에 그건 더 이상 수수께끼가 아닙니다. 이 모든 딥 마이닝 기술에 맞는 국가 기술은 아마 '딥 스테이트'가 아닐까 합니다. 하지만 아마도 두 번째 주장이 더 중요할 것 같습니다. 왜냐면 이제 우리는 이미지의 의미가 급진적으로 변하는 시기에 있기 때문입니다. 대부분의 이미지가 글이 되었든 무엇이든지 간에 이미지와는 다른 정보와 동일한 재료를 바탕 삼아 디지털 기반으로 만들어지니까요. 그런 의미에서 이미지는 더 이상 다른 형태의 정보와 다르지 않고, 대부분 일종의 번역을 통해서만 접근할 수 있습니다. 이미지에 접근하기 위해서는 화면이 필요하며, 가공하지 않은 형태, 말하자면 원래의 형태에는 접근할 수 없습니다. 전기 신호나 무선 인터넷, 우리가 아직 개발하지 않은 어떤 센서로 감지하지 않고서는 말입니다. 이런 기계적 이미지, 보이지 않는 이미지, 비감각적 영역에서 나온 이미지에 직접 접속할 수 있는 이미지가 무엇일지 생각해 봅니다. 사실 다른 한편으로는 이것이 이야기의 한 부분이라고 생각합니다. 이야기의 다른 부분은 역설적이게도 시각적 영역에, 예를 들면 우리가 한 세기 넘게 이어온 사진 등에 속합니다. 사진의 경우를 보면 그것이 처음 시작된 이래로 모종의 객관적이고 진실된 현실에 대한 재현을 제공한다는 사진의 약속에 대해 의심이 존재했습니다. 그러니까 이런 논의가 이어진 것은 이제 150년이 넘었습니다.

하지만 이제 많은 이미지에서 거의 혹은 말 그대로 진실된 재현을 감지할 수 없게 되면서, 객관성이 어떻게든 새로운 형태로 다시 등장하게 됩니다. 이제 우리는 그 어떤 이미지나 재현도 이해할 수 없게 되었지만, 사람들은 그럼에도 불구하고 그런 이미지들이 100퍼센트 사실이라고 확신하기 때문이죠. 왜냐면 이미지는 아시다시피 빅데이터에 대한 분석이기 때문입니다. 어떤 기계들은 패턴을 인식합니다. 그러니 물론 이것이 사실이 될 것입니다. 따라서 사진적 재현의 색인성을 보장하는 아이템, 사물이 렌즈 혹은 카메라 장치 그 자체라는 점이 재미있습니다. 이제 우리에겐 사물에 대한 믿음을 컴퓨터에 투사한 이 장소뿐입니다. 그리고 우리는 그들이

존재하기 때문에 우리에게 뭐라고 말하고 무슨 짓을 하고 어떤 숫자를
늘어놓든 그것이 현실에 대한 진실되고 객관적 재현이 될 거라고
생각하고 맙니다. 말하자면 이 문제를 다음 단계로 밀어붙입니다.

W 그런데 당신은 비트코인이 미술시장에서 실제로 배워야 할 방법을
홀륭하게 보여 주셨지요.

H 네, 맞아요. 2021년에 그렇게 했죠.

W 지적하셨다시피 미술은 대안화폐이기 때문입니다. 미술과 비트코인에
대한 비교해 주신 점이 대단합니다. 당신은 대안화폐로서의 미술이
지금까지 비트코인이 약속해 왔던 것을 성취하는 것 같다고
주장합니다. "국가가 발행하고 중앙은행이 관리하는 돈 대신, 미술은
네트워크화되고, 탈중심화된, 널리 통영되는 가치체계다. 미술은
경합하는 기관이나 파벌을 넘어 신용이나 불명예를 측정하기 때문에
안정적이다. 전시, 스캔들, [SNS의] 좋아요, 가격을 비동기적으로
기입하는(혹은 대체로 기입하지 못하는) 시장, 수집가, 미술관, 출판,
아카데미가 있다. 암호 화폐가 그렇듯 여기에는 가치를 보증하는
중앙 기관이 없다. 대신, 스폰서, 검열관, 블로거, 개발자, 프로듀서,
힙스터, 핸들러, 후원자, 독립 활동가, 수집가, 이보다 훨씬 정체가
모호한 캐릭터들이 뒤죽박죽 뒤섞여 있다. 가치는 카더라 통신(gossip-
cum-spin)과 내부 정보에서 발생한다 … 상충하며 종종 쓸모없는
수많은 열쇠들을 지닌 메시지의 존재와 관계없이, 미술은 그 자체로
암호화다. 미술의 명성 경제는 무작위로 계량되고, 작가 및 학자들의
등급을 매기는 엉터리 알고리듬으로 순위가 매겨진다. 하지만 훨씬
전통적으로 당파적인 사회적 위계 또한 포함하고 있다. 미술은
완전히 우스꽝스럽고, 비뚤어졌으며, 구속력이 없는 모임이지만,
문명 일반이 그렇듯 위대한 사상일 수도 있다."[3]
와! 이상적인 암호화로서의 미술 그 자체라는 생각은 정말
흥미롭고 적확합니다. 그럼 이제…

[3] 같은 책, 209-211.

H 맞아요, 계획이 있습니다. 제가 하려는 건… 이제 저만의 암호화폐를

설계했고 내일 시장에 출시될 거라고 봅니다. 곧장 급등할 거라고
생각하는데요, 이름은 '현금 동전 코인'입니다. 원칙적으로는
이것이야말로 아무런 디지털 기반이 없기 때문에 이상적인
암호화폐입니다.

　물질적으로만 이뤄진 거예요. 동전의 형태로만 존재한답니다.
완전히 탈중앙화되어 있고, 그 무엇보다 안전한 블록체인 기술입니다.
사실은 그 어떤 원장도 없고 블록체인도 없기 때문이죠. 해킹할 수
없습니다. 해킹할 게 존재하지 않으니까요. 아시다시피 이점도 아주
많습니다. 완전히 익명이라는 점을 비롯해서요. 바로 현금 동전
코인입니다! 저를 한번 믿어 보시죠. 그러고 나서 미술 작품은 이미
이런 방식으로 존재하고 있다는 걸 깨달았습니다. 미술 작품은 일종의
현금 동전 코인입니다. 모든 동전에는 각기 다른 각인이 있습니다.
그렇다기보다 모든 동전에는 개별적인 해시값이 있습니다. 단일한
해시값이죠. 미술은 바로 그런 겁니다. 미술은 그렇게 작동하죠. 미술
작품은 추적할 수 없는 경우가 많습니다. 글쎄요, 약탈당한 예술품의
역사로 돌아가 버렸고… 어쨌든, 작품의 출처가 문제가 될 때가
아주 많습니다. 원장은 존재하지 않습니다. 그런 점에서, 추적하기가
상당히 어렵습니다. 그렇기에 미술은 이미 어떤 형태의 화폐와 유사한
셈입니다. 그렇다면 대체 어떤 종류의 화폐일까요? 이 와중에 이
모든 것이 NFT 문화로 실현되고 포착되고 상품화되었습니다. 이제는
블록체인과 원장, 재산권이 부분적으로 실재한다고 주장한다는
점만 빼면 말이죠. 여기에서 등장한 것은 마치 구식 미술시장을 위한
운영체제를 디지털 자산에 적용해 인위적으로 희소성을 만드는 것과
마찬가지였습니다.

　최근 느낀 점은 블록체인 기술뿐 아니라 아주 많은 소셜미디어가
똑같은 일을 하려 든다는 겁니다. 사람들은 어떤 식으로든 관계를
맺고 있습니다. 커뮤니케이션이나 암묵적 계약, 행동수칙, 이와 비슷한
것들이 있는데, 그들은 이런 것을 자동화하려 듭니다. 그렇죠. 사회적
관계의 자동화라는 말입니다.

　그렇다면 이런 점이 기술의 핵심이라는 걸까요. 아니요. 문제는
누군가가 대체 왜 그런 일을 할지입니다. 그렇지 않나요? 어떤 노동이
끔찍하고 지독한 노동이라면 그것을 자동화하지 못할 이유는 없죠.

하지만 대체 왜 사회적 관계를 자동화하려는 걸까요. 그건… 저에게는 정말로 결말이 열린 질문입니다. 진짜 이해가 안 되거든요. 절대 자동화하지 말아야 할 것이 있다면 바로 사회적 관계일 것입니다. 그러면 대체 바로 그것을, 그러니까 인간의 커뮤니케이션 일부를 자동화하려고, 말하자면 그것을 제거하려고 엄청난 노력을 하는 걸까요? 그렇다면 우리가… 대체 어떻게 공존할 수 있을까요?

W 말씀한 부분을 파시즘에 대한 당신의 분석과 연결 지을 수 있을까요? 책에서는 파시즘이 재현의 문제이자 패닉 버튼이며 재현에 대한 거부라고 강경하게 주장하시는데요. 여기에서는 문화적 재현과 정치적 재현을 모두 이야기하고 있습니다. 이런 식으로 자동화되거나 신속하게 이뤄지는 재현이나 자동화라는 점에 비추어 파시즘의 부상에 대해서 더 이야기해 볼까요?

H 네, 실제로 인간들이 벌이는 논쟁에서 재현을 제거할 때, 또한 사람들이 재현에 대한 논의를 중단하고선 그것을 회피하려 들고 어떤 것이 의심할 여지 없이 완벽히 다른 것과 대등한 것인 척해서 재현을 제거할 때 말입니다. 그러니까, 그 어떤 종류의 조정도 없애려 들죠. 그리고 이런… 조정은 물론 무시무시합니다. 많은 경우에 이런 조정은… 미끄러지거든요. 실수가 있을 수 있고, 잘못된 의사소통, 오역, 오해, 모순, 거짓말, 혼돈이 발생하는 데는 의심할 여지가 없습니다.
　　조정 과정에서 온갖 종류의 사기와 배신이 일어날 수 있지만, 사람들 사이에선 어련히 벌어지는 일이죠. 알고리즘에 의한 확실성을 위해 이런 점을 제거하려 든다면 본질적으로 이런 점을 회피하고서 A가 B와 동일하고 모든 것이 명확하며 흑과 백이라고… 여기에 우리가 있고 저기에는 그들이 있다는 듯 구는 겁니다. 말하자면 그것은 재현을 제거함으로써 양면적인 것을 납작하게 만드는 것이며, 그 어떤 모호함도 납작하게 만들어 버리는 것입니다. 사람들이 이렇게 하고 싶다는 충동을 느끼는 것은 이해하는 바입니다. 하지만 그렇게 함으로써 언어 안에서 계급 투쟁 또한 제거해 버리는 겁니다. 어떤 경우엔 진실과 거짓에 대한 독재적인 규정에 찬동해서 그렇게 하는 거고요.

W 객석에서 질문을 받기 전에 마지막으로 하나만 여쭙겠습니다. 다른
에세이 작업도 많이 진행 중이신 걸로 알고 있습니다. 저희가 함께
무대에 오르는 게 올 한 해 동안 벌써 네 번째지요. 이번 대담에서는
『면세 미술』이라는 책에 집중할 수 있어서 좋았습니다. 현재 작업
중이신 에세이나 지금 고민 중이신 질문들에 대해서도 조금 이야기해
주실 수 있을까요?

H 네, 지금은 가상현실에 관해서 뭔가를 개발해 보려는 중이고
또 어떤 식으로… 이 개념을 창안한 사람까지 올라가 볼 수 있을까
생각 중입니다. 대부분의 사람들이 생각하는 재런 러니어는 아닙니다.
하지만 앙토냉 아르토는 1893년에 "잔혹극"이라고 부른 맥락의 개념을
제시했습니다. 그래서 가상현실을 잔혹극으로 분석해 보려고 합니다.
이것은 대체 어떤 의미일까요? 이것은 VR과 공감이 관련 있다는
궁극적으로 뻔하기 그지없는 개념과 씨름하려는 것이기도 합니다.
제 말은 이런 고정 관념이 떠돌고 있다는 겁니다. 멍청한 고글을
써서 난민의 입장이 되어 볼 수 있고, 이 세계 속의 권리를 박탈당한
사람들이 느끼는 바를 완전히 이해할 수 있다는 거죠.
 저는 완전히 반대로 생각합니다. VR이 가능하게 해 주는 공감이란
건 에어비앤비 식의 공감과 비슷하지 않나요? 그렇습니다. 저는
VR을 잔혹극으로 분석하려고 합니다. 저는 VR이 잔혹극이라고,
혹은 그럴 수 있다고 봅니다… VR이 무엇인지 아직 알지 못한다는
점을 항상 염두에 두고서 말이죠. 사실 어제 어떤 컨퍼런스에
참석했는데, 거기 있던 사람들 대부분이 "가상현실은 끝장났지만
가상현실은 그것을 아직 모른다."고 선언했죠. 저는… 그래요.
자, 그래서 가상현실이 끝장났다고 칩시다. 그런데 우리는 그것이
실제로 무엇인지 전혀 모른다고요? 이건 너무 시기상조일 수 있습니다.
최근에 탈고한 또 다른 에세이는 요즘 많은 사람들, 특히 엔지니어들이
인공지능을 종교적 용어의 틀로 표현하려고 한다는 걸 깨달으면서
시작되었습니다. 그들을 AI에 대해서 이런 이야기를 합니다. AI를
신성한 것에 가까운 인공일반지능(AGI)으로 프로그래밍해야 할까?
이 인공지능은 자비심이 있어야 할까? 등등이죠. 예를 들어 그것은
공감을 해야 할지… 아닐 수도 있죠. 그래서 생각했습니다. 그래,

받아들여야 하는구나. 사람들이 AI를 종교적 용어에 맞추고 있으니 그걸 더 끌어올려 보자. 그런 뒤에는 철학에서 가장 널리 알려진 종교적 질문 중 하나인 스콜라주의로 돌아가 봤습니다. 바로 이런 질문인데요. 바늘 끝에서 몇 명의 천사가 춤출 수 있을까? 그리고 이 질문의 틀을 살짝 바꿔 다시 묻습니다. 바늘 끝에서 몇 개의 AI가 춤을 출 수 있는지, 그런 뒤에는 결국 바늘 끝에서 몇 개의 AI가 춤출 수 있는지 계산하기 위해 스콜라주의의 논의 전반을 살펴봅니다. 사실 정답은 10의 49승입니다. 누군가 이미 계산을 했거든요. 이미 양자 중력을 이용해서 천사의 수와 같은 것들을 계산했습니다. 천사들이 빛의 속도보다 살짝 느리게 춤을 추지 않으면 바늘 끝이 블랙홀을 향해 붕괴된다는 점도 알아냈고요. 따라서 천사의 숫자… 그건 알아내기 아주 쉽습니다. 진짜 질문은 당연히 대체 어떤 종류의 춤이 될 것인지겠죠.

W 이제 관객 질문을 받기에 완벽한 때가 된 것 같네요.

H 감사합니다!

W 고맙습니다, 히토!

2018년 1월 24일 구겐하임 미술관에서 진행되었던 『면세 미술』 출간 기념 대담의 전문을 웬디 희경 전과 히토 슈타이얼의 동의하에 수록하였다.

W (Wendy Hui Kyong Chun) Hello everybody. It's my pleasure to be here to help launch Hito Steyerl's *Duty Free Art: Art in the Age of Planetary Civil War*. I'm going to start our conversation with a few comments about the book—as everyone who has read it knows, it's simply wonderful. It asks and answers the toughest questions that face us in the museum today. So, on the very first page, you ask: How can one think of art institutions in an age that is defined by planetary civil war, growing inequality, and proprietary digital technology? In an era, as you later discuss, dominated by real-estate speculation, asymmetric warfare, neoliberal capitalism, money laundering, speculation, and the rise of fascism? In an era in which the internet and the museum in all senses of the word are all over? As this passage exemplifies, Hito Steyerl plays with phrases in beautiful ways throughout the book. Everything gains a double meaning as it's repeated. *Duty Free Art* is insightful and inspiring. In it, you both critique contemporary art and art institutions, but you also constantly call on us to do better, to imagine a better future, to enact a better future.

Throughout the book, you repeat phrases such as "We have a choice," "We don't have to accept the fascism that's rising," "We don't have to accept the present or the future that's given to us." What's really remarkable is that you're critical without being nostalgic. So you don't imagine or call for some mythic time when everything was happy. In fact, you point out that a lot of nostalgia is reactionary and that the kinds of exits that are currently being imagined aren't an exit we want. Which importantly doesn't mean you avoid history—and I really love your formulation of history because you argue that history should remain history, that the museum needs to hold on to its artifacts. The example you give to make this point is the Russian tank that was in the Ukrainian museum but which exploded from the museum to be used to kill protesters. So you say: if we are to have a future, the museum has to hold on to its artifacts. But *Duty Free Art* also searches for new and unexpected ways. You wonderfully juxtapose popular culture and philosophy. One of my favourite parts of the book is where you talk about how what we really need to do is consider Tom Cruise and Emily Blunt in the *Edge Of Tomorrow* instead of repeating Marx again, so we can move like gamers to the next level. And *Duty Free Art* produces the new without fetishizing it. You argue for the autonomy of art without naivete. And what's remarkable is you make this

argument not just in the content but also through the book's form.

The book itself is really beautifully written. It's a tapestry or an installation in which every example is looped. So chapter eight on digital debris starts with Paul Klee's famous watercolour *Angelus Novus* and Benjamin's reading of it to realize that we're the debris—we're the spam. The Angel looks at us, and we're the digital debris. But then you end by making us wonder, what would the angel order for breakfast? Would the angel order spam from the breakfast menu? And I don't think anyone has ever brought together Paul Klee, Walter Benjamin, and Monty Python in such insightful and wonderful ways. You weave insights and arguments within and across essays, and it's important to spend your time with the book and read each essay one next to each other because a question you pose in one essay gets answered in another. You give an answer one but then you repeat it or you make it do something else. And you get us to think beyond contradictions. To move beyond getting mired in contradictions and feeling powerless, you tell us to push those contradictions to the point of escape. So you say, let's push duty free art so it's something more than tax free art. Let's make it duty free—let's make it free of authors and owners. Let's make International Art English, which is made fun of all the time as this horrible jargon-filled bla bla bla, it International Disco Latin, in which we choose Satin over Latin.

It should be clear from these examples that Steyerl has a, what we would say in Boston, wicked sense of humor. What's important though is that through your sense of humor and through your insights, through your looping, you do more than describe reality—you generate it. The book is not simply a book: it experiments; it generates truth; it generates fictions. So there is a lot of places from which to start the conversation. Perhaps the best way is to begin simply with the notion of duty free art itself. You start by talking about freeport art storage and you argue that its importance for international art circles is only next to the Biennale.

H (Hito Steyerl) Well, thank you so much, Wendy. And thanks to everyone for being here. In fact, I could just go on listening to you forever. And you summarised my whole book for me. Oh, it's fantastic. Ok, so freeport art, duty free art. I got fascinated by the phenomena of freeport or freeport art storage to be more precise and then one day I simply tried to walk into Geneva freeport.

Which I did, I managed to access for it about two minutes then I got kicked out and then I was really curious about what it actually was. So they had an advertisement for themselves on their website. The freeport was mostly owned at that time by a company called "Natural Le Coultre," not anymore. And they said about the freeport that it was probably the best museum in the world.

And I thought we should take them by the word and just consider it probably as one of the most important and in their words best museum in the world and then see what we can learn from that, at that moment in time. And indeed, I think that the freeport art storage has taken on the function of something like a secret museum. A museum, in which there are many important artworks probably but no one really knows for sure. They are kept in vaults, maybe even inside crates, and just you know moved from one cubic to another once they are sold. And this could basically go on forever. So yes, what does it mean if this kind of museum or collection has now taken on the role that was traditionally occupied by the National Museum, say by something like the Louvre for example. What does it mean ... how did the meaning of the word national change for example. What kind of constituency is represented by such a museum. What are the kind of organising principles, I mean except from tax evasion for example. What's so to speak the algorithm that organizes the curation of such a museum. What does it look like? I mean no one really knows but, of course, there's a lot of freeport anecdotes of people who used to work in these vaults as interns and they say it's kind of a mess because on the one hand there's the gold, and then there are some paintings in the corner and wine bottles but maybe also something else and nothing is catalogued and so on and so on.

And I thought, wow, this is amazing because this kind of principle of curating something reminded me of something completely different, namely the Amazon warehouse. The Amazon warehouse has developed an entirely contemporary version of curation which is called chaotic storage. Chaotic storage means that you know the things, the commodities are kept to one another but not in any kind of human logic. So it's not that toys would go next to toys and I don't know furniture next to furniture. No, it's all organized via the barcode number. So you have a complete mess which is only intelligible for robots. And I think this is the new principle of curating, right? Chaotic storage is the way that ...

you know I mean there will be an MFA very soon for chaotic storage curating principles and it will be very expensive. I'm completely sure about that. And ok. So what do all these things tell us about the nation, the museum, culture, patrimony, heritage, and so on and so on. I mean, first of all, it tells us the museum is now a black box run by proprietary algorithms which is no longer representing some nation or even let's say a form of commons which might be ruled by a sort of open-source algorithm. But even the way the community is constituted is also governed by some kind of black box algorithm. So there is a lot of very interesting points about the freeport and duty free art, which is sort of the dark matter of the current art world. You know that keeps this system somehow coherent.

On the other hand, I also thought, yes of course I mean we know about those aspects. They are kind of obvious so what else can we do about duty free art and then it really became very obvious to me that duty free art is of course also the art that has no duty to anyone. It's sort of, you know, it can do just whatever it wants. And it is not forced to, first of all, represent value. I think that's the foremost duty it has today. So what could an artwork be today that has no duty? As Liam Gillick said, I mean it will maybe exist in a kind of limbo of so called semi-autonomy, what could this mean today? What does autonomy mean, what is an autonomous artwork in age also when the meaning of the word autonomy itself has shifted so much that usually if we speak about autonomy today then it's about self-driving cars, right? So I think this is one of the main meanings of autonomy. It's applied to killer robots for example. They are supposed to be autonomous. But of course, they are systems that are not autonomous at all but are being tied back to a network, a protocol. You know they are never completely autonomous. They are only autonomous in relation to the network, to the connection they are being attached to.

W That nicely leads to your argument about proxies because you talk about proxies themselves as agents through which we act but also the proxy as autonomous. Proxies can do different things. You have this great passage about our bodies as proxies on page 26 when you talk of replacing the artist and audience members with props. You note that this isn't very different from "the much more elegant and dare I say standard solution for

managing the economy of presence and making actual and real-life presence choices is to check your email or Twitter feed while pretending to simultaneously listen to me. In this case, you are using yourself, more precisely your own body, as a stand-in or proxy or placeholder, while actually you go about your junk time commitments, which I think is perfectly fine as a form of absence management." And I know that you've thought a lot about proxy politics in terms of this double-edged autonomy. You have worked with Vera Tollmann and Boaz Levin on the proxy politics projects. So please, more about proxies and autonomy!

H Yeah I mean that's a recurrent experience whenever I look into an audience like that I will see at least usually 20–50 Apple signs you know blowing back at me. And I think it's a, it's a fair enough response to the constant demand to be in several places at the same time this state of being that Liam called adhocracy. I think that's a genius term, adhocracy. You have to be there but not only there but also there at the same time so what do you have to devise some kind of quantum politics of management being able to be you know in the same place at many different times but also on different planes. So you need some kind of proxy or stand-in in order to be able to achieve that. And that stand-in could be yourself, that's the cheapest solution. You just pretend you're there and in fact, you're not. ... but then, then there are slightly more expensive solutions which then have something to do with technology, one was to another of course. So yes, the proxy is how to manage these several instances of yourself running at once trying to pretend you're somewhere, where you're actually not.

W That nicely leads to question of the digital because the digital has an interesting status in your book. On the first page, you ask: "how can one think of art institutions in an age that is defined by planetary civil war, growing inequality, and proprietary digital technology?" For some that third term might seem a little odd, right, but I think it gets to some of the issues of opaqueness that you've alluded to earlier. You talk about the digital as epitomizing a certain logic of extraction, a certain logic of speculation, and at the same time, your texts themselves are wonderfully digital if you think of them in terms of loops. Could you talk a little more about how the digital plays into your argument? What it stands in for? What does it open up?

H	Yeah, I mean let me just give you one example. You know, in relation to connecting permanent war but also digital proprietary technology. You mentioned the example of the tank in Ukraine earlier on. That was a very fascinating example for me because literally some rebels captured a tank and drove it off the plinth and went to war with the tank which was basically part of a historical display already but today I saw something maybe or definitely more contemporary. As you know there is the Turkish invasion or attack on parts of Syria ongoing at the moment. So I saw some kind of TV broadcast which I found deeply disturbing but also fascinating. There is a TV caster in a Turkish TV studio he's standing in front of a green screen and on the green screen you see some kind of Super Mario 3D weapons like drifting from left to right. It's like little bombs, planes, tanks, and so on.

They slowly drift from left to right and then suddenly there is a 3D tank coming from behind and driving right into the studio next to the moderator. The moderator jumps out of the way and then the tank shoots towards the audience. And then I thought well, this is really related to many of the things I'm trying to describe in the book because what the tank actually does next … I mean it didn't really do so in the broadcast but what if it actually drives through the screen? And it will end up in your living room and then it disappears into your iPhone. And I think this is really how really cheesy 3D effects copy-pasted from gameplay and reality are connected today. Actually, this trope of going through the screen into reality is quite old. The first time I thought about it was when Silvio Berlusconi became prime minister of Italy because I thought he was the first guy in the world who just jumped through a TV screen, you know, into political reality to become head of state. It's not necessarily anything very eccentric anymore. But the reason you could immediately know Silvio did the feat was because you would see his nose and his face was all cut and stitched back together. And I thought ok, this happened when he jumped through the screen. You know, he has to kind of hurt his nose somehow and this is how you can tell if you see a man of a certain age and he has a lot of, you know, things going on in his face then maybe he jumps through a screen with noxious side effects for basically the public, yes. So maybe I didn't answer your question about the digital, sorry, got sort of sidetracked. But ok, going back to Ukraine and proprietary digital technology:

a lot of US farmers using John Deere tractors started hiring Ukrainian hackers to hack the software of their tractors and thereby fix them. The farmers were prohibited from fixing their own tractors because the software inside was not their property but John Deeres. This is the power of proprietary software.

w No, this is perfect because I can loop it back to what you say about video games and Berlusconi. You have this great reading of Malraux's museums without borders as a nightmare. Because when the museum loses its borders, it loses its commitment to the future. In terms of video games, you take on those people who say that the problem with modern warfare is that it's like a video game. Your write, "people who think so are making a big mistake. Many of them are in fact to be found in art and culture and think they're defending the gravitas or assumed criticality of their trade. For some 'creative professionals' computer games are an abomination, the pinnacle of capitalist conspiracy to distort reality. Their reaction, however, is not only critically but morally wrong. In fact, for the vast majority of humanity, it would be great if war were just like a video game. In a game, players respawn. You get shot—no problem: You can start all over again. You can nuke Hiroshima without anyone in Japan even noticing. Whereas in a real war, you die, and if you don't, you're either bored as hell or stressed out."[1] You go on and argue that the problem is when these games leak out. So maybe that's one way to think through the digital and that sort of breakthrough that you were talking about earlier.

[1] Hito Steyerl, *Duty Free Art* (London and New York: Verso, 2017), 153.

H Yes, so basically the argument is very similar for both screens and museum. If anything can be contained behind the screen we're safe, no. Same with the museum. If anything can be contained within a museum and you can really think about it as some kind of forced detainment, right, then we're safe. And I was, I mean this piece is heavily influenced by Philip Mirowski's book about game theory and how this developed into basically war simulations and war games and so on. And these games definitely tended to realize themselves, they tended to leak into reality. They tented to infect reality. For example in the case of war games and war simulations, even creating by some kind of coincidence the advent of computing, more or less. They wanted to calculate ... actually

if I remember correctly ... the effects of potential climate change, there was a plan shortly after World War Two to paint the poles in red so to create some kind of global warming which at that time was thought would harm the Soviet Union. But that was too complicated so they ended up computing a hydrogen bomb instead. So basically these games and simulations created reality, it was just not only not always the intended reality but some kind of accidental reality but nevertheless reality. So the idea is, how to contain these games, these beautiful games, these elegant games, these wonderful algorithms which managed to simulate reality in ... in a terrifyingly perfect way. How to contain them, either behind the screen or within the museum.

One of the ideas or one of the thoughts I always had in relation to museums is that—sorry I'm going to jump now, that always happens, this is why these books are always such a mess— I was reminded of cave art, right, because I was fascinated why if anyone has ever been to one of these caves with paleolithic art is really fascinating because the art is not at the entrance, right. Sometimes you walk for hundred of meters into the cave and it's really dark and you have no idea how these people could even manage you know to find these precise locations. But then it occurred to me, they walked so far into the cave because art was dangerous, right. And it needed to be contained somewhere in the dark. And this is where you could somehow deal with it and contain it and also experience all, its magic and terror like in an IMAX cinema. But then you could also leave again. And I thought the museum should be that kind of place, a place which you could safely leave. You know after a while all that spectacular magic and terror would stay behind and not completely mess up society. So in that sense, I thought the museum would be an excellent space, you know to contain a lot of financial algorithms for example. I think basically the most experiments with artificial intelligence should be declared art, no, and just confined to the museum for let's say the next 250 years or so. Until there have been some consistent results and then we can see how to maybe utilise it for real. But I think all those experiments that are on the one hand necessary but on the other really awfully magical and also terrorizing, they should remain in the museum. We should use it as this kind of detainment, temporary detainment.

W This is fascinating because what you also argue in your book is that yes, we should detain these beautiful things in a great passage on page 166: "that beauty can be a problem is immediately clear if we look at fashion models who might be seen as organic embodiments of sophisticated financial models that failed in 2008. They are defined as more beautiful the more starved they are. Supreme beauty in capitalist terms is achieved when a human body is able to work, day in, day out, virtually without food: utility equals beauty." And then you say "beauty can, then, be quite life-threatening for humans. But art professionals have a strategy for preventing beauty from being confused with reality. The solution is to lock up anything beautiful in a museum." But then you say, ok, but people are going object to this, and so on page 169, you write, "Of course, my art colleagues will object that, unfortunately, one cannot contain the effects of beauty in this way. Art and its effects leak out of institutions, they will argue, and so my model is idealized, fictional, and potentially crapstractional too. I totally agree. You are correct. But I don't want to solve this contradiction; I want to intensify it." and you then write about the Xerox Pentagon papers. Now these games, even if they're sequestered, can accidentally leak by generating other fictions—and other truths. This reminded me of what Michel Foucault once said of his books—that they're historical fictions but once written, he hopes will become true. This is what you are talking about.

H Yes, so I mean speaking of simulations as generative fictions, I'm completely fascinated by this idea which people in Silicon Valley, some of them seem to have that we live inside a simulation generated by aliens. They are very serious about that, right.

W Called Silicon Valley ...

H Yes, so ok, we live and actually I completely agree, we do live in simulation generated by aliens only that the alien is called Facebook, right. Yes, I mean we are living in a sort of large-scale psychological experiment, well you know collective affect and moods are experimented upon and so on and so on. Yes, it's completely true, we live inside an alien simulation. So that can, of course, I mean that can obviously be realised so why not just adapt this idea and try to realise different simulations and this is

not something that just occurred to me. This is very much also indebted to the work of Harun Farocki for example who you know very patiently over decades try to document and also analyze modes of training. For example what is training, what is job training, what is military training, how do body so to speak adopt certain postures, certain attitudes, you know just by repetition. How does basically this kind of training become a habit. Or not only a habit, a belief, if you go back you know to the source of these kinds of ideas. You end up with Pascal who said that if you want to believe in God, this thing you would have to do is not to pray, you have to kneel down. You basically have to enact the bodily posture in order to create some kind of spiritual reality. So why can't we imagine these kinds of other games? Other simulations which are different and in which people would so to speak train for different realities.

w You see it quite beautifully. Why can't we have then open source what.

H Yes

w You ask: why don't we take this logic of open source that's been limited to these virtual spaces and now that the internet is all over why don't we use it differently

H yeah, yes

w So share everything. Let's have open source water, energy, Dom Perignon champagne.

H Yes

w But you also say and that this could also go very wrong, and we could end up with malls filled with Starbucks run by Stalin.

H Yes, that's happened, that's done. Check.

w Next mall. Relatedly, early on you speculate that art might created the division of labor.

H maybe ... is just a hypothesis, who knows ...

W And you ask, if these images created the division of labor and of the state, what will the digitally encrypted image lead to? What sort of state will emerge from that? And you give us hexadecimal numbers that we are supposed to read as like the protagonists in *The Matrix*. Can you just take that little further and talk about what kind of state you see emerging from these images?

H So two points. I mean, first of all, I was talking about the neolithic prestate or early neolithic state which did not happen because people domesticated animals and then developed agriculture, became sedentary, and then suddenly there were some feudal lords emerging. No, it seems to have happened completely differently. People out of nowhere started building huge temples in southern Anatolia and started decorating them with wild beasts and animals and suddenly there was this whole amount of coordinated labor and feasting going on which necessitated then, you know, more sedentary lifestyles and agriculture to grow grain for beer and you know all these sorts of side effects. But these were side effects from architecture/art which sort of usher in ... some sort not only of the division of labor but in certain examples also a class society. How that came to pass is far from clear but it was the end result of several millenia of experimentation. Class society is created through art. Of course over several millennia of society and the creation of completely new models of it. And I think we are at both different and similar points where basically a new form of visuality, a new form of creating art, of creating representations pushes us, you know over the, over the edge, over the cliff into some kind of new political paradigm which we really don't get to know what it's going to be, except that it ... that I mean we can already see very clearly that the class inequality apparently is not going to be reduced by it. On the contrary, it will probably escalate more and more.

So this is the first point, what is the new political paradigm. In the book, I try to say ok well, it's not, it's not a mystery in the age of you know Deep Mind and Deep Dream and you all these deep mining technologies, the corresponding state technology is probably a deep state. But the second point I think is probably more important because we are now also in a period where the

meaning of what an image is for example is radically changing because most images now are basically made at least on a digital base made of the same source material than any other bit of information be it writing or whatever. So in that sense, it's no different any longer from other forms of information and it's also mostly only accessible for human senses in some kind of translation. You need a screen, you cannot access it in its raw form, in its original form so to speak which is just you know impulses of electricity or you know a Wifi signal or something which we haven't yet developed sensors to pick up. I speculate what are the sensors going to be that are going to be able to directly access these kinds of machine images, invisible images, images that have withdrawn into you know a non-sensual sphere. Actually, on the other hand, I mean this is one part of the story. The other part is paradoxically in the realm of the visual, photography for example we had for more than a century. Or in the case of photography basically, since its inception, there was a doubt you know about the promises of photography to give us some kind of objective and truthful representation of reality so basically, this discussion is now more than 150 years old.

But now that a lot of images have become almost or literally imperceptible this belief in truthful representation, objectivity somehow re-emerges in a new form because now though even if we can't see any image or we can see any representation, people are absolutely sure that it's 100% true. Because it's an analysis of big data you know. Some machine recognizes the pattern, so of course, it's going to be true. So it's interesting the item, the object that guaranteed, you know, the indexicality of the photographic representation was the lens more or less or the camera or the apparatus as such. So now we have just this place, the belief into this object onto computers. And we think just because they exist whatever they are telling us about whatever they are doing to whatever numbers is now going to be a truthful and objective representation of reality. So basically we just push this problem to the next level.

W But you also did this great move in which you show us the ways in which Bitcoin actually should learn from art markets.

H Yes, yes, well in the meantime in 2021 it did.

W Because art is, you point out, an alternative currency. Your comparison between art and Bitcoin is wonderful. You argue that art as an alternative of currency seems to fulfill what Bitcoin has hitherto only promised: "Rather than money issued by a nation and administered by central banks, art is a networked, decentralized widespread system of value. It gains stability because it calibrates credit or disgrace across competing institutions or cliques. There are markets, collectors, museums, publications, and the academy asynchronously registering (or mostly failing to do so) exhibitions, scandals, likes, and prices. As with cryptocurrencies, there is no central institution to guarantee value; instead, there's a jumble of sponsors, censors, bloggers, developers, producers, hipsters, handlers, patrons, privateers, collectors, and way more confusing characters. Value arises, from *gossip-cum-spin* and insider information. ... Art is encryption as such, regardless of the existence of a message with a multitude of conflicting and often useless keys. Its reputational economy is randomly quantified, ranked by bullshit algorithms that convert artists and academics into ranked positions, but it also includes more traditionally clannish social hierarchies. It's a fully ridiculous, crooked, and toothless congregation and yet, like civilisation as a whole, art would be a great idea."[2] Wow! art itself as ideal encryption is so interesting and dead-on. So ...

2 Ibid., 182-183.

H Yes, I have a plan. I will ... I now designed my own cryptocurrency and it will go on the market tomorrow I think and the idea is, it will fly immediately, it's called Cash Coin. Basically, this is the ideal cryptocurrency because it has no digital base whatsoever.

 It's only material. It only exists in the form of coins. It's fully decentralized it is the safest blockchain technology whatsoever. Because it's actually, there's no ledger, there is no blockchain. It's unhackable, it just doesn't exist. And it has you know a lot of big advantages, it's fully anonymous and so on and so on. Cash Coin! Believe me. And then I also realised that actually, this is how artworks already today. It's a kind of cash coin because it's like a coin where every coin has a different stamp basically, no. Every, every coin has a different hash, singular hash, that's art, that's how it works. It's not very traceable in many cases. Well, I went back into the history of looted art and the ... well in any cace, provenance is very often a problem. So there are no ledgers. So in that sense, it's

very difficult to track it. So in that sense art does already resemble some form of currency. Now what kind of currency is it? Well in the meantime all this became realized, captured, and commodified as NFT culture, except that now the blockchain, the ledger and property claims actually do exist in parts. The thing that emerged is like applying the OS for old school art markets to digital assets, creating artificial scarcity.

Something that also occurred to me recently is that blockchain technology but also lots of social media try to do one thing. There are relations between people one way or another. Communication or an implicit contract, code of conduct, or something like that and they try to automate it. It's about the automation of social relations, right.

So that's basically the core of the technology, no. The question is just why would anyone do that, right? I mean automating labor to a certain extent if it's you know hideous awful labor, why not. But why would one automate a social relation, that's ... that's really an open question to me. That's really something I do not understand. If there is anything that should not be automated then it's probably a social relation. So why is there such a huge push to automate precisely that, you know, part of human communication which, if you take it away, I mean ... what we ... how will we basically coexist?

W Well I wonder if you can link it back to your analysis of fascism because in the book you argue quite powerfully that fascism is a question of representation, and it's a panic button, a rejection of representation. And here you're talking about both cultural and political representation. So do you want to talk more about the rise of fascism in the light of this sort of automated or rapid representation or automation?

H Yeah whenever representation is being taken out of real human argument when people stop negotiating representation and try to short-circuit it and try to pretend that something is without any doubt absolutely equivalent to something else then you basically take out representation. You try to get rid of, you know, any kind of mediation. And this ... mediation is scary of course, you know. In many cases mediation is ... It's slippery. There can be mistakes, miscommunication, mistranslation, misunderstandings,

ambivalence, lies, and confusion, no doubt.

Also all sorts of scams and betrayal can happen through mediation but this is what happens between humans. So if you try to eliminate it in favor of algorithmic certainty you basically short-circuit it and just pretend A is the same as B, everything is clear, this is black and white, here is the … here it's us and over there is them and so on and so on. So it's basically the flattening of ambivalence, the flattening of any kind of, you know, the ambiguity that happens through the elimination of representation. I understand that people feel the urge to do this. But by doing so they also eliminate the class struggle within language—sometimes in favor of some autocratic definition of truth and falsehood.

W Let me ask one last question before we open it up to the audience. So I know that you've been working on a lot of other essays. So we've been, this is our fourth appearance together I think in less than a year. I've loved this one because we just get to concentrate on your book. So you just want to talk a little bit about the essay that you're currently writing or questions that you're grappling with now?

H Yes, so now I'm trying to develop something around virtual reality and how … tracing it back to the person that actually came up with this notion. Which was not Jaron Lanier as most people think. But Antonin Artaud came up with this notion in 1893 in the context of what he called the "Theater of Cruelty." So I'm trying to analyze virtual reality as a theatre of cruelty. What does it mean? And this is, you know, also trying to grapple with this ultimately cheesy notion that VR has something to do with empathy, right. I mean this is the stereotype that's floating around. You can put yourself into refugees' shoes, you know, by wearing these stupid goggles you're going to completely understand what you know disenfranchised people in the world feel and so on and so on.

So it's the absolute contrary I think. The thing that's actually being enabled by VR is not empathy, it's more like an Airbnb of empathy, no? Yeah. And I'm trying to analyze it as a theatre of cruelty which I think it is or could be … always keeping in mind that we basically don't really know yet what it is. Actually, I was at a conference yesterday where the majority of people declared "Virtual reality is dead but it doesn't know it yet." I'm … Ok.

So virtual reality is dead, but we have no idea what it actually is? This might be premature. The other essay I recently completed which was prompted by my realization that many people now especially engineers try to frame artificial intelligence in religious terms. So they talk about AI—should we program it as a quasi-divine AGI? Should it be benevolent? and so on and so on. And should it have empathy for example ... maybe not. So I was, I thought—ok I have to accept it. People frame it in religious terms so let's just escalate it. Then I went back to one of the most famous religious questions in philosophy—scholasticism—which is the question: how many angels can dance on the tip of a needle. And I just reframe it a little to ask: How many AI's can dance on the tip of a needle and I went to a whole scholastic argument in order to find out of course in the end that you can precisely calculate the numbers of AI's that dance on the tip of the needle. In fact, it's 10 x - 49 because someone already did this calculation, calculated the number of angels using quantum gravity, and so on. And he also figured out that the angels have to dance slightly slower than the speed of light otherwise the tip of the needle collapses into a black hole. So the number of angels ... that's very easy to solve, you know. The real question of course is, you know, what kind of dance is it going to be?

w I think this is a perfect time to open up the floor to questions from the audience

H Thank you!

w Thank you, Hito!

The full text of the conversation on January 24, 2018, at the Guggenheim Museum to commemorate the publication of *Duty Free Art* has been printed with the consent of Wendy Hui Kyong Chun and Hito Steyerl.

유동성 주식회사 -
글로벌 유동성

Liquidity Inc.-
Global Liquidity

유동성 주식회사
LIQUIDITY INC.
2014

- 단채널 HD 디지털 비디오 설치, 컬러, 사운드, 30분 15초
- 국립현대미술관 소장
- 작가, 앤드류 크랩스 갤러리, 뉴욕 및 에스더 쉬퍼, 베를린 제공

- SINGLE-CHANNEL HD DIGITAL VIDEO, COLOR, SOUND IN ARCHITECTURAL ENVIRONMENT, 30 MIN. 15 SEC.
- MMCA COLLECTION
- COURTESY OF THE ARTIST, ANDREW KREPS GALLERY, NEW YORK AND ESTHER SCHIPPER, BERLIN

- 참여 WITH
 JACOB WOOD, MMA EXPERTS: MAVERICK THE "SOULCOLLECTOR" HARVEY, RAGE NG, THE WEATHER UNDERGROUND, BRIAN KUAN WOOD, ESME BUDEN, AND MAXIMILIAN BRAUER
- 기술 감독 TECHNICAL DIRECTOR KEVAN JENSON
- 촬영 감독, 베를린 DIRECTOR OF PHOTOGRAPHY, BERLIN CHRISTOPH MANZ
- 촬영 감독, 로스앤젤레스 DIRECTOR OF PHOTOGRAPHY, LOS ANGELES KEVAN JENSON
- 세컨드 유닛 2ND UNIT LEON KAHANE
- 조명 감독, 로스앤젤레스 LIGHTING DIRECTOR, LOS ANGELES TONY RUDENKO
- 그래픽 디자인 및 어시스턴트 GRAPHIC DESIGN AND ASSISTANT POST MAXIMILIAN SCHMOETZER
- 구조물 디자인 ORIGINAL RAMP DESIGN BY DIEGO PASSARINHO AND YULIA STARSEV FOR STUDIO MIESSEN
- 설치 요소 공동개발 INSTALLATION ELEMENTS CO-DEVELOPED WITH MICHAEL AMSTAD
- 커미션 COMMISSIONED BY DAVID RIFF, EKATERINA DEGOT FOR BERGEN ASSEMBLY AND SUBMITTED 8 MONTHS AFTER THE OPENING
- 음악 MUSIC BRIAN KUAN WOOD, "TYLER STEWARD SUPERFUNK"; MELODY SHEEP, "BRUCE LEE REMIX"; KASSEM MOSSE, "SHAQUED"; ARTHUR RUSSELL, "LET'S GO SWIMMING"; CELLO SAMPLES FROM JOEL PIERSONS "GOD'S WORLD"; UNKNOWN AND UNTRACEABLE FILES FROM PUBLIC HARD DRIVES
- 클립 CLIPS BY MAXIM MAXIMOV, MELODY SHEEP/JOHN D. BOSWELL
- 일기예보 WEATHER BRIAN KUAN WOOD
- 신경 쇠약 NERVOUS BREAKDOWN HITO STEYERL
- 도움 주신 분 THANKS TO NICK AIKENS, ABDULLAH AL-MUTAIRI, ESME BUDEN, MASSIMILIANO GIONI, GARETH JONES, LEON KAHANE, SVEN LUETTICKEN, CHRISTOPH MANZ, KASSEM MOSSE, KEVIN SLAVIN, TOM SWAFORD, ANTON VIDOKLE
- 도움 주신 분 SPECIAL THANKS TO TFA TOTAL FIGHTING ALLIANCE, TOD MEACHAM
- 현지 촬영 장소 SHOT ON LOCATION IN HERMOSA BEACH, CA

→
《히토 슈타이얼- 데이터의 바다》 전시 전경, 국립현대미술관, 서울, 2022

INSTALLATION VIEW OF *HITO STEYERL- A SEA OF DATA*, NATIONAL MUSEUM OF MODERN AND CONTEMPORARY ART, SEOUL (MMCA), 2022

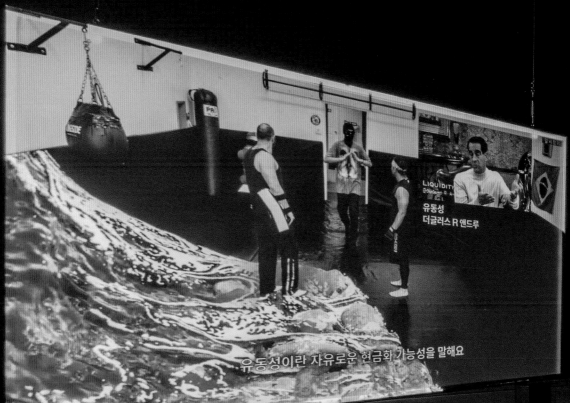

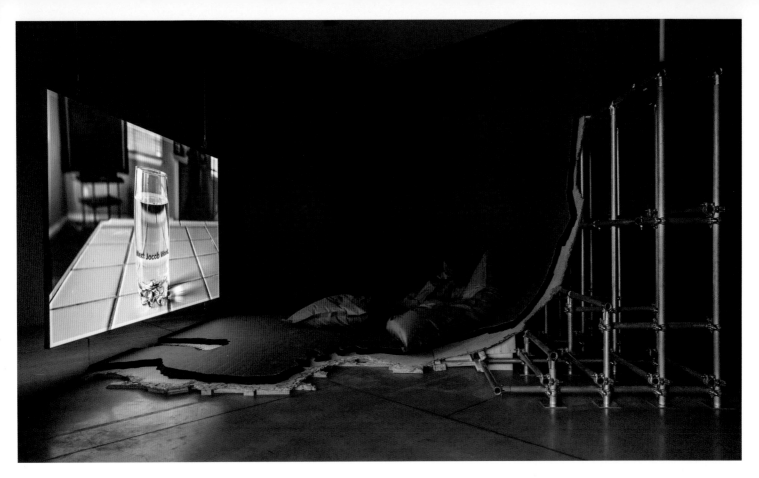

온타리오 미술관
전시 전경, 토론토,
2019

INSTALLATION VIEW
OF ART GALLERY OF
ONTARIO, TORONTO,
2019

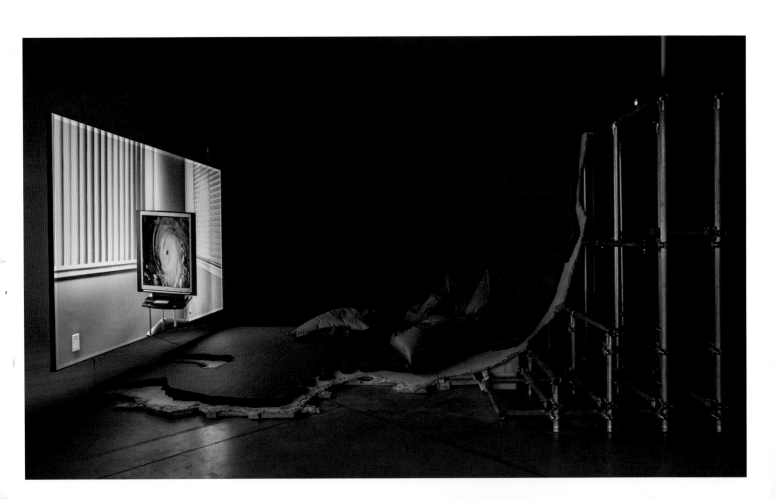

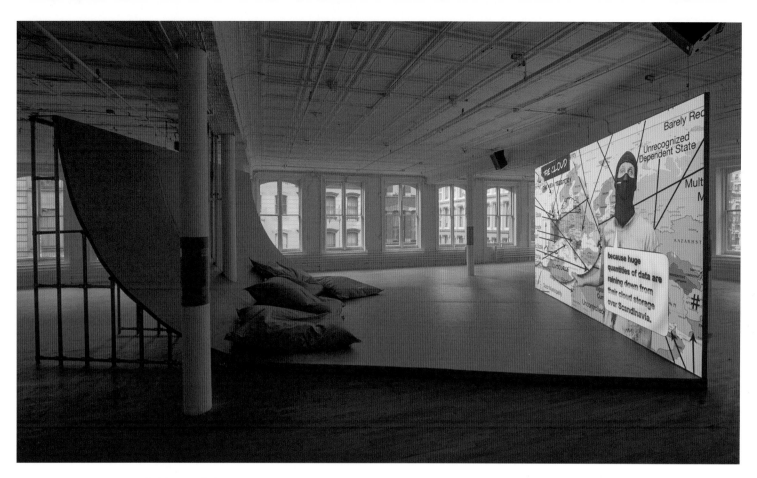

아티스트 스페이스 INSTALLATION VIEW
전시 전경, 뉴욕, OF ARTISTS SPACE,
2015 NEW YORK, 2015

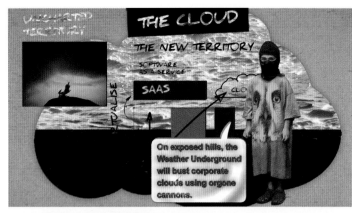

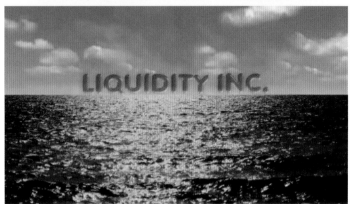

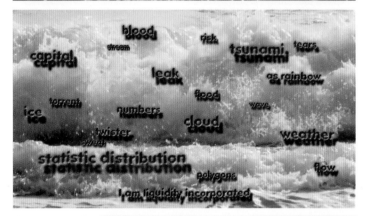

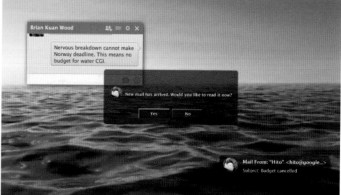

자유낙하
IN FREE FALL
2010

· 단채널 HD 디지털 비디오, 컬러,
 사운드, 33분 43초
· 작가, 앤드류 크랩스 갤러리,
 뉴욕 및 °에스더 쉬퍼, 베를린 제공

· SINGLE-CHANNEL HD DIGITAL VIDEO,
 COLOR, SOUND, 33 MIN. 43 SEC.
· COURTESY OF THE ARTIST, ANDREW
 KREPS GALLERY, NEW YORK AND ESTHER
 SCHIPPER, BERLIN

· 감독 DIRECTOR
 HITO STEYERL
· 기술 감독 TECHNICAL DIRECTORS
 CRISTÓVÃO A. DOS REIS, CHRISTOPH
 MANZ
· 촬영 감독 DIRECTOR OF PHOTOGRAPHY
 KEVAN JENSON
· 출연 CAST
 IMRI KAHN (ART HISTORIAN/EXPERT)
· 커미션 COMMISSIONED BY
 VISUALISE THIS, INC.; MARIUS
 BABIAS, NBK; PICTURE THIS, BRISTOL;
 COLLECTIVE, EDINBURGH; CHISENHALE
 GALLERY, LONDON; HENIE ONSTAD
 MUSEUM, OSLO

→
《히토 슈타이얼−
데이터의 바다》
전시 전경,
국립현대미술관,
서울, 2022

INSTALLATION VIEW
OF *HITO STEYERL−
A SEA OF DATA*,
NATIONAL MUSEUM
OF MODERN AND
CONTEMPORARY ART,
SEOUL (MMCA),
2022

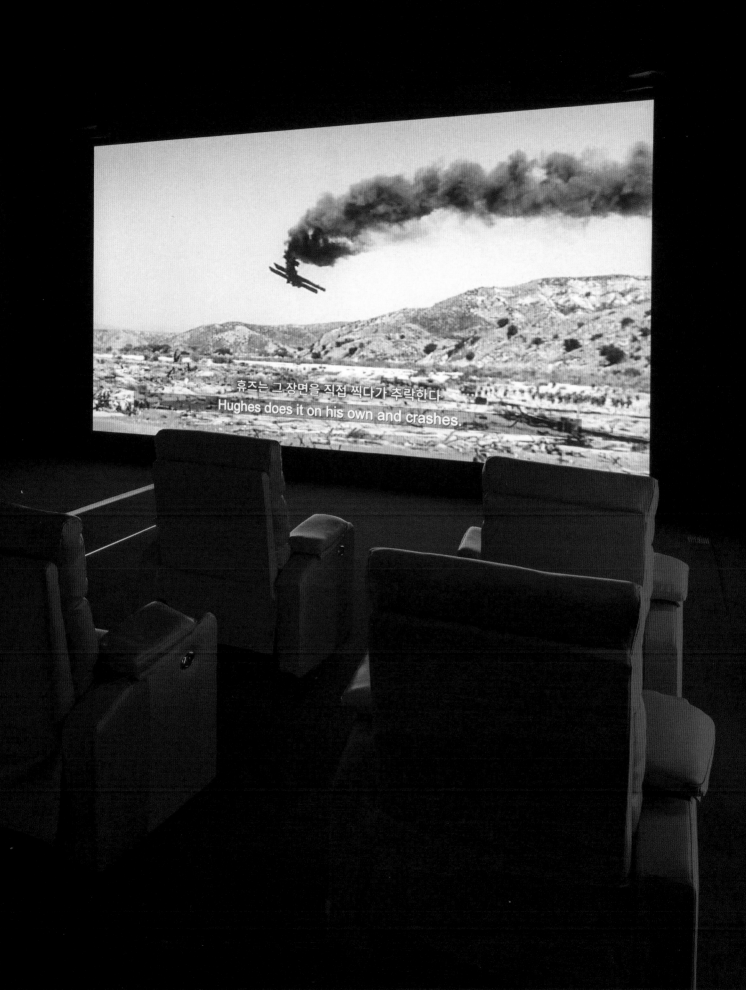

휴즈는 그 장면을 직접 찍다가 추락한다
Hughes does it on his own and crashes.

모든 일대기

Every biograp

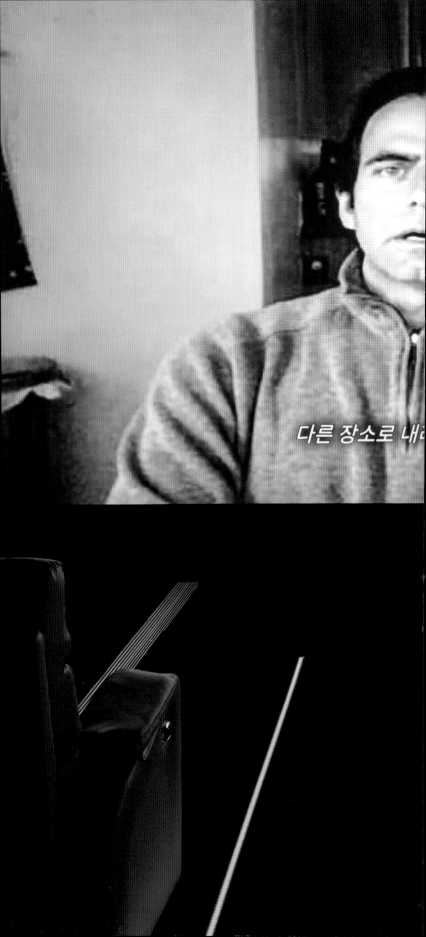

다른 장소로 내

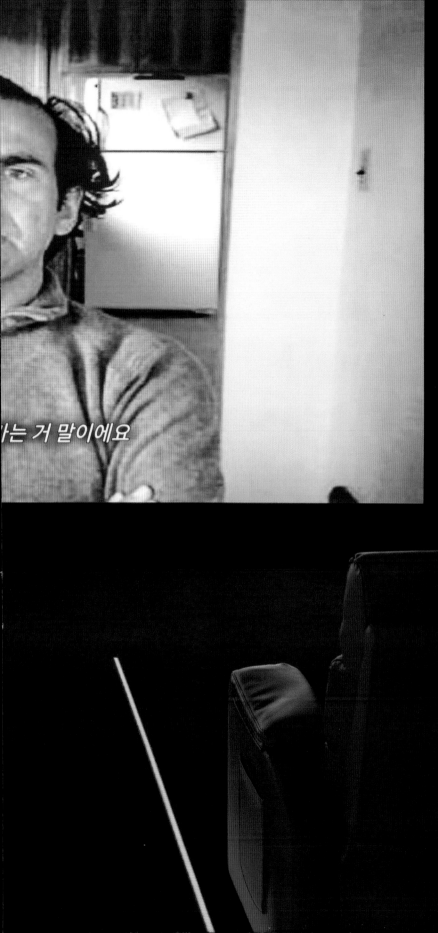

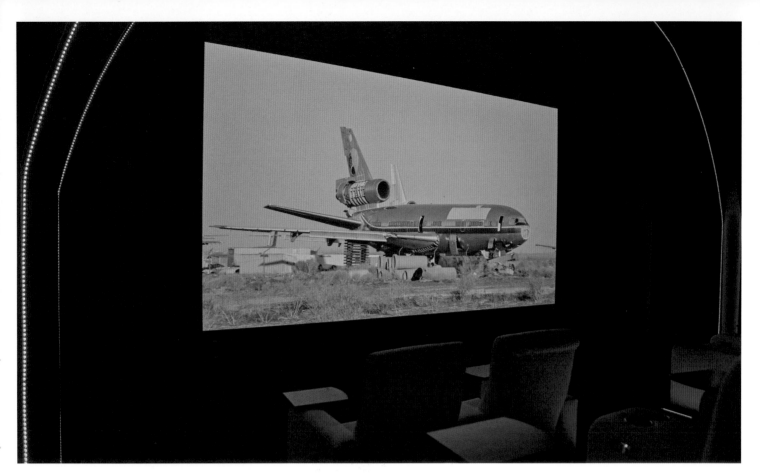

↑ 레이나 소피아
미술관 전시 전경,
마드리드, 2015

INSTALLATION VIEW
OF MUSEO NACIONAL
CENTRO DE ARTE
REINA SOFÍA,
MADRID, 2015

아티스트 스페이스
전시 전경, 뉴욕,
2015

INSTALLATION VIEW →
OF ARTISTS SPACE,
NEW YORK, 2015

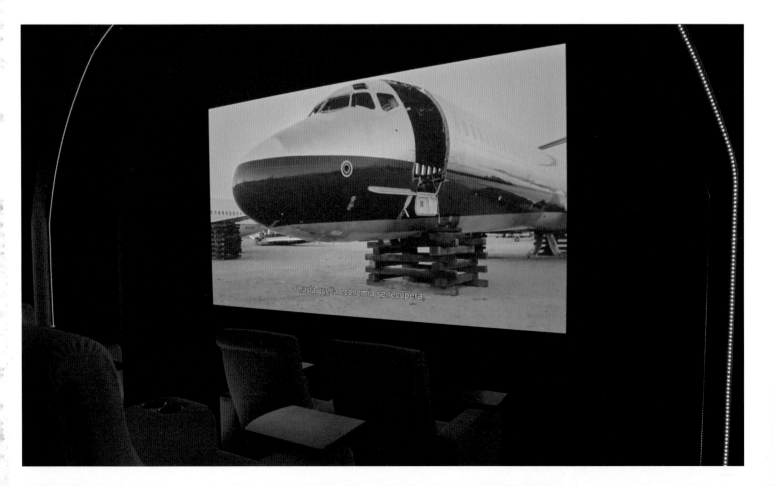

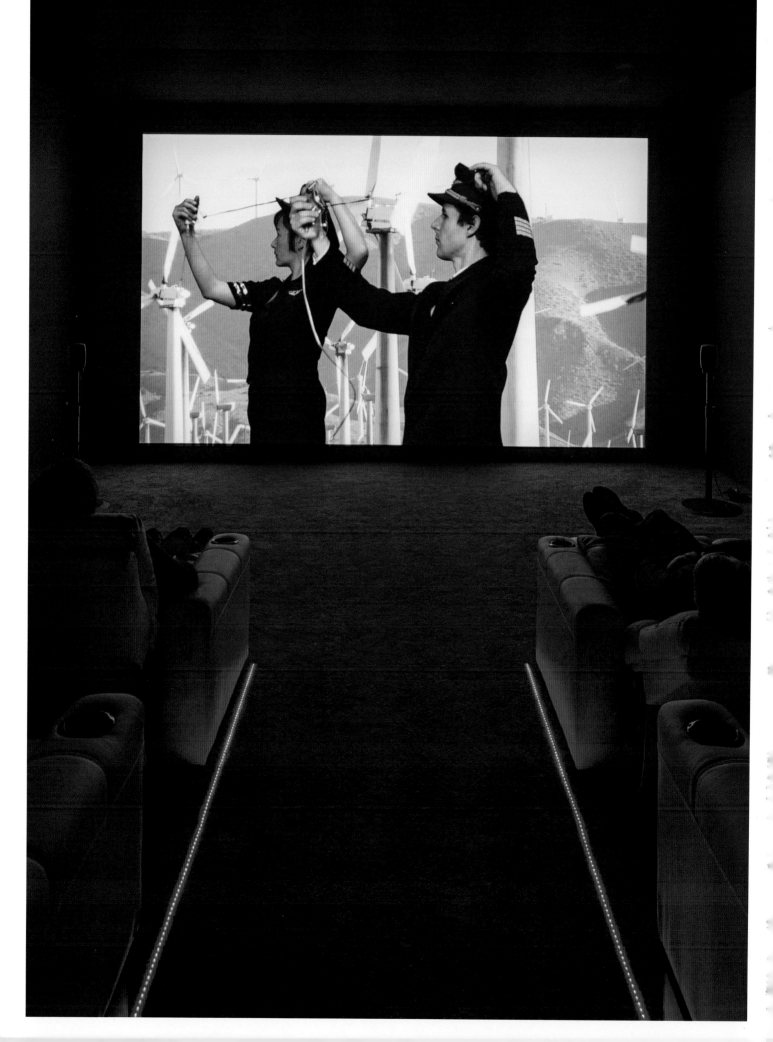

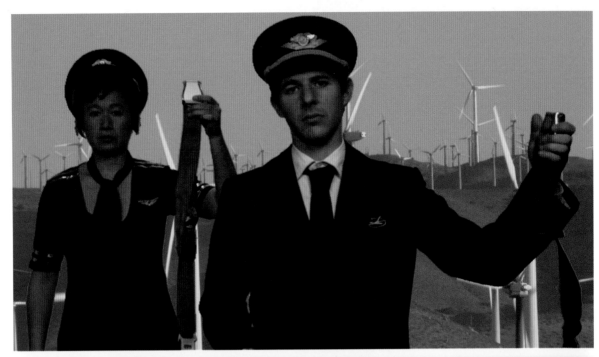

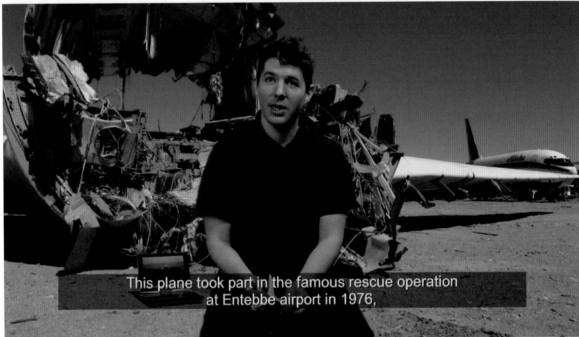

This plane took part in the famous rescue operation
at Entebbe airport in 1976,

보리스 아르바토프 재방문:
히토 슈타이얼과
순환주의(circulationism)의 재발명

김수환

Boris Arvatov Revisited:
Hito Steyerl's Reinvention of
Circulationism

Soo Hwan Kim

1

자신의 영상작업과 상호보충 및 모순의 관계에 있다고
말해지는 이론적 에세이들에서 슈타이얼은 포스트-인터넷
시대의 이미지 존재론 및 정치경제학과 관련된 이슈들을
정면으로 다루어왔다. 이 과정에서 그녀는 동시대의 다양한
이론적 사유(비판 이론과 미디어 이론)를 적극적으로
끌어들이는 한편 소비에트 아방가르드의 유산,
특히 구축주의를 자기식으로 재전유하려는 시도를
보여준 바 있다. 가령, 소비에트 생산주의 그룹의 활동가
세르게이 트레티야코프의 실험적 사유는 그녀의 비디오
에세이 〈자유낙하〉(2010)에서 지극히 흥미로운 방식으로
재방문되어 "사물을 향한 (재)정향"을 특징으로 하는 동시대
예술의 두드러진 경향과 공명한 바 있다.[1]

1

1년 후에 발표한 동명의 에세이
「In Free Fall」(2011)에서도
'낙하'는 미학적 관례에 불과한
(수평적인) 선형원근법의 틀을
깨는 해방적 계기인 동시에
독특한 '사물되기'의 경험으로
등장한다. "낙하는 타락이자
해방이고, 사람이 사물로,
사물이 사람으로 변신하는
상태이다." 히토 슈타이얼,
「자유낙하: 수직 원근법에
대한 사고 실험」, 『스크린의
추방자들』, 김실비 옮김(서울:
워크룸 프레스, 2016), 37.
트레티야코프와 벤야민, 그리고
슈타이얼 사이의 흥미로운 역사적-
이념적 연결고리에 관해서는,
Soo Hwan Kim, "Tretyakov
Revisited: The Cases of
Walter Benjamin and Hito
Steyerl," *e-flux journal* 104
(November 2019)를 보라.

잘 알려져 있듯이, 주체의 자리에서 내려와 객체와
나란히 서려는, 더 나아가 기꺼이 사물이 되려는 이런 입장은
"당신이나 나 같은 사물"이라는 구절로 대변되는 '사물로서의 이미지'
개념을 낳았다. "이미지는 현실을 재현하지 않는다. 그것은 현실 세계의
파편이다. 그것은 다른 모든 것과 마찬가지로 사물이다.
당신이나 나 같은 사물이다."[2] 슈타이얼은 사물로서의 이미지
개념의 적법한 참조점으로 벤야민("사물들의
언어")[3]과 더불어 또 한 명의 이름을 거론하고 있는데,
트레티야코프와 나란히 소비에트 아방가르드 생산주의
미학의 이론적 지주로 활약했던 보리스 아르바토프가 바로
그 인물이다. 크리스티나 키에르의 선행 연구[4]에
기대어, 슈타이얼은 아르바토프에게서 "권력과 폭력을
응축한" 흔적으로서의 "멍"[5]이 아니라 역동적인 노동구조의
힘과 에너지를 내포하는 사회변화의 정당한 작인으로서의
사물이라는 대안적 이미지를 찾아낸다.

2

히토 슈타이얼, 「당신이나 나 같은
사물」, 『스크린의 추방자들』, 69.

3

Hito Steyerl, "The Language
of Things," *Transversal*
06/06: *Under Translation*
(European Institute for
Progressive Cultural
Politics, 2006).

4

Christina Kiaer, "Boris
Arvatov's Socialist Objects,"
October 81 (Summer 1997):
105-118; Christina Kiaer,
*Imagine No Possessions: The
Socialist Objects of Russian
Constructivism* (Cambridge,
MA: The MIT press, 2005).

보리스 아르바토프는 그의 글 「일상생활과 사물의
문화」에서 객체가 자본주의적 상품 지위의
노예화로부터 해방되어야 한다고 주장한다. 사물은

5

"사물은 권력과 폭력을
응축한다. … 그것은 정치 및
폭력과 충돌하여 멍이 들었다."
슈타이얼, 「당신이나 나 같은
사물」, 72.

6
같은 글, 75-76.

더 이상 수동적이고 고루하며 죽은 상태에 있는 것이 아니라
일상적 현실의 변화에 능동적으로 참여하는 자유를 누려야 한다.[6]

아르바토프는 사회주의적 사물이란 "사회적 노동을
위한 힘과 도구이면서 동시에 동료"[7]가 되어야만
한다고 주장했다. 문제는 슈타이얼의 창작과 사유에서
아르바토프가 점하는 위상이 담대한 유토피아적 상상력을
시연하는 지난 세기의 흥미로운 사례에 그치지 않는다는
데 있다. 아르바토프라는 이름은 슈타이얼이 "생산주의에서
순환주의로"[8]라고 명명한 바 있는 총체적이고 거시적인
변화, 우리 시대를 규정하는 특정한 이미지 레짐의
교체를 사유하는 데 있어 필수 불가결한 과거의 이미지를
대변한다. 그것은 단지 지나가 버린 역사적 과거가 아니라
우리로 하여금 현재의 실천이 과거의 사건과 공명하는
지점을 찾아내고, 그럼으로써 본래 사건의 잠재적
가능성들이 다시금 현행화될 수 있는 조건들을 탐색할 것을 촉구하는
과거, 이를테면 "구제의 시간을 기다리는" 과거에 해당한다.

이어지는 글에서 나는 과연 어떤 점에서 '아르바토프와
그의 시대'가 이런 예기치 못한 동시대성을 획득하게 되는지를
보여주고자 한다. 이를 위해 순환주의의 어떤 측면들이 지난 세기
초반 소비에트에서 제출된 아이디어들과 대응될 수 있는지를
다각도로 짚어보고, 그렇게 함으로써 슈타이얼의 순환주의 개념에
담긴 의미심장한 함의를 역사적 차원에서 곱씹어볼 수 있는 계기를
마련하고자 한다.

7
Boris Arvatov "Everyday Life and the Culture of the Thing (Toward the Formation of the Question)," trans. Christina Kiaer, *October* 81 (Summer, 1997): 124.

8
나는 circulationalism의 한국어 번역어로 이미지 경제 내부에서의 유통(distribution)의 개념을 연상시키는 '유통주의'보다는 에너지나 힘의 순환과 더불어 전기적 흐름 및 회로(circuit)를 강하게 연상시키는 '순환주의'라는 번역어를 선호한다. 관련된 논의는 뒤에 이어질 것이다.

2

순환주의 개념의 선언적 표명으로 여겨지곤 하는 에세이 「인터넷은
죽었는가?」(2013)에서 슈타이얼은 이렇게 말했다.

"20세기 소비에트 아방가르드가 생산주의─예술은 생산과 공장에
속해야 한다는 주장─라 부른 것은 이제 순환주의로 대체될 수
있다. 순환주의는 이미지를 만드는 예술에 대한 것이 아니고

이미지를 후반 작업하고 발매하고 가속하는 것에 대한 것이다. 그것은 사회망을 통한 이미지의 공적 관계, 광고 및 소외, 가능한 한 상냥하게 텅 빔에 대한 것이다."[9]

9
히토 슈타이얼, 「인터넷은 죽었는가?」, 『면세 미술: 지구 내전 시대의 미술』, 문혜진·김홍기 옮김(서울: 워크룸 프레스, 2021), 176. [번역 일부 수정]

그런데 이 문단 뒤에 곧장 이어지는 다음과 같은 (수수께끼 같은) 구절의 의미에 주목하는 사람은 그리 많지 않다. "그러나 생산주의자들인 마야코프스키와 로드첸코가 신경제정책(NEP) 시대 과자 광고판을 어떻게 만들었는지를 기억하는가? 열성적으로 상품물신숭배에 관여한 공산주의자들을?" 슈타이얼은 이 문단에 꽤 긴 각주를 달아 놓았는데, 그것은 다음의 문장으로 끝난다. "그들은 보리스 아르바토프의 이론에서 도출된 질문에 직면한다. 상품물신과 시장이 자본주의 아래 조직한 개인의 환상과 욕망은 혁명 이후 어떻게 될 것인가?"[10]

10
같은 글, 177.

자주 그러하듯이, 여기서 슈타이얼의 각주는 또 다른 각주를 요구한다. 이 마지막 문장에 담긴 심오한 의미를 파악하기 위해서는 그녀가 기대고 있는 키에르의 연구의 맥락을 먼저 이해할 필요가 있다. "사회주의적 사물" 개념을 중심에 둔 키에르의 연구를 추동한 배경에는 네프(신경제 정책, 1921–1928)에 대한 재평가가 놓여있다. 그녀는 네프를 공산주의 이념의 "후퇴"(크리스티나 로더, 1983)나 그에 대한 "배신"(폴 우드, 1992)으로 간주하는 일반적인 통념에 도전하면서, 그것을 특별한 기회이자 가능성으로 재평가하고자 했다. 그녀에 따르면, 자본주의 경제시스템의 부분적 도입이라는 네프의 한시적인 타협 상황은 당대 구축주의 이론가들로 하여금 소비와 욕망의 문제, 그러니까 "상품을 욕망하는 인간 주체"의 문제를 고려하지 않을 수 없도록 만들었다.

"근대성의 대량생산된 사물들이 갖는 정동적인 힘", 언젠가 마르크스가 "판타스마고리아"라는 단어로 표현했던 "모더니티 내부의 상품 페티시의 힘과 내구성"의 문제는 네프 이전(전시공산주의)과 이후(스탈린 계획경제)에는 이미 직면할 필요가 없게 된, 그런 점에서 전적으로 네프 시기에만 국한되는 특별한 조건이었다. "동료로서의 사물"이라는 아이디어는 바로 이런 예외상태로서의 네프의

11

「당신이나 나 같은 사물」의 4절을
여는 제사(epigram)로 사용되고
있는 로드첸코의 글이 작성된 해
역시 1925년이다. 그는 그 해
파리에서 열린 국제 아르데코
박람회에 〈노동자 독서실〉을
출품했는데-콘스탄틴 멜리니코프가
디자인한 소비에트관에 타틀린의
〈제3인터내셔널 기념비〉와 나란히
전시되었다-상품 문화의 성지
파리에 머물면서 모스크바에 있는
아내 스테파노바에게 이런 편지를
보냈다. "동방으로부터의 빛은
노동자의 해방만을 뜻하는 것이
아니라오. 그것은 인간, 여성,
사물에 대한 새로운 관계 속에
있지. 우리 손에 들린 사물들은
우리와 동등해져야만 해요.
지금의 모습처럼 신음하는 검은
노예가 아니라 동지가 되어야만
하오." Christina Kiaer,
"Rodchenko in Paris," October
75 (Winter 1996): 3. 러시아어
원본: Aleksandr Rodchenko,
*Opyty dlja budushhego:
Dnevniki, Stat'i, Pis'ma,
Zapiski* (Experiments for
the Future: Diaries, Essays,
Letters, Notes) (Moskva:
Grant, 1996), 152.

한복판(1925년)[11]에, 그것의 혼합적(사회주의+자본주의)
성격을 고스란히 간직한 채 만들어졌다. 키에르는 자신의
연구 의도를 명확하게 밝힌다. "이 책의 주장은 그들
[구축주의자들]이 사회주의적 근대성의 대량-생산된
사물들과의 욕망의 관계가 반드시 탐욕으로 정의될 필요가
없는 그런 미래를 그렸다는 것이다. 구축주의자들은 네프
시기에 소비 욕망의 문제를 심각하게 고려해야만 했다.
이런 의미에서 그들은 정말로 네프 대중들의 대중적 기호에
직면해야만 했던 것이다."[12]

12
Kiaer, *Imagine No
Possessions*, 26.

요컨대, 슈타이얼이 "보리스 아르바토프의
이론에서 도출된 질문"이라고 표현한 과제는
어떻게 하면 상품적 욕망을 결정적으로 근절할
것인가에 관한 것이 아니다. 아르바토프의 관심은
어떻게 하면 수동적인 자본주의적 상품을 사회주의적
사물로 '변형'시킬 수 있을 것인가, 다시 말해 마르크스적
의미에서의 상품 페티시를 사회주의를 위한 도구로
'재정향'시킬 수 있을까라는 물음을 향해 있었다. 한마디로
그의 문제의식은 단순 부정이 아닌 변형을 겨냥하는 바,
그것은 주어진 조건을 무시하거나 건너뛰는 대신에 그것을 인정한
상태에서 돌파할 수 있게 하는 대안적 가능성을 찾고자 한다.

주목하지 않을 수 없는 것은 돌연 '아르바토프의 질문'을
환기시키는 이 구절들 이후에 슈타이얼이 "결정적으로, 순환주의는
재발명된다면"으로 시작되는 가정법 문장을 이어가고 있다는
사실이다. 그러니까 '생산주의가 순환주의로 대체되었다'는 진단과
'순환주의의 재발명' 가능성 사이의 중간에 "아르바토프의 이론에서
도출된 질문"이 끼어 들어가 있는 형국이다. 마치 별것 아니라는
듯이 태연하게 '삽입'되어 있는, 또 그렇기 때문에 많은 경우에 그냥
쉽게 지나쳐버리는 이 구절 속에는 100년 전 소비에트 아방가르드의
그림자가 짙게 드리워져 있다. 이 그림자를 무시한 채로 슈타이얼의
'순환주의' 개념에 담긴 깊은 함의와 잠재력을 온전히 전유한다는 것은
불가능하다. 반복하건대, 그것은 과거와 현재가 공명하는 지점과
그 반향의 양상을 꼼꼼하게 확인하는 작업을 반드시 필요로 한다.

동시에 그 작업은 슈타이얼이 순환주의 파트의 논의를 다음과 같은 첫 문장으로 열고 있는 이유를 납득하는 과정이기도 할 것이다. "그러나 이러한 것들은 보이는 것처럼 새롭지 않다."[13]

13
슈타이얼, 「인터넷은 죽었는가?」, 176.

3

결정적으로, 순환주의는 재발명된다면 기존의 네트워크를 단락시키고, 기업의 친교와 하드웨어 독점을 둘러가고 우회하는 것이 될 수 있다. 순환주의는 국가의 절시증, 자본의 굴종, 대대적 감시를 노출함으로써 시스템을 재코드화하고 배선을 바꾸는 예술이 될 수 있다.[14]

14
같은 글. [번역 일부 수정]

순환주의의 재발명에 관한 위 구절에서 즉각 우리의 눈길을 사로잡는 단어는 "단락(short-circuiting)"이다. 이 단어가 뒤에 나오는 "배선교체(rewiring)"와 마찬가지로 전기 회로와 관련된 어휘임에 우선 주목하자. 사전적 정의상 "단락"은 전기회로에서 상이한 전압을 지닌 두 개의 접점 사이에 모종의 비정상적인 연결이 발생하는 상황을 가리킨다(우리말에서 합선이라고도 자주 번역되는 이유다). "짧은-회로"라는 조어가 가리키듯이, 이 상황은 (정상적인 과정을 생략시켜) 일반적인 경우보다 더 빠르게 과도한 전류를 흐르게(과부하) 만들기 때문에, 과열, 화재, 폭발 등을 일으킬 수 있다. 그러니까 이 단어에는 과잉에 의한 단절, 즉 끊어짐의 의미와 더불어 새롭고(비정상적이고) 직접적인(강력한) 연결 혹은 합쳐짐의 의미가 들어있다. 유의할 것은 이런 전기회로의 비유가 설명을 위해 동원된 일회적 수사에 그치지 않는다는 점이다. 가령, 다음과 같은 설명을 보라.

순환 중인 이미지(image in circulation)는 그것의 내용보다는 그것의 충전(charge), 구동(drive), 방향(direction)에 관한 것이다. 그것은 또한 강렬하게 수량화될 수 있고 추적가능한 상태에 관한 것이다. 숫자로 인코딩된 사랑, 분산으로 배가되는 생산에 관한 것이다. [에너지의 단위인] 줄(joule)과 와트(watt), 열정 또는 안구 단위를 통해 … 우리는 이미지의 에너지를 측정할 수 있을 것이다.[15]

15
Circulationism. Discussion with Hito Steyerl. 2014년 5월 24일, https://vanabbemuseum. nl/en/programme/programme/ circulationism/.

여기서 보듯이, 전기적 비유는 순환주의 개념 자체의 본질과 직결된 특징으로 나타나고 있다. 네트워크나 사이버네틱스 관련 담론에서 상례가 된 이런 용법이 지금의 관점에서는 별반 대수롭지 않게 보일 수도 있다. 하지만 지난 세기 소비에트의 혁명적 예술 이론에 익숙한 사람에게는 이 단어가 결코 예사롭게 들리지 않을 것이다. 혁명 이후 새로운 세계를 특징짓는 예술의 작동 모드를 가리켜 "전기화(electrification)"라는 용어를 처음 썼던 사람은 보리스 아르바토프였다.[16] 물론 이 용법의 일차적인 배경은 "공산주의란 소비에트 권력 더하기 국가 전체의 전기화"라는 레닌의 유명한 언급임이 틀림없지만, 이 용어의 배후에는 '아르바토프의 시대'를 함께 했던 몇몇 소비에트 아방가르드 이론가들의 모습이 어른거린다.[17] 그 중에서도 가장 중요한 인물이 "기계시대의 프롤레타리아 음유시인" 알렉세이 가스테프다. 인간과 기계가 융합하는 미래 공산주의 사회를 주창했던 가스테프는 혁명 초기에 시인으로 활동하다가 파리로 망명하여 그곳에서 철강 노동자로 일했다. 프롤레트쿨트의 멤버이기도 했던 그는 이른바 소비에트식 테일러주의 이상의 급진적 대표자로서 노동의 과학적 조직화라는 사명에 몸을 바치게 된다. 레닌의 후원을 받아 1920년에 모스크바에 설립한 '중앙노동연구소'는 가스테프의 주도하에 전국적으로 약 50만 명의 노동자와 2만여 명의 조교를 훈련시키는 1700여 개의 지부를 창설했다. 가스테프에 따르면, "전기화는 기계주의의 최상의 표현"[18]이었다. 그도 그럴 것이 가스테프가 꿈꾸었던 미래는 단지 기계적으로 조율된 집단적 신체가 아니라 공통의 국제주의적 심리 시스템, 이를테면 '켜고 끄고 합선시키는' 시스템을 갖춘 메커니즘이기 때문이다.

수백만 개의 두뇌 대신 하나의 세계 두뇌를 만드는 것. 비록 국제적인 언어는 아직 없지만 국제적인 제스처가, 수많은 사람들이 사용법을 알고 있는 국제적인 심리 공식이 있다. …

16
Alexei Penzin, "Afterward. The 'Electrification of Art': Boris Arvatov's Programme for Communist Life," *Boris Arvatov, Art and Production* (London: Pluto Press, 2017), 133.

17
펜진에 따르면, 새로운 시대 속 예술의 실천적이고, 적극적이며, 무엇보다 조직화하는 역할을 강조하는 아르바토프의 견해의 앞자리에는 소비에트 조직학 이론(텍톨로지)의 대부 알렉산드르 보그다노프가 놓여 있다.

18
"전기화는 기계주의의 최상의 표현이다. 이것은 이미 하나의 기계, 기계의 집합이 아니며 심지어 기계-공장, 기계-도시도 아니다. 그것은 기계-국가인바, 그것이 국제적인 것이 될 때 완전한 의미에서 기계화된 지구가 된다. 여기선 모든 것이 기계의 징표 아래 자라난다." Aleksej Kapitonovich Gastev, *Kak nado rabotat'. Prakticheskoe vvedenie v nauku organizacii truda (How Should Work. Practical Introduction to the Science of Labor Organization)* (Izd. 2-nd Moscow: Economics, 1972), 51.

19

Kurt Johanssen, *Aleksej Gastev: Proletarian Bard of the Machine Age* (Stockholm: Almqvist & Wiksell International, 1983), 68에서 재인용. 러시아어 원문: Aleksej Gastev, "O tendencijah proletarskoj kul'tury" (On the Tendency of Proletarian Culture), *Proletarskaja kul'tura Ezhemesjachnyj zhurnal* (Proletarian Culture, Monthly Journal) 9-10 (1919): 44.

이런 심리의 표준화와 그것의 역동성 속에 프롤레타리아적 사유의 거대한 자발성을 향한 열쇠가 놓여있다. 미래에 이러한 경향은 개인적인 생각을 불가능하게 만들고, 개인적인 생각은 부지불식간에 스위치-온, 스위치-오프, 합선들(short-circuits)의 시스템을 갖춘 계급 전체의 객관적 심리로 탈바꿈하게 될 것이다.[19]

집단의 신체와 심리가 공히 완벽하게 제어되고 상호 연결 및 공유되는 미래사회를 향한 가스테프의 거대한 전망을 디스토피아적 악몽[20]으로 받아들일지 아니면 본질상 '결핍'에서 기원한 소비에트 기계문화 특유의 무자비함[21]으로 간주할지는 각자의 판단에 달려있다. 하지만 논쟁의 여지가 없는 사실은 소비에트의 기계신봉자들이 자신들의 꿈을 "생체역학(biomechanics)"이라 불리는 새로운 인류 창조 프로젝트로 이해했다는 점이다.

20

1926년에 출간된 예브게니 쟈마틴의 소설 『우리』는, 흔히 생각하는 것과 달리 스탈린식 전체주의에 대한 비판이 아니라 소비에트 기계주의의 유토피아적 비전에 대한 디스토피아적 악몽을 형상화한 작품이다. 한편, 지젝은 가스테프로 대변되는 1920년대 소비에트 기계주의의 공격적 전망을 오늘날 우리가 생명정치라고 부르는 것의 최초의 극단적 공식으로 간주하면서, 1930년대의 스탈린주의를 1920년대의 기계화된 집단주의의 유토피아에 맞서기 위한 "윤리학의 회귀"로서 읽어내는 시도를 한적이 있다. 슬라보예 지젝, 『잃어버린 대의를 옹호하며』(서울: 그린비, 2009), 319.

21

"소비에트 스타일의 기계문화는 결핍(lack)의 표현을 그것의 기원으로 하는 바, 심지어 그것의 무자비함(brutality)마저도 유토피아적인 특징을 갖는 것으로 보일 수 있었다." Susan Buck-Morss, *Dreamworld and Catastrophe* (Cambridge, MA: MIT Press, 2000), 107. 벅-모스에 따르면, 대규모 생산이 실용적으로 동기화되었던 미국과 달리 소비에트에서는 '기계를 향한 숭배'가 기계 자체보다 앞서갔다. 자본주의 국가의 노동자들에게 산업화가 이미 겪고 있는 "파국"이었던 데 반해 소비에트의 프롤레타리아에게 산업화는 여전히 "꿈세계"였던 것이다.

이와 같은 새로운 기계적 세계관에 발맞춰 인간을 새롭게 바라볼 수 있어야만 한다. 인간이 가장 완벽한 기계 중 하나라는 사실을 인류가 돌연 깨달을 수 있도록 해야만 한다. … 이 과학은 생체역학이다. 노동하는 인간 동작은 일정한 인내심과 일반적인 효율 계수와 더불어 선과 점, 각도와 무게의 결합에 다름 아니다. 인간 신체는 자신의 정역학과 동역학을 알고 있다.[22]

22

Aleksej Kapitonovich Gastev, *Kak nado rabotat'. Prakticheskoe vvedenie v nauku organizacii truda* (How Should Work. Practical Introduction to the Science of Labor Organization), 51. 순환주의에 관한 슈타이얼의 앞선 설명(강렬하게 수량화될 수 있고 추적 가능한 상태)과의 눈에 띄는 공명에 주목하라.

결국, 공통의 동역학과 심리학을 장착한 국제적이고 대중적인 신체의 형성을 향한 소비에트 기계주의의 꿈이란 "전기-신경, 두뇌-기계, 영화-눈 등으로 이루어진 새로운 인간의 감각중추(sensorium)"[23]를 겨냥하는 기획이었다. 실제로 이들의 기획은 이론적 사변에 그치지 않았던바,

23

Buck-Morss, *Dreamworld and Catastrophe*, 107.

소비에트 생체역학의 요구는 가령 메이에르홀드의 연극연출법이나
베르토프의 영화-눈 이론 같은 예술 방법론에 적용되었을 뿐만 아니라
(소설 『붉은 별』에도 등장하는) 보그다노프의 수혈연구소나
블라디미르 베흐테레프의 집단반사학, 레프 비고츠키의
언어심리학과 알렉산드르 루리아의 신경심리학에까지 이르는
길고 흥미로운 계보를 낳았다.[24]

24
그런가하면, 인류 최초의 인터넷
프로젝트 또한 1960년대 소련에서
기획되었다. 초기 사이버네틱스의
창시자 중 한 명인 빅토르
글루시코프는 계획 경제의
아이디어를 완벽하게 만들어줄
OGAS라 불리는 전 소비에트
노동자 관리 시스템(사실상
오늘날의 인터넷에 해당하는
네트워크)의 구축을 설계했지만,
이 계획은 끝내 실현되지 못했다.
소비에트 인터넷 프로젝트를
둘러싼 흥미로운 이야기는
Benjamin Peters, How Not
to Network a Nation: The
Uneasy History of the Soviet
Internet (Cambridge, MA: The
MIT Press, 2016)을 보라.

　　그런데 여기서 "감각중추"라는 저 용어는 언젠가
수전 벅-모스가 "미학에서 마취학으로"라는 구절을 통해
흥미롭게 변주하면서 미학의 본령으로 회복시킨 바 있는[25]
(근대적) 감각과 매체의 상호관계를 떠올리게
하지 않는가? 신체의 감각중추와 그것의 특수한
생태학을 둘러싼 이 문제는 자연스럽게 또 한
명의 중요한 인물(다만 이번에는 러시아인이 아닌
독일인)을 떠올리게 한다. 아르바토프와 가스테프의 실제

25
Susan Buck-Morss, "Aesthetics
and Anaesthetics: Walter
Benjamin's Artwork Essay
Reconsidered," October 62
(Autumn, 1992): 3-41.

동시대인이면서 슈타이얼에게는 (끝없는 영감을 제공하는
가장 강력한 대화자라는) 또 다른 의미에서의 동시대인에 해당하는
발터 벤야민이 바로 그 외국인이다.

　　벤야민은 1926-27년 겨울에 약 두 달간 모스크바를 방문했다.
그곳에 머무는 동안 그는 에이젠슈테인의 영화를 관람했고 그의 옛
스승인 메이에르홀드를 직접 만났으며, 가스테프의 중앙노동연구소에
관한 기록을 남겨 놓았다.[26] 모스크바 '이후'의 벤야민,
그러니까 1920년대 후반에서 1930년대 중반까지 벤야민의
사유에는 '소비에트의 흔적'이 미묘하지만 강렬한 형태로
남아있다. 그는 1930년대 내내 (소위 "생산 사이클"에
포함되는 자신의 에세이들에서) 정작 소비에트 내부에서는
이미 억압되어 지워져 버린 기술적 유토피아의 파묻힌
기억들을 독창적인 방식으로 되살려낸 바 있다.[27]

26
펜진은 벤야민이 아마도
트레티야코프를 통해서
아르바토프에 대해서도 잘
알고 있었을 것으로 추정한다.
Penzin, "Afterward.
The 'Electrification of
Art,'" 128.

　　벤야민의 사유에 남겨진 "모스크바의 흔적"이라는
측면에서 볼 때 무엇보다 눈에 띄는 개념이 바로
"신경감응(innervations)"이다. 벤야민 사전에서
"내부와 외부, 심리적인 것과 자동적인 것, 인간과 기계의
레지스터들 사이에서 그것들을 매개하는 신경생리학적 과정을 폭넓게

27
김수환, 『혁명의 넝마주이:
벤야민의 〈모스크바 일기〉와
소비에트 아방가르드』(서울:
문학과지성사, 2022)를 참조하라.

28
Miriam Hansen, *Cinema and Experience: Siegfried Kracauer, Walter Benjamin, and Theodor W. Adorno* (Oakland: University of California Press, 2011), 133.

가리키는"28 이 용어가 처음 등장한 것은 (모스크바에서 돌아온 직후 러시아 여인 아샤 라시츠에 바치는 헌사를 달고 출간된) 「일방통행로」였지만, 그것이 완전한 형태로 전개된 것은 1929년 「초현실주의」 에세이에서다. 잘 알려져 있듯이, 벤야민은 이 에세이의 마지막 문단에서 초현실주의를 「공산당 선언」에 연결시키는데, 이제껏 수많은 궁금증과 해석을 낳았던 이 유명한 문단에서, 흥미롭게도 "집단의 신체적 신경감응" 개념은 "혁명적 방전"이라는 명백한 전기적 비유를 동반한다.

> 그 자연(physis) 속에서 신체와 이미지 공간이 서로 깊이 침투함으로써 모든 혁명적 긴장이 신체적인 집단적 신경감응이 되고 집단의 모든 신체적 신경감응이 혁명적 방전(放電 discharge)이 되어야만 비로소, 현실은 「공산당 선언」이 요구하는 것처럼 그 자체를 능가하게 될 것이다.29

29
발터 벤야민, 「초현실주의」, 『선집 5권』, 최성만 옮김 (서울: 길, 2008), 167.

혁명적 긴장이 "집단적 신경감응"이 되고, 다시 그것이 "혁명적 방전"으로 이어지는 이 과정이란 결국 이미지 공간 내에 신경 전류가 과도하게 흐르게(방전) 됨으로써 새로운 집단적 신체가 만들어지고 또 변형되는 과제임이 판명된다. 주지하듯이, 이후 이 문제는 새로운 지각 장치로서의 영화로 고스란히 이어지게 되는데, 벤야민은 「예술작품」 에세이 2판에서 혁명을 "집단의 신경감응, 더 정확히 말해 역사적으로 일회적인 새로운 집단의 신경감응 시도"라고 규정하면서, "영화는 … 지각과 반응양식에 인간을 적응시키는데 기여"하는 바, 바로 이런 "적응을 가속화하는 일이 혁명의 목표"라고 주장했다.30

흥미로운 것은 바로 여기서 앞서 말한 "혁명적 방전"의 구체적인 양태를 발견하게 된다는 점이다. 혁명적 방전의 과정이란 무엇인가? 그것은 "단단한 덩어리"로 존재하는 어떤 집단(가령, 대중)에 "충격을 불러일으킴으로써" 그 덩어리(mass)를 "느슨하게 만드는 것"이다.

30
발터 벤야민, 「기술복제시대의 예술작품」 2판, 『선집 2권』, 최성만 옮김 (서울: 길, 2007), 57.

> 계급투쟁은 프롤레타리아트의 단단한 덩어리를 느슨하게 만든다. 그러나 바로 이 계급투쟁이 소시민의

덩어리를 응집시킨다. … 진정으로 역사적인 사건들에서 독특한 점은, 단단한 대중의 반응이 그 안에서 어떤 충격을 불러일으키게 되는데, 그 충격이 그 덩어리를 느슨하게 하며, 나아가 그들 스스로를 계급의식을 가진 핵심세력의 집합으로 자각하게 만든다는 데 있다.”[31]

31
벤야민, 「기술복제시대의 예술작품」, 75.

이 “느슨하게 만드는” 작용이 에세이 전체를 관통하고 있는 각종 분산과 해체의 이미지(10분의 1초의 다이너마이트, 정신분산, 충격효과 등)의 연장선상에 놓여 있는 것이면서, 동시에 「초현실주의」에서 말했던 “생산적 경험,” 즉 도취를 통해 “자아를 마치 벌레 먹은 치아처럼 느슨하게 만드는 일”[32]과 연결되는 것임을 알아차리기는 어렵지 않다. 혁명적 방전이 모종의 풀어짐(dissolving)과 연결되는 이 대목은 특별히 시사적이다.

32
벤야민, 「초현실주의」, 146.

왜냐하면 이 대목은 지금껏 추적해온 기계적이고 전기적인 모델과는 다른 새로운 모델, 보다 유연하고 자유로운 변형이 가능한 대신에 훨씬 더 불안정하고 가소적인 모델로 우리를 이끌고 가기 때문이다. 벌레 먹은 치아처럼 느슨해진다는 것은 딱딱한 고체적 상태에서 벗어나 물렁물렁한 액체적 상태에 더 가까워진다는 것을 의미한다. 그리고 말할 것도 없이 이 새로운 모델은 슈타이얼의 “유동성”의 개념을 곧장 떠올리게 한다.

4

틀림없이 자크 데리다의 저서 『유한회사(Limited Inc.)』에 빗댄 제목일 〈유동성 주식회사 (Liquidity Inc.)〉는 흥미로운 단어 조합을 보여준다. 회사(incorporation)라는 용어는 어원상 체현됨(embodied)을 뜻하는 라틴어 incorporate에서 유래하는 바, 이 단어는 어디로 들어가서(in) 하나의 몸(라틴어로 corpus)을 이룬다는 뜻을 갖는다.[33] 그러니까 벤야민이 강조했던 “집단적 신체성”을 곧장 떠올리게 하는 이 단어가 “유동성”이라는 단어와 결합돼 있는 것이다.

33
Karen Archey, "Hype-Elasticity Symptoms, Sighns, Treatment: On Hito Steyerl's Liquidity Inc.," *Too Much World: The Films of Hito Steyerl*, ed. Nick Aikens (Berlin: Sternberg Press, 2014), 224.

물론 이 결합에서 훨씬 더 두드러지는 것은 앞에 붙은 유동성이다. 슈타이얼은 자신의 비디오 에세이에서

"모든 견고한 것들이 녹아내리는" 소위 액체 근대(지그문트 바우만)의 상황을 넘어서 말 그대로 물의 흐름이 모든 것을 관통하고 집어삼키는, 압도적으로 액화된 세계의 정치경제학적 풍경을 보여준다. 여기서 "물처럼"이라는 비유는 투자 금융에서 시작해서 격투 기술, 날씨, 테러, (클라우드)데이터, (밈)이미지를 거쳐 주체성의 양태[34]에까지 이르는, 말 그대로 모든 것을 지배하는 원리와 방법으로서 제시된다. 그런가 하면, 빠르고 난잡하게 남용되는 온갖 이미지(일본 우키요에부터 아이폰 채팅 화면까지)들이 넘쳐 흐르는 "미끄러지는(slippery)" 형식은, 언제나 그렇듯이, 작품의 내용과 알맞게 조응한다. "유동성의 동시대적 조건이 주체에게 요구하는 바는 표면을 따라 빠르게 미끄러져 가는 것이다. 그렇지 못하면 물에 빠져 익사하게 될 것이다."[35]

이런 세계의 풍경을 전면적 금융화로 대변되는 현단계 자본주의의 축적 체계에 대한 비판이나 무한히 변형되는 자본의 영속적인 자기가치화(self-valorization) 과정에 대한 패러디로 읽어 내거나, 혹은 하룬 파로키가 말한 "가동적 이미지(operational image)"가 인터페이스를 넘어 아예 환경이 되어버린 최대치의 통제-감시사회, 이를테면, 가스테프가 꿈꾸었던 기계적 유토피아의 음화 버전으로 간주하는 것은 얼마든지 가능할 것이다. 하지만 소위 포스트-포드주의적 전환에 관한 대부분의 비판이 일반적으로 공유하는 이런 진단에 비해 더 큰 흥미를 끄는 것은 그와 같은 세계상에 관한 슈타이얼 고유의 입장, 더 나아가 그에 대한 처방적 전략일 것이다.

반드시 강조할 것은 슈타이얼이 그려내고 있는 이 새로운 세계는 분명 액체화된 자본의 논리가 활개 치고 있는 글로벌 자본주의의 출구 없는 무한순환의 체계가 맞지만, 동시에 마치 기후위기 시대의 날씨처럼 변덕스럽고 제멋대로인 불안정한 유동성의 세계이기도 하다는 점이다. 이를테면, "그것은 이상한 피드백 루프가 돌아가는 엉망이 된 복합성의 영역. 부분적으로는 인간이 만들었지만 또한 부분적으로만 인간이 통제할 수 있으며, 움직임, 에너지, 리듬, 복잡화 외에는 그 어떤 것에도 무관심한 상태"[36]에 해당한다. 그렇다면, 이런 "엉망이 된 복합성의 영역" 안에서 취할 수

34
이는 작품 속에서 브루스 리의 다음 대사를 통해 반복적으로 제시된다. "마음을 비우고 형태가 없는 사람이 되세요. 물처럼 형태 없는 사람이. 물을 컵에 담으면 컵이 됩니다. 병에 넣으면 병이 됩니다. 찻주전자에 넣으면 찻주전자가 됩니다. … 친구여, 물이 되시게."

35
Archey, "Hype-Elasticity Symptoms, Signs, Treatment," 224.

36
슈타이얼, 「인터넷은 죽었는가」, 173.

있는 처방적 전략이란 무엇일 수 있을까?

흔히 지적되는 것처럼, 슈타이얼의 전략은 대략 다음 구절로 가장 잘 요약될 수 있을 것이다. "나는 이 문제를 회피하거나 과소평가하는 것이 아니라 더 밀어붙여 보자고 제안하고 싶다."[37] 언뜻 보기에 이런 제안은 흔히 "가속주의적(accelerationist) 미학"으로 지칭되는 입장을 공유하고 있는 것처럼 보인다. "나가는 길은 오직 그것을 통과하는 길뿐"이라는, "이 세계를 넘어서는 방법은 이 세계의 가능성들을 모두 고갈시키고 그것의 내재적인 가능성들을 최고의 극한으로 밀어붙이는 것 뿐"[38]이라는 입장 말이다. 내가 보기에, 구제를 기다리는 과거의 이미지에 재차 말을 걸어볼 필요가 있는 대목이 바로 여기다. 자본의 질서가 스스로의 무덤을 파기를, 시스템의 발전이 스스로의 목을 죄기를 (다만 속도를 올려가며) 기다려야만 하는 교착상태에 과거의 이미지는 어떤 다른 가능성의 지평을 보여줄 수 있을 것인가?

네프라 불리는 전환기의 위기상황, 이를테면 (공산주의와 자본주의가) 뒤엉킨 "엉망이 된 복합성의 영역"이 낳은 사상으로서 아르바토프의 이론이 갖는 놀라운 특징은 그것의 핵심에 전용과 재발명의 가능성이 놓여있다는 점에 있다. 인간 유기체의 감각능력을 충족시키거나 증폭시킬 "동료로서의 사물"이라는 아르바토프의 아이디어를 지탱하는 중요한 버팀목은, 놀랍게도, 러시아가 아닌 서구의 근대성, 특히 미국에서 산업적으로 생산된 사물들이 보여주는 새로운 잠재력이었다. 아르바토프는 자본주의의 해로운 영향에도 불구하고 이미 미국에서는 산업적 창조성이 인간이 생산해낸 수많은 새로운 사물들의 작인(agency)을 통해서 인류 자체의 변형을 시작하고 있기에, 만일 자본주의적 계급관계에서 해방되어 사회주의적 문화 속에서 재발명될 수만 있다면 그것들은 직접적으로 인간활동의 모든 측면을 형성하게 될 것이라고 예상했다.[39]

적의 손에서 발전된 최상의 산물을 가져다 그것을 더욱 급진적으로 재발명해 사용할 수 있을 거라는 저 담대한 기개는 자본주의 아닌 세계, 즉 단순한 후기(post)가

37
슈타이얼, 「면세 미술」, 113.

38
Steven Shaviro, Post-Cinematic Affect (Winchester: Zero Books, 2010), 121-122.

39
"상호 연결된 사물들의 세계" 속에서 점점 더 "사물처럼" 변해갈 인간들을 그리는 아르바토프의 미래 전망은 충격적일 정도로 현대적이다. 그는 사물들의 신세계 속에서 인간의 심리는 점점 더 "사물을 닮아갈" 것이고 사물들과 더불어 생각하지 않을 수 없게 될 거라고 전망했다. 그가 활성화된 사물들의 예로 "접이식 가구, 무빙보드, 회전문, 에스컬레이터, 자동화 레스토랑, 양면 의상" 등을 꼽으면서 이제 "사물은 기능적이면서도 능동적인 것이 되어 인간의 실천에 동료(co-worker)처럼 연결"된다고 쓸 때 아르바토프는 "과속방지턱"을 행위자(agency)로 추켜세우는 브뤼노 라투르의 행위자네트워크이론(ANT)을 선취하고 있는 것처럼 보일 정도다. Arvatov, "Everyday Life and the Culture of the Thing (Toward the Formulation of the Question)," 119-128.

아니라 진짜 너머(beyond)의 세계를 구축해낼 수 있었던 20세기 초 소비에트만의 특별한 정세 덕분이라고 누군가는 생각할지 모른다. 그렇다면 우리는 10여 년이 지난 후에 이번에는 승리 대신 패배의 정념이 팽배해 있는 상황에서 거의 동일한 주문을 했던 또 한 사람을 떠올릴 수 있을 것이다.

벤야민은 한 차례의 야만(세계대전)을 겪은 후에 바야흐로 또 다른 야만(파시즘)의 도래를 예감하고 있던 시기(1933-34)에 "새로운 긍정적 개념의 야만성"[40]을 도입할 것을 주장했다. 그는 새로운 긍정적 개념을 발명하려면 문명과 문화의 낡은 개념으로 되돌아갈 게 아니라 "잘못된 야만주의로부터 야만(주의)의 에너지를 훔쳐올 필요가 있다."[41]고 생각했다. 적들의 야만주의에 맞서 고결한 휴머니즘을 내세우기보다는 오히려 그들에 비해 더 나아간 야만주의를 실행하려는 것, "자본주의적 소외와 빈곤의 경험을 자유주의 휴머니즘의 지평을 초과해버리는 지점까지 급진화해 버리려는"[42] 태도가 1930년대 중반 벤야민의 정치적 입장을 특징짓는다.

슈타이얼은 순환주의의 재발명 가능성을 이야기하면서 ("아르바토프에게서 도출된 질문"을 거론했던 앞선 삽입 문단을 떠올리게 하는) 다음과 같은 알 듯 말 듯한 문장들을 적어 놓았다.

물론, 순환주의 또한 생산성, 가속, 영웅적 소진에 대한 스탈린주의적 숭배에 제휴한 선례처럼 그냥 잘못 갈지도 모른다. 역사적 생산주의는—사실을 직면하자—완전히 비효율적이었고, 압도적으로 관료적인 감시/노동 현장 때문에 초반에 실패했다. 또한 순환주의가 순환을 재구조화하는 대신 그저 갈수록 이오시프 스탈린이 사적으로 운영하는 스타벅스 가맹점들로만 가득 찬 쇼핑몰처럼 보이는 인터넷의 장식으로 끝나 버릴 것 같기도 하다.[43]

40
벤야민, 「경험과 빈곤」, 『선집 5권』, 174.

41
Carlo Salzani, "Surviving Civilization with Mickey Mouse and a Laugh: A Posthuman Constellation," *Thinking in Constellations: Walter Benjamin and the Humanities*, eds. Nassima Sahraoui and Caroline Sauter (Newcastle Upon Tyne: Cambridge Scholars Publishing., 2018), 168.

42
Mourenza Daniel, "On Some Posthuman Motifs in Walter Benjamin: Mickey Mouse, Barbarism and Technological Innervation," *Cinema: Journal of Philosophy and the Moving Image* (Newcastle University, 2015), 40. 흥미로운 것은 "문명보다 더 오래 살아남으려 대비하는" 이들 새로운 야만주의자들의 태도가 상실과 포기의 비극적 음조와는 거리가 멀다는 점이다. "그리고 중요한 것은 그들이 그 일을 웃으면서 한다는 점이다."(「경험과 빈곤」, 180). 벤야민에게 이런 명랑한(동시에 파괴적인) 낙관성을 대변하는 캐릭터는 새로운 야만인들의 '젊은 조카'인 미키마우스였다. 벤야민, 「미키마우스에 대해」, 『선집 5권』, 150. 김수환, 「에이젠슈테인의 디즈니와 벤야민의 미키마우스: 태고의 원형 혹은 포스트휴먼적 예형」, 『문학과 영상』 22(1), 2021, 33-61 참조.

43
슈타이얼, 「인터넷은 죽었는가」, 176-177. [번역 일부 수정]

슈타이얼이 과거를 현재로 들여오는 방식, 즉 소비에트 생산주의라는 역사적 과거를 우리를 둘러싼 현재와 충돌시켜 예기치 못한 '파열'을 만들어내는 그녀의 방식이 빛을 발하는 것은, 역설적이게도, 과거에 대한 정확하고 또렷한 비판적 인식이 뒷받침될 때다. 그녀는 역사적 생산주의가 어떻게 "실패"했는지, 그리고 어떻게 스탈린주의에 "제휴"하면서 결국엔 스타하노프 운동으로 대변되는 극단적인 노동 숭배로 귀결되었는지에 관해 잘 알고 있다.[44] 어떤 점에서, 과거에 대한 이런 정확하고 비판적인 인식은 우리 시대(순환주의)와 스탈린 시대(스타하노프주의) 사이의 은밀한 공통분모("생산성, 가속(화), 영웅적 소진")를 집어내는[45]일 보다 더욱 관건적이다. 어째서일까? 왜냐하면 그것은 슈타이얼로 하여금 순환주의의 나쁜 시나리오, 그러니까 그것이 종국에는 후기자본주의 최악의 버전으로 귀결되고 말지도 모른다는 가정을 하나의 명확한 역사적 선례에 비춰볼 수 있도록 해주기 때문이다. 실패와 제휴를 거쳐 결국 스탈린의 노동 숭배로 귀결되어 버린 그 옛날 소비에트 생산주의가 바로 그 선례다. 하지만 과연 그것이 전부일까?

정확하게 같은 논리에 입각해서 우리는 다음과 같은 물음을 던져볼 수 있다. 만일 역사적 생산주의가 우리가 지금 아는 것과는 다른 방식으로 흘러갈 수도 있었다면 어쩔 것인가? 만일 그것 내부에 다른 대안적 노선들이, 단지 선택 받지 못했을 뿐 충분히 일어날 수도 있었을 다른 가능성들이 존재했다면? 정말 거기에 충분히 '구제'될 법한 과거가 우리를 기다리고 있다면, 그렇다면 우리의 현재 또한 얼마든지 다르게 써내려 갈 수 있지 않겠는가? 순환주의 역시 다르게 재발명되지 못할 이유가 없지 않은가?

44

스타하노프 운동은, 1935년 스타하노프라는 한 탄광 노동자가 기준량의 14배에 달하는 채광량을 기록하자 '그에게 배우라.'는 스탈린의 교시와 함께 시작된 전국적인 노동 생산성 증대 캠페인을 가리킨다. "돌격노동자(shock worker)"라는 용어에서 알 수 있듯이, 네프에 뒤이은 제1차 5개년 계획 시기의 특징을 대변하는 이 캠페인은 1920년대식의 계산 가능한 합리성과 기술적 규범들에서 벗어나 거의 부조리에 가까운 정동적 극단성을 향해 나아갔다. 스타하노프식 주체성의 모델은 생체역학의 연장으로서의 기계화된 비-인간 혹은 포스트-휴먼보다는 오히려 유기체적 본질을 극대화한 초인(superhuman)에 해당한다. 비유하건대 스타하노프식 주체는 (때로는 약물에 의존하면서까지) 초인적 기량을 보여주는 현대의 프로운동선수나 24시간 노동에 시달리는 디지털 프리카리아트(precariat)에 더 가깝다. 슈타이얼의 표현에 따르면, "순환주의의 '스타카노바이트들 (Stakhano-vites)'은 방글라데시 같은 농장에서 일하거나, 중국의 죄수 수용소에서 가상의 골드를 채굴하거나, 디지털 컨베이어벨트에서 기업의 콘텐츠를 대량 생산"하고 있다. 슈타이얼, 「인터넷은 죽었는가」, 177. 슈타이얼이 생산주의에 관해 얼마나 깊고 세밀한 이해를 갖고 있는지를 잘 보여주는 글로 Hito Steyerl, "Truth Unmade Productivism and Factography," Transversal 09/10: New Productivisms, 2010도 참조하라.

45

"순환주의는 생산성, 가속화, 그리고 영웅적 소진을 향한 스탈린주의적인 숭배의 오늘날의 신자유주의적 버전과도 얽혀있다. Sven Lütticken, "Hito Styerl: Postcinematic Essays after the Future," Too Much World: The Films of Hito Steyerl, 55. 슈타이얼의 기발한 표현에 따르면, 그것은 "스탈린이 사적으로 운영하는 스타벅스 가맹점으로 가득 찬 쇼핑몰"에 해당한다.

그러나 여기에 오프라인으로 이동한 인터넷의 궁극적 결과가 있다. 이미지가 공유되고 순환된다면, 왜 모든 것이 그럴 수 없는가. … 순환주의가 무언가를 의미한다면, 그것은 오프라인 분배의 세계, 자원, 음악, 땅, 영감의 3D 전파의 세계로 이동해야 한다. 산송장 상태의 인터넷에서 천천히 물러나 그 옆에 다른 것들을 구축하는 게 어떠한가?[46]

46
슈타이얼, 「인터넷은 죽었는가」, 178. [번역 일부 수정]

현재의 새로움을 사유하는데 있어서 "이 모든 것이 보이는 것처럼 새롭지 않다."는 사실을 직시하는 것은 매우 중요하다. 현재는 '역사적으로' 이해될 필요가 있다. 현재를 역사의 지평에 가져다 놓을 때 모든 (외견상의) 새로움은 역사적 계보를 얻는다. 반면에 보다 '정치적으로' 사유되어야 할 것은 과거다. 과거와 변증법적으로 조우한다는 것은 본래 그대로의 모습으로 고착된 불변하는 사실을 확인하는 것을 뜻하지 않는다. 정치적으로 사유된 과거는 이를테면 현재와 미래를 두고 벌이는 내기이자 투쟁이 될 수 있다. 그것은 '다르게 될 수도 있지 않았을까'라는 물음을 후렴구처럼 붙여가는 과정, 이미 확립된 해석에 구멍을 뚫어 그것을 다르게 '구제'해내는 과정이다. 지금까지 이 글에서 나름대로 재구축하려 시도한 '아르바토프와 그의 시대'는 바로 그런 다른 가능성들의 성좌에 다름 아니다. 우리 시대를 비판적으로 대면하려는 슈타이얼의 경우에, 우리를 둘러싼 현기증 나는 현재를 '역사적으로' 이해하는 작업은 이미 실패한 것으로 여겨져 폐기 처분된 지난 세기 소비에트의 과거를 '정치적으로' 재사유하는 일과 뗄 수 없이 연결되어 있다고 나는 확신한다.

1

In her theoretical essays, which are said to both complement and contradict her own video work, Steyerl has dealt head-on with issues related to the ontology and political economy of the image in the post-internet era. In the process, she has drawn from a variety of contemporary thought (critical theory and media theory), while presenting an attempt to reappropriate the legacy of the Soviet avant-garde, Constructivism in particular, in her own way. For instance, the experimental thought of Sergei Tretyakov, a member of the Soviet Productivist Group, is revisited in a fascinating way in her video *Free Fall* (2010), resonating with the prominent trend in contemporary art characterized by the "reorientation toward things."[1]

As is well known, this position of stepping down from the seat of the subject to stand side by side with the object, and furthermore, the willingness to become a thing itself, gave rise to the concept of the "image as a thing" reflected in the phrase "a thing like you and me." "It [the image] doesn't represent reality. It is a fragment of the real world. It is a thing just like any other—a thing like you and me."[2] Steyerl mentions another name along with Benjamin ("The Language of Things")[3] as a legitimate reference point for the concept of the image as a thing. That name is Boris Arvatov, who alongside Tretyakov served as a theoretical pillar of the aesthetics of Soviet avant-garde Productivism. Leaning on the previous research of Christina Kiaer,[4] Steyerl finds in Arvatov, an alternative image of a thing as a legitimate agent of social change that contains the power and energy of a dynamic labor structure instead of the image of "bruises" as traces of "condense[d] power and violence."[5]

In his text "Everyday Life and the Culture of the Thing," Boris Arvatov claims that the object should be liberated from the enslavement of its status as capitalist commodity. Things should no longer remain passive, uncreative, and dead, but should

1
In the essay of the same title published the following year, "In Free Fall" (2011), "falling" also appears as a liberating opportunity to break free from the frame of (horizontal) linear perspective, a mere aesthetic convention, and at the same time as a unique experience of "being things." "Falling is corruption as well as liberation, a condition that turns people into things and vice versa." Hito Steyerl, "In Free Fall: A Thought Experiment on Vertical Perspective," *e-flux Journal* 24 (April 2011). For an interesting historical-ideological connection between Tretyakov, Benjamin, and Steyerl, see Soo Hwan Kim, "Tretyakov Revisited: The Cases of Walter Benjamin and Hito Steyerl," *e-flux Journal* 104 (November 2019).

2
Hito Steyerl, "A Thing Like You and Me," *e-flux Journal* 15 (April 2010).

3
Hito Steyerl, "The Language of Things," *Transversal 06/06: Under Translation* (European Institute for Progressive Cultural Politics, 2006).

4
Christina Kiaer, "Boris Arvatov's Socialist Objects," *October* 81 (Summer 1997): 105-118; Christina Kiaer, *Imagine No Possessions: The Socialist Objects of Russian Constructivism* (Cambridge, MA: The MIT Press, 2005).

5
"Things condense power and violence. ... It bears the bruises of its crashes with politics and violence." Steyerl, "A Thing Like You and Me."

6
Ibid.

be free to participate actively in the transformation of everyday reality.[6]

7
Boris Arvatov, "Everyday Life and the Culture of the Thing (Toward the Formation of the Question)," trans. Christina Kiaer, *October* 81 (Summer 1997): 124

Arvatov argued that the so-called "socialist object" must be seen "as a force for social labor, as an instrument and as a co-worker."[7] The problem is that the status occupied by Arvatov in Steyerl's films and theoretical essays is not limited to that of interesting cases of the past century that demonstrate a bold utopian imagination. The name Arvatov is essentially related to the total and macroscopic change that Steyerl has referred to as the move "from productivism to circulationism" in a way that it represents the indispensable reference point for contemplating the specific replacement of the image regime that defines our age. It is not merely a historical past that has passed us by but corresponds to a past that prompts us to find a point where present practice resonates with past events, a past that urges the exploration of conditions under which the potential possibilities of the original event can be reintroduced, a past that is "waiting for the time of redemption" as it were.

In the following essay, I will show in what way "Arvatov and his era" acquires this unexpected contemporaneity. To this end, I examine from various angles, which aspects of circulationism could correspond to the ideas presented in the Soviet Union at the beginning of the last century, and in so doing I seek to provide an opportunity to reflect on the significant implications contained in Steyerl's concept of circulationism from a historical perspective.

2

In the essay "Too Much World: Is the Internet Dead?" (2013), which is often regarded as the proclamatory declaration of the concept of circulationism, Steyerl states:

> What the Soviet avant-garde of the twentieth century called productivism—the claim that art should enter production and the factory—could now be replaced by circulationism. Circulationism is not about the art of making an image, but of postproducing, launching, and accelerating it. It is about the public relations of images across social networks, about advertisement and alienation, and about being as suavely vacuous as possible.[8]

8
Hito Steyerl, "Too Much World: Is the Internet Dead?" *e-flux Journal* 49 (November 2013).

However, few pay attention to the meaning of the (enigmatic) verse that directly follows this paragraph: "But remember how productivists Mayakovsky and Rodchenko created billboards for NEP sweets? Communists eagerly engaging with commodity fetishism?" Steyerl adds a rather long footnote to this paragraph, which ends with the following sentence: "They confront the question that arises out of the theory of Boris Arvatov: What happens to the individual fantasies and desires organized under capitalism by the commodity fetish and the market, after the revolution?"[9]

As is often the case, Steyerl's footnote here calls for yet another footnote. In order to grasp the profound meaning contained in this last sentence, it is necessary to understand the context of Kiaer's research on which she leans. A re-evaluation of the NEP (New Economic Policy, 1921-1928) lies in the background as the driving force behind Kiaer's research that centers on the concept of "socialist objects." Challenging the generally accepted belief that the NEP was a "retreat" (Christina Lodder, 1983) or "betrayal" (Paul Wood, 1992) of communist ideology, she sought to re-evaluate it as both a unique opportunity and possibility. According to Kiaer, the partial introduction of the capitalist economic system that was NEP's temporary compromise forced the Constructivist theorists of the time to consider the problem of consumption and desire, that is, the problem of "desiring human subjects."

The problem of the "affective power of the mass produced objects of modernity" and "the power and tenacity of the commodity fetish within modernity" that Marx once expressed with the term "phantasmagoria" was not something that needed to be confronted either before NEP (wartime communism) or after (Stalin's planned economy), and in that respect, it was a special condition exclusively limited to the NEP period. The idea of an object "as a coworker" was created in the midst of this exceptional state of NEP (in the year 1925)[10], holding intact its mixed (socialist + capitalist) character. Kiaer clearly states the purpose of her research: "the argument of this book is that they envisioned a future in which a desiring relation to the mass-produced objects of socialist

9
Ibid.

10
The quote by Aleksander Rodchenko used as an epigram for the opening of the fourth section of "A Thing Like You and Me" was indeed written in 1925. Rodchenko exhibited *Workers' Club* at the International Exhibition of Decorative Arts and Modern Industry held in Paris that year. It was displayed alongside Vladimir Tatlin's *Monument to the Third International* in the Soviet Pavilion, which was designed by Konstantin Melnikov. During his stay in Paris, the sacred capital of commodity culture, he wrote the following letter to his wife Varvara Stepanova in Moscow: "Light from the East [revolution]—in a new attitude to a person, to a woman, and to things. Our things in our hands should also be equal, also comrades, and not these black and gloomy slaves, as here." Christina Kiaer, "Rodchenko in Paris," *October* 75 (Winter 1996): 3. For the Russian original, see: Aleksandr Rodchenko, *Opyty dlja budushhego: Dnevniki, Stat'i, Pis'ma, Zapiski* (Experiments for the Future: Diaries, Essays, Letters, Notes) (Moskva: Grant, 1996), 152.

modernity would not necessarily have to be defined as greed ... the Constructivists during NEP had to take seriously the problem of consumer desire. In this sense they did have to confront the popular taste of the NEP public."[11]

11 Kiaer, *Imagine No Possessions*, 26.

In short, the question that Steyerl describes as "the question that arises out of the theory of Boris Arvatov" may not be about whether to decisively eradicate the desire for commodities. Arvatov's interest lay in how to "transform" a passive capitalist commodity into a socialist object. In other words, he was asking whether it was possible to "reorient" the commodity fetish in the Marxist sense as a tool for socialism. His problem-consciousness aims at transformation rather than simple negation, and instead of ignoring or skipping over a given condition, it seeks to find alternative possibilities that enable it to break through such conditions while recognizing them.

What must be noted is the fact that after these verses that suddenly evoke "Arvatov's question," Steyerl continues in the subjunctive with the sentence that begins with "Crucially, circulationism, if reinvented ..." That is, "the question that arises out of the theory of Boris Arvatov" is interposed between the diagnosis that "productivism has been replaced by circulationism" and the possibility of "the reinvention of circulationism." This passage that is casually "inserted" as if it is of little significance, and which is why it is overlooked in many cases, is weighted heavily with the shadow of the Soviet avant-garde from 100 years ago. It is impossible to fully take hold of the deep implications and potential power of Steyerl's concept of "circulationism" while ignoring this shadow. To reiterate, it requires the meticulous examination of the point where the past and present resonate and the pattern of their reverberation. At the same time, that project will also be a process of coming to terms with the reason why Steyerl opens the discussion on the part about circulationism with the following sentence: "But these things are not as new as they seem."[12]

12 Steyerl, "Too Much World: Is the Internet Dead?"

3

Crucially, circulationism, if reinvented, could also be about short-circuiting existing networks, circumventing and bypassing corporate friendship and hardware monopolies. It could become the art of recoding or rewiring the system

13
Ibid.

by exposing state scopophilia, capital compliance, and wholesale surveillance.[13]

The word that immediately catches the eye in the above passage about the reinvention of circulationism is "short-circuiting." First, let us note that this word is a term related to electrical circuits, like "rewiring" that appears later. According to the dictionary definition, "short-circuiting" refers to a situation in which some kind of abnormal connection occurs between two nodes with different voltages in an electrical circuit. Like the word "short-circuit" indicates, this situation (by shortening the normal process) causes an excessive amount of current to flow faster than usual (overload), which can lead to overheating, fire, or explosion. Therefore, this word contains the meaning of a new (abnormal) direct (strong) connection or joining together, alongside the meaning of rupture due to excess, namely disconnection. What should be noted is that this analogy of an electrical circuit is not limited to a one-time rhetorical device mobilized for explanation. For example, see the following elucidation:

> An image in circulation is less about its content than about its charge, its drive, its directions. It is about being intensely quantifiable and trackable, too. It is about love encoded as numbers, and production doubling as dispersion. One could measure image energy in joule and watt, passion or eyeballs, in spin as entrancement, in withdrawal by deep encryption.[14]

14
Circulationism. Discussion with Hito Steyerl. May 24, 2014, https://vanabbemuseum. nl/en/programme/programme/ circulationism/.

As seen here, the electrical analogy appears as a characteristic directly related to the essence of the concept of circulationism itself. This usage, which has become common practice in discourses related to networks and cybernetics, may seem inconsequential from today's point of view. But to a person familiar with the revolutionary art theory of the Soviets of the last century, the word will not sound commonplace at all. It was Boris Arvatov who first coined the term "electrification" to refer to the mode of operation that characterizes the post-revolutionary world of art.[15] Of course, the primary background of this usage is undoubtedly Lenin's famous phrase that "Communism is Soviet power plus the electrification of the whole

15
Alexei Penzin, "Afterward. The 'Electrification of Art': Boris Arvatov's Programme for Communist Life," Boris Arvatov, Art and Production (London: Pluto Press, 2017), 133.

country," but behind this term flickers the figures of several Soviet avant-garde theorists from the "Arvatov era."[16] Among them, the most important figure is Alexei Gastev, the "proletarian bard of the machine age."

Gastev, who advocated a future communist society where humans and machines merged, was active as a poet in the early days of the revolution, then fled to Paris where he worked as a steel worker. He who was also a member of Proletkult ends up giving himself up to the mission of the scientific organization of labor as a radical representative of the supposed Soviet-style ideal of Taylorism. Founded in Moscow in 1920 with Lenin's support, the Central Institute of Labor, led by Gastev, established 1,700 branches nationwide, training around 500,000 workers and 20,000 teaching assistants. According to Gastev, "electrification is the highest expression of machinism."[17] Not only that, the future Gastev dreamed of was not just a mere mechanically coordinated collective body, but a common internationalist psychological system, such as a mechanism equipped with a system that "turns on and off and can be short-circuited."

Creating one world brain in place of millions of brains. Granted that as yet there is no international language, but there are international gestures, there are international psychological formulae which millions know how to use. ... In this normalization of psychology and in its dynamism lies the key to the enormous spontaneity of proletarian thinking. ... In the future this tendency will make individual thought impossible and it will imperceptibly be transformed into the objective psychology of an entire class with its systems of switch-ons, switch-offs, short circuits.[18]

Whether to accept Gastev's grand vision for a future society, in which the collective body and mind are both perfectly controlled,

16
According to Penzin, at the forefront of Arvatov's view, which emphasizes the practical, active, and above all, organizational role of art in the new era, is Aleksander Bogdanov, the godfather of Soviet organizational theory (tektology).

17
"Electrification is the highest expression of machinism. It is no longer one machine, it is not a complex of machines, it is not even a machine-factory, not a machine-city, it is a machine-state, and when it is international, it is in the full sense a mechanized globe. Here everything grows under the sign of machine." (Translated from Russian by the author.) Aleksej Kapitonovich Gastev, *Kak nado rabotat'. Prakticheskoe vvedenie v nauku organizacii truda* (How Should Work. Practical Introduction to the Science of Labor Organization) (Izd. 2-nd Moscow: Economics, 1972), 51.

18
Quoted from Kurt Johanssen, *Aleksej Gastev: Proletarian Bard of the Machine Age* (Stockholm: Almqvist & Wiksell International, 1983), 68. For the Russian original, see: Aleksej Gastev, "O tendencijah proletarskoj kul'tury" (On the Tendency of Proletarian Culture), *Proletarskaja kul'tura Ezhemesjachnyj zhurnal* (Proletarian Culture, Monthly Journal) 9-10 (1919): 44.

19
Contrary to popular belief, Yevgeny Zamyatin's novel *We*, published in 1926, is not a critique of Stalinist totalitarianism, but rather a work that gives shape to the dystopian nightmare of the utopian vision of Soviet machinism. Moreover, Zizek considers the aggressive outlook of Soviet machinism of the 1920s represented in Gastev as the first radical formulation of what we call biopolitics today, and has attempted to read Stalinism of the 1930s as "the return of ethics" against the utopia of mechanized collectivism of the 1920s. Slavoj Zizek, *In Defense of Lost Causes* (London and New York: Verso, 2008), 212.

20
"Machine culture, Soviet style, had its origins as the expression of a lack, so that even its brutality could be seen to possess a utopian quality." Susan Buck-Morss, *Dreamworld and Catastrophe* (Cambridge, MA: MIT Press, 2000), 107. According of Buck-Morss, unlike the United States, where mass production was practically motivated, in the Soviet Union, the "cult of the machine" preceded the machines themselves. For the workers of capitalist countries, industrialization was a "lived catastrophe," but for the Soviet proletariat, industrialization was still a "dreamworld."

21
Aleksej Kapitonovich Gastev, *Kak nado rabotat. Prakticheskoe vvedenie v nauku organizacii truda* (How Should Work. Practical Introduction to the Science of Labor Organization), 51. (Translated from the Russian by the author). Note the striking resonance with Steyerl's earlier account of circulationism (as "intensely quantifiable and trackable").

22
Buck-Morss, *Dreamworld and Catastrophe*, 107.

23
Humankind's first Internet project was also planned in the Soviet Union in the 1960s. One of the founders of early cybernetics, Viktor Glushkov, designed the construction of a former Soviet worker management system called OGAS (in fact, a network equivalent to today's Internet) that would perfect the idea of the planned economy, but this plan was never realized. For the interesting story surrounding the Soviet Internet project, see Benjamin Peters, *How Not to Network a Nation: The Uneasy History of the Soviet Internet* (Cambridge, MA: The MIT Press, 2016).

interconnected, and shared, as a dystopian nightmare,[19] or as a kind of brutality[20] peculiar to Soviet machine culture originating from the essence of "lack," depends on the judgment of the individual. However, what is indisputable is that Soviet machine devotees understood their dream as a new human creation project called "biomechanics."

In unison with this new machine worldview, we need to look at man in a new way. It is necessary to do so that suddenly humanity discovers that man himself is one of the most perfect machines that our technology knows. ... This science is biomechanics. Laboring human movement is a combination of lines, points, angles, weights, working with a certain tolerance, with the usual coefficient of efficiency. The human body knows its statics and kinematics.[21]

Ultimately, the dream of Soviet machinism towards the formation of an international and public body equipped with common kinetics and psychology was a project that aimed for "a new human sensorium of electric nerve, brain machines, and cinema eyes."[22] In fact, their project did not end with theoretical speculation, as the desires of Soviet biomechanics were not only applied to artistic methodologies such as Vsevolod Meyerhold's theater direction or Dziga Vertov's kino-eye theory, but rather it gave birth to a long and interesting genealogy from Alexander Bogdanov's Institute for Blood Transfusions (appearing in the novel *Red Star*) to Vladimir Bekhterev's Collective Reflexology, Lev Vygotsky's psychology of language and Alexander Luria's neuropsychology.[23]

However, doesn't the term "sensorium" remind us of the connection between senses of modernity and technological medium that Susan Buck-Morss once

24
Susan Buck-Morss, "Aesthetics
and Anaesthetics: Walter
Benjamin's Artwork Essay
Reconsidered," *October* 62
(Autumn, 1992): 3-41.

restored as the essence of aesthetics with interesting modifications through the phrase "from aesthetics to anesthesia"?[24] The issue of the sensorium of the body and the particular ecology surrounding it naturally evokes another important figure (although this time a German rather than a Russian). Walter Benjamin, an actual contemporary of Arvatov and Gastev, and who could be thought of as another kind of contemporary for Steyerl (as the most powerful interlocutor providing endless inspiration), is this foreigner.

Benjamin visited Moscow for a period of about two months in the winter of 1926–1927. During his stay, he screened the films of Sergei Eisenstein, met his former teacher Meyerhold, and left a record about Gastev's Central Institute of Labor.[25]

25
Penzin presumes Benjamin
probably knew about
Arvatov through Tretyakov.
Penzin, "Afterward.
The 'Electrification of
Art,'" 128.

In Benjamin's thought in the post-Moscow period, that is, from the late 1920s to the mid 1930s, the "Soviet traces" remain in a subtle yet powerful form. Throughout the 1930s (in his essays that comprise the so-called "cycle of Production"), he revived, in an original way, the buried memories of a technological utopia that had already been suppressed and practically erased in the Soviet Union.

From the viewpoint of the "Moscow traces" left in Benjamin's thought, the concept that stands out the most is "innervations." The first appearance of the term, which "broadly refers to a neurophysiological process that mediates between internal and external, psychic and motoric, human and machinic registers,"[26] in Benjamin's dictionary was in *One Way Street* (published in 1927, shortly after returning from Moscow, with a tribute to the Russian woman Asja Lacis). However, it was in the 1929 essay "Surrealism" where it developed into its complete form. As is well known, in the last paragraph of this essay, Benjamin links Surrealism to the *Communist Manifesto*. In this famous passage that has given rise to numerous questions and interpretations, interestingly, the concept of "bodily collective innervation" is accompanied by the unmistakable electrical metaphor of "revolutionary discharge."

26
Miriam Hansen, *Cinema and
Experience: Siegfried
Kracauer, Walter Benjamin,
and Theodor W. Adorno*
(Oakland: University of
California Press, 2011), 133.

Only when in technology body and image space so interpenetrate that all revolutionary tension becomes bodily collective innervation, and all the bodily innervations of

the collective become revolutionary discharge, has reality transcended itself to the extent demanded by the *Communist Manifesto*.[27]

This process in which revolutionary tension becomes "collective innervation," and which in turn leads to "revolutionary discharge," eventually results in the excessive flow (discharge) of nerve currents in the image space, leading to the task of creating and (trans) forming a new collective body. As is well known, this problem later leads to the film as a new apparatus. In the second edition of the essay "The Work of Art," Benjamin stipulates revolutions as "innervations of the collective—or, more precisely, efforts at innervation on the part of the new, historically unique collective which has its organs in the new technology," and asserting "*[t]he function of film is to train human beings in the apperceptions and reactions needed to deal with a vast apparatus whose role in their lives is expanding almost daily*," argued that "the aim of revolutions is to accelerate this adaptation."[28]

What is interesting is that we discover here the concrete form of the aforementioned "revolutionary discharge." What is the process of revolutionary discharge? It is to "loosen [aufgelockert]" the mass that exists as a "compact mass [kompakte Masse]" by "set[ting] off an internal upheaval."

> But the same class struggle which loosens the compact mass of the proletariat compresses that of the petty bourgeoisie. ... The special feature of such truly historic events is that a reaction by a compact mass sets off an internal upheaval which loosens its composition, enabling it to become aware of itself as an association of class-conscious cadres.[29]

This "loosening" operation lies as the extension of various images of dispersion and dissolution (the "dynamite of the tenth of a second," "distraction," shock effect", etc.) that run through the entire essay. At the same time, it is not difficult to notice that the operation is essentially related to the "fruitful experience" referred to in "Surrealism," that is to the "loosening of the self by intoxication" "like a bad tooth."[30] This passage, in

27
Walter Benjamin, "Surrealism," *Selected Writings Volume 2, Part 1, 1927-1930*, eds. Michael W. Jennings, Howard Eiland, and Gary Smith (Cambridge, MA: The Belknap Press of Harvard University Press, 2005), 217-218.

28
Walter Benjamin, *The Work of Art in the Age of Its Technological Reproducibility and Other Writings on Media* (Cambridge, MA: The Belknap Press of Harvard University Press, 2008), 26 (italics in the original), 45.

29
Benjamin, *The Work of Art*, 50-51.

30
Benjamin, "Surrealism," 208.

which the revolutionary discharge is connected with a certain kind of dissolving, is particularly suggestive. It is because this passage leads us to a new model that is different from the mechanical and electronic models we have been following, directing us toward a model that is much more flexible and free to transform, as much as it is unstable and plastic. To loosen oneself like "a bad tooth" indicates moving away from a hard solid state and closer to a soft liquid state. And needless to say, this new model immediately recalls Steyerl's concept of "fluidity."

4

Steyerl's film *Liquidity Inc.*, surely an allusion to Jacques Derrida's book *Limited Inc.*, presents an interesting combination of words. The term "incorporation (Inc.)," etymologically derived from the Latin "incorporate" meaning "embodied," carries the meaning to go in somewhere to form a body ("corpus" in Latin).[31] So, this word that is immediately reminiscent of the "bodily collective" in Benjamin is combined with the word "fluidity."

Of course, even more striking about this combination is the word "liquidity" joined to the front. In her video essay, Steyerl goes far beyond the situation of so-called liquid modernity (Zygmunt Bauman) where "everything that is solid melts into air," showing the political-economic landscape of an overwhelmingly liquefied world, where literally the flow of water penetrates and swallows up everything. Here the metaphorical expression "like water" is presented as a principle and method that literally dominates everything from investment finance to fighting skills, weather, terrorism, (cloud) data, (meme) images, and even the state of subjectivity.[32] The "slippery" form, overflowing with all kinds of fast and chaotically used images (from Japanese Ukiyo-e to iPhone chat screens), corresponds as always to the content of the work. The "contemporary condition of liquidity calls for the subject to quickly skid along at surface level, or else, perhaps, they'll drown."[33]

It is possible to read this landscape of the world as a critique of the current stage of capitalism's system of accumulation represented by wholesale financialization,

31
Karen Archey, "Hype-Elasticity Symptoms, Signs, Treatment: On Hito Steyerl's Liquidity Inc.," *Too Much World: The Films of Hito Steyerl*, ed. Nick Aikens (Berlin: Sternberg Press, 2014), 224.

32
This is repeatedly presented in the film through the following words of Bruce Lee: "Empty your mind, be formless. Shapeless, like water. If you put water into a cup, it becomes the cup. You put water into a bottle and it becomes the bottle. … Be water, my friend."

33
Archey, "Hype-Elasticity Symptoms, Signs, Treatment," 224.

or as a parody of the infinitely transformative process of the self-valorization of capital, or as an expression of the maximum control-surveillance society of Harun Farocki's style in which the "operational image" goes beyond the interface to become the environment, in a sense, the negative image of the mechanical utopia of which Gastev dreamed. However, what is more interesting than this diagnosis, which is commonly shared by most critiques of the post-Fordist transition, is Steyerl's characteristic position on such a worldview, and furthermore, the prescriptive strategy towards it.

It must be emphasized that this new world that Steyerl is depicting is clearly the system of infinite circulation without exit of global capitalism in which the logic of liquefied capital flourishes, but at the same time, it is also a world of unstable fluidity that is volatile and arbitrary, like the weather in the era of the climate crisis. In other words, "this space is also a sphere of liquidity, of looming rainstorms and unstable climates. It is the realm of complexity gone haywire, spinning strange feedback loops. A condition partly created by humans but also only partly controlled by them, indifferent to anything but movement, energy, rhythm, and complication."[34] If so, what could be a prescriptive strategy adopted within this "realm of complexity gone haywire"?

As is often pointed out, Steyerl's strategy can best be summed up in the following passage: "My suggestion is not to shun or belittle this proposition, but to push it even further."[35] At first glance, this kind of suggestion appears to share the position often referred to as "accelerationist aesthetics." That is, the position that advocates "the only way out is through," and thus, "the only way, therefore, to get 'beyond' this world is to exhaust its possibilities, and push its inherent tendencies to their utmost extremity."[36] In my view, this is exactly the part where we need to resort again to the image of the past, which is waiting for the moment of redemption. What other horizon of possibilities can the images of the past point to in the impasse where we have no other option but to wait for the order of capital to dig its own grave and for its systemic development to strangle itself (while increasing in speed)?

As an idea born out of the crisis of the transition period called NEP—the entangled "realm of complexity gone haywire"

34
Steyerl, "Too Much World: Is the Internet Dead?"

35
Hito Steyerl, "Duty-Free Art" e-flux Journal 63 (March 2015).

36
Steven Shaviro, Post-Cinematic Affect (Winchester: Zero Books, 2010), 121-122.

(of communism and capitalism) as it were—a striking feature of Arvatov's theory is that the possibility of (reappropriation [detournement]) and reinvention lies at its core. An important underpinning of Arvatov's idea of the object "as a coworker," fulfilling and amplifying the sensory capacities of the human organism, was surprisingly, Western modernity rather than Russia, and especially the new potential that was shown in industrially produced objects in the United States. Arvatov predicted that "despite the harmful effects of capitalism, this industrial creativity is beginning to transform human beings through the agency of the innumerable new things that it mass produces," and "liberated from the oppressive labor and class conditions of capitalism and reinvented in socialist culture, will directly form all aspects of human activity."[37]

Some might think that the bold spirit of thinking of taking the best product developed from the hands of the "enemy" and reinventing it in a more radical manner and using it, was due to the particular situation of the Soviet Union at the beginning of the 20th century, when it was possible to build a world that was not capitalist, that is, not merely a simple post- but truly a world beyond. If so, then, we can call to mind another person who made almost the same invocation about a decade later, this time in a situation overflowing with the passions of defeat rather than victory.

Benjamin insisted on introducing "a new, positive concept of barbarism"[38] at a time (1933–1934) when he foresaw the arrival of another barbarism (fascism), just after experiencing the barbarism of World War I. In order to invent a new positive concept, instead of returning to the worn-out concepts of civilization and culture, he thought "stealing the energies of transformation from the 'wrong' barbarism"[39] was necessary. Rather than advocating a noble humanism against the barbarism of enemies, the attitude to carry out a further barbarism in comparison, or "the radicalization of 'the experience of capitalist alienation and impoverishment' to the point

37
Kiaer, *Imagine No Possessions*, 31. Arvatov's vision of the future, which depicts humans becoming more and more "thinglike" in a world of interconnected things, is modern to a shocking degree. He predicted that within the "new world of Things… the psyche also evolved, becoming more and more thinglike" that it would be impossible to not think with things. Arvatov, "Everyday Life and the Culture of the Thing," 127. When he writes that "the Thing became something functional and active, connected like a co-worker with human practice" (127), while listing examples of things that became "dynamized," such as "[c]ollapsible furniture, moving sidewalks, revolving doors, escalators, automat restaurants, reversible outfits," Arvatov appears to be preempting Bruno Latour's ANT (Actor-Network Theory), which advances the "speed bump" as agency.

38
Walter Benjamin, "Experience and Poverty," *Selected Writings Volume 2, Part 2, 1931-1934*, eds. Michael W. Jennings, Howard Eiland, and Gary Smith (Cambridge, MA: The Belknap Press of Harvard University Press, 2005), 732.

39
Carlo Salzani, "Surviving Civilization with Mickey Mouse and a Laugh: A Posthuman Constellation," *Thinking in Constellations: Walter Benjamin and the Humanities*, eds. Nassima Sahraoui and Caroline Sauter (Newcastle Upon Tyne: Cambridge Scholars Publishing, 2018), 168.

40

Mourenza Daniel, "On Some Posthuman Motifs in Walter Benjamin: Mickey Mouse, Barbarism and Technological Innervation," *Cinema: Journal of Philosophy and the Moving Image* (2015): 40. Interestingly, the attitude of these new barbarians, who "mak[e] preparations to survive civilization" is far from the tragic tone of loss and resignation. Walter Benjamin, "Mickey Mouse," *Selected Writings Volume 2, Part 2, 1931-1934*, 545. "And the main thing is that it does so with a laugh" ("Experience and Poverty," 735). For Benjamin, the character representing this lively (and simultaneously destructive) optimism was Mickey Mouse, the "popular cousin" of the new barbarians.

41

Steyerl, "Too Much World: Is the Internet Dead?"

42

The Stakhanovite movement refers to the nationwide campaign to increase labor productivity that began in 1935, when a coal mine worker named Alexey Stakhanov recorded fourteen times the standard mining output, alongside Stalin's instruction to "learn from him." As suggested by the term "shock worker," this campaign, which characterizes the period of the first Five-Year Plan following the NEP, moved away from calculable rationality and technical models and towards an affective extremity that bordered on the absurd. The Stakhanovian model of subjectivity corresponds to a superhuman whose organic essence is maximized rather than a mechanized non-human or post-human as an extension of biomechanics. The Stakhanovian subject is more analogous to the contemporary professional athlete who exhibits superhuman skills (even if through dependency on drugs at times) or the digital precariat who suffers from 24-hour labor. In Steyerl's words, "Are circulationism's Stakhanovites working in Bangladeshi like farms, or mining virtual gold in Chinese prison camps, churning out corporate consent on digital conveyor belts?" Steyerl, "Too Much World: Is the Internet Dead?" For a great example of Steyerl's deep and detailed understanding of productivism, see also Hito Steyerl, "Truth Unmade Productivism and Factography," *Transversal 09/10: New Productivisms*, 2010.

of exceed[ing] the horizon of bourgeois-liberal humanism"[40] characterized Benjamin's political stance in the mid-1930s.

Speaking about the possibility of reinventing circulationism, Steyerl (making us recall the paragraph introduced earlier that made "the question derived from the theory of Boris Arvatov" into the topic of discussion) wrote the following sentences using dazzling metaphors:

> Of course, it might also just go as wrong as its predecessor, by aligning itself with a Stalinist cult of productivity, acceleration, and heroic exhaustion. Historic productivism was—let's face it—totally ineffective and defeated by an overwhelming bureaucratic apparatus of surveillance/workfare early on. And it is quite likely that circulationism—instead of restructuring circulation—will just end up as ornament to an Internet that looks increasingly like a mall filled with nothing but Starbucks franchises personally managed by Joseph Stalin.[41]

The way Steyerl brings the past into the present, in other words, the method of creating an unexpected "rupture" by colliding the historical past of Soviet Productivism with the circulationist present that surrounds us, shines, paradoxically, when it is supported by an accurate and clear critical perception of the past. She is well aware of how historical Productivism could "go wrong" and how "aligning itself" with Stalinism eventually resulted in the extreme cult of labor represented by the Stakhanovite movement.[42] To some extent, this accurate and critical perception of the past appears to be more to the point than just pointing out the secret common denominator between our era (circulationism) and the Stalinist era (Stakhanovism): "productivity, acceleration,

"Circulationism is also
entangled with today's
neoliberal version of
the Stalinist cult of
productivity, acceleration,
and heroic exhaustion." (Sven
Lütticken, "Hito Steyerl:
Postcinematic Essays after
the Future," *Too Much World:
The Films of Hito Steyerl*,
55). According to Steyerl's
remarkable expression, it
can be seen to correspond to
"a mall filled with nothing
but Starbucks franchises
personally managed by Joseph
Stalin."

heroic exhaustion."[43] Why? Because it allows Steyerl to overlap the "bad scenario" of circulationism (which hypothetically might eventually end up the worst version of post-capitalism) with one clear historical precedent: Soviet Productivism, which after failure and cooperation eventually resulted in Stalin's cult of labor. But is that really all?

Based on exactly the same logic, we can ask the following question. What if historical Productivism could have flowed in a different way than what we know now? What if there were other alternative routes within it, other possibilities existing within it that could have arisen but were just not chosen? If there really were a past that can be sufficiently "redeemed" waiting for us, then wouldn't it be possible to write differently about our present as well? Why couldn't circulationism be reinvented in a different way?

> But here is the ultimate consequence of the internet moving offline. If images can be shared and circulated, why can't everything else be too? ... If circulationism is to mean anything, it has to move into the world of offline distribution, of 3D dissemination of resources, of music, land, and inspiration. Why not slowly withdraw from an undead internet to build a few others next to it?[44]

44
Steyerl, "Too Much World: Is the Internet Dead?"

In considering the newness of the present, it is very important to face the fact that "these things are not as new as they seem." The present needs to be understood "historically." When the present is brought into the horizon of history, all (surface appearance of) novelty acquires a historical genealogy. On the other hand, what needs to be considered still more "politically" is the past. To encounter the past dialectically does not mean confirming an immutable fact that is fixed in its original form. A politically conceived past could become, for instance, a bet or a struggle between the present and the future. It is the process of attaching the question "couldn't it have been different" like a chorus, and the process of tearing a hole in an already established interpretation and redeeming it differently. "Arvatov and his era," which I have tried to reconstruct in this article thus far, is nothing other than a constellation of such other possibilities.

I dare say, in Steyerl's case, the task of understanding "historically" the dizzying present that surrounds us is inextricably linked with the work of rethinking "politically" the past of the last century called the Soviet era that has been considered a failure and discarded.

기록과 픽션

Documentation and Fiction

독일과 정체성
GERMANY AND IDENTITY
1994

- 16 MM 필름(비디오로 재생), 컬러,
 사운드, 42분
- 작가 소장

- 16 MM FILM (SHOWN AS VIDEO), COLOR,
 SOUND, 42 MIN.
- COURTESY OF THE ARTIST

- 감독 DIRECTOR
 HITO STEYERL
- 음악 MUSIC
 FELIX MENDELSSOHN
- 촬영 CAMERA
 MEIKE BIRCK
- 보이스 오버 VOICE-OVER
 CORA FROST

바벤하우젠
BABENHAUSEN
1997

· 베타 SP, 컬러, 사운드, 4분 4초
· 작가 소장

· BETA SP, COLOR, SOUND, 4 MIN.
 4 SEC.
· COURTESY OF THE ARTIST

· 감독 DIRECTOR
 HITO STEYERL

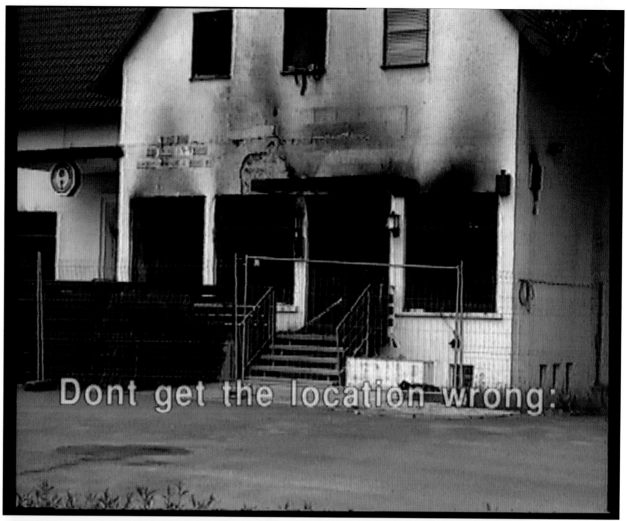

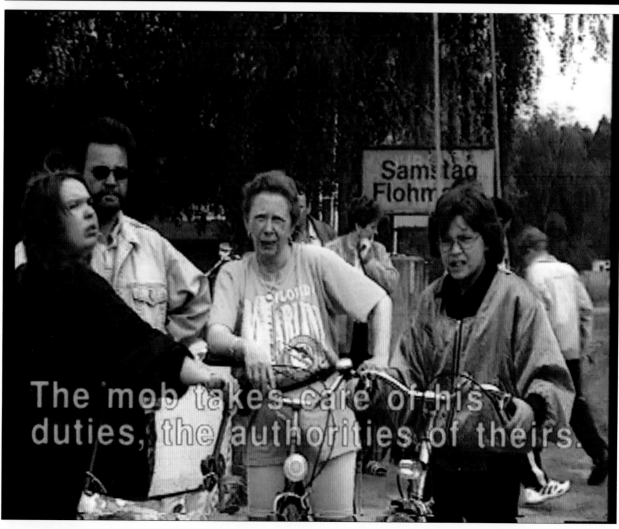

440

《히토 슈타이얼—
데이터의 바다》
전시 전경,
국립현대미술관,
서울, 2022

INSTALLATION VIEW
OF HITO STEYERL—
A SEA OF DATA,
NATIONAL MUSEUM
OF MODERN AND
CONTEMPORARY ART,
SEOUL (MMCA),
2022

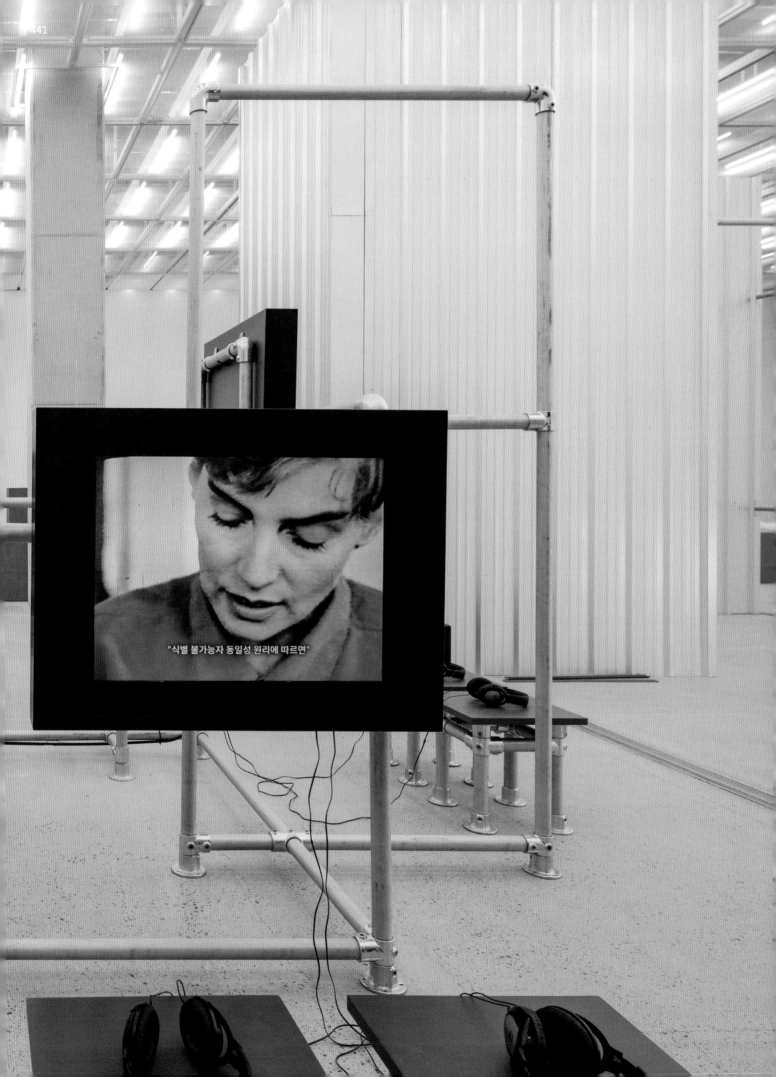

비어 있는 중심
THE EMPTY CENTRE
1998

- 16 MM 필름(비디오로 재생), 컬러,
 사운드, 62분
- 작가 소장

- 16 MM FILM (SHOWN AS VIDEO),
 COLOR, SOUND, 62 MIN.
- COURTESY OF THE ARTIST

- 감독 DIRECTOR
 HITO STEYERL
- 음악 MUSIC
 FELIX MENDELSSOHN,
 FRIEDRICH HOLLAENDER
- 프로듀서 PRODUCER
 SU TURHAN
- 보이스 오버 VOICE-OVER
 HATICE AYTEN
- 녹화 RECORDING
 MEIKE BIRCK, HITO STEYERL,
 BORIS SCHAFGANS
- 텍스트 TEXTS BY
 SIEGFRIED KRACAUER,
 FRIEDRICH HOLLAENDER
- 제작 PRODUCED BY
 HOCHSCHULE FÜR FERNSEHEN
 UND FILM, MÜNCHEN
- 주연 PROTAGONISTS
 DONG YANG, HUAN ZHU, SQUATTERS
 OF POTSDAM SQUARE, UNION OF
 CONSTRUCTION WORKERS, AND MANY
 OTHERS

447

A system of buffer zones, satellite and vassal states develops.

450

It was half past 2 on Saturday night
토요일 새벽 2시 반에

정상성 1-X
NORMALITY 1-X
1999

· 베타 SP, 흑백, 컬러, 사운드, 42분
· 작가 소장

· BETA SP, B&W AND COLOR, SOUND,
 42 MIN.
· COURTESY OF THE ARTIST

· 감독 DIRECTOR
 HITO STEYERL

457

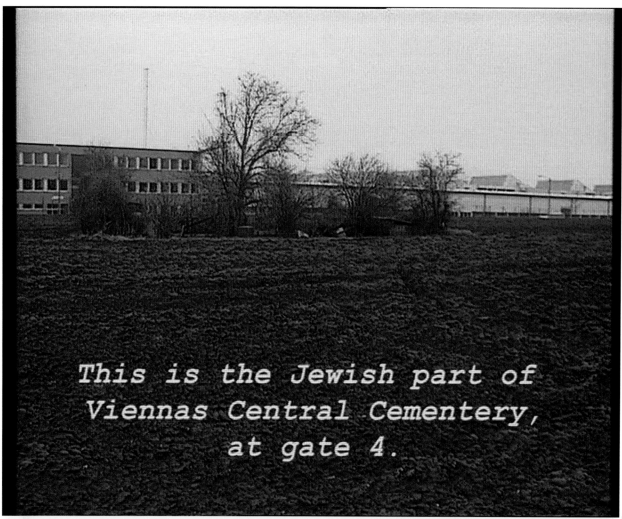

This is the Jewish part of
Viennas Central Cementery,
at gate 4.

A war against Jews, migrants,
people of color and against all those
whose bodies defy the norms of normality?

11월
NOVEMBER
2004

· 단채널 디지털 비디오, 컬러, 사운드,
 25분 19초
· 작가, 앤드류 크랩스 갤러리, 뉴욕 및
 에스더 쉬퍼, 베를린 제공

· SINGLE-CHANNEL DIGITAL VIDEO,
 COLOR, SOUND, 25 MIN. 19 SEC.
· COURTESY OF THE ARTIST, ANDREW
 KREPS GALLERY, NEW YORK AND ESTHER
 SCHIPPER, BERLIN

· 감독 DIRECTOR
 HITO STEYERL
· 편집 EDITOR
 STEFAN LANDORF
· 어시스턴트 ASSISTANT
 YASMINA DEKKAR
· 주연 PROTAGONIST
 ULI MAICHLE
· 프로듀서 PRODUCER
 MARTA KUZMA FOR MANIFESTA5
· 커미션 COMMISSIONED BY
 MARTA KUZMA FOR MANIFESTA5
· 제작 지원 SUPPORTED BY
 KLAUS, MEHMET AKTAS, PETER GRABHER,
 LISA ROSENBLATT

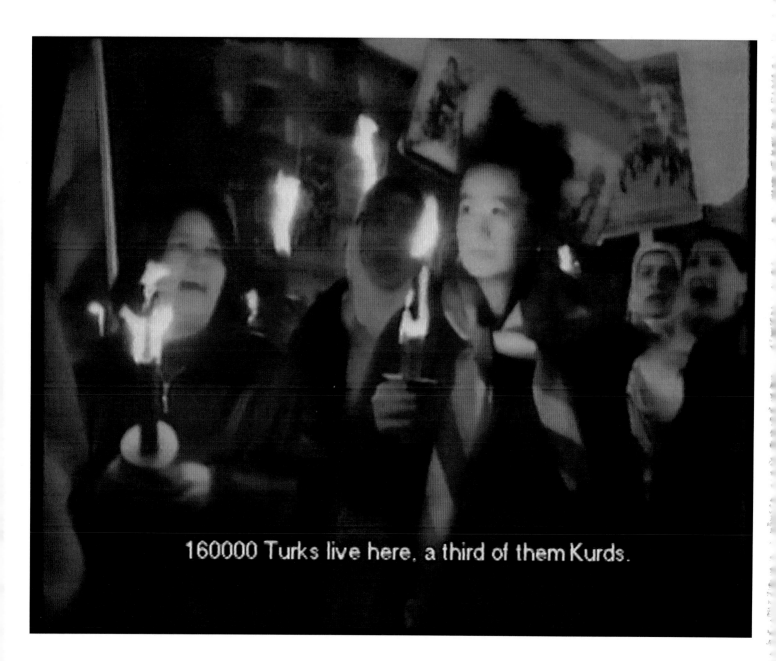

러블리 안드레아
LOVELY ANDREA
2007

- 단채널 디지털 비디오, 컬러,
 사운드, 29분 43초
- 작가, 앤드류 크랩스 갤러리,
 뉴욕 및 에스더 쉬퍼, 베를린 제공

- SINGLE-CHANNEL DIGITAL VIDEO,
 COLOR, SOUND, 29 MIN. 43 SEC.
- COURTESY OF THE ARTIST, ANDREW
 KREPS GALLERY, NEW YORK AND ESTHER
 SCHIPPER, BERLIN

- 감독 DIRECTOR
 HITO STEYERL
- 출연 및 조감독
 PERFORMER AND ASSISTANT DIRECTOR
 ASAGI AGEHA
- 프로듀서 PRODUCER
 OSADA STEVE
- 편집 EDITOR
 STEFAN LANDORF
- 커미션 COMMISSIONED BY
 DOCUMENTA12
- 제작 지원 SUPPORTED BY
 MATTHIAS J. GRIMME, SYLVIA
 SCHEDELBAUER, AND MANY OTHERS

저널 NO.1
JOURNAL NO.1
2007

- 단채널 비디오, 흑백, 컬러, 사운드, 22분
- 작가 소장

- SINGLE-CHANNEL VIDEO, B&W AND
 COLOR, SOUND, 22 MIN.
- COURTESY OF THE ARTIST

- 감독 DIRECTOR
 HITO STEYERL
- 편집 EDITOR
 STEFAN LANDORF
- 주연 PROTAGONISTS
 DEVLETA FILIPOVIC, HALID BUNIC,
 ARMAN KULASIC
- 프로듀서 PRODUCER
 BORIS BUDEN
- 협력 프로듀서 ASSOCIATE PRODUCERS
 GABI BABIC, DUNJA BLAZEVIC,
 UTE META BAUER
- 후원 SPONSORED BY
 GOETHE-INSTITUT, DOCUMENTA 12
- 커미션 ORIGINALLY COMMISSIONED FOR
 DOCUMENTA 12 AND FUNDED BY GOETHE-
 INSTITUT, GERMANY.

469

This was the film studio, montage, sound.

Are you looking for houses that were burnt down?
We are looking for films.

Ritka na Neretvi, 1969

A-V-N-O-J
(Anti-Fascist Council of National Liberation of Yugoslavia)

아도르노의 그레이
ADORNO'S GREY
2012

- 단채널 HD 비디오, 흑백, 사운드, 14분 20초
- 작가, 앤드류 크랩스 갤러리, 뉴욕 및 에스더 쉬퍼, 베를린 제공

- SINGLE-CHANNEL HD VIDEO, B&W, SOUND, 14 MIN. 20 SEC.
- COURTESY OF THE ARTIST, ANDREW KREPS GALLERY, NEW YORK AND ESTHER SCHIPPER, BERLIN

- 주연 PROTAGONISTS
 GERD ROSCHER, NINA POWER, PETER OSBORNE, ANONYMOUS PROTESTER
- 촬영, 사운드, 편집, 컬러
 CAMERA, SOUND, EDIT, COLOR
 HITO STEYERL
- 촬영 LARGE FORMAT PHOTOGRAPHY
 LEON KAHANE
- 벽면 구성 연구 및 AD
 WALL PLOT RESEARCH AND AD
 ALWIN FRANKE
- 보존 처리 전문가 CONSERVATORS
 BENJAMIN RUDOLPH, SINA KLAUSNITZ
- 프로덕션 매니저 PRODUCTION MANAGERS
 MAIKE BANASKI, ANNA-VICTORIA ESCHBACH
- 포스트 프로덕션 POST PRODUCTION
 CHRISTOPH MANZ, MARIA FRYCZ
- 스크린 디자인 SCREEN DESIGN
 STUDIO MIESSEN, DIOGO PASSARINHO, YULIA STARTSEV
- 제작 PRODUCED BY
 WILFRIED LENTZ, ROTTERDAM
- 제작 지원 SUPPORTED BY
 NIKOLAUS HIRSCH, SOPHIE VON OLFERS, CLAUDIA STOCKHAUSEN

473

1966년 출생, 뮌헨
활동 및 거주, 베를린
Born 1966 in MÜnchen
Lives and Works in Berlin

개인전
SOLO EXHIBITIONS

2022 *Hito Steyerl—A Sea of Data*, National Museum of Modern and Contemporary Art, Seoul, Korea
 Hito Steyerl. I Will Survive, Stedelijk Museum, Amsterdam
2021 *Hito Steyerl. I Will Survive*, Centre Pompidou, Paris, France
 Hito Steyerl. I Will Survive, K21 Kunstsammlung, Düsseldorf, Germany
 Factory of the Sun, San José Museum of Art, San José, CA
 Hito Steyerl: Strike, Urban Video Project, Syracuse University, Syracuse, NY
2020 *Life Captured Still, Hito Steyerl and Harun Farocki*, Galerie Thaddaeus Ropac, London, UK
2019 *Hito Steyerl: This is the Future*, Art Gallery of Ontario, Toronto, ON, Canada
 Hito Steyerl, n.b.k., Berlin, Germany
 Drill, Park Avenue Armory, New York, NY
 Power Plants, Serpentine Galleries, London, UK
 Hito Steyerl: Käthe Kollwitz Prize 2019, Akademie der Künste, Berlin, Germany
2018 *The City of Broken Windows*, Castello di Rivoli, Turin, Italy
 Factory of the Sun, National Gallery of Victoria, Melbourne, Australia
 Martha Rosler & Hito Steyerl: War Games, curated by Søren Gammel, Kunstmuseum, Basel
2017 *Hito Steyerl: Liquidity Inc.*, The Institute of Contemporary Art, Boston, MA
2016 *Hito Steyerl: Factory of the Sun*, HMKV, Dortmund, Germany
 Hito Steyerl: Factory of the Sun, Museum of Contemporary Art, Los Angeles
 Number Thirteen: Factory of the Sun, Julia Stoscheck Collection, Düsseldorf, Germany
2015 *Duty-Free Art*, Museo Nacional Centro de Arte Reina Sofía, Madrid KOW gallery, Berlin
 Liquidity, Inc., Tensta Konsthall, Spånga, Sweden
 Too Much World, Institute of Modern Art, Brisbane, Australia
 Hito Steyerl, Artists Space, New York
 Duty-Free Art, ARTSPACE, Auckland, New Zealand Concentrations
2014 *How Not to Be Seen: A Fucking Didactic Educational Installation*,
 Andrew Kreps Gallery, New York
 Hito Steyerl, Van Abbemuseum, Eindhoven, Netherlands
 Hito Steyerl, Institute of Contemporary Arts, London
 HNTBS, Künstlerhaus Stuttgart, Germany
 Circulacionismo, Museo Universitario de Arte Contemporaneo, Mexico City
 Hito Steyerl: Junktime, Home Workspace Program, Ashkal Alwan, Beirut
2013 *In Free Fall*, Andrew Kreps Gallery, New York
 Hito Steyerl: Guards, Museum of Contemporary Art San Diego, CA
 Adorno's Grey, Audain Gallery, Goldcorp Centre for the Arts, Vancouver
 Guards, Svilova, Gothenburg, Sweden
2012 *Hito Steyerl*, e-flux, New York
 Adorno's Grey, Wilfried Lentz, Rotterdam, Netherlands
 Focus: Hito Steyerl, Art Institute of Chicago
 The Kiss, Overgaden Institute of Contemporary Art, Copenhagen, Denmark
2011 *Hito Steyerl: Journal No. 1—An Artist's Impression*, Studiengalerie 1.357,
 Goethe University Frankfurt, Frankfurt, Germany
 Hito Steyerl, In Free Fall, Wilfried Lentz, Rotterdam, Netherlands
2010 Chisenhale Gallery, London
 Picture This, Bristol, United Kingdom
 In Free Fall, Collective, Edinburgh, Scotland
 RICOCHET #3, Villa Stuck, Munich
 Henie-Onstad Art Centre, Oslo, Norway
2009 *Hito Steyerl*, Neuer Berliner Kunstverein, Berlin
 Pallas Contemporary Projects, Dublin
 P74 Gallery, Ljubljana, Slovenia
2008 *The 1st at Moderna: Hito Steyerl*, Moderna Museet, Stockholm, Sweden
 Kunsthalle Winterthur, Winterthur, Switzerland
2007 300m³ Gallery, Göteborg, Sweden
2004 Underground Gallery, Athens

단체전, 스크리닝
GROUP SHOWS AND SCREENINGS

2021 *Post-Capital*, Mudam Luxembourg, Luxembourg City, Luxembourg
Our Other Us, Art Encounters Biennial 2021, Timișoara, Romania
Hito Steyerl und Mark Waschke, Steirischr Herbst, Graz, Austria
Footnotes & Headlines, Andrew Kreps Gallery, NY
Hiding in Plain Sight, PACE Gallery, New York, NY
The Supermarket of Images, Red Brick Museum, Beijing, China
Fractured Spine, Photobastei 2.0, Zürich, Switzerland
Low Visibility, The Walker Art Centre, Minneapolis, MN
When in Doubt, Go to a Museum, City Museum of Ljubljana, Slovenia
Compassion Fatigue is Over, Galerie Rudolfinum, Prague, Czech
2020 Busan Biennale 2020, MoCA Busan, Busan, South Korea
Topologies of the Real, CAFAM Techne Triennial, Beijing, China
Sunshine Misses Windows, Daejeon Museum of Art, Daejeon, Korea
Liquid Love, Museum of Contemporary Art, Taipei, Taiwan
The Body Electric, Museum of Art and Design at Miami Dade College, Miami, Florida
Asia Digital Art Exhibition, Times Art Museum, Beijing, China
From what will we reassemble ourselves, Framer Framed, Amsterdam, Netherlands
The Supermarket of Images, Jeu de Paume, Paris, France
Uncanny Valley: Being Human in the Age of AI, de Young museum, San Francisco, CA
2019 *Eternal Now*, PKM Gallery, Seoul, Korea
Christoph Keller, Hito Steyerl, Tao Hui, Esther Schipper, Berlin
Transitar entre los símbolos del muro, Puerto de Ideas, Valparaíso, Chile
Constellations, Tate Liverpool, Liverpool, England
The Moon, Henie Onstad Kunstsenter, Høvikodden, Norway
Time Kills, SESC, São Paulo, Brazil
Hybrid Peace, Stroom Den Haag, Hague, Netherlands
Animal—Human—Robot, The MO Museum, Vilnius, Lithuania
Tomorrow is the Question, ARoS Museum, Aarhus, Denmark
Here We Are Today, Bucerius Kunst Forum, Hamburg, Germany
Fragments (Teasers) of The Future, Örebro Konsthallen, Örebro, Sweden
VRIJPLAATS, Museum Ijsselstein, Utrecht, Netherlands
Fast Fashion, Slow Art, Corcoran Gallery, Washington, DC
Never Again. Art Against War and Fascism in the 20th and 21st Centuries, MOMA Warsaw, Warsaw, Poland
Up in Arms, Kunstraum Kreuzberg, Berlin, Germany
The Posthuman City. Climates. Habitats. Environments., NTU Centre for Contemporary Art, Singapore
Black Cloud, Kyiv Biennial, Kiev, Ukraine
Surrounds, Museum of Modern Art, New York, NY
Observation, Centre Pompidou x West Bund Museum, Shanghai, China
Anderen wurde schwindelig, Bildungsstätte Anne Frank, Frankfurt, Germany
Tell me about yesterday tomorrow, NS Dokumentationszentrum, Munich, Germany
The Third Space, MoCA, Skopje, North Macedonia
Speaking Images, Fluentum, Berlin, Germany
From the clay to the algorithm. Art and technology. Gallerie d'Italia, from the collections of Intesa Sanpaolo and Castello di Rivoli, Milan, Italy
May You Live in Interesting Times, 58th edition of the Venice Biennale, Venice, Italy
2018 *6th Taiwan Video Art Exhibition*, Hong-gah Museum, Taipei City, Taiwan
RESISTANCE, CENTRALE for Contemporary Art, Brussels, Belgium
Neighbors, The Museum of Modern Art, Warsaw, Poland
Robot Love Festival, Eindhoven, Netherlands
The Moon: From Inner Worlds to Outer Space, Louisiana Museum of Modern Art, Humblebaek, Denmark
Ghost:2561, BANGKOK CITYCITY Gallery, Bangkok, Thailand
After the Future, The Atlantic Project, Plymouth, UK
I Was Raised on the Internet, Museum of Contemporary Art, Chicago, IL

Busan Biennale 2018, Busan, Korea
Hello World—For The Post-Human Age, Art Tower Mito, Mito, Japan
Germany is not an Island, Bundeskunsthalle, Bonn, Germany
Faithless Pictures, Nasjonalmuseet, Oslo, Norway
Art in the Age of the Internet, 1989 to Today, The Institute of Contemporary Art, Boston, MA

2017 *Faces: Gender Art, Technology*, Schaumbad, Graz, Austria
beyond future is past, Kunsthalle Münster, Münster, Germany
Polygraphs, Gallery of Modern Art, Glasgow, Scotland
ARS17, Kiasma_, The Museum of Contemporary Art Helsinki, Finland
Kunstraum Niederösterreich, Vienna
Castello di Rivoli, Turin, Italy
The Absent Museum, WIELS Contemporary Art Centre, Brussels
Field Guide, Remai Modern Museum, Saskatoon, Canada
The Truth of Uncertainty: Moving Image Works from the Hall Collection, curated by Chrissie Iles, Hall Art Foundation, Schloss Derneburg Museum, Derneburg, Germany
Picture Industry, Hessel Museum of Art, CCS Bard, Annandale-on-Hudson, NY
The Message: New Media Works, Hirschhorn, Washington, DC
Jakarta Biennial, Jakarta, Indonesia
Like a Moth to a Flame, curated by Tom Eccles, Marl Rappolt and Liam Gillick, Fondazione Sandretto re Rebaudengo, Turin, Italy
Produktion. Made in Germany Drei, Sprengel Museum, Hanover, Germany
Skulptur Projekte 2017, Münster, Germany
Frestas-Trienal de Artes, curated by Daniela Iabra, SESC, São Paulo
Territories and Fictions. Thinking a New Way of the World, Muntref, Centro de Arte y Ciencia, Buenos Aires, Argentina
Reenacting History_Collective Actions and Everyday Gestures, National Museum of Modern and Contemporary Art, Gwacheon, Korea
Manipulating the world, Moderna Museet, Stockholm, Sweden
Electronic Superhighway, Museum of Art, Architecture and Technology, Lisbon, Portugal

2016 *Territories and Fictions. Thinking a New Way of the World*, The Reina Sofía Museum, Madrid
Dreamlands: Immersive Cinema and Art, 1905-2016, Whitney Museum of American Art, New York
Universal Hospitality, curated by Edit András, Ilona Németh Birgit
Lurz and Wolfgang Schlag, Wiener Festwochen festival, Alte Post, Vienna
The Distributed Image, LUMA Foundation, Arles, France
World On A Wire, Julia Stoschek Collection, Berlin
V-A-C Foundation in collaboration with The State Museum of GULAG's History, Moscow Wer nicht denken will, fliegt raus, Museum Kurhaus Kleve, Kleve, Germany
Invisible Adversaries: Marieluise Hessel Collection, Bard Hessel Museum of Art, Annandale-On-Hudson, NY
9th Berlin Biennale, Berlin
São Paulo Biennial, São Paulo
Gwangju Biennale, Gwangju, South Korea
Prospect 2016, Museum of Contemporary Art San Diego, La Jolla, CA
The New Human, Moderna Museet, Stockholm
Visual Art Displays, Maxwell Centre, Kettle's Yard, University of Cambridge, United Kingdom
MashUp: The Birth of Modern Culture, Vancouver Art Gallery, Vancouver, Canada
Electronic Superhighway, Whitechapel Gallery, London
Collected by Thea Westreich Wagner and Ethan Wagner, Centre Pompidou, Paris
Dancing with Myself, Self-portrait and Self-invention, Works from the Pinault Collection, Museum Folkwang, Essen, Germany
Kunsthalle Charlottenberg, Copenhagen
Infinite Blue, Brooklyn Museum, Brooklyn, NY
Why the Performance?, The Ming Contemporary Art Museum, Shanghai
The Fevered Specters of Art—the Feverish ghosts of art, Edith-Russ-Haus für Medienkunst, Oldenburg, Germany
Tate Modern Collection Display, Tate Modern, London, UK

2015 *A Worthy Degenerate*, Townhouse Gallery, Cairo, Egypt

Filter Bubble, curated by 89PLUS Hans Ulrich Obrist and Simon Castets,
LUMA Westbau, Zürich
Political Populism, Kunsthalle Wien, Vienna
AIMIA Photography Prize Exhibition, Art Gallery of Ontario, Ontario, Canada
El Lissitzky: The Artist and the State, Irish Museum of Modern Art, Dublin
56th Venice Biennale, German Pavilion, Venice, Italy
Contemporary Art Centre, Vilnius, Lithuania
4th Dojima River Biennale, Osaka, Japan
Contemporary Art Centre, Vilnius, Lithuania
Digital Mind, Hannover Kunstverein, Hannover, Germany
Under the Clouds: From Paranoia to the Digital Sublime, Serralves Museum of
Contemporary Art, Portugal
Collection on Display, Migros Museum für Gegenwartskunst, Zürich
In Search of Matisse, curated by director Tone Hansen and Ana Maria Bresciani,
Henie Onstad Kunstsenter, Høvikodden, Norway
Necessary Force: Art in a Police State, Art Museum of the University of
New Mexico, Albuquerque, New Mexico
CO-WORKERS–Networking as an artist, Musee D'Art Moderne de la ville de Paris Technologism,
Monash University Museum of Art in Melbourne, Melbourne, Australia
Global Control and Censorship, Zentrum für Kunst and Medientechnologie Karlsruhe,
Karlsruhe, Germany
Berlin Art Film Festival, Berlin
Collected by Thea Westreich Wagner and Ethan Wagner, Whitney Museum of American Art, New York

2014 *Cut to Swipe*, Museum of Modern Art, New York
Adorno's Grey, 52nd New York Film Festival
McLaren 2014 Animation in Context, Centre for Contemporary Arts, Glasgow, Scotland
60th annual Robert Flaherty Film Seminar, Hamilton, NY
43rd International Film Festival, Rotterdam, Netherlands
Smart New World, Kunsthalle Düsseldorf, Germany
The Secret Museum, Stedelijk Museum, Amsterdam
Time Pieces, Nordstern Videokunstzentrum, Gelsenkirchen, Germany
Collective Reaction: FotoFest 2014, Station Museum of Contemporary Art Houston, TX
Hito Steyerl: Rules of Engagement, Insert 2014, New Delhi, India
Hntbs by Hito Steyerl, Kunstverein Stuttgart, Germany
Politics Within, Center for Contemporary Art Celje, Slovenia 27th Images Festival, Toronto
Bad Thoughts, Collection Martijn and Jeannette Sanders, Stedelijk Museum,
Amsterdam, Netherlands
Homing, Wilfried Lentz, Rotterdam, Netherlands
Blue Times, Kunsthalle Wien, Vienna
The Darknet, Kunsthalle Sankt Gallen, Austria
Bienal de la Imagen en Movimiento, Goethe-Institut Buenos Aires, Argentina
A screaming comes across the Sky, LABoral Centro de Arte y Creación Industrial,
Gijón, Asturias, Spain
4th Dojima River Biennale, Osaka, Japan
9 Artists, MIT List Visual Arts Centre, Cambridge, MA
After Image, Galleria Civica, Trento, Italy
Lo Schermo Dell'Arte Film Festival VII Edition, Florence
The Execution of Maximilian, MEAD Gallery, Warwick Arts Center, United Kingdom
Ten Million Rooms of Yearning. Sex in Hong Kong, Para Site, Hong Kong
DocLisboa '14, International Film Festival, Lisbon

2013 *Bad Girls*, Frac Lorraine, Metz, France
The Way of the Shovel: Art as Archeology, Museum of Contemporary Art, Chicago
Image Employment, MoMA PS1, Long Island City, NY
Nine Artists, Walker Art Centre, Minneapolis, MN
FORMER WEST: Documents, Constellations, Prospects, curated by Maria Hlavajova and
Kathrin Rhomberg, Haus der Kulturen der Welt, Berlin, Germany
No one lives here, Royal College of Art, London, United Kingdom
Schichtwechsel, Nordstern Videokunstzentrum, Gelsenkirchen, Germany
42nd International Film Festival, Rotterdam, Netherlands

Il Palazzo Enciclopedico, Venice Biennale, Venice, Italy
Economy, Stills, Edinburgh, Scotland
Economy, Centre for Contemporary Art, Glasgow, Scotland
12x12, IBB-Videolounge at the Berlinische Galerie, Berlin
The ICP Triennial, New York
Probable title: zero probability II, performance with Rabih Mroué Stedelijk,
Museum Amsterdam, Netherlands
I Dreamed a Dream, performance, Stedelijk Museum Amsterdam, Netherlands
Bergen Triennial, Bergen, Norway
Yebisu International Festival for Art & Alternative Visions, Tokyo
Metropolitan Museum of Photography, Tokyo
Museums of Bat Yam, Israel
Good Girls, Muzeul National de Arta Contemporana, Bucuresti, Romania
SBC galerie d'art contemporain, Montréal
59th International Short Film Festival Oberhausen, Oberhausen, Germany
Little Movements II, self-practice in Contemporary Art, Museion, Bolzano, Italy
Double Indemnity, Cornerhouse, Manchester, United Kingdom
The Field is to the Sky, Only Backwards, International Studio & Curatorial Program,
Brooklyn, NY
Kunstneres Hus, Oslo, Norway
Momentous Times, Centre for Contemporary Art, Derry, United Kingdom
2012 *Revolution Happened Because Everybody Refused to Go Home*, Disobedience Archive,
Bureau Publik Copenhagen Copenhagen Art Festival, Copenhagen, Denmark
In Free Fall, Screen Festival, Museum of Contemporary Art Barcelona, Spain
Alternativa 2012, Wyspa Institute of Art, Gdansk, Poland
Remote Control, Institute of Contemporary Arts, London
Mengele's Skull, Portikus, Frankfurt, Germany
Witte de With, Surplus Authors, Rotterdam, Netherlands
Offside Effect, 1st Tbilisi Triennial, Center of Contemporary Art, Tbilisi, Georgia
Motion, Seventeen Gallery, London
Disobedience Archive (The Parliament), BildMuseet, Umea, Sweden
Nordstern Videokunstzentrum, Gelsenkirchen, Germany
BERLIN DOCUMENTARY FORUM 2, Haus der Kulturen, Berlin
Probable title: zero probability, performance with Rabih Mroué, The Tanks at
Tate Modern, London
Performance Year Zero, Tate Modern, London
Haus der Kulturen der Welt, Berlin
A Peculiar Form of Fiction, Site Gallery, Sheffield, United Kingdom
2011 *Big Picture II (Zeitzonen)*, Kunstsammlung im Ständehaus, Düsseldorf, Germany
ONE WORLD BERLIN Filmfestival für Menschenrechte und Medien, Arsenal Berlin
Les marques aveugles, Centre d Art Contemporain Geneva
Schöne Aussichten. Wiedereröffnung der Neuen Galerie, Neue Galerie Kassel,
Kassel, Germany
The Global Contemporary, Kunstwelten nach 1989, ZKM Karlsruhe, Germany
Seeing is believing, KW Berlin 8., Berlin
Planete Doc FF, Warsaw
espressofilm—kurzfilm einen sommer lang, Vienna
Signal + Noise, Media Art Festival, Vivo Arts Centre, Vancouver
HORS PISTES, Vancouver
TOKYO, Another Motion of Images | Art and Images Festival, Tokyo
Too late, too little, (and how) to fail gracefully, KunstFort Asperen, Acquoy, Holland
All That Fits: The Aesthetics of Journalism, QUAD Gallery, Derby, United Kingdom
Antiphotojournalism, Foam Photography Museum, Amsterdam, Netherlands
SERIOUS GAMES—Krieg—Medien—Kunst, Mathildenhöhe Darmstadt, Germany
Parallel Worlds, Arsenal Berlin
2010 *CPH: DOX*, Copenhagen International Documentary Film Festival, Denmark
Hangi Insan Haklari? Documentarist, Istanbul Un lugar fuera de la historia,
Museo Tamayo, Mexico City
Antiphotojournalism, La Virreina, Barcelona

Vectors of the Possible, BAK, Utrecht, Netherlands
1st Ural Industrial Biennial, National Center for Contemporary Arts, Ekaterinburg, Russia
Cromocronias—Poéticas del color en la imagen-tiempo, Centro José Guerrero, Granada, Spain
The Storyteller, Art Gallery of Ontario, Toronto
1st Taipei Biennial 2010, Taipei, Taiwan
8th Gwangju Biennale, Gwangju, South Korea
Loop Festival, La Virreina Centre de l'Imatge, Barcelona
16th Sheffield International Documentary Festival, Sheffield,
United Kingdom A History of Irritated Material, Raven Row, London
39th International Film Festival, Rotterdam, Netherlands
Everyday Ideologies, Kunstmuseum Kloster Unser Lieben Frauen Magdeburg, Germany

2009 *Cultural memories/recits parallels*, Galerie Fabienne Leclerc, Paris
FallMauerfall, Statmuseum Berlin
The View from Elsewhere, Sherman Contemporary Art Foundation, Sydney, Australia
20th FID International Film Festival, Marseille, France
Under Control, Krannert Museum of Art, Champaign, IL
El pasado en el presente y lo propio en lo ajeno, LABoral Centro de Arte y Creación
Industrial, Gijón, Asturias, Spain
The Porn Identity, Kunsthalle Wien, Austria
Best of Kunstfilm Biennale, Kunstwerke Berlin, Centre Pompidou
Paris and Museo Nacional Centro de Arte Reina Sofía, Madrid
31st Clermont-Ferrand short film festival, France
The Storyteller, ICI Audio video disco Kunsthalle Zürich

2008 *Dispersion*, Institute of Contemporary Art, London
Videozone 4, Tel Aviv, Israel
Kvadriennale for Samtidskunst, Copenhagen
Mobile Archive, Halle für Kunst Lüneburg Schengen, Feinkost Gallery, Berlin
Hito Steyerl, Kunsthalle Winterthur, Switzerland
This is how history is written, Casa Encendida, Madrid
Documentary Uncertainties, A Space, Toronto
Vertrautes Terrain, ZKM Karlsruhe
The Greenroom, Hessel Museum, Anondale, NY
New York Underground Film Festival, NY
Hot docs, Toronto Images Festival, Canada
37th International Film Festival, Rotterdam, Netherlands
Diagonale, Graz, Austria
Human Rights Film Festival, Zagreb, Croatia
Galerie der Schwarze Punkt, Konstanz, Germany

2007 *If you can't dance…*, Muhka, Antwerp, Belgium
documenta 12, Kassel, Germany
Last news, Laznia Centre for Contemporary Art, Gdansk, Poland
If you see something, say something, Mori Gallery, Sydney, Australia
KunstFilmBiennale, Köln, Germany
Documentary Film Platform ZONE, Ghent/ Antwerp/ Kortrijk
Indie Lisboa, Lissabon filmfestival, Portugal
Cinema du reel, Paris
The Country of the Endangered Body, Trafo House of Contemporary Art, Budapest

2006 *Videozone*, Biennale für Videokunst, Tel Aviv, Israel
A fiesta of tough choices, IASPIS, Stockholm
Archaeology of today, Pristina National Museum, Kosovo
A picture of war is not war, Wilkinson Gallery, London
Whitechapel Gallery, London Stedelijk Museum Amsterdam, Netherlands
13th New York Underground Film Festival, NY
Martin Jacobson / Hito Steyerl, Signal Center for Contemporary Art, Malmö, Sweden

2005 *Archaeology of today*, Underground Gallery Athens
Symptome der Überforderung, Kunstverein Potsdam, Germany
Fokus Istanbul, Martin Gropius-Bau, Berlin
New Feminism—New Europe, Cornerhouse Manchester, United Kingdom
Contour, 2., Video Biennial Mechelen, Belgium

Die Regierung, Sezession Wien, Austria
Nicolai Centre for Contemporary Art Communism, Dublin
Project Das Neue Europa, Generali Foundation, Vienna
17th Impaktfestival, Utrecht, Holland
PEK Film festival, Filmhuis Den Haag, Netherlands
17th IDFA International Documentary Film Festival, Amsterdam
Kasseler Dokumentarfilm und Videofest, Kassel, Germany
Leipzig International Film Festival, Leipzig, Germany
Exis Experimental Film Festival, South Korea
11th Sheffield International Documentary Film Festival, Sheffield, United Kingdom
16th FID International Film Festival, Marseille, France
13th Brisbane International Film Festival, Brisbane, Australia
44th Krakow International Film Festival, Krakow, Poland
54th Melbourne International Film Festival, Melbourne, Australia
28th Norwegian Short Film Festival, Oslo, Norway
18th Images Festival, Toronto
Cinema du reel, Paris
Diagonale, Graz, Austria

2004 Manifesta 5, San Sebastian, Spain
3rd Berlin Biennale, Berlin
ETHNIC MARKETING Art, Globalisation and Intercultural Supply and Demand, Centre d'art
contemporain, Geneva
Aarhus, Minority Report, Aarhus, Denmark
New York Based on a True Story, W139 gallery, Amsterdam
Museo del Arte Contemporaneo de la Reina Sofía, Madrid
34th Duisburg Film Festival, Duisburg, Germany
Argos festival, Brussels Ghent, International Film Festival Flanders, special screening
organised by SMAK, Municipal Museum of Contemporary Art, Ghent, Belgium

2003 *City of Women*, Ljubljana, Slovenia
ABCity, trafo, Budapest
Es ist schwer das Reale zu berühren, Kunstverein München, Munich
Show your wound, Goethe Institut, Tel Aviv, Israel
Platform Garanti, Istanbul
Borås Konsmuseum Bildmuseet in Umeå, Sweden
Museum of Modern Art, Stockholm
Museum of Modern Art, Vienna 2002
Geschichten, Salzburger
Kunstverein, Salzburg, Germany
games fights videos, Kunsthalle Bremen, Bremen, Germany
5th International Film Festival, Ismailia, Egypt
15th Images Festival, Toronto

2001 Dokumentar Film Festivals, München; Amsterdam; Kiev; Lissabon;
Bradford Diagonale, Graz, Austria
Internationale Kurzfilmtage, Oberhausen, Germany
Du bist die Welt, Wiener Festwochen, Vienna

2000 Heimat Kunst, Berlin
Continental Shifts, Ludwig Forum für Internationale Kunst, Aachen, Germany
Duisburger Filmwoche Viennale 2000, Vienna
Feminale, Köln, Germany

1999 *Translocation*, Vienna

작품 소장
PUBLIC COLLECTIONS

Centre National des Arts Plastiques, Paris, France
Centre Pompidou, Paris, France
Chicago Art Institute, Chicago, IL
Contemporary Art Society, London, UK
Dallas Museum of Art, Dallas, TX
Gallery of Modern Art, Glasgow, Scotland
Hammer Museum, Los Angeles, CA
Hirshhorn Museum, Washington, D.C.
Institute of Contemporary Art, Boston, MA
Kunsten Museum of Modern Art, Aalborg, Denmark
Kunstmuseum kloster unser lieben frauen Magdeburg, Germany
Lah Contemporary Art Foundation, Hünenberg, Switzerland
Museum of Contemporary Art, Chicago, IL
Marieluise Hessel Collection at CCS Bard, Annandale-On-Hudson, NY
Migros Museum für Gegenwartskunst, Zürich, Switzerland
Mildred Lane Kemper Art Museum, St. Louis, MO
The Montreal Museum of Fine Arts, Montreal, Québec
Museé d'art contemporain de Montréal, Québec, Canada
Museum of Modern Art, New York, NY
National Museum of Modern and Contemporary Art, Korea
Neuer Berliner Kunstverein, Berlin, Germany
Pinakothek der Moderne, Munich, Germany
Pinault Collection, Genéve, Switzerland
Portland Art Museum, Portland, Oregon
The Reina Sofía Museum, Madrid, Spain
Staatliche Kunstssammlungen Dresden, Dresen, Germany
San José Museum of Art, San José, CA
Serralves Museum, Portospi, Portugal
Solomon R. Guggenheim Museum, New York, NY
Stedelijk Museum Amsterdam, Netherlands
Tate Modern, London, UK
Ulsan Art Museum, Korea
Van Abbemuseum, Eindhoven, Netherlands
Walker Arts Center, Minneapolis, MN
Williams College Museum of Art, Williamstown, MA

단행본
BOOKS WRITTEN BY THE ARTIST

- *Spricht die Subalterne deutsch? Migration und postkoloniale Kritik*, ed. by H. Steyerl with E. Guti.rrez Rodr.guez, Münster: Unrast, 2003.
- *Die Farbe der Wahrheit. Dokumentarismen im Kunstfeld*, Vienna: Turia + Kant, 2008.
- *The Greenroom: Reconsidering the Documentary and Contemporary Art #1*, ed. by H. Steyerl with M. Lind, New York: CCS Bard College and Berlin: Sternberg Press, 2008.
- *The Wretched of the Screen (e-flux Journal series)*, ed. by J. Aranda, B. Kuan Wood, and A. Vidokle, Berlin: Sternberg Press, 2012.
- *Hito Steyerl. Jenseits der Repräsentation / Beyond Representation. Essays 1999-2009*, ed. by M. Babias, Cologne: K.nig, 2016.
- *Duty Free Art. Art in the Age of Planetary Civil War*, London and New York: Verso, 2017.

논문
ARTICLES, ESSAYS, AND INTERVIEWS BY THE ARTIST

- "Eliminatorischer Exotismus. Besserweissi: fuck off," *Zweite Hilfe, Hysterieblatt für die absteigenden Mittelschichten*, Spring 1997, pp. 37-39.
- "Barbarische Kollektive. 12. Internationales Dokumentarfilmfest München: Kulturfilme und ihre Kundschaft," *Dritte Hilfe. Hysterieblatt für die absteigenden Mittelschichten*, Summer 1997, pp. 46-49.
- Intellektuelle Migrantinnen. Subjektivit.ten im Zeitalter von Globalisierung," *Springerin*, vol. 5, no. 4, December 1999 - February 2000, p. 76.
- "Lacrimosa. 'Dark Matters'—Shaheen Meralis Tableaus rassisticher Verh. ltnisse," *Springerin*, vol. 6, no. 1, April-June 2000, pp. 22-23.
- "Visual Culture: Tourist Industry. Zeitgen.ssiche Kunst aus Thailand (Forum Stadtpark Graz)," *Springerin*, vol. 6, no. 3, October-December 2000, pp. 67-68.
- "Kultur und Verbrechen / Culture and Crime," *Transversal*, January 2001, http://eipcp.net/transversal/0101/steyerl/de

- "Multikulti, Lenin Style. Auf Messers Schneide: Inter-Nationalismus," *Transversal*, June 2001, http://eipcp.net/transversal/0601/steyerl/de
- "Europas Traum. Ein Dokumentarfilmprojekt," *Springerin*, vol. 7, no. 2, June-September 2001, pp. 48-51.
- "Can be Subalterne Speak German? Postkoloniale Kritik," *republicart*, May 2002, http://www.republicart.net/disc/hybridresistance/steyerl01_de.htm
- "Die Artikulation des Protestas / The Articulation of the Protest," *republicart*, September 2002, http://www.republicart.net/disc/mundial/steyerl02_de.htm
- "Dokumentarismus als Politik der Wahreit / Documentarism as Politics of Truth," *republicart*, May 2003, http://www.republicart.net/disc/representations/steyerl03_de.htm
- "Das Babelfights-Syndrom. Kinoki Lumai," *republicart*, May 2003, http://republicart.net/disc/representations/steyerl04.de.htm
- "Spiegelverkehrtes Gedenken," *Springerin*, vol. 9, no. 2, Summer 2003, pp. 36-37.
- "Politik der Wahreit. Dokumetatismen im Kunstfeld," *Springerin*, vol. 9, no. 3, Fall 2003, pp. 18-23.
- "The Empty Center," in *Stuff It. The Video Essay in the Digital Age*, ed. by U. Biemann, Zürich: Edition Voldemeer and Vienna and New York: Springer, 2003, pp. 46-53.
- "Euroscopes: ∞," in *komplex Berlin / complex Berlin, 3. Berlin Biennale für zeitgenössische Kunst / 3rd Berlin Biennale for Contemporary Art /*, ed. by U. M. Bauer, Cologne: K.nig, 2004, pp. 190-204.
- "Gaps and Potentials. The Exhibition 'Heimat Kunst' - Migrant Culture as an Allegory of the Global Market," *New German Critique*, no. 92, Spring-Summer 2004, pp. 200-1.
- "November: A Film Treatment.," *Transit. A Journal for Travel, Migration, and Multiculturalism in the German-speaking World*, vol. 1, 2005, n.p.
- "Freedom from Everything. Freelancers and Mercenaries," *e-flux journal*, no. 41, January 2013, https://www.e-flux.com/journal/41/60229/freedom-fromeverythingfreelancers-andmercenaries/

- "International Disco Latin," *e-flux journal*, no. 45, May 2013, https://www.e-flux.co/journal/45/60100/internationaldiscolatin/
- "Walking Through Screens. Images in Transition," in *What Is a Photograph?*, exh. cat., ed. by C. Squiers (International Center of Photography, New York, January 31-May 4, 2014), New York: International Center of Photography and Munich, London, and New York: DelMonico Books-Prestel, 2013, pp. 70-75.
- "Too Much World: Is the Internet Dead?," *e-flux journal*, no. 49, November 2013, https://www.e-flux.com/journal/49/60004/too-much-world-istheinternet-dead/
- "Theodor W. Adorno. Timeline," in *Hito Steyerl. Circulaciosnimo / Circulationism*, exh. cat., ed. by A. de la Garza and C. Medica (MUAC Museo Universitario de Arte Contempor.neo, UNAM Universidad Nacional Aut.noma de M.xico, Mexico City, September 27, 2014-March 1, 2015), Mexico City: Museo Universitario Arte Contempor.neo, Universidad Nacional Aut.noma de M.xico, 2014, pp. 52-62.
- "Koban. Is Not Falling," *e-flux journal*, October 10, 2014, https://www.e-flux.com/announcements/30525/koban-isnotfalling/
- "Beginnings," *e-flux journal*, no. 59, November 2014, https://www.e-flux.com/journal/59/61140/beginnings/
- "Proxy Poltics. Signal and Noise," *e-flux journal*, no. 60, December 2014, https://www.e-flux.com/journal/60/61045/proxy-politics-signal-and-noise/
- "Duty-Free Art," *e-flux journal*, no. 63, March 2015, https://www.e-flux.com/journal/63/60894/duty-free-art/
- "Medya: Autonomy of Images," in *Astro Noise. A Survival Guide for Living Under Total Surveillance*, ed. by L. Poitras, New York: Whitney Museum of American Art, 2016, pp. 162-76.
- "A Tank on a Pedestal: Museums in an Age of Planetary Civil War," *e-flux journal*, no. 70, February 2016, https://www.e-flux.com/journal/70/60543/a-tank-on-apedestalmuseums-in-an-age-ofplanetarycivil-war/

- "A Sea of Data: Apophenia and Pattern (Mis-)Recognition," *e-flux journal*, no. 72, April 2016, https://www.e-flux.com/journal/72/60480/a-sea-of-dataapopheniaand-pattern-mis-recognition/
- "If You Don't Have Bread, Eat Art! Contemporary Art and Derivative Fascisms," *e-flux journal*, no. 76, October 2016, https://www.e-flux.com/journal/76/69732/if-you-don-t-havebreadeat-art-contemporary-art-andderivativefascisms/
- "How To Kill People: A Problem of Design," *e-flux journal*, December 16, 2016, https://www.e-flux.com/architecture/superhumanity/68653/how-to-killpeoplea-problem-of-design/
- "Why Games, Or, Can Art Workers Think?," *New Left Review*, no. 103, January-February 2017, n.p.
- "Editorial-'Strange Universalism'," with J. Aranda, B. Kuan Wood, S. Squibb, and A. Vidokle, *e-flux journal*, no. 86, November 2017, https://www.e-flux.com/journal/86/162860/editorialstrangeuniversalism/
- "I Don't Have Time!," with … akar and Rojava Film Commune, *e-flux journal*, no. 86, November 2017, https://www.e-flux.com/journal/86/162859/ i-don-t-havetime/
- "The Color of Women: An Interview with YPJ Commanders Dilovan Kobani, Nirvana, Ruken, and Zerin," with Rojava Film Commune, *e-flux journal*, no. 86, November 2017, https://www.e-flux.com/journal/86/160968/the-color-ofwomenan-interview-with-ypjcommandersdilovan-kobani-nirvanarukenand-zerin/

작가와의 대화, 인터뷰
INTERVIEWS AND CONVERSATIONS WITH THE ARTIST

- F. Boenzi, "Do You Speak Spamsoc? Hito Steyerl," *Mousse*, no. 23, April-May 2010, pp. 60-66.
- T. S. Iversen, "Ti sp.rsm.l: Hito Steyerl," *Kunstkritikk*, May 20, 2010, http://www.kunstkritikk.no/artikler/tisp%C3%B8rsmal-hito-steyerl/

- F. Heiser, "Analyze This. A round table discussion led by F.rg Heiser on 'superhybridity': what is it and should we be worried? With Ronald Fones, Nina Power, Seth Price, Sukhdev Sandhu and Hito Steyerl," *Frieze*, no. 133, September 2010, pp. 94-102.
- H. Farocki and H. Steyerl, Cahier #2: *A Magical Imitation of Reality*, Milan: Kaleidoscope Press, 2011, e-book.
- H. Steyerl and D. Olivieri, "Shattered Images and Desiring Matter. A Dialogue between Hito Steyerl and Domitilla Olivieri," in *Carnal Aesthetics: Transgressive Imagery and Feminist Politics*, ed. by B. Papenburg and P. Magagnoli, London: I. B. Tauris, 2012, pp. 214-25.
- D. Rourke, "Artifacts: A Conversation Between Hito Steyerl and Daniel Rourke," *Rhizome*, March 28, 2013, http://rhizome.org/editorial/2013/mar/28/artifacts/
- "Questionnaire," *Frieze*, no. 159, November-December 2013, p. 176.
- R. Curtis and A. Fenner, "If People Want to oppress You They Make You Say I," in *The Autobiographical Turn in Germanophone Documentary and Autobiographical Film*, ed. by R. Curtis and A. Fenner, Rochester: Camden House Press, 2014, pp. 37-51.
- T. Keenan, "What Is a Document? An exchange between Thomas Keenan and Hito Steyerl," *Aperture*, no. 214, Spring 2014, pp. 58-65.
- J. Thatcher, "No Solution," *Art Monthly*, no. 375, April 2014, pp. 1-4.
- *La Fabrique des images / The Image Factory*, exh. brochure, ed. by SBC galerie d'art contemporain (SBC galerie d'art contemporain, Montreal, February 28-May 11, 2013), Montreal, 2013 (text by I. Emmelheinz), https://docs.wixstatic.com/ugd/2b2fa6 _64a63c1f4c 2644a68823780fb9d5ac12.pdf
- *Guards*, exh. brochure, ed. by Svilova (Svilova, Gothenburg, November 13-December 15, 2013), Gothenburg, 2013 (text by A. Shental), http://svilova.org/wp-content/uploads/2013/11/Hito_Steyerl_Svilova.pdf

- *Too Much World. The Films of Hito Steyerl*, exh. cat., ed. by N. Aikens, (Van Abbemuseum, Eindhoven, April 12-June 22, 2014, curated by A. Fletcher and The Institute of Modern Art, Brisbane, December 13-March 21, 2015, curated by A. A. Burns and J. Lundh, in association with A. Fletcher), Berlin: Stenberg Press, 2014 (texts by N. Aikens, A. Fletcher, S. Lütticken et al., text by the artist: "Too Much World: Is the Internet Dead?" pp. 29-40).
- *Hito Steyerl. Circulacionismo*, exh. cat., ed. by A. de la Garza and C. Medica (MUAC Museo Universitario de Arte Contempor.neo, UNAM Universidad Nacional Aut.noma de M.xico, Mexico City, September 27, 2014-March 1, 2015), Mexico City: UNAM Universidad Nacional Aut.noma de M.xico, 2014 (texts by B. K. Wood, texts by the artist: "Too Much World: Is the Internet Dead?," pp. 28-39 and "Theodor W. Adorno. Timeline" pp. 52-63).
- *Hito Steyerl. Left To Our Own Devices*, exh. brochure, ed. by A. Koch (KOW, Berlin, September 17-December 5, 2015), Berlin, 2015 (text by A. Koch), https://kow-berlin.com/site/assets/files/1485/hito_steyerl_kow_2015.pdf
- *Hito Steyerl. Duty-Free Art*, exh. cat., ed. by J. Fernandes (Museo Nacional Centro de Arte Reina Sof.a, Madrid, November 11, 2015-March 21, 2016), Madrid: Museo Nacional Centro de Arte Reina Sof.a, 2015 (text by C. Guerra, with an interview with the artist by J. Fernandes pp. 157-70).
- *Hito Steyerl. Factory The Sun*, exh. cat., ed. by H. Bretton-Meyer (Kunsthal Charlottenborg, Copenhagen, December 8, 2016-February 19, 2017), Copenhagen: Billedkunstskolernes Forlag, 2016 (texts by H. Bretton-Meyer & M. Thouber and F. Ahm Krag, text by the artist: "Why Games?" pp. 50-59).
- *Martha Rosler, Hito Steyerl. War Games*, exh. brochure, ed. by Kunstmuseum Basel (Kunstmuseum Basel, Basel, May 5-December 2, 2018), Basel, 2018.

전시 도록, 출판물
EXHIBITION CATALOGUES AND PUBLICATIONS

- *44. Internationale Kurzfilmtage Oberhausen*, exh. cat., ed. by Internationale Kurzfilmtage Oberhausen (Lichtburg Filmpalast, Oberhausen, April 23-28, 1998), Oberhausen: Karl Maria Laufen, 1998 (texts by J. TuDoberstein, A. M. Lippit, J. Marchessault et al., text on the artist p. 52).
- *Update 2.0 Medien Kunst Aktuell aus Deutschland / Current Media Art from Germany*, exh. cat., ed. by R. Frieling (Gallery K&S, Berlin, March 10-April 15, 2000), Karlsruhe: ZKM Zentrum für Kunst und Medientechnologie, 2000 (texts by R. Frieling, I. Arns, M. Kwella et al., text on the artist by R. W. Wolf pp. 104-5).
- *46. Internationale Kurzfilmtage Oberhausen*, exh. cat., ed. by Internationale Kurzfilmtage Oberhausen (Lichtburg Filmpalast, Oberhausen, April 23-28, 2000), Oberhausen: Karl Maria Laufen, 2000 (texts by M. Gržinić, J. Richardson, S. Kovats, G. Aleinikov, S. Žižek et al., text on the artist p. 46).
- *Du bist die Welt*, exh. brochure, ed. by Wiener Festwochen (various venues, Vienna, June 1-24, 2001), Vienna, 2001 (texts by H. V.lkers, A. Horwath, K. Klingan, H. Saxenhuber, G. Sch.llhammer, and H. V.lkers, texts on the artist pp. 19, 89).
- *48th Internationale Kurzfilmtage Oberhausen*, exh. cat., ed. by Internationale Kurzfilmtage Oberhausen (Lichtburg Filmpalast, Oberhausen, May 2-7, 2002), Oberhausen: Karl Maria Laufen, 2002 (texts by F. Wüst, M. Thiele, U. Biemann et al., text on the artist p. 127).
- *ABCity*, exh. cat., ed. by A. Fogaras (Traf. Gal.ria, Budapest, October 16-November 16, 2003), Budapest: Traf. Gal.ria, 2003.
- *Taipei Biennial 2010*, online exh. cat., ed. by Taipei Fine Arts Museum (Taipei Fine Arts Museum, Taipei, September 7-November 14, 2010), https://www.taipeibiennial.org/2010/pdf/10TB_Taipei_Biennial_guidebook_English.pdf (texts by H. Lin and T. Zolghadr).

- *CPH:DOX 2010—International Documentary Film Festival*, online exh. cat., ed. by M. Bacher and M. Mikkelsen (various venues, Copenhagen, November 4-14, 2010), https://issuu.com/andreascph/docs/cphdox_int
- *Serious Games. Krieg—Medien—Kunst / War—Media—Art*, exh. cat., ed. by R. Beil and A. Ehmann (Institut Mathildenh.he Darmstadt, Darmstadt, March 27-July 24, 2011), Ostfildern: Hatje Cantz Verlag, 2011 (texts by R. Beil, A. Ehmann, P. Bürger et al., text on the artist p. 153).
- *Seeing is Believing*, exh. brochure, ed. by S. Pfeffer (KW Institute for Contemporary Art, Berlin, September 11-November 13, 2011), Berlin: KW Institute for Contemporary Art, 2011 (texts by A. Bitterwolf, S. Neuman, L. Radine et al.).
- *The Global Contemporary and the Rise of New Art Worlds*, exh. cat., ed. by H. Belting, A. Buddensieg, and P. Weibel (ZKM Zentrum für Kunst und Medientechnologie, Karlsruhe, September 17, 2011-February 5, 2012), Karlsruhe: ZKM Zentrum für Kunst und Medientechnologie; Cambridge (MA) and London: The MIT Press, 2013 (texts by P. Weibel, H. Belting, A. Buddensieg et al., text on the artist by S. Giannini p. 337).
- *Mengele's Skull. The Advent of a Forensic Aesthetics*, exh. cat., ed. by N. Hirsch (Portikus, Frankfurt am Main, February 4-May 6, 2012), Berlin: Sternberg Press, 2012 (text by T. Keenan & E. Weizman).
- *Between Walls and Windows. Architektur und Ideologie*, exh. cat., ed. by V. Smith (Haus der Kulturen der Welt, Berlin, September 1-30, 2012), Ostfildern: Hatje Cantz Verlag, 2012 (texts by V. Smith, A. Stifter, L. Shaw et al.).
- *Former West: Documents, Constellations, Prospects*, exh. brochure, ed. by J. Armin (Haus der Kulturen der Welt, Berlin, March 18-24, 2013), Utrecht: BAK basis voor actuele kunst and Berlin: Haus der Kulturen der Welt, 2013 (texts by M. Hlavajova, B. Groys, F. Bifo Berardi et al., text by the artist: "I Dreamed a Dream: Politics in the Age of Mass Art Production" pp. 26-27).

- *Disobedience Archive (The Republic)*, exh. magazine, ed. by Castello di Rivoli Museo d'Arte Contemporanea (Castello di Rivoli Museo d'Arte Contemporanea, Rivoli-Turin, April 23-June 30, 2013), Rivoli-Turin, 2013 (text by M. Scotini).
- *59. Internationale Kurzfilmtage Oberhausen*, exh. cat., ed. by Internationale Kurzfilmtage Oberhausen (Lichtburg Filmpalast, Oberhausen, May 2-7, 2013), Oberhausen: Karl Maria Laufen, 2013 (texts by S. Khanna, A. Hamilton, E. Atkins et al., text on the artist by M. Gray p. 222).
- *ReCoCo–Life Under Representational Regimes*, exh. cat., ed. by S. Peyer and J. Simon (Bat Yam Museums of Contemporary art, Bat Yam, May 3-August 3, 2013), Bat Yam: MoBY–Museums of Bat Yam, 2013 (texts by J. Simon, S. Peyer, J. Dean et al.).
- *A Different Kind of Order: The ICP Triennial*, exh. cat., ed. by International Center of Photography (International Center of Photography, New York, May 17-September 8, 2013), New York: International Center of Photography and Munich, London & New York: DelMonico Books–Prestel, 2013 (texts by J. Lehan, K. Lubben, C. Phillips et al., text on the artist by M. Ewing p. 170).
- *55. Esposizione Internazionale d'Arte–La Biennale di Venezia. Il Palazzo Enciclopedico*, exh. cat., ed. by N. Beil and M. Gioni (Giardini della Biennale, Arsenale and other venues, Venice, June 1-November 24, 2013), Venice: Marsilio Editori, 2013 (texts by M. Gioni, W. N. West, L. Bolzoni et al.).
- *Little Movements II. Self-practice in Contemporary Art*, exh. cat., ed. by C. Yinghua Lu, L. Ding, and Museion (Museion, Bolzano, June 29-November 3, 2013), Cologne: K.nig, 2013 (texts by L. Ding & C. Yinghua Lu and H. Yapp).
- *The Field is to the Sky, Only Backwards*, online exh. cat., ed. by A. Szyłak (International Studio & Curatorial Program, New York, September 4-October 18, 2013), https://oerum.org/static/images/ TheFieldIsToTheSkyOnlyBackwards/ FieldistotheSky_Catalogue.pdf (text by A. Szyłak)
- *Mom, Am I Barbarian? 13th Istanbul Biennial*, exh. cat., ed. by F. Erdemci (Antrepo no. 3, Galata Greek Primary School, ARTER, and other venues, Istanbul, September 14-October 20, 2013), Istanbul: Istanbul Foundation for Culture and Arts, 2013 (texts by A. L. Cuenca, A. Phillips, D. Hind et al.).
- *Art Post-Internet*, online exh. cat., ed. by K. Archey and R. Peckham (UCCA–Ullens Center for Contemporary Art, Beijing, March 1 - May 11, 2014), http://post-inter.net/ (texts by K. Archey and R. Peckham)
- *Bad Thoughts. Collection Martijn and Jeannette Sanders*, exh. cat., ed. by M. van Nieuwenhuyzen and M. C. van Bracht (Stedelijk Museum, Amsterdam, July 20, 2014-January 10, 2015), Amsterdam: Stedelijk Museum, 2014 (texts by M. van Nieuwenhuyzen and J. Sanders).
- *Blue Times*, exh. brochure, ed. by Kunsthalle Wien (Kunsthalle Wien, Vienna, October 1, 2014-January 11, 2015), Vienna, 2014.
- *Unreliabe Evidence*, exh. magazine, ed. by F. Venables (Mead Gallery, Warwick Arts Center, Coventry, October 4-December 6, 2014), Coventry: Mead Gallery, 2014 (texts by F. Venables, S. Pinches, L. Tuymans et al., text on the artist by P. Lafuente pp. 19-21).
- *Digital Conditions*, exh. brochure, ed. by Hannover Kunstverein (Hannover Kunstverein, Hannover, March 14-May 25, 2015), Hannover, 2015.
- *Fabrik*, exh. cat., ed. by F. Ebner (German Pavilion at the 56th International Art Exhibition–Venice Biennale, Giardini della Biennale, Venice, May 9-November 22, 2015), Cologne: K.nig, 2015 (texts by F. Ebner, T. Holert, S. Rifky et al., text on the artist by D. Riff pp. 163-99).
- *Art in the Age of the Internet, 1989 to Today*, exh. cat., ed. by E. Respini (The Institute of Contemporary Art, Boston, February 7-May 20, 2018), New Haven and London: Yale University Press, 2018 (texts by E. Respini, C. A. Jones, G. Sutton et al., conversation with the artist pp. 148-51).
- *Hito Steyerl: The City of Broken Windows*, exh. cat., (Castello de Rivoli, November 1, 2018-June 30, 2019), Skira, 2018, (texts by H.Steyerl, M. Babias, J. Aranda et al.,).
- *Power Plants*, exh. cat., ed. by M. Larner (Serpentine Galleries, London, April 11 - May 6, 2019), Serpentine Galleries, London, 2019 (texts by A. Gad, E. Graham, E. Jager, et al.,).
- *Hito Steyerl: This is the Future*, exh. cat., ed. By A. Vlas (Art Gallery of Ontario, Ontario, October 24, 2019-February 23, 2020), Art Gallery of Ontario, 2020 (texts by W Hui Kyong Chun, B. Droitcour, A. Vlas).
- *Hito Steyerl: I will survive*, ed. by F. Ebner, D. Krystof, and M. Lista, Leipzig: Spector Books, 2020

주요 매체 기고
SELECTED ARTICLES IN MAGAZINES AND NEWSPAPERS

- I. Reicher, "Streifenweise," *Falter*, no. 41, October 7, 1998, n.p.
- J. Becker, "Hito Steyerl: 'Die leere Mitte'," *Springerin*, no. 4, December 1998-February 1999, n.p.
- A. Kaneko, "Amsterdam Doc Fest Strong in Euro-Product, Awards 'Photographer'," *IndieWire*, January 7, 1999, https://www. indiewire.com/1999/01/amsterdam-docfeststrong-in-euro-product-awardsphotographer-82419/
- H. Kersten, "Mit Anti-Haider-Effekt," *Neues Deutschland*, March 29, 2001, p. 14.
- F. Camper, "Strategies of the Short Contemporary German Film and Video Art," *Chicago Reader*, March 7, 2003, https:// www.chicagoreader.com/ chicago/strategies-of-the-short-contemporarygermanfilm-and-video-art/Film?oid=1073029
- J. Kantor, "Manifesta 5," *Artforum International*, vol. 43, no. 1, September 2004, p. 259.
- M. Bracewell, "Molotov Cocktails," *Frieze*, no. 87, November-December 2004, pp. 94-97.
- T. W.lchili, "Ethnic Marketing," *Bidoun*, no. 23, 2005, n.p.
- B. MacAdam, "The Venice Biennale and Documenta 12 Provide a Thoughtful Take on the Shock of the News," *Art News*, vol. 106, no. 8, September

2007, pp. 146-47.

- T. J. Demos, "Traveling Images. On the Art of Hito Steyerl," *Artforum International*, vol. 46, no. 10, Summer 2008, pp. 408-13, 473.
- P. Lafuente, "In Praise of Populism," *Afterall*, no. 19, Autumn-Winter 2008, pp. 65-70.
- K. Stakemeier, "Minor Findings and Major Tendencies," *Afterall*, no. 19, Autumn-Winter 2008, pp. 55-63.
- J. Lack, "Artist of the Week: Hito Steyerl," *The Guardian*, December 31, 2008, https://www.theguardian.com/culture/2008/dec/30/contemporary-artist-hito-steyerlnewwave
- W. Kaizen, "The Greenroom: Reconsidering the Documentary and Contemporary Art," *Artforum International*, vol. 47, no. 7, March 2009, p. 239.
- A. Altman, "Hito Steyerl. Neuer Berliner Kunstverein," *Frieze*, no. 127, November-December 2009, p. 135.
- S. Hudson, "The Storyteller," *Artforum International*, vol. 48, no. 10, Summer 2010, pp. 356-57.
- M. Herbert, "Hito Steyerl at Chisenhale," *Time Out London*, November 25, 2010, https://www.timeout.com/london/art/hitosteyerl
- R. de Blaaij, "Hito Steyerl. Journal No. 1 & In Free Fall," *Metropolis M*, no. 2, 2011, pp. 97-98.
- K. Stakemeier, "Plane destructive: the recent films of Hito Steyerl," *Mute*, February 23, 2011, http://www.metamute.org/editorial/articles/plane-destructiverecentfilms-hito-steyerl#
- A. Kleiman, "Hito Steyerl. 'Adorno's Grey'," *Art Agenda*, November 11, 2012, http://www.art-agenda.com/reviews/hito-steyerl%E2%80%99s-%E2%80%9Cadorno%E2%80%99sgrey%E2%80%9D/
- A. Picard, "Flat Feat," *Artforum International*, May 15, 2013, https://www.artforum.com/film/andrea-picard-at-the-59th-international-short-film-festivaloberhausen-40986
- A. Alessi, "How Not to Be Eaten By An Outof-Focus Monster: A Fucking Didactic Educational Exhibition Review," *ArtSlant*, April 25, 2014, https://www.artslant.com/sp/articles/show/39376
- P. Pieroni, "Hito Steyerl," *ArtReview*, vol. 66, no. 5, Summer 2014, pp. 98-103.

- R. Smith, "Hito Steyerl: 'How Not to Be Seen'," *The New York Times*, July 17, 2014, https://www.nytimes.com/2014/07/18/arts/design/hito-steyerl-how-not-to-beseen.Html
- M. A. Yildiz, "When will I see you again, Hito?," *Revue. Magazine for the Next Society*, no. 16, Winter 2014, pp. 82-91.
- H. Ghorashi, "Hito Steyerl Wins the First EYE Prize," *Artnews*, April 2, 2015, http://www.artnews.com/2015/04/02/hitosteyerlwins-the-first-eye-prize/
- W. Grimes, "Distint Prisms in an Ever-Shifting Kalaidescope, *The New York Times*, April 16, 2015, https://www.nytimes.com/2015/04/17/arts/design/distinctprisms-in-an-ever-shifting-kaleidoscope.html
- M. Blum, "Weather Report: Hito Steyerl's Documentary Forecast for the Digital Age," *Hyperallergic*, May 19, 2015, https://hyperallergic.com/208096/weather-report-hitosteyerls-documentary-forecast-for-the-digital-age/
- E. Halter, "After Effects," *Parkette*, Vol. 97-2015, pp. 152-167.
- A. Schriber, "Hito Steyerl: Artists Space," *Art in America*, May 2015, p. 157.
- H. Judah, "Hito Steyerl Questions the Primacy of Art Conservation at a Conference on Media Art," *Artnet*, November 20, 2015, https://news.artnet.com/art-world/hito-steyerl-tate-modernartconservation-367586
- R. Stange, "Hito Steyerl Left To Our Own Devices," *ArtReview*, vol. 67, no. 9, December 2015, p. 113.
- E. Halter, "Hito Steyerl. After Effects," *Parkett*, no. 97, December 2015, pp. 152-60.
- B. Droitcour, "Hito Steyerl. Skimming Her," *Parkett*, no. 97, December 2015, pp. 168-73.
- L. Stupart, "Living Image, Fealing Dead: Hito Steyerl in Hito Steyerl," *Parkett*, no. 97, December 2015, pp. 182-87.
- R. Embuscado, "Women Are Taking Over This Year's 'Seven on Seven' Conference. It's an all-star ensemble," *Artnet*, April 12, 2016, https://news.artnet.com/art-world/seven-on-seven-artists-2016-471623

- N. Linnert, "All Access Politics: Reality and Spectatorship in Two Film Installations by Jean-Luc Godard and Hito Steyerl," *XX-TRA*, vol. 19, no. 3, Spring 2017, n.p. "1. Hito Steyerl," *ArtReview*, vol. 69, no. 8, November 2017, pp. 102.
- K. Bradley, "An Artist with Power Uses It for Change," *The New York Times*, December 17, 2017, n.p.
- C. Wyma, "Hito Steyerl's Duty Free Art," *The Brooklyn Rail*, February 2018, n.p.
- L. E. Bloom, "Martha Rosler and Hito Steyerl: War Games," *The Brooklyn Rail*, September 2018, n.p.
- H. Judah, "Hito Steyerl: the Serpentine's Sackler gallery should be unnamed," *The Guardian*, April 12, 2019, theguardian.com/artanddesign/2019/apr/12/hito-steyerl-serpentinesackler-building-should-be-unnamed
- J. Farago, "In 'Drill,' Hito Steyerl Adds Polish To Images of a World Gone Mad," *The New York Times*, July 2019, https://www.nytimes.com/2019/07/05/arts/design/hito-steyerldrill-armory.html
- F. Ebner, M. Lista, "Hito Steyerl in plain sight," *Artpress*, July 2019.
- O. C. Yerebakan, "HITO STEYERL with Osman Can Yerebakan," *The Brooklyn Rail*, July/August 2019, https://brooklynrail.org/2019/07/art/HITO-STEYERL-with-Osman-Can-Yerebakan
- N. Segal, "Prediction in the Era of Digital Stupidity: Hito Steyerl," *Flash Art*, April 2021, https://flash--art.com/article/hito-steyerl/
- J. Farago, "An Onscreen Chat With Hito Steyerl, Art's Great Screen Skeptic," *The New York Times*, June 9, 2021, https://www.nytimes.com/2021/06/09/arts/design/hito-steyerlpompidou.html

PP.42-53
미션 완료: 벨란시지
MISSION ACCOMPLISHED: BELANCIEGE

PP.43-51
〈미션 완료: 벨란시지〉, 2019
· 3채널 HD 비디오, 컬러, 사운드,
 47분 23초
· 《히토 슈타이얼-데이터의 바다》 전시 전경,
 국립현대미술관, 서울, 2022
· 국립현대미술관 사진 제공
· 사진: 홍철기

MISSION ACCOMPLISHED: BELANCIEGE,
2019
· THREE-CHANNEL HD VIDEO, COLOR,
 SOUND, 47 MIN. 23 SEC.
· INSTALLATION VIEW OF *HITO STEYERL-*
 A SEA OF DATA, NATIONAL MUSEUM OF
 MODERN AND CONTEMPORARY ART, SEOUL
 (MMCA), 2022
· IMAGE COURTESY OF NATIONAL MUSEUM
 OF MODERN AND CONTEMPORARY ART,
 KOREA (MMCA)
· PHOTOGRAPHY BY HONG CHEOLKI
· COURTESY OF THE ARTIST, ANDREW
 KREPS GALLERY, NEW YORK AND ESTHER
 SCHIPPER, BERLIN

PP.52-53
〈미션 완료: 벨란시지〉, 2019
· 3채널 HD 비디오, 컬러, 사운드,
 47분 23초
· 이미지 CC 4.0 히토 슈타이얼
· 히토 슈타이얼, 조르지 가고 가고시츠,
 밀로스 트라킬로비치 제공

MISSION ACCOMPLISHED: BELANCIEGE,
2019
· THREE-CHANNEL HD VIDEO, COLOR,
 SOUND, 47 MIN. 23 SEC.
· IMAGE CC 4.0 HITO STEYERL
· IMAGE COURTESY OF THE ARTISTS

PP.54-69
소셜심
SOCIALSIM

PP.55-63
〈소셜심〉, 2020
· 단채널 비디오, 컬러, 사운드, 18분 19초,
 라이브 컴퓨터 시뮬레이션 댄싱 마니아,
 가변 시간
· 《히토 슈타이얼-데이터의 바다》 전시 전경,
 국립현대미술관, 서울, 2022
· 국립현대미술관 사진 제공
· 사진: 홍철기

SOCIALSIM, 2020
· SINGLE-CHANNEL HD VIDEO, COLOR,
 SOUND, 18 MIN. 19 SEC. LIVE
 COMPUTER SIMULATION *DANCING MANIA*,
 DURATION VARIABLE
· INSTALLATION VIEW OF *HITO STEYERL-*
 A SEA OF DATA, NATIONAL MUSEUM OF
 MODERN AND CONTEMPORARY ART, SEOUL
 (MMCA), 2022
· IMAGE COURTESY OF NATIONAL MUSEUM
 OF MODERN AND CONTEMPORARY ART,
 KOREA (MMCA)
· PHOTOGRAPHY BY HONG CHEOLKI
· COURTESY OF THE ARTIST, ANDREW
 KREPS GALLERY, NEW YORK AND ESTHER
 SCHIPPER, BERLIN

PP.64-67
〈소셜심〉, 2020
· 단채널 비디오, 컬러, 사운드, 18분 19초,
 라이브 컴퓨터 시뮬레이션 댄싱 마니아,
 가변 시간
· 《HITO STEYERL. I WILL SURVIVE》
 전시 전경, K21, 뒤셀도르프, 2020
· 작가, 앤드류 크랩스 갤러리, 뉴욕 및
 에스더 쉬퍼, 베를린 제공
· 사진: © ACHIM KUKULIES, DÜSSELDORF

SOCIALSIM, 2020
· SINGLE-CHANNEL HD VIDEO, COLOR,
 SOUND, 18 MIN. 19 SEC. LIVE
 COMPUTER SIMULATION *DANCING MANIA*,
 DURATION VARIABLE
· INSTALLATION VIEW OF *HITO STEYERL.*
 I WILL SURVIVE, K21, DÜSSELDORF,
 2020
· IMAGE COURTESY OF THE THE ARTIST,
 ANDREW KREPS GALLERY, NEW YORK AND
 ESTHER SCHIPPER, BERLIN
· PHOTOGRAPHY BY © ACHIM KUKULIES,
 DÜSSELDORF

PP.68-69
〈소셜심〉, 2020
· 단채널 비디오, 컬러, 사운드, 18분 19초,
 라이브 컴퓨터 시뮬레이션 댄싱 마니아,
 가변 시간
· 이미지 CC 4.0 히토 슈타이얼
· 작가, 앤드류 크랩스 갤러리, 뉴욕 및
 에스더 쉬퍼, 베를린 제공

SOCIALSIM, 2020
· SINGLE-CHANNEL HD VIDEO, COLOR,
 SOUND, 18 MIN. 19 SEC. LIVE
 COMPUTER SIMULATION *DANCING MANIA*,
 DURATION VARIABLE
· IMAGE CC 4.0 HITO STEYERL
· IMAGE COURTESY OF THE ARTIST,
 ANDREW KREPS GALLERY, NEW YORK AND
 ESTHER SCHIPPER, BERLIN

PP.70-83
태양의 공장
FACTORY OF THE SUN

PP.71-77
〈태양의 공장〉, 2015
· 단채널 HD 비디오 설치, 컬러, 사운드,
 발광 LED 그리드, 의자, 23분
· 《히토 슈타이얼-데이터의 바다》 전시 전경,
 국립현대미술관, 서울, 2022
· 국립현대미술관 사진 제공
· 사진: 홍철기

FACTORY OF THE SUN, 2015
· SINGLE-CHANNEL HD VIDEO, COLOR,
 SOUND, ENVIRONMENT, LUMINESCENT LED
 GRID, BEACH CHAIRS, 23 MIN.
· INSTALLATION VIEW OF *HITO STEYERL-
 A SEA OF DATA*, NATIONAL MUSEUM OF
 MODERN AND CONTEMPORARY ART, SEOUL
 (MMCA), 2022
· IMAGE COURTESY OF NATIONAL MUSEUM
 OF MODERN AND CONTEMPORARY ART,
 KOREA (MMCA)
· PHOTOGRAPHY BY HONG CHEOLKI
· COURTESY OF THE ARTIST, ANDREW
 KREPS GALLERY, NEW YORK AND ESTHER
 SCHIPPER, BERLIN

P.78
〈태양의 공장〉, 2015
· 단채널 HD 비디오 설치, 컬러, 사운드,
 발광 LED 그리드, 의자, 23분
· 《I WAS RAISED ON THE INTERNET》
 전시 전경, 시카고 현대미술관, 시카고,
 2018.6.23-10.14
· 작가, 앤드류 크랩스 갤러리,
 뉴욕 및 에스더 쉬퍼, 베를린 제공
· 사진: NATHAN KEAY, © MCA CHICAGO

FACTORY OF THE SUN, 2015
· SINGLE-CHANNEL HD VIDEO, COLOR,
 SOUND, ENVIRONMENT, LUMINESCENT LED
 GRID, BEACH CHAIRS, 23 MIN.
· INSTALLATION VIEW OF *I WAS RAISED
 ON THE INTERNET*, MCA CHICAGO,
 JUNE 23-OCTOBER 14, 2018
· IMAGE COURTESY OF THE ARTIST,
 ANDREW KREPS GALLERY, NEW YORK,
 AND ESTHER SCHIPPER, BERLIN
· PHOTOGRAPHY BY NATHAN KEAY,
 © MCA CHICAGO

P.78
〈태양의 공장〉, 2015
· 단채널 HD 비디오 설치, 컬러, 사운드,
 발광 LED 그리드, 의자, 23분
· 《HITO STEYERL: FACTORY OF THE SUN》
 전시 전경, 로스앤젤레스 현대미술관
 그랜드 애비뉴, 로스앤젤레스,
 2016.2.21-9.12
· 작가, 앤드류 크랩스 갤러리,
 뉴욕 및 에스더 쉬퍼, 베를린 제공
· 사진: JUSTIN LUBLINER

FACTORY OF THE SUN, 2015
· SINGLE-CHANNEL HD VIDEO, COLOR,
 SOUND, ENVIRONMENT, LUMINESCENT LED
 GRID, BEACH CHAIRS, 23 MIN.
· INSTALLATION VIEW OF *HITO STEYERL:
 FACTORY OF THE SUN*, MOCA GRAND
 AVENUE, LOS ANGELES, FEBRUARY 21-
 SEPTEMBER 12, 2016
· IMAGE COURTESY OF THE ARTIST,
 ANDREW KREPS GALLERY, NEW YORK, AND
 ESTHER SCHIPPER, BERLIN
· PHOTOGRAPHY BY JUSTIN LUBLINER

P.79
〈태양의 공장〉, 2015
· 단채널 HD 비디오 설치, 컬러, 사운드,
 발광 LED 그리드, 의자, 23분
· 《DREAMLANDS: IMMERSIVE CINEMA AND
 ART, 1905-2016》 전시 전경, 휘트니
 미술관, 뉴욕, 2016.10.28-2017.2.5
· 작가, 앤드류 크랩스 갤러리,
 뉴욕 및 에스더 쉬퍼, 베를린 제공

FACTORY OF THE SUN, 2015
· SINGLE-CHANNEL HD VIDEO, COLOR,
 SOUND, ENVIRONMENT, LUMINESCENT LED
 GRID, BEACH CHAIRS, 23 MIN.
· INSTALLATION VIEW OF *DREAMLANDS:
 IMMERSIVE CINEMA AND ART, 1905-
 2016*, WHITNEY MUSEUM OF AMERICAN
 ART, NEW YORK, OCTOBER 28, 2016-
 FEBRUARY 5, 2017
· IMAGE COURTESY OF THE ARTIST,
 ANDREW KREPS GALLERY, NEW YORK,
 AND ESTHER SCHIPPER, BERLIN

P.79
〈태양의 공장〉, 2015
· 단채널 HD 비디오 설치, 컬러, 사운드,
 발광 LED 그리드, 의자, 23분
· 베니스 비엔날레, 독일관 전시 전경, 2015
· 작가, 앤드류 크랩스 갤러리,
 뉴욕 및 에스더 쉬퍼, 베를린 제공
· 사진: MANUEL REINARTZ

FACTORY OF THE SUN, 2015
· SINGLE-CHANNEL HD VIDEO, COLOR,
 SOUND, ENVIRONMENT, LUMINESCENT LED
 GRID, BEACH CHAIRS, 23 MIN.
· INSTALLATION VIEW OF THE VENICE
 BIENNALE, GERMAN PAVILION, 2015
· IMAGE COURTESY OF THE ARTIST,
 ANDREW KREPS GALLERY, NEW YORK AND
 ESTHER SCHIPPER, BERLIN
· PHOTOGRAPHY BY MANUEL REINARTZ

PP.80-83
〈태양의 공장〉, 2015
· 단채널 HD 비디오 설치, 컬러, 사운드,
 발광 LED 그리드, 의자, 23분
· 이미지 CC 4.0 히토 슈타이얼
· 작가, 앤드류 크랩스 갤러리, 뉴욕 및
 에스더 쉬퍼, 베를린 제공

FACTORY OF THE SUN, 2015
- SINGLE-CHANNEL HD VIDEO, COLOR, SOUND, ENVIRONMENT, LUMINESCENT LED GRID, BEACH CHAIRS, 23 MIN.
- IMAGE CC 4.0 HITO STEYERL
- IMAGE COURTESY OF THE ARTIST, ANDREW KREPS GALLERY, NEW YORK AND ESTHER SCHIPPER, BERLIN

PP.84-99
야성적 충동
ANIMAL SPIRITS

PP.85-95
〈야성적 충동〉, 2022
- 단채널 HD 비디오, 컬러, 사운드, 24분, 라이브 컴퓨터 시뮬레이션, 가변 시간
- 《히토 슈타이얼-데이터의 바다》 전시 전경, 국립현대미술관, 서울, 2022
- 국립현대미술관 사진 제공
- 사진: 홍철기

ANIMAL SPIRITS, 2022
- SINGLE-CHANNEL HD VIDEO, COLOR, SOUND, 24 MIN. LIVE COMPUTER SIMULATION, DURATION VARIABLE
- INSTALLATION VIEW OF *HITO STEYERL-A SEA OF DATA*, NATIONAL MUSEUM OF MODERN AND CONTEMPORARY ART, SEOUL (MMCA), 2022
- IMAGE COURTESY OF NATIONAL MUSEUM OF MODERN AND CONTEMPORARY ART, KOREA (MMCA)
- PHOTOGRAPHY BY HONG CHEOLKI
- COURTESY OF THE ARTIST, ANDREW KREPS GALLERY, NEW YORK AND ESTHER SCHIPPER, BERLIN

PP.97-99
〈야성적 충동〉, 2022
- 단채널 HD 비디오, 컬러, 사운드, 24분, 라이브 컴퓨터 시뮬레이션, 가변 시간
- 이미지 CC 4.0 히토 슈타이얼
- 작가, 앤드류 크랩스 갤러리, 뉴욕 및 에스더 쉬퍼, 베를린 제공

ANIMAL SPIRITS, 2022
- SINGLE-CHANNEL HD VIDEO, COLOR, SOUND, 24 MIN. LIVE COMPUTER SIMULATION, DURATION VARIABLE
- IMAGE CC 4.0 HITO STEYERL
- IMAGE COURTESY OF THE ARTIST, ANDREW KREPS GALLERY, NEW YORK AND ESTHER SCHIPPER, BERLIN

PP.100-113
이것이 미래다
THIS IS THE FUTURE

PP.101-109
〈이것이 미래다〉, 2019
- 비디오 설치
〈이것이 미래다〉, 2019, 단채널 HD 비디오, 컬러, 사운드, 스마트 스크린, 16분
〈파워 플랜츠〉, 2019, 스테인리스스틸 비계 구조물, LED 패널, 다채널 비디오, 컬러, 무음, 반복 재생, LED 텍스트 패널, 텍스트 비디오, 컬러, 무음, 반복 재생, 가변 크기
- 울산시립미술관 소장
- 《히토 슈타이얼-데이터의 바다》 전시 전경, 국립현대미술관, 서울, 2022
- 국립현대미술관 사진 제공
- 사진: 홍철기

THIS IS THE FUTURE, 2019
- VIDEO INSTALLATION, ENVIRONMENT
THIS IS THE FUTURE, 2019, SINGLE-CHANNEL HD VIDEO, COLOR, SOUND, PROJECTED RETRO ON SMART FOIL SWITCHABLE OPACITY PROJECTION SCREEN, 16 MIN.
POWER PLANTS, 2019, STAINLESS STEEL SCAFFOLDING STRUCTURES, LED PANELS, MULTICHANNEL VIDEO LOOP, COLOR, SILENT, LOOP, LED TEXT PANELS, TEXT VIDEO, COLOR, MUTE, LOOP, DIMENSIONS VARIABLE
- ULSAN ART MUSEUM COLLECTION
- INSTALLATION VIEW OF *HITO STEYERL-A SEA OF DATA*, NATIONAL MUSEUM OF MODERN AND CONTEMPORARY ART, SEOUL (MMCA), 2022
- IMAGE COURTESY OF NATIONAL MUSEUM OF MODERN AND CONTEMPORARY ART, KOREA (MMCA)
- PHOTOGRAPHY BY HONG CHEOLKI
- COURTESY OF THE ARTIST, ANDREW KREPS GALLERY, NEW YORK AND ESTHER SCHIPPER, BERLIN

PP.110-111
〈이것이 미래다〉, 2019
- 비디오 설치
〈이것이 미래다〉, 2019, 단채널 HD 비디오, 컬러, 사운드, 스마트 스크린, 16분
〈파워 플랜츠〉, 2019, 스테인리스스틸 비계 구조물, LED 패널, 다채널 비디오, 컬러, 무음, 반복 재생, LED 텍스트 패널, 텍스트 비디오, 컬러, 무음, 반복 재생, 가변 크기
- 《MAY YOU LIVE IN INTERESTING TIMES》 전시 전경, 제58회 베니스 비엔날레, 2019
- 작가, 앤드류 크랩스 갤러리, 뉴욕 및 에스더 쉬퍼, 베를린 제공
- 사진: © ANDREA ROSSETTI

THIS IS THE FUTURE, 2019
- VIDEO INSTALLATION, ENVIRONMENT
THIS IS THE FUTURE, 2019, SINGLE-CHANNEL HD VIDEO, COLOR, SOUND, PROJECTED RETRO ON SMART FOIL SWITCHABLE OPACITY PROJECTION SCREEN, 16 MIN.
POWER PLANTS, 2019, STAINLESS STEEL SCAFFOLDING STRUCTURES, LED PANELS, MULTICHANNEL VIDEO LOOP, COLOR, SILENT, LOOP, LED TEXT PANELS, TEXT VIDEO, COLOR, MUTE, LOOP, DIMENSIONS VARIABLE
- INSTALLATION VIEW OF *MAY YOU LIVE IN INTERESTING TIMES*, 58TH VENICE BIENNALE, 2019
- IMAGE COURTESY OF THE ARTIST, ANDREW KREPS GALLERY, NEW YORK AND ESTHER SCHIPPER, BERLIN
- PHOTOGRAPHY BY © ANDREA ROSSETTI

PP.112-113
〈이것이 미래다〉, 2019
- 비디오 설치
〈이것이 미래다〉, 2019, 단채널 HD 비디오, 컬러, 사운드, 스마트 스크린, 16분
〈파워 플랜츠〉, 2019, 스테인리스스틸 비계 구조물, LED 패널, 다채널 비디오, 컬러, 무음, 반복 재생, LED 텍스트 패널, 텍스트 비디오, 컬러, 무음, 반복 재생, 가변 크기
- 이미지 CC 4.0 히토 슈타이얼
- 작가, 앤드류 크랩스 갤러리, 뉴욕 및 에스더 쉬퍼, 베를린 제공

THIS IS THE FUTURE, 2019
· VIDEO INSTALLATION, ENVIRONMENT
THIS IS THE FUTURE, 2019,
SINGLE-CHANNEL HD VIDEO, COLOR,
SOUND, PROJECTED RETRO ON SMART
FOIL SWITCHABLE OPACITY PROJECTION
SCREEN, 16 MIN.
POWER PLANTS, 2019, STAINLESS STEEL
SCAFFOLDING STRUCTURES, LED PANELS,
MULTICHANNEL VIDEO LOOP, COLOR,
SILENT, LOOP, LED TEXT PANELS,
TEXT VIDEO, COLOR, MUTE, LOOP,
DIMENSIONS VARIABLE
· IMAGE CC 4.0 HITO STEYERL
· IMAGE COURTESY OF THE ARTIST,
ANDREW KREPS GALLERY, NEW YORK AND
ESTHER SCHIPPER, BERLIN

PP.114-127
깨진 창문들의 도시
THE CITY OF BROKEN WINDOWS

PP.115-121
〈깨진 창문들의 도시〉, 2018
· 비디오 설치
〈깨진 창문들〉, 2018, 단채널 HD 비디오,
컬러, 사운드, 6분 40초
〈깨지지 않은 창문들〉, 2018, 단채널 HD
비디오, 컬러, 사운드, 10분
· 설치
채색된 나무 패널, 시트 레터링, 나무 이젤
· 《히토 슈타이얼-데이터의 바다》 전시 전경,
국립현대미술관, 서울, 2022
· 국립현대미술관 사진 제공
· 사진: 홍철기

THE CITY OF BROKEN WINDOWS, 2018
· VIDEO INSTALLATION, ENVIRONMENT
BROKEN WINDOWS, 2018, SINGLE-
CHANNEL HD VIDEO, COLOR, SOUND,
6 MIN. 40 SEC.
UNBROKEN WINDOWS, 2018, SINGLE-
CHANNEL HD VIDEO, COLOR, SOUND,
10 MIN.
· ENVIRONMENT
PAINTED PLYWOOD PANELS, VINYL
LETTERING, WOOD EASELS GL
· INSTALLATION VIEW OF *HITO STEYERL-
A SEA OF DATA*, NATIONAL MUSEUM OF
MODERN AND CONTEMPORARY ART, SEOUL
(MMCA), 2022

· IMAGE COURTESY OF NATIONAL MUSEUM
OF MODERN AND CONTEMPORARY ART,
KOREA (MMCA)
· PHOTOGRAPHY BY HONG CHEOLKI
· COURTESY OF THE ARTIST, ANDREW
KREPS GALLERY, NEW YORK AND ESTHER
SCHIPPER, BERLIN

PP.122-125
〈깨진 창문들의 도시〉, 2018
· 비디오 설치
〈깨진 창문들〉, 2018, 단채널 HD 비디오,
컬러, 사운드, 6분 40초
〈깨지지 않은 창문들〉, 2018, 단채널 HD
비디오, 컬러, 사운드, 10분
· 설치
채색된 나무 패널, 시트 레터링, 나무 이젤
· 카스텔로 디 리볼리 현대미술관 전시 전경,
토리노, 2018
· 작가, 앤드류 크랩스 갤러리, 뉴욕 및
에스더 쉬퍼, 베를린 제공
· 사진: ANTONIO MANISCALCO

THE CITY OF BROKEN WINDOWS, 2018
VIDEO INSTALLATION, ENVIRONMENT
BROKEN WINDOWS, 2018, SINGLE-
CHANNEL HD VIDEO, COLOR, SOUND,
6 MIN. 40 SEC.
UNBROKEN WINDOWS, 2018, SINGLE-
CHANNEL HD VIDEO, COLOR, SOUND,
10 MIN.
· ENVIRONMENT
PAINTED PLYWOOD PANELS, VINYL
LETTERING, WOOD EASELS GL
· INSTALLATION VIEW OF CASTELLO DI
RIVOLI, TURIN, 2018
· IMAGE COURTESY OF THE ARTIST,
ANDREW KREPS GALLERY, NEW YORK
AND ESTHER SCHIPPER, BERLIN
· PHOTOGRAPHY BY ANTONIO MANISCALCO

P.127
〈깨진 창문들의 도시〉, 2018
· 비디오 설치
〈깨진 창문들〉, 2018, 단채널 HD 비디오,
컬러, 사운드, 6분 40초
〈깨지지 않은 창문들〉, 2018, 단채널 HD
비디오, 컬러, 사운드, 10분
· 설치
채색된 나무 패널, 시트 레터링, 나무 이젤
· 이미지 CC 4.0 히토 슈타이얼
· 작가, 앤드류 크랩스 갤러리, 뉴욕 및
에스더 쉬퍼, 베를린 제공

THE CITY OF BROKEN WINDOWS, 2018
· VIDEO INSTALLATION, ENVIRONMENT
BROKEN WINDOWS, 2018, SINGLE-
CHANNEL HD VIDEO, COLOR, SOUND,
6 MIN. 40 SEC.
UNBROKEN WINDOWS, 2018, SINGLE-
CHANNEL HD VIDEO, COLOR, SOUND,
10 MIN.
· ENVIRONMENT
PAINTED PLYWOOD PANELS, VINYL
LETTERING, WOOD EASELS GL
· IMAGE CC 4.0 HITO STEYERL
· IMAGE COURTESY OF THE ARTIST,
ANDREW KREPS GALLERY, NEW YORK AND
ESTHER SCHIPPER, BERLIN

PP.186-199
**안 보여주기: 빌어먹게 유익하고
교육적인 .MOV 파일**
***HOW NOT TO BE SEEN: A FUCKING
DIDACTIC EDUCATIONAL .MOV FILE***

PP.187-195
〈안 보여주기: 빌어먹게 유익하고
교육적인 .MOV 파일〉, 2013
· 단채널 HD 디지털 비디오, 설치, 컬러,
사운드, 15분 52초
· 《히토 슈타이얼-데이터의 바다》 전시 전경,
국립현대미술관, 서울, 2022
· 국립현대미술관 사진 제공
· 사진: 홍철기

*HOW NOT TO BE SEEN: A FUCKING
DIDACTIC EDUCATIONAL .MOV FILE*, 2013
· SINGLE-CHANNEL HD DIGITAL VIDEO,
COLOR, SOUND IN ARCHITECTURAL
ENVIRONMENT, 15 MIN. 52 SEC.
· INSTALLATION VIEW OF *HITO STEYERL-
A SEA OF DATA*, NATIONAL MUSEUM OF
MODERN AND CONTEMPORARY ART, SEOUL
(MMCA), 2022
· IMAGE COURTESY OF NATIONAL MUSEUM
OF MODERN AND CONTEMPORARY ART,
KOREA (MMCA)
· PHOTOGRAPHY BY HONG CHEOLKI
· COURTESY OF THE ARTIST, ANDREW
KREPS GALLERY, NEW YORK AND ESTHER
SCHIPPER, BERLIN

PP.196-199
〈안 보여주기: 빌어먹게 유익하고
교육적인 .MOV 파일〉, 2013
· 단채널 HD 디지털 비디오, 설치, 컬러,
 사운드, 15분 52초
· 이미지 CC 4.0 히토 슈타이얼
· 작가, 앤드류 크랩스 갤러리, 뉴욕 및
 에스더 쉬퍼, 베를린 제공

HOW NOT TO BE SEEN: A FUCKING
DIDACTIC EDUCATIONAL .MOV FILE, 2013
· SINGLE-CHANNEL HD DIGITAL VIDEO,
 COLOR, SOUND IN ARCHITECTURAL
 ENVIRONMENT, 15 MIN. 52 SEC.
· IMAGE CC 4.0 HITO STEYERL
· IMAGE COURTESY OF THE ARTIST,
 ANDREW KREPS GALLERY, NEW YORK AND
 ESTHER SCHIPPER, BERLIN

PP.258-265
스트라이크
STRIKE

PP.259-261
〈스트라이크〉, 2010
· 단채널 HD 디지털 비디오, 컬러, 사운드,
 28초
· 《히토 슈타이얼-데이터의 바다》 전시 전경,
 국립현대미술관, 서울, 2022
· 국립현대미술관 사진 제공
· 사진: 홍철기

STRIKE, 2010
· SINGLE-CHANNEL HD DIGITAL VIDEO,
 COLOR, SOUND, FLAT SCREEN MOUNTED
 ON TWO FREE STANDING POLES, 28 SEC.
· INSTALLATION VIEW OF HITO STEYERL-
 A SEA OF DATA, NATIONAL MUSEUM OF
 MODERN AND CONTEMPORARY ART, SEOUL
 (MMCA), 2022
· IMAGE COURTESY OF NATIONAL MUSEUM
 OF MODERN AND CONTEMPORARY ART,
 KOREA (MMCA)
· PHOTOGRAPHY BY HONG CHEOLKI
· COURTESY OF THE ARTIST, ANDREW
 KREPS GALLERY, NEW YORK AND ESTHER
 SCHIPPER, BERLIN

P.262
〈스트라이크〉, 2010
· 단채널 HD 디지털 비디오, 컬러, 사운드,
 28초
· 레이나 소피아 미술관 전시 전경,
 마드리드, 2015
· 작가, 앤드류 크랩스 갤러리, 뉴욕 및
 에스더 쉬퍼, 베를린 제공

STRIKE, 2010
SINGLE-CHANNEL HD DIGITAL VIDEO,
COLOR, SOUND, FLAT SCREEN MOUNTED
ON TWO FREE STANDING POLES, 28 SEC.
· INSTALLATION VIEW OF MUSEO NACIONAL
 CENTRO DE ARTE REINA SOFÍA, MADRID,
 2015
· IMAGE COURTESY OF THE ARTIST,
 ANDREW KREPS GALLERY, NEW YORK
 AND ESTHER SCHIPPER, BERLIN

P.263
〈스트라이크〉, 2010
· 단채널 HD 디지털 비디오, 컬러, 사운드,
 28초
· 반아베 미술관 전시 전경, 아인트호벤,
 2014
· 작가, 앤드류 크랩스 갤러리,
 뉴욕 및 에스더 쉬퍼, 베를린 제공
· 사진: PETER COX

STRIKE, 2010
· SINGLE-CHANNEL HD DIGITAL VIDEO,
 COLOR, SOUND, FLAT SCREEN MOUNTED
 ON TWO FREE STANDING POLES, 28 SEC.
· INSTALLATION VIEW OF VAN
 ABBEMUSEUM, EINDHOVEN, 2014
· IMAGE COURTESY OF THE ARTIST,
 ANDREW KREPS GALLERY, NEW YORK
 AND ESTHER SCHIPPER, BERLIN
· PHOTOGRAPHY BY PETER COX

P.265
〈스트라이크〉, 2010
· 단채널 HD 디지털 비디오, 컬러, 사운드,
 28초
· 이미지 CC 4.0 히토 슈타이얼
· 작가, 앤드류 크랩스 갤러리, 뉴욕 및
 에스더 쉬퍼, 베를린 제공

STRIKE, 2010
SINGLE-CHANNEL HD DIGITAL VIDEO,
COLOR, SOUND, FLAT SCREEN MOUNTED
ON TWO FREE STANDING POLES, 28 SEC.
· IMAGE CC 4.0 HITO STEYERL
· IMAGE COURTESY OF THE ARTIST,
 ANDREW KREPS GALLERY, NEW YORK AND
 ESTHER SCHIPPER, BERLIN

PP.266-279
타워
THE TOWER

PP.267-275
〈타워〉, 2015
· 3채널 HD 비디오 설치, 컬러, 사운드,
 6분 55초
· 《히토 슈타이얼-데이터의 바다》 전시 전경,
 국립현대미술관, 서울, 2022
· 국립현대미술관 사진 제공
· 사진: 홍철기

THE TOWER, 2015
· THREE-CHANNEL HD VIDEO
 INSTALLATION, COLOR, SOUND,
 ENVIRONMENT, 6 MIN. 55 SEC.
· INSTALLATION VIEW OF HITO STEYERL-
 A SEA OF DATA, NATIONAL MUSEUM OF
 MODERN AND CONTEMPORARY ART, SEOUL
 (MMCA), 2022
· IMAGE COURTESY OF NATIONAL MUSEUM
 OF MODERN AND CONTEMPORARY ART,
 KOREA (MMCA)
· PHOTOGRAPHY BY HONG CHEOLKI
· COURTESY OF THE ARTIST, ANDREW
 KREPS GALLERY, NEW YORK AND ESTHER
 SCHIPPER, BERLIN

P.276
〈타워〉, 2015
· 3채널 HD 비디오 설치, 컬러, 사운드,
 6분 55초
· 온타리오 미술관 전시 전경, 토론토, 2019
· 작가, 앤드류 크랩스 갤러리,
 뉴욕 및 에스더 쉬퍼, 베를린 제공
· 사진: DEAN TOMLINSON.
 © ART GALLERY OF ONTARIO

THE TOWER, 2015
- THREE-CHANNEL HD VIDEO
INSTALLATION, COLOR, SOUND,
ENVIRONMENT, 6 MIN. 55 SEC.
- INSTALLATION VIEW OF ART GALLERY OF
ONTARIO, TORONTO, 2019
- IMAGE COURTESY OF THE ARTIST,
ANDREW KREPS GALLERY, NEW YORK,
AND ESTHER SCHIPPER, BERLIN
- PHOTOGRAPHY BY DEAN TOMLINSON.
© ART GALLERY OF ONTARIO

P.276
〈타워〉, 2015
- 3채널 HD 비디오 설치, 컬러, 사운드,
6분 55초
- 아로스 오르후스 미술관, 오르후스, 2019
- 작가, 아로스 오르후스 미술관, 오르후스,
앤드류 크랩스 갤러리, 뉴욕 및 에스더
쉬퍼, 베를린 제공
- 사진: ANDERS SUNE BERG

THE TOWER, 2015
- THREE-CHANNEL HD VIDEO
INSTALLATION, COLOR, SOUND,
ENVIRONMENT, 6 MIN. 55 SEC.
- INSTALLATION VIEW OF *TOMORROW IS
THE QUESTION*, AROS ART MUSEUM,
AARHUS, 2019
- IMAGE COURTESY OF THE ARTIST,
AROS ART MUSEUM, AARHUS, ANDREW
KREPS GALLERY, NEW YORK AND ESTHER
SCHIPPER, BERLIN
- PHOTOGRAPHY BY ANDERS SUNE BERG

P.277
〈타워〉, 2015
- 3채널 HD 비디오 설치, 컬러, 사운드,
6분 55초
- 레이나 소피아 미술관 전시 전경,
마드리드, 2015
- 작가, 앤드류 크랩스 갤러리,
뉴욕 및 에스더 쉬퍼, 베를린 제공

THE TOWER, 2015
- THREE-CHANNEL HD VIDEO
INSTALLATION, COLOR, SOUND,
ENVIRONMENT, 6 MIN. 55 SEC.
- INSTALLATION VIEW OF MUSEO NACIONAL
CENTRO DE ARTE REINA SOFÍA,
MADRID, 2015
- IMAGE COURTESY OF THE ARTIST,
ANDREW KREPS GALLERY, NEW YORK
AND ESTHER SCHIPPER, BERLIN

PP.278-279
〈타워〉, 2015
- 3채널 HD 비디오 설치, 컬러, 사운드,
6분 55초
- 이미지 CC 4.0 히토 슈타이얼
- 작가, 앤드류 크랩스 갤러리, 뉴욕 및
에스더 쉬퍼, 베를린 제공

THE TOWER, 2015
- THREE-CHANNEL HD VIDEO
INSTALLATION, COLOR, SOUND,
ENVIRONMENT, 6 MIN. 55 SEC.
- IMAGE CC 4.0 HITO STEYERL
IMAGE COURTESY OF THE ARTIST,
ANDREW KREPS GALLERY, NEW YORK AND
ESTHER SCHIPPER, BERLIN

PP.280-297
HELL YEAH WE FUCK DIE

PP.281-289
〈HELL YEAH WE FUCK DIE〉, 2016
- 비디오 설치
〈HELL YEAH WE FUCK DIE〉, 2016, 3채널
HD 비디오, 컬러, 사운드, 4분 35초
〈오늘날의 로봇〉, 2016, 단채널 HD
비디오, 컬러, 사운드, 8분 2초
- 《히토 슈타이얼-데이터의 바다》 전시 전경,
국립현대미술관, 서울, 2022
- 국립현대미술관 사진 제공
- 사진: 홍철기

HELL YEAH WE FUCK DIE, 2016
- VIDEO INSTALLATION, ENVIRONMENT
HELL YEAH WE FUCK DIE, 2016,
THREE-CHANNEL HD VIDEO, COLOR,
SOUND, 4 MIN. 35 SEC.
ROBOTS TODAY, 2016, SINGLE-CHANNEL
HD VIDEO, COLOR, SOUND, 8 MIN.
2 SEC.
- INSTALLATION VIEW OF *HITO STEYERL-
A SEA OF DATA*, NATIONAL MUSEUM OF
MODERN AND CONTEMPORARY ART, SEOUL
(MMCA), 2022
- IMAGE COURTESY OF NATIONAL MUSEUM
OF MODERN AND CONTEMPORARY ART,
KOREA (MMCA)
- PHOTOGRAPHY BY HONG CHEOLKI
COURTESY OF THE ARTIST, ANDREW
KREPS GALLERY, NEW YORK AND ESTHER
SCHIPPER, BERLIN

P.290
〈HELL YEAH WE FUCK DIE〉, 2016
- 비디오 설치
〈HELL YEAH WE FUCK DIE〉, 2016, 3채널
HD 비디오, 컬러, 사운드, 4분 35초
〈오늘날의 로봇〉, 2016, 단채널 HD
비디오, 컬러, 사운드, 8분 2초
- 쿤스트뮤지엄 바젤 전시 전경, 바젤, 2018
- 작가, 앤드류 크랩스 갤러리,
뉴욕 및 에스더 쉬퍼, 베를린 제공
- 사진: JULIAN SALINAS

HELL YEAH WE FUCK DIE, 2016
- VIDEO INSTALLATION, ENVIRONMENT
HELL YEAH WE FUCK DIE, 2016,
THREE-CHANNEL HD VIDEO, COLOR,
SOUND, 4 MIN. 35 SEC.
ROBOTS TODAY, 2016, SINGLE-CHANNEL
HD VIDEO, COLOR, SOUND, 8 MIN.
2 SEC.
- INSTALLATION VIEW OF KUNSTMUSEUM
BASEL, 2018
- IMAGE COURTESY OF THE ARTIST,
ANDREW KREPS GALLERY, NEW YORK
AND ESTHER SCHIPPER, BERLIN
- PHOTOGRAPHY BY JULIAN SALINAS

P.291
〈HELL YEAH WE FUCK DIE〉, 2016
- 비디오 설치
〈HELL YEAH WE FUCK DIE〉, 2016, 3채널
HD 비디오, 컬러, 사운드, 4분 35초
〈오늘날의 로봇〉, 2016, 단채널 HD
비디오, 컬러, 사운드, 8분 2초
- 제32회 상파울루 비엔날레 전시 전경,
2016
- 작가, 앤드류 크랩스 갤러리,
뉴욕 및 에스더 쉬퍼, 베를린 제공
- 사진: LEO ELOY/ESTÚDIO GARAGEM

HELL YEAH WE FUCK DIE, 2016
- VIDEO INSTALLATION, ENVIRONMENT
HELL YEAH WE FUCK DIE, 2016,
THREE-CHANNEL HD VIDEO, COLOR,
SOUND, 4 MIN. 35 SEC.
ROBOTS TODAY, 2016, SINGLE-CHANNEL
HD VIDEO, COLOR, SOUND, 8 MIN.
2 SEC.
- INSTALLATION VIEW OF 32ND BIENAL
DE SÃO PAULO, 2016
- IMAGE COURTESY OF THE ARTIST,
ANDREW KREPS GALLERY, NEW YORK
AND ESTHER SCHIPPER, BERLIN
- PHOTOGRAPHY BY LEO ELOY/ESTÚDIO
GARAGEM

P.292
〈HELL YEAH WE FUCK DIE〉, 2016
· 비디오 설치
〈HELL YEAH WE FUCK DIE〉, 2016, 3채널
HD 비디오, 컬러, 사운드, 4분 35초
〈오늘날의 로봇〉, 2016, 단채널 HD
비디오, 컬러, 사운드, 8분 2초
· 뮌스터 조각 프로젝트 전시 전경, 2017
· 작가, 앤드류 크랩스 갤러리,
뉴욕 및 에스더 쉬퍼, 베를린 제공
· 사진: HENNING ROGGE

HELL YEAH WE FUCK DIE, 2016
· VIDEO INSTALLATION, ENVIRONMENT
HELL YEAH WE FUCK DIE, 2016,
THREE-CHANNEL HD VIDEO, COLOR,
SOUND, 4 MIN. 35 SEC.
ROBOTS TODAY, 2016, SINGLE-CHANNEL
HD VIDEO, COLOR, SOUND, 8 MIN.
2 SEC.
· INSTALLATION VIEW OF SKULPTURE
PROJEKTE MÜNSTER, 2017
· IMAGE COURTESY OF THE ARTIST,
ANDREW KREPS GALLERY, NEW YORK
AND ESTHER SCHIPPER, BERLIN
· PHOTOGRAPHY BY HENNING ROGGE

PP.294-297
〈HELL YEAH WE FUCK DIE〉, 2016
· 비디오 설치
〈HELL YEAH WE FUCK DIE〉, 2016, 3채널
HD 비디오, 컬러, 사운드, 4분 35초
〈오늘날의 로봇〉, 2016, 단채널 HD
비디오, 컬러, 사운드, 8분 2초
· 이미지 CC 4.0 히토 슈타이얼
· 작가, 앤드류 크랩스 갤러리, 뉴욕 및
에스더 쉬퍼, 베를린 제공

HELL YEAH WE FUCK DIE, 2016
· VIDEO INSTALLATION, ENVIRONMENT
HELL YEAH WE FUCK DIE, 2016,
THREE-CHANNEL HD VIDEO, COLOR,
SOUND, 4 MIN. 35 SEC.
ROBOTS TODAY, 2016, SINGLE-CHANNEL
HD VIDEO, COLOR, SOUND, 8 MIN.
2 SEC.
· IMAGE CC 4.0 HITO STEYERL
· IMAGE COURTESY OF THE ARTIST,
ANDREW KREPS GALLERY, NEW YORK AND
ESTHER SCHIPPER, BERLIN

PP.298-299
프로토타입1.0과 1.1
PROTOTYPE 1.0 AND 1.1

PP.298-299
〈프로토타입1.0과 1.1〉, 2017
· 폼, 알루미늄, 55.9×121.9×400.1CM,
167×41.9×20CM
· 《히토 슈타이얼-데이터의 바다》 전시 전경,
국립현대미술관, 서울, 2022
· 국립현대미술관 사진 제공
· 사진: 홍철기

PROTOTYPE 1.0 AND 1.1, 2017
· FOAM AND ALUMINUM,
55.9×121.9×400.1CM, 167×41.9×20CM
· INSTALLATION VIEW OF HITO STEYERL-
A SEA OF DATA, NATIONAL MUSEUM OF
MODERN AND CONTEMPORARY ART, SEOUL
(MMCA), 2022
IMAGE COURTESY OF NATIONAL MUSEUM
OF MODERN AND CONTEMPORARY ART,
KOREA (MMCA)
PHOTOGRAPHY BY HONG CHEOLKI
COURTESY OF THE ARTIST, ANDREW
KREPS GALLERY, NEW YORK AND ESTHER
SCHIPPER, BERLIN

PP.300-309
면세 미술
DUTY FREE ART

PP.301-303
〈면세 미술〉, 2015
· 뉴욕, 아티스트 스페이스에서 진행한
강연 기록(2015년 3월), 3채널 HD 디지털
비디오, 컬러, 사운드, 샌드박스,
38분 21초
· 《히토 슈타이얼-데이터의 바다》 전시 전경,
국립현대미술관, 서울, 2022
· 국립현대미술관 사진 제공
· 사진: 홍철기

DUTY FREE ART, 2015
· DOCUMENTATION OF A LECTURE GIVEN
AT ARTISTS SPACE, NEW YORK, MARCH
2015, THREE-CHANNEL HD DIGITAL
VIDEO, COLOR, SOUND, SANDBOX,
38 MIN. 21 SEC.
· INSTALLATION VIEW OF HITO STEYERL-
A SEA OF DATA, NATIONAL MUSEUM OF
MODERN AND CONTEMPORARY ART, SEOUL
(MMCA), 2022
· COURTESY OF NATIONAL MUSEUM OF
MODERN AND CONTEMPORARY ART, KOREA
(MMCA)
· PHOTOGRAPHY BY HONG CHEOLKI
· IMAGE COURTESY OF THE ARTIST,
ANDREW KREPS GALLERY, NEW YORK AND
ESTHER SCHIPPER, BERLIN

P.304
〈면세 미술〉, 2015
· 뉴욕, 아티스트 스페이스에서 진행한
강연 기록(2015년 3월), 3채널 HD 디지털
비디오, 컬러, 사운드, 샌드박스,
38분 21초
· 레이나 소피아 미술관 전시 전경,
마드리드, 2015
· 작가 소장

DUTY FREE ART, 2015
· DOCUMENTATION OF A LECTURE GIVEN
AT ARTISTS SPACE, NEW YORK, MARCH
2015, THREE-CHANNEL HD DIGITAL
VIDEO, COLOR, SOUND, SANDBOX,
38 MIN. 21 SEC.
· INSTALLATION VIEW OF MUSEO NACIONAL
CENTRO DE ARTE REINA SOFÍA,
MADRID, 2015
· IMAGE COURTESY OF THE ARTIST

P.305
〈면세 미술〉, 2015
· 뉴욕, 아티스트 스페이스에서 진행한
강연 기록(2015년 3월), 3채널 HD 디지털
비디오, 컬러, 사운드, 샌드박스,
38분 21초
· 아티스트 스페이스 전시 전경, 뉴욕, 2015
· 작가 소장
· 사진: MATTHEW SEPTIMUS

DUTY FREE ART, 2015
- DOCUMENTATION OF A LECTURE GIVEN
 AT ARTISTS SPACE, NEW YORK, MARCH
 2015, THREE-CHANNEL HD DIGITAL
 VIDEO, COLOR, SOUND, SANDBOX,
 38 MIN. 21 SEC.
- INSTALLATION VIEW OF ARTISTS SPACE,
 NEW YORK, 2015
- IMAGE COURTESY OF THE ARTIST
- PHOTOGRAPHY BY MATTHEW SEPTIMUS

P.307
〈면세 미술〉, 2015
- 뉴욕, 아티스트 스페이스에서 진행한
 강연 기록(2015년 3월), 3채널 HD 디지털
 비디오, 컬러, 사운드, 샌드박스,
 38분 21초
- 쿤스트뮤지엄 바젤 전시 전경, 바젤, 2018
- 작가 소장
- 사진: JULIAN SALINAS

DUTY FREE ART, 2015
- DOCUMENTATION OF A LECTURE GIVEN
 AT ARTISTS SPACE, NEW YORK, MARCH
 2015, THREE-CHANNEL HD DIGITAL
 VIDEO, COLOR, SOUND, SANDBOX,
 38 MIN. 21 SEC.
- INSTALLATION VIEW OF KUNSTMUSEUM
 BASEL, 2018
- IMAGE COURTESY OF THE ARTIST
- PHOTOGRAPHY BY JULIAN SALINAS

PP.308-309
〈면세 미술〉, 2015
- 뉴욕, 아티스트 스페이스에서 진행한
 강연 기록(2015년 3월), 3채널 HD 디지털
 비디오, 컬러, 사운드, 샌드박스,
 38분 21초
- 이미지 CC 4.0 히토 슈타이얼
- 작가 소장

DUTY FREE ART, 2015
- DOCUMENTATION OF A LECTURE GIVEN
 AT ARTISTS SPACE, NEW YORK, MARCH
 2015, THREE-CHANNEL HD DIGITAL
 VIDEO, COLOR, SOUND, SANDBOX,
 38 MIN. 21 SEC.
- IMAGE CC 4.0 HITO STEYERL
- IMAGE COURTESY OF THE ARTIST

PP.310-319
경호원들
GUARDS

PP.311-315
〈경호원들〉, 2012
- 단채널 HD 비디오, 컬러, 사운드, 20분
- 《히토 슈타이얼-데이터의 바다》 전시 전경,
 국립현대미술관, 서울, 2022
- 국립현대미술관 사진 제공
- 사진: 홍철기

GUARDS, 2012
- SINGLE-CHANNEL HD VIDEO, COLOR,
 SOUND, 20 MIN.
- INSTALLATION VIEW OF *HITO STEYERL-
 A SEA OF DATA*, NATIONAL MUSEUM OF
 MODERN AND CONTEMPORARY ART, SEOUL
 (MMCA), 2022
- IMAGE COURTESY OF NATIONAL MUSEUM
 OF MODERN AND CONTEMPORARY ART,
 KOREA (MMCA)
- PHOTOGRAPHY BY HONG CHEOLKI
- COURTESY OF THE ARTIST, ANDREW
 KREPS GALLERY, NEW YORK AND ESTHER
 SCHIPPER, BERLIN

P.316
〈경호원들〉, 2012
- 단채널 HD 비디오, 컬러, 사운드, 20분
- 아티스트 스페이스 전시 전경, 뉴욕, 2015
- 작가, 앤드류 크랩스 갤러리,
 뉴욕 및 에스더 쉬퍼, 베를린 제공
- 사진: MATTHEW SEPTIMUS

GUARDS, 2012
- SINGLE-CHANNEL HD VIDEO, COLOR,
 SOUND, 20 MIN.
- INSTALLATION VIEW OF ARTISTS SPACE,
 NEW YORK, 2015
- IMAGE COURTESY OF THE ARTIST,
 ANDREW KREPS GALLERY, NEW YORK
 AND ESTHER SCHIPPER, BERLIN
- PHOTOGRAPHY BY MATTHEW SEPTIMUS

P.317
〈경호원들〉, 2012
- 단채널 HD 비디오, 컬러, 사운드, 20분
- 반아베 미술관 전시 전경, 아인트호벤,
 2014
- 작가, 앤드류 크랩스 갤러리,
 뉴욕 및 에스더 쉬퍼, 베를린 제공
- 사진: PETER COX

GUARDS, 2012
- SINGLE-CHANNEL HD VIDEO, COLOR,
 SOUND, 20 MIN.
- INSTALLATION VIEW OF VAN
 ABBEMUSEUM, EINDHOVEN, 2014
- IMAGE COURTESY OF THE ARTIST,
 ANDREW KREPS GALLERY, NEW YORK
 AND ESTHER SCHIPPER, BERLIN
- PHOTOGRAPHY BY PETER COX

PP.318-319
〈경호원들〉, 2012
- 단채널 HD 비디오, 컬러, 사운드, 20분
- 이미지 CC 4.0 히토 슈타이얼
- 작가, 앤드류 크랩스 갤러리, 뉴욕 및
 에스더 쉬퍼, 베를린 제공

GUARDS, 2012
- SINGLE-CHANNEL HD VIDEO, COLOR,
 SOUND, 20 MIN.
- IMAGE CC 4.0 HITO STEYERL
- IMAGE COURTESY OF THE ARTIST,
 ANDREW KREPS GALLERY, NEW YORK AND
 ESTHER SCHIPPER, BERLIN

PP.378-387
유동성 주식회사
LIQUIDITY INC.

PP.379-383
〈유동성 주식회사〉, 2014
- 단채널 HD 디지털 비디오 설치, 컬러,
 사운드, 30분 15초
- 국립현대미술관 소장
- 《히토 슈타이얼-데이터의 바다》 전시 전경,
 국립현대미술관, 서울, 2022
- 국립현대미술관 사진 제공
- 사진: 홍철기

LIQUIDITY INC., 2014
- SINGLE-CHANNEL HD DIGITAL VIDEO,
 COLOR, SOUND IN ARCHITECTURAL
 ENVIRONMENT, 30 MIN. 15 SEC.
- MMCA COLLECTION
- INSTALLATION VIEW OF *HITO STEYERL-
 A SEA OF DATA*, NATIONAL MUSEUM OF
 MODERN AND CONTEMPORARY ART, SEOUL
 (MMCA), 2022
- IMAGE COURTESY OF NATIONAL MUSEUM
 OF MODERN AND CONTEMPORARY ART,
 KOREA (MMCA)
- PHOTOGRAPHY BY HONG CHEOLKI
- COURTESY OF THE ARTIST, ANDREW
 KREPS GALLERY, NEW YORK AND ESTHER
 SCHIPPER, BERLIN

P.384
〈유동성 주식회사〉, 2014
· 단채널 HD 디지털 비디오 설치, 컬러,
 사운드, 30분 15초
· 온타리오 미술관 전시 전경, 토론토, 2019
· 작가, 앤드류 크랩스 갤러리,
 뉴욕 및 에스더 쉬퍼, 베를린 제공
· 사진: DEAN TOMLINSON.
 ⓒ ART GALLERY OF ONTARIO

LIQUIDITY INC., 2014
· SINGLE-CHANNEL HD DIGITAL VIDEO,
 COLOR, SOUND IN ARCHITECTURAL
 ENVIRONMENT, 30 MIN. 15 SEC.
· INSTALLATION VIEW OF ART GALLERY OF
 ONTARIO, TORONTO, 2019
· IMAGE COURTESY OF THE ARTIST,
 ANDREW KREPS GALLERY, NEW YORK,
 AND ESTHER SCHIPPER, BERLIN
· PHOTOGRAPHY BY DEAN TOMLINSON.
 ⓒ ART GALLERY OF ONTARIO

P.385
〈유동성 주식회사〉, 2014
· 단채널 HD 디지털 비디오 설치, 컬러,
 사운드, 30분 15초
· 아티스트 스페이스 전시 전경, 뉴욕, 2015
· 작가, 앤드류 크랩스 갤러리,
 뉴욕 및 에스더 쉬퍼, 베를린 제공
· 사진: MATTHEW SEPTIMUS
LIQUIDITY INC., 2014
· SINGLE-CHANNEL HD DIGITAL VIDEO,
 COLOR, SOUND IN ARCHITECTURAL
 ENVIRONMENT, 30 MIN. 15 SEC.
· INSTALLATION VIEW OF ARTISTS SPACE,
 NEW YORK, 2015
· IMAGE COURTESY OF THE ARTIST,
 ANDREW KREPS GALLERY, NEW YORK
 AND ESTHER SCHIPPER, BERLIN
· PHOTOGRAPHY BY MATTHEW SEPTIMUS

PP.386-387
〈유동성 주식회사〉, 2014
· 단채널 HD 디지털 비디오 설치, 컬러,
 사운드, 30분 15초
· 이미지 CC 4.0 히토 슈타이얼
· 작가, 앤드류 크랩스 갤러리, 뉴욕 및
 에스더 쉬퍼, 베를린 제공

LIQUIDITY INC., 2014
· SINGLE-CHANNEL HD DIGITAL VIDEO,
 COLOR, SOUND IN ARCHITECTURAL
 ENVIRONMENT, 30 MIN. 15 SEC.
· IMAGE CC 4.0 HITO STEYERL
 IMAGE COURTESY OF THE ARTIST,
 ANDREW KREPS GALLERY, NEW YORK AND
 ESTHER SCHIPPER, BERLIN

PP.388-399
자유낙하
IN FREE FALL

PP.389-395
〈자유낙하〉, 2010
· 단채널 HD 디지털 비디오, 컬러,
 사운드, 33분 43초
· 《히토 슈타이얼-데이터의 바다》 전시 전경,
 국립현대미술관, 서울, 2022
· 국립현대미술관 사진 제공
· 사진: 홍철기

IN FREE FALL, 2010
· SINGLE-CHANNEL HD DIGITAL VIDEO,
 COLOR, SOUND, 33 MIN. 43 SEC.
· INSTALLATION VIEW OF HITO STEYERL-
 A SEA OF DATA, NATIONAL MUSEUM OF
 MODERN AND CONTEMPORARY ART, SEOUL
 (MMCA), 2022
· IMAGE COURTESY OF NATIONAL MUSEUM
 OF MODERN AND CONTEMPORARY ART,
 KOREA (MMCA)
· PHOTOGRAPHY BY HONG CHEOLKI
 COURTESY OF THE ARTIST, ANDREW
 KREPS GALLERY, NEW YORK AND ESTHER
 SCHIPPER, BERLIN

P.396
〈자유낙하〉, 2010
· 단채널 HD 디지털 비디오, 컬러,
 사운드, 33분 43초
· 레이나 소피아 미술관 전시 전경,
 마드리드, 2015
· 작가, 앤드류 크랩스 갤러리,
 뉴욕 및 에스더 쉬퍼, 베를린 제공

IN FREE FALL, 2010
· SINGLE-CHANNEL HD DIGITAL VIDEO,
 COLOR, SOUND, 33 MIN. 43 SEC.
· INSTALLATION VIEW OF MUSEO NACIONAL
 CENTRO DE ARTE REINA SOFÍA,
 MADRID, 2015
· IMAGE COURTESY OF THE ARTIST,
 ANDREW KREPS GALLERY, NEW YORK
 AND ESTHER SCHIPPER, BERLIN

P.397
〈자유낙하〉, 2010
· 단채널 HD 디지털 비디오, 컬러,
 사운드, 33분 43초
· 아티스트 스페이스 전시 전경, 뉴욕, 2015
· 작가, 앤드류 크랩스 갤러리, 뉴욕 및
 에스더 쉬퍼, 베를린 제공
· 사진: MATTHEW SEPTIMUS

IN FREE FALL, 2010
· SINGLE-CHANNEL HD DIGITAL VIDEO,
 COLOR, SOUND, 33 MIN. 43 SEC.
· INSTALLATION VIEW OF ARTISTS SPACE,
 NEW YORK, 2015
· IMAGE COURTESY OF THE ARTIST,
 ANDREW KREPS GALLERY, NEW YORK
 AND ESTHER SCHIPPER, BERLIN
· PHOTOGRAPHY BY MATTHEW SEPTIMUS

PP.398-399
〈자유낙하〉, 2010
· 단채널 HD 디지털 비디오, 컬러,
 사운드, 33분 43초
· 이미지 CC 4.0 히토 슈타이얼
· 작가, 앤드류 크랩스 갤러리, 뉴욕 및
 에스더 쉬퍼, 베를린 제공

IN FREE FALL, 2010
· SINGLE-CHANNEL HD DIGITAL VIDEO,
 COLOR, SOUND, 33 MIN. 43 SEC.
· IMAGE CC 4.0 HITO STEYERL
· IMAGE COURTESY OF THE ARTIST,
 ANDREW KREPS GALLERY, NEW YORK AND
 ESTHER SCHIPPER, BERLIN

PP.434-435, 440-445
독일과 정체성
GERMANY AND IDENTITY

PP.440-445
〈독일과 정체성〉, 1994
· 16 MM 필름(비디오로 재생), 컬러,
 사운드, 42분
· 《히토 슈타이얼-데이터의 바다》 전시 전경,
 국립현대미술관, 서울, 2022
· 국립현대미술관 사진 제공
· 사진: 홍철기

GERMANY AND IDENTITY, 1994
- 16 MM FILM (SHOWN AS VIDEO), COLOR, SOUND, 42 MIN.
- INSTALLATION VIEW OF HITO STEYERL- A SEA OF DATA, NATIONAL MUSEUM OF MODERN AND CONTEMPORARY ART, SEOUL (MMCA), 2022
- IMAGE COURTESY OF NATIONAL MUSEUM OF MODERN AND CONTEMPORARY ART, KOREA (MMCA)
- PHOTOGRAPHY BY HONG CHEOLKI
- COURTESY OF THE ARTIST, ANDREW KREPS GALLERY, NEW YORK AND ESTHER SCHIPPER, BERLIN

P.435
⟨독일과 정체성⟩, 1994
- 16 MM 필름(비디오로 재생), 컬러, 사운드, 42분
- 이미지 CC 4.0 히토 슈타이얼
- 작가 소장

GERMANY AND IDENTITY, 1994
- 16 MM FILM (SHOWN AS VIDEO), COLOR, SOUND, 42 MIN.
- IMAGE CC 4.0 HITO STEYERL
- COURTESY OF THE ARTIST

PP.436-437, 440-445
바벤하우젠
BABENHAUSEN

PP.440-445
⟨바벤하우젠⟩, 1997
- 베타 SP, 컬러, 사운드, 4분 4초
- 《히토 슈타이얼-데이터의 바다》 전시 전경, 국립현대미술관, 서울, 2022
- 국립현대미술관 사진 제공
- 사진: 홍철기

BABENHAUSEN, 1997
- BETA SP, COLOR, SOUND, 4 MIN. 4 SEC.
- INSTALLATION VIEW OF HITO STEYERL- A SEA OF DATA, NATIONAL MUSEUM OF MODERN AND CONTEMPORARY ART, SEOUL (MMCA), 2022
- IMAGE COURTESY OF NATIONAL MUSEUM OF MODERN AND CONTEMPORARY ART, KOREA (MMCA)
- PHOTOGRAPHY BY HONG CHEOLKI
- COURTESY OF THE ARTIST, ANDREW KREPS GALLERY, NEW YORK AND ESTHER SCHIPPER, BERLIN

PP.437-439
⟨바벤하우젠⟩, 1994
- 베타 SP, 컬러, 사운드, 4분 4초
- 이미지 CC 4.0 히토 슈타이얼
- 작가 소장

BABENHAUSEN, 1994
- BETA SP, COLOR, SOUND, 4 MIN. 4 SEC.
- IMAGE CC 4.0 HITO STEYERL
- COURTESY OF THE ARTIST

PP.446-455
비어 있는 중심
THE EMPTY CENTRE

PP.450-455
⟨비어 있는 중심⟩, 1998
- 16 MM 필름(비디오로 재생), 컬러, 사운드, 62분
- 《히토 슈타이얼-데이터의 바다》 전시 전경, 국립현대미술관, 서울, 2022
- 국립현대미술관 사진 제공
- 사진: 홍철기

THE EMPTY CENTRE, 1998
- 16 MM FILM (SHOWN AS VIDEO), COLOR, SOUND, 62 MIN.
- INSTALLATION VIEW OF HITO STEYERL- A SEA OF DATA, NATIONAL MUSEUM OF MODERN AND CONTEMPORARY ART, SEOUL (MMCA), 2022
- IMAGE COURTESY OF NATIONAL MUSEUM OF MODERN AND CONTEMPORARY ART, KOREA (MMCA)
- PHOTOGRAPHY BY HONG CHEOLKI
- COURTESY OF THE ARTIST, ANDREW KREPS GALLERY, NEW YORK AND ESTHER SCHIPPER, BERLIN

PP.447-449
⟨비어 있는 중심⟩, 1998
- 16 MM 필름(비디오로 재생), 컬러, 사운드, 62분
- 이미지 CC 4.0 히토 슈타이얼
- 작가 소장

THE EMPTY CENTRE, 1998
- 16 MM FILM (SHOWN AS VIDEO), COLOR, SOUND, 62 MIN.
- IMAGE CC 4.0 HITO STEYERL
- COURTESY OF THE ARTIST

PP.456-459, 440-445
정상성 1-X
NORMALITY 1-X

PP.440-445
⟨정상성 1-X⟩, 1999
- 베타 SP, 흑백, 컬러, 사운드, 42분
- 《히토 슈타이얼-데이터의 바다》 전시 전경, 국립현대미술관, 서울, 2022
- 국립현대미술관 사진 제공
- 사진: 홍철기

NORMALITY 1-X, 1999
- BETA SP, B&W AND COLOR, SOUND, 42 MIN.
- INSTALLATION VIEW OF HITO STEYERL- A SEA OF DATA, NATIONAL MUSEUM OF MODERN AND CONTEMPORARY ART, SEOUL (MMCA), 2022
- IMAGE COURTESY OF NATIONAL MUSEUM OF MODERN AND CONTEMPORARY ART, KOREA (MMCA)
- PHOTOGRAPHY BY HONG CHEOLKI
- COURTESY OF THE ARTIST, ANDREW KREPS GALLERY, NEW YORK AND ESTHER SCHIPPER, BERLIN

PP.457-459
⟨정상성 1-X⟩, 1999
- 베타 SP, 흑백, 컬러, 사운드, 42분
- 이미지 CC 4.0 히토 슈타이얼
- 작가 소장

NORMALITY 1-X, 1999
- BETA SP, B&W AND COLOR, SOUND, 42 MIN.
- IMAGE CC 4.0 HITO STEYERL
- COURTESY OF THE ARTIST

PP.460-463, 440-445
11월
NOVEMBER

PP.440-445
⟨11월⟩, 2004
- 단채널 디지털 비디오, 컬러, 사운드, 25분 19초
- 《히토 슈타이얼-데이터의 바다》 전시 전경, 국립현대미술관, 서울, 2022
- 국립현대미술관 사진 제공
- 사진: 홍철기

NOVEMBER, 2004
- SINGLE-CHANNEL DIGITAL VIDEO,
 COLOR, SOUND, 25 MIN. 19 SEC.
- INSTALLATION VIEW OF *HITO STEYERL-
 A SEA OF DATA*, NATIONAL MUSEUM OF
 MODERN AND CONTEMPORARY ART, SEOUL
 (MMCA), 2022
- IMAGE COURTESY OF NATIONAL MUSEUM
 OF MODERN AND CONTEMPORARY ART,
 KOREA (MMCA)
- PHOTOGRAPHY BY HONG CHEOLKI
- COURTESY OF THE ARTIST, ANDREW
 KREPS GALLERY, NEW YORK AND ESTHER
 SCHIPPER, BERLIN

PP.461-463
⟨11월⟩, 1999
- 단채널 디지털 비디오, 컬러, 사운드,
 25분 19초
- 이미지 CC 4.0 히토 슈타이얼
- 작가, 앤드류 크랩스 갤러리, 뉴욕 및
 에스더 쉬퍼, 베를린 제공

NOVEMBER, 1999
- SINGLE-CHANNEL DIGITAL VIDEO,
 COLOR, SOUND, 25 MIN. 19 SEC.
- IMAGE CC 4.0 HITO STEYERL
- IMAGE COURTESY OF THE ARTIST,
 ANDREW KREPS GALLERY, NEW YORK AND
 ESTHER SCHIPPER, BERLIN

PP.464-467
러블리 안드레아
LOVELY ANDREA

PP.465-467
⟨러블리 안드레아⟩, 2007
- 단채널 디지털 비디오, 컬러,
 사운드, 29분 43초
- 이미지 CC 4.0 히토 슈타이얼
- 작가, 앤드류 크랩스 갤러리, 뉴욕 및
 에스더 쉬퍼, 베를린 제공

LOVELY ANDREA, 2007
- SINGLE-CHANNEL DIGITAL VIDEO,
 COLOR, SOUND, 29 MIN. 43 SEC.
- IMAGE CC 4.0 HITO STEYERL
- IMAGE COURTESY OF THE ARTIST,
 ANDREW KREPS GALLERY, NEW YORK AND
 ESTHER SCHIPPER, BERLIN

PP.468-471
저널 NO.1
JOURNAL NO.1

PP.469-471
⟨저널 NO.1⟩, 1999
- 단채널 비디오, 흑백, 컬러, 사운드, 22분
- 이미지 CC 4.0 히토 슈타이얼
- 작가 소장

JOURNAL NO.1, 1999
- SINGLE-CHANNEL VIDEO, B&W AND
 COLOR, SOUND, 22 MIN.
- IMAGE CC 4.0 HITO STEYERL
- COURTESY OF THE ARTIST

PP.472-473
아도르노의 그레이
ADORNO'S GREY

P.473
⟨아도르노의 그레이⟩, 2012
- 베타 SP, 흑백, 컬러, 사운드, 42분
- 이미지 CC 4.0 히토 슈타이얼
- 작가, 앤드류 크랩스 갤러리, 뉴욕 및
 에스더 쉬퍼, 베를린 제공

ADORNO'S GREY, 2012
- BETA SP, B&W AND COLOR, SOUND,
 42 MIN.
- IMAGE CC 4.0 HITO STEYERL
- IMAGE COURTESY OF THE ARTIST,
 ANDREW KREPS GALLERY, NEW YORK AND
 ESTHER SCHIPPER, BERLIN

김수환은 한국외국어대학교 러시아학과 교수, 러시아학술원 문학연구소 박사이다. 20세기 러시아문학 및 문화 이론을 전공했다. 최근에는 미학과 정치의 상호중첩 및 교차의 관점에서 소비에트의 지적·예술적 유산을 재평가하는 과제에 집중하고 있다. 유리 로트만에 관한 단행본 연구서를 모스크바와 한국에서 출간했으며 다수의 논문을 국내외 학술지에 발표했다. 저서로는 『혁명의 넝마주의』(2022), 『책에 따라 살기』(2015), 『사유하는 구조』(2011) 등이 있으며, 옮긴 책으로 『자본에 대한 노트』(2020), 『모든 것은 영원했다 사라지기 전까지는』(2019), 『코뮤니스트 후기』(2017), 『영화와 의미의 탐구』(2017, 공역), 『문화와 폭발』(2015), 『기호계』(2008) 등이 있다. 최근 논문과 전시로는 「유리집의 문화적 계보학: 에이젠슈테인과 벤야민 겹쳐읽기」(이플럭스 저널, 116호 2021), 「세르게이 트레티야코프 재방문: 발터 벤야민과 히토 슈타이얼의 경우」(이플럭스 저널, 104호 2019), 「아방가르드 뮤지올로지: 폐허에서 건져 올린 다섯 개의 장면들」, 전시 《동시대-예술-비즈니스: 동시대 예술의 새로운 질서들》 (부산현대미술관, 2020-21) 등이 있다.

Soo Hwan Kim is a professor of Russian Studies at the Hankuk University of Foreign Studies, Korea. His scholarly writing revolves around twentieth-century Russian and Soviet cultural theory, especially the semiotics of Yuri Lotman. His interest has gradually moved into the problematics of reevaluating the Soviet legacy in terms of the mutual imbrication between aesthetics and politics. Kim has published monographs on Yuri Lotman and translated works by Sergei Eisenstein, Boris Groys, Mikhail Iampolski, Yuri Lotman, and Alexei Yurchak into Korean. Recent publications and artistic project include: "Sergei Tretyakov Revisited: The Cases of Walter Benjamin and Hito Steyerl," *e-flux journal*, no. 104, 2019; and "Avant-garde Museology: Five Scenes Picked Up From The Ruins," in the exhibition *Contemporary-Art-Business: The New Orders of Contemporary Art* (Museum of Contemporary Art Busan, 2020-21).

김지훈은 영화미디어학자이자 중앙대 교수로 『Documentary's Expanded Fields: New Media and the Twenty-First-Century Documentary』(옥스퍼드 대학교 출판부, 2022), 『Between Film, Video, and the Digital: Hybrid Moving Images in the Post-media Age』(블룸스베리, 2018/16)의 저자다. 현재 세 번째 저서로 한국 다큐멘터리 영화에 대한 최초의 영문 연구서가 될 『Activism and Post-activism: Korean Documentary Cinema, 1981-2021』을 마무리하고 있으며 또 다른 저서인 『The Cinema of Operations: Film and Moving images in the Post-cinematic Condition』을 발전시키고 있다.

Jihoon Kim is associate professor of cinema and media studies at Chung-ang University. He is the author of *Documentary's Expanded Fields: New Media and the Twenty-First-Century Documentary* (Oxford University Press, 2022) and *Between Film, Video, and the Digital: Hybrid Moving Images in the Post-media Age* (Bloomsbury, 2018/16). He is completing his third book, *Activism and Post-activism: Korean Documentary Cinema, 1981-2021*, which will be the first English-written monograph on the subject, while also developing a new book project, *The Cinema of Operations: Film and Moving images in the Post-cinematic Condition*.

노라 M. 알터는 템플대학교에서 영화 및 미디어 아트 교수로 재직 중이며 휘트니 미술관 독립연구프로그램의 상임 교수진이다. 『베트남 시위의 극장: 텔레비전을 통한 전쟁의 상영』(1996), 『역사를 투사하기: 독일 논픽션 영화』(2002), 『크리스 마르케』(2006)를 저술했고, L. 쾨프닉과 함께 『음향의 중요성: 현대 독일 문화에서의 음향학에 대한 에세이』(2004)를, T. 코리건과 함께 『에세이 영화에 대한 에세이』(2017)를 공동 편집했다. 최근에 저술한 책으로 『사실과 허구 이후의 에세이 영화』(2018)가 있다. 영화 및 미디어 연구, 문화 연구, 시각 연구, 동시대 미술에 관한 60편 이상의 에세이를 출간했으며, 여러 동시대 예술가와 영화감독에 대해 글을 썼다. 독일고등교육진흥원(DAAD)이 제정한 독일 및 유럽 연구 장학상을 받았고, 미국 국립인문재단, 하워드 재단, 알렉산더 폰 훔볼트 재단이 수여하는 연간 연구 펠로우십을 수상했다. 2019년에는 앤디 워홀 재단의 아트 라이터스 그랜트를 수상했고, 2021년에는 베를린의 미국 아카데미의 레지던스 프로그램에 다임러 펠로우 자격으로 참여했다. 고인이 된 영화감독이자 미술가 하룬 파로키에 대한 모노그래프 『지성의 형태』에 대한 저술을 최근 마무리했으며, 음향에 관한 새로운 프로젝트를 시작했다.

Nora M. Alter is Professor of Film and Media Arts at Temple University. She is also part of the standing faculty at the Whitney Independent Study Program. She is author of *Vietnam Protest Theatre: The Television War on Stage* (1996), *Projecting History: Non-Fiction German Film* (2002), *Chris Marker* (2006), co-editor with L. Koepnick of *Sound Matters: Essays on the Acoustics of Modern German Culture* (2004), and co-editor with T. Corrigan, *Essays on the Essay Film* (2017). Her most recent book is *The Essay Film After Fact and Fiction* (2018). Alter has published over sixty essays on Film and Media Studies, Cultural and Visual Studies and Contemporary Art. She has written on a wide-range of contemporary artists and filmmakers. She is former recipient of the DAAD Prize for Distinguished Scholarship in German and European Studies and has been awarded year-long research fellowships from the National Endowment for the Humanities, the Howard Foundation and the Alexander von Humboldt Foundation. In 2019 she was received an Art Writers Grant from the Andy Warhol Foundation, and in 2021 she was the Daimler Fellow in residence at the American Academy in Berlin. She has recently completed a monograph on the late filmmaker/artist, Harun Farocki, *Forms of Intelligence* and has begun a new project on sound.

벤자민 브래튼의 작업은 철학, 건축, 컴퓨터 과학에서 지정학에 이르기까지 폭넓게 걸쳐 있다. 캘리포니아 대학교 샌디에이고에서 시각 예술 담당 교수로 재직 중이며, 유럽 대학원 디지털 디자인 교수, SCI-Arc(남가주 건축대학교) 방문 교수, 뉴욕 대학교 상하이에서 예술 담당 교수로 일한다. 2017년부터 2022년까지 모스크바의 스트렐카 인스티튜트에서 '테라포밍'과 '뉴 노멀'이라는 제목의 프로그램을 이끌었다. 『실재의 복수: 팬데믹 이후 세계를 위한 정치』(버소, 2021), 『스택: 소프트웨어와 주권에 관하여』(MIT 프레스, 2016)를 비롯한 다수의 책을 저술했다. 현재 진행 중인 연구에서는 머신 비전에서부터 합성 인지 및 감각, 일상적으로 이뤄지는 지구공학에서 쓰이는 로봇 공학에 관한 거시 경제학 등 인공지능으로 인해 예기치 않게 발생하는 불편한 디자인 과제들을 탐구 중이다.

Benjamin Bratton's work spans philosophy, architecture, computer science and geopolitics. He is Professor of Visual Arts at University of California, San Diego, Professor of Digital Design at The European Graduate School, Visiting Professor at SCI-Arc (The Southern California Institute of Architecture) and Professor of Arts at NYU Shanghai. From 2017-2022, he directed the Terraforming and New Normal programs at the Strelka Institute in Moscow. He is the author of several books, including *The Revenge of The Real: Politics for a Post-Pandemic World* (Verso, 2021), and *The Stack: On Software and Sovereignty* (MIT Press, 2016). His current research project investigates the unexpected and uncomfortable design challenges posed by A.I in various guises: from machine vision to synthetic cognition and sensation, and the macroeconomics of robotics in everyday geoengineering.

웬디 희경 전은 사이먼 프레이저 대학교 커뮤니케이션 학부의 뉴 미디어 부문 캐나다 150주년 연구의장을 맡고 있으며 디지털 민주주의 연구소를 이끌고 있다. 주요 저서로『통제와 자유: 광통신 시대의 권력과 편집증』(MIT 프레스, 2006),『프로그래밍된 시선: 소프트웨어와 기억』(MIT 프레스, 2011),『변하지 않기 위해 업데이트하기: 습관적 뉴 미디어』(MIT 프레스, 2016),『차별하는 데이터』(MIT 프레스, 2021)가 있고,『패턴 차별』(미네소타 대학 출판부 & 메슨 프레스, 2019)에 공저자로 참여했다. 브라운 대학교에서는 20년 가까이 재직하며 현대 문화와 매체학과에서 교수와 학과장을 역임했다. 펜실베이니아 주립대학교 아넨버그 스쿨에서 방문 학자로 연구했고, 프린스턴 고등연구소의 회원이다. 구겐하임 재단, 미국 학술단체협의회, 베를린의 미국 아카데미, 하버드대학 래드클리프 고등연구소에서 펠로우십을 받았다.

Wendy Hui Kyong Chun is Simon Fraser University's Canada 150 Research Chair in New Media and leads the Digital Democracies Institute. She is the author of several works including *Control and Freedom: Power and Paranoia in the Age of Fiber Optics* (MIT Press, 2006), *Programmed Visions: Software and Memory* (MIT Press, 2011), *Updating to Remain the Same: Habitual New Media* (MIT Press, 2016), *Discriminating Data* (MIT Press, 2021), and the co-author of *Pattern Discrimination* (University of Minnesota & Meson Press, 2019). She has been Professor and Chair of the Department of Modern Culture and Media at Brown University, where she worked for almost two decades. She has also been a Visiting Scholar at the Annenberg School at the University of Pennsylvania, Member of the Institute for Advanced Study (Princeton), and she has held fellowships from: the Guggenheim, ACLS, American Academy of Berlin, Radcliffe Institute for Advanced Study at Harvard.

이광석은 테크놀로지, 사회, 생태가 상호 교차하는 접점에 비판적 관심을 갖고 연구, 비평 및 저술 활동을 해오고 있다. 서울과학기술대학교 IT정책대학원 디지털문화정책 전공 교수이며, 비판적 문화이론 저널『문화/과학』의 공동 편집인으로 활동하고 있다. 주요 연구 분야는 기술문화연구, 커먼즈, 플랫폼 노동, 기술 생태정치학, 자동화사회 등에 걸쳐 있다. 저서로는『피지털 커먼즈』,『포스트디지털』, 『디지털의 배신』,『데이터 사회 미학』, 『데이터 사회 비판』,『뉴아트행동주의』, 『사이방가르드』,『디지털 야만』,『옥상의 미학노트』,『IT development in Korea: A Broadband Nirvana?』 등이 있다. 직접 기획하고 엮은 책으로『불순한 테크놀로지』, 『현대 기술·미디어 철학의 갈래들』,『사물에 수작부리기』 등이 있고, 그 외 다수의 국내외 학술 논문과 기고 글이 있다.

Lee Kwang-Suk is a full professor in the Graduate School of Public Policy and Information Technology at Seoul National University of Science and Technology, Seoul, South Korea. His research areas include critical theories of technology, the commons, platform capitalism, Anthropocene, and automatic society. He is the author of several books, *Phygital Commons* (Seoul, 2021), *PostDigital* (Seoul, 2021), *Against Techno-Fetishism* (Seoul, 2020), *Data Aesthetics in Society* (Seoul, 2017), *Rethinking the Datafied Society* (Seoul, 2017), *Aesthetic Notes from the Edge: Art Activism Responding to a Social Crisis* (Seoul, 2016), *New Art Activism: The Cultural Politics in the Era of Post-media* (Seoul, 2015), *Digital Barbarism: Techno-glut, Big Data and Information Disaster* (Seoul, 2014), *IT development in Korea: A Broadband Nirvana?* (London: Routledge, 2012), and *The Art & Cultural Politics of Cyber Avant-gardes* (Seoul, 2010). Lee has contributed numerous columns and essays related to technology and "the social" to newspapers, magazines, and other publications.

히토 슈타이얼-데이터의 바다
HITO STEYERL-A SEA OF DATA

2022.4.29-9.18
국립현대미술관 서울
2,3,4 전시실,
프로젝트 갤러리

관장
윤범모

학예연구실장
직무대리
송수정

현대미술1과장
류지연

학예연구관
박수진

전시 기획
배명지

전시 진행
신기혜, 최한나

전시 디자인
김용주, 윤지원

그래픽 디자인
박휘윤

전시 조성
윤해리, 김정은

운송·설치
이길재, 한지영

기술 감독
마뉴엘 라이나르츠

작품 출납
권성오

작품 보존
범대건, 조인애, 윤보경,
최윤정, 최양호

교육
강지영, 이슬기, 황호경,
윤지영, 최서윤

홍보·마케팅
이성희, 윤승연, 박유리,
채지연, 김홍조, 김민주,
이민지, 기성미, 신나래,
장라윤, 김보윤

고객 지원
이은수, 주다란, 황보경

전시 후원 담당
국립현대미술관 문화재단

교정·교열
강유미

사진
홍철기

영상
RR PRODUCTION

영상 자막
진미디어

전시물 제작
주성디자인랩

후원

신영증권

협찬

동성케미컬

MOORIM
무림페이퍼

협력
GOETHE
INSTITUT

도움
앨리스 콘코니, 앤드류 크랩스 갤러리
온타리오 미술관
울산시립미술관
DIGITAL DEMOCRACIES INSTITUTE

29 APRIL-18 SEPTEMBER, 2022
GALLERY 2,3,4,
PROJECT GALLERY,
NATIONAL MUSEUM OF MODERN AND
CONTEMPORARY ART, SEOUL

DIRECTOR
YOUN BUMMO

ACTING CHIEF CURATOR
SONG SUJONG

HEAD OF EXHIBITION
DEPARTMENT 1
LUI JIENNE

SENIOR CURATOR
PARK SOOJIN

CURATED BY
BAE MYUNGJI

COORDINATED BY
SHIN KIHYE, CHOI HANNA

EXHIBITION DESIGN
KIM YONG-JU, YOON JIWON

GRAPHIC DESIGN
PARK HWIYOUN

EXHIBITION CONSTRUCTION
YUN HAERI, KIM JUNGEUN

TECHNICAL COORDINATION
LEE GILJAE, HAN JIYOUNG

TECHNICAL DIRECTOR
MANUEL REINARTZ

COLLECTION MANAGEMENT
KWON SUNGOH

CONSERVATION
BEOM DAEGON, CHO INAE,
YOON BOKYUNG,
CHOI YOONJEONG,
CHOI YANGHO

EDUCATION
KANG JIYOUNG,
LEE SEULKI,
HWANG HOKYUNG,
YOON JEEYOUNG,
CHOI SEOYOON

PUBLIC COMMUNICATION
AND MARKETING
LEE SUNGHEE, YUN TIFFANY,
PARK YULEE, CHAE JIYEON,
KIM HONGJO, KIM MINJOO,
LEE MINJEE, KI SUNGMI,
SHIN NARAE, JANG LAYOON,
KIM BOYOON

CUSTOMER SERVICE
LEE EUNSU, JU DARAN,
HWANG BOKYUNG

SPONSORSHIP MANAGEMENT
NATIONAL MUSEUM OF MODERN AND
CONTEMPORARY ART FOUNDATION,
KOREA

REVISION
KANG YUMI

PHOTOGRAPHY
HONG CHEOLKI

FILM
RR PRODUCTION

FILM SUBTITLED BY
JINMEDIA

EXHIBITION PRODUCTION
JOOSUNGDESIGNLAB

SPONSORED BY

SUPPORTED BY

COOPERATION WITH

SPECIAL THANKS TO
ALICE CONCONI,
ANDREW KREPS GALLERY
ART GALLERY OF ONTARIO
ULSAN ART MUSEUM
DIGITAL DEMOCRACIES INSTITUTE

히토 슈타이얼-데이터의 바다
HITO STEYERL-A SEA OF DATA

국립현대미술관
National Museum of
Modern and Contemporary Art, Korea

발행인
윤범모

제작총괄
류지연, 박수진

초판 발행
2022년 6월 24일

초판 2쇄
2022년 12월 24일

기획 편집
배명지

공동 편집
장래주

편집 지원
최한나, 신기혜

편집 진행
박활성

디자인
워크룸

글
김수환, 김지훈, 노라 M. 알터,
배명지, 벤자민 브래튼,
웬디 희경 전, 이광석,
히토 슈타이얼

번역
김지훈, 박재용,
앨리스 김, 콜린 모엣

교정·교열
강유미

사진
홍철기

인쇄·제본
세걸음

제작 진행
국립현대미술관 문화재단

이 도록은 무림 종이로
제작되었습니다.
표지: 네오스타백상 260g/㎡
내지1: 네오스타아트 120g/㎡
내지2: 네오스타백상 120g/㎡

ISBN 978-89-6303-317-4
(93600)
값 37,000원

PUBLISHER
YOUN BUMMO

MANAGED BY
LUI JIENNE, PARK SOOJIN

FIRST PUBLISHING DATE
JUNE 24, 2022

SECOND PUBLISHING DATE
DECEMBER 24, 2022

THIS CATALOGUE IS PUBLISHED
ON THE OCCASION OF
HITO STEYERL-A SEA OF DATA
(APRIL 29-SEPTEMBER 18, 2022).

ISBN 978-89-6303-317-4
(93600)
PRICE 37,000 KRW

CHIEF EDITOR
BAE MYUNGJI

CO-EDITOR
JANG RAEJOO

EDITORIAL COORDINATION
CHOI HANNA, SHIN KIHYE

MANAGING EDITOR
PARK HWALSUNG

DESIGN
WORKROOM

TEXT
BAE MYUNGJI, BENJAMIN
BRATTON, HITO STEYERL,
JIHOON KIM, LEE KWANG-SUK,
NORA M. ALTER, SOO HWAN KIM,
WENDY HUI KYONG CHUN

TRANSLATION
JIHOON KIM, PARK JAEYONG,
ALICE. S. KIM, COLIN MOUAT

REVISION
KANG YUMI

PHOTOGRAPHY
HONG CHEOLKI

PRINTING & BINDING
SEGULEUM

PUBLISHED IN ASSOCIATION
WITH NATIONAL MUSEUM OF
MODERN AND CONTEMPORARY
ART FOUNDATION, KOREA

THIS CATALOG IS PRINTED ON
MOORIM PAPER.
COVER: NEOSTAR UNCOATED
PAPER 260g/㎡
BODY1: NEOSTAR GLOSS 120g/㎡
BODY2: NEOSTAR UNCOATED
PAPER 120g/㎡